T0320042

MARKETING MAXIMILIAN

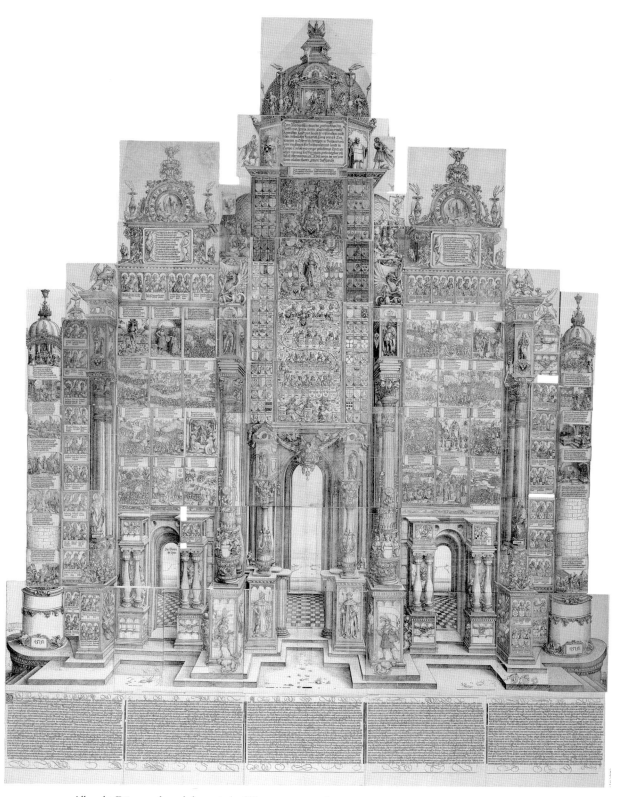

Albrecht Dürer and workshop, *Arch of Honor*, ca. 1515–18.

MARKETING MAXIMILIAN

The Visual Ideology of a Holy Roman Emperor

LARRY SILVER

PRINCETON UNIVERSITY PRESS

Princeton and Oxford

Copyright © 2008 by Princeton University Press
Published by Princeton University Press, 41 William Street, Princeton, New Jersey 08540
In the United Kingdom:
Princeton University Press, 3 Market Place, Woodstock, Oxfordshire OX20 1SY
All Rights Reserved

Library of Congress Cataloging-in-Publication Data

Silver, Larry, 1947–
 Marketing Maximilian : the visual ideology of a Holy Roman Emperor / Larry Silver.
 p. cm.
 Includes bibliographical references and index.
 ISBN 978-0-691-13019-4 (hardcover : alk. paper)
 1. Maximilian I, Holy Roman Emperor, 1459–1519—Art patronage. 2. Art—Political aspects—Holy Roman Empire.
3. Holy Roman Empire—Intellectual life. 4. Holy Roman Empire—History—Maximilian I, 1493–1519. I. Title.
 DD174.3.S45 2008
 943'.029092—dc22
2007028777

British Library Cataloging-in-Publication Data is available

This book has been composed in Bembo
Printed on acid-free paper. ∞

pup.princeton.edu

Printed in Canada
10 9 8 7 6 5 4 3 2 1

Contents

Preface

Outlining the political process of consolidating a permanent state structure around the powerful leadership of a single figure, Max Weber coined the phrase, awkward at first to English ears, "the routinization of charisma." This process can be seen more generally to underlie virtually all central authorities and kingships in world history, accompanied inevitably by ritual in the political process.[1] Although the details of the relationship between a ruler and his or her subjects vary with each instance and evolve over time, the authority of that ruler, even the legitimation of that authority, remains the crucial bedrock of power in the polity.[2] As Clifford Geertz and other cultural anthropologists have reminded us, much authority is consolidated, even engineered, through public manipulation of shared symbols and through appeals to common tradition.[3] Even for the seventeenth-century kingship of Louis XIV, surely the most absolute of absolute rulers in the West, the presentation both of the king's own features and of the symbols of the nation he ruled remained paramount concerns.[4]

For the German-speaking world of Maximilian I of Habsburg, political boundaries and centralized instruments of statecraft were anything but assured. The German regions were radically fractured into a crazy quilt of electorates, duchies, independent imperial cities, and their respective spheres of influence. The German constitution, established by the Golden Bull of Emperor Charles IV in 1356, had guaranteed regional sovereignty to the territories of seven electors, who in turn selected each new emperor: the archbishops of Cologne, Trier, and Mainz, along with the princes of Saxony, Bohemia, Brandenburg, and the Rhineland Palatinate.[5] Indeed, Hajo Holborn has aptly dubbed the Golden Bull as "the Magna Charta of German particularism." Significantly,

despite the power of the Habsburg dynasty in Austria, which had already contributed three emperors prior to Maximilian's own father, and despite the increasing might of the Wittelsbach dynasty in Bavaria, neither territory was granted a role of elector in the new confederation. The sixteenth century would see reconsolidation of territory and power for both regions and families. Yet even when Maximilian succeeded his father, Emperor Frederick III (d. 1493), thereby retaining the title within this Habsburg family line for the first time, the continuity of Habsburg emperors was anything but assured (even though the dynasty would in fact retain control of the imperial title until the end of the First World War).

Moreover, the political power base under the control of the emperor was precarious indeed. He had no authority to tax, and all his own proposed reforms for more centralized imperial authority—whether judicial, financial, or administrative—were roundly rebuffed by the territorial princes who made up the imperial Diet.[6] For a time those princes were led by their own consolidated reform movement, headed by the Mainz elector, Archbishop Berthold of Henneberg, between 1495 (Diet of Worms) and 1504, Berthold's death. That pan-Germanic initiative, even though fragmentary and either princely or electoral, has been characterized by most modern historians as the more promising and patriotic prospect for national consolidation rather than Maximilian's Habsburg-dominated centralization. Thus, the proposed imperial reforms, jointly instituted in 1495, remained unimplemented, chiefly because Berthold withheld financial support for Maximilian's continual calls for a military crusade against the Turks.[7]

Maximilian, however, had his own supporters and admirers. Many of the learned humanists in the German-speaking world also became his apologists, beginning with Sebastian Brant in Alsace in the last decade of the fifteenth century.[8] Indeed, the geographical location of Brant and his fellow Alsatian humanists (especially Jakob Wimpheling and Heinrich Bebel) suggests one of their motivations for supporting the energetic young emperor: they needed to shore up their precarious political ties to German rather than to French authority in a border region. Maximilian followed his father's example (and ultimately the prior model of Emperor Charles IV in the fourteenth century) by designating a number of German writers as imperial poets laureate, beginning with Conrad Celtis in 1486.[9]

But Maximilian did not simply leave his promotional publicity to these professional writers. He had suffered tumultuous political setbacks during the first decade of the sixteenth century, reaching a climax after his coronation as emperor-elect at Trent in 1508, when his own coronation journey to Rome according to the time-honored tradition since Charlemagne was blocked by opposition from an enemy, Venice. Around this time Maximilian began to work on his own public image in both text and image.[10] Some of these projects encompassed a history of his reign, beginning with the Latin *Historia Friderici et Maximiliani*, first drafted at the turn of the century and possibly intended as a guide to princely conduct for his eldest grandson and heir, Charles (the future Charles V).[11] Even that book project, however, preserved in its original incomplete manuscript version (authored by Joseph Grünpeck), was intended to be accompanied by illustrations (drawn by the young Albrecht Altdorfer of Regensburg).[12] This kind of

collaborative combination of authors and artists, of texts and images, would dominate many of Maximilian's publication projects over the next decade of his life and reign. Indeed, scholars have often pointed out the degree to which this monarch realized the potential of the printing press for what we moderns would call his "public relations"—to address both his contemporary audiences, chiefly the recalcitrant German princes who resisted his authority, as well as future generations.

Other major book projects offered a fictionalized, quasi-allegorical recounting of Maximilian's youth and subsequent reign. Although for the most part uncompleted, these works were planned to have extensive woodcut illustrations about jousting tournaments (*Freydal*); about adventures and hunts (*Teuerdank*, published with woodcuts in 1517); and about battles and diplomacy (*Weisskunig*) in which the emperor distinguished himself. Further glorification of the entire Habsburg dynasty was to have been produced, celebrating both the elaborate *Genealogy* as well as the putative family *Saints*, but these, too, remained incomplete, even though preparation advanced quite far on their comprehensive woodcut illustrations.

Maximilian never really had a proper court center or a capital like London or Paris, though he did bestow some of his patronage energies on a palace at Innsbruck, which eventually became the the site of his massive tomb project (incomplete but continued for half a century after his death) as well as a pair of public facades, the Golden Roof (Goldenes Dachl) and the Armorial Tower (Wappenturm, destroyed). Most of his efforts involving ceremony or splendor concentrated more on portable and replicable renderings or simulations, chiefly in the form of woodcut ensembles. The guiding programs for these woodcut assemblages were dictated personally by the emperor to his private secretary (Marx Treitzsaurwein): an incomplete frieze of a *Triumphal Procession* and an *Arch of Honor*. Both of these works evoke the precedent of ancient Roman imperial celebrations of military prowess and authority; however, like the illustrated written histories of Maximilian's reign, they are also garnished with considerable attention to those princely interests and personal qualities that distinguish Maximilian as both a courtier and a ruler.

This book will analyze the programs of Maximilian's extended campaign of self-aggrandizement through public relations—his own effort to use the arts in the service of Weber's "routinization of charisma." It was chiefly written during the waning years of the twentieth century, when the experience of media-as-message became firmly encoded in everyday perceptions. Indeed, the constant manipulation of television coverage by political leaders and the production of electoral advertising seem to be a most direct outcome of the shaping of public opinion by Maximilian through both print and visual imagery. This study first began around the time of Ronald Reagan, who was called "the Great Communicator" in America—both for his speeches appealing to traditional national values and for his "telegenic" sincerity. It also responded to Clifford Geertz's historical study (1980) of a non-Western rulership, the "theater state" of Negara in Bali, which showed how political authority could be grounded chiefly in the dramatic presentation of symbols around a noble ruler. Both on an experiential level of modern communications and on an academic level of the analysis of culture, therefore, the program of Maximilian offered a topical historical instance exemplifying

what one modern advertising campaign (for, of all things, a brand-name camera, maker of images) proclaimed: "image is everything."

Following that dictum, the chapters that follow will chiefly analyze the thematic range and overlapping programs of Maximilian's image production, both in verbal texts and visual artworks. The guiding principles of his reign—his ideology—will be located as they are visualized in the major initiatives of his art patronage. His elective imperial title was construed as confirmation of Maximilian's own family descent, which he claimed entitled him to leadership of European kings as well as to his vast territorial claims; therefore, genealogy, an ongoing obsession of the emperor, will constitute a separate chapter (chapter 2). The next thematic chapter examines how Maximilian utilized the Roman imperial heritage of his title, even as he insisted on the concept of "translation of empire" (*translatio imperii*) to the "German nation" through the coronation of Charlemagne (chapter 3). A subsequent chapter will consider the emperor's traditional role as defender of the faith, taken especially seriously by Maximilian in his orientation toward a crusade against the Islamic threat of the Turks against both his lands and Christendom in general (chapter 4). Of course, his central demonstration of leadership lay in his generalship and campaigns on the battlefield, which included innovations of artillery and infantry combat as well as continuing chivalric values (chapter 5). Yet all work and no play makes for an insufficient prince, and Maximilian was assiduous in the promotion of his favorite princely pastimes: jousting tournaments, hunts, and ceremonies, both diplomatic and festive (chapter 6). And because Maximilian's cultural campaign of cultivating authority through imagery ultimately was a form of political rhetoric, the conclusion (chapter 7) will evaluate the effectiveness of his visual and verbal projects—chiefly in terms of their legacy to his Habsburg heirs but also in terms of their reception by his political contemporaries (and their own artists).

This book studies a ruler as image maker, not an agent of political history. Hence it departs from the basic, protracted argument concerning Maximilian and his role in German history and historiography.[13] Since the time of the unification of Germany under Bismarck in the later nineteenth century, scholars have debated whether or not Maximilian, with all his charisma and popularity, might have been an earlier force for unification in the sixteenth century. A century ago, German national realpolitik as well as the then recent victory of Bismarck's Prussia over Habsburg unification interests conditioned the historical assessment. Heinrich Ulmann indicted Maximilian in his large, two-volume biography (1884–1891), promulgating a view of his role that largely still stands: a self-absorbed warlord, placing both his personal and dynastic interests ahead of the consolidation of a unified German state (see also Leopold von Ranke). In this view, his frequent wars with France and his continual squabbles over money with the Diet, largely to pursue those very wars with France, undermined any larger leadership role for a unified Germany that Maximilian might have achieved.

Over the past quarter-century, the massive, five-volume biography of Maximilian by the Austrian historian, Hermann Wiesflecker, has provided the Habsburg rejoinder to the Prussian critique by Ulmann. Consequently, Wiesflecker's comprehensive biography signals the personal

ambitions and accomplishments of the emperor, as it includes such important matters of personal history, excluded by Ulmann, as his youth, Burgundian marriage, and ongoing wars. Not only are realpolitik activities examined as appropriate topics but also cultural activity, including literary and artistic patronage, as a form of agitprop. Not surprisingly Wiesflecker's twentieth-century, Austrian assessment of Maximilian is sympathetic and positive, rebutting the negative, nineteenth-century, German evaluation of Ulmann.

This book attempts primarily to take Maximilian on his own terms, using the manipulation of culture for ideological purposes through the media of visual art and literature. Hence, it lies closer to Wiesflecker's approach (while also depending utterly on his encyclopedic research as well as on primary sources). Given the massive and assertive ego of Maximilian, such an analysis cannot help being "supportive" (although not uncritical) of his goals and stated principles; however, the evaluative concluding chapter should provide more balanced assessment of the success and failure of his ambitious enterprise.

This study has taken many years to complete. It began as an initiative in cultural history, stimulated by contact with symbolic anthropologists, including Geertz, at the Institute for Advanced Study at Princeton (over a quarter-century ago!). A book that has taken so long has many debts to acknowledge, and memory may not serve well. What must be gratefully acknowledged, first and foremost, is the financial and research support of several agencies and institutions. The Institute for Advanced Study, and its School of Historical Studies, guided for me by Irving Lavin but also by John Elliott, and its School of Social Studies, led by Clifford Geertz and Thomas Kuhn, formed a nurturing incubator. I remain further indebted to friends and colleagues from that year for critical influences on my subsequent thought and development of this project: Shelley Errington (now an honored art-historical colleague and lifelong friend), Carl Pletsch, Ron Inden, and David Hollinger. From Princeton University, the generosity and insights of Anthony Grafton and Thomas DaCosta Kaufmann—himself the authority figure on Habsburg imagery—can scarcely be credited fully enough. I also had the precious opportunity to get to know Carl Schorske in his final year of undergraduate teaching about fin-de-siècle Vienna. Later, a generous grant from the Humboldt-Stiftung permitted a year of study in Munich's Zentralinstitut für Kunstgeschichte, with access to the local museums as well as frequent visits to Vienna and Innsbruck to view Maximilianic works of art and manuscripts. Indispensable colleagues from that unforgettable year include Willibald Sauerländer, the late Jörg Rasmussen, Konrad Renger, Hans Belting, Pieter and Dorothea Diemer, Victor Stoichita, Bruce Livie, and Angelika Arnoldi. Later still, I had the great good fortune to be able to continue the project at the Center for Advanced Study in the Visual Arts, surely the most nurturing visual arts institution in Christendom, where Henry and Judy Millon, Shreve Simpson and Richard Kagan, Susan Barnes, Therese O'Malley, Frederick Bohrer, and Annette Michelson, as well as the visits of esteemed colleagues Peter Parshall and Jan Piet Filedt Kok, provided rich stimulus and warm friendship.

The ongoing interest and dialogue with fellow tillers in the Germanic vineyard has been a constant source of support and inspiration: Peter and Linda Parshall, Jeffrey Chipps Smith, Keith

Moxey, Charles Talbot, Dagmar Eichberger, Thomas DaCosta Kaufmann, Stephen Goddard, Pia Cuneo, Andrew Morrall, Alison Stewart, Corinne Schleif, Donald McColl, Christopher Wood, Charles Zika, the late Bob Scribner, Lyndal Roper, Gerhild Scholz Williams, and—especially—Elaine Tennant, whose constant dialogue and gentle but probing criticism have greatly improved the ideas and the expression of this text from its inception. I never became as well acquainted as I had hoped with such inspirational scholars as Fedja Anzelewsky and Hans Mielke in Berlin, but I would also like to acknowledge my indebtedness to their indispensable work, especially on Dürer and Altdorfer. Of course, the endnotes offer additional, ongoing testimonial to the lasting contributions, even after more than a century, of the great Viennese scholars who reawakened interest in the artworks and literature generated by Maximilian.

For their patience and forbearance, this book is dedicated to both my wife and my son, who was almost named Max until that name seemed a little too close to this project. Elizabeth Silver-Schack had the persistent hope and profound belief that it would someday appear, even with interminable delays and constant interruptions, and she has shared its own growth and maturation along with that of our family. Zachary, born in Munich when this project really began to develop, has seen this book span his entire lifetime, and he has even learned to tease his father mercilessly about that fact. Its completion means that I get the last laugh, even more so now that he has shown scholarly dedication in his own right, albeit in other kinds of large projects. Because so much of what Maximilian prized centers on his own family, both ancestors and future generations, it seems only fitting that with this work I honor my family, too, and also remember my parents of blessed memory while celebrating the next generation.

MARKETING MAXIMILIAN

1 | Introduction: Maximilian's Artwords

Willibald Pirckheimer, learned Nuremberg patrician and close friend of Albrecht Dürer, relates the tale of his five-hour crossing of Lake Constance to Lindau with Maximilian (27–29 July 1499).[1] Shortly after a crushing defeat at the hands of "rebellious" Swiss troops at Dorneck during the Swiss Revolt for independence, the emperor determined to dictate the events of his reign (*res gestae*) in Latin to a secretary. He asked for Pirckheimer's criticisms of his "soldier's Latin" (*ista militaris latinistas dicteo*), an obvious allusion to Julius Caesar's *Commentaries on the Gallic Wars*, first published more than a quarter of a century earlier (1469, Rome; 1473 Esslingen). His ambitions were to narrate for historians of posterity.

This Latin autobiography project was short-lived, but from this brief dictation came the germ of all of Maximilian's literary projects as well as his ongoing relation to the graphic arts that would eventually illustrate them; moreover, from such beginnings stemmed Maximilian's continual use of scholarly advisers, such as Pirckheimer, to supervise and edit his texts.

Already as early as 1492, the humanist Heinrich Bebel pressed Maximilian to begin a Latin autobiography. In it he charts his life as an oscillation between poles: the misfortune of his natal horoscope, counterbalanced by divine providence (*Ergo notandum in posterum est semper deus misericors et e converso spiritus malus constellacionis sue*).[2] This dialectic lies at the heart of the later plot structure of *Teuerdank*, Maximilian's fictionalized, autobiographical, verse romance, and it finds echos in *Weisskunig*, especially chapter 22, "How the Young White King Learned the Art of Stargazing [*Sternsehens*]": "After this the young White King mastered political knowledge. . . . He

thought it would be useful to recognize the stars and their influence; otherwise he would not completely understand the nature of men."[3]

Joseph Grünpeck, scribe for both the Constance Latin dictation and eventual author of the Latin autobiography, was a cleric and noted Latinist from Ingolstadt, also noted for his astrological prognostications.[4] In 1497, he had presented Maximilian with a Latin drama, featuring a morality play in which the monarch himself was asked to choose, like Hercules, between Virtus and Fallacicaptrix, virtue and base pleasure. In August 1498, Grünpeck was crowned a poet laureate by Maximilian. Taken on as a "confidential" or private secretary for the emperor during 1501, Grünpeck was stricken with the effects of syphilis and had to curtail his offices.[5] He later added an update to the Latin autobiography, *Commentaria divi Maximiliani*, covering the years 1501 through 1505 and thus spanning Maximilian's reign from his Burgundian marriage to the successful conclusion of the Bavarian-Palatine War of Succession. But by this time, Maximilian had already abandoned the use of Latin for his autobiography in favor of the German vernacular. The early outlines of his German allegorical autobiography, consisting of two further books in German, *Teuerdank* and *Weisskunig*, can be documented to this period.[6] Nonetheless, a final redaction in Latin, the *Historia Friderici et Maximiliani*, was compiled by Grünpeck and presented to Maximilian with drawn illustrations in February 1516.

These drawings were produced by a young Albrecht Altdorfer, who like Grünpeck lived in Regensburg.[7] Chronologically, the *Historia* drawings end with the emperor's siege of Kufstein (October 1504), although chapter 36, the final segment of the Latin text, speaks of Maximilian's forty-ninth year, that is, 1508. The emphasis of these drawings lies more on the interests and activities of the emperor and his father than on their full biographies; virtue and wisdom are the dominant qualities. For Maximilian especially, youthful training, particularly in the martial arts (chapters 5–6) as well as adult accomplishments (including tournaments, masquerades, hunts, and language abilities) within his "open" administration, fill out the illustrations. These feats anticipate the central third of the later *Weisskunig* text in German, discussing Maximilian's wide-ranging training, as well as the side towers, also devised by Altdorfer, added to the *Arch of Honor*, a set of woodcuts that depict the emperor's personal qualities. At one point in his examination of the *Historia* drawings, however, even Maximilian clearly found their panegyric excessive. Alongside one drawing (no. 36) he added the remark "better [to have] posthumous praises" (*lyber laudis post mortem*). Such supervision by Maximilian himself of both text and image is entirely characteristic of his involvement with other artistic projects. He personally lined through two *Historia* drawings (nos. 12 and 46), both of which adopt the fascination in Grünpeck's text for celestial portents of the death or advent of great kings—here Frederick III (fo. 30r) and Maximilian (fo. 85r), respectively—because of his own later vision, less favorable to such astrological determinism.[8] On two drawings of battle scenes Maximilian notes that a more comprehensive treatment in text and illustrations would appear later and more fully in "*weysk*," that is, *Weisskunig*.[9] This notation shows that he was already clearly planning a fuller series of illustrated dictated texts to record his lifetime accomplishments, particularly those most worthy of imperial leadership—victories on the battlefield.

The layout of the *Historia* drawings suggests a one-to-one correspondence between chapters of text and their illustrations, including, prior to the section on Maximilian, a traditional dedication page illustration (no. 15, fo. 36r; fig. 1), in which the enthroned young grandson and heir, Archduke Charles, to whom the book is dedicated, receives it from the kneeling author, while a proud Maximilian stands beside and looks on.[10] In addition to the correspondence of text and illustrations, as in the censored chapters on astrology, Benesch and Auer argue for the supervision and coordination of details by Grünpeck himself.[11] Every indication, including the revisions demanded by Maximilian, suggests the real possibility of realizing Grünpeck's ambition of publishing this Latin text with woodcut illustrations made after the sketchy drawing designs. The author even produced an expanded, second edition, which he offered after Maximilian's death to his successor in Austria, his grandson, Ferdinand.[12]

A suggestion of Maximilian's overall activity with his secretaries is provided within the *Historia* drawings (no. 42, fo. 79r; fig. 2), where the king, seated at supper before a brocaded cloth of honor with two active, speaking advisers by his side, nonetheless also retains two scribes to record his dictations. In addition, a court fool is depicted entertaining in front of the table, while an extra (military?) court figure stands behind the secretaries at the right edge of the

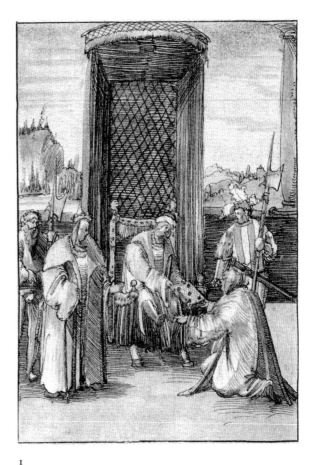

1

Albrecht Altdorfer (attributed), *Author Joseph Grünpeck Presents His Text to Archduke Charles*, from *Historia Friderici et Maximiliani*, ca. 1508–10, ink. Vienna, Haus-, Hof-, und Staatsarchive, Hs. Blau 9, fo. 36r.

drawing. The accompanying chapter (no. 44) speaks *de eius irremissibilibus laboribus*, and it amplifies a previous chapter (no. 40), concerning the intelligence and working methods of Maximilian and his court, often exercised during hunts or at mealtimes (this is what is meant by the term "open" administration, utilized above).[13] Marginal notations (*Hoc etiam pingere*), already contained in the original fragment of Latin dictation, indicate an original intention by Maximilian himself to produce an illustrated text. His dictated text of *Weisskunig* makes this clear: "And thus to make at the outset an explanation of my book I have added painted figures to the text with which the reader with mouth and eye may understand the bases of this painting of my book, which ground I have established, and in the same fashion have written and depicted chronicles, as I have seen such out of other chronicles of my predecessors."[14] Thus, as Grünpeck's

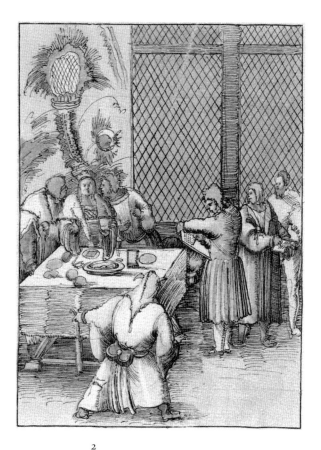

2

Albrecht Altdorfer (attributed), *King Maximilian Conducts Affairs of State and Other Business While Dining*, from *Historia Friderici et Maximiliani*, ca. 1508–10, ink. Vienna, Haus-, Hof-, und Staatsarchive, Hs. Blau 9, fo. 79r.

uncompleted *Historia* project already indicates, the pattern of Maximilian's literary and visual production of books was already embryonically defined at the very turn of the sixteenth century, and his own ambitions to provide the most modern publishers and graphic artists of print and woodcut found willing collaborators in the roles of secretaries, literary advisers, and artists.

While Grünpeck during his chronic illness was out of sight and mind of Maximilian, the emperor's literary plans turned around 1505 to his German-language autobiography, to be given the romance-like title, *Weisskunig*. For this project the center of supervision shifted from Regensburg to Augsburg, and from Grünpeck to Maximilian's most trusted adviser, Dr. Konrad Peutinger.[15] Its title derives from the identification of the hero with his pure, white armor, which contrasts with the identifying arms worn by other kings, dressed in blue (France), green (Hungary), red and white (England), or distinguished by means of heraldic attributes (flints for Burgundy, fish for Venice).[16] This tradition derives from courtly romances featuring knights in armor, such as Ulrich von Liechtenstein's *Frauendienst*, whose poet-narrator is the "green knight." Also foundational, the fifteenth-century Burgundian tradition, which Maximilian knew through his marriage (1477) to Mary of Burgundy, provided both fictional romances (Olivier de la Marche, *Le chevalier délibéré*, 1483; translated into Spanish for Charles V in 1522) and chronologies of splendid reigns (by such historians as Enguerrand de Monstrelet, George Chastellain, and Philippe de Commynes), as powerful models.[17]

The *Weisskunig* text was organized along the same lines as the *Historia*, in three parts: the history (here just the marriage) of Maximilian's parents; the birth and training of the young Maximilian; and finally, the chronicle of his military campaigns (1477–1513) against his fellow "kings." As Misch has outlined his ambitions, Maximilian "stylized" the events of his own life in order to provide a melodramatic romance as an *apologia* for his necessary, yet involuntary, wars as responses to the aggressions of his grasping or envious neighbors. At the same time, those victorious battles, as well as his own education and training, were conceived by Maximilian in terms of an ideal model, suitable for use as a "Mirror of Princes" for emulation by his successors.[18]

The outlines of the *Weisskunig* and *Teuerdank* texts were not dictated directly to Peutinger, but rather were given to a principal private secretary, Marx Treitzsaurwein (d. 1527), a man recorded in documents by 1501 and related to a family of armorers in Mühlau, near Innsbruck (where Maximilian's armor as well as the bronze statues for his tomb were cast; see chapter 2). The earliest indications of such planned texts appears in a memorandum book, datable to the period 1505–8, where *Teuerdank* is mentioned (fo. 169r), not yet split off in concept from *Weisskunig*.[19] The earliest redaction by Treitzsaurwein of *Weisskunig* recounts the youth of Maximilian; it also includes corrections by the emperor.[20] In essence, as secretary, Treitzsaurwein fulfilled the role of herald for his master's deeds, just as a fictional herald, Ehrenhold, the constant companion and witness for *Teuerdank*, holds the sole duty to sing the praises of his fictional lord. No clear distinction can be made between the emperor's own words and those of his "ghost writer." Treitzsaurwein was later authorized in 1526 by Ferdinand, Maximilian's successor, to publish an edition of *Weisskunig*, but the secretary's death the next year interrupted that project permanently. Various drafts survive, some with accompanying woodcut illustrations, such as the proof set (ms. F) submitted to Maximilian for captions around 1512, followed by another manuscript (ms. A; completed 1514) to be inspected for final revisions.[21] In addition, a "Question Book" (ms. H, 1515), including eighty-two woodcuts and thirty-four drawings, as well as a "Control Book" served to clarify uncertainties concerning the selection and order of text and illustrations of details in mss. A and E prior to the final, definitive publication of *Weisskunig*.[22]

Peutinger coordinated all 251 illustrations for *Weisskunig* in Augsburg. He divided their artistic production almost equally between two local artists: Hans Burgkmair (118 images) and Leonhard Beck (127); Hans Springinklee and Hans Schäufelein were responsible for the other six illustrations.[23] The nature of his concerns went beyond the recruitment and supervision of Augsburg artists and extended to technical issues, chiefly the cutting of woodblocks after the artists' designs by *Formschneider*.[24] Peutinger had already enlisted Burgkmair to produce a multicolor (including overlay of gold or silver) equestrian portrait woodcut for Maximilian in 1508 for the occasion of his coronation as emperor-elect at Trent (chapter 3).[25] He also utilized Burgkmair to design figures of ninety-two ancestors for Maximilian's intended publication of his *Genealogy* (chapter 2), for which he also enlisted a wood sculptor (*Schreiner*) and two block carvers (*Formschneider*).[26] Among the *Formschneider* in Augsburg, one Netherlandish virtuoso craftsman, Jost de Negker, personally wrote to the emperor (27 October 1512) to claim credit for supervising the other cutters and for producing a chiaroscuro portrait of Maximilian's local Augsburg adviser and financial minister, Hans Paumgartner.[27] Augsburg was also the headquarters of Maximilian's designated "printer for life," Hans Schönsperger, who invented *Fraktur*, or gothic German type, for the emperor's exclusive use.[28] Peutinger's multiple projects for Maximilian, including *Weisskunig*, reach a climax in his letter to the emperor of 9 June 1516, where the illustrations of *Weisskunig*, *Teuerdank*, and *Freydal*, as well as the pictorial suite, *Triumphal Procession*, are all described as "designed, cut, and printed" (*gerissen, geschniten und ausgemacht worden*), while others are still moving along in the process, with five Augsburg cutters and one more in Nuremberg waiting for work.[29]

From the surviving drawings of the *Weisskunig* we can glean some insights into the processes by which illustrations for texts were produced.[30] Whatever designs were created by the artists, Burgkmair and Beck, have disappeared entirely, either destroyed during the process of transferring and carving them onto the woodblocks, or else not prized as objects in themselves for safekeeping. Nor do any drawings survive from *Teuerdank* or the *Genealogy*, Maximilian's other major publication projects. Yet in the "Question Book" (ms. H), thirty-four sketches made prior to actual woodcut designs remain, arranged according to their appropriate chapters; and a further fifty-two drawings, overlapping with the ones in ms. H, can be found in a similar volume (ms. G; Boston Museum of Fine Arts, formerly in Liechtenstein).[31] Because these works duplicate each other as copies, they can be understood as "working drawings" for supervision and correction by the emperor prior to a final, "permanent" design to be cut for woodblock printing.

Even woodblocks could still be corrected or amended later, surely at the behest of the emperor in such advanced stages of production. Such change is evident from revisions made by Beck to several of Burgkmair's and Schäufelein's illustrations for *Teuerdank*.[32] But *Weisskunig* sketches, like a modern photocopy, provided figures and compositions for inspection, and in the margins of the text manuscript redactions such designs are often duly noted, as in the case of *Teuerdank* for illustration no. 39 (cod. 2867, fo. 54): "*Das gemäl ist gemacht und nach der schrifft gerecht und hat das zaichen* (The sketch is made, corrected according to the text, and has the design [for the block])." In the case of one of the *Weisskunig* sketches, Beck's woodcut no. 166 from ms. F, Maximilian seems to have given approval, as the notation in his own hand reads: "*Das gemäl ist also recht* (The sketch is correct as is)," meaning either that the sketch is now consonant with the approved text or else that Maximilian's desired visual presentation, here a battle scene, has been met. Other sketches in Vienna and Boston include corrections, especially concerning dress, armor, or weapons to be added or altered. From such drawings and comments, we detect the attention and meticulous scrutiny that Maximilian devoted to illustrations as well as to the texts of his published projects. When more major questions of accuracy were involved, as in the specifics of Habsburg ancestry (chapter 2), entire projects could be halted permanently (*Genealogy*), or at least seriously delayed (*Arch of Honor*). In the case of the *Genealogy*, surviving proofs of the earlier states of the woodcuts received added pen corrections and detailed indications of heraldry.[33] Both the *Historia* as well as the *Prayerbook* (chapter 3) reveal surviving drawings, never cut for prints but still integral to the unique luxury edition owned by Maximilian himself. Surely more complex scenes, such as battles, or the records of ceremonial moments requiring exact detail, such as kings in their crowns and regalia, required close editorial checking of drawings or proof woodcut impressions in order to provide the authoritative historical record.

At the stage of carving the blocks, contemporary sophistication by German craftsmen in carving limewood figures in three dimensions reveals how subtly the *Formschneider* could transfer drawings or translate linear graphics into carved ridges and valleys.[34] De Negker's letter of 1512 to Maximilian further indicates how he, as supervising cutter, could standardize all the carvings for printing, "So I will be there to organize and prepare all matters of the two *Formschneider* and

finally with my own hand to finish and complete and make pure, so that the work and the pieces will all be alike in carving and finally no more than one hand may be recognized therein."[35] In practice such absolute consistency was rarely achieved, but where the designer, especially Burgkmair, provided clear and consistent graphic syntax, his distinctive manual style usually could be translated with minimal variation from print to print. For the preserved *Weisskunig* blocks, there is little surviving information; however, for the woodcuts of Beck's designs for the series of *Habsburg Family Saints* (chapter 2), many of the blocks are signed and dated by their carvers. Laschitzer studied these blocks and identified de Negker as well as the additional *Formschnitzer* active on the project between November 1516 and September 1518.[36] Several of these same names also appear in single mentions on *Weisskunig* blocks.[37] However, Laschitzer justly observes that the differences of carving are far more evident on the blocks than as printed images.

Only one book project was completed as planned and actually published during Maximilian's lifetime: *Teuerdank*.[38] Like the *Prayerbook*, it was intended for a restricted audience, to be presented by the emperor to his principal noble subjects in imitation of luxury manuscripts but produced in multiple copies, using the most modern technical means of printing. The script simulated scribal calligraphy by means of Schönsperger's *Fraktur* type (as well as movable flourishes cut by Jost de Negker to imitate manual virtuosity). In place of illuminations, seventy-seven woodcut illustrations were designed by Beck, twenty by Hans Schäufelein, thirteen by Burgkmair, and a remaining eight by unknown hands.[39] As fictionalized autobiography, *Teuerdank* has the same genesis as *Weisskunig*, the dictated memoranda around 1505–8. There it was paired with the fictionalized book of Maximilian's tournaments, *Freydal*, as the "*tragedi*" counterpart to "*comedi*."[40] The title designates an eponymous knightly hero, whose thoughts are occupied by *teuerlichen Sachen*, that is, "serious matters," natural to a fearless adventurer. Again this temperament is contrasted to Freydal, whose name indicates a "free spirit." By the time of Maximilian's letter (14 October 1512) to his trusted associate (*Silberkämmerer*), Sigmund von Dietrichstein, *Weisskunig* and *Freydal* are each described as "half-made," with the "figures" still to be cut, while *Teuerdank* in an alias title, "Neithart," remains in the adviser's hands. Maximilian asks for the volume in order to review it with court scholar Johann Stabius before sending it on to Peutinger for final preparation and printing.[41] Whether von Dietrichstein and/or Marx Treitzsaurwein had previously developed the primary text from Maximilian's dictation, the final, verse redaction of *Teuerdank* was produced for publication by Melchior Pfinzing, provost of St. Alban's in Mainz and St. Sebald's in Nuremberg.[42] Pfinzing also added an appendix, called a "key" (*Clavis*), to match up the fictional deeds of Teuerdank with events from the life of Maximilian himself.[43] Meanwhile, Peutinger continued supervising the actual printing of text and illustrations in Augsburg, culminating in the book with a foreword by Schönsperger, dated 1 March 1517. Some forty parchment volumes were printed, some of them with hand-colored illustrations, while another three hundred exemplars were printed on the cheaper support of normal paper, akin to a similar, two-tiered hierarchy of editions planned for the *Prayerbook*, also printed by Schönsperger (chapter 4).

Jörg Kölderer and the Innsbruck court artists seem to have provided original designs for the most pictorial—and best documented—of Maximilian's printed projects: the *Arch of Honor* and *Triumphal Procession* (chapter 3).[44] In the case of the *Procession* we have the basic text dictated by Maximilian to Treitzsaurwein (along with *Freydal* and two other works) in 1512 (Vienna, National Library, no. 2835), as well as the outline of an additional, unrealized project, the "Arch of Devotion."[45] From this *Procession* program, a luxury manuscript edition on parchment (Vienna, Albertina) was prepared by Albrecht Altdorfer and his workshop in Regensburg, presumably after lost designs by Kölderer, under the supervision of Maximilian's court scholar, Johann Stabius.[46] These illuminated miniatures by Altdorfer were a working copy for Maximilian himself, finished while the designs for the woodcuts of the *Procession* were also under production in Augsburg, following designs chiefly by Burgkmair. A copy of the dictated program for the *Procession* survives amid the Burgkmair woodcut proofs (Dresden), along with a signature by the artist and the date: "H. Burgkmair maler. Angefangen 1516 And. 1 Abrilis." Dates on the woodblocks (Vienna, Albertina) range between 12 November 1516 and 25 August 1518. Fully twelve different cutters, including Dürer's favorite in Nuremberg, Hieronymus Andreae, worked on the project.[47] Burgkmair designed the first 57 woodcuts and contributed a total of about half of the 139 that were completed, although this project also was interrupted by Maximilian's death in early 1519 and only issued posthumously by his grandson and successor, Ferdinand, in 1526. Therefore, many items in the planned program were never actually produced.

Stylistically, the remaining *Procession* woodcuts have been attributed to Altdorfer (thirty-eight), Beck, Schäufelein, and Dürer's pupil, Hans Springinklee (twenty-two). The *Burgundian Marriage* woodcut was produced by Dürer himself, and Dürer took responsibility for the centerpiece: the *Triumphal Chariot* with Maximilian and his descendants. However, Dürer and Pirckheimer altered the program for this triumphal cart and received approval from Maximilian in 1518 on their presentation drawing of an allegorical *Great Triumphal Chariot* (W. 685; Vienna, Albertina). This woodcut series of eight blocks was only published posthumously and separately in 1522.[48] A series of other Dürer drawings of riding trophy-bearers (W. 690–99; Vienna, Albertina) was also surely intended to have been cut for woodcuts for inclusion in the *Triumphal Procession*.

For the *Arch of Honor* the process must have been similar, but the results were more tightly coordinated in Dürer's Nuremberg workshop, so the final product appeared during Maximilian's lifetime—with a 1515 date on the woodcuts but actually a couple of years later owing to the controversy over the details of the central portion with the Habsburg genealogy (chapter 2).[49] In the lower right corner appear the coats of arms of Stabius, Kölderer, and Dürer, respectively. Stabius coordinated the program and wrote the elaborate explanatory colophon at the base of the assembled *Arch*, while Kölderer produced two colored designs, one for Stabius, the other eventually sent to Maximilian's daughter in the Netherlands, regent Margaret of Austria.[50]

Whether a luxury edition of the *Arch*, like that of the *Procession*, was ever produced on parchment can no longer be determined, because none survives, even in copies. Unlike the *Procession*

and the unrealized project (chapter 4) for an "Arch of Devotion," no dictated program from Treitzsaurwein remains. Dürer remained artistic supervisor for the entire project, and (except for the two flanking towers added by Altdorfer) he and his workshop (chiefly Hans Springinklee and Wolf Traut) produced the architecture, its decorations, and the main historical scenes. Only a few figures were actually designed by Dürer himself, according to scholarly consensus. In some cases, noted by Strieder, such as the *Burgundian* and *Spanish Marriages*, striking overlaps between the Altdorfer *Procession* miniatures and the *Arch* woodcuts suggest a common model, presumably drawn by Kölderer, but the possibility remains that Stabius provided the link between Altdorfer's miniatures in Regensburg and Dürer's woodcuts in Nuremberg. Altdorfer's narrower side towers are not linked seamlessly with the remainder of the *Arch* and thus seem to have been a later addition to the overall ensemble. The *Arch* woodcuts were carved locally in Nuremberg by Hieronymus Andreae and his workshop.

The core historical woodcut scenes from the *Arch of Honor*, definitively issued during Maximilian's lifetime in 1518 and reinforced by *Weisskunig* (which remained incomplete) reveal the major events—chiefly dynastic marriages and major battles—that were singled out for lasting memory by Emperor Maximilian, so they can also serve as a capsule (auto)biography.[51] After an initial image of a youthful Maximilian, strong and virtuous, comes the significant start of his reign through the marriage to Mary of Burgundy (1477; fig. 3). In this scene the two principals stand alone and side by side before a cloth of honor under a large, barrel vaulted arch. Their coats of arms are prominently displayed. At the center Mary bestows hers to her new armored bridegroom, who wears the same archducal hat on his head as tops his own Austrian heraldry, which looms large in the lower left corner of the print—the true, lasting subject of the event.[52] This wedding, strenuously opposed by the French crown, led to military conflicts over the rulership of the Low Countries from 1477 to the Peace of Senlis in 1493, led by unruly cities, zealous to protect their local privileges and trade.

The first battle scenes out of the sixteen on the *Arch* encompass several from this extended Netherlands campaign, reading across and then down: (left side) Wars for the Burgundian Lands (1477–79), Battle of Therouanne/Guinegate (7 August 1479), First Guelders War (1481), and the

3

Albrecht Dürer workshop, *Marriage of Maximilian to Mary of Burgundy*, from *Arch of Honor*, ca. 1517–18, woodcut.

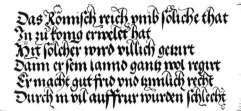

4

Albrecht Dürer workshop, *Coronation of
Maximilian as King of the Romans*, from *Arch
of Honor*, ca. 1517–18, woodcut.

Utrecht Conflict (1483–84); (right side) First Flemish Rebellion and Liberation of [Maximilian's son] Philip the Fair (held captive in Bruges; 1484–85), Siege of Liège (1482–83), and the Second Flemish Rebellion and Subjection (1488–89). These varied scenes have a sameness of presentation that truly requires their rhyming captions for identification, though doubtless Maximilian closely inspected these compositions for historical accuracy. Most of them show various combinations of the military components of Maximilian's forces, which contained traditional mounted and armored knights, complemented by the recent innovations of large siege cannons and infantry squadrons (*Landsknechten*), armed with pikes and broadswords (chapter 5). A good example of this multifaceted imagery is the *Guelders War*, where the foreground scene shows the imperial forces fighting under their Burgundian banner—the cross of St. Andrew with sparking flints—and dispersing the Swiss mercenaries under their red cross flag. The middle scene shows a troop of armored equestrians, also routing their foes from left to right; in the distance a variety of cannons besiege a fortified city. Some military scenes on the *Arch* feature a surrender, notably the staging of the liberation of Philip the Fair, plus the final scene of the Netherlands campaign, the *Conquest over France*, a conclusion in the lower right of the sequence. Just before this moment, the later (1506) alliance between Maximilian (in an imperial crown and wearing the Order of the Golden Fleece) and Henry VIII (whose banner shows Tudor roses) is staged as two armored groups, facing each other at a seacoast meeting before sailing ships on open water.

Grouped with these military scenes on the top row of the right side a significant royal moment is staged: *Coronation of Maximilian as King of the Romans* (Aachen, 9 April 1486; fig. 4), when he attained the title of heir apparent to the imperial crown held by his father, Frederick III. Here the enthroned young monarch sits beneath a cloth of honor, surrounded by six electors, led by the three ecclesiastics who bestow his new crown. The remaining three ducal electors in turn (and according to protocol) convey imperial sword, orb, and scepter.[53] The baldachin above the throne shows suggestive spiritual ornament above young Maximilian in the form of the dove of the holy spirit flanked by hovering angels. This scene is accompanied by a generalized poetic

caption: "The Diet then for everything / Elected him as Roman King. / To everyone it was quite plain / That competently he would reign. / He fought for peace and for his right / Suppressing all unrest with might."

A further dozen history scenes on the *Arch* continue the story with events closer to the homelands of Austria. They begin with the reconquest of territories occupied by Matthias Corvinus, the late king of Hungary (d. 1490) and Maximilian's true contemporary rival; these losses had occurred while Maximilian was preoccupied with his succession in the Low Countries. According to the inscription, these lands were lost by Maximilian's father but were restored in a mere three months. This process is exemplified through the conquest of a besieged city by Maximilian's troops, followed by a second battle scene to the right, probably Stuhlweissenburg, the Hungarian coronation site mentioned in the caption as well as in both texts, *Weisskunig* (four woodcuts) and the *Historia*.[54] The significance of the Hungarian campaign lay in its resulting hereditary claims through the Peace of Pressburg (Bratislava, 1491) to annex the region into what eventually remained Austria-Hungary throughout the Habsburg imperium.

Next follows another dynastic scene of marriage, this time to the royal house of Spain, when Philip the Fair wedded Joanna, while his sister Margaret of Aus-

Die sachen er gantz wol betracht
Seinn sinn ein gmahel zwegen bracht
Des künges töchter wol bekannt
Von hispania damit zuhannt
Er zu im bracht erblicher weys
Sechs künigreich mit hohem preys

5

Albrecht Dürer workshop, *Marriage of Philip the Fair*, from *Arch of Honor*, ca. 1517–18, woodcut.

tria married the Spanish heir Juan (1496): "And in a well-considered act / He made his son's betrothal fact. / The daughter of the King of Spain / Would bring his dynasty great gain. / For by inheritance one day / Six kingdoms thus would come his way" (fig. 5). Of course, the lasting significance of this marriage diplomacy would result in the eventual kingship of Spain by Maximilian's grandson and successor as Emperor Charles V and the realization of his Habsburg ambitions to achieve truly royal status to go with the imperial title. This woodcut image, also by Dürer himself, essentially replicates his previous marriage scene with Mary of Burgundy, except that now Maximilian has also been included in the scene underneath the archway. Now wearing the bicuspid imperial crown as well as the Order of the Golden Fleece inherited from Burgundy, the emperor-elect (after the death of Frederick III in 1493) stands above his larger shield in the lower left corner, which repeats the imperial crown above the imperial double eagle. Philip's

crowned shield pairs both the Austrian and Burgundian arms, and he receives the varied arms of Castile and Aragon and other Spanish lands from Joanna.

Beneath this row comes Maximilian's most galling setback: the Swiss War of 1499, depicted as a standoff between two facing infantry forces with pikes and their respective national banners before a scenic mountain valley landscape. The vague caption puts the best face on this debacle, which established Swiss independence by claiming that Maximilian "demonstrated faith quite unafraid" as he came to the aid of the army of the Swabian League. The next woodcut also shows further military conflict on behalf of the Spanish (his in-law King Ferdinand), halting and reversing the French incursion into Italy at Naples (1503). This scene is followed by one of Maximilian's greatest successes: the Battle of Wenzenberg during the Bavarian War of 1504. He waged this war in support of the legitimate Munich heir (his brother-in-law) against the Bohemian troops who backed Palatinate claims to the Bavarian succession of Landshut. After losing Switzerland in a regional rebellion, Maximilian surely now felt vindicated in his authority, particularly as a prince among princes, by quelling another potential resistance so close to his family and heartland.

A further reception scene follows, akin to the coronation as king of the Romans, celebrates Maximilian's feudal sovereignty over Milan (1512), first solemnized with his marriage to Bianca Maria Sforza (1494–1511). In this woodcut the crowned emperor is depicted enthroned and receiving obeisance from a representative of Milan, signified by a Visconti serpent banner that complements the imperial double eagle. The timing of the ceremony stems from the recent development of the Holy League, in which the pope and Venice teamed up with Ferdinand of Spain to oppose France, later joined by Maximilian at the end of 1512. Initially, this alliance led to the withdrawal of occupying French forces (although the short-lived Sforza revival in Milan was soon overturned at the Battle of Marignano, under the leadership of young King Francis I). "With great endeavor and with pride / He succeeded in bringing Milan to his side / Although by sly maneuver and crime / He lost it again after a time. / Yet his wisdom on behalf of the nation / Soon brought about its restoration."[55] The ambiguity of these lines also points to the vicissitudes of Milanese fortunes and politics from 1494 to 1515 (and even later with the reconquest of Milan by Charles V over Francis I at the Battle of Pavia, 1525, later woven for him into a commemorative tapestry cycle by 1531; see chapter 7).

Out of chronological sequence, the next scene is a battle against Venice, whose opposition to Maximilian prevented his imperial coronation trip to Rome, so that he had to be crowned instead in the safe border territory of Trent (6 February 1508). The ensuing war (1508–10) against Venice actually resulted in a costly stalemate, but the *Arch* woodcut depicts the battle before open water and shows its outcome tilting toward the imperial forces over the Venetian soldiers under the banner of the lion of St. Mark, and the caption makes the same rosy claims.[56]

The remaining two events occurred before the 1515 official date on the *Arch* (though its actual execution lasted at least two more years as details, particularly of the early Habsburg genealogy were being worked). But their deep significance is evident from their authorship, ascribed to Dürer himself. The first of these is another alliance image of 1513, essentially reinforcing the 1506

link with Henry VIII of England against the common enemy, France, which had formed the subject of a prior historical woodcut on the *Arch*. Marked by their army banners—the Burgundian flints/St. Andrew's cross and the Tudor rose—both rulers face each other in the foreground. Both sit astride their steeds wearing elaborate battle armor of the latest design, complete with pleated skirt *Faltenrock Harnisch*), as they stretch out their right hands to seal the pact. Their meeting occurs in a generic pictorial space, representing the alliance forged in the aftermath of the Holy League in 1513. This putative encounter follows joint siege victories over French forces in the Netherlands at both Thérouanne (the Battle of the Spurs) and Tournai, each town mentioned in the caption text.[57]

But the ultimate image of the *Arch* history scenes—another woodcut by Dürer, to complement the initial marriage scene to Mary of Burgundy—is the Vienna Congress of 1515. Along with the acquisition of territorial claims to Spain through marriage diplomacy a generation earlier (Philip the Fair and Margaret of Austria), this double wedding of Maximilian's grandchildren linked Austria to central Europe, that is, Hungary, Bohemia, and Poland, and firmly established what would become the Austro-Hungarian Empire (fig. 6). The two children of King Vladislav of Hungary and Bohemia were joined to the Habsburgs, Ferdinand and Mary (later known as Mary of Hungary) with the political sanction of Sigis-

6

Albrecht Dürer workshop, *Double Marriage Ceremony in Vienna, 1515,* from *Arch of Honor,* ca. 1517–18, woodcut.

mund of Poland.[58] In Dürer's woodcut the three crowned rulers all stand under the most ornate of his archways, supported on Corinthian columns and adorned with carved coffers—redolent of the opulence of the actual event. Maximilian, visibly older and with portrait-like features, stands, as always, at the heraldically superior left side above his double eagle heraldry surmounted by the imperial crown. In the center Vladlislav brings his own coat of arms and presents both of his children, Anna of Hungary and crown prince Ladislaus. Soon afterward, in 1516, the death of Ferdinand of Spain would bring Charles, son of Philip the Fair, to the kingship of Spain, and the death of Ludwig in battle against the Ottoman Turks at the Battle of Mohàcs (1526) would elevate Ferdinand to rulership over Austria-Hungary. With the Vienna Congress the historical scenes of the *Arch* conclude, just when the future fortunes of the Habsburg dynasty had become firmly established, even though Dürer left space to add one more woodcut. In planning the presentation of his *Arch*,

Maximilian surely knew that his reign was nearing its conclusion, but he doubtless did not expect to suffer his fatal illness so soon—only a few years later (12 January 1519).

Even more than for his memorial publications and images, Maximilian fretted over his only monumental project to be brought close to a point of near-completion: the bronze statue ensemble that he designed for his tomb memorial (chapter 2). Just as Maximilian provided the tomb for his own father, Frederick III, in St. Stephen's cathedral Vienna, so did he prepare for his own ensemble, whose partial completion was realized posthumously, when Ferdinand rendered the same act of filial piety toward him.[59] Its planning and execution offer the most complex process ever undertaken for Maximilian, exemplifying the collaboration inherent in all of his projects. Forty life-size bronze statues were planned for the tomb, along with thirty-four busts of Roman emperors and one hundred statuettes of Habsburg family saints. Of that number, only eleven bronzes were actually cast during the lifetime of Maximilian, in the crucial decade between 1508 and the end of 1518. At least three of those (Arthur, Theoderic, and Albrecht of Habsburg; probably also Zimburgis of Masovia) were subcontracted to bronze casters outside the court foundry at Innsbruck-Mühlau.[60] The execution of the project was first entrusted in 1502 to Gilg Sesselschreiber, *maler von München* (painter from Munich), who collected visual documentation and then provided canvas designs (*Visierungen*) for the eventual statues, which he presented to Maximilian as well as to Konrad Peutinger in Augsburg in 1508. Peutinger's role as adviser not only included his historical background in Habsburg genealogy, then being coordinated for publication with illustrations by Hans Burgkmair, but also drew on his special interest in Roman history, including his considerable coin collection, used as models for the busts of the ancient emperors. Amazingly, despite his complete inexperience with the technical aspects of bronze casting, Sesselschreiber was then sent to Innsbruck and placed in charge of the entire project. He began by utilizing the skills of the local artillery caster, Peter Löffler, to make the first figure, Ferdinand of Portugal. Then he developed his own workshop, consisting of a painter, two carvers, two casters, and a smith. After the initial casting of each separate part of a figure, a comprehensive wooden sculpture model was then used as an armature, covered in wax, and modeled before being cast in sections. Thus both the Sesselschreiber design and the wooden model remained as templates for the finished statues in bronze.

However, the work dragged on because of the time needed for polishing, chasing, and refining the numerous surface details; instead of the four statues per year promised by Sesselschreiber, only portions of statues were produced, according to a 1513 inventory. Separate contracts for figures were issued by Maximilian in 1513–14 to the bronze sculptor Peter Vischer in Nuremberg and to the wood sculptors Veit Stoss of Nuremberg and Hans Leinberger of Landshut. Dürer made figure designs for Leinberger (*Count Albrecht IV of Habsburg*, drawings in Liverpool and Berlin; fig. 7)[61] and probably also for Vischer as well (*Theoderic* and *Arthur*, now lost). By 1517, an impatient Maximilian had instructed Peutinger to dismiss Sesselschreiber, and the artist's shop, headed by his son and son-in-law, completed work on the statues cast to date. Already Peutinger had employed an Augsburg carver, Jörg Muskat, and two bronze caster brothers, Hans and Laux Sartor, for the

busts of twenty-one Roman emperors (chapter 3). In addition, Stefan Godl of Nuremberg, a bronze caster, was installed as the permanent replacement for Sesselschreiber. Godl had begun in 1514 with Leonhard Magt as his carver to execute designs by Jörg Kölderer (after Mennel's illustrated genealogical text) of the Habsburg saints for the planned series of twenty-three statuettes. On the basis of these trouble-free and efficient casts, Godl won the job of supervisor of the entire project in 1518, completing Leinberger's *Count Albrecht of Habsburg*, previously delayed by casting difficulties, to the full satisfaction of the emperor. By using the lost-wax process of casting bronze, Godl thus produced more statues in less time and at a considerable cost savings. For Ferdinand I, Godl created twelve statues with the aid of a single sculptor, Magt, and four assistant bronze casters.

Kölderer's role as designer continued as well. As in the case of the statuettes, Magt followed his models quite literally, albeit somewhat stiffly. Filling in the gaps left by Sesselschreiber's drawings and final designs, Kölderer produced his own full-size *Visierungen* as well as a parchment codex of thirty colored drawings (ca. 1522–23) of the tomb figures—at once an inventory of the previously completed statues, plus a copy or modification of Sesselschreiber's additional designs (Vienna, National Library, no. 8329).[62] A later parchment (ca. 1530, Vienna, Kunsthistorisches Museum, inv. nr. KK 5333) consists of thirty-nine colored drawings by the Kölderer workshop to be used as a control guide during the execution of the final pieces.[63]

This cursory survey of Maximilian's main memorial artistic projects reveals a number of important patterns regarding the emperor's working methods with both advisers and artists. Most immediately striking is the collaborative nature of all of Maximilian's projects, which involved designers, cutters, and printers of woodcuts (or carvers and casters of the bronze statues) as their production technicians, not to mention

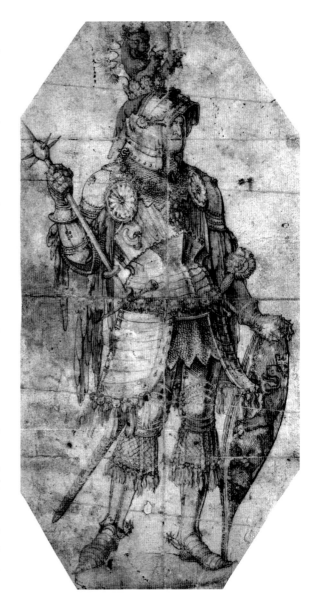

7
Albrecht Dürer (attributed), *Count Albrecht IV of Habsburg*, design for tomb of Emperor Maximilian I, ca. 1515, ink. Berlin, Kupferstichkabinett (KdZ 4260; W. 677). Photo: Bildarchiv Preussischer Kulturbesitz/ Art Resource, NY.

the secretaries, editors, and scholarly advisers who supervised both texts and programs. The role of Innsbruck as court center remained relatively small compared with either the Augsburg of Peutinger and Burgkmair's group or to the Nuremberg of Pirckheimer and Dürer. In addition, several court advisers had no fixed center of operations; instead they traveled to the appropriate centers of production. This situation applied particularly to Johann Stabius.

Regarding the role of court artists at Innsbruck, the focus falls on Jörg Kölderer, who came as close as anyone to the traditional role of *Hofkünstler*.[64] Documented from 1497, Kölderer's tasks often included menial assignments, such as painting coats of arms or banners, but he was also involved in architectural design and decoration: the 1499 facade paintings of the Tower of Arms (Wappenturm) of the Innsbruck palace, or the frescoes of the Golden Roof (Goldenes Dachl) of the palace at the Old Town Square. He also illustrated favorite manuscript books for Maximilian, including the *Tyrol Hunting Book* (1500) and the *Tyrol Fishing Book* (1504).[65] The stipulations of Kölderer's 1501 retainer obliged him only to spend a quarter of each year at the court and to produce "economical" paintings for the court.[66] Kölderer later made the pictorial inventories (sketches 1507, completion 1512) for Maximilian's *Zeugbücher*, or itemized weapons in the armories (chapter 5), and he produced colored drawings of the imperial fortifications in the south.[67] It was this quality of his art—his literal and meticulous recording of actual objects or symbolic complexes, such as coats of arms—that rendered him ideally suited to record (or to supervise a workshop that recorded) human inventories as well, such as the Habsburg family saints or the tomb project statues. Even in the hunting and fishing books, Kölderer soberly recorded the topographies of Maximilians favorite *Revieren*, or game preserves. Documents also mention Kölderer as the equivalent of a secretary, transcribing visual ideas instead of verbal texts, such as the early *Visierungen* of the *Triumphal Procession* in 1507 and the "two *Triumfwagen*" of 1512.[68]

In that same year of 1507, a renewal of Kölderer's court artist status absolved him of the costs of his artistic materials and provided him with two workshop apprentices, thus raising him above the ordinary responsibilities of a guild artist in the cities.[69] Erich Egg provides the overview of his duties: "paintings of diplomatic boxes, banners, hunts, decorative paintings in interior castles, restoration of the old frescoes in Castle Runkelstein, arms for funerals and on buildings, plans of fortifications, designs of hunting trophies."[70] Manifold and often menial, both public and private, invariably pragmatic, these artistic duties often serve as the visual equivalent of princely memoranda. Hardly the stuff out of which the modern, sovereign, learned, and independent artist emerges, as Warnke suggests of the prototype Renaissance court artist, such as Mantegna at the Gonzaga court in Mantua.

Parallel to Kölderer stands the "private secretary" (*Geheimsschreiber*), Marx Treitzsaurwein. He devised the early drafts of texts from dictation, particularly the fictionalized autobiographical texts: *Weisskunig*, *Teuerdank*, and *Freydal*. He also recorded the program of the *Triumphal Procession*. Like Kölderer, Treitzsaurwein seems to have been used by Maximilian chiefly as a recorder and transmitter rather than as an originating source of ideas or as a scholarly editor or adviser.

In contrast to these draftsman-secretary types, who remained close to Maximilian himself in and around Innsbruck, another level of more "executive" or productively original artists were usually recruited from outside the narrower court circle at Innsbruck. Sometimes, as with the case of Sesselschreiber, their success with important design led to later, supervisory responsibilities that got them involved over their heads. Maximilian's usual dependence on project coordinators, such as Peutinger, as intermediaries within the imperial cities was hardly infallible. Yet precisely this kind of division of labor permitted more efficient graphic artists, particularly Dürer and Burgkmair, to produce an astonishing quantity and quality of designs on a contractual basis. Indeed, the nature of their contact with Maximilian and his projects seems most closely to conform to the pattern described by Warnke as that of the *Hoflieferant*, or contractor to the court.[71] These were nonresident artists who chose to live away from court in major cities but who nonetheless were retained by rulers to perform occasional personal services as well as considerable artistic activity for their patrons.

In the Netherlands of the fifteenth century, Jan van Eyck offers a prototype of this artist-contractor. He lived in Bruges but was still closely tied to the court of Philip the Good, duke of Burgundy, first in Lille and later in Brussels.[72] A century after Maximilian, Rubens served his Habsburg descendants in the Netherlands, Albrecht and Isabella, at their court in Brussels, but he still lived in his hometown of Antwerp when not on diplomatic service for his sovereigns.[73] In the case of Dürer, contractual arrangements between Maximilian and the artist were settled indirectly, by annual payment of one hundred florins from the city of Nuremberg to the artist, a sum that was credited by the emperor against the city's yearly tax debt.[74] Previously Maximilian had asked the city to absolve Dürer of civic responsibilities, such as taxes, on account of his *Visierungen* in service to the emperor.[75] Dürer's own letter in mid-1515 (30 July) to Christoph Kress, a fellow townsman in contact with the emperor, requests payment by means of Stabius's intervention for three busy years of work, including the "Triumph" (that is, the *Arch of Honor*) and other *Visierungen*; the artist claims that had he not striven mightily to complete these works, nothing would have been accomplished.[76]

In contrast, Burgkmair never received direct payment or even reference from Maximilian, but rather was supported indirectly as the protégé of Peutinger. Burgkmair did create for Peutinger paired luxury woodcuts with gold or silver on parchment, *Maximilian on Horseback* and *St. George on Horseback*, as presents for the emperor in 1508, the year of his coronation at Trent.[77] However, he had already produced printed publicity for the emperor in 1504 in the form of a commemorative news broadsheet, celebrating Maximilian's victory over the Bohemian forces, led by Count Palatine Rupprecht at Regensburg (12 September 1504).[78] This crudely cut vision of the battle offers a foretaste of Burgkmair's later, extensive images of battle scenes in the woodcut illustrations of *Weisskunig* as well as similar images by Altdorfer in the *Triumphal Procession* miniatures or by the Dürer workshop in the *Triumphal Arch*. It displays topographical accuracy, clear composition of large groups of figures, and informative labels by means of both banners and captions. This woodcut was later complemented by a Latin "rhapsody" by Maximilian's original poet laureate,

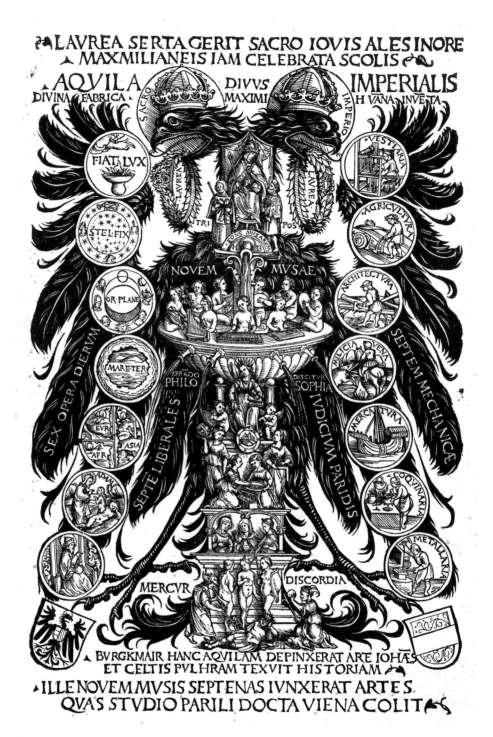

8

Hans Burgkmair, *Imperial Eagle of Conrad Celtis*, 1507, woodcut.

Conrad Celtis (1459–1508), the head of the emperor's College of Poets and Mathematicians in Vienna as well as an active intellectual leader of German humanist scholars, including Peutinger.[79] Burgkmair had also altered and "corrected" a dedication page woodcut of Celtis presenting his book, *Quattuor libri amorum* (1502), to an enthroned, frontal Maximilian; this second state, probably also made in 1504, like the battle broadsheet, chiefly reworks the faces of the two principals, emphasizing their prominence as well as their portrait character.[80] In all likelihood, Celtis himself brought the woodblock for his book from Nuremberg to Augsburg and requested the alterations directly from Burgkmair. Burgkmair continued to produce images for Celtis: a woodcut portrait medallion and a 1507 epitaph to (and for) the poet a year before he actually died of syphilis.[81] Thus, Burgkmair became quite closely involved with Germany's leading humanist, and the portrait prints made for Celtis anticipate the eventual mass publicity and empirewide "memorial" function later replicated in the *gedechtnus* projects of Maximilian. Panofsky was the first to see this important relationship between artist and patron, first the poet, then the emperor. He speaks of the German Renaissance movement as "bourgeois and centripetal," having to "propagandize for culture and its representatives" by means of such portraits on paper.

That the humanist world of Celtis was inextricable from the cultural side of Maximilian's imperial world is further underscored by Burgkmair himself in a complex allegorical woodcut (fig. 8) of the imperial eagle, presumably based on a lost 1506 Celtis drama for Maximilian.[82] The purpose of the print—and presumably of Celtis's drama—is to praise Maximilian as promoter of the arts and sciences. The crowned emperor sits on his throne at the top of the print, bestowing laurel crowns in the mouths of the double-headed imperial eagle. His imperial heralds complete the Apollonian "tripos" above the "fons musarum," which flows downward into a central basin with the nine muses, each with a musical instrument. Flowing from the basin, the waters of the muses splash over the enthroned figure of Philosophia and the Seven Liberal Arts. At the base of their realm lies a world of earthly distraction and temptation, the Judgment of Paris, with a dreaming hero asleep between Mercury and Discordia.[83] But this potential for destruction of knowledge is counteracted just above the base of the fountain by three modestly clad females, the Trivium of the Liberal Arts. Enfolding all of these accomplishments are the protective wings of the imperial eagle, on one side revealing the "divina fabrica," God's creation in the six days of Genesis, on the other side presenting mankind's own improvements, "humana inventa," the Seven Mechanical Arts.[84] Taken together, then, the liberal arts and philosophy flourish at the College of Poets and Mathematicians in Vienna under the aegis of the muses, but the whole is also fostered by Maximilian himself, the very opposite of Paris and the incarnation of Apollo within God's creation and mankind's cultivation.

Such a print offers a visual *summa* of Celtis's ambitions on behalf of his patron for classical learning in Germany, and here again we sense the powers of printed art and textual programs to promote an ideal of education. Grünpeck's allegory of *Virtus et Fallacicaptrix*, performed before Maximilian in Augsburg (November 1497) had already taken up the theme of the monarch and his wise choice of virtue over pleasure, like the choice of Hercules or the Judgment of Paris,

and that play had even involved Maximilian himself in the drama from his throne.[85] Celtis also penned a play for Maximilian as early as 1501: *Ludus Dianae*, performed at Linz for the emperor, offers a panegyric of his virtues. Led by Diana, the goddess of his beloved hunt (chapter 6), the drama praises Maximilian as both hunter and warrior and urges him to go on crusade against the Turks (chapter 4). Near the end of the play Vinzenz Lang, an associate of Celtis in the humanist Danube Sodality, was crowned poet laureate (in the costume of Bacchus) by the emperor on the spot. Shortly afterward, Celtis went on to write his 1504 "Rhapsody" in praise of Maximilian's victory at Regensburg.

German humanists proffered broader visions for Maximilian in the form of German history and topography.[86] Celtis gave ultimate vision to this program in his plans for a historical-political geography of Germany, the *Germania illustrata*, never written, but based on *Roma triumphans* and *Italia illustrata* by Flavio Biondo. Celtis's *Four Books of Love*, presented to Maximilian in 1502, was also organized geographically according to four separate regions of Germany; its dedication promises an epic *Maximilianeis* as well as a more comprehensive overview of the German nation, "its customs, language, and religion, character, and power." The rediscovery of Tacitus's vision of the ancient Germans as heroic antipodes of the ancient Romans did much to confirm Celtis's concepts, and he published an edition of Tacitus, supplemented by his own *Germania generalis* (Vienna, 1500), an outline of the intended *Germania illustrata*, organized around the four great rivers.[87]

Patriotic strains were particularly strong in the border region of Alsace. There Jakob Wimpheling's 1501 *Germania* traces the German descent of Alsace since Caesar as well as the German descent of all emperors since Charlemagne.[88] In similar fashion, Heinrich Bebel of Tübingen presented a 1501 Innsbruck oration, based on Tacitus, "De laudibus atque amplitudine Germaniae," based on the occasion of his own coronation as poet laureate by Maximilian. In 1508, Bebel defended the indigenous character of the Germans (*De laud . . . veterum Germanorum*) on the occasion of Maximilian's coronation at Trent.[89] These treatises of Wimpheling and Bebel were based on the nationalistic German and apologetic pro-Habsburg sentiments of Sebastian Brant of Strasbourg, a particularly ardent promoter of Maximilian as the ideal head of Christendom and leader of a crusade (see chapter 7).

Besides defenses of Maximilian and of the worthy history of the German nation, the most important general history produced for the court was imperial history, a blend of both nationalist and humanist interests. With the "translation of empire" under Charlemagne as the critical concept (chapter 3), an unbroken succession of "caesars" linked Maximilian to Julius Caesar and the heritage of ancient Rome, even older than the papacy itself. Here the key figure once more is Peutinger, whose humanist antiquarianism coincided perfectly with his imperial bonds to Maximilian in his research on a *Kaiserbuch*.[90] Based on Peutinger's collection of coins, inscriptions, and ancient sources, from as early as 1503 that scholar collated historical data for the succession of emperors in much the same methodical fashion as Stabius, in the wake of Jakob Mennel, evaluated data concerning the succession of Habsburg ancestors (chapter 2). The result, never published, was to have been an unbroken row of Caesar portraits in word and image from Julius Caesar

through Maximilian, chiefly concentrating on the dates of each reign and the death of individual emperors, data obtained largely through citations of coins, inscriptions, and documents. In keeping with the documentary character of Peutinger's researches, the accompanying woodcut illustrations by Burgkmair—ca. 1506, his first close association with Peutinger after the previous associations with Celtis—depended heavily on the authentic profile portraits to be found on ancient coins. Only 20 of Burgkmair's emperor woodcuts survive (most of those were inserted within Peutinger's personal copy of Suetonius), but presumably a full 185 were planned to be complements to Peutinger's entire list of imperial biographies, and his marginal notes indicate numbers of woodcuts in preparation.[91] Johannes Cuspinian, an Austrian humanist and follower of Celtis, took up the project of the *Caesars* on his own and eventually completed it in 1540, with a particular emphasis on the lessons to be learned from ancient history and the exemplary reigns of the first Staufer and then Habsburg emperors in Germany: "No one can better describe the deeds of German emperors than a German man, who has seen and heard them."[92] Thus, the program of learned praise of the imperial office (and of the Austrian state—Cuspinian went on to write a Latin *Austria*, 1528) was produced as the ultimate complement to Maximilian's own personal literary *gedechtnus*, or memorial projects. In this respect Cuspinian's arranging of the 1515 double wedding in Vienna (chapter 6) forms the parallel in life as well as the modern fulfilment in text form for the historical events commemorated in the *Kaiserbuch*.[93]

Of course, for Maximilian the Habsburg dynasty, the German nation, and the imperial office all fused in his person. Thus, he could have neither conflict nor ambiguity about any of these separate roles or allegiances. Even as his extended humanist circles of admirers boosted the claims of Germany or of the Holy Roman Empire, Maximilian himself could commission from Stabius or Mennel texts that were centered on himself and his ancestors. That these were not irreconcilable oppositions becomes clear when we analyze Maximilian's unique promotion of Germanic history as the product of its epic past. As the autobiographical texts make clear, Maximilian had considerably greater interest in the history of kings and heroes from his ancestry than in the broader humanistic program of the liberal arts. After the young prince in *Weisskunig* mastered the liberal arts, the text turns his attentions to the interests of a future king: "he also read texts that speak of past histories and of human nature and courage and of their status."[94]

As Müller points out, there was little distinction for Maximilian between old, epic texts (*poeterey*) and ancient German history, that is, between "story" and "history."[95] The *Heldenbücher* of past knights and kings served as the models for Maximilian's own autobiographical narratives in *Freydal*, *Teuerdank*, and *Weisskunig*.[96] In his preface to *Teuerdank*, its final editor, Melchior Pfinzing, expressly states that he emulates the "histories" to be found in *Heldenbücher*: "Of a praiseworthy, profound and renowned hero and knight with the name Lord Teuerdank, clever history [*history*] and deeds . . . in form, mass, and manner of *Heldenbücher*, to be described in hidden form."[97] These Maximilianic texts stress stereotypical events (tournaments, battles) and patterned stories (knightly quests and bridal journeys) for formulaic characters—ideal heroes, distinguished by means of their coats of arms or emblematic attributes, or allegorized in their very names. In the

case of *Teuerdank* or *Weisskunig*, these formulas have been marked by the new technologies of gunpowder and standing armies as well as the particular adventures derived from Maximilian's own hunts, water voyages, or dangerous travels (recounted and identified in the supplementary appendix key, *Clavis*, by Pfinzing). But in the texts themselves, as in their *Heldenbücher* models, it is the general that dominates over the specific. Thus, the hero's ideality in his virtues and his deeds—and consequently in his nobility, both in rank and family—becomes his principal characteristic. From the same chapter (no. 21) of *Weisskunig* on the "secret knowledge and experience of the world," we learn of the young prince's five "articles of understanding": the almighty, the influence of the planets, human reason, clemency in rule, and moderation—the latter serving as the motto for Maximilian, "*Halt mass!* (Be moderate)."

Maximilian directly promoted the preservation of German *Heldenbücher*, particularly by means of his luxury compilation, now known as the *Ambras Heldenbuch*.[98] In this anthology of twenty-five old, *Mittelhochdeutsch* texts, fifteen survive uniquely. The transcription process into this large, parchment tome lasted from 1504 to 1516; the scribe was Hans Ried, drawn from the imperial chancery, chiefly for his calligraphic rather than his paleographic skills.[99] A dedication by Sebastian Rank to Maximilian speaks of searching through cloisters and libraries all over Germany for *antiquitates und geschichte der alten*, because the emperor is "innately drawn to the very old histories and tales."[100] A major, central portion of the *Ambras Heldenbuch* (nos. 8–15) is devoted to native German epics: *Nibelungenlied*, *Kudrun*, *Biterolf*, and the sagas of Dietrich von Bern, the same Theoderic who was included among the statues of Maximilian's ancestors for his tomb. Other texts (nos. 3, 6, 7) present Arthurian tales of knighthood and chivalry concerning love (*Frauendienst*): *Iwein*, *Der Mantel*, and *Erec*.

Maximilian had similar preservation instincts for the visual arts, dispatching painters, first Friedrich Pacher and then Marx Reichlich, between 1504 and 1508 to Castle Runkelstein in South Tyrol in order to restore (*vernewen*) the old fresco paintings there.[101] These painted cycles include narratives of other epic heroes: Tristan, Garel, and Wigalois. Runkelstein was decorated at the turn of the fifteenth century, and it also offered a cluster of triads of ideal knights from history, conforming to the *topos* of the "Nine Worthies" (pagan, Jewish, and Christian) as well as further triads drawn from epic and romance literature: Arthurian knights, loving couples, Germanic heroes, strong giants, and wild dwarves.[102] Thus, older art as well as literature preserves the models of ideal knights and kings, such as the Christian worthies—Arthur, Charlemagne, and Godefroid of Bouillon—who were also included among Maximilian's ancestral tomb statues. Such texts and images present "history" in the form of stories of great—especially Germanic—individuals. So Maximilian can display his own form of "antiquarianism," even if not toward the antique Latin literature prized by contemporary German humanists. From such Germanic models, Maximilian drew the formulas so important for his own self-presentation of *alten istory* in the form of composed history through the texts of *Freydal, Teuerdank,* and *Weisskunig*. In his case, he could rely not only on following their model but could actually claim to be the blood descendant of such key figures as Dietrich of Bern, Arthur, Charlemagne, and Godefroid of Bouillon.

For this reason, the autobiographical texts of Maximilian should be regarded as written to conform to actual events and individual to prescribed ideals. It is significant that for his own tomb Maximilian wished to humble his physical remains by interring them under the foot of the officiating priest before the altar (chapter 4), yet he also prescribed inclusion of his own standing bronze statue among the other ancients, between Charlemagne and his own father, Frederick III, yet above the same altar (*ob den altärn*; never executed). In this manner, he presented his lasting portrait memorial in the company of his models and predecessors, and he offered himself as the latest incarnation of these heroic and chivalric kings and emperors. Thereby, Maximilian's own tomb effigy anticipates his place in history and presents him with a costume appropriate to his "dignity" and permanent legacy.

In a number of other portraits, Maximilian's distinctive facial features were fused with the attributes of saintly or revered figures, such as St. George (chapter 4), thus linking him as an individual with an ideal type. This is surely also the intention of his stressing the continuity of the imperial office, as in the *Kaiserbücher* of Peutinger and Cuspinian, or the busts of ancient Roman emperors in the gallery of Maximilian's tomb.[103] Humanist learning proved decisive for such tributes to Maximilian in the guise of ancient emperors or heroes. A rare early instance is a broadsheet

9

Anonymous, *Maximilian as Hercules Germanicus*, ca. 1495–1500, woodcut. Vienna, Albertina.

woodcut, *Maximilian as Hercules Germanicus* (fig. 9).[104] The text praises the hero, endowed with the features of Maximilian, as the restorer of order, *pacator orbis, salvator mundi*, but also as the promoter of virtue and knowledge, *musageticus* (cf. also the Apollo image in the later Burgkmair allegorical woodcut, tied to the play by Celtis, above). In a lower zone a crowned shield of the German kingdom is surrounded by the captioned chain of the Order of the Golden Fleece, thus explicitly identifying the scene with Maximilian; but he is also shown, captioned, on horseback in full armor, accompanied by two of his infantry *Landsknechten* (see chapter 5). His various troops from far-flung regions of the empire are grouped around his central position and labeled by means of banners (Bohemians, Milanese, Swiss, etc.). The formulator of this image, *Hercules Germanicus mundi monarcha gloriosissimus*, was a Regensburg friend of Celtis, Janus Tolophus (Johannes Tolhopf), who probably issued the tribute prior to 1493, when Maximilian succeeded

Frederick III as emperor. As the several images of Hercules by Dürer in Maximilian's *Prayerbook* attest (fos. 39v, 47r; chapter 4), the identification of the hero with the emperor, as indeed with most rulers of Europe, remained powerful. Even one of the later genealogies devised for the emperor by Stabius includes "Hercules Libycus, son of Osiris," as an early ancestor after Noah and Ham.[105] Hercules was also believed by Tacitus to have visited ancient Germany and there to have become the object of warrior cults; according to Tacitus, the German god, Tuisco, father of the nation (*Teutones*), was also associated with a son of Noah and a father of Hercules Alemannus, one of the purported early rulers of the Germans.[106] From this association the hero's valor converges with the general fortitude associated with the ancient Germans by Tacitus, together forming an ideal type for a *Hercules Germanicus*. Once more the adoption of the mythic hero as a model results from both Germanic associations as well as the ideal traits for the youthful ruler, employed for him in panegyric by German humanists.

The *Hercules Germanicus* offers an early harbinger of the kind of extended allegory that would be produced for Maximilian at the end of his reign by the collaborative efforts of Dürer and Willibald Pirckheimer.[107] The two Nuremberg friends first collaborated on a Latin translation with illustrations (1512-13) from a Greek text, *Hieroglyphica*, ascribed to a second- or third-century author, Horus Apollo.[108] Their joint effort, presented to Maximilian at Linz in April 1514, contains seventy colored ink drawings by Dürer or after him. The frontispiece presents an enthroned Maximilian, surrounded by hieroglyphic animals to create a rebus expressing both his powers and his accomplishments. Later reused for the topmost panel of the *Triumphal Arch* (fig. 10), this pictorial "mysterium" is decoded by Stabius in the colophon of the *Arch* as follows:

> The tabernacle above the title is a mysterium of ancient Egyptian letters deriving from King Osiris. It has been interpreted word by word to describe Maximilian as a most pious [star on crown], generous, mighty, powerful [lion], and prudent sovereign; a prince [dog with stole] of unforgettable, eternal [basilisk on crown], and honorable blood [papyrus], born of a lineage blessed with all gifts nature can bestow [dew from sky], endowed with the knowledge of art and wise teachings, Roman emperor [eagle], and lord of a great portion of the early [snake on scepter]. He has by force of arms and superb victory [falcon on orb] yet with the greatest modesty [bull] subdued the most powerful king [of France; cock], a thing all men had thought impossible [feet in water], and thereby has prudently guarded himself [crane with raised foot] from further attack.[109]

Pirckheimer's coded eulogy has its informed foundations in the twin princely virtues extolled in Maximilian's *Weisskunig*, chapter 21: strength and mildness, symbolized by the lion and the bull on which the emperor rests. In addition, various of these learned elements inform the decorative scheme of the *Triumphal Arch*, in some cases by means of classical references. These include the temptress sirens and harpies, explained by Stabius; other cases employ the same hieroglyphic references, such as the lion or deer skins (longevity) or other animals (goats for hearing, cranes for vigilance).[110]

10

Albrecht Dürer workshop, *Mysterium Tribute to Maximilian in Pseudo-Hieroglyphs*, from *Arch of Honor*, ca. 1517–18, woodcut.

In 1518, Pirckheimer and Maximilian exchanged letters concerning "a new chariot of my personality, different from the other one" (that is, altering the previous centerpiece of the *Triumphal Procession*, originally conceived with Maximilian and his immediate family, designed by Dürer, ca. 1512–13, W. 671; fig. 33, Vienna, Albertina).[111] A newer Dürer drawing of the revised *Triumphal Chariot* program, also in the Albertina (W. 685; fig. 34), is dated 1518. Their immediate contact person in Nuremberg was Melchior Pfinzing, councillor to Maximilian and local prior of St. Sebald's, who had recently completed the final text of *Teuerdank* for publication. Pirckheimer's reply indicates that Maximilian, "being most knowledgeable in such matters," should alter or correct the program of Pirckheimer, "which is no ordinary triumph but one of philosophy and

morality," delayed only because "it has taken a long time to arrange the virtues in proper order." Pirckheimer also praises Dürer's diligence in pictorially realizing this allegorical *Great Triumphal Chariot*. In addition to the *Great Chariot*, Pirckheimer also designed a *Laurea* or *Ehrenkrantz*, a panegyric of sixty aspects of Maximilian's qualities, arranged in triads according to the letters of the alphabet. This procession, never executed, would have had great laurel wreaths hanging from staffs borne by mounted riders, as in the drawing (Berlin) by Dürer's pupil, Hans von Kulmbach.[112] Almost as elaborate is the allegorical program of the *Great Triumphal Chariot*. Pirckheimer's text accompanies the Dürer figures on eight woodcuts (fig. 11), published posthumously in 1522 after Maximilian's death:

> First, because his Imperial Majesty exceeds all kings and princes in glory, honor, magnificence, and dignity, the chariot in which His Majesty rides is supported by four wheels of honor. . . . Following the four angelic virtues, Justicia, Fortitudo, Prudentia, and Temperantia are placed on four pedestals upon the chariot. From these all other virtues spring without which neither king nor lord can be, nor wish to be. No empire will last which suffers from a lack of character, reason, and modesty. These four virtues are interrelated and cannot be separated.

The charioteer of the whole ensemble is Reason, holding reins labeled Nobility and Power. Maximilian is crowned by a winged allegory of Victory, whose wings bear the names of his military campaigns. But, to borrow the words of Erwin Panofsky, the *Great Triumphal Chariot* no longer honors the emperor as an individual; instead, it sets his triumph "not as a dynastic manifesto but as a personal apotheosis."[113] Its use of rebuslike images with texts generalizes the significance of the woodcuts and underscores the overall glorification of the imperial office: "As in heaven is the ☼, so on earth is Caesar [shield]." Or again: "The ♥ of the king is in the hand of God," a tribute to the piety of the emperor and his role as the vicar of Christ (chapter 4). This latter phrase could also serve as a memorial, in light of the recent death (in early 1519) of Maximilian. The learned Latin commentary by Pirckheimer extends the universal timelessness of this triumph of Maximilian, who is presented in solemn profile like the *Kaiserbuch* images of ancient emperors, while dressed in full regalia. The entire production takes its place within the tradition of the "Mirror of Princes," treatises that outline the ideal virtues and conduct of the perfect prince.[114] Maximilian thus uses a humanist program to present himself as the exemplification of princely virtues. Learned allegory replaces assimilation to the features of a saint or mythic hero to glorify the emperor as an ideal type.

Within the context of Maximilian's artworlds, it is important to note the peripheral, if productive, position of both Dürer and Pirckheimer. In the *Great Triumphal Chariot*, Dürer no longer fulfils the charge issued him by Maximilian's local project supervisor of the *Triumphal Procession*, in the manner of Stabius's direction of him for the *Arch of Honor*. Indeed, Pirckheimer was not a close associate of the emperor. When Stabius wrote to Pirckheimer (December 1517), concerning the favorable reaction by Maximilian concerning the *Laurea*, he mentions that the emperor garbled his name

to "Perkinger, who now rules Nuremberg."[115] Stabius thus acted as an intermediary with Maximilian, just as he diplomatically intervened when an angry emperor chastized Dürer for departing too much from the Kölderer outline design for the *Arch of Honor*: "The trial proof of the Arch of Honor which we have now seen is not according to our instructions and does not correspond to the model in your hands. We do not like it and are displeased. We ask you to suspend further work on it and to prepare yourself for a journey to meet us. You will bring along the original design of the Arch of Honor which was given to you. We will then show you where it is lacking and how we wish it to be corrected."[116] By contrast, the Dürer-Pirckheimer collaboration on the *Great Triumphal Chariot* was "freelance," an independent submission to Maximilian, akin to the 1508 Burgkmair equestrian portrait woodcut with gold or silver coloration and its pendant of *St. George on Horseback*—both works produced with the counsel of Peutinger, who was quite close to Maximilian.

In similar fashion, despite the claims of Bernhard Strigel to be the exclusive "Apelles" of Maximilian (as Alexander the Great), Dürer also made a chalk sketch from life (W. 567, Vienna, Albertina; fig. 83) of the emperor at the Diet of Augsburg in 1518 and then went on to produce three unsolicited posthumous portraits: one on panel with a Latin inscription (Vienna, Kunsthistorisches Museum; fig. 82), one on canvas with a German inscription (Nuremberg, Germanisches Nationalmuseum; fig. 81), and one in woodcut (fig. 39) with a brief Latin formula.[117] To some extent, these posthumous tributes, including the *Great Triumphal Chariot*, may have been devised by Dürer with the intention of retaining his one hundred-florin pension from Maximilian's successors; he also produced a design for Nuremberg's 1521 silver medal, executed by Hans Krafft, to honor Charles V (chapter 7; fig. 84).[118]

Viewed, then, from the standpoint of proximity to Maximilian, Dürer can be seen to have occupied a peripheral position within the emperor's artistic sphere. Like the organist Paul Hofhaimer (chapter 6), or the printer Hans Schönsperger, Dürer received a lifetime pension from Maximilian; however, whereas the former musician frequently accompanied the emperor during his travels, Dürer and Schönsperger remained in their respective imperial cities, Nuremberg and Augsburg, where they devised formal solutions to technical problems of producing replicable images and texts. They offered designs rather than performances and thus could absent themselves from the person of the emperor himself. Both men were subject to local imperial supervisors, Stabius and Peutinger, as well as to ultimate criticism by Maximilian himself. Both received preliminary outlines from an inner circle of attending court artists and secretaries, chiefly Kölderer and Treitzsaurwein. Both of them then delegated completion of their tasks to their own local workshops, to talents such as Hans Springinklee and Wolf Traut for Dürer or Jost de Negker and other cutters for Schönsperger. In the one case where both men were involved on a single project, the *Prayerbook* (chapter 4), they were interrupted by external problems so that their own achievements remain fragments. Schönsperger never received the final text copy with the liturgical calendar composed of Habsburg saints, while Dürer, busy completing the *Arch of Honor*, had his marginal illustrations supplemented with the work of Burgkmair, Cranach, Baldung, Breu, and Altdorfer (with his workshop).

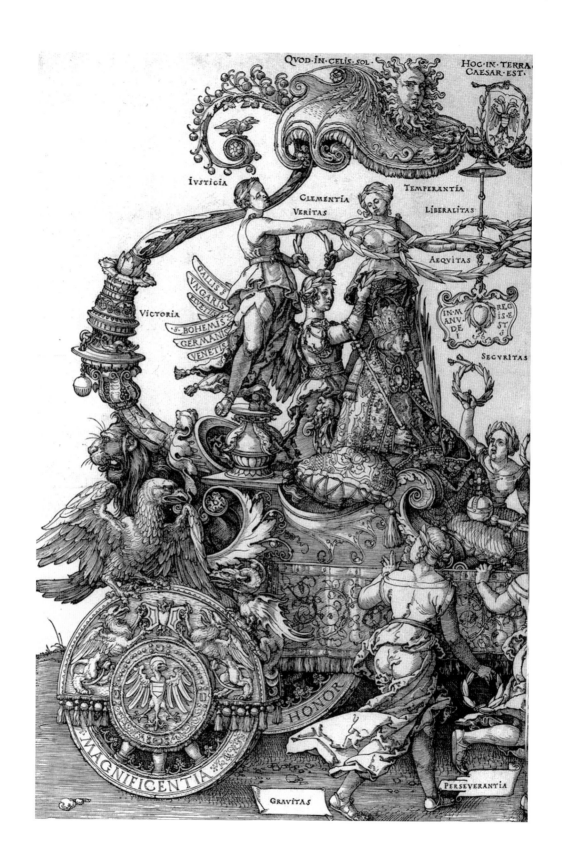

QVOD·IN·CELIS·SOL· HOC·IN·TERRA CAESAR·EST.

IVSTICIA CLEMENTIA TEMPERANTIA

VERITAS LIBERALITAS

AEQVITAS

VICTORIA

GALLIS

VNGARIS

HELVETIIS

BOHEMIS

GERMANIS

VENETIS

IN·M ANV· DE I REG IS·E ST 5

SECVRITAS

MAGNIFICENTIA HONOR

GRAVITAS PERSEVERANTIA

11

Albrecht Dürer, *Great Triumphal Chariot of Maximilian I*,
1522, woodcut. Vienna, Albertina.

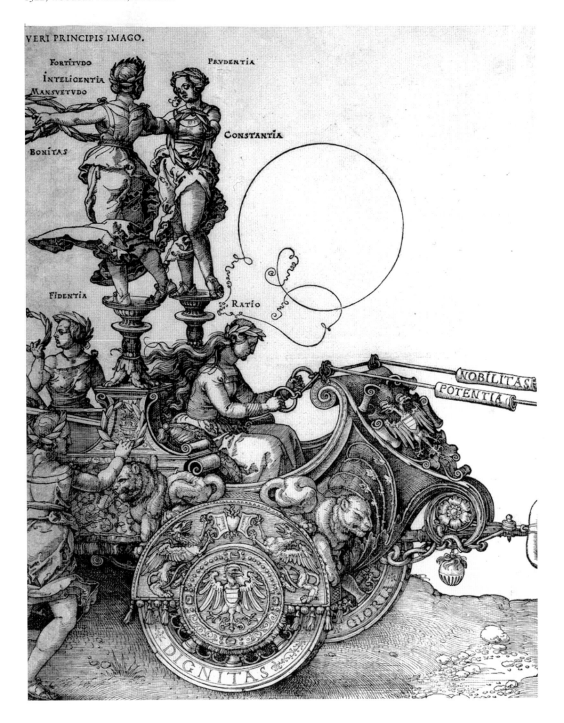

The relationship of Altdorfer to Maximilian casts further light on Dürer's role.[119] Like Dürer, Altdorfer rarely departed far from his native Regensburg in order to work for Maximilian. There, possibly through a local connection to Grünpeck, he secured the important commission to work first on the *Historia Friderici et Maximiliani*, followed by the miniatures of the *Triumphal Procession*. Also like Dürer, Altdorfer employed workshop assistants for both the miniatures of the *Triumphal Procession* and the marginal illustrations for the *Prayerbook*. Thereafter his printmaking skills were employed for the supplementary side towers of the *Arch of Honor* as well as for the baggage train (six woodcuts) and the mounted standard-bearers and musicians of the printed *Triumphal Procession*. Here we find again the powerful influence of Konrad Peutinger, who had added Altdorfer to the roster of favored artists in his "stable" along with Burgkmair and Beck as well as Jörg Breu in Augsburg. Altdorfer was the only artist distant from Augsburg to have been enlisted by Peutinger for the *Triumphal Procession* woodcuts, just as he had been grafted by Stabius onto the flanks of the *Arch of Honor*. Indeed, the connections between these advisers seems to have been Altdorfer's link to the *Prayerbook* project, if Diane Strickland's reading of a Peutinger letter fragment is correctly redirected to Stabius rather than to Mennel—and thus concerned with Altdorfer rather than Hans Baldung: "[Stabius] dear friend, I am sending you herewith three triple-folds. The first sheet is to have on the bottom a scene in the manner of the artistic Trinity, as drawn near the beginning of the Prayer of the Virgin according to the Roman usage, as done by Master Cranach and my good friend Dürer on 29 sheets.[120]

The *Prayerbook* folios were "subcontracted" to a series of prominent German artists, selected by the adviser, when the supervising artist, here Dürer, found himself overcommitted. The case of the *Prayerbook* parallels the case of the tomb project, where various statues were reassigned to leading sculptors in other cities—Nuremberg's Vischer and Stoss; Landshut's Leinberger. But always the goal of each project remained clear: to secure the approval of Maximilian himself for the artistic ensemble. The emperor was scrupulous in his personal editorial reviews, as attested by the penned corrections to the preliminary drawings for the *Historia* or the *Weisskunig*, or as his letter of anger about Dürer's independence from his models in the proofs of the woodcuts for the *Arch*. In similar fashion, the later corrections, such as Beck's alterations of woodblocks by Burgkmair and Schäufelein for *Teuerdank*, stem from Maximilian himself. In general, artists such as Burgkmair, Beck, and Altdorfer were more tractable and more literal in their transcriptions from designs (Kölderer's as well as Maximilian's) than Dürer. Thus, they succeeded better with Peutinger, who as the representative of Maximilian declared that the emperor prefers "mediocre artists because they follow his prescriptions in painting and imaging."[121]

Much the same conformity to prescribed ideas was the lot of Maximilian's team of learned advisers who supervised his artistic projects, chiefly Peutinger and Stabius.[122] Because of the collaborative nature of Maximilian's artistic projects between text and image or between designer and producer(s), these men assumed particular importance as intermediaries between the emperor and his art. Although friends and associates of purely literary Latinists and academics, such as Celtis, these men were not primarily rhetoricians or writers. Instead, they were public

servants, often both of their cities and of Maximilian. Peutinger, in particular, was city secretary (*Stadsschreiber*) of Augsburg (1497–1534), as well as a delegate of the city at imperial Diets, so his role as intermediary also extended to diplomacy between his native city and its sovereign, the emperor. In addition, Maximilian consulted him on other pressing questions of both law and economics.[123] In contrast, Stabius was trained as a mathematician and had considerable expertise in astronomy and geography. He even directed Dürer in the production of woodcut star maps and world maps.[124] His historiographic critical acumen developed as needed when Maximilian engaged him to work on the *Arch of Honor* genealogy. He became a learned polymath, a kind of scholarly generalist, just as Cuspinian, trained as a physician, became a historian, poet, and diplomat in the service of Maximilian. Pirckheimer never became this kind of trusted court *Rat*, or councillor, remaining in his native Nuremberg and contributing, like Celtis, to the emperor chiefly in matters of philology.

Yet for all these men, imperial publicity became a raison d'être. They provided the general public presentation of the emperor in print that complemented the elite, private world of rhetoric in diplomacy, which was then emerging among the "new monarchs" of Europe.[125] At the same time, their programs, dramas, and poems offered a loftier and more learned version of the "propagandistic" publicity issued by Maximilian to elicit broad popular support for his policies.[126] Celtis's *Rhapsodia* on the occasion of the 1504 victory at the Battle of Regensburg, accompanied by Burgkmair's early woodcut, offers an instance in which the humanist would closely approximate the world of popular vernacular broadsheets. Larger literary creations, however, or the textual programs for imperial artistic projects aspired to be permanent memorials (*Gedechtnus*) for Maximilian.[127] Thus the real task of these humanists was to write *istory*, that elevated and poetic version of chronicle-as-epic, which combined *poeterey* with *historien*. Like diplomacy, such writing employs rhetoric in the service of advocacy, specifically of Maximilian as the ideal prince. To use Pirckheimer's prefatory words from the text of the *Great Triumphal Chariot*, "your imperial majesty is gifted by God almighty before all other kings and lords with inexpressible worth, honor, and power, as well as with particular virtues high and great."

The figure missing from this account thus far is Maximilian himself, who in addition to his memorial texts held vast ambitions to write practical books on almost every branch of knowledge.[128] His use of secretaries as extensions of this thought was codified, in prototypical fashion, within a chapter (no. 26) of *Weisskunig*, "How the Young White King Learned the Handling of the Office of Secretary":

> The old White King noticed one day and found in his regime that where a mighty king was not experienced and clever in the offices of Chancery and of secretary, that same king in time developed a disadvantage. . . . Thus the old White King took his son to him and practiced him at writing (*Scheiberey*), what belonged to a Chancellor and secretary. . . . The son gave his father the response, "Whichever king puts his trust in one person and allows him dealings with his beautiful speech, then he will reign and not the king. . . ." When

the young White King reached maturity and assumed the throne he had many secretaries, whom he gave enough to do, and he raised those secretaries from youths to do his bidding. He let no letter go out, on great or small matters, before he relinquished the letter he subscribed all letters with his own hand. He was also so surpassing with correspondence and with his memorial (*gedachtnus*) that he often used 9, 10, 11, and 12 secretaries at one time, each with a different letter, and the entire rule of all his kingdom and land is his alone, in addition to the great wars that he led in enemy nations and lands.[129]

By such means, the "authorship" of Maximilian's texts, edited by teams of scholars from his own outlines or dictations and then finally approved by him, was as much a collaborative or group product as any of his artworks.[130] An extreme case is *Teuerdank*, successively refined by Treitzsaurwein and Siegmund von Dietrichstein, Stabius, Peutinger, and then definitively versified by Melchior Pfinzing. Thereafter the German text was translated into Latin as *Magnanimus* by Richard Sbrulius.[131]

With this curious combination of delegation to these secretaries while preserving ultimate control, Maximilian dictated to Treitzsaurwein in 1512 his programs of books to be written. They included many of the titles well known as his works of *Gedechtnus*: "Tomb Portal of Honor" *(Grab-Erenporten)*, *Weysskunig*, *Teurdannckh*, *Freydannk*, *Tryumpfwagen*, "Genealogy" (*Stamcronick*), "Family Tree" (*Der Stam*), and the several aspects of what became the *Prayerbook* (*Moraliteit, Andacht, Sant Jorgen*). But additional chapters reveal specialized tracts concerning Maximilian's special interests: artillery, heraldry, seven pleasure resorts (*7 Lustgezirk*), a *Stalbuch*, armor, hunting, fowling, cooking, fishing, gardening, and architecture. A later program appends further books on religious dogma (*Das Puech der xxiv Glauben*), jousting *(Gestächpuech)*, cellar and household, music and art, and even two books on black magic (*Schwartzcunnstpuech*) and magic *(Zauberpuech)*. Although only the books on hunting and fishing were ever completed to any degree (see above; also chapter 6), the sequence of chapters on the education of the ideal young prince in *Weisskunig* presents a corresponding succession of interests and early accomplishments.

As soon as he has built a foundation of piety (chapter 18), Prince Weisskunig begins with enough Latin to read scriptures, and he then commences to learn to write (chapter 19). Next he masters the seven liberal arts (chapter 20), proclaiming his five articles of practical lore for the "secret knowledge and experience of the world" (chapter 22), followed by the "black arts," or occult sciences (chapter 23), though he properly rejects this magic as devilish in origin ("forbidden and exterminated in the Christian faith and according to the imperial law . . . damnable to the soul"). This sequence unfolds in both the text and in Burgkmair's lively woodcut illustrations.

The young prince's interest in history as *alten gedachtnus* of royal lineages is celebrated along with the famous passage of chapter 24 concerning his own expenditure for his personal fame: "Whoever prepares no memorial for himself during his own lifetime has none after his death and is forgotten with the sound of the bell that tolls his passing." This *gedechtnus* is provided by the secretarial organization of chapter 26, as quoted above, and by his mastery of minting coins

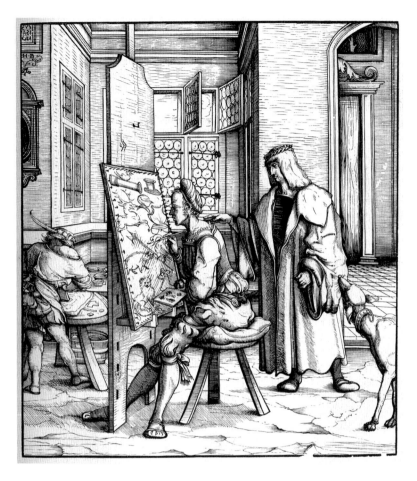

12

Hans Burgkmair, *Emperor Maximilian Supervising a Court Painter*,
from *Weisskunig*, ca. 1518, woodcut.

(chapter 35). The young king needs to learn medicine both as a means of healing souls (*seelhayl*)
and as an antidote to the damnable black arts, and it serves him well in practicing temperance and
moderation in the arts of cuisine; furthermore, medical knowledge helps him to counteract illness
and poisons on his own.[132] The prince has a gift for multiple languages; he learns Wendish and
Bohemian from his young bride along with Flemish from an "old princess." His manual skills are
manifold: stone construction (chapter 30), carpentry (chapter 31; very useful in siege warfare), and
mining (after the discussion of coins at chapter 36). He includes painting within the manual arts
(chapter 29), useful for "the true soldier and general" because of its ability to render landscapes.
The Burgkmair woodcut illustration (fig. 12) concerning painting, however, shows game animals
as well as designs for armor and weapons on the easel, as if in emulation of specific assignments
for armor given to Burgkmair himself or of the numerous animal paintings requested of Lucas

Cranach, painter at the Saxon court of Frederick the Wise.[133] The text also praises the potential of painting for designs of "jousts, buildings, and inventions (*Ritterspielen, Bauten, und Erfindungen*)."

The remaining princely skills exemplify the exercise of regal magnificence, first by means of music (chapter 32) as well as banquets and mummeries (chapter 34). Hunting, another main princely pastime, should be mastered in various forms: archery (chapter 37), crossbow (chapter 38), hawking (chapters 39, 42), game hunts (deer, chamois, mountain goats, boars, and bears; chapter 40), and fishing (chapter 41). Finally—and to Maximilian perhaps most important—the ideal prince knows how to fight in either tournaments or battlefields: unarmed (chapter 43), with shield (chapter 44), armed (chapter 45), in jousts (chapter 46), on horseback (chapter 47), as the master of armor technology (chapter 48), with artillery (chapter 49), and behind a *Wagenburg*, or portable fortress, constructed out of clustered wagons (chapter 50).

Several *Historia* images following sections of that text set out praise of the emperor's charisma and clemency (nos. 33–34; see also *Weisskunig*, chapter 27, on generosity, *miltigkait*). The *Historia* also outlines the same princely interests in a more condensed form, including hunting (no. 35), tournaments (no. 36), masquerades (no. 37), and promotion of knowledge (no. 38, *De eius litterariis otiis prasertim cosmogrphiae et historiarum studiis*).[134] This latter image shows the emperor with his hand on a globe while addressing a courtly circle of listeners. Such an idealized image projects Maximilian's desire to be a man of substance, knowledgeable as well as powerful.

Had Maximilian completed his program of books beyond his dictated list of titles of cursory chapters in *Weisskunig*, then he could have exhibited his nonmilitary and nonpolitical accomplishments and passed on his own experiences to posterity. Herein lies his second major ambition besides the memorial/historical commemoration of his reign. As the second section of *Weisskunig* reveals, the ideal prince exemplifies vast practical learning (*kunst*), arts in the sense of skills rather than liberal arts (although also including a basic foundation of Latin and scholarly learning).[135] That such interests were not trivial to Maximilian is confirmed by the Altdorfer woodcuts on the side towers of the *Arch of Honor*, which glorify Maximilian's "honorable, unforgettable, and useful activities . . . [which] cannot properly be considered to be triumphal [that is, historically significant and suitable for *Gedechtnus*] but do serve as good examples to others." Stabius's colophon lists these interests as "artillery, fields and streams, architecture, foreign tongues, jousting and other Christian pursuits," along with various achievements in the field of religion: the canonization of St. Leopold, the rediscovery of the relic of Christ's robe at the cathedral of Trier, promotion of the Order of St. George, and his planned crusade against the Turks (see chapter 4). In addition, the *Triumphal Procession* itemizes courtly pastimes at the head of its parade: hunting (nos. 5–14), music and mummeries (nos. 17–32), jousting (33–56), as well as the heraldry required of a prince in his territories (nos. 57–88). Significantly, these activities appear before the float of Maximilian's marriage and the sequence of his wars.

Although completed only at the level of sketches, Maximilian's artworlds also included a number of alternative projects besides the celebration of his fame, or *Gedechtnus*. In much the same fashion as the proposal for an (unexecuted) "Arch of Devotion" (*Andachtspforte*) alongside

the *Arch of Honor*, Maximilian's books of technical expertise would have amplified his legacy. Presumably like the more finished hunting and fishing books, illustrated with full-page miniatures by Jörg Kölderer and written in the finest chancery cursive by Wolfgang Hohenleiter, these other practical tracts would have been intended as luxurious private editions. In some respects, Kölderer's meticulous illustrations to Maximilian's armories, the *Zeugbücher*, offer a further hint of what such treatises might have looked like, and the additional Kölderer decorations of palace walls in Innsbruck for the Wappenturm and Goldenes Dachl strongly suggest that he was the likely supervisor and designer for such proposed imagery.

How can we interpret these additional fragmentary imperial book (series) projects? Not according to a humanist, literary measure, which considers *lernung* to be essentially literary and Latin, *pace* Müller, who emphasizes Maximilian's later Latin translations of works originally composed in German and highlights the arcane esoterism of hieroglyphs and allegories, submitted by Pirckheimer.[136] A more likely and consistent outlook (considering the esoterism to be a late, limited ambition) would recognize that the young White King, after all, remains an untested prince in his "apprenticeship" period, prior to the life-defining experiences of marriage, warfare, and general rulership, those events of royal maturity that comprise part 3 of *Weisskunig* and the main highlights of the *Arch of Honor*. By contrast, *Teuerdank* pursues hunts, jousts, and roaming adventures prior to his marriage—corresponding to the learning period of part 2 of *Weisskunig*. The young White King in chapter 17 is placed among the most gifted (*allergeschicktesten*) noble youths of the kingdom in order to learn to speak and to play all manner of games. He, of course, turns out to be even more gifted and inventive than his companions. A natural leader, he goes on to promote concord among those youths when they quarrel. As the Burgkmair illustrations to that and the following chapter reveal, Maximilian's interests include as many physical activities as intellectual contemplations, and the limits of "book learning" are stated expressly in *Weisskunig*, for example in a passage within the chapter on the seven liberal arts (chapter 20), stressing a well-rounded rather than a specialized education: "The Master realized that it would be neither good nor useful to burden him further with this instruction. If one wants to teach someone more than is necessary, that is an excess and hinders other projects."[137] Practical training and exercise carry more emphasis than theory of untested knowledge ". . . because one who wishes to become famous in this [here, jousting; chapter 46] needs practice with deeds and not learning from books."[138]

Ultimately the purpose of all this training—intellectual as well as practical—is to polish and perfect the natural, innate nobility of the well-born prince, to supplement nature with nurture, and thus to fulfil every potential of the monarch's superiority.[139] Thus, the *topos* of each chapter of the *Weisskunig* finds the young prince eventually teaching his own teachers, or else surpassing the full-time specialists in each succeeding field of endeavor. One instance of this natural talent is the stress given to his prodigious language abilities and his capacity to learn from, and to speak to, peasants and soldiers as well as nobles in their own idiom. In *Weisskunig* Burgkmair and Beck illustrate successively (nos. 64–69) the rapid acquisition of the following languages: French, Flemish, English, Spanish, and Italian (*Welsch*), as well as the overall mastery of seven languages.[140] The

illustrations of the *Historia* follow the promise of Maximilian's early childhood accomplishments and leadership (no. 19) in similar fashion, with images of the emperor successfully leading his soldiers in their camp (no. 32, where he distributes his own meal to them), negotiating unarmed with them at a time of mutiny (no. 41), and also graciously receiving the petitions of his subjects (no. 40).[141] But the quintessence of this peacetime exercise of natural talent and charisma is the next *Historia* illustration (no. 42), in which Maximilian sits at the royal meal table listening to his advisers while he simultaneously dictates to a pair of secretaries.

In short, what Pirckheimer allegorized in the *Great Triumphal Chariot* was the concatenation of virtues toward which Maximilian strove—but in exceedingly practical terms, to be exercised rather than theorized or allegorized. In similar fashion, the chapter on piety (chapter 18) in *Weisskunig* already underscores this concept of nobility through accomplishment: "As a precious jewel shines beautiful and clear, so much more noble and precious [*edler und kostlicher*] is this stone; in such a way are in me the purity of untarnished honor [*eer*], the kingly virtues [*tugent*] and the justice [*gerechtigkait*] of God's laws so well rooted, that through me the most beautiful honor and rule will shine in the world."[142]

In this respect, Maximilian as a promoter of princely and practical "arts" more closely resembles the ideal Courtier of Castiglione than the bold practitioner of power politics, Machiavelli's Prince. Castiglione, too, debates about the relative importance of nobility of birth versus nobility of manners: "Therefore, besides his noble birth, I would wish the Courtier favored in this other respect, and endowed by nature not only with talent and with beauty of countenance and person, but with that certain grace which we call an 'air.'"[143] Like Maximilian, the Courtier's practical skills feature martial arts (1.17: "The principal and true profession of the Courtier must be that of arms"), specifically the handling of weapons and horses, as well as jumping, running, wrestling, and swimming. Related sports, especially hunting (1.22: "because it has a certain resemblance to war") and jousting, as well as tennis, bullfighting, and stickthrowing, round out the basic physical exercise of the Courtier. Yet learning is his essential educational complement: "to no one is learning more suited than to a warrior; and I would have these two accomplishments conjoined in our Courtier, each an aid to the other" (1.46). Knowledge of both Latin and Greek, of both poets and historians, forms the foundation of such learning and should stimulate creative writing (1.44). Letters are praised for the "light of glory" that they shed on a man, to make him immortal. Music, read as well as played, offers a decorous leisure activity and a moral harmony (1.47). In addition, for Castiglione—as for Maximilian—art proves useful, as an image can help in warfare and also serve as the image of God's creation (1.49). Taken together, then, this court-centered composite ideal of the "Renaissance man" provides a program for perfecting the individual by blending both arms and letters, action and contemplation, mechanical as well as liberal arts. Ultimately the goal remains moral strength, expressed in the forms of both physical and mental gracefulness, but Castiglione's model actually stretches from Vergil's epic through late medieval prose romances.[144] Maximilian's princely education thus must produce the perfect courtier, who leads through example and personal accomplishment before he assumes the mantle of monarch.

APPENDIX
Principal Text Projects and Participants

1. *Historia Friderici et Maximiliani* (Vienna, Haus-, Hof-, und Staatsarchiv, MS Blau 9/Böhm 24)

Narrative of the life of Frederick III and Maximilian to 1508.

AUTHOR: Joseph Grünpeck, text completed 1515–16.

ARTIST: Albrecht Altdorfer (?), 46 drawing illustrations, ca. 1508–10 (?).

REFERENCES: Otto Benesch and Erwin Auer, *Die Historia Friderici et Maximiliani* (Berlin, 1957); Hans Mielke, *Albrecht Altdorfer*, exh. cat. (Berlin, 1988), 68–72, no. 30.

2. *Genealogie*, 1510–12 (illustrations), 1512–17 (text)

Ancestry of Maximilian.

AUTHORS: Jakob Mennel, Johannes Stabius, Ladislaus Sunthaym (text incomplete).

ARTISTS:

Manuscript: Mennel Master, *Zaiger* (Vienna, Österreichische Nationalbibliothek, cod. Vindob. 7892), 1518; Mennel Master, *Fürstliche Chronik/Geburtsspiegel*, 6 vols. (3072–77★★) [throughout, asterisks indicate shelf marks].

Prints: Hans Burgkmair, ca. 1510–12, 77 woodcut proofs (out of a planned 92) (Vienna, Österreichische Nationalbibliothek, cod. 8018, 8048).

REFERENCES: Anna Coreth, "Dynastisch-politische Ideen Kaiser Maximilians I," *Mitteilungen des Österreichischen Staatsarchivs* 3 (1950), 81–105; Simon Laschitzer, "Die Genealogie des Kaisers Maximilians I," *Jahrbuch der Kunsthistorischen Sammlungen der Allerhöchsten Kaiserhauses* 7 (1888), 1–200.

3. *Habsburg Saints*, 1516–18

Would-be saints as would-be ancestors in Maximilian's extended genealogy.

AUTHOR: Jakob Mennel, supervised by Konrad Peutinger.

ARTISTS:

Manuscript: Jörg Kölderer workshop (Master of Mariazell?), outline sketches (Vienna, Österreichische Nationalbibliothek, cod. Vindob. 2857); Jörg Kölderer, miniatures (Vienna, Österreichische Nationalbibliothek, cod. Vindob. ser. n. 4711); Mennel Master, *Genealogy,* vol. 3 (Vienna, Österreichische Nationalbibliothek, cod. Vindob. 3077★★★).

Prints: Leonhard Beck, 89 proofs (out of a planned 123) (Vienna, Albertina).

REFERENCES: Simon Laschitzer, "Die Heiligen aus der Sipp-, Mag- und Schwägerschaft des Kaisers Maximilian I," *Jahrbuch der Kunsthistorischen Sammlungen der Allerhöchsten Kaiserhauses* 4 (1886), 70–289; 5 (1887), 117–262.

4. *Freydal*, 1512–ca. 1516

Sequence of 64 tournament contests and festivities, planned as an introduction to *Teuerdank*.

AUTHOR: Dictated sketch by Maximilian to Marx Treitzsaurwein, 1512 (Österreichische Nationalbibliothek, cod. Vindob. 2835).

ARTISTS:

Manuscript: Anonymous, several (Vienna, Kunsthistorisches Museum, KK 5073).

Prints: Albrecht Dürer, 5 prints (out of a planned 255), 1516.

REFERENCES: Quirin von Leitner, ed., *Freydal: Des Kaisers Maximilian; Turniere und Mummereien* (Vienna, 1880–82).

5. *Teuerdank,* ca. 1510–17; published by Hans Schönsperger (Augsburg, 1517), parchment

Bridal journey of the young knight despite dangers and obstacles.

AUTHOR: Dictated sketch by Maximilian to Treitzsaurwein; redaction by Melchior Pfinzing.

ARTISTS: Anonymous (8 prints), Leonhard Beck (77), Hans Burgkmair (13), Hans Schäufelein (20).

REFERENCES: Horst Appuhn, ed., *Kaiser Maximilians Theuerdank* (Dortmund, 1979); Simon Laschitzer, "Theuerdank," *Jahrbuch der Kunsthistorischen Sammlungen der Allerhöchsten Kaiserhauses* 8 (1888); Jan-Dirk Müller, *Gedechtnus* (Munich, 1982), 108–30, 159–72, passim; H. Theodor Musper, ed., *Kaiser Maximilians Teuerdank* (Stuttgart, 1968).

6. *Weisskunig,* ca. 1505–16, revised 1526–27

Fictionalized autobiography, featuring the coronation of Frederick III; the birth and education of Maximilian; and reign to 1513.

AUTHOR: Dictation from Maximilian to Treitzsaurwein; 11 MSS (A–L; there is no "I"), including *Fragbuch* (1515; Vienna, Österreichische Nationalbibliothek, cod. 3034, with woodcuts).

ARTISTS: Leonhard Beck (127 prints), Hans Burgkmair (118), Hans Schäufelein (2), Hans Springinklee (4).

REFERENCES: Jan-Dirk Müller, *Gedechtnus,* 130–48, passim; H. Theodor Musper et al., eds., *Kaiser Maximilians I Weisskunig* (Stuttgart, 1956); Alwin Schultz, ed., "*Der Weisskunig* nach den Dictaten . . . ," *Jahrbuch der Kunsthistorischen Sammlungen der Allerhöchsten Kaiserhauses* 6 (1888).

7. *Prayerbook,* 1513–ca. 1515; published by Johann Schönsperger the Elder (Augsburg, 1513)

Collection of prayers, probably dedicated for use by the Order of St. George. Font based on calligrapher Leonhard Wagner.

ARTISTS:

Manuscript margins: Albrecht Altdorfer and workshop (28), Hans Baldung (7), Jörg Breu (22), Hans Burgkmair (4), Lucas Cranach (8), Albrecht Dürer (56).

Maximilian exemplar: Besançon (Bibliothèque Municipale); Munich (Staatsbibliothek).

REFERENCES: Magdalena Bushart, *Sehen und Erkennen: Albrecht Altdorfers religiöse Bilder* (Munich, 2004), 159–92; Eduard Chmelarz, "Das Diurnale oder Gebetbuch des Kaisers Maximilian I," *Jahrbuch der Kunsthistorischen Sammlungen der Allerhöchsten Kaiserhauses* 3 (1885), 88–102; Karl Giehlow, *Kaiser Maximilians I Gebetbuch mit Zeichnungen von Albrecht Dürer und anderen Künstlern* (Vienna, 1907); Andrew Morrall, *Jörg Breu the Elder* (Aldershot, 2001), 78–97; Hinrich Sieveking, *Das Gebetbuch Kaiser Maximilians: Der Münchner Teil* (Munich, 1987); Walter Strauss, ed., *The Book of Hours of the Emperor Maximilian the First* (New York, 1974); Hans Christoph von Tavel, "Die Randzeichnungen Albrecht Dürers zum Gebetbuch Kaiser Maximilians," *Münchner Jahrbuch der bildenden Kunst* 16 (1965), 55–120.

8. *Triumphal Procession*, 1507–18

Woodcut frieze with captions, encompassing court life (hunts, music, tournaments), territories, marriages, wars, ancestors, imperial majesty, imperial princes, soldiers, and captives.

AUTHOR: Dictation from Maximilian to Treitzsaurwein, 1512.

ARTISTS: Lost sketch by Jörg Kölderer.

Manuscript: Albrecht Altdorfer and workshop (Vienna, Albertina, nos. 49–109, plus copies of lost miniatures, nos. 1–48).

Prints: Albrecht Altdorfer (38), anonymous (11), Hans Burgkmair (67), Albrecht Dürer (2), Hans Springinklee (22), plus the *Great Triumphal Chariot* (1522, 8 sheets, after the program by Willibald Pirckheimer) by Dürer.

REFERENCES: Stanley Appelbaum, ed., *The Triumph of Maximilian I* (New York, 1964); Horst Appuhn ed., *Kaiser Maximilians Triumphzug* (Dortmund, 1979); Hans Mielke, *Albrecht Altdorfer*, exh. cat. (Berlin, 1988), 180–87; Jan-Dirk Müller, *Gedechtnus* (Munich, 1982), 149–53; Franz Schestag, "Kaiser Maximilian I: Triumph," *Jahrbuch der Kunsthistorischen Sammlungen der Allerhöchsten Kaiserhauses* 1 (1883), 154–81; Franz Winzinger, *Die Miniaturen zum Triumphzug Kaiser Maximilians I* (Graz, 1972).

9. *Arch of Honor*, before 1519

Mural display of family tree, events of reign to 1515, princely interests, earlier emperors, ruling relatives, territorial arms within the framework of a triumphal arch structure.

AUTHOR: Johann Stabius.

ARTISTS: Lost sketch by Jörg Kölderer. Woodcuts: Albrecht Altdorfer (10); Albrecht Dürer and workshop (Hans Springinklee, Wolf Traut) (167).

REFERENCES: Eduard Chmelarz, "Die Ehrenpforte des Kaisers Maximilian I," *Jahrbuch der Kunsthistorischen Sammlungen der Allerhöchsten Kaiserhauses* 4 (1886), 289–319; Jan-Dirk Müller, *Gedechtnus* (Munich, 1982), 153–58; Thomas Schauerte, *Die Ehrenpforte für Kaiser Maximilian I* (Munich, 2001); Larry Silver, "Power of the Press: Dürer's *Arch of Honour*," in Irena Zdanowicz, ed., *Albrecht Dürer in the Collection of the National Gallery of Victoria*, exh. cat. (Melbourne, 1994), 45–62.

10. Tomb, begun 1508, cenotaph completed 1561–83

Ensemble planned for Wiener Neustadt, erected at Innsbruck, Hofkirche (built 1553–63). Life-size bronze ancestor figures (40 planned, 28 executed); miniature emperor busts (34 planned, 22 executed); miniature Habsburg ancestors (100 planned, 23 executed).

AUTHOR: Konrad Peutinger.

ARTISTS:

Sketches: Albrecht Dürer; Jörg Kölderer, 2 series (Vienna, Österreichische Nationalbibliothek, cod. Vindob. 8329, 30 figures; Vienna, Kunsthistorisches Museum, KK 5333, roll with 39 figures).

Sculptors: Hans Leinberger; Leonhard Magt, carver, with Stephan Godl, caster (1518–34, ancestors and saints); Jörg Muskat, carver, with Laux Zotman, caster (1509–17, emperor busts);

Gilg Sesselschreiber, with bronze caster Peter Löffler (1508–18); Veit Stoss; Peter Vischer and workshop (ca. 1513–18).

REFERENCES: Erich Egg, *Die Hofkirche in Innsbruck* (Innsbruck, 1974); Vinzenz Oberhammer, *Die Bronzestandbilder des Maximiliangrabmales in der Hofkirche zu Innsbruck* (Innsbruck, 1935); Karl Oettinger, *Die Bildhauer Maximilians am Innsbrucker Kaisergrabmal* (Nuremberg, 1966); Elisabeth Scheicher, *Das Grabmal Kaiser Maximilians I in der Innsbrucker Hofkirche* (Vienna, 1986); Scheicher, "Kaiser Maximilian plant sein Grabmal," *Jahrbuch der Kunsthistorischen Sammlungen in Wien* 93 (1999), 81-118; Jeffrey Chipps Smith, *German Sculpture of the Later Renaissance c. 1520–1580* (Princeton, N.J., 1994), 185–92.

All the lineages in the world can be reduced to these: some had humble beginnings, and extended and expanded until they reached the heights of greatness; others had noble beginnings, and preserved them, and still preserve them just as they were; still others may have had noble beginnings but, like pyramids, they tapered to a point, having diminished and annihilated their origins until they ended in nothingness.

—CERVANTES, *Don Quixote*

Bella gerant alii / Tu felix Austria nube.
(Let others war, / As you, fortunate Austria, marry.)

2 | Family Ties: Genealogy as Ideology for Emperor Maximilian I

The first systematic personal monument of Maximilian I of Habsburg, Holy Roman Emperor from 1493 until his death in 1519, is a manuscript biography of his father and himself: the *Historia Friderici et Maximiliani.*[1] Written near the turn of the century but later illustrated for the edification of the emperor's grandson and eventual successor, the future Charles V, this manuscript edition begins with an image that runs like a leitmotif through the other projects of Maximilian (fig. 13). The *Historia* text was intended to serve as a didactic princely history, or *Fürstenbuch*, of the House of Habsburg. Consequently, its first illustration, derived from the medieval tradition of the Tree of Jesse for Christ's own genealogy, shows a family tree emerging quite literally from the heart of a patriarchal ancestor at its base.[2] Two chief branches divide above this greybeard, signifying the Styrian and Tyrolian branches of the Habsburg family.[3] Near the beginnings of the branches only youthful, bareheaded males adorn the leaves of this family tree, tokens of an early period of family history, when the rank of count was as lofty as the family could claim for itself. But during the three centuries previous to Maximilian, Habsburg representatives held the offices of emperor and made claims to be both kings and princes; these august titles adorn the figures higher up on the tree branches in the form of golden chains of office and differentiated crowns. At the top left leaf, we find a crown of kingship on a figure resembling Maximilian himself, while at the top center is the figure of Frederick III, given precedence while wearing the distinctive arched crown (*Bügelkrone*) of the Holy Roman Empire.[4] Thus, the figures who appear highest in the tree are not only the newest "growth," that is the most recent family representatives; they are also the most "elevated" in rank, including the imperial rank of both Maximilian and his father, Frederick III, the

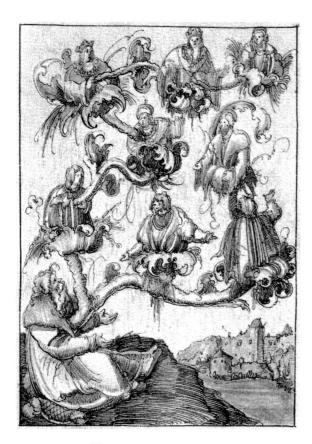

13

Albrecht Altdorfer (attributed), *Habsburg Family Tree*, from *Historia Friderici et Maximiliani*, ca. 1508–10, ink. Vienna, Haus-, Hof-, und Staatsarchive, Hs. Blau 9, fo. 6r.

dual subjects of this Latin biography. The landscape in the lower right corner also makes a family reference by depicting the literal roots of the Habsburg dynasty: the ruins of their ancestral castle, Habensburg, in Switzerland (see below).

The *Historia* images also figure (chapter 6) in the context of Maximilian's princely pastimes, but the entire *Historia* project of personal history clearly begins with a concept of "roots," that is, family history and genealogy. From awareness of his forefathers, the youthful prince Charles, Maximilian's heir, was to draw strength and instruction. However, the vagueness in this drawing concerning earlier ancestors was to remain an ongoing problem for genealogists around Maximilian, as the emperor vacillated between situating his forefathers among the ancient Romans, or alternatively, among a decidedly non-Italian lineage of ancient Trojans and Franks.[5] On the manuscript text of the *Historia*, Maximilian himself made annotations that included a desire to see proper corrections appended in later editions as researchers discovered more material about the ancestors prior to his father, Frederick III.[6]

This charming, sketchy drawing from the *Historia* manuscript (after 1508) was produced under the direction of the author of the text, Joseph Grünpeck, by a young Albrecht Altdorfer of Regensburg, a city where Grünpeck often published his other texts.[7] This drawing and its forty-seven mates were designed to form an integral part of the book with its text. Indeed, a "first draft" in the Vienna Staatsarchiv, published by Schultz, already includes notations for painting certain narrative details from the text. Maximilian's personal supervision of projects such as this one and his stress on illustration as well as of text formed the cornerstone of his autobiographical publications: "And thus to make at the outset an explanation of my book I have added painted figures to the text with which the reader with mouth and eye may understand the basis of this painting of my book, which ground I have established, and in the same fashion have written and depicted chronicles, as I have seen such out of other chroniclers of my predecessors."[8]

Although these pictorial narratives chiefly centered on Maximilian's memoirs, including the *Historia* as well as the *Teuerdank* and the *Weisskunig*, the same concept of speaking pictures also informed major projects devoted exclusively to Habsburg ancestors. These projects included vast

publications dedicated to Habsburg forebears—relatives, as well as saints, but they also extended to the extensive tomb ensemble of Maximilian, where a phalanx of forty life-size bronzes was planned to serve as both an entourage and as timeless family witnesses to the obsequies of the deceased emperor. For all of these works an army of artists and craftsmen worked closely with a complementary team of historians and other scholars who drew up the succession of genealogies to be "figurated." By examining these projects, we can discover not only how Maximilian produced the works he intended to carry his name and fame into the ages, but we can also discern the shifting patterns of Maximilian's dynastic ambitions and self-image through his choice and use of ancestors.

The central publication of Maximilian's ancestry was to have been a published *Genealogy*, accompanied by woodcuts by Hans Burgkmair of Augsburg.[9] The project coordinator and Augsburg liaison with Maximilian was Konrad Peutinger (1463–1547), a close and trusted associate (*Kaiserlicher Rat* as of 1506; see chapter 1).[10] Peutinger, Augsburg city chancellor, had studied law in Italy and was also a noted antiquarian and humanist back in Germany.[11] His chief service to the emperor, however, lay in his political counsel and diplomacy in addition to his intervention in large art projects produced in Augsburg. In part because of his close association with Peutinger, Maximilian developed a particular rapport with the city and people of Augsburg, who, in turn, benignly delighted in calling him their honorary mayor.[12] Augsburg was also a noted publishing center, including the versatile Erhard Ratdolt, who had been a printer in Venice for a decade before coming back to Augsburg in 1486.[13] With such a constellation of talent in one city, Maximilian could safely entrust this important *Genealogy* project to Peutinger and his chosen team, namely Burgkmair as designer and Ratdolt as printer.

Peutinger seems to have relied consistently on Burgkmair for woodcut projects designated by Maximilian, beginning with the multicolor woodcut of *Maximilian on Horseback* (see chapter 3), made by Burgkmair in response to a request by Peutinger in 1508, the very year of Maximilian's proclamation as emperor-elect at Trent.[14] Significantly, the *Genealogy* was the first full-scale publication project undertaken by Maximilian, and it was to be the only one whose woodcut illustrations were entirely delegated to Burgkmair, whose initials appear on them all. According to a letter from Peutinger to Maximilian (17 November 1510) many of the woodblocks had already been cut by that date, and at the end of 1510, Peutinger authorized a payment to Burgkmair for 92 images (*bilder*), presumably the *Genealogy* woodcuts.[15] One proof impression in Munich (Graphische Sammlung) bears the artist's name and an inscribed date of 1511, the period of corrections and of added genealogical elements, chiefly coats of arms and emblems for the individual ancestors.[16] By late in 1512, Maximilian had completed his own inspection of the entire series, as he writes to a close associate, Siegmund von Dietrichstein: "We have also finished the day before yesterday and concluded our entire family tree and sent same to Peutinger for printing, which will then be ready in about a fortnight.[17] According to Frimmel's study of a volume from the Habsburg collections at Schloss Ambras, some thirteen leaves were excluded from the final proof copy of seventy-seven woodcuts then presented to Maximilian.[18] Included among these

discarded forebears was a woodcut of Noah, then in disfavor as an ancestor. Indeed, controversy concerning the precise set of ancestors to be claimed by Maximilian caused the project of the *Genealogy* to be tabled, and it was never published as planned, with architectural frames around the figures and accompanying rhyming verses, which appear on several of Burgkmair's own proofs (today in Berlin and Wolfenbüttel).[19] The fragment features a sequence of isolated standing male figures in armor, each labeled with majuscule letters by Ratdolt and accompanied by heraldic coats of arms, which provides a cumulative and chronological family album across time from origins to the present.[20] Their attention to such details reinforces the suggestion of historical accuracy and careful documentation.

Thanks to the researches of Geissler, we can now follow the surviving stages of production of Burgkmair's woodcuts from an early series of figures without coats of arms through sketchy annotations of heraldic details and the addition of titles in Peutinger's hand (in the Peutinger working edition, now in the Augsburg Staatsbibliothek).[21] Moreover, several unlabeled Burgkmair woodcuts survive in unique impressions (Stuttgart, Graphische Sammlung), which in stance, costumes, and figure types appear to relate to the extant *Genealogy* but which are printed on different paper and display oblique monograms by Burgkmair.[22] In all likelihood, these supplementary images were prepared by a different cutter (without Burgkmair's close supervision, according to Geissler) in the event of eventual need, but they were never utilized when the total of ancestors was winnowed down by Maximilian and his advisers.

Laschitzer and Lhotsky have traced the succession of advisers and alternate genealogies undertaken for Maximilian over the course of a decade of research. The basis of Burgkmair's designs in 1509 was a redaction prepared in Vienna by Professor Ladislaus Suntheim and Dr. Jakob Mennel, but it was by no means the first such family tree, nor was it, unfortunately, the last. Suntheim had been appointed "Chronikmaister" around 1500 and instructed to reexamine the chronicles of Maximilian's ancestor, Rudolf of Habsburg, with its descent from Roman ancestors. Suntheim was succeeded in this role around 1505 by Freiburg Professor Jakob Mennel, appointed imperial *Rat*, or adviser.[23] The completed genealogical work by Mennel was finally submitted to Maximilian in 1518 as a multivolume luxury manuscript ensemble, entitled the *Geburtsspiegel*, or "Mirror of Birth."[24] Mennel made numerous research trips to seek documents and sources for Habsburg history in order to supplement the material he had inherited from Suntheim. In his colophon concluding this massive project, Mennel asserts to Maximilian the thoroughness of his research: "So I have set herein not only all that I have taken out of books but also what I have found from letters and figures of old and new spiritual and secular foundations and texts as well as from sarcophagi in churches, church walls, gravestones, and registers and foundation records, the same from old portals and doorways and old letters, seals, and others."[25]

Already in 1507, Mennel had produced a rhyming chronicle plus an unpublished manuscript that included the Habsburg as well as the Babenberg dukes who had previously ruled in Austria. Around 1509, however, Maximilian decided to emphasize his derivation from the ancient Trojans, specifically from Hector (fig. 14).[26] This genealogy, based on research by both

Sunthaim and Mennel, served as the basis of Burgkmair's woodcut series. Even while the woodcuts were being readied by Burgkmair, discrepancies between the various genealogies had to be reconciled before any definitive publication could be issued, despite the completion of Burgkmair's lively and variegated woodcuts by 1512.[27] If anything, the waters were muddied rather than clarified by the problem of establishing the links between the Merovingian dynasty of France and Hector of Troy, as well as by the spurious documentation, attributed to a Frank named Hunibald but never found again, as supplied by the abbot of Sponheim, Johannes Trithemius.[28]

The publication of Trithemius's *History of the Franks* in 1515 (Constance: Johann Haselberg), with a privilege granted by Maximilian himself, sent Mennel back once more to the drawing board for modifications in his own meticulously compiled researches. Shortly thereafter, Maximilian's chief court historian, Johannes Stabius, who was then working on the program, including a genealogy, for the giant woodcut *Arch of Honor*, directly attacked the work as well as the personal integrity of Abbot Trithemius.[29] Stabius labeled him a "fabulator" and castigated his publication as a "chimera."

HECTOR PRIAMI MAGNI REGIS TROIANORVM FIL

14

Hans Burgkmair, *Hector*, from *Genealogy of Maximilian I*, ca. 1510–12, woodcut. Austrian National Library, picture archives, Vienna + signatures. Cod. 8018.

Stabius's own careful reference to reliable sources as well as his cross-checking of the discrepant contemporaneity of figures across different genealogies demonstrates the modern historiographic method of critical reading of sources and detachment relative to the past and its authorities that has been credited as one of the fundamental changes in outlook of the Renaissance era.[30] This goal of ongoing research was truly fostered by Maximilian, as the text of *Weisskunig* (echoing Mennel) attests: "And when he [the young Weisskunig] attained maturity, he spared no costs but dispatched learned scholars, who did nothing else but report what they had learned in every foundation and cloister, every book and scholarly conversation, and he had all such matters put into print, to the honor and praise of those royal and princely lines."[31]

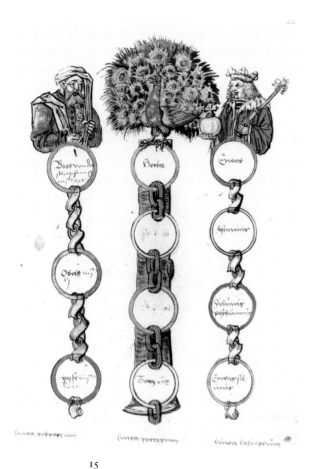

15

Mennel Master, *Chains of Family Descent*, from
Jakob Mennel, *Princely Chronicle*, or *Mirror
of Birth*, ca. 1512–17, illuminated miniature.
Austrian National Library, picture archives,
Vienna + signatures. Cod.Vind. palat. 3072, I,
fo. 44.

After consulting in 1517 in Augsburg with
Peutinger and with Stabius, who was then consoli-
dating his own family tree for the place of honor
in the top center of the *Arch of Honor*, Mennel fi-
nally completed his researches. He finally presented
the resulting massive nine-volume *Geburtsspiegel* to
Maximilian in January 1518. In the first volume (cod.
3072★), the family trees begin in three parallel rows
of linked chains (fig. 15). On the left, headed by the
patriarch Boas, ancestor of the lineage of Christ, runs
the "Hebrew line." It is matched on the right by
the "Latin line," beginning with Aeneas (founder of
Rome) and crowned by a king with orb and scepter.
In the center, under a Habsburg family peacock, lies
the "Greek line," beginning with Hector.[32] The He-
brew line begins, like some trees of Jesse (Matthew
1:5–6), with Boas, the husband of Ruth, and runs
through the ancestors of Christ to an image of the
Nativity (fo. 48r) and then on to the succession of
the popes as the representatives of Christ in spiritual
affairs. Beneath the Nativity lie the papal arms of St.
Peter, and links descend to the current pope, Leo X
(fo. 62). The Latin line extends through the Roman
emperors down to Maximilian's successor, Charles V,
"Karolus Katholicus." In the central Greek line
Habsburg descent is traced out of a Trojan ancestry;
it too ends with Charles and his brother Ferdinand,
the two male scions of Maximilian's only son, Philip
the Fair. This genealogy receives more detailed ex-
position in the second volume of the *Geburtsspiegel*
(cod. 3073), which describes successive generations from Merovingian King Clovis, first baptized
Christian ruler of the Franks, down to Charles V.

A sample page (fo. 39r) shows the arms of Burgundy above the name of St. Rudolphus, king
of Burgundy, whose daughter (here called a saint) Adelheid, became empress as the wife of Otto
I. Volume 3 (cod. 3074) traces side lines of the dynasty; volume 4 (cod. 3075) records the related
dynasties of Europe. In this compendium of relatives we find a magnificent double-page illus-
tration of a Habsburg peacock with imperial crown, sword, and scepter, nestling the royal coats
of arms of other European countries under its ample wings (fo. 12v–13r). The fifth and sixth
volumes (cod. 3076–77) catalogue the saints and blessed figures (*Heiligen und seligen*) among the

ancestors and relatives of the Habsburgs. This work itself formed a supplement to an earlier redaction of 1514 (3077★, 3077★★) of Habsburg saints. A final, supplementary volume (cod. 3077★★★), titled *Book of the Noteworthy and Famous Women of the Praiseworthy House Habsburg* (*Buch von den erlauchtigen und verumbten weybern des loblichen husz Habsburg*), offers biographies of female ancestors, ending with Maximilian's first wife, Mary of Burgundy. Mennel also appended a kind of "gallery guide" or digest to these massive volumes, a captioned, pictorial survey volume of the entire *Geburtsspiegel*, called the *Zaiger* (cod. 7892).

The *Zaiger* itself has thirty-seven pages of family trees and twenty-one full-page illustrations. Its title page (fo. 2r; fig. 16) shows Mennel presenting his five volumes of the princely chronicle to Maximilian before a great mirror with the sun at its center, symbolizing the Mirror of Birth and the image of the emperor as the sun among earthly rulers (like the canopy of the 1518 *Triumphal Chariot* woodcut by Dürer, which reads, "*Quod in celis sol, hoc in terra Caesar est*—as is the sun in heaven, so is Caesar on earth"). To the right of Mennel's symbolic mirror stands a saintly woman, dressed as a nun, who serves two functions: witness to this presentation and representative of the pious Habsburg female ancestors.

The *Zaiger* reveals Maximilian's family aspira-

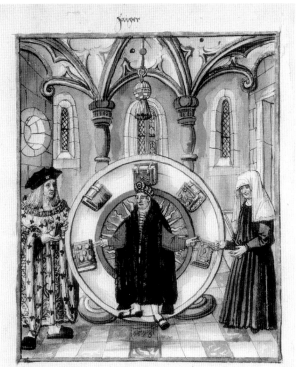

16

Mennel Master, frontispiece, from Jakob Mennel, *Der Zaiger*, 1518, illuminated miniature. Austrian National Library, picture archives, Vienna + signatures. Cod. 7892, I, fo. 44.

tions particularly well, because it also uses three successive illustrations of allegorical ladders to show the ambitious trajectory of all this history from past to present and into the future. The first of these ladders (fig. 17), made of silver, leads up to a moonlit sky. On the eight rungs of the ladder stand Maximilian's various ancestors, graded according to social rank; he sits at the top of the silver ladder receiving the imperial crown from two angels. The second ladder, golden, leads to a sunlit sky (fig. 18). Here seven successive Habsburg ancestors ascend in rank from hermit and monk up through bishops and cardinals to a figure who is being offered the papal tiara by angels. These figures are described as those "who left worldly rank and became spirituals, thus becoming hermit, monk, abbot, bishop, archbishop, cardinal, and pope." Together these paired ladders convey the medieval theory of authority, the "two lights theory," where the greater spiritual power of the papacy outshines the temporal power of the emperor, as gold outshines silver or the sun

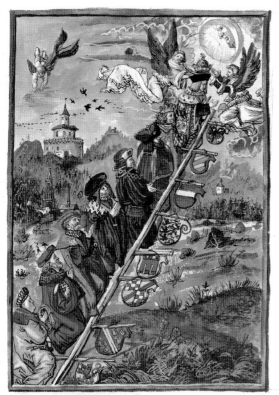

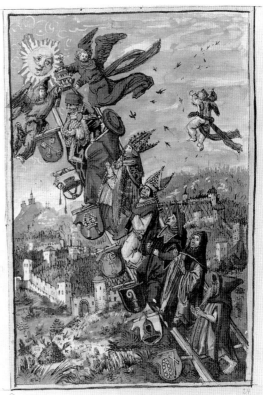

17

Mennel Master, *Silver Ladder of Habsburg
Ancestors*, from Jakob Mennel, *Der Zaiger*,
1518, illuminated miniature. Austrian
National Library, picture archives, Vienna +
signatures. Cod. 7892, I, fo. 23.

18

Mennel Master, *Golden Ladder of Habsburg
Ancestors*, from Jakob Mennel, *Der Zaiger*,
1518, illuminated miniature. Austrian
National Library, picture archives, Vienna +
signatures. Cod. 7892, I, fo. 24.

the moon. Yet the *Zaiger* also includes a third dimension of power and holiness—an additional jeweled ladder of five rungs (fig. 19), on which holy Habsburg women and men ascend to the empyrean, where at the top God Himself bestows a haloed crown on a flagellant penitent (who again resembles Maximilian). This is the world of saints, the most elect of the House of Habsburg, of the "most praiseworthy family (*Geschlecht*), virgins, wives, widows (*Beichtiger*), and martyrs." In short, like the contemporary theory of indulgences, the modern greatness and ascent of the Habsburg lineage depends on cumulative merit and grace attained by its collective ancestors, and the greatest of these are the saints.[33]

Mennel's researches concerning Habsburg saints (the original fifth volume of his *Geburtsspiegel*) developed into a project with its own life. His scrupulous compilations in the princely chronicles (cod. 3077★, 3977★★) include carefully colored coats of arms, as well as an illustration

of the individual saint. We can follow earlier redactions of this work on saints in a series of three sketchbooks (cod. 2857, 1598, 2627), including one by the anonymous Master of Mariazell, plus a codex of miniatures produced personally for Maximilian (no. 4711).[34] The miniatures of the luxury codex were produced in the workshop of Maximilian's court artist, Jörg Kölderer. The sketchbooks, in turn, and the 1514 codices served as the model for another Augsburg artist, Leonhard Beck, to produce designs for a woodcut cycle of Habsburg saints.[35] Like Burgkmair, by this time (ca. 1516–18), Beck had already produced numerous woodcuts for Maximilian, collaborating with Burgkmair and Schäufelein as a chief contributor (seventy-seven woodcuts) of illustrations for *Teuerdank*.[36] Burgkmair himself was then extremely busy with the final stages of his own woodcut illustrations to *Weisskunig* (1514–16) and with his preliminary designs for the woodcut frieze of the *Triumphal Procession*; therefore Beck remained the dominant designer for this project of the Habsburg saints.

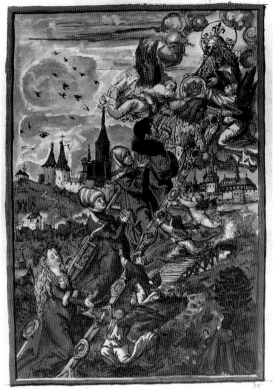

19

Mennel Master, *Jeweled Ladder of Habsburg Ancestors*, from Jakob Mennel, *Der Zaiger*, 1518, illuminated miniature. Austrian National Library, picture archives, Vienna + signatures. Cod. 7892, I, fo. 125.

The sketchbooks all present a pattern that is repeated in the imperial codex of miniatures: a full-length saint, standing on a socle with central coat of arms, derives from a common, colored model, now lost.[37] Most of the saints are presented in three-quarter profile holding attributes or personal symbolic objects. Attention is given to their costumes, both worldly and spiritual, and in the cases where a nobleman took holy orders, a crown or hat on the ground bears witness to eminent, if renounced, worldly status. The sketchbooks usually employ background building interiors rather than landscapes. However, the codex presents images of two saints within a single folio, each above a common socle with the respective arms centered on each half. In most miniatures, the sketchbook model is followed fairly closely for both the figures and the settings except for a greater elaboration in the backgrounds.

Many of these same basic features carry over into Beck's woodcut cycle, although frames are absent and heraldry is often included within the image, usually moved around for visual variety (fig. 20). Richer backgrounds and figure postures as well as drapery masses adorn the woodcut figures, in contrast to the simpler, more repetitive sketchbooks. Yet the attributes and symbols of the sketchbook figures are retained virtually unaltered in the woodcuts, and their costumes are also

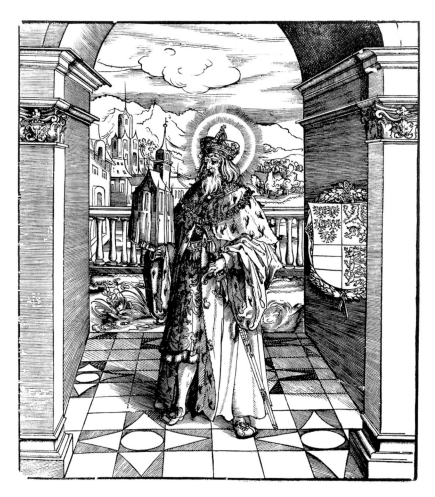

20

Leonhard Beck, *St. Charlemagne*, from *Habsburg Family Saints*,
ca. 1516–18, woodcut. Vienna, Albertina.

transposed. Thus, the essential iconography survives amid a wealth of original formal elaboration
or variation.

From these stages of production we can infer a massive, original, essentially nonartistic pro-
totype, which served as the common model for the various sketchbooks and, eventually, for
the divergent goals of the imperial codex and the Beck woodcut cycle. Based on a meticulous
compilation of heraldic arms, attributes, and costumed figures, the anonymous craftsmen of the
manuscript and the Augsburg artisans around Beck developed their cycles—one for the personal
delectation of Maximilian himself in the form of a *Reimschrift*, or proof edition, the other for a
wider circle of admirers (though his death occurred prior to the publication, so we cannot infer
his intended audience of distribution). Dates of presentation on the surviving woodblocks record
the names of the cutters and a period of production from 3 November 1516 through 7 September

1518. In most cases, the markings of the blocks correspond with the ninety-six separate markings in the Codex A sketchbook (cod. 2857) from which the images of the saints "were made."

At the same time as Mennel was concluding his researches and Stabius was critiquing the fictional genealogies of Abbot Trithemius, work was nearing completion on Maximilian's great *Arch of Honor*, produced in Nuremberg by the workshop of Albrecht Dürer under the supervision of Stabius, who wrote the extensive programmatic colophon printed below.[38] At its chief place of honor, that is, at the top center of the entire arch, stands a vast ascending family tree of Maximilian, culminating with his own portrait, enthroned and flanked below by his first wife, Mary of Burgandy, and his daughter-in-law, Joanna the Mad. Immediately below Maximilian stands his son and heir, Philip the Fair, flanked by his two sons and four daughters; underneath them, the parents of Maximilian, Emperor Frederick III and Eleonore of Portugal (fig. 21). According to the colophon of Stabius, this is the program for this family tree:

> The central tower above the main gate is decorated with the family tree of the honorable House of Austria and its ancient lineage from which the Emperor is descended. At the very bottom will be seen three matrons who represent the most distinguished nations of Troy, Sicambria, and Francia. It must be understood that the male line of the Merovingian dynasty extends back to the first king of France; who is descended from the magnanimous Hector of Troy and who conquered the Pannonian territories, now known as Hungary and Austria, and gained victory over the Sicambrians, subsequently known as the Franks, and over the Gauls. Although there are many heathen kings in the line of descent, from father to son, these are not pictured because they were neither baptized nor did they believe in the Christian faith. Their names will be given in another book [i.e., the *Genealogy*]. In the present family tree the lineage therefore begins with Chlodvig [Clovis], the first Christian king of the aforementioned Merovingian and royal French dynasty. It then continues from person to person, i.e., from father to son, from ancient times wherefore the princes of Habsburg, and therefore the archdukes of Austria, are descended, down to the present Emperor Maximilian. This same Emperor Maximilian is here shown in his painted likeness sitting uppermost in Imperial majesty. Below him, on his right, his wife, Lady Mary, Archduchess of Burgundy, descended on both her father's and mother's side from the ruling house of France. On his left, Lady Joanna, Queen of Spain and Castile, the wife of Philip, of Spain and Castile. Below the wife of the Emperor is seated Lady Margaret of Austria and Burgundy, His Imperial Majesty's only daughter, an ornament of womanhood. Following this, weighed down by His Majesty's exemplary dignity, the branches and fruit of the tree of his family are bent towards His Most Serene and Noble Highness, King Philip, His Majesty's only son. He may be seen standing below His Imperial Majesty, flanked by his children by Lady Joanna, Queen of Spain and Castile. On one side stand his sons, Charles and Ferdinand, and on the other side, his daughters, the Ladies Leonora, Isabella, Mary, and Catherine.[39]

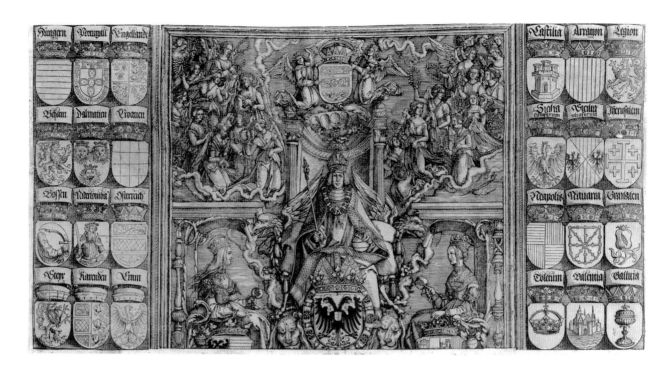

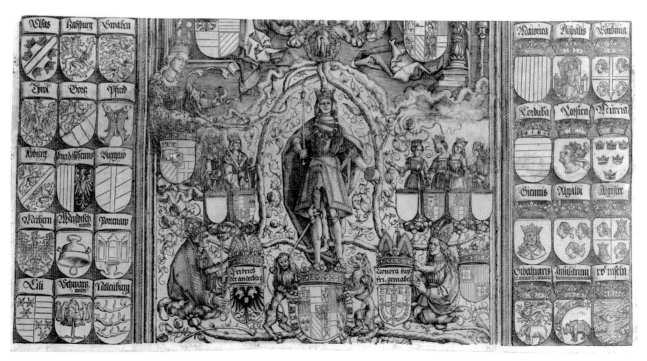

21

Albrecht Dürer workshop, *Family Tree of Maximilian I,*
from *Arch of Honor,* ca. 1517–18, woodcut.

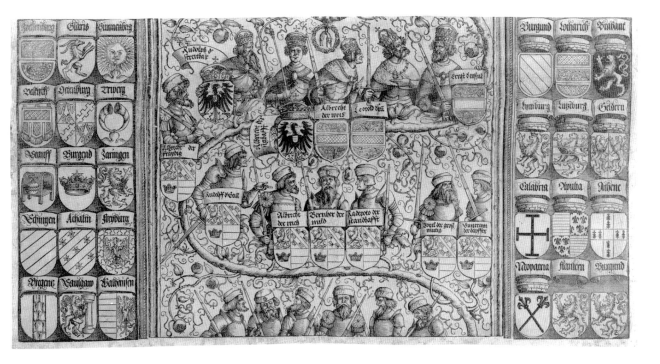

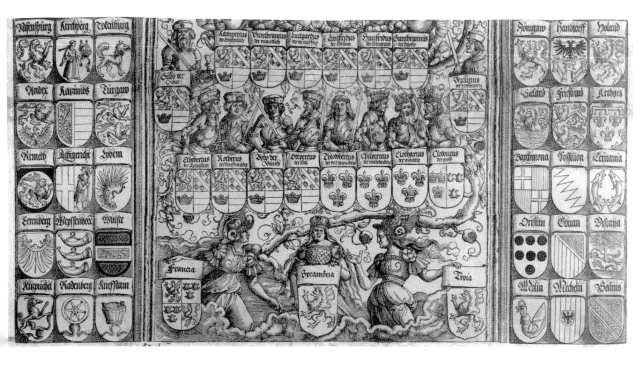

This description reveals several essential facts. First, the questionable ancestry linking the Merovingian kings back to ancient Troy has been conveniently eliminated in its fuzzy details, finessed through the presence of generalized allegorical female personifications—Troy, Sicambria, Francia. Despite these ambitious Habsburg ancestral claims, in the context of the *Arch of Honor* Stabius acted as diplomat and chose to begin the specific individuals on the Habsburg tree with Clovis, the first Christian king, hence the prototype for Maximilian in both his rulership as well as his religion. Thus, the *Arch* could generally preserve the Habsburg historical claims yet also retain that historiographic rigor advocated by Stabius during a moment of intense debate about Habsburg family history. As a result, unlike other genealogical projects, such as the Burgkmair Ancestors or the Beck Saints, the *Arch* actually got published during Maximilian's lifetime, albeit some two years after the 1515 date inscribed on the woodcuts by Dürer.[40] Stabius's colophon also alludes specifically to the details of the early ancestors as forthcoming "in another book," namely, the pending, if unpublished, *Genealogy* with its Burgkmair illustrations. The descent of the Habsburgs is traced scrupulously from father to son in the kinship known to anthropologists as agnatic.

Around the family tree in the *Arch of Honor* sit the coats of arms of all the dominions claimed (however spuriously, as in the case of Jerusalem) by Maximilian, the legacy of his family's conquests as well as its marriage alliances. As if in echo of these claims, another major portion of the *Arch*, running along and down the right side of the structure, makes claims of kinship to current territorial rulers of Europe, just as does the page in the *Zaiger* with the imperial peacock embracing heraldry under its wings (fig. 22). Stabius's program explains: "The historical scenes on the Portal of Nobility are surrounded by kings and other powerful princes. They are identified both by their names and by their coats-of-arms. These princes comprise His Imperial Majesty's relatives and in-laws; in each case the degree of the relationship is stated. . . . It is because the honorable House of Austria has branched out far and wide throughout Christendom that the Gate of Nobility is decorated with these royal, princely, and illustrious personages."[41]

Finally, the *Arch of Honor* presents famous Habsburg ancestors in key symmetrical placements in the form of full-size, standing, labeled statues. These figures include not only the prominent Habsburg ancestor saints, Bishop Arnulf and Archduke Leopold, but also the four prior Habsburg emperors, Albrecht I, Albrecht II, Rudolf, and Frederick III. In the words of Stabius:

> On the capitals of the two great columns flanking the tower above the Portal of Praise, among other ornaments, are likenesses of considerable size representing Frederick III the Devout and Albrecht the Victorious. Together with Rudolph the Valiant and Albrecht the Fortunate, who appear on the capitals of the great columns of the Portal of Nobility, these are the emperors who are descended from the House of Austria and the line of Habsburg. Although they are pictured in the family tree, they also appear on these columns as they have particularly added to the glory of the House of Austria.[42]

In short, the *Arch of Honor* accords its greatest prominence to illustrious Habsburg ancestors as well as to the family tree of Maximilian and his immediate relatives, but it also makes extended

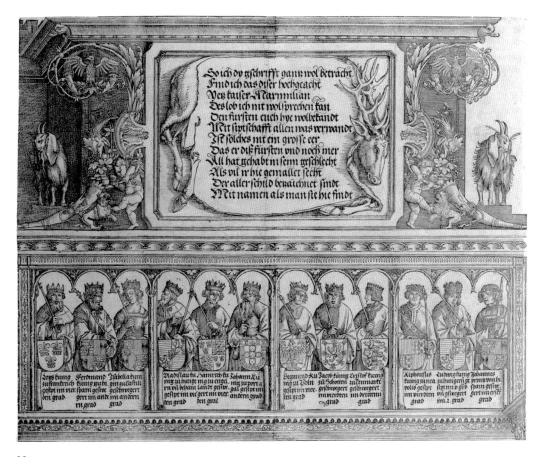

22

Albrecht Dürer workshop, *Royal Relatives of Maximilian I,*
from *Arch of Honor,* ca. 1517–18, woodcut.

claims by means of kinship both to widely scattered territories and to other ruling houses. This crucial claim to power and to reverence is made by Maximilian by means of his family history.

By choosing Trojan origins, the Habsburgs could obviously claim for themselves both an ultimate antiquity as well as the blood of heroes. Such claims were by no means unique or even uncommon among royal houses. Specifically, the French royal house already claimed Trojan origins, and in light of Maximilian's having grafted his own house onto French history by means of the Merovingian dynasty, this overlap follows directly.[43] However, the earliest family trees of the Habsburgs from as early as the time of Albrecht I traced descent from a late-antique Roman family. Before the death of Emperor Rudolf I in 1291, the family history had already commenced in an early effort as establishing kingliness and legitimacy for rule, including an alternate assertion of Alemannic rather than Roman origins.[44] Because Rudolf's 1273 election as emperor over King Ottakar of Bohemia led to recriminations by the latter to Pope Gregory X against the status of such a minor, the Habsburg need for self-apology was established early.

Family Ties 55

Roman ancestors were deemed preferable at first as a means of avoiding connections with the rival Hohenstaufens, at a time when no connections either to the earlier imperial dynasties or to Charlemagne could be found. Thus, by the early fourteenth century, the Habsburg chroniclers had developed a legend of two banished Roman brothers, who founded the royal house in upper Alemannia. Eventually these brothers are identified by the name of Colonna by Thomas Ebendorfer in the midfifteenth century.[45] The reason for this convergence lies in the fact that since the eleventh century the Colonna believed themselves to be descendants of the Julian line of Roman emperors.[46] It was Mennel who refuted such claims by noting that the Habsburgs were already living in Germany prior to the claimed advent of any Aventine counts from Rome.[47]

As noted, Maximilian's desire was to locate his ancestors in an alternative sphere of influence from Rome: the Trojan lineage of Hector. The Franks had already claimed their descent from Troy in works as early as Gregory of Tours and in the tenth-century *Annolied*.[48] This argument became dogma in the world history (*Chronica*) of Otto of Freising (d. 1158; uncle of Emperor Frederick I of Barbarossa), in Godfried of Viterbo's twelfth-century *Speculum regum* (dedicated to Emperor Henry VI), and in Vincent of Beauvais's *Speculum historiale* (1244; written for Louis IX of France).[49] According to these legends, codified for the Habsburgs by Heinrich von Klingenberg (ca. 1300) and then by Mennel, the son of Hector, Francio, led the migration northward after the destruction of Troy, even as Aeneas went westward to found Rome. Thus is the Germanic race, according to Mennel, of equal antiquity and dignity with that of Italy, because both descend from Troy.[50] As elected emperor, Maximilian had no need for family descent from Roman imperial houses, so he could thereby utilize his ancestry for other purposes—namely, to assert for himself a truly national, that is, German, blood.

For this claim, too, he could utilize precedents, particularly the model of Emperor Charles IV of the House of Luxemburg.[51] Relying on such sources as Vincent of Beauvais, the Antwerp chronicler Jan de Klerck (d. 1351) devised a genealogy for Charles IV running from the Trojans and the Franks to Charlemagne and the dukes of Brabant as well as the Luxemburgs, who had marriage with Brabant. The great palace of Charles IV at Karlstein near Prague was decorated with frescoes (ca. 1356–57), now lost but preserved in a manuscript copy made in the late sixteenth century for a later Habsburg namesake, Emperor Maximilian II.[52] This independence from Italian origins held particular significance during an era of German cultural assertion and independence from the classical heritage of Italy.[53]

The Franks, then, claimed descent from their eponymous Trojan ancestor, Francio, who led them to Pannonia, or modern Hungary. This land they called Sicambria after Sicamber, a (grand)son of Francio. The advantage of having ancestral rulers in Hungary was particularly opportune for Maximilian in light of his *Ostpolitik*, or his marriage diplomacy with the Jagiellonian kingdoms of Bohemia and Hungary, climaxed by the 1515 double marriage ceremony in Vienna. The legend continues with the story of Marcomirus, son of Priam, the last Sicambrian king, who led his people to Germany and settled along the river Main, where they built the city

of Frankfurt, city of the Franks, as they were then called, and site of the coronation of German kings.[54] Thereafter, the conquest of Gaul and supremacy over the Romans under Pharamund, king of the Franks, led to the historical succession of the Frankish kings: Clodius and Meroveus, ancestor of the Merovingian dynasty, and his grandson, the first Christian king of the Franks, Clovis. At this point, we find ourselves on the firmer historical ground of the genealogy of the *Arch of Honor*, where the pre-Christian history remains encapsulated by the successive personifications of Troy, Sicambria, and Francia. (The coat of arms of Troy and Sicambria are identical and are quartered with three frogs in Francia.)

Through the Merovingians, political power passes to the Carolingians, in particular to Charlemagne, the original northern emperor after the year 800 and the spiritual successor as both saint and ruler to King Clovis. Of course, Maximilian was claiming kinship at this point to all of these venerated ancestors of his principal rivals, the kings of France. Mennel declares: "After the last king of France of this line has developed by right of law (*von rechtswegen*) the same kingdom to that of the Habsburg; in light of this fact . . . Carolingians and Habsburgs are one family (*ains geschlecht*) . . .[55] Thus, Maximilian could claim the right to turn the tables and actually to lay claim to the throne of France!

Others, however, remained conscious of the French taint of this genealogy. Jacob Wimpheling, for example, took pains to argue that the Capetians were usurpers to the throne of the Frankish kings. His history (*Germania*, 1501) draws the distinction between true Franks, *Franci,* and the mixed-race French, *Francigenae*.[56] In this light, Trithemius's "Urfranken" fabrications became additional attempts to provide ancestors prior to any contact with the Romans. Thus, except for Wimpheling, the importance of Charlemagne in direct descent was downplayed in most genealogies for Maximilian by Mennel et al., and direct Habsburg descent from the Merovingians was used to bypass the later Carolingians. On the *Arch of Honor*, for example, Charlemagne appears among the succession of elected emperors rather than among the ancestors on the family tree of Maximilian. Maximilian also avoids connections to previous German imperial houses, preferring instead to preserve the basic integrity and separation of the Habsburgs.

By choosing to draw his ancestors from the younger son of Clovis, that is, heir to the kingdom of Burgundy rather than the older son, king of France, Maximilian successfully avoids congruence with French royal history and further establishes the heritage of his own historic ties to Burgundy.[57] These ties, of course, were renewed with Maximilian's 1477 marriage to Mary of Burgundy, heiress of these lands and titles. Therefore, both his own blood lines and the marital alliance of Maximilian reunite the heritage out of which his family has descended. The eventual family title, count of Habsburg, was bestowed by the king of Burgundy on his younger son, Ottpert, who remained content with his diminished rank and status rather than quarrel with his older brother over the kingship, as if in anticipation of the appanage of Burgundy for Philip the Bold in the midfourteenth century. By this means, the question of how the Habsburgs could claim to have been kings once but then lost their thrones is answered through the issue of primogeniture and birthright of succession from father to son. But just as in the case of the blessed

second sons of the Bible (e.g., Isaac and Jacob in Genesis), the Habsburgs also felt destined to recover eventually and enhance their patrimony through divine providence.

As a result of this family history, therefore, Maximilian emerges as a new culmination for the House of Habsburg. By reuniting the long-divided strands of Trojan lineage, the Franks with the Romans, he personally—and literally—incorporates both the heritable virtues and the historical powers developed throughout all of Europe over the centuries since the fall of Troy. He is blood heir to the German nation and the worthy bearer of imperial election and dignity. Thus, his current title, Holy Roman Emperor of the German Nation, is fulfilled and climaxes in the person of Maximilian of Habsburg.

Yet the very impulses that prompted Maximilian to find saintly ancestors in his family line also prodded his abortive attempt in his final years to incorporate divinities into his family tree.[58] Again, the model of the Luxemburg genealogy for Charles IV lay near to hand.[59] Beginning with Noah and his son Ham, the seventh and eighth ancestors of Charles IV are named as Saturn and Jupiter, respectively! Maximilian, too, asked Stabius to draw up a family tree headed by Noah and even including Osiris and Hercules Libycus; this genealogy was submitted to the faculty of Vienna University and found consonant with Old Testament scriptures.[60] The significance of Noah also lay in one claim of his direct parenthood of the Germans through another son, Tuiscon, taken as an eponymous ancestor of the Germans from Tacitus. In particular, Ham was assumed to be the forefather of the Africans, and thus, eventually, of the Trojans.[61] Osiris held importance owing to the non-Roman antiquity of this Egyptian forefather deity, as well as because of his association with occult learning in the Renaissance.[62] The Stabius colophon on the *Arch of Honor* refers to a "mysterium of ancient Egyptian letters, deriving from King Osiris," that is, a pseudo-hieroglyph of Maximilian enthroned and surrounded by symbolic animals. Hercules in the Renaissance served as the quasi-divine prototype of princely powers and virtues and was even fused with Maximilian in a woodcut of 1493 called "Hercules Germanicus."[63]

Just as Charles IV had posited his family's sanctity through the Bohemian saintly ancestors, Wenceslaus and Ludmilla (another fresco cycle placed along the uppermost staircase at Karlstein Castle), so did Maximilian utilize St. Koloman, son of a Scottish king and a patron saint of Austria, where he was martyred.[64] In addition to this putative Habsburg family connection with a saint, Emperor Frederick III, following Rudolf IV, had pressed for the canonization (1485) of Leopold III (d. 1136), the Babenberg margrave and founder of Klosterneuburg, who was the object of a cult of popular veneration in Austria.[65] Frederick III not only tied Leopold to national worth and sanctity but also called him his "own flesh and blood" (*seines geslechts und pluets*). St. Leopold could serve at once as a national saint for Austria and as a kind of saintly ruler, in the manner of St. Louis IX of France or St. Stephen of Hungary. We find Leopold in the company of Koloman, plus Quirinus, Maximilian, Florian, and Severinus in Albrecht Dürer's woodcut, the *Patron Saints of Austria* (1515), a work accompanied by a hexameter verse by Stabius dedicated to a learned canon of St. Stephen's cathedral in Vienna, Andreas Stiborius.[66] Moreover, Maximilian in his Austrian archduke hat led the celebration in February 1506, when the relics of St. Leopold were translated in a newly made

silver sarcophagus to the shrine in Klosterneuburg.[67] Significantly, a standing figure of St. Leopold occupies a prominent place on the structure of the *Arch of Honor* on the far right pillar (fig. 23), as well as in a rare Dürer scene among the princely activities at the far left tower, which proudly declares the pious deeds (see also chapter 4) of Maximilian: ". . . The story also there is told / Of Austria's margrave, St. Leopold."[68]

The Habsburg saints of Maximilian's woodcuts and manuscripts by and large lay outside the canonical figures of the regular church calendar or such venerated clusters as the "Fourteen Helper Saints." Instead, they held personal, family, or national significance for the Habsburg monarch, who actually had Mennel develop his own calendar of 122 Austrian and family saints for canonization and papal approval.[69] Mennel offers a justification in his prologue to the calendar:

> Hereafter follows the aftercalendar, in which are placed the beloved saints, called *beati*, that is the blessed [*seligen*] kings, princes, and lords along with their holy wives, children, and grandchildren, related to Emperor Maximilian through kinship [*sipp*] or blood [*magshaft*] and who according to their god-fearing and virtuous lives as well as their miracles and great wonders, which the Almighty worked through them, are taken as holy, but have not yet been elevated by the Holy Christian Church at Rome, or whether they have already been elevated there, I do not know—therefore, these so that they may not be forgotten have been placed in this calendar.[70]

Such saints held particular importance because of their wonder-working powers and abilities to inter-

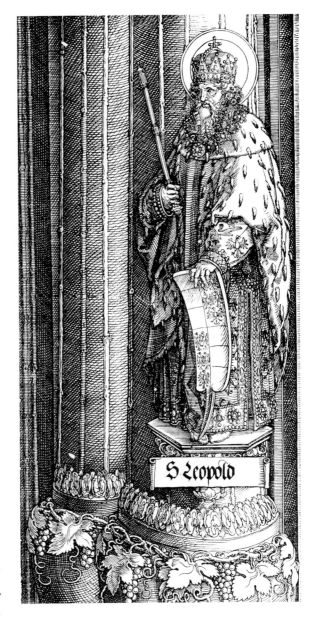

23
Albrecht Dürer and workshop, *St. Leopold*, from *Arch of Honor*, ca. 1517–18, woodcut.

cede on behalf of the living.[71] Therefore, having a personalized stable of family saints offered special spiritual gifts. Presumably Maximilian's own intercession in this life on behalf of the canonization of his forebears would be met with reciprocity from them in the next world for him. Virtually all of these Habsburg saints had demonstrable princely blood like Maximilian; by implication, he also inherited something of their sanctity, combining heavenly crowns with those on earth, as Beck

explicitly shows in his woodcuts. The broader range of family relationships for these saints not only included numerous women but also collateral branches of the family tree. In this manner, distant saints who were also rulers now include Charlemagne, as well as Leopold, plus a pair of popes and the Habsburg patron, Bishop Arnulf of Metz. Like Leopold, Arnulf also graces the *Arch of Honor* at the base of its outermost column, above the conclusions of the rows of emperors and kindred rulers of Europe. Stabius accounts for their presence: "On the bottom of the two great columns, flanking the Gate of Praise on the left and the Gate of Nobility on the right, are shown two saints, Saint Arnulf, Bishop of Metz, who blessed the dynasty, to that it would grow and continue, endowed with princely virtue and dignity forever, and St. Leopold, the gentle prince of Austria. May he protect his dynasty with the help of God and by his benediction and gentle patronage forever."[72]

The closest analogy for this family pantheon of saints is provided during Maximilian's era by the princely collections of saintly relics, usually catalogued and illustrated in *Heiltumbücher* issued by the proud possessors. To date, no systematic analysis of these collections has been made by scholars, but we can find important examples quite close to Maximilian: in the Wittenberg relics of Frederick the Wise, in the Halle relics of Archbishop Albrecht von Brandenburg, and in the Hall (Tyrol) relics of Maximilian's own valued companion, Florian von Waldauf.[73] In the case of the Hall collection, a 1492 chapel in the church of St. Nicholas was dedicated in 1505, and Florian von Waldauf commissioned Burgkmair to produce a *Heiltumbuch* around 1508–9, just about the time of the artist's first intense activity for Maximilian. These relics offered various indulgences individually, and a pilgrimage to such a spiritually charged site usually provided a general indulgence to the pious visitor, for example, the indulgence granted by Pope Julius II to the Wittenberg chapel for the veneration of the cult of the eucharist, the Madonna, and St. Anne (8 April 1510). The *Heiltumbücher* not only served to catalogue the spiritual treasures and to show the individual shrines, monstrances, and reliquaries in a church setting, but at the same time they enumerated all of the local privileges and indulgences conferred on the site for the visitor. Whereas Maximilian never possessed actual relic objects from his family saints, in his view as their actual heir he was linked by blood ties to their sanctity, and his woodcut cycle by Beck would have provided the public circulation of this personal and dynastic heritage.

Rarely does the system of beliefs concerning genealogy emerge explicitly from the pages of Mennel or Stabius to enlighten us about the reason for these massive enterprises of family history. But the underlying doctrine seems to rest on a complex of heritable grace through noble blood, what Hauck has termed *Geblütsheiligkeit*.[74] For example, venerated Carolingian family saints, including Charlemagne and Arnulf of Metz as well as others (Begga, Ermolindis, Remeldis, Oda, Ita, Gerdrudis, and Gudula), found inclusion in Maximilian's family pantheon.[75] To some extent the belief in divine grace conferred on kings at the time of their coronation carried over into a belief in their special sanctity.[76] That such grace could be cumulative within the unbroken heritage of a single family dynasty seems to be the suggestion of Maximilian's miniature of the silver ladder of worldly attainment, wherein the Habsburgs ascend from the ranks of count and duke to attain the pinnacle of the imperial crown.

But there is another sanction for seeing God's plan working itself out through successive generations: the Bible.[77] Whether the ancestors of Christ, that genealogy concretized in the visual tradition in the form of the Tree of Jesse, as recounted at the outset of the Gospel of Matthew, or else the succession of kings of Israel, sketched in I Chronicles, these biblical lineages provide continuity through history by means of the organizing concept of generations.[78] Often, however, the destiny of God's will is invested in the Bible not in primogeniture, but rather in election of a younger or youngest son, from Isaac and Jacob and Joseph onward.[79] This alternative genealogy informs sacred history, linking the present to the biblical past in an unbroken chain akin to apostolic succession.

Such a series of "family trees" forms the organizing principle of the major German world chronicle of Maximilian's era: Hartmann Schedel's 1493 *Nuremberg Chronicle*.[80] Here, as in Maximilian's *Zaiger*, the "linea Christi" organizes the biblical history alongside rows of kings from the ancient world, including Troy and, eventually, Rome. From Troy, Francio again is posited as the son of Hector who fled Troy and gave his name to the French (fo. 37r). The current, Christian era, sixth age of the world according to the Augustinian schema adopted by the *Nuremberg Chronicle*, charts both popes and emperors systematically through the structure of trees of descent, placing them alongside other images of contemporary individual saints or rulers.

Visually, the resemblance between Maximilian's family trees and the medieval traditions of the Tree of Jesse or the consanguinity trees of blood relationships shows the importance of both generational descent and family boundaries.[81] Just as the consanguinity trees are usually presented by a figure of authority and power, often in the guise of an emperor (alternatively of a pope, guarantor of canon law), these images of family descent assert the purely hereditary lineage. In the first volumes of the *Geburtsspiegel* (cod. 3072–73), the tree is confined only to a trunk, that is, conveying only direct descent, whereas in the later two volumes (cod. 3074–75), the fuller, collateral lines appear in the form of flowering branches. This urge toward family consolidation into lineages became a marked interest of noble families as early as the twelfth century.[82]

Marriage was then intimately bound up with family alliances and with the establishment of social position; thus, the metaphor of the tree provided an organic, continuous image of the family's "growth" and development over time. The *Arch of Honor* family tree of Maximilian climaxes, like the Tree of Jesse formula, at its apex, which justifies the entire family line—in the one case Maximilian, in the other Christ. The tree construction thereby suggests the same progressive ascent as the silver ladder in the *Zaiger* miniature. In the case of Christ, ancestors (such as Boas or Jesse) actually assume their importance owing to their fulfilment in Christ. To a certain extent, the same is true of Maximilian, not only because he occupies the highest office in secular Christendom, that is, the same secular sphere as these ancestral rulers, but also because he exists in the present and already points to a glorious future: the enlarged, true "world empire" of his descendants, especially Charles V.[83] Thus, the ancestors referred to in both the *Geburtsspiegel* and the *Arch of Honor* are like the boundaries or the trunk of a tree of consanguinity; they are direct ancestors, all with less power and status than Maximilian himself, who then forms the climax of their upward progress.

As for the broader kinship groups and the extended kinship clusters that include saintly an-
cestors, these resemble the most distant branches of the consanguinity tree. For these filiations,
the principle of selection has been elucidated by Schneider in his study of American kinship as
the phenomenon he calls the "famous ancestor."[84] Whenever a person in the present age wishes
to bask in the glow, even distant and dim, of a famous forebear, then kinship is claimed proudly,
regardless of how "far removed." This is especially important in the case of a national ruler-saint,
as we see in the cases of St. Leopold for Austria or St. Wenceslaus for the Bohemia of Charles IV.
Comparably distant ancestors who are not famous are usually forgotten entirely, but fame of a
desired and culturally prized kind transcends the forgetfulness imposed by intervening time and
generations. For Maximilian, that prized value was above all blessedness, regardless of sex or rank,
although all of his claimed ancestors had noble blood of some kind. Such blessedness was the
only element of grace that Maximilian lacked in order to complete his noble blood of the Franks
and Trojans along with his exalted title as heir to the Roman emperors. Blessedness was the third
chain, the Hebrew chain, to go with the Trojan and Roman chains in history. This, for Maximil-
ian, was the true "triple crown" of earthly existence, akin to the papal tiara or even the mitred
imperial crown that he already wore proudly. Significantly, in 1511 after the death of his second
wife and the rumored illness of Pope Julius II in Rome, Maximilian even seriously contemplated
taking holy vows and standing for the office of pope (or, alternatively, antipope)![85]

For the distant kinship ties of the other rulers of Europe with Maximilian, we must seek a
different, more global explanation. That these relationships are fundamental to social authority
becomes explicit from Mennel's prologue to the volume on saints:

> It is for Maximilian useful and pleasurable, as well as good in the end and therewith to
> behold, whoever in Your Majesty's time is gifted from God with particular graces in one
> or another measure and does not command such description of your forefathers, as if they
> merely lived in the distant past or never even existed. Then afterwards what losses grew
> out of the negligence or bore fruit of such care for the future no tongue can express; for
> we realize that our most worthy mother, the holy Christian Church in the divine offices
> be taken in itself with song and reading as well as by revelation as the inspired stories of
> our ancestors [vorelter] (in order thereby that we be bettered by them), so that all canon
> and civil law spring from it and so that each reasonable person himself and others may be
> led thereby from sins to virtues.[86]

If the self-contained virtues of Habsburg blood remained restricted by means of the agnatic, that
is, male, direct descent on the narrower family tree, then in contrast the saints of both sexes stem
from the broadest possible kinship, including matrilineal, or cognatic, descent or even by virtue
of marriage.[87] It is this marriage exchange that provides the basis of calling the other European
houses "cousins." Rather than scrupulously limiting the integrity of the Habsburg house itself
by means of a centripetal, ancestor-conscious endogamy, this is instead the fabled exogamy of
Habsburg marriage diplomacy, a centrifugal radiating outward to other houses and centers of

power through matrimony. Maximilian's own marriage to Mary of Burgundy and that of his father with Eleonore of Portugal had begun this trend. Then the 1496 double alliance with the royal houses of Spain and the 1515 double marriage with the royal houses of Hungary and Bohemia consolidated the Habsburg successes for the descendants of Maximilian in both Iberia and eastern Europe. These conquests by contract are memorialized in the witty Latin epigram: "Bella gerant alii / Tu felix Austria nube (Let others war / As you, fortunate Austria, marry)." The marriage alliances, then, or even the claimed distant kinship up to a fifth remove, serve to link these houses and to require the mutual allegiance of kinsmen. Thus, as if perpendicular to the vertical, confined descent of the Habsburg lineage—the trunk of the family tree—lies a horizontal spread of kinship in various degrees—the branches—expanding the house and recruiting new members to it. By investing kinship with this comprehensiveness of alliances, the Habsburgs are able to define the world through their own perceptions into the polarities of an inclusive notion of "us" versus the remaining, excluded group of "them." At the same time, they continue to center the nexus of family power and status upon themselves, defining all relationships from that family dynastic center outward.[88]

As titular head of Christendom, Maximilian thus reaffirms his own centrality by tracing his marital alliances through time. These extended, ancient genealogies permit him to maximize his collateral kinship circle to include most of the other ruling houses in Europe. This vast network of family ties, in turn, confirms Maximilian's own high status, like a ruler with his retinue, here an emperor surrounded by lesser kings who are also his "relatives." Retroactively through the succession of Habsburg marriages with the other ruling houses of Europe and through their shared children, a nearly global network of shared ancestors grows even wider, providing the extended kinship claims between Maximilian and traditional royalty.[89]

If any art project can be said to summarize and to climax all of Maximilian's family and territorial aspirations for the ages, then that monument surely is his vast tomb project.[90] This program extended well beyond the death of Maximilian, only to be completed through an act of filial piety by his grandson Ferdinand some eighty years after it was first begun in 1502. The ambitions of this tomb and its grandeur are extolled in the verses of the *Arch of Honor* about Maximilian's attention to his own father's tomb, in St. Stephen's Cathedral, Vienna:

His father's tomb he built of stone
And thought thereafter of his own.
Conceived with great magnificence,
No other Emperor's was immense
Or costly as this work of art
Which he demanded on his part.[91]

Ancestors constitute the essence of this tomb project, life-size bronze statues of ancestors, of which forty were planned and twenty-eight were finally executed and installed in the eventual site, the Hofkirche in Innsbruck.[92] Additional sculptures would have filled the balustrade of the

church to complete the ensemble: one hundred small bronzes of the related saints plus thirty-four busts of Roman emperors were planned (for the latter, see chapter 3). Carved by Leonhard Magt (d. 1532) and cast by Stephan Godl (d. 1534), twenty-three of the relatives were cast; twenty-two emperors were finally completed. The overall program suggested by these divisions once again accords the greatest importance to the direct ancestors and to the relatives of the extended family, all presented at full-size and accompanied by their coats of arms, as if to embody the territories as well as the ancestry of Maximilian. More reduced in scale and importance are the less personal claims of imperial rank or family sanctity, whose figures in the empyrean offer a more distant legitimacy to the worldly and spiritual titles assumed by the emperor.

Maximilian had already anticipated the completed statues of his ancestors when he produced the *Triumphal Procession* with its section of woodcuts by the Dürer pupil, Hans Springinklee, depicting what are called "funerary statues" in the dictated text of 1512.[93] That text explains the images as follows: "The statues following represent the bold emperors, kings, archdukes, and dukes whose coat of arms and name Emperor Maximilian bears and whose land he rules. . . . Then the funerary statues shall be arranged, one after the other with their coats of arms and borne on horseback, as on a litter." The procession of statues is headed by Maximilian's father and predecessor as emperor, Frederick III, who is displayed alone and in imperial regalia. Immediately following according to the text comes Charlemagne and a trio of Habsburg emperors, Rudolf and Albrecht I and II, but in the final woodcut by Springinklee, Charlemagne is followed by Clovis and by the saintly Stephen of Hungary. The next float of statues (fig. 24) begins with the proto-Habsburg, Ottobert of Provence, followed by King Arthur, King John of Portugal, and Godfrey of Bouillon, king of Jerusalem. Arthur and Godfrey, together with Charlemagne, were held up as paragons of Christian rulers in the canonical series of heroes known as the "Nine Worthies," drawn from pagan, Jewish, and Christian history in the manner of Maximilian's three historical chains.[94] Maximilian was to repeat his claims of descent from these almost mythical figures in the tomb statues. The next float begins again with Habsburgs, Albrecht I and II, and emphasizes the connection with Hungary again through King Ladislaus, before turning to the other chief marriage alliance in the person of Ferdinand of Spain. A final float features Maximilian's son, Philip of Castile; St. Leopold of Austria; Archduke Sigmund, the previous Habsburg ruler of Tyrol; and Maximilian's father-in-law, Charles the Rash of Burgundy.

These woodcut floats essentially replicate the arrangements in the miniatures of a vellum manuscript *Triumphal Procession* (see chapter 3), produced by Albrecht Altdorfer of Regensburg and his workshop for Maximilian during the years 1513–15, presumably after preliminary designs by the court artist, Jörg Kölderer.[95] In the colored miniatures, these statues are presented as slightly larger than life-size and gilded, standing in the round within niches framed by columns (fig. 25). Like the miniatures of the saints (Vienna, National Library, cod. 4711), each ancestor miniature has a label and a shield with his coat of arms so that the noble ancestry is underscored. Already by the time of the miniatures, Maximilian had altered both the selection and the ordering of his ancestors. Here, too, he begins with Frederick III in isolation and in full regalia, followed by Charlemagne,

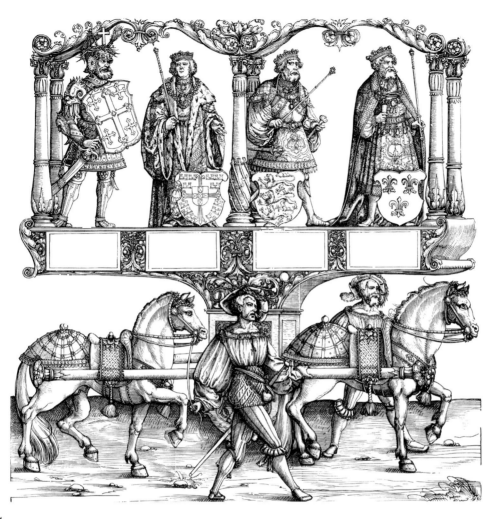

24

Hans Springinklee (attributed), *Habsburg Ancestor Statues*,

from *Triumphal Procession*, ca. 1516–18, woodcut.

also in full regalia, along with Clovis, Ferdinand of Spain, and Ottobert. The second miniature begins with the son of Maximilian, Philip (the Fair) of Castile, then his Habsburg ancestors, Rudolf I, St. Stephen, and Albrecht I of Habsburg. The third cluster begins with King Arthur and then introduces the Habsburg Albrecht II, Johann of Portugal, and Ladislaus Postumus. Godfrey of Bouillon completes the triad of noble worthies as he introduces the next miniature, followed by Archduke Albrecht II of Habsburg, Archduke Ernst the Iron, and Archduke Leopold III. Heading the next cluster is Maximilian's kinsman Archduke Sigmund the Wealthy of Tyrol, Count Albrecht of Habsburg (the father of Rudolf I), Charles the Rash of Burgundy, and St. Leopold. The next miniature begins with Ottoprecht/Ottobert and then moves on to include the females closest to Maximilian: his mother, Eleonore of Portugal; his second wife, Bianca Maria Sforza; and then the

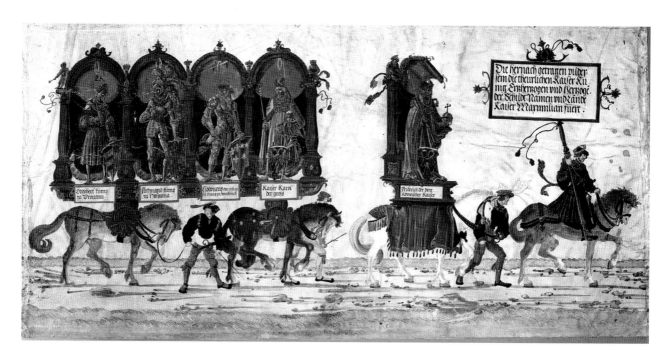

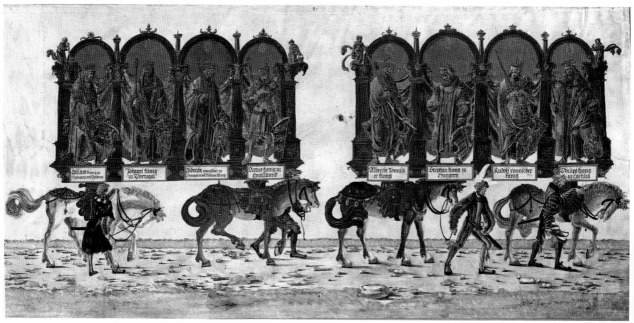

25

Albrecht Altdorfer, *Habsburg Ancestor Statues*, from *Triumphal Procession*, ca. 1512–17, illuminated miniatures. Vienna, Albertina.

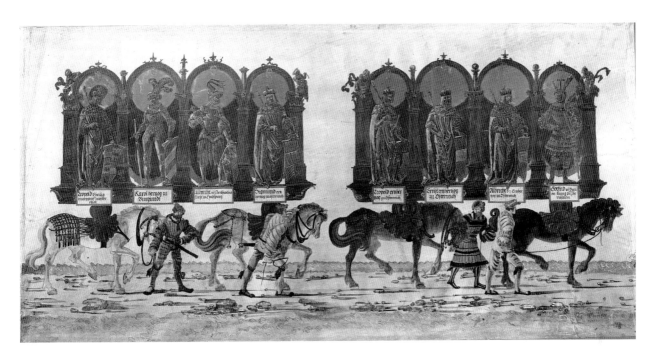

Leopold d'heilig | Karol hertzog zu | Albrecht der | Sigmund der
marggraf inster | Burgund | fürst zu haspurg | hertzog zu österreich
reich | | |

Leopold erster | Ernst erczherczog | Albrecht d: eruber | Gotfrid d'heil
son zu österreich | zu österreich | tzog zu österreich | en kunig pi de
| | | rudoleru

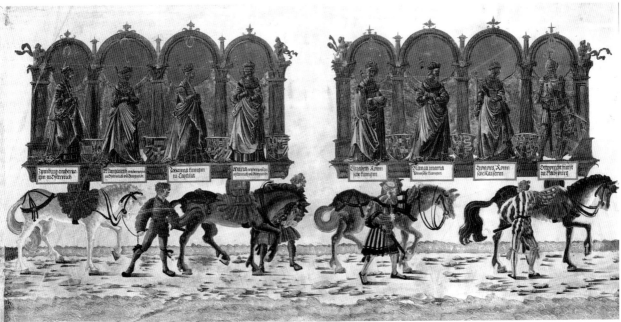

Zymburg erwber | Margareth erwber | Johanna kunigin | Maria erwberin zu
gin zu österreich | neöesterreich vn durgund | zu Castilia | österreich vn durgund

Elizabeth Romi | Blanca maria | Leonora Romi | Ottoprecht fürst
sche kunigin | terwische kunigin | sche kaiserin | zu Kadwurg

wife of Albrecht II, Elizabeth. Maximilian's first wife, Mary of Burgundy, heads the next cluster, along with the wife of his son Philip, Joanna of Castile; his daughter, Margaret of Austria; and his grandmother, wife of Ernst the Iron, Zimburgis of Masovia. The final miniature begins with Maximilian's sister, Kunigunde; and then presents the wife of St. Stephen, Geysula; the wife of Leopold III, Virida; and the Habsburg princess Ita. An isolated female figure completes the procession of ancestors and complements the lone figure of Frederick III, but she is unlabeled.[96]

What this series of ancestors reveals about Maximilian goes back to both his *Genealogy* as well as to his *Saints* projects. This selection of ancestors draws on his immediate forebears and direct Habsburg ancestors as well as on his "famous ancestors," those fabled models whom he certainly wished to make his own. In the second list we find the three Christian worthies—Charlemagne, Godfrey of Bouillon, and Arthur—as well as the sainted rulers, Leopold and Stephen, representing his consolidated realms of Austria and Hungary. By including Clovis and Charlemagne, Maximilian could assert the continuity of Christian rulership in northern Europe in the line of the Frankish people. Literal Habsburg descent emerges from the mythical Ottobert and runs through Archduke Albrecht to Rudolf I and the closer family and in-laws of Maximilian. Even collateral family lines are included, ending in Ladislaus Postumus (the Albertine line, which included kings of Hungary and Bohemia) and Sigmund the Wealthy (the Tyrolian line).

These clusters of representatives also form the basic patterns of the tomb ancestors. According to the list of figures drawn up in inventory for Maximilian's successor, originally forty figures were planned for the ensemble.[97] These groups form three principal clusters: (1) the more distant relatives in both time and kinship, beginning with Julius Caesar, Theodoric, Arthur, Clovis, and Charlemagne (nos. 1–14); then (2) the critical succession of Habsburgs from Count Albrecht IV and his son Emperor Rudolf I through the ends of the collateral branches (nos. 15–25, including several wives); and finally (3) the immediate family of Maximilian, from his grandparents and his in-laws to his children and theirs (nos. 27–40). Here women fill an equal role, made the more important by virtue of their being the agents of acquiring power and territory, particularly Mary of Burgundy and Joanna of Castile during the reign of Maximilian himself. The general plan of the tomb was not drawn up during Maximilian's lifetime, but shortly afterward Kölderer produced both a codex (now in Vienna, National Library, cod. 8329, and a later picture roll, ca. 1530, Ambras Castle inv. 5333, now Vienna, Kunsthistorisches Museum) showing images of the figures that had already been cast by this time (1522–23) as well as the plans for figures yet to be cast.[98]

Such a massive project had to be coordinated by a production team, and the entire task was entrusted to a painter, Gilg Sesselschreiber, in Munich in 1502.[99] Originally Sesselschreiber was charged with collecting documentary visual material concerning the ancestors, akin to the data being compiled at the same time by Jacob Mennel. Clearly these elements became the basis for drawings and plans for the three-dimensional figures of the bronzes. Although none have survived, a number of the replications in the Kölderer codex of the tomb, for example, St. Stephen (fo. 33), show unexecuted statues that must depend on figure designs by Sesselschreiber.

Although only a few examples of Maximilian's documentation survive, these are telling instances of the emperor's passion for accuracy in detail, even of the visages of his ancestors. On 24 April 1508, he dispatched a court artist, Hans Knoderer of Augsburg, to Speyer Cathedral in order to make a painted copy on canvas of the tomb of Rudolf I in the crypt of that church; the canvas survives (Vienna, Kunsthistorisches Museum), along with the receipt for the task (fig. 26).[100] The resemblance of features can be found in the face of the bronze figure of Rudolf I executed by Sesselschreiber. In similar fashion, the portraits of Maximilian's grandparents seem to have been based on a gravestone in the Plague Chapel in Stift Rein (near Graz) and on the likenesses in stained glass in the Palace Chapel, Wiener Neustift.[101] For the more recent ancestors, such as Mary of Burgundy, surviving painted portraits served as the sources.[102]

Although Sesselschreiber began in 1502 as the designer of the figures, "according to the order as each belongs after the other," he became much more involved with the figures after a 1508 meeting in Augsburg with Maximilian and Peutinger to go over the designs and make corrections. At that point, Sesselschreiber was sent to Innsbruck (Mühlau) to supervise Peter Löffler, an experienced bronze caster and artillery master, in the creation of the full-size statues from his designs. The collaboration involved a number of coworkers: the designer, the carver of the forms, casters, a smith, and a chaser or goldsmith. In addition, the work of the carver in wood had to be covered in wax up to the thickness of the bronze, then dried, and placed between layers of clay to be cast by the "lost wax" process. The entire process became bogged down in the rich details, which usually had to be cast separately, especially during the experimental years of the first few figures. Such details are particularly evident in the armor of the first of the figures, Ferdinand of Portugal (1510-16).[103] Several

26

Hans Knoderer, *Rudolf I*, 1508, painted copy of Speyer monument. Vienna, Kunsthistorisches Museum (KK 9).

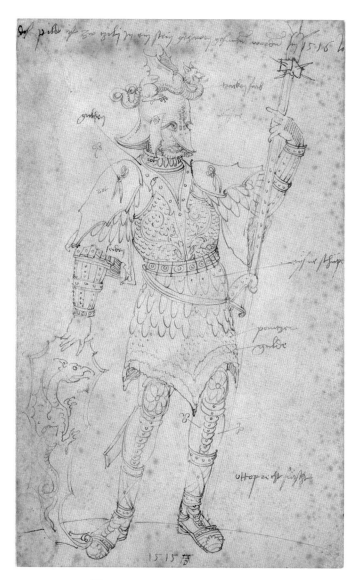

27

Albrecht Dürer (attributed), *Ottobert of Habsburg* (design for tomb of Emperor Maximilian I), ca. 1515, ink. Berlin, Kupferstichkabinett (KdZ 26812). Photo: Bildarchiv Preussischer Kulturbesitz/Art Resource, NY.

of the statues remained incomplete or were badly cast in some of their parts, so much so that Kölderer complains to Ferdinand about their weakness of technique and execution.[104] Three Sesselschreiber figures were eventually discarded for these reasons: Eleonore of Portugal, the Burgundian King Theobert (father of Ottobert), and Ladislaus Postumus. When Löffler decided to quit after the first figure, Sesselschreiber wound up in over his head, and the project dragged on—with an agonizingly slow pace for Maximilian. He subcontracted individual figures out to different regions.

The figure of Count Albrecht of Habsburg was based on a drawing by Dürer (Liverpool, Walker Art Gallery, Winkler 676), which was then worked up into a more detailed model drawing (Berlin-Dahlem, Kupferstichkabinett, W. 677; see fig. 7), and then developed into a working sketch by Jörg Kölderer (Braunschweig, Herzog Anton Ulrich-Museum). Then the figure was carved, probably by Hans Leinberger of Landshut, and was to have been cast in Landshut but had to be cast definitively in Innsbruck.[105] A sketchier Dürer drawing for Ottobert (1515; Berlin, inv. KdZ 26812; fig. 27) offers a particularly fantastic fusion of ancient and medieval armor (with a dragon helmet!) for this important Habsburg family founder.[106] The two most lively and admired figures, Arthur and Theodoric, were both carved and cast in 1513 by the bronze sculpture workshop of Peter Vischer the Elder and his sons in Nuremberg, doubtless after further drawings (lost) by Dürer.[107] In addition, the famed Nuremberg wood-carver Veit Stoss received a commission for a figure in 1514, but the casting of the figure was rejected locally by bronzeworkers who resented this intrusion on their traditional preserve. The model for *Zimburga of Masovia*, with its deep-cut, heavy folds, has been related to Stoss figures by numerous scholars.[108]

Despite these desperation measures and despite the powerful presence of the massive figures completed by Sesselschreiber, the prospect of finishing all forty figures planned by Maximilian was clearly beyond his talents after ten years of labor to this point.[109] Hence, the aging and impatient Maximilian reassigned the direction of his tomb project in 1517 to a professional bronze caster from Nuremberg, Stefan Godl.[110] Godl dared to complete the casting of Albrecht of Habsburg in Innsbruck in 1518 at his own expense for the approval of the emperor and his advisers, Kölderer and Leonhard Offenhauser. Cast in one piece from modeled clay, the work was both cheaper and faster than any of the Sesselschreiber figures; with time of the essence, Maximilian soon appointed Godl to head the production of the remaining figures. He remained on the job until his death in 1532, producing seventeen large ancestor figures, twelve of them for Ferdinand after 1522, out of the twenty-eight that eventually formed the final ensemble.[111]

Godl had already been summoned by Maximilian to Innsbruck in 1508 to advise in the setting up of the bronze foundry for casting the figures. Then in 1514 Godl cast the smaller figures of the Habsburg saints after designs by Kölderer and carvings by Leonhard Magt.[112] Beginning only with the completion of the Mennel manuscripts in August 1514, Godl had managed to cast twenty-three of these figures by the time of the interruption of the project in 1520 after Maximilian's death. The second sketchbook of the Habsburg saints from the Kölderer workshop (cod. 2627) served as the principal model for these small bronze figures.[113] For the busts of the Roman emperors, thirty-four planned, the personnel consisted of still different agents: Jörg Muskat the sculptor, Hans and Laux Zotmann the casters, based in Augsburg, ca. 1509–17.[114] Models for these emperor figures were based on the imagery on Roman coins assembled by Peutinger in Ausburg, and all thirty-four busts were inventoried in 1534, although only twenty-one survive today in Innsbruck (plus *Probus* in Munich, Bayerische Nationalmuseum; see fig. 30).[115]

The plans of Maximilian remained important enough to him to be a major part of the will he drew up at Wels: "Item. In Neustadt in St. George's church [are] wooden statues and saints, which stand in the gallery all around, which should be disposed of and placed together in the tower which is called the Tower of the Virgin, a room which one should thereafter board up; and in place of the wooden statues we order that the 134 cast statues be placed all around, however so far from the other that one may see to the altar of the church and the same gallery still be filled."[116] The figures mentioned equal the sum of the planned Habsburg saints (one hundred) plus the busts of the Roman emperors (thirty-four), and their placement in the gallery of the St. George's Chapel in Wiener Neustadt indicates a preference by Maximilian for additional family heritage. Wiener Neustadt was his birthplace, the burial site of his mother, and the site of the St. George Order founded by his father and renewed by Maximilian (see chapter 4). The lesser sculptures, then, would have ornamented the gallery above the chapel, while the life-size ancestors, mistakenly numbered at twenty-eight in the testament (*grossen achtundzwainzig gegossen pilder*) were to have been placed on the main floor of the sanctuary.[117] Indeed, Maximilian even in his latter days devoted considerable attention to the details—including fantastic additional supports from chains hung from the ceiling—of installation of his tomb figures. His concern about the great weight

of the figures on the floor of the St. George's crypt may also have led to alternative plans for the construction of another church just to house the tomb figures.[118]

Also according to the last will of Maximilian, the foremost figures in the St. George's Chapel were to have been Charlemagne, Frederick III, Maximilian himself, and two others not named: "But [of] the great twenty-eight cast statues, should our person, our father, Emperor Charles, and still two others near us, be placed at the front . . . and according to the order, be placed above the altar."[119] Thus, according to this plan, the focus of attention and the culmination of the ensemble of statues would eventually have included Maximilian himself as well as his father and predecessor as emperor. The inclusion of Charlemagne here would jointly convey a distant, saintly relative as well as the first northern, Christian emperor and an ideal model of knightly virtue, one of the "Nine Worthies." Those figures, however, were never executed, and in 1549, Ferdinand revised the location to the present Hofkirche in Innsbruck; construction on the site began in 1553.

Precedent for the rows of attending figures comes from the great ducal tombs of Burgundy during the preceding century, beginning with Claus Sluter's tomb of Philip the Bold (d. 1404) for the Chartreuse de Champmol, Dijon, and emulated in the Low Countries (where Maximilian could have seen it) by the tomb of Philip the Good in Bruges.[120] Around the cenotaph, or *tumba*, of the deceased a cluster of miniature mourners (*pleurants*) surrounded the bier. Separately carved, these figures increasingly took on distinctive costumes and personalities of their own. In the second half of the fifteenth century, small bronze statues in contemporary costumes now served less as mourners and more as family witnesses to the solemnities of the burial rites. Examples include the tombs of Louis de Male in Lille (1454–55), Joan of Brabant in Brussels (1458–59), and Isabella of Bourbon in Antwerp (1476?); ten bronzes from Isabella's tomb survive in Amsterdam (Rijksmuseum).[121] Isabella (d. 1465) was the mother of Mary of Burgundy, Maximilian's first bride, so it is inconceivable that he was unfamiliar with the tomb that she worked to erect in the Abbey of St.-Michel in Antwerp (destroyed in 1566). Thus, the prototype for the presence of bronze figures of ancestors around a tomb lay within the heritage of the very Burgundian relatives whose own sculptures lie within the ensemble for Maximilian in Innsbruck. It was Maximilian's variation to reserve the form of the statuette for the less closely related saintly relatives of the Habsburgs.

To the commemorative and family elements of the bronze tomb figures of Isabella of Bourbon's tomb, Maximilian added the element of scale. His larger than life-size figures had already been envisioned in the *Triumphal Procession* miniatures and woodcuts, and the bronze medium employed the costliest possible sculptural materials.[122] We cannot know whether Maximilian envisioned his bronzes to be gilded, as were the statues of the *Procession* miniatures, but in view of the presence of gilded armor for solemn processions as worn by his successor, Charles V, we can suppose that such accoutrements were equally appropriate for these august ancestors.[123] Maximilian had worn a silver suit of armor with gilded decorations when he made his own triumphal entry into Ghent (18 August 1477).[124]

Oberhammer has suggested literary inspirations from classical texts for the tomb project.[125] He refers to the passages from Dio Cassio's *Roman History* that recount the funeral of Augustus,

describing how three portraits of the deceased followed in train behind other images of both relatives and historically important figures. Dio also describes how the busts of all excellent Romans, along with images of the provinces, personified, formed part of the funeral procession for Pertinax. We know that Peutinger owned a copy of Suetonius, in which the funeral of Augustus is described, but with far less specificity than in Dio, so it is possible that an authority on antiquity like Peutinger informed Maximilian about precedents like Dio while consulting with him on the details of the *Genealogy* and the tomb project.[126] In the absence of specific evidence, this textual source must remain hypothetical, but the concept doubtless lay in the model of ancient Rome and the incorporation of ancestor cult figures (*splendor generis*) into family funeral ceremonies.

Oberhammer's argument makes evident, however, the degree to which Maximilian's retinue of ancestors can no longer be regarded simply as the heritage of mourners from the Burgundian tomb tradition. When Maximilian supervised the tomb in Bruges, Notre Dame, for his first wife, Mary of Burgundy, he already anticipated some of the elements of his own later plan. That tomb, also in bronze, substitutes coats of arms for figures along the side of the bier, although it still employs the recumbent effigy on a *tumba*. (The body of Mary, like that of Maximilian himself, was placed under the altar; see chapter 4.)[127] This attention to the assertive, rather than the mournful, side of family ancestry and possessions marks Maximilian's concept of the tomb, as well as of the *Triumphal Procession* statues, "whose coat of arms and name Emperor Maximilian bears and whose land he rules." If the Sesselschreiber figures were conceived as bearing long candles in solemn procession, still retained in the drawings of the Vienna codex (cod. 8329, ca. 1522–23) by Kölderer, the later figures were transfigured even more by being given scepters and weapons to hold. They have been transformed from mourners into guardians, whose heraldic arms have become armor.

What, then, are they guarding? Not the literal body of Maximilian, for his effigy would have stood among them at the site of the altar. These figures collectively form the phalanx of the House of Austria, as it came progressively to be defined during the period of Frederick III and Maximilian.[128] This is the concept of the "house" as defined in ruling families of Europe in the later Middle Ages, namely, the "spiritual and material heritage, comprising dignity, origins, kinship, names, and symbols, position, power, and wealth, which once assumed . . . took account of the antiquity and distinction of the other noble lineages."[129] This is the ongoing lineage of the dynasty, founded on its name and goods and titles, but backed by this "continuing" heritage of kinship or claimed affinity. Oberhammer has rightly pointed out that these bronze ancestors display a kind of figured heraldry, akin to the coats of arms on the tomb of Mary of Burgundy, along with an embodied family history. It simultaneously contains all meanings of the term "house" (*domus*): family, castle/ancestral site (the "Habensburg"), domain (*dominium*), and economy in the traditional sense of housekeeping. Just as other ruling houses became associated with their territories and titles, so can the House of Austria take its place with Saxony and Bavaria as mainstays of the German Kingdom, or, as the text of the dictated *Triumphal Procession* has it, "the Austrian territories related to the Empire." Thus, the ensemble of bronzes collectively defend,

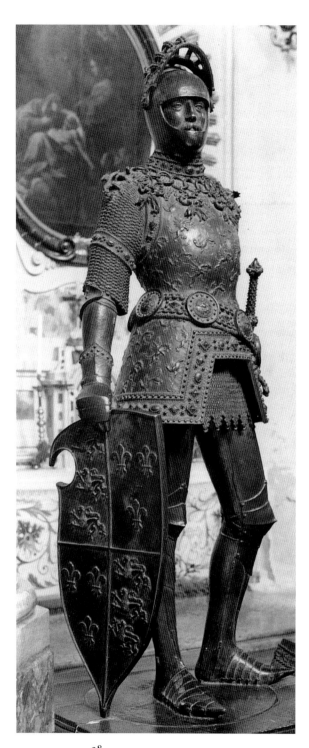

28

Peter Vischer and workshop, *King Arthur*,
1510s, bronze. Innsbruck, Hofkirche.

incorporate, and stand behind the power, authority, prestige, and history of the House of Austria. They are its founders and its guarantors, just as the holy blood of the Habsburg saints conjoins behind Maximilian to assure his election and holy mission. Because of the importance of marriages to the "capture" of lands and titles, many of these statues commemorate famous ancestral women as well as the wives and daughters of Maximilian's immediate family. And because of the accretion of titles, lands, and dignities, the affiliation with Julius Caesar, Clovis, and Charlemagne or St. Leopold of Austria seems consistent with the ambitions of kinship in the broader sense, namely, to establish genealogical legitimacy for the titles inherited from all lines. Ancestry thus coincides with power and status; genealogy supports ideology.

The ancestors who best exemplify these claims are the two magnificent figures created by the Vischer workshop in Nuremberg in 1513, presumably after designs by Dürer: King Arthur of England (fig. 28) and King Theodoric the Ostrogoth. These two figures exemplify valor in a leader, what Oberhammer calls the model of a *Ritterkönig*, or knight-king. Arthur already formed part of the canonical "Nine Worthies," mentioned above, as one of three good Christian knight-kings. Moreover, both Arthur and Theodoric were heroes in the romance literature of the later Middle Ages, the tales of chivalric deeds, so beloved by Maximilian that he had many of them recorded in the 1517 *Ambras Heldenbuch*.[130] It is in this context that the less familiar figure of Theodoric plays a prominent part, as the epic personage, "Dietrich von Bern" or Theoderic "of Verona," better known as Theoderic the Ostrogoth. That there was little discrimination between romances and what we now call "historical" sources led to the importance for history of Theodoric as a figure analogous to Clovis.[131] This Arian heretic and Germanic foe of Rome also appeared in Trithemius's history of the Franks and Goths and served as a counter-Roman,

74 Chapter 2

29

Hans Weiditz, *Memorial of the Death of Maximilian I*, 1519,

woodcut. Vienna, Albertina (inv. 1949/368).

Germanic role model for venerable Habsburg family history. Arthur, in turn, served a strategic purpose as a symbol of Habsburg pretensions toward the crown of England. Maximilian used the stepmother of Mary of Burgundy, Margaret of York, wife of Charles the Rash, as the basis of his claims to the title of king of England after the "usurpation" by Tudor monarchs, and he included the arms of England among the "seven kingdoms" that he proudly proclaimed in his heraldic arms.[132] Thus, the two figures produced by the Vischer workshop exemplify particular virtues and Nordic historical precedents that Maximilian sought in his ancestry, but they also served to legitimize his claims to imperial lands in northern Italy as well as to England. In this respect, the substitution by Dürer of weapons and true shields rather than heraldic arms may be taken as significant, even if done in ignorance of Sesselschreiber's original designs for figures with candles—the sword

of Arthur and the lance of Theodoric make them truly martial guardian figures of the titles and the lands claimed by the House of Austria.

The tomb of Maximilian was the most extended, ambitious, and costly of his genealogical projects, and it remained the work that most preoccupied him. Yet its authenticity and legitimacy rested on the researches of Mennel and other scholars, and its claims were codified in the manuscripts of the emperor's personal library, such as the *Geburtsspiegel* as well as by publications for wider distribution with images, such as the *Genealogy* (Burgkmair woodcuts) or the *Habsburg Saints* (Beck woodcuts). We can see from the Wels testament that Maximilian was still working out the details of the tomb and revising his plans on the very eve of his death. That this concern was not an isolated phenomenon, however, emerges clearly from a commemorative woodcut, prepared posthumously to record the last days of the emperor (fig. 29). The Latin text of this 1519 woodcut, whose design is now ascribed to the Petrarca Master of Augsburg (Hans Weiditz), celebrates the contributions of Maximilian to the revival of chivalric military orders.[133] But the center of the woodcut features a scene showing Mennel reading to the sickly emperor at night by candlelight, captioned: "Cesari antiquissime et nobilissime Genealogie eius per Manlium libri leguntur." The subject used as deathbed consolation for the ailing emperor was the history of his ancestors and of the illustrious members of the Order of the Golden Fleece that he had headed.[134] To the very end of his days, Maximilian remained steeped in the lore of his illustrious ancestors, whose achievements and powers he saw as the firmest foundation of both his territories and his talents.

The Holy Roman Empire is neither holy, nor Roman, nor an Empire.

—VOLTAIRE, *Essai sur les Moeurs*

3 | Translation of Empire

Hovering in the gallery above the main ensemble of life-size, standing bronze figures at the tomb of Maximilian in Innsbruck (chapter 2) sits a smaller cycle: busts of Roman emperors, beginning with Julius Caesar (fig. 30).[1] The sculptor of these busts, Jörg Muskat of Augsburg, received his first payment in 1509, along with bronze casters Hans and Laux Zotmann.[2] These busts display a notable effort by their sculptor to assimilate portrait likenesses of the antique figures accurately from whatever sources he could find. Thus, these bronzes attempt simultaneously to distinguish individual features as well as to replicate the trappings of antique costumes, laurels, and coiffure. Even their orthography recalls ancient lettering.

Sources for these busts consisted chiefly of antique coins with profile portraits of the emperors.[3] Peutinger owned a renowned collection of ancient coins, which added to his valued availability as artistic adviser and liaison for Maximilian and doubtless helped determine the choice of Muskat, an Augsburg artist, for the task. Peutinger had been involved in early consultations on the tomb figures: in the spring of 1508 he met with Maximilian and Sesselschreiber in Augsburg to coordinate plans prior to the first casting of the large ancestor bronzes. Later, when his own labors dragged on, Sesselschreiber complained that portions of the tomb were subcontracted to other artists, especially Peutinger's favorites from Augsburg: ". . . not just Swabians and outsiders alone become famous, while here and in this region there are also good masters."[4]

Peutinger's interest in antique coins and in ancient history had already borne artistic fruit. He commissioned Hans Burgkmair to produce woodcut portrait medallions, based on the ancient coins, that were to serve as illustrations for a proposed *Kaiserbuch* ("book of Caesars"), formally

30

Jörg Muskat, *Julius Caesar*, ca. 1510, bronze.
Karlsruhe, Bädische Landesmuseum.

titled *Imperatorum Augustorum et tyrannorum quorundam Romani imperii gestorum annotatio.*[5] This giant history of all the emperors from Julius Caesar to Maximilian was a life's work for Peutinger, based on all available information and accompanied by portraits as accurate as possible. Begun by 1503, it remained unpublished at his death. A report from fall of 1505 mentions completing the project, "one with images and insignia" (*una cum imaginibus et insigniis prope absolvimus*)."[6] Originally, more than one hundred woodcut portraits were planned. A volume of Peutinger's literary legacy (Munich, Staatsbibliothek, cod. lat. 4009), studied by König, reveals (fo. 8) an "*index ad sculptas imagines caess.*" with 185 names of ancient rulers up through the Byzantine Empress Irene.[7] Burgkmair's name is specifically indicated when the artist is credited as having completed the image of Emperor Phocas. Thus, prior to his engagement by Maximilian, via Peutinger, to produce full-length woodcut portraits of Habsburg ancestors for the *Genealogy* (chapter 2), Burgkmair had already begun work on a series of careful likenesses after antique coins of all the Roman emperors for Peutinger's history text, itself dedicated to Maximilian. The authenticity of Muskat's busts of the emperors for Maximilian's tomb clearly relied on these coins and previous portrait prints in Augsburg.

Weihrauch's study makes clear that there was also an overlap in planning that further suggests Peutinger's direction for the bronze cycle of Roman emperors.[8] A similar row of emperors ornamenting the left attic of the *Arch of Honor* makes the same selection with the same omissions out of the roster of later emperors (fig. 31): Lucius Verus, Severus Alexander, Gordianus III, Philippus Arabs, and Theodosius. The *Arch* cycle has been further cosmeticized by the omission of some of the more despicable emperors from the display: Caligula, Nero, Galba, Otho, Vitellius, and Domitian. Of course, the fact that we know for certain that Peutinger possessed a copy of Suetonius explains his desire to sanitize the imperial history, particularly when space considerations on the *Arch* made some omissions necessary (although he also omitted Marcus Aurelius). In addition, the figures who appear on the *Arch* but do not appear in the surviving Muskat bronzes total fourteen.[9] Together with the extant bronzes, the total names of emperors number thirty-four,

Der keiser so hie seind formiert
Der merer theil hat wol regirt
Zu mache das römisch reich gerracht
Altzeit nach lob vnnd eer gedacht
Nit minder Maximilian
Mag loblich bei den allen stan
Dci im souil geschriben ist
Als man von keinem keiser list
Treslicher ding vnnd grosser thue
Dartzu got im geholffen hat
Dann er den hochberumbten standt
Beschirmet hat mit streitpar handt

Alexander Seuerus Antonius
der Gütsam der Ernst der guttig
lich

Hadrian Traianus Nerua der
arckenst der Best mitsam

Titus Iust Vespasian Claudius
der Senn. ob rach des Vim
scheu gots derpar

Tiberius Augustus Julius In
der Tzart der glückf. fürtzkaiser
lig lichen Vca
testat

31

Albrecht Dürer workshop, *Roman Emperors,* from *Arch of Honor,*
ca. 1517–18, woodcut.

including Constantine and the Byzantine emperors Anastasios I, Justinian, and Heraklios. That number exactly matches the number reported in the Innsbruck inventories of the delivered emperor busts for the tomb.

All three of these emperor series projects clearly reveal a desire for a historical link to the Roman Empire on the part of Maximilian. But the key to this link is election and succession, not the strong and continuous blood links and descent of genealogy, which forms the background to the large ancestor figures of the tomb plan (chapter 2). Significantly, the first "Germanic" ruler of the Roman Empire included in the series on the *Arch* (after Odoacer, whom he vanquished) is Theoderic (as "Dietrick von Pern"), Gothic king and Roman citizen, who is claimed as one of Maximilian's "ancestors" among the life-size bronzes of the tomb, the supple figure designed by Dürer and cast by the workshop of Peter Vischer.[10] Just below Theoderic on the *Arch* comes Charlemagne, omitted from the direct ancestors of the family tree at the center of the *Arch* but intended to stand alongside Frederick III and Maximilian himself at the head of the row of ancestors at the

tomb. Charlemagne completes a triad headed by the great Byzantine lawgiver, Justinian, and Eradius, "warrior of the holy cross." In short, the *Arch* goes beyond the emperor busts of the tomb to suggest the fuller continuity of Peutinger's *Kaiserbuch* succession of emperors from Julius Caesar to Maximilian himself. Above the heads of the rows of emperors in the attic of the *Arch*, the verses of Stabius proclaim the underlying reason for their presence in terms of the modern empire:

> The Emperors as from above ordained,
> in many ways they well have reigned,
> The Roman Reich has thereby grown,
> with praise and honor they have sown.[11]

Then the text goes on to compare Maximilian to these prototypes.

Although Maximilian's genealogical claims (chapter 2) emphasized his several lines of descent, represented in three chains in his visual lineage, or *Geburtsspiegel*, he includes—in addition to the biblical *linea hebraeorum* and the Trojan *linea grecorum*—a *linea latinorum* of Roman emperors. Thus, for him, the heritage of the Roman Empire was a discreet element alongside his mission on behalf of the Church (chapter 4) or his own family dynasty. To understand the role of figures like Julius Caesar and Charlemagne in his tomb as well as the ambitions of his grand woodcut ensembles, the *Arch of Honor* and the *Triumphal Procession*, requires examination of Maximilian's core concept of what constituted a contemporary version of the Holy Roman Empire of the German Nation.

Claims to world dominion by the ancient Romans had become fused with Christian claims to religious truth and universal supremacy ever since the fourth-century conversion of Emperor Constantine. But in establishing a second Rome in his eponymous capital, Constantinople, Constantine had invited the notion that his imperial dominion was transferable. To Maximilian, who claimed his own personal ancestry from the Trojans, this later Byzantine Empire among the Greeks seemed like an inevitable completion of the cycle begun with the Trojan War, when the two branches—the Latins, out of Aeneas, and the Franks, out of Hector—had been dispersed. In the West, non-Romans, such as Theoderic, had assumed the mantle of leadership and greatness during a period of decline in Rome. Eventually, the Frank Charlemagne, truly absorbed the role of emperor of all Christendom and in the process fully united all three strands of history: the biblical, Church history of the Hebrews; the imperial history of the Romans and Byzantines; and the Trojan history of the Frankish people, headed by Charlemagne himself.[12]

Nicolaus of Cusa's *Concordantia catholica* (Basel, 1431–33), written during the Conciliar struggles of the early fifteenth century, codified the doctrine of both continuity and authority of the modern Holy Roman Empire, as founded in ancient Rome.[13] The emperor is vicar of Christ, lord of all Christians, and heir to the Christian emperor, Constantine. He is the guarantor of the laws, like Justinian, and protector of the faith. If the *sacerdotium* of the Church and the papacy is the soul of Christendom, then the *imperium* of the emperor is the body, including the strong right hand, with the emperor himself as its head. He is the first monarch, ruling through kings, who ought to see him as foremost among them all. This office tops a true hierarchy, with each

higher rung subsuming the natures and powers of the rungs below.[14] Thus, the modern empire, ruled by Germans after Charlemagne and Otto I, forms the true continuation of ancient Roman dominion, first made Christian and thereby sanctified by Constantine.

This doctrine of imperial migration is known as the *translatio imperii*, and it has a long history.[15] In part, the concept of the translation of empire depends on the prior conception of the "four empires" prophesied in the Bible and elaborated in relation to the Roman Empire by Augustine and other medieval commentators and historians. Following Augustine's suggestion that he write a world history justifying the salutary effects of Christianity on the world, Orosius published around 418 his *Seven Books of History against the Pagans*, a work that would have profound influence on later world histories as well as the sixteenth century.[16] In that work, Orosius formulated the concept of the four empires: Babylon in the east, Carthage in the south, Macedonia in the north, and finally Rome in the west. Over time a steady movement shifted the dominant empire to the west, where it has endured under its Christian leadership as embodiment of God's purpose on earth: *Tunc orientis occidit et ortum est occidentis imperium*. Under providence, the Roman Empire served as the precondition for the advent of Christ on earth, and the empire remains the site for the working out of providence under the Christian religion. This conception of world history, in turn, rests on the visionary writings in the Book of Daniel, where a dream vision refers to four winds of heaven and four great beasts, supplanted by the vision of the Ancient of days on his throne: "The fourth beast shall be the fourth kingdom upon earth, which shall be diverse from all kingdoms, and shall devour the whole earth. . . . And the kingdom and dominion, and the greatness of the kingdom under the whole heaven, shall be given to the people of the saints of the most High, whose kingdom is an everlasting kingdom, and all dominions shall serve and obey him" (Daniel 7:23, 27).

Orosius's conception of the four empires was received and accepted by the imperial apologist, Otto von Freising, in his twelfth-century world chronicle, *Chronica sive Historia de duabus civitatibus*.[17] Otto, uncle of Emperor Frederick I Barbarossa, refers to the westward migration of the empire, first to the Rome of Augustus, then to the Frankish kingdom of Charlemagne, and he affirms the supremacy of the empire over other princes in the world.

That such views were still a commonplace in the era of Maximilian can be seen in the vernacular verses of the *Ship of Fools* (Basel, 1494), by Sebastian Brant. Its Chapter 56, "On the End of Power," concerning worldly vanity, begins with Julius Caesar and evokes at its end the theory of the four empires:

> Great folly 'tis to have great might,
> It often lives one day or night.
> When all the states on earth I scan,
> Th'Assyrian, Persian, Median,
> And Macedon, the states of Greece,
> Or Carthage, Rome, they found their peace,
> They all now slumber under sod.

Our Roman Empire trusts in God,
He's granted it a time and fate,
May He still fashion it so great
That all the world its cause may serve
To such extent as it deserve.[18]

Elsewhere in the same volume (chapter 99), the German inheritance of the mantle of leadership of the Roman Empire is evoked by Brant:

The Germans once were highly praised
And so illustrious was their fame,
The Reich was theirs and took their name.[19]

Maximilian's contemporary virtues make him superior to even the great emperors of the past, and Brant addresses him as *Traiano melior*, better than Trajan.[20]

In this same spirit, the two ensembles of *Arch* and *Procession* were devised in emulation of the triumphs of ancient Roman emperors after their military victories. The *Arch* in the explanatory words of Stabius's colophon is a modern re-creation of those antique celebrations:

The Arch of Honor of the Most Serene and Mighty Emperor and King Maximilian is constructed after the model of the ancient triumphal arches of the Roman Emperors in the city of Rome. Some of these have crumbled, but others may still be seen. . . . Because the Emperor Maximilian was honorably elected to the society of Roman Emperors and Kings, and because His Majesty has worn the Roman Crown with great distinction, . . . an Arch of Honor, similar to a Triumphal Arch, has been erected for him.[21]

The history of this program has been carefully traced by modern scholars, particularly Giehlow.[22] At the right base of the *Arch* three coats of arms appear: those of Stabius, Kölderer, and Dürer, in descending order of size. What these arms reveal is that Jörg Kölderer, Maximilian's chief court artist (chapter 1), provided preliminary designs for the *Arch*—a reason for the often-noted similarity between the central tower of the Dürer woodcut and the 1496 Innsbruck Wappenturm (Armorial Tower), erected after earlier Kölderer designs (see below). Around 1512, both the *Arch* and the *Procession* were linked together as "triumphs," as the letter of 14 October from Maximilian to Siegmund von Dietrichstein reveals: "Stabius has also directed the Triumphal Chariot [*Triumfwagen*] completely under way, but we have not yet seen it."[23] Moreover, in the dictations of Maximilian to his private secretary, Marx Treitzsaurwein, of around 1512 (Vienna, National Library, cod. 2835), the two projects are conflated into a single word: "*Triumphwagen*."[24] Around the same time, Dürer writes, he began his energetic service for Maximilian; his letter to Christoph Kress of Nuremberg in 1515 avers that he had already been working on projects, chiefly the *Arch*, for three years.[25] A 30 March 1507 receipt (Regest. 831) to Kölderer records that he had by then delivered "six models for the Triumphal Chariot of Austria with lines [i.e., drawings], five false."[26]

Documents record that Kölderer delivered two *Triumfwägen*, bound in tube, leather, and cloth, on 12 January 1512 (Regest. 1057).[27] At this point, then, the program designs in the form of drawings had been compiled by Kölderer. These presumably formed the basis for Dürer's initial sketch for the *Triumphal Chariot* (Vienna, Albertina, W. 671), a drawing presumably made in connection with Maximilian's visit to Nuremberg from 4 February to 21 April 1512.[28]

As the researches of Winzinger reveal, however, the next stage of the creation process for the *Procession* was carried on by Albrecht Altdorfer of Regensburg and his workshop, which produced the splendid miniatures, about half of which (nos. 49–109) are preserved in the Albertina, with copies of the remainder in Madrid.[29] A letter from Maximilian to Stabius (26 January 1513; Regest. 304) indicates his continued close supervision of the project, as he commands an additional small chariot before his own in the *Procession*, which would include a single empress behind three seated queens.[30] The Altdorfer miniatures omit the Vienna double wedding of 1515, so they must have been completed before that date. (The Vienna Congress does appear on the *Arch*.) Like the analogy of the miniatures and the woodcuts of the Habsburg family saints, there is no reason to think that the woodcuts and the miniatures of the *Procession* could not have been executed from analogous Kölderer models by different artistic workshops delegated during the same period. At the conclusion of the miniatures is a double portrait of two men with banderoles: the dark-bearded individual is recognizable as Stabius (cf. Dürer's drawing, 1517; Vienna, Liechtenstein coll.; W. 572); the second figure in court dress is usually identified as Kölderer.[31]

The miniature codex was doubtless made for the delight and personal possession of Maximilian himself, while the woodcuts were intended for broad distribution. Burgkmair's proof impressions of the woodcuts in Dresden include a dated personal signature by the artist: "H. Burgkmair maler. Angefangen 1516 Adn. 1. Abrilis."[32] That the Kölderer preparatory sketches overlapped between the *Arch* and *Procession* can be seen in the basic agreement between the woodcuts by the Dürer school and the miniature by the Altdorfer school for the subject of the marriage of Philip the Fair and Joanna of Castile, adapted in essentials by Springinklee for the *Procession* woodcut (fig. 32). Although no Kölderer drawings have been preserved and no miniatures survive for the *Arch*, we may infer that the relationships between *Visierung* models by the court artist and the subsequent miniatures or woodcuts pertained for both projects. Indeed, for elements of the *Procession* for which there was not yet a final sketch, Dürer provided his own working drawings, as in the case of the small chariot with the children and grandchildren of Maximilian (Vienna, Albertina, W. 671; fig. 33).[33] For the *Arch*, later events were included than in the *Procession*; in addition to the Vienna Congress of 1515, the miraculous finding of the seamless cloak of Christ in Trier (1512; see chapter 4, fig. 48) and the second battle of Therouanne (1513) were inserted into the woodcut cycle of the *Arch*, but the battle scene related to other battles, whereas the Trier discovery was itself a secondary scene, executed by the Dürer workshop amid Altdorfer woodcuts.[34]

A letter from Maximilian in Cologne to Stabius (5 June 1517) shows concern by the monarch with the progress of the *Arch* and the continuing desire to monitor and correct its details: "And so we have seen the painted *Arch* [*bemelt Eernporten*] and received your text, and we have found

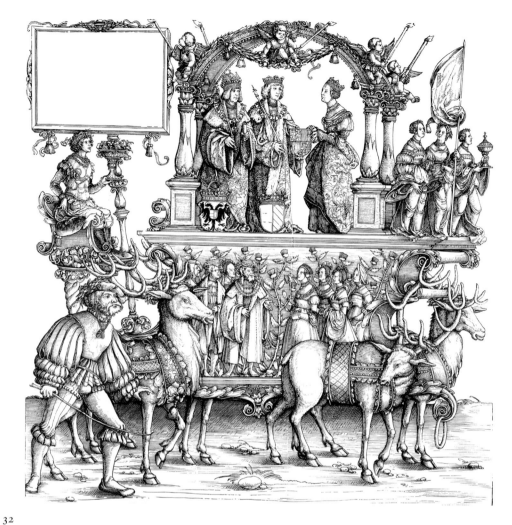

32

Hans Springinklee (attributed), *Marriage Chariot of Philip the Fair*,
from *Triumphal Procession*, ca. 1516–18, woodcut.

that such an Arch is not rendered according to the content of our command and according to
the exemplar that you have in your hand and that you should use as your direction, so that we are
greatly displeased; not satisfied either about the work on this planned *Arch.*" He goes on to order
Stabius to cease work immediately and to come to him for consultation, bearing the exemplar
for further corrections: "Thus will we then show you, what we find lacking in it and how we
opine to prepare the same."[35]

These "new" *Arch* images were doubtless the proofs of the woodcuts issued by Dürer, and
the problems were connected to debates over the correct genealogy for Maximilian. On 19 May
(Regest. 1270), a letter from Maximilian in Antwerp to Stabius asks for a copy of the *Genealogy*
to be forwarded to him for inspection and requires Stabius not to complete the genealogy on the

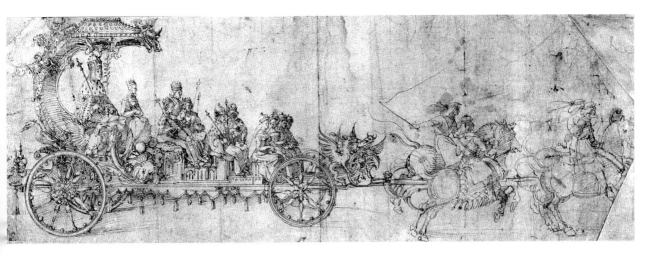

33

Albrecht Dürer, *Design for Triumphal Carriage with Family of Maximilian*,

ca. 1512, ink. Vienna, Albertina (W. 671)

Arch on its four blocks before checking the accuracy [*bevor er wisse, was mit der Genealogie beschlossen sei*].[36] By implication, the "new" *Arch* had to be based on an "older" one, analogous to the working drawings prior to the miniatures and the woodcuts of the *Procession*, and produced, as the coats of arms on the final redaction display, by Kölderer prior to being forwarded to Stabius and Dürer.

That the *Arch*, too, might have been painted simultaneously in the form of a luxury miniature ensemble seems possible on the basis of two letters sent by Maximilian to his daughter, Margaret of Austria, in the Netherlands.[37] In the first letter (18 January 1516), Maximilian speaks of a "*porte d'honneur en painture . . . pour nostre et vostre perpétuelle gloire*"; it was then in Margaret's possession, which he desires her to return after she has "corrected, augmented, and diminished" it.[38] It was against this original conception that Maximilian wished to compare Stabius's proofs to check the details of any emendations underlying the final woodcut program. No parchment miniatures pertaining to the *Arch* have survived, so it is also possible that the images held by Margaret were working designs by Kölderer as well. In the second letter (17 February 1518), Maximilian sends to Margaret a final, printed version of the *Arch*, which he now declares to be "*parfaicte, plus belle et mieulx pourtraicte.*"[39]

The process of creation of the *Arch* and *Procession* thus remained firmly under the control of Maximilian himself, who delegated the execution of his visual ideas to Kölderer, who had been named court artist and supplied with materials and assistants by 1507 (chapter 1).[40] Kölderer then transformed these outlines into line drawings, to be fleshed out by teams of artists in several regional centers, chiefly the Nuremberg of Dürer, the Augsburg of Burgkmair, and the Regensburg of Altdorfer. At the same time, Maximilian transmitted his verbal ideas for both the overall programs and the precise text to a network of scholars and secretaries: Treitzsaurwein, his private secretary, and Fuchsmagen, followed by Stabius, his scholarly consultants and historians. Then

the verbal program, too, was diffused into the regional centers, where trusted local intellectual advisers, chiefly Pirckheimer with Stabius in Nuremberg and Peutinger in Augsburg served to coordinate the illustrations with the program.[41] During the period of painting the *Procession* miniatures, Maximilian dispatched Stabius to Regensburg, where he was given a house and garden.[42] Delegation of execution, division of labor, decentralization of responsibility—all are hallmarks of this working method; however, the ultimate supervision and final decision making remained solely and firmly in the hands of Maximilian alone.

Dürer's letter to Kress (30 July 1515) suggests something of the nature of the artist's involvement with the project: "Point out in particular to his Imperial Majesty that I have served his Majesty for three years, spending my own money in so doing, and if I had not been diligent the ornamental work would have been nowise so successfully finished. . . . You must also know that I made many other drawings for his Majesty besides the 'Triumph.'"[43] The program of the *Arch* was already developed by the time of Maximilian's 1512 letter, yet the general nature of Kölderer's designs can be inferred from the later difficulties over discrepancies or divergences from the emperor's exemplar, for which Stabius had to be summoned in 1517. Dürer clearly had to subdivide the massive work on the *Arch* among his pupils. He was assisted principally by Hans Springinklee and Wolf Traut.[44] Scholars have assigned relatively few sections of the *Arch* to Dürer himself: decorations of the principal gate, most notably the angel with a crown over the central portal, as well as much of its ornamental decoration (harpies, armored putti, repeated in reverse on the symmetrical opposite side by a pupil); outer column decorations, including the ornament of the base, the statues of the Habsburg saints, and several griffins; the pelts with inscriptions around the central tower; and several busts of the ancient emperors (Constantine to Honorius). A number of the separate scenes have also been ascribed to Dürer.[45]

This roster reveals that Dürer's single-handed contribution was skillfully integrated within the overall decoration of the altarpiece, in which Dürer surely participated as both designer and supervisor. Dürer's own careful supervision of sections of ornament led to replication by means of reversal on the opposite side of the *Arch*. His own familiarity with Italianate motifs, such as putti, and with animal studies led to his strong control of ornamental motifs throughout the ensemble, even down to the pelts bearing inscriptions high up on the *Arch*. Dürer executed only a few of the numerous historical scenes, though he seems to have elected to stress the events most closely involved with portraitlike solemnity and small numbers of figures, particularly the three weddings.[46] Dürer also seems to have lavished his attentions more on the isolated, specifically Habsburg figures who stand on the columns of the *Arch* rather than on the rows of portrait busts of former emperors and kinsmen at the sides. For these latter, as well as in the Trier scene, he seems to have started things off with a sample woodcut and then to have delegated responsibility to his workshop for the remaining scenes. Of course, this procedure in no way suggests that Dürer drawings and sketches might not underlie many of the other woodcuts on the *Arch*. Much of the overall consistency of the appearance of the *Arch* is surely due to Dürer's capable supervision as well as to his pupils' careful adherence to his example.

When the *Procession* was produced as an extended frieze of woodcuts, beginning in early 1516, if we may judge by the date and signature of Burgkmair in Dresden, some of its principal images were still reserved for the Dürer workshop as well. Of the extent woodcuts, twenty-two were produced by Springinklee, and the two principal chariots were made by Dürer himself. The first is a float commemorating the Burgundian marriage, a subject he had already rendered among the history scenes on the *Arch*. But the centerpiece of the *Procession*, the climactic float with Maximilian himself, was greatly altered by Dürer from the initial drawing design of the emperor and his immediate family (Vienna, Albertina), cited above. Eventually, Dürer separated this *Great Triumphal Chariot* from the *Procession* as a whole, and he developed an entirely separate program with Pirckheimer to represent Maximilian as an allegorical image of the perfect prince.[47] This program, first presented to Maximilian in an elaborate drawing of 1518 (Vienna, Albertina, W. 685; fig. 34), was then eventually published as a posthumous tribute to the emperor in four woodcut blocks (see fig. 11) with text in 1522.[48]

But Dürer and Springinklee were both too preoccupied with the woodcuts of the *Arch* to do full justice to the *Procession*. As a result, artists of Augsburg, supervised by Peutinger as in the case of the *Teuerdank* and *Weisskunig* illustrations, took over the bulk of the *Procession* woodcuts. The chief Augsburg artist remained Peutinger's protégé, Hans Burgkmair, who was entrusted with a written copy of the program, presumably to be compared with Kölderer designs. The proof set of Burgkmair's woodcuts for the *Triumphal Procession* survives in Dresden with this program text. Burgkmair went on to provide fully 67 of the 137 executed woodcut images, including the first 57 in a row, but the cycle remained incomplete and unpublished in the form that has come down to us. Perhaps as many as forty more woodcuts were planned, if we can extrapolate from the omissions within the dictated text of 1512 as recorded by Treitzsaurwein. Divergence from details of the miniatures indicates that the woodcuts also derived from Kölderer outlines rather than the miniatures themselves. However, after the completion of the miniatures, Altdorfer and his workshop added portions of the *Procession* woodcuts as well: the banner carriers and the *Tross*, or baggage train that brings up the rear.[49] Other Augsburg artists also participated in the *Procession* while simultaneously engaged in the larger project of illustrating *Teuerdank* for Maximilian: Leonhard Beck (seven woodcuts) and Hans Leonhard Schäufelein (two).

At the most material level, the designs by these artists were further subcontracted to professional woodcarvers, who transformed their drawings on blocks into printable reliefs.[50] These ten cutters included Hieronymus Andreae in Nuremberg, Dürer's favorite *Formschneider*, and the renowned Augsburg carver Jost de Negker, who often collaborated with Burgkmair. Many of these same craftsmen also were busy at the same time carving the illustrations for *Weisskunig* and for the cycle of Habsburg family saints, designed by Beck. Thus, there is little wonder that the *Procession* remained incomplete at the time of Maximilian's death in January 1519. Dates inscribed on the blocks preserved in Vienna range from late 1516 (12 November) to mid-1518 (25 August). A posthumous edition of the *Procession* was published without text for Maximilian's successor in Austria, Ferdinand, in 1526. It failed to include Dürer's *Great Triumphal Chariot*, along with some

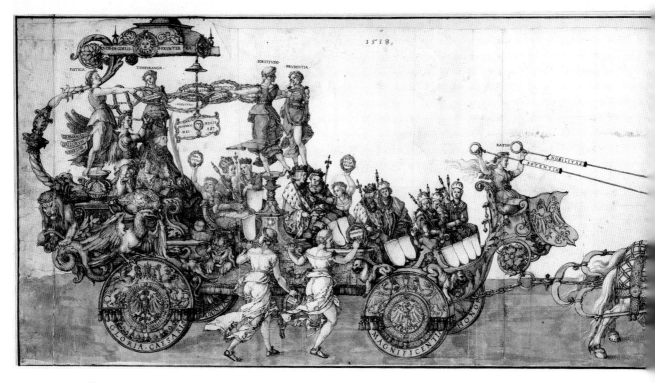

34

Albrecht Dürer, *Design for Great Triumphal Chariot*, 1518,

ink. Vienna, Albertina (W. 685)

Dürer drawings never cut into blocks, notably the 1518 series of riders with standards, preserved at the Albertina (W. 690–99).[51]

Like the *Weisskunig*, then, the *Triumphal Procession* remained a large fragment, in which the illustrations, themselves incomplete, still reached a more polished state of development than the proposed text. In contrast to the *Weisskunig*, however, both the *Triumphal Procession* and the *Arch of Honor* were conceived primarily as visual works with verbal accompaniment. They were designed from the beginning to function on the level of spectacle, with Stabius's colophon and the accompanying verse captions appended to the *Arch* in order to serve the same function as a handbook or "key" to primarily pictorial imagery.[52] In the historical scenes of the *Arch*, a fully differentiated series of images, each with its own discreet location (usually, however, a battlefield), cluster together to form a frieze in several successive strips.

The ultimate model for this historical strip frieze is ancient Roman monuments—not so much the triumphal arches invoked by the colophon, for these have varied assemblages of both symbolic and historic imagery, but rather the unfurling sequences of triumphal columns.[53] The friezes of ancient triumphal arches, such as the Arches of Titus and Trajan, described in low relief the actual triumphal processions that formed the occasion for the erection of that particular arch.

Obviously such imagery was fundamental to Maximilian's own *Triumphal Procession* frieze, but it was the ribbon of relief wound around a column, such as the one hundred scenes of the Dacian campaign on the Column of Trajan that provided the battle scenes and the ceremonial gatherings (*adlocutio*; surrender) as a visual history akin to Maximilian's own *Arch of Honor*.[54] The forms of the helical spiral on the column were not closely followed by Maximilian's German artists; indeed, they can scarcely be read clearly in the presence of the original monuments in Rome. But their cumulative visual argument of the success and importance of the sponsoring emperor did provide an enduring model, already alluded to in the opening lines of Stabius's colophon.

Many of the features of Maximilian's *Arch of Honor* do indeed stem from some kind of direct awareness, usually via literature, of actual Roman arches: the presence of a dedicatory inscription, filled with the titles and names of the triumphant ruler, together with compliments to his worthiness and invincibility. The addition by Dürer of trophies and winged victories to the basic schema of arched openings and columns on high bases further points to an awareness of classical models for the woodcut ensemble:

> Flanking the great tower above the Portal of Honor and Might, above the Griffons and below the heralds are placed two ancient Roman banners. The one on the left has an eagle; that on the right has a dragon. These emblems were used in Roman times and carried into battle. Those who carried them were called Aquiliferi and Draconiferi. Because

the Emperor Maximilian was honorably elected to the society of Roman Emperors and Kings, and because His Majesty has worn the Roman Crown with great distinction, and furthermore an Arch of Honor, similar to a Triumphal Arch, has been erected for him, it is only proper that the two Eagle and Dragon leaders, together with their pipers and drummers, be placed upon it and thus remembered forever.[55]

Yet the *Arch* fails to resemble a Roman imperial arch of triumph, a form that was surely known to Maximilian as well as to Dürer by virtue of the colored woodcut of 1508, produced for him by Hans Burgkmair on the occasion of his crowning as emperor-elect at Trier (fig. 35).[56] That Burgkmair print emphasizes fully the reference to ancient Rome by means of the architecture of the arch opening, under which the equestrian figure of the armored emperor stands, and by means of the block letters, recording his identity: "IMP CASE MAXIMAL AUG." Here again the advice of Peutinger and his knowledge of ancient inscriptions on Roman coins surely conditioned the appearance of the forms, for it was Peutinger who commissioned the production of this woodcut from Burgkmair.[57]

As the Stabius colophon makes clear, the antique references in the *Arch* served as an inspiration but not precisely as a model. This "Arch of Honor" is "similar to a Triumphal Arch," but it is not a replica, as is the Burgkmair arch of the 1508 woodcut. Instead, it is a hybrid, intended on the one hand to assimilate the traditions of the ancient Roman emperors, along with attendant figures, like the Aquiliferi and Draconiferi. But at the same time, it was meant to glorify the present holder of the imperial office. This glorification came through praise of his military victories and other deeds of state, recorded in the twenty-four historical scenes of the *Arch*. But just as the row of emperors ran from Julius Caesar through to the medieval Germans who included Habsburgs among them, so does the architecture of this *Arch of Honor* also bring the ancient forms of the Romans into a contemporary reincarnation.

From the earliest studies of the *Arch*, its forms have been linked with the heraldic tower, or Wappenturm, built by Maximilian in Innsbruck after designs by Kölderer.[58] The reason for this is Maximilian's desire to stress the continuity of the modern empire out of the ancient heritage. To be sure, the central tower construction, like the Innsbruck Wappenturm also provided a kind of billboard for family propaganda, where Maximilian could proclaim his own ancestry as well as display the coats of arms of his claimed territories. All of these advantages would have been impossible in the narrow attic and nearly square profile of an ancient triumphal arch. But the fanciful, hybrid architectural creation finally produced by Dürer also incorporates additional elements, foreign to the building designs to be found in Innsbruck. Besides the emulation of Roman columns in the Altdorfer columns on the flanks of the *Arch*, Dürer's design features a central cupola, backed by two other domes behind the central tower and echoed loosely in the melon-shaped peaks of Altdorfer's columns. These domes surely derive from the quintet of domes atop the cathedral of San Marco, well known directly to Dürer as a result of his two trips to Venice. In combination with the Wappenturm elements and the references to Roman arches and columns,

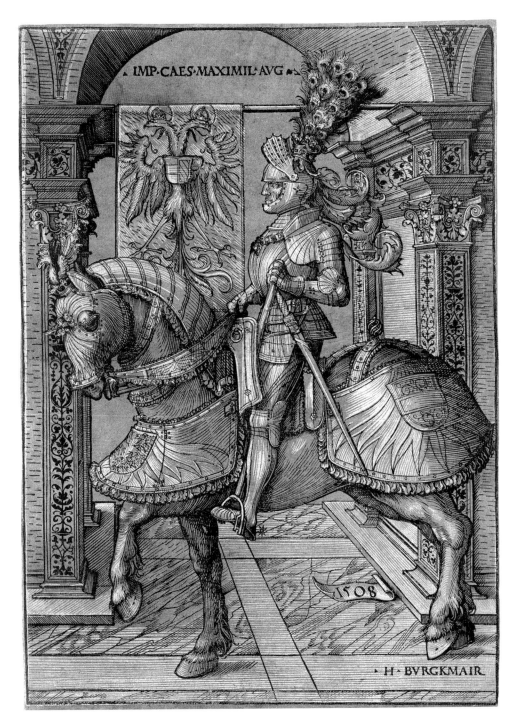

IMP·CAES·MAXIMIL·AVG

1508

·H·BVRGKMAIR·

35

Hans Burgkmair, *Emperor Maximilian on Horseback*, 1508,

woodcut on blue paper. © The Cleveland Museum of Art,

2000. John L. Severance Fund 1950.72.

this Italo-Byzantine feature forms the keystone of an ensemble that seems to recapitulate the ongoing history of the empire itself, translated from Romans to Greeks to Germans yet enduring and remaining powerful in its current guise.

Thus, the final construction of the *Arch* incorporates the full architectural heritage descended from the Roman Empire and mirrors its modern grandeur. If Maximilian is not renowned as a builder of actual buildings (see chapter 6), then he can at least be noted for this large fantasy hybrid creation on paper.[59] Significantly, at the very top of Dürer's central dome sits the Habsburg miter crown of the emperor, the item he chose to wear along with his regalia in his most formal individual portraits by his chosen portraitist, Bernhard Strigel (Vienna).[60]

This same kind of assimilation of modernity and antiquity is realized through the rows of emperors who proceed down from the attic of the *Arch* at the left, along what Stabius calls in his colophon the "Portal of Praise": "The historical scenes on the Portal of Praise are surrounded by the portraits of Emperors and Kings. These are selected from the catalog of all kings and emperors and represent those most deserving the honor. The Portal of Praise denotes, therefore, that the Emperor Maximilian, because of his virtues and his loyalty, has been elected to their company forever and will be counted among them for having earned honor and praise in equal measure."[61] Careful inspection of the row of emperors reveals that they run only as far as the advent of the Habsburgs, whose imperial ancestors are then represented on the central portals of the *Arch* in positions of greater prominence, because they continue the line of imperial succession but also bestow prestige on the family line as "famous relatives" (see chapter 2):

> On the capitals of the two great columns flanking the tower above the Portal of Praise, among other ornaments, are likenesses of considerable size representing Frederick III the Devout and Albrecht the Victorious. Together with Rudolph the Valiant and Albrecht the Fortunate, who appear on the capitals of the great columns of the Portal of Nobility, these are the emperors who are descended from the House of Austria and the line of Habsburg. Although they are pictured in the family tree, they also appear on these columns as they have particularly added to the glory of the House of Austria.[62]

In this respect, then, the *Arch* conforms to the pattern of the tomb program, where the emperors themselves appear as secondary figures, in the form of the bronze busts situated in the gallery above the main, full-size figures related to the House of Austria itself. This vision does not mean that the dynasty is favored over the empire in the *Arch*, for the figures who are highlighted are precisely at the points of overlap between dynasty and empire. If the emperors on the Portal of Praise are balanced by the Habsburgs' ruling kinship on the Portal of Nobility, opposite (see chapter 2), then it is in the very center, alongside the Portal of Honor and Might, where Habsburg emperors combine these ingredients of family blood and imperial election. Of course, these figures herald the destiny of Maximilian himself, whose *Arch* simultaneously celebrates his family glory and his imperial accomplishments. This general ambition of the *Arch* in connection

with the previous emperors is made explicit on the inscribed lion skin above the Portal of Praise, whose text by Stabius, cited above, continues:

> The Emperors as from above ordained,
> in many ways they well have reigned
>
> .
>
> Also in Maximilian's case,
> He's earned himself eternal praise,
> So many were his glorious deeds
> As of no other sovereign one reads
>
> .
>
> As he protected from all spite
> His lofty office with great might.[63]

This confluence of ancient customs with modern embodiments lies behind the entire program of the *Arch* and also serves to explain numerous details of ornament added by Dürer to provide antique visual vocabulary as a form of personal glorification. An example is the cluster of winged victories hovering over the portrait of Maximilian at the top of his family tree in the center of the *Arch*. These are personifications borrowed from ancient art, but they serve to praise Maximilian, just as angels hover around the form of the enthroned Christ as a sign of his holiness.[64] According to Stabius's text: "Above the Emperor will be seen the twenty-three Victories, who are winged ladies carrying laurel wreaths of honor. The laurel tree has been dedicated to victory since ancient times. Its leaves are used to crown conquerors because they never wither but stay green forever. Likewise an honorable victory or conquest should never fade or wither in the memory of succeeding generations."[65]

In similar fashion, the *Triumphal Procession* offers an elaborate conceit, borrowed from the descriptions of ancient imperial triumphs, but also brought up-to-date with contemporary renderings of Maximilian's own court retinue, modern soldiers, and even modern captives—all on parade. This triumphal pageant adheres more closely to its Roman heritage, because the re-creation of Roman triumphs had already been emulated in woodcut cycles (and canvas paintings) of the Italian Renaissance. The emphasis on military victory implied in the historical scenes of the *Arch* becomes explicit as the raison d'être of the *Procession*, as a series of floats commemorate Maximilian's series of battles (woodcuts 91–102). The dictated text recorded by Treitzsaurwein specifies: "Now a few *Landsknechte* shall carry some castles and towns in the ancient Roman style [*auf alt Römisch*]."[66] Then follows in the text a request for a float, never executed in woodcut, commemorating the "Roman Coronation" of Maximilian, together with the verses on a plaque:

> See His Imperial Majesty
> Chosen in election free

O'er Holy Roman realm to reign
And Germany's kingdom to maintain:
Maximilian of world renown
Wearing the imperial crown.

There was to have followed a "Roman woman," or personification of the city, dressed in imperial robes and wearing an imperial crown. Three "finely dressed people (in honorable clothing of old style)" were to come next, bearing three Roman crowns—of straw, of iron, and of gold. Then a similar phalanx of the German kingdom would have completed this allegorical procession, where "the Emperor shall sit like a Roman King [i.e., king of the Romans, emperor-elect, not yet crowned by the pope as emperor]," followed by the three houses of Austria, Bavaria, and Saxony and by the three archbishoprics of Magdeburg, Salzburg, and Bremen. Drawing up the rear would have come a second personification, "the German woman." After numerous other floats of wars and the trophy cars with weapons, armor, and banners that follow them, Maximilian intended to assert his imperial rank by presenting the treasures and the regalia of the Holy Roman Empire. Again, these woodcuts were never executed, but the text is clear, and some of these images were rendered in miniatures by the Altdorfer workshop: the imperial jewels (*Secular Treasure*), the *Sacred Treasure*, and the imperial sword, borne on horseback by the imperial marshal. Directly after the sword was to come the emperor's own triumphal chariot, the one designed by Dürer and eventually altered into an allegory for Maximilian with text by Pirckheimer.

In its broad outlines the *Triumphal Procession* of Maximilian conforms to the prototypes, known from literary descriptions, such as Appian (on Scipio) or Plutarch (on Aemilius Paulus), from ancient Rome.[67] Many of these ancient references were incorporated into the Italian Renaissance visions of Roman triumphs in both Flavio Biondo's *Roma Triumphans* (written 1457–59; printed in Mantua, 1472?) and Roberto Valturio's *De re militari* (1460; printed in Verona 1472).[68] Stabius's tribute to laurel in his colophon for the *Arch* makes clear how much he had absorbed of Roman customs, for the laurel was the sine qua non of a triumph and was invariably held as a branch by the victorious general or emperor in addition to forming the material of crowns. Moreover, the succession of images in the *Procession* corresponds to the texts of both Plutarch and Appian, as well as the generic outline of a typical Roman triumph: the first part of the parade was a display of spoils and booty, followed by a climactic *curris triumphalis* of the victorious emperor and his family and close staff, and it ended with the march of the victorious soldiers, often with captives (who could also appear in the first section with the display of booty). Indeed, the original triumphal chariot drawing by Dürer, showing the emperor in majesty along with his descendents (1512; Vienna, Albertina) specifically includes the obligatory laurel branch along with the arched imperial crown, robes, and scepter.

We shall see later (chapter 6) that Maximilian also took this occasion in his *Procession* to pay tribute to the splendor of his court officials—hunters, musicians, entertainers, jousters—who enriched his princely life. But he also centered the *Procession* on the display of his cumulative

military conquests, twelve floats with fantastic mechanisms and gears, derived from Valturio, on which were painted landscapes and towers of cities, sometimes with battle scenes, representing his victories in battle (nos. 91–104) as well as chariots of trophies: "Now a few *landsknechte* shall carry some castles and towns in the ancient Roman style."[69] Never executed, a float commemorating the election of Maximilian as emperor was then planned, prior to the appearance of the "Roman woman" mentioned earlier:

> See His Imperial Majesty
> Chosen in election free
> O'er Holy Roman realm to reign
> And Germany's kingdom to maintain:
> Maximilian of world renown
> Wearing the Imperial crown.[70]

A generic "warfare plaque" ends this first section, with a verse proclaiming: "In this triumph are shown the territories that His Imperial Majesty conquered by the sword; the towns, castles, fortifications, and manors are without number, and too many to be remembered by one person."[71]

After tribute to the territory of Lombardy (a continuation of the banners and territories of Austria and Burgundy earlier in the procession), the second or imperial segment of the *Procession* begins with the secular and sacred treasures, never illustrated in woodcut but pictured in the cycle of miniatures. Then follow the images of his ancestors, akin to the figures described at Roman funerals by Dio Cassius.[72] A cluster of prisoners "from all nations" is succeeded by men bearing figures of winged victories:

> The members of this captive band
> Are prisoners from every land
> Where Maximilian waged war—
> The battles were all shown before.
> Marching in this Triumph now,
> To his Imperial will they bow.[73]

Then the imperial heralds and trumpeters announce the advent of the imperial family, climaxing with Maximilian's own triumphal chariot. Although never executed, an entire suite of woodcuts was planned next to feature the princes, counts, barons, knights, and meritorious soldiers who would come directly in the train of the emperor.

The bulk of the army formed the third segment of the triumph, from arquebusiers through foot soldiers with lances and swords, ending with the *Wagenburg*, or mobile fortress:

> The worthy soldiers in every war
> With knightly spirit hunger for
> Fame everlasting and honors grand

Through the Emperor's counsel and command.
And so his praise is justly sung
By rich and poor and old and young.[74]

A second, distinctive cluster of captives brings up the rear. These are the *People of Calicut*, based on the voyage to India organized by Augsburg merchants out of Lisbon (1505–6) and recounted by Balthasar Springer (1508), with accompanying illustrations by Burgkmair (fig. 36).[75] Already Burgkmair's woodcuts of these black peoples had been conceived as a frieze, so these figures were easy to adapt to the context of the *Procession*:

The Emperor in his warlike pride,
Conquering nations far and wide,
Has brought beneath our Empire's yoke
The far-off Calicuttish folk.
Therefore we pledge him with our oath
Lasting obedience and troth.[76]

This segment truly offers the traditional sense of a Roman procession, celebrating the extension of the boundaries of the empire while exhibiting the exotic races of captured territories to the subjects at home.

One final, seemingly gratuitous modern intrusion ends the *Procession*: a *Baggage Train*, executed in six woodcuts by the Altdorfer workshop.[77] Here Maximilian pays credit to the troupe of suppliers who truly made the modern army "march on its stomach." Included in the images are the sutlers and "camp followers" who were an inevitable element in army life (satirized in the drawings of another soldier-artist, Urs Graf).[78] In this respect Maximilian shows himself to have been a soldier with considerable experience in the field, and his *Procession* celebrates the various armaments and divisions of his army in an up-to-date reworking of the Roman model, complete with artillery, halberdiers, arquebusiers, *Landsknechte*, *Wagenburg*, and baggage train (see also chapter 5).

To measure how modernized Maximilian's *Procession* has become requires only a comparison to its most famous predecessor, a cycle that could have been familiar to Maximilian through engraved copies if not through direct viewing of the canvas originals: Andrea Mantegna's *Triumph of Julius Caesar*.[79] This cycle of nine canvases was produced for the Gonzaga court at Mantua between the years 1486 and 1492. The Mantegna workshop engravings after this series offer numerous parallels to the woodcut *Procession* of Maximilian. They begin with trumpeters and picture-bearers, showing the towns and fortresses captured in battles, followed by soldiers bearing captured booty and trophies of arms. In similar fashion, Maximilian's *Procession* places at its center the Valturio-inspired floats with military campaigns and a large trophy wagon. Closer in form to the Mantegna model is the elephant of the Calicut woodcut, who replicates the animal in profile of the second Mantegna engraving, featuring sacrificial oxen and giant candelabras, and documents at least this much visual awareness of the Mantegna work as a precedent. Ahead of Mantegna's Caesar come

36

Hans Burgkmair, *People of Calicut*, from *Triumphal Procession*,
ca. 1516–18, woodcut.

captives, buffoons, and soldiers, as well as musicians and standard-bearers; these groups reappear in
the *Triumphal Procession* as well but in a form quite at odds with the antique manner advanced by
Mantegna in his canvases (among other things, these figures appear chiefly on floats in the Burgk-
mair woodcuts rather than on foot as in Mantegna). For the chariot of Caesar himself, Mantegna
created a horse-drawn, flat-topped vehicle, which differs considerably from the canopied inven-
tions of Dürer in both his 1512 Albertina drawing and his eventual 1522 woodcut, so it is doubtful
that this important image served as a model for the Maximilian emulation.[80]

Except for the specific borrowing of the elephant, however, Mantegna's cycle remained
chiefly important as a thematic source and a multiple image model of a procession in succes-
sive prints rather than as a visual model. The ambition to re-create an ancient procession was

taken up before Maximilian by another Italian printmaker, Jacob of Strasbourg, who produced a twelve-block woodcut series, issued in Venice in 1503, after Benedetto Bordon: the *Triumph of [Julius] Caesar.*[81] Bordon's woodcuts amplify the model of Mantegna but alter the arrangement of the triumph in accord with the texts of Appian, Plutarch, and others. These woodcuts introduce figures behind Caesar, both on foot and on horseback, akin to the German nobility and soldiers envisioned by Maximilian but never fully executed.[82] Another possible adoption of Bordon's imagery is the griffin that introduces Maximilian's *Procession*, even though the Venetian prototype is a unicorn, allegedly derived from the peculiar horse with toes, described by Suetonius (chapter 61) as belonging to Caesar.[83] Visually, the woodcut frieze by Bordon and Jacob of Strassburg offers a consistent precedent for Burgkmair and the other artists of Maximilian by presenting a connected ground line and an uncrowded file of figures.[84]

Clearly both the *Procession* and the *Arch* only loosely re-create the ancient triumph in formal terms. The German artists under Dürer and Burgkmair incorporated both textual and visual precedents into their woodcuts, but they never strove to appear classical, like Mantegna or Benedetto Bordon. On the contrary, Maximilian's programs explicitly go beyond the Roman contexts of his models to incorporate living figures, including his own courtiers, who are labeled in the programs and on many of the woodcuts themselves. (In the *Procession*, these names were prescribed but never cut.)

The other component of Maximilian's triumphs is their emulation of actual festival entries performed in the capitals of Europe during the Renaissance era.[85] Particularly in the Netherlands, rulers were received shortly after their accession, and in the ceremony, they regranted privileges to the cities in return for oaths of allegiance. Usually the pageants produced for the visiting rulers of these *joyeuse entrées* or *blijde inkomsten* consisted of a sequence of stations with temporary structures, on which were arrayed allegorical personifications and laudatory references to the virtues of the ruler and his family. Often the ancestry, both legendary and genealogical, of the ruler was celebrated. Eventually, these entries were accompanied by commemorative books, usually drafted by eminent scholars and often illustrated (the entry of Charles V into Bruges in 1515 and into Bologna in 1530 are early instances of what became a regular production).[86] Clearly the panegyric of the *Arch of Honor* must be considered to be one of the earliest instances of the combination of text and image in tribute to a sovereign. Its particular contribution was to emphasize the visual over the verbal and to provide such a high standard of virtuoso woodcut productions. Instead of commemorating an actual entry, however, the *Arch* creates its own ideal occasion, unrestricted by a particular time and place and hence better adaptable to distribution throughout the entire Holy Roman Empire. The use of antique models as a starting point was not initially a feature of the Flemish entries, but increasingly in Italy and in France the modern festive arrival of a prince was conceived to have been rendered *selon l'ancienne coustume des Romains*, as the reception of King Louis XII into Milan declared (1509).[87] The procession of the victorious or triumphant ruler himself was not always as large a feature of the entry pageantry, but increasingly the motif of a triumphal chariot after the model of the ancients came to dominate the Renaissance hybrid procession,

so Maximilian's *Procession* also infuses the customary state pageants of his day with antique references and customized details of his imperial rank and his individual or dynastic identity.

In particular, the "triumphs" of Maximilian seem to be reactions to a specific stimulus: the recent French royal entries. Scheller has surveyed the imperial claims and the royal iconography of the French kings Charles VIII and Louis XII, and in several cases he has uncovered a hostile dialogue between Maximilian and his French rivals (see also chapter 6).[88] Scheller points out the analogy between the procession of the monarch and his retinue and the religious processions of Corpus Christi; in similar fashion, Kantorowicz analyzed a correspondence between the Roman imperial *adventus*, a kind of generalized triumphal procession, and Christ's own entry to Jerusalem, reenacted in numerous medieval religious images and actual processions.[89] The important entry by Louis XII in 1498 underscored both the kingship title and the monarch himself through the procession and its decorative scaffolds (*echafauds*). This kind of political emphasis through combined procession and scaffolds shaped the same ambition for the paper triumphs of Maximilian less than two decades later. In the French example, many of the elements emulated by Stabius on the *Arch* already make their appearance on the scaffolds: a family tree highlighting famous ancestors (particularly Charles V), an emphasis on the personal devices of the ruler (reinforced in Stabius's colophon), and heraldic arms to claim territories. Of course, in the case of Maximilian's *Arch*, these personal claims are fused into a single image, based on Roman precedents, as befits the claim of the translated Roman Empire. Significantly, however, the *Procession*, while also drawing on the antique textual sources for elements of Roman pedigree, also stresses the presence of actual regalia, particularly the imperial sword and dress surrounding the person of the emperor. In similar fashion, Louis XII had already made his entry in armor but with a crown described as that "of an emperor." Scheller devotes considerable attention to the French awareness of distinctions in regalia, particularly for the unique double-arched crown, or *Bügelkrone*, of the empire, imitated by the French monarchs in their processions and images as part of their claim to imperial status.[90]

Indeed, although they were never produced as woodcuts, miniatures of the *Procession*, around which the entire progress turns, assert the same kinds of rank and status in their sequence (following imperial trumpeters and heralds to underscore their significance): imperial banner, imperial sword, and triumphal chariot of Maximilian and family (followed by the entire retinue of German princes, then counts, lords, and knights who support his power).[91] The banner-carrier, designated as Christoph Schenk in the dictated program, is particularly imposing in his gilded armor, as he supports a vast golden banner larger than both him and his horse. Then follows Maximilian, enthroned in ceremonial vestments with his scepter, *Bügelkrone*, and palm branch within a highly ornate chariot. The presence of his family certainly reinforces dynastic interests of the Habsburgs (chapter 2), but at the same time it assures imperial succession, for already the fortunes of both the Empire and the House of Austria were fused. This succession and fusion also form the core message of the *Arch of Honor*, where the central image on the ancient Roman form is the family tree that runs from Troy to Maximilian. Indeed, ever since the first Habsburg emperors, who appear away from the direct succession that begins with Julius Caesar, these

37

Ulrich Ursenthaler,
commemorative guildiner
coin of Maximilian I, obverse
and reverse, 1509, silver.

two heritages, imperial and dynastic, have become one. Hence, on the *Arch* at the top of this family tree, Maximilian sits enthroned with the same regalia—scepter, robes, and imperial crown—that he wears in the *Procession* (in place of the palm of victory, he holds the orb of dominion in his left hand).

Maximilian had begun to assert his imperial dignity in the form of replicable images several years before beginning the programs of the *Arch* and the *Procession* in earnest. Coinciding with his proclamation as emperor-elect in Trent (4 February 1508), Maximilian began to enlarge the mint he inherited from Sigmund of Tyrol in Hall and to issue coins and collectors' editions that proclaimed his office.[92] His mint master, Bernhard Behaim the Elder, who had worked at Hall since 1477 and been master there since 1482, supervised all of Maximilian's projects of coins and medals and delegated cutting of the dies to a team of carvers; his son, Behaim the Younger, continued in this position after his father's death in 1507, so many of the most important examples should be credited to him. The earliest gold guldiner coins minted in Hall show a half-length, armored figure of Maximilian in profile, sword in his right hand and orb in his left, wearing a king's crown. Dated 1495 and cut by Konrad Koch, this coin already identifies Maximilian as the heir to the title of emperor after the 1493 death of Frederick III with the inscription "MAXIMILIAN : ROMA: SEMPER : AUGUST : 1495."[93] Here, as in all of his artistic projects, Maximilian exercised meticulous supervision, and he returned proofs to the cutter Benedikt Burkhart in 1501 for revisions of his portrait likeness.[94] In later versions of this same guldiner by Burkhart, Maximilian wears the *Bügelkrone* and carries a lily scepter, with an inscription in careful antiqua script after the Roman model: "MAXIMILIANUS : DEI GRA : ROMANOR : REX : SP : AUGUST."

More spectacular, however, than the guldiner and half-guldiner coins in general circulation were the presentation coins, collectors' items known as *Schaumünze*. Chief among these is the so-called *Reiterguldiner*, a special issue equestrian coin struck to commemorate the Trent coronation in 1508 (fig. 37).[95] The large size of this coin and its splendid cutting by Burkhart's successor, Ulrich Ursentaler, make it the finest of Maximilian's minted products and an effective object of public relations when distributed. This kind of commemorative issue, although based on the model of a similar coin of 1486 by Sigmund of Tyrol, actually anticipates the later sixteenth-century practice of producing medals rather than coins in honor of exalted personages following the Italian Renaissance custom of medals invented after the antique by Pisanello.[96]

Documents record that such special coins were dispatched with ambassadors for distribution, and one ambassador, Hieronymus Cassola, reported in 1508 that princes and noblemen eagerly requested such coins from him.[97] Prior to 1508, presentation coins resembled the guldiners in having a half-length portrait likeness with armor and crown on the obverse (1504–5), based on a painted model by Maximilian's court portraitist, Bernhard Strigel of Memmingen (see below).[98] In 1507–8, a smaller special issue coin appeared in half-guldiner size. Created by Ursentaler, it already bears the imperial title ("MAXIMILIANUS : ROMANORUM : IMPERATOR : SEMPER : AUGUSTUS : ARCHIDUX : AUSTRIE") and features the imperial crown on a half-length, profile, armored figure of the emperor. On the reverse, rather than the usual cluster of coats of arms of territories around the imperial arms, a knight in armor with an upraised sword rushes on horseback above the arms of Maximilian's lands (with the inscription "PLURIUMQ : EUROPE : PROVINCIARUM : REX : ET : PRIN-CEPS : POTENTISSIMUS").[99] As if in fulfillment of this imagery, the great *Reiterguldiner* of 1508–9 by Ursentaler presents a majestic prancing equestrian figure of Maximilian in profile.[100] Dressed in armor but wearing his imperial crown, the emperor bears an imperial banner in his right hand, like the figure in the Altdorfer *Procession* miniature a few years later. The inscription is the same Roman-based imperial title as the 1507–8 coin by Ursentaler except for the addition of "DEI : GRA," but the large size allowed for the personal motto of Maximilian to be inscribed along the saddle armor of his horse ("Halt. Mas. in. al. n. ding"). This coin was forwarded along with ambassador Lucca de Rainaldis in December 1508 to Maximilian's foes in Venice, and a gold coin was given to the doge while silver coins were presented to each of the members of the Signoria.[101] Thus, in a more treasured material, these coins served the same role as the larger woodcut cycles of the "triumphs" of the next decade: they proclaimed the rank and title of Maximilian and as-serted his claims to kingdoms and territories. Moreover, they served directly to commemorate the event of his proclamation as emperor-elect in Trent in 1508 and acted as an expensive form of publicity, which documents inform us was often communicated through diplomatic channels.

Maximilian also patronized an equivalent distribution of his portrait likeness as emperor in the form of paintings dating from precisely this period of the commemorative coins, that is, around the coronation year, 1508. The earliest painted portraits of Maximilian by Bernhard Stri-gel are difficult to pinpoint in terms of date, but the occasion of the Diet of Constance in the summer of 1507, has often been taken as a likely occasion for contact between artist and impe-rial patron.[102] Otto also hypothesizes an earlier contact, when Maximilian and a large entourage, including his new bride, Bianca Maria Sforza, passed through Strigel's native Memmingen in 1494.[103] An early portrait on parchment support, now mounted on wood (Berlin, Deutsches Historisches Museum), describes the emperor as age forty (i.e., the year 1499), if its damaged in-scription is reliable.[104] A posed, formal portrait in half-length (but three-quarters pose rather than profile) like the coins, it emphasizes most of the same imperial elements as the coins: a scepter in the right hand, the hilt of a sword in the left hand, gilded armor underneath a jewel-trimmed mantle, and finally an imperial crown with an arch (or juncture of two arches) surmounted by a cross. This same portrait—pose, costume, attributes, and eccentric crown—survives in numerous

other replicas (1507; formerly Strasbourg; also Vienna).[105] The Strasbourg picture was painted in the same year as the Constantine altarpiece with its included profile portrait of Maximilian, but its entire purpose is to awe. The gilded armor and ornate crown are effectively set off against an elaborate brocade with formal inscription (replaced in other replicas of the portrait with window views). That inscription also aids us in reconstructing the purpose of this picture, which was given as a gift and souvenir of thanks by the emperor to the Johannite cloister in Grünen Wörd in Strasbourg after his sojourn there in spring of 1507. This gift was sent from Constance during the period of the Diet, when Strigel surely had the occasion to paint the emperor. (No surviving portrait by Strigel of this type is accepted as an unqualified "original.") As the Schäfer and Strasbourg pictures confirm, however, such paintings were no less replicable than portraits on coins, despite the more intensive labor needed for their reproduction. Inscriptions were important to each image; moreover, they complemented the purpose of such works, equally suitable as formal gifts of either thanks or diplomacy. Emphasis on imperial regalia in these portraits overlaps with the personal desire to have his own features recorded. In combination, this is Maximilian as emperor.

Similar ambitions informed a slightly later special issue coin of 1514 by Ursentaler, where Maximilian deliberately concentrated on the portrait likeness of his features more than on the regalia of his office.[106] The obverse presents a strict profile portrait, this time at bust-length in order to devote more detail to the features; the armor and imperial crown are retained (the crown resembles that of the Strigel portraits in its ornate floral ornament and its seemingly single arch, surmounted by a cross). The reverse features a triumphant warrior knight on horseback subduing a foe above a field with coats of arms of territories, so here the motif of equestrian triumph, already featured in the prancing 1508 *Reiterguldiner* as well as the 1507 reverse with a knight wielding a sword on horseback, is accentuated in the form of a battle conquest. If the obverse portrait closely approximates a commemorative medal, then the reverse now recalls military victory. Together, these elements condense the essentials of the two woodcut *Triumphs* into another replicable, if more portable, monument that is at once imperial and triumphant, personal and idealized.

The equestrian prototype of imperial dignity had its own important place among the artistic projects of Maximilian. Just before the production of the *Schaumünze* with Maximilian in armor on horseback, Burgkmair had created a woodcut of the emperor, mounted in front of an accurately rendered triumphal arch (see fig. 35, above).[107] Coinciding with the year of Maximilian's proclamation as emperor-elect at Trent in 1508, this woodcut was conceived by Peutinger rather than by Maximilian himself and emulated a similar mounted woodcut, *St. George on Horseback*, by Lucas Cranach, ca. 1507. Cranach's woodcut had incorporated a new technique of printing visual images with overlays of gold and silver, and Peutinger was eager to take advantage of Burgkmair's training in color printing under the innovative Augsburg printer, Erhard Ratdolt.[108] The result of this experiment by Burgkmair was a woodcut image with the associated luxury of expensive materials, including not only the added gold or silver, preserved on impressions in Chicago, Oxford, and Berlin, but also the richness of printing on parchmentlike illuminated manuscripts rather

than on paper like most woodcuts.[109] In the examples of Oxford and Cleveland, pictorial experimentation is extended to the printing of the images on toned papers (vermilion and aquamarine, respectively).[110] Thus, like the commemorative coin *Schaumünze*, this woodcut by Burgkmair was consciously designed as a collector's item as well as a form of publicity for Maximilian in commemoration of his new status as emperor-elect.

The imperial iconography of the Burgkmair woodcut is quite orthodox and Roman.[111] In addition to the carefully rendered arch of triumph, the inscription in Roman block letters proclaims the imperial identity of the rider: "IMP . CAES . MAXIMIL . AUG." The double-headed eagle of the empire also adorns a banner hanging from the arch behind the emperor.[112] Both inscription and banner also appeared in the commemorative coin of the same year. In brief, this woodcut is a condensed image of a triumph, incorporating the strongly Roman flavor that Maximilian would have demanded from the pope had he been allowed to receive his official coronation in Rome itself rather than in provincial Trent. The equestrian presentation, however, departs from the ancient tradition of returning conquerors in triumphal chariots, re-created in Maximilian's own *Procession*. Instead, it presents an alternative form of imperial entry, also sanctioned by ancient Roman practice and more closely analogous to the Renaissance custom of ceremonial royal entries of princes into their realms: the *adventus* tradition, entry of the emperor on horseback.[113] Later imperial coins had already featured such an image of the emperor's advent in armor on horseback, and Burgkmair has simply modernized the armor worn by Maximilian to accord with the artist's own familiarity with contemporary armor design in Augsburg as well as Maximilian's own profound attention to armor (see chapter 6).[114] An *adventus* signaled the dawn of a new era. Thus, it was a perfect choice of imagery for the inauguration of Maximilian's new dignity as emperor-elect, in all likelihood the product of Peutinger's knowledge of Roman custom and visual traditions on coins (including the Latin letters).

Burgkmair went on to design yet another equestrian image of Maximilian: a highly finished drawing (Vienna, Albertina; fig. 38) intended to be the final design for a stone monument.[115] Planned to be housed in the Augsburg church of Saints Ulrich and Afra, for which Maximilian had already laid the cornerstone during the Diet at Augsburg in 1500, this stone monument would have realized in three dimensions the equestrian image of the 1508 woodcut. Peutinger also stands behind this Augsburg project in his capacity as the composer of the Latin epitaph: "*Imp. Cae. Maximilianus Aug. Chori huius primum a fundamentis lapidem posuit ex aedificatione quae eius solitar liberalitate invit. Ann. M. C. III. kl's Julius.*"[116] The exact location of this proposed monument cannot be determined today, as the statue based on this design was never completed; however, a midsixteenth-century account adduced by Habich speaks of a "*freie Platz*" in front of the St. Ulrich choir and calls the rider monument an "*epitaphium*."[117] The large stone block for the monument was already in Augsburg by 20 October 1509, so the project and even the Vienna drawing—or a preliminary version of it—had been begun by then.[118] The sculptor of this massive stone monument was "maister Gregori," that is, Gregor Erhart, who is also credited with casting a number of small bronze horses related to this larger project.[119] Habich advanced a hypothesis,

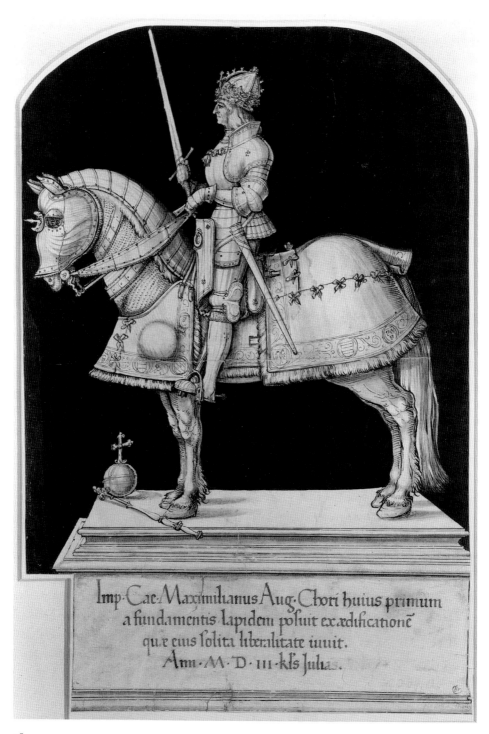

Imp·Cæ·Maximilianus Aug·Chori huius primum
a fundamentis lapidem posuit exædificationē
quæ eius solita liberalitate inuit.
Ann·M·D·III·kls Julias.

38

Hans Burgkmair, *Design for Equestrian Monument of Maximilian I,*
ca. 1509, ink on parchment. Vienna, Albertina.

tantalizingly similar to the overlay of gold on the Burgkmair woodcut in Chicago, that the imperial regalia of Gregor Erhart's monument could not have been carved in stone and therefore would have been cast in bronze.[120] Unfortunately, the untimely death in 1510 of Conrad Mörlin, the local abbot who had supported the project, halted this equestrian monument project.

Examination of the Burgkmair project drawing in Vienna reveals a more static and stable image of the rider than his 1508 woodcut, but this quality follows from the limitations imposed by a stone block. In particular, Maximilian's horse now stands firmly and fully on all four legs instead of lifting the left foreleg, as in the woodcut. Thus, the important suggestion of movement in procession, implying the advent of the ruler, is absent from the sculpture. On the other hand, the sculpture does feature imperial regalia to emphasize the majesty and rank of the equestrian emperor. In Burgkmair's drawing, Maximilian wears in place of the helmet and visor of an armed knight the same Habsburg imperial miter crown as in Strigel's most formal portraits (see above) and as the crown atop the *Arch of Honor*. Scepter and orb appear at the feet of the emperor's horse, while Maximilian holds a mighty, presumably ceremonial sword in his hand.[121]

Two important precedents of imperial riders in Germany underlie Maximilian's Augsburg equestrian monument. The first of these, the *Magdeburg Rider*, is a public statue now in the city marketplace of the former capital—the new Rome—of Emperor Otto the Great, the most important early Germanic emperor north of the Alps after Charlemagne.[122] In Maximilian's day this monument was clearly identified as Otto I, according to documents. Von Einem quotes a late fourteenth-century source, the *Sächsischen Weichbildrecht* (1386–87), alleging that the monument "is a common confirmation of all their freedoms, which this Emperor Otto the Red has done." Chronicles from 1492 and the early sixteenth century both call the emperor of the monument Otto I, and a woodcut accompanying the *Chronika der Sachsen und Niedersachsen* (Wittenberg, 1588) not only shows the *Magdeburg Rider* under its contemporary Gothic baldachin but also transmits its Latin inscription: "*Divo Ottoni I. imperatori invictissimo vindici / libertatis patri patriae senatus populusque / Magdeburgensis posuit 973.*"[123] In terms of formal overlaps, the stone material and stable pose of the horse parallel the later Augsburg equestrian monument. We also know that Charlemagne, too, associated himself with an equestrian statue, in this case the monument that Theoderic had erected before his own palace in Ravenna.[124] Charlemagne's transfer of this rider figure for his own palace in Aachen served as a symbol of his larger notion of the *translatio imperii* (see above).[125] Aachen was thereby denoted as the new Rome, akin to the imperial city of Augustus and Constantine. Rome had its own rider figure, then believed to be Constantine: the massive bronze, then located before the Lateran Palace (today on the Capitoline Hill and identified as Marcus Aurelius).[126]

The other venerable German equestrian monument is the *Bamberg Rider*, a work that appears in a church space, like the Augsburg equestrian monument, but one that has no definite identification with a specific emperor. Nonetheless, there are several reasons to connect the *Bamberg Rider* with Constantine.[127] In any case, even if the Bamberg figure is not an emperor at all, his crowned head, motionless horse, and location within a church share features with the Augsburg equestrian monument and suggest a model pious ruler figure.

We already know that Maximilian maintained serious interest in his own ancestors (chapter 2), particularly his predecessors as emperor. Documents record that he paid one of his court artists, Hans Knoderer, to leave Augsburg and copy on canvas the stone grave monument in Speyer Cathedral of Rudolf I (see fig. 26).[128] Although we cannot prove that Maximilian directly modeled his Augsburg equestrian monument on either Magdeburg or Bamberg precedents, we can thus at least be sure that he was conscious of certain illustrious monuments of his imperial predecessors in Germany.

To that number, Maximilian also proposed to add his own stone monument in Speyer Cathedral. He commissioned a large, red marble ensemble from the aging Salzburg sculptor Hans Valkenauer (1514–19) that would have comprised a round temple on twelve octagonal pillars with the whole surmounted by a giant crown.[129] Like most Maximilianic sculptural monuments, this great work was never completed (remains in Salzburg, Museum Carolino Augusteum). What is especially striking about this monument in the context of imperial projects of Maximilian is that the subjects of this monument were the medieval German emperors and empresses, each of them depicted as a statue on the columns of the monument: Conrad II, Henry III, Henry IV, Henry V, Philip of Swabia, Rudolf of Habsburg, Adolf of Nassau, Albrecht I of Habsburg, and Gisela, Berta, Beatrix, and Agnes. Of course, one of the principal purposes of this selected group consists of glorification of the Habsburg ancestors who were elected emperor, whose precedent confers both luster and legitimacy to Maximilian as their successor (see chapter 2). These were the same ancestors singled out for separate attention on the *Arch of Honor* in the form of separate sculptures of their own: Rudolph the Valiant and Albrecht the Fortunate, as they are called by Stabius.

The other rulers, however, cluster as the Germanic emperors who are buried in Speyer Cathedral. These emperors began the latter era of a new imperial line, the Salic, after the death of the Saxon Henry II, and their successors, the Hohenstaufen and the Habsburgs, also were interred at Speyer.[130] Their elected succession to imperial office was essential for the later Habsburg ascendancy, and they are the emperors near the end of the row of emperors at the base of the *Arch* (the last figure is Lewis of Bavaria). Moreover, among these emperors the figure of Henry IV is celebrated for his defense of imperial prerogatives against papal domination during the Investiture Conflict in the late eleventh century; for Maximilian's own struggles with the papacy, this assertion by German emperors of their rights and privileges could have served as an important precedent.[131] That the imperial office itself is being celebrated by the Speyer monument is clear from the imperial crown (*kaiserliche cron*) designed to surmount the entire ensemble, according to the 1514 contract with Valkenauer.[132] A further letter by Maximilian to Bishop Georg von Speyer speaks of wishing to celebrate (*zieren*) "*unser vorfaren am reich Romische kaiser, kunig und kaiserin.*" The figures of the emperors wear miter crowns and ceremonial robes; one of them carries an orb, and several likely would have held scepters, but these have been lost. So the figures would have upheld the imperial majesty and dignity by decorous example, even as they collectively were to support the crown that they held in common.

The Speyer monument to the German emperors was under way at precisely the same time as the *Arch of Honor*, and the juxtaposition of these two projects reveals complementary elements of Maximilian's imperial ideology. In both works the medieval links between Roman past and German present are underscored, and for both the crown of the imperial office caps the entire enterprise. If the *Arch* elaborates the personal history of Maximilian and adopts many of the precedents of ancient triumphs, it nonetheless fosters the sense of the importance of the imperial office as the "honor and might" to which Maximilian has been selected as the latest of a long line of emperors, aligned along the Portal of Praise. Thus, the imperial dignity has come to reside in Germany, as the Speyer monument also demonstrates. With the translation of empire, initiated by Charlemagne, the political entity truly exemplifies its title of Holy Roman Empire of the German Nation.

Just as Frederick I Barbarossa had pressed for the canonization of Charlemagne as a saint (1165) and had massively endowed Charlemagne's capital center at Aachen, so did Maximilian honor his imperial predecessors at Speyer.[133] Indeed, Barbarossa's donation of the massive chandelier for the Aachen minster offers a precedent for Maximilian's stone monument for the German emperors at Speyer.[134] The octagonal shape and the towers attached to this chandelier announce it as the image of the heavenly Jerusalem, and Frederick's inscription makes this comparison explicit. If the German emperors at Speyer were not fully canonized saints, after the example of Charlemagne (or even Emperor Henry II), nonetheless the numerical symbolism of twelve supports for the marble crown in the church setting suggests the same kind of mystical union of "living stones" (*lapides vivi*), evocative of the spiritual majesty of the German imperial office.[135]

Maximilian's evocation of his imperial office and of the specifically German character of that office shows up most vividly in the "propaganda" that he issued during his reign.[136] His numerous calls for crusades and for defense of the empire derive from a profound sense of the need for active assertion of his imperial office against the foes of Christendom, that is, Turks but also Frenchmen. Through the valor of the Germans, the legacy of the Greeks and the Romans had come northward, and it was the duty of Maximilian to display the same valor, virtue, and strength of character in the modern world in order to assure the continuity of the empire in the German world and its role as the protector of all Christendom: "[because] our forefathers, the Germans, performed upright virtuous deeds and acts diligently and particularly such manly, comforting, and hardy on account of our holy Christian faith, for the sake of which they spilled . . . their blood.[137]

Thus did the modern role of the German nation become an essential part of the concept of empire at the time of Maximilian (see chapter 7). Jakob Wimpheling's treatise *Germania* (1501) argues forcefully for the "German-ness" of Charlemagne, and the same author praises the prior examples of Emperors Frederick I and II for the modern era.[138] The ambition of Wimpheling was to use history to justify present, nationalist concerns and to exhort modern Germans under the banner of the emperor to defend themselves against the Turks, the French, and even the decadent Italians of modern Rome. In similar fashion, Conrad Celtis promoted the cultivation of

modern learning and intellectual vigor in Germany as a form of local cultural valor akin to the political valor advocated by Wimpheling.[139]

Consequently, the "German Nation" component of the modern Holy Roman Empire loomed large in the intellectual circles who so admired the younger Maximilian. In this respect, his universal aspirations did not conflict with, but rather reinforced, the nationalist dreams of contemporary German humanist writers. Thus could the Germanic character of the empire form the wellspring of its valor on behalf of all Christendom, and thus could the modern Habsburg ruler truly be the heir to the greatness of Roman as well as German predecessors. From such ambitions grew the designs for both the Speyer monument and the *Arch of Honor*.

In Maximilian's tomb, the genetic strands of Habsburg family saints are balanced by the elective succession of Roman emperors. Both in miniature and in the life-size ancestor figures who constitute the mass of the ensemble we find the blending of imperial and family roots of Maximilian himself. Included in the original plan, even if not executed, were both Charlemagne and Julius Caesar, along with the completed figure of the Ostrogoth usurper Theoderic.[140] The prime figures of the translation of empire, who figured in the eventual delivery of his office to Emperor Maximilian, thereby found their respective places alongside his personal tomb. In addition, each of these important figures holds his place in the succession of emperors that runs the vertical length of the *Arch*.

We can surmise that it is this mixture of the Roman with the German, of the universal with the national, of the traditional with the modern that colored the visual forms devised for the glory of Maximilian as emperor. The accurate rendition of an actual, Roman triumphal arch as produced by Burgkmair in his 1508 woodcut simply was not sufficient for this overlap of layers of meaning. Thus, when Dürer developed his forms for the *Arch of Honor*, that ultimate imperial monument of broad, public ambition absorbed additional models and references, including the Byzantine domes of San Marco in Venice and the proud palace tower of the Innsbruck Armorial Tower (Wappenturm). Like its subject, Maximilian, the *Arch* proclaims itself to be a blend of traditions, fully assimilated and blended into the exalted person of the reigning emperor and fully consonant with the rich and diverse heritage of the Holy Roman Empire of the German Nation.

All these and many other great feats are, were, and will be the works of fame, which mortals desire as a reward and as part of the immortality which their famous deeds deserve, though we as Christians, Catholics, and knights errant must care more for future glory, eternal in the ethereal and celestial spheres, than for the vanity of the fame achieved in this present and transitory world . . . God brings his children to heaven by many paths: chivalry is a religion, and there are sainted knights in glory.

—CERVANTES, *Don Quixote*

4 | *Caesar Divus*: Leader of Christendom

The posthumous commemorative woodcut (1519, B. 154; fig. 39) of Maximilian that Dürer produced, based on a study from life taken at the Augsburg Diet on 28 June 1518 (W. 567; see fig. 83, below), bears the following inscription: "Imperator Caesar Divus Maximilianus / Pius Felix Augustus."[1] Of course, all of these terms have a history steeped in ancient Roman usage; in particular, the word "*divus*" referred to the cult of deceased emperors, believed to become deities after their deaths and subsequent apotheoses.[2] The term had already become a staple as an honorific title for emperors by the time of Suetonius's *Life of the Caesars*, a book well known to the humanist advisers of Maximilian.[3] In similar fashion, the appellation "Pius" was appended to the name of the second-century emperor, Antoninus Pius, and Vergil celebrates "Pius Aeneas." Konrad Peutinger's project of gathering up for Maximilian all of the historical biographies of earlier emperors (see chapter 3) surely contributed to his knowledge of such terms and their meanings within ancient Roman inscriptions.[4] All of these descriptive terms denote piety and sense of duty, especially toward religious matters, as well as personal good fortune and holiness, when spoken of the dead. They were used in another learned epitaph from out of the circle of Peutinger, the commemorative stone epitaphs for Maximilian and his heirs in the Dominican Church in Augsburg, church of the Dominican adviser of the emperor, Johann Faber, where Maximilian is also termed "*aug pio felici*."[5]

What these terms suggest, beyond the erudition in antique texts and inscriptions of Maximilian's advisers, is that the emperor felt particularly conscious of the religious burdens and responsibilities of his office as well as the unique personal sanctification conferred by it. He manifested his concern for spiritual leadership in various ways, dominated by his ongoing desire to mount

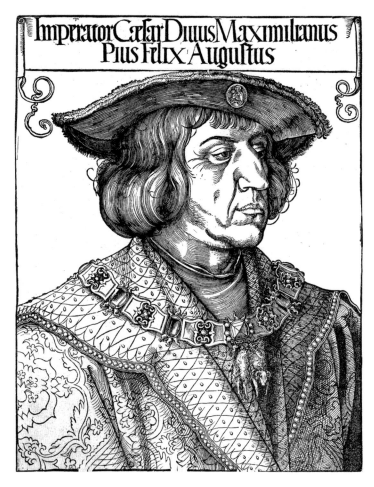

39

Albrecht Dürer, *Portrait of Maximilian I*, 1519, woodcut.

© Board of Trustees, National Gallery of Art, Washington.

a modern crusade against the Ottoman Turks and to recapture Jerusalem for the Christian faith. Related to that concern was his patronage and support of the Order of Saint George, a saint long associated with the crusades as well as an order founded by Maximilian's father, Frederick III. In addition to these ambitious activities, which gave rise to art commissions as well as "propaganda" broadsheets, Maximilian also sponsored individual religious artifacts as pious donations.

Yet there was another side to the spirituality of the emperor, in which he saw himself not just as a leader of the Christian faith, but rather as a sanctified, even saintly, individual, eminently qualified to consider taking vows and standing for papal election (1511) and worthy of canonization after the example of his beatified Habsburg ancestors (see chapter 2). In this vein, Maximilian wished to have himself buried under the altar of a church, and his autobiographical materials often make explicit textual and visual comparisons of Maximilian to Christ. Thus, the epithet of "*divus*"

for the deceased emperor was surely more than just a topical antique reference, and that Christo-mimetic aspect of Maximilian needs to be examined against his personal interest in his birth, his horoscope, and the heavenly signals during his reign in the form of comets and other portents that implied divine direction of his empire.

Many of the responsibilities of the leader of Christendom follow from his initial concept of the Holy Roman Empire (see chapter 3). In this case, the surviving world empire, inherited from Rome and "translated" to northern Europe through the coronation of Charlemagne by the pope in Rome in the year 800, is fused with the notion of Christendom. As Otto von Freising outlined in his midtwelfth-century universal history (*Chronica*), a work in the library of Peutinger, the two cities of Augustine, earthly as well as heavenly Jerusalem, were now fused in the final world empire prophesied by the Book of Daniel.[6] The administration of the Holy Roman Empire was divided between the pope and the emperor; of course, the question of supremacy between them was always hotly contested, no less so during the lifetime of Maximilian, especially by the aggressive Pope Julius II.[7]

The moderate, German-based doctrine of separate realms and equal powers can be

40

Hans Burgkmair, title page of Johann Stamler, *Dialogue*, 1508, woodcut.

found visualized in the frontispiece by Burgkmair to Johann Stamler's Augsburg publication, *Dialogus de diversarum gencium sectis et mundi religionibus* (1508; fig. 40).[8] This book on world religions, written by another member of the Augsburg humanist circle around Peutinger, shows "Sancta Mater Ecclesia" enthroned at the top between banners with the papal keys and the double-headed imperial eagle, under which kneel the pope, in his tiara receiving his keys, and the emperor, in his miter crown receiving his sword. As in the 1506 panel by Dürer in Venice, the *Festival of the Rose Garlands* (Prague), the pope receives the privileged position of the dexter side of the Madonna/Church, while the emperor is subordinated slightly by being placed on the

sinister side.[9] Their roles are spelled out on the frontispiece as "*ora et cura*" (prayer and care) for the pope, "*protégé impera*" (protect the empire) for the emperor. Significant within the Burgkmair imagery is the self-conscious superiority claimed by the Christian faith over heretical creeds, depicted with broken lances and sorrowful personifications on steps below the allegory of Mother Church: Sinagoga, in traditional medieval blindfold for the Jews, and Saracena, with a banner of "Machometus" for Islam, at one side, with pagan religion ("Gentilitas" with the banner of Jupiter) and Asian faiths ("Tartarica" with the banner of "Chingista") opposite. Thus, the picture spells out a potential need for imperial defense of the creed and lands of Christendom against the threat of the Turks. Falk adduces a letter by Peutinger with much the same sentiment, "Christus Iesus duos gladios esse voluit" (Christ Jesus wanted to wield two swords), that is, a crusade calls for the unification of the two powers ("swords") of the faith in order to defend it against attack.[10]

Peutinger also commissioned Burgkmair to produce the multicolor woodcuts, *Emperor Maximilian on Horseback* (see fig. 35) and its pendant, *St. George on Horseback* (fig. 41), in the same year as the frontispiece to Stamler's treatise.[11] Of course, the other vital importance of the year 1508 is the coronation of Maximilian as emperor-elect at Trent (4 February).[12] Later that same year (December 1508) he concluded the League of Cambrai with the pope and the kings of France and Aragon toward the purpose of mounting a crusade against the Turks (and Venice, who had hindered Maximilian's official coronation in Rome).[13] Taken together, these elements—the pride in a new imperial title plus the renewed call for a crusade—inform both Burgkmair woodcuts and dictated the choice of St. George as a pendant to the equestrian portrait.

The armor in the equestrian portrait is a "*kuriss*," the kind of armor used in both tournaments and in the field of battle (see chapters 5 and 6), and it was modeled on a multicolored woodcut of an equestrian *St. George* by Lucas Cranach (ca. 1507, Dresden, and London, British Museum).[14] Thus, the implied use of this armor was in military conquest, and the background triumphal arch (here in the canonical Roman architectural form rather than the later hybrid of Dürer for the 1515 *Arch of Honor*) behind the seated riding emperor confirms his identity as the victorious *imperator*. So does the inscription: "IMP . CASE . MAXIMIL . AUG." (see fig. 35).

The military significance of the *St. George* woodcut is just as explicit. The formal model of the victorious, armored saint is in fact the bronze equestrian portrait of a victorious Italian military figure, the Venetian *condottiere* portrayed by Andrea del Verrocchio: *Colleoni* (ca. 1479–88, Campo Ss. Giovanni e Paolo).[15] Burgkmair has closely adapted the dynamism of the Verrocchio rider, who stares downward from his perch and thrusts his baton forward in his right hand; in the woodcut the baton has become a broken lance, held in a powerful grip like a sword. In addition, the assertive diagonal of the saint further suggests his martial vigor. The remainder of the lance lies imbedded in the slain dragon at his feet, like the dragon underneath the horse in Cranach's woodcut, and his victory is confirmed by the inscription: "DIVUS GEORGIUS CHRISTIANORUM MILITUM PROPUGNATOR" (Saint George, Vanguard of the Army of Christians). Of course, both the crest of his helmet and his horse's padded protection are decorated with the red cross of St. George, but his self-sacrifice in the service of the faith is further emphasized by the presence of a symbolic

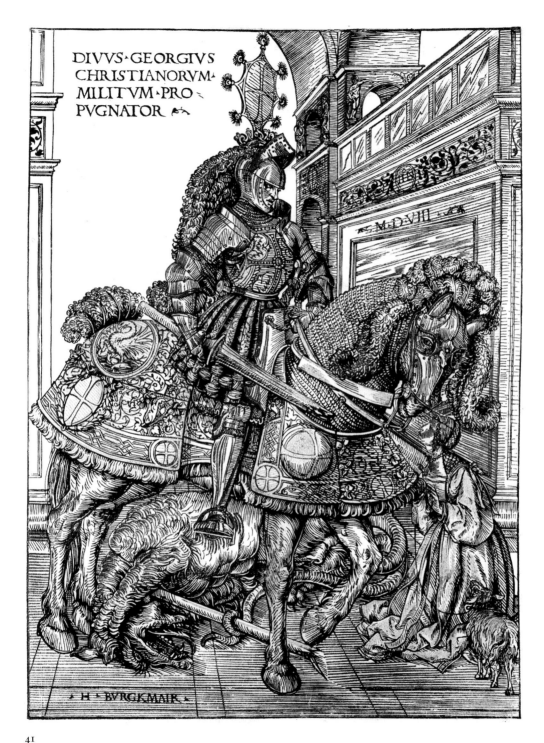

DIVVS·GEORGIVS
CHRISTIANORVM·
MILITVM·PRO·
PVGNATOR

·M·D·VIII·

· H · BVRGKMAIR ·

41

Hans Burgkmair, *St. George on Horseback*, 1508, woodcut.

Photo: Bildarchiv Preussischer Kulturbesitz/Art Resource, NY.

pelican, the bird in medieval bestiaries who, Christ-like, sheds her own blood in order to nourish her young. The religious significance of the saint's heroism is also attested by the IHS monogram of Christ (Jesus Humanorum Salvator) on the triumphal arch above.

St. George was the primary patron saint of knights ever since the first crusades on account of both his noble ancestry and his military prowess.[16] The legend of the dragon also seems to have been the product of crusaders, for it cannot be traced to an earlier period, and it perfectly embodies the contrast of absolute battle between good and evil.[17] As a result of this association with knightly victory, St. George came to be the royal patron of knightly orders, chiefly the early foundation of the Order of the Garter in England under Edward III in 1348. (George has remained ever since the patron saint of England, even during the purges of other religious figures as patrons during the Elizabethan era).[18] George was also adopted as the personal patron of Maximilian's father-in-law, Charles the Rash of Burgundy, and was featured with the kneeling duke in a splendid gold reliquary, donated to the Cathedral of St. Lambert, Liège (1468–71).[19]

For Maximilian, the cult of St. George had additional personal meaning. His father, Emperor Frederick III, had founded a knightly order of St. George in 1467, which was confirmed by Pope Pius II during his winter stay in Rome in 1468–69.[20] This order had a charge to struggle against the steady encroachment of the Turks, who made their first inroads on Habsburg lands against Krain in 1469 and then Styria and Carinthia in 1473 and 1475. The ongoing concern for the Turkish menace was transmitted along with this legacy of the Order of St. George to the young Maximilian by his father. After 1479, the site of this order was Wiener Neustadt, the palace center of Frederick III; its high master, Hans Siebenhirter (1468–1508) served well into the reign of Maximilian. On the palace facade of the St. George Church at Wiener Neustadt, Frederick III placed the cluster of heraldic arms of his territories and claims (1453; see chapter 6).[21] After the death of his father, Maximilian renewed and expanded the Order of St. George into a lay brotherhood, then sanctioned by Pope Alexander VI.[22] For Maximilian, this order was not just a defensive reaction to the Turks at his doorstep, in the manner of his father, but rather an organization dedicated to active crusade activity, as well as to chivalric allegiance under the leadership of the ruler, after the Burgundian model of the Order of the Golden Fleece, founded by Philip the Good in 1430.[23] In that order, the ruling duke was the master and sovereign of the order, and the restricted membership of nobles was the only group allowed to wear the prestigious collar of the order, a mainstay on Maximilian's monuments (e.g., the *Arch*) and portraits, just as he used the emblems of the order, the flints and cross of St. Andrew, as his battle ensign.

In essence, these fraternal orders of knights offered a secular counterpoint to the monastic brotherhoods of the clergy, within the "three orders" concept of the world as divided into clergy, knighthood, and others.[24] Their bond was a serious confirmation of chivalric values as well as a balance to the religious vows of the praying order, just as the Burgkmair woodcut pictured pope and emperor in balance alongside Mother Church. Their earlier medieval models were the Knights of St. John and the Templars. Of course, the orders also had the political function of continuing feudal traditions of fealty to a sovereign into the modern, royal state, and Maximilian would surely have

appreciated the consolidating value of the Order of St. George. We shall see (below) his serious, ongoing patronage on behalf of the order and its patron saint. But his testimonial on its behalf is already an essential part of the left outer tower of the *Arch*, where a pair of woodcuts by Albrecht Altdorfer celebrates the order as well as the organization of a crusade by Maximilian. In the first of these images a central, enthroned, crowned Maximilian bestows a church model to a quartet of kneeling knights, as a pair of pious, kneeling nuns frame the scene with the cruciform banners of St. George (W. 66). The text commemorates the contributions to the order:

> Beset by danger and worries great
> He proved his valor, bravery innate.
> And grateful was he to the Lord
> For what in life he could afford.
> Knightly friendships he did forge
> By strengthening the Order of St. George.[25]

In the second woodcut a standing, crowned Maximilian presents the crusader's banner of St. George to an assembled group of kneeling princes (W. 67; fig. 42). The text elucidates:

> With earnestness and diligence
> he came to Christendom's defense.
> For soon he planned a new Crusade
> and asked all princes for their aid.
> Pray God that very soon each nation
> obeys the call for Christendom's salvation.[26]

This, then, is Maximilian acting, as did St. George himself, as *Trost*, that is "consolation of all Christendom."

From Maximilian's point of view, the Order of St. George was one of his chief legacies from his father, and the *Historia* miniatures (see chapter 1) include an image of Frederick III as founder of the order (no. 10).[27] The image shows a crowned emperor appearing at the work site of a chapel under construction, where the priest brothers of the religious order greet him. This image reinforces the first of the two woodcuts on the *Arch* in stressing the constructive contributions of the emperors as heads of the order.

The other woodcut's crusading ambitions also emerge from a Flemish miniature, produced around the time of the death of Frederick III and Maximilian's own renewal of the Order of St. George, that is, 1493. In this image, the old emperor, Frederick, kneels before an altar with a votive image of St. George, while behind him Maximilian and other leading kings of Europe (Ferdinand of Spain; Henry VII of England; Philip the Fair, Maximilian's heir; and—at a slight distance—Maximilian's chief rival, Charles VIII of France) also gather.[28] This is clearly an assembly of the Christian kings, consecrating themselves to a crusade under the leadership of the ruling emperor, which Frederick and then Maximilian envisioned as the raison d'être of the Order of St. George.

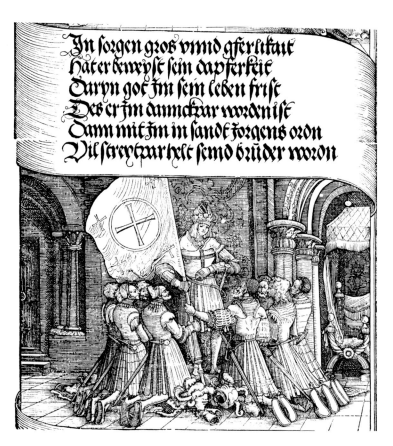

In sorgen gros vnnd gferlikait
Hat er bewyst sein dapferkeit
Daryn got jm sein leben friste
Des er jm danncknar worden ist
Dann mit jm in sanct Jorgens oron
Vil streytparhelt semd brüder woron

42

Albrecht Altdorfer, *Order of St. George*, from *Arch of Honor*,
ca. 1517–18, woodcut.

Such a call for a crusade was a leitmotif throughout the reign of Maximilian. Indeed, much of
the "propagandistic" publicity of the emperor was devoted to exhorting the German princes and
their subjects to this great cause of Christendom.[29] The principal periods of Maximilian's zeal for
a crusade were the years 1490, 1493–94, 1502–03, and 1517–18—in short, those brief periods when
he was not beset with wars with France or major resistance from the German princes within
the empire.[30] Subsequent scholars have often cynically assumed that these crusading intentions
were insincere, since they produced donated funds, often through promised indulgences, yet were
never launched.[31] Yet the prose is powerful, as Diedrichs points out. The Turks are presented as
a visitation of God's anger on a sinful Christian world and a palpable danger to the empire. On
28 October 1494 a call went out to the German nation for the St. George Order to be the army
of a crusade, just as they were presented later in the woodcut of the *Arch*. The crusade was also
taken to be the logical extension of Maximilian's proposed trip to Rome for his coronation, and
broadsheets emphasized numerous divine portents that promised the timeliness and necessity of
combat against the Turks (see below). When Venice opposed Maximilian's coronation, he lumped

their stubbornness with the traditional enemies, the Turks, and used his international diplomacy (see chapter 6) to produce the League of Cambrai in December 1508. Together with the pope and the kings of both France and Spain, he planned a campaign, ostensibly against the Turks but also as an act of vengeance against Venice. That this idea never left Maximilian is clear from his renewed, even more international appeals for a crusade (with the pope's blessing) in 1517–18 despite his age and failing health; moreover, his grandson and successor Charles V would carry the same dream to a military encounter in Tunis in 1531 (see chapter 7).[32]

This dream was soon shared by contemporary writers, particularly Sebastian Brant, to be seen in some of the more fiery broadsheets that were issued with illustrations by Brant.[33] Already in 1493, in a broadsheet "On the Honorable Battle of the Germans at Salins" (*Von der erlichen schlacht der Tutschen by Salyn*), Brant writes:

> . . . many a rich and mighty land
> Is yours, inherited to command.
> The world fears you and every nation
> Turk and heathen, subjugation
> Beneath your power, command, coronation . . .

and he ends with this phrase, "May be returned to us the Holy Land / God grant the conquest to your hand."[34] The accompanying woodcut illustration shows a fierce conflict, where the Turkish forces with pikes and cannons are opposed by mounted European knights under the banner of the French fleurs-de-lis. Austrian and imperial coats of arms as well as Burgundian symbols of flints and the cross of St. Andrew ornament the text margins of the woodcut. Another Brant broadsheet (1502?) offers an array of crowned royalty with their coats of arms, standing together under a joint French and imperial banner and linked by strong chains, held together and blessed by the hand of God extended from a cloud at the top center. Like Maximilian, Brant sees no conflict between the heightened magnificence of the House of Austria and its role as the defender of Christendom through the imperial office: the text for this image proposes "to honor his majesty the King of the Romans [Maximilian's pre-imperial title] concerning the union of kings and the attack on the Turks":

> Thus may God grant both luck and health
> To the kings and Christian commonwealth
> And may their army as it goes
> Defeat the Turks and other foes
> And thus bring on a lasting peace
> For Empire and the Christian reach
> And honor to the pious king
> That he be lord of the world's wide ring.[35]

A final woodcut, illustrating Brant's collected poems (*Varia Carmina*, 1498) presents a victorious, crowned, youthful Maximilian in full armor under the banner of St. George, standing outside a

topographically plausible rendition of Jerusalem as he receives a sword as well as a palm of victory from the outstretched arm of God in the heavens.[36]

A fusion of the figure of St. George with the conduct of a fictional, ideal knight and especially with his goal of a crusade against the Turks clearly emerges from the penultimate chapter (no. 117) of the *Teuerdank*. In that 1517 verse romance, the eponymous knight of the tale, an alter ego of Maximilian, overcomes many obstacles to win the hand of his noble bride, Queen Ehrenreich.[37] Yet the first request of his pious consort after her hero has conquered all evil opposition in her court is that he leave her to go on a crusade.[38] Then follows the woodcut illustration in which Teuerdank appears as a simulacrum of St. George at the head of an army of mounted knights. His armor and theirs bear the cross in circle insignia of the order, and both his horse and his banner repeat the motif. His majestic profile echoes the pose of Burgkmair's woodcut *Emperor Maximilian on Horseback*, and his costume replicates that of the pendant woodcut *St. George on Horseback*. Yet beneath this image, the intended chapter on the "honorable conflict" (*eerlich streyt*) was never written and remained a blank—an ironic, if fitting tribute to the frustrated intentions and thwarted ambitions of Maximilian's own dreams of a crusade.

Thus, when St. George was singled out by Burgkmair as the pendant to the triumphal, imperial, equestrian portrait of Maximilian, his presence had a strong ideological imperative, underscoring the emperor-elect's resolve to combat and conquer the infidel Turks as the fulfillment of his role as leader of Christendom. This role was set for him from his earliest moments, even in the choice of name given to the boy. According to the *Historia*, Frederick and Eleonore hesitated between the names of George, the knightly saint, and Constantine, the first Christian emperor and the founder of Constantinople, lost to the Turks in 1453.[39] Instead, the saint whose name was chosen, Maximilian of Lorch, was a martyr in Cilli (d. 284), whose homeland in Bosnia was then under direst threat of Turkish domination and whose identity provided a special calling to liberate the Balkans from the infidel. In the smaller figurines made for the gallery of saints above the life-size ancestor figures of Maximilian's tomb (chapter 2), his own patron saint is portrayed after a careful preliminary sketch (unique among these figurines) not as a bishop but rather as an armored knight, "a helmeted [figure] with opened visor instead of the bishop's miter."[40]

But the essential identification of Maximilian with St. George persisted long after the Burgkmair woodcut pendants. In an etching by Daniel Hopfer whose circle often ornamented the armor of Maximilian, St. George and Maximilian are literally fused (fig. 43).[41] The features of the figure are those of the elderly emperor, wearing the same soft hat and golden chain as in the "private" commemorative Dürer portraits of 1519 (see chapter 1); here, however, the chain is not the Order of the Golden Fleece but rather of the Order of St. George, with the crucifix hanging from links of crosses and cherubs. That this figure is St. George himself is evident from several attributes: the brilliant halo, the dragon underfoot, the angelic attendants (reminiscent of the *Standing St. George* woodcut, 1506, by Lucas Cranach), and the cruciform insignia on both banner and shield held by the angels.[42] Made near the end of Maximilian's life, this etched portrait tribute to the emperor underscores his devotion to George as the patron of the order and

as model chivalrous knight, whose conquest over the dragon makes him the "vanguard of the army of Christians." A similar, posthumous equestrian tribute, fusing the identities of Maximilian with St. George, was produced in limestone relief by Hans Daucher, also of Augsburg (ca. 1522, Vienna; fig. 44), produced in the context of a menacing Turkish advance (the 1521 conquest of Belgrade).[43] It bears the same inscription as the Burgkmair woodcut of the equestrian Maximilian: "IMP CAES MAXIMILIANUS AUGUSTU." It, too, shows an informal emperor in a soft hat but wearing the fashionable rounded armor with skirt and horse armor that shows his martial valor. (The horse armor closely resembles Burgkmair's *St. George* woodcut as well as his drawing for the stone equestrian sculpture in Augsburg; see chapter 3.) The horse blanket shows both the double eagle of the empire and the globe with cross of St. George. Underfoot, as in the Burgkmair woodcut of the saint, lies the vanquished dragon. This portrait was produced alongside two equestrian images of Emperor Charles V made by Daucher and dated 1522 (Innsbruck; Paris, private coll.), so it clearly has posthumous dynastic encomium as its purpose, but the identification of Maximilian with the chivalric St. George remains constant.

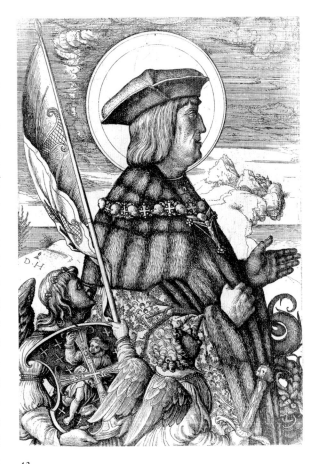

43

Daniel Hopfer, *Maximilian as St. George*, ca. 1519, etching. Vienna, Albertina.

A final image of St. George sums up the devotion to him by Maximilian. In a single woodcut by Hans Springinklee, the standing, armored saint, marked by halo, banner, and dragon underfoot, appears as if in answer to the prayer of the kneeling emperor, who wears both his imperial crown and mantle, joined by a clasp with the cross of St. George, over a full suit of armor.[44] Behind Maximilian is a chapel in a wooded glade; the tiles of its roof are ornamented with the flints of the Golden Fleece. This miniaturized donation of a pious building associated with St. George reminds us of the woodcut concerning the order on the *Arch*, where Maximilian bestows a model chapel to the brethren. According to Laschitzer and Giehlow, this woodcut was originally intended to ornament a planned statute book for the order, but like the chapel itself, that volume remained only a good intention that was never carried out.[45] One other sign of the emperor's piety regarding the saint was his own donation of a George altarpiece, carved by Sebald Bocksdorfer and with wings painted by Sebastian Scheel, given to a church dedicated to St. George at Schloss Ambras, near Innsbruck (now destroyed).[46] The shrine displays the crowned heraldic arms of Maximilian

44

Hans Daucher, *Maximilian as St. George*, ca. 1522,
limestone relief. Vienna, Kunsthistorisches
Museum (inv.-nr. 7236).

after his 1508 coronation at Trent: the king-
doms of Austria, Hungary, Portugal, England,
Bohemia, and Naples, and the double eagle
of empire, and surely was commissioned by
the emperor himself. The three-dimensional
carved saint in the center area wears the lat-
est "skirt" fashions in his gilded armor (see
chapter 6), as does his horse, whose protec-
tion features the same cross in circle of the
Order of St. George as the Burgkmair wood-
cut. Heraldic arms above signal the imperial
rank and main territories of Maximilian and
underscore his patronage.

Maximilian made numerous items for
the St. George Order. Chief among the
ceremonial objects is the sword, created for
Johannes Siebenhirter, high master of the
order, in 1499.[47] Such a sword is the chival-
ric ceremonial equivalent within the order
to the elaborate engraved swords produced
for Maximilian himself by the official sword
maker, Hans Sumersperger, in 1496 (see
chapter 6). The initial 1469 Roman installa-
tion of Siebenhirter as high master was also
celebrated in a painting of that ceremony
(ca. 1510, Klagenfurt), featuring Frederick III,
Pope Paul II, and Siebenhirter.[48] Thus, the
tradition of this latest, local knightly order
was created with self-conscious pomp and
circumstance, like the creation of the Order
of the Golden Fleece in Burgundy a generation earlier (1430). To serve as a kind of foundation for
the order, Maximilian issued reprints of the papal and royal privileges accorded to it in the form of
a broadsheet in 1503; he also prepared a special calendar, consisting of entries about his Habsburg
family saints as well as the annual saints' days, for members of the order.[49] The calendar, prepared by
Jakob Mennel (see chapter 2), was intended to celebrate the days of the Habsburg saints as a major
element of the church year. Those saints were printed in blue, the color secondary only to the red
of the major feast days and superior to the black tones of the remaining saints on the calendar.

However, the chief artistic and religious project for the Order of St. George was Maxi-
milian's printed *Prayerbook*.[50] Thanks to the researches of Giehlow, the genesis of this object is

now reasonably clear. The new type design, emulating written "gothic" court script, was produced by Johannes Schönsperger of Augsburg, official court printer.[51] This printed script was enhanced by the invention of "movable flourishes," an innovation claimed by Jost de Negker, a Netherlandish cutter and designer then living in Augsburg. A letter from de Negker to the emperor (27 October 1512) complains that Schönsperger is already laying claim to his invention.[52] The letter makes clear that the project is being supervised, like most of those by Maximilian in Augsburg (see chapter 1) by Konrad Peutinger, whose reply to an enquiry by Maximilian (5 October 1513) indicates the current state of production.[53] The ten prayerbooks on parchment that were ordered are still in preparation, owing to six weeks' delay with Schönsperger's presses in repair, but a sample (*Muster*) on parchment is enclosed and a satisfactory report on the cutters (*Formschneider*, such as de Negker) of the project suggests a speedy completion. The date on the colophon of the published volume corresponds to the modern date of 27 December 1513. Nine printed copies of the *Prayerbook* survive: eight on parchment, plus a ninth (Vienna) on paper.[54]

The notebooks of Maximilian reveal that by 1512 his plans for a *Prayerbook* for the St. George Order were part of a larger program of pious productions.[55] According to dictations to his private secretary, Marx Treitzsaurwein, Maximilian grouped his *Prayerbook*, here called the *Moraliteit*, as one of three projects; the other two he called *Andacht* (*Devotion*; see below) and *St. Jorgen* ("St. George"). Like many of Maximilian's memos, these were intended to be book-length tracts, most of which were never completed except for rarities, such as the *Jagdbuch* (see chapter 6).[56] The *Saint George* is related to memos from as early as 1502: "Item. The king should have made for the above-mentioned brotherhood its own book" (*Item kunig sol zu obgemelter pruderschaft ain aigen puch machen lassen*). In all likelihood this would have been a formal constitutional foundation for the order, a statute book, either lost or never completed. (The Springinklee woodcut of St. George and the emperor was presumably produced for that statute book.) As for the *Moraliteit*, Giehlow explains its association with the *Prayerbook* as deriving from the association of moral behavior with prayer (cf. the Latin autobiography: "moralitas et cibi et ire, devocionis plasvemie").[57] Here the morality acquired deeper significance, because Maximilian was also working through his prayers on their behalf and through his promotion of their cult(s) to confirm official holy status, that is, canonization, for Habsburg family saints (cf. chapter 2). His later memoranda refer to the "new prayerbook" and the "saints calendar" instead of the *Morality*. One reference even makes a distinction between the "Prayerbook, one ordinary, the other extraordinary." This status definition corresponds to the two kinds of printed editions of the *Prayerbook*, one on luxury parchment, the other, smaller, on ordinary paper.

The *Prayerbook* emulated luxury manuscripts by virtue of its calligraphic gothic script typeface (including the use of red lines for the boundaries of the text, an old scribal technique completely unnecessary for set type, and occasional red letters for capitals and headers) and by its use of traditional, expensive parchment support. In addition, like the luxury courtly manuscripts of France and Burgundy, it would have provided illustrations in its margins. Once again, these illustrations would have simulated the painted miniatures of manuscripts but would have produced them by means

dei quod gloriose honorifica
tum est, in secula seculor Amen
De sancto Georgio·
Georgi miles Christi:
palestinā deuicisti ma
nu tua valida· Ortus tuus ge
nerosus: actus tuus bellicosus
fides erat feruida : per lanceā
in vibrantem et draconēm vul
nerantē: viuit regis filia· Sic
in sancta trinitate : de Silena
ciuitate: credunt multa milia:
princeps feror et insanus: cui⁹
nomē Datianus: corpus tuū

45

Albrecht Dürer, *St. George*, from *Prayerbook* of
Maximilian I, printed 1513, ink on parchment. Munich,
Bayerische Staatsbibliothek (membr. 64, fo. 23v).

of mechanical reproduction. As Giehlow was the first to suggest, the marginal drawings added in colored inks to the margins of Maximilian's own copy of the *Prayerbook* (today divided between Munich and Besançon) were probably produced as models for reproduction in the form of woodcuts, a printing job no more difficult for *Formschneider* like de Negker or Hieronymus Andreae of Nuremberg than the intricate designs of the *Arch of Honor,* which featured work by many of the same artists.[58] As the red letters within the text reveal, the technology of printing in colored inks, even within an otherwise black-and-white text was already available. In fact, Erhard Ratdolt had introduced much bolder experiments in color printing to Augsburg (and to Burgkmair) late in the fifteenth century.[59] Moreover, the several participating artists were careful not to produce multicolor drawings in the margins (only in a few cases are different inks placed in the margins of adjacent pages).[60] Maximilian himself owned this uniquely decorated copy, but in no way does this fact contradict the contention that eventually it was intended for replication as woodcuts for other luxury imprints on parchment. Often, as we have seen (chapter 1), Maximilian kept prototype exemplars of his art projects that were intended to be reproduced, and these models were often on parchment, such as the Altdorfer miniatures of the *Triumphal Procession*, the illustrated *Historia* (here drawings, like those of the *Prayerbook* margins), *Freydal* (where Dürer did execute five woodcut copies from the prototype), and the Habsburg Saints (where the Beck woodcuts and the miniatures of Maximilian's codex derive from a common drawings source, akin to the lost *Procession* model).

Giehlow conclusively established that the *Prayerbook* was intended for the Order of St. George.[61] The choice of prayers is particularly instructive concerning the purpose of the book. Two are dedicated to George himself, each one illustrated with a handsome Dürer drawing in its margin (fo. 9r, 23v; fig. 45). The first of these is clearly a group prayer prior to battle; the second is

more of a general prayer of intercession, but it highlights the distinctive qualities of the saint that would appeal to an order of high status knights: "O George, soldier of Christ, who conquered Palestine with thy strong hand, thy birth was noble, thy bearing manly, thy faith fervent. Because of thy lance, flying to wound the dragon, the king's daughter is alive. . . ."[62] In both Dürer renderings of the saint, he appears in full armor with his cruciform banner on a lance; the first image is a standing saint, the second a mounted horseman. In the second drawing, a smaller dragon offspring still lives, and it lurks over the skeletal remains of a human, like a reminder of additional knightly quests for members of the order. (The second prayer also goes on to speak of "the cruel and mad king, whose name was Datian [i.e., Roman Dacia]," who martyred George and opposed the Christian faith that his deed had established: "Therefore many thousand citizens of Silena believe in the Holy Trinity.")

Thus is sounded the crusade theme in conjunction with the order's patron saint, "who conquered Palestine." Palestine is the object of Psalm 122, which appears twice in the *Prayerbook* (fo. 76v, 90r), accompanied by two Jörg Breu illustrations: one an allegory of War and Peace, the other an image of the temple in Jerusalem, as if in echo of the words of the psalm: "Our feet have been standing within thy gates, O Jerusalem. . . . O pray for the peace of Jerusalem." The previous Psalm 121 also precedes this illustrated testimonial to the crusading zeal of the order to reconquer the Holy Land for Christianity; its lines provide the moral charge to the enterprise: "Behold, he that keepeth Israel shall neither slumber nor sleep. . . . The Lord shall preserve thee from all evil."

In keeping with the military orientation of the order, a number of additional prayers respond to the concerns of knights and soldiers in battle. Particularly poignant are the prayers in case of a sudden death, such as the prayer of which it is said (fo. 12r) "to him who recites this prayer with devotion, it will come to mind in the agony of death and will give him aid and consolation." This text is accompanied by a Dürer image (monogrammed and dated 1515) of death at the shoulder of a *Landsknecht*, as in his 1510 woodcut of *Death and the Soldier* (B. 132). The *Prayerbook's* very first petition is addressed "to the guardian angel . . . that he may defend me today, and that he may protect me from all my enemies." The prayer goes on to invoke archangel Michael to "defend me in battle, that I may not perish in the fearful judgment." Michael, foot on a globe with sword upraised in his right hand, is the very figure in Breu's allegory with Psalm 122, and his presence at the apocalyptic final battle signals the epic and religious struggle implied for this crusade. St. Michael and the apocalyptic dragon, related of course to the concept of St. George, reappears in a Dürer image (fo. 26v) alongside a triumphant oriental potentate, whose orb of rule is topped by the crescent moon of Islam. This sultan rides in an anti-Christian, demonic chariot, drawn by a goat and a cupid figure and decorated with a sensuous, bare-breasted harpy with a long serpentine tail. The text with this image is Psalm 57, the reaction to Jonathan's battles against the Philistines, labeled in red, "Against powers." It is followed immediately by "two psalms to be recited in time of war" (Psalms 92, 35; fo. 28–33), each accompanied by Dürer images of battle under the protection of guardian angels (the first against peasants, the second against "foreigners";

fo. 28r, 29v). Use of the torments of Christ and His eventual triumph against enemies is invoked—in obvious parallel to the Turks—by a section titled "How the Jews Fell to the Ground" (fo. 33–34v). Here Dürer's drawing shows the grieving Mater Dolorosa and the Holy Spirit above a scene in which Jesus's gesture flattens his armed captors. The prayer begs that "all my enemies, seen and unseen, may feel fear in thy sight, and be deprived by thee of their strength."

Evidence that these prayers evoke the unique imperial situation of Maximilian as warrior leader of Christendom emerges from a similar prayer, "a recognition of his own frailty with gratitude to God" (fo. 9v): "Because thou hast endowed me, thy poor creature, without my meriting it, more than others, with all the things of the earth." Another prayer on the occasion of death includes another distinctly imperial reference, "Lord of Lords, who constituted me from nothing that I, thy humble creature, might preside over thy people . . ." Of course the name saint of the emperor also receives his own prayer and illustration by Dürer, in which he holds the bishop's crozier but also wields the imperial sword (cf. Dürer's 1512 painted image of *Charlemagne* for Nuremberg) and wears the Habsburg miter crown of empire (fo. 25v; fig. 46).[63] The saint is called "gracious confessor of the Lord, favorer of the eternal king, Maximilian, consort of the saints, fellow citizen of the angels," so he is a powerful intercessor indeed. The prayer goes on to speak of the "ministry of the blessed Maximilian to the people of eternal salvation," indicating ambiguously that the current emperor has his own powerful role as a vicar of Christ and a protector of the flock of Christians. The support of the Lord for righteous battle is given to his chosen heroes, chiefly Samson and David, rendered by Breu (fos. 85r, 91r), in both cases together with Psalm 127 ("Except the Lord guard the city, the watchman waketh but in vain"). Maximilian's identification with King David also extends to the inclusion three times of the soulful

46

Albrecht Dürer, *St. Maximilian*, from *Prayerbook* of Maximilian I, printed 1513, ink on parchment. Munich, Bayerische Staatsbibliothek (membr. 64, fo. 25v).

pentitential psalm "De profundis" (Psalm 130; fo. 16v, 97v, and 104); the first appearance is marked by a beautiful drawing by Dürer of David kneeling in prayer with harp before a blessing vision of the Lord, with His own crown and orb with cross (cf. also a smaller image of a crowned David beneath the faint traces of another vision in the clouds by Breu, fo. 89r).[64]

This imagery conforms to Maximilian's emulation of the example of King David as well as Alexander the Great in the *Weisskunig* chapter (no. 32; see chapter 6, below) about his youthful training in music. The emperor sees these two figures as models of divine favor, cultivated through music—and by prayer: "He was thinking once about King David, that the almighty God should have given him so much grace. And he read the psalter, in which he found: 'Praise God with song and with the harp. . . .' That kindled the heart of the young White King to emulate King David in the praise of God and King Alexander in valor . . . for he determined that for a king the praise of God and the conquering of his enemies are the two highest virtues."[65]

In the final segment of the *Prayerbook*, images by Albrecht Altdorfer (fo. 114v) also reinforce the special status of David as king and prophet (*rex et propheta*), where a page offers the Gospel prophecy (Luke 1:32–33) of Christ's role as descendent of David as revealed at the Annunciation: "and the Lord God will give him the throne of his father David / And he will reign over the house of Jacob forever, and of his kingdom there will be no end." Altdorfer's image shows the divine plan through a bearded prophet bearing a book and sitting above a fortified castle, often the symbol of a noble house like Maximilian's imagery of the Habsburg castle, here clearly the "house of Jacob." On the right page the image is completed by a profile portrait of King David, derived from the formulas of Roman emperors (see chapter 3) beside a smiling cherub with an apple, seated between grapevines.[66]

As the *Prayerbook* of the Order of St. George, then, this text also became the expression of the leader of the order, Emperor Maximilian himself. It conveyed his crusader goals along with the more general martial spirit and piety of warrior knights common to all knightly orders (see chapter 5). But it also promoted the memory and the efficacy of the Habsburg saints, who were to have been such a major element in the ecclesiastical calendar of the order. The reciprocal role of these saints with the order can also be discerned within some of the prayers, such as the early call "for the intercession of benefactors" (fo. 15r, accompanied by a Dürer image of a rich man giving alms to a beggar). Here are advanced the prayers "of a sinner for the souls of the departed who have prayed to thy majesty for me." Those departed souls, in turn, intercede in heaven for the living; the holiest of them, such as the Habsburg saints, assure a spiritual power of persuasion, especially in the cumulative numbers of Maximilian's ancestors. The result is assured salvation, as illustrated on the following page (fo. 16r), where Dürer shows a soul drawn up by an angel out of Purgatory toward the heavenly image of a crowned God on a cloud. Thus do the living pray for the salvation of the dead, but the saintly dead, already assured of salvation, can in turn help provide grace to the living. Later, a "prayer to the saints" (fo. 67r) is accompanied by a Lucas Cranach drawing that shows a ducal castle above a fertile plain, punctuated with a church behind protective walls; above this tranquil, Christian setting of both piety and rank is a cloud filled with

a host of cherubic angels. This scene comes as if in illustration of the prayer text "that all thy saints may come to our help everywhere, and, as we remember their merits, so may we feel their protection." That prayer, too, ends with calls on behalf of the dear departed for eternal rest and salvation (it is repeated again on fo. 78v).

Here we see again the importance of the patron saint and of the Order of St. George as a pious activity. Such a knightly order under the protection of the archetypal Christian knight provided an aristocratic, military orientation toward the crusade ideals of Maximilian, even as that order served to reinforce his leadership as both emperor and commander. In this respect, it served the cause of social association and organization, like the related orders under the "new monarchies" in England, France, and Spain.[67] What such orders provided their members was akin to the services rendered by contemporary urban religious confraternities: self-help welfare societies that held collective meetings and religious festivities and attended to the needs of their members, including burial. But in addition to being an instrument of a new, theocratically oriented purpose of the emperor, the order—and its *Prayerbook*, issued by the emperor—also established a reciprocity with a group of saints and protectors, headed by George, but also including other military sponsors: Barbara (artillery; fo. 7v), Sebastian (archers; fo. 8r), and Andrew (Burgundian patron, associated with the Order of the Golden Fleece; fo. 25r), plus nonmilitary saints Apollonia, Matthew, Ambrose, and the Virgin Mary. If the selected prayers indicate the overall purpose of the order, then its religious dimension offered a blend of pious humility and the call for God's support, sometimes by means of His saints, to protect His loyal followers in their glorious campaign for His faith and the Holy Land. Moreover, the pious prayers normally uttered privately on behalf of the emperor by his subjects have now been institutionalized within the text of the *Prayerbook*. By means of the order, Maximilian has been able to distribute his own wishes and a set of prayers on his behalf among his loyal subjects. Together, they can campaign more strongly for the aid of God and the saints; together, like the community of saints in heaven, they offer a cadre of strength on earth on behalf of the Holy Roman Empire of the German Nation for the defense of Christendom and the reconquest of the Holy Land.

If we examine more closely the kinds of ornamental images by Dürer, Burgkmair, Baldung, Cranach, Breu, and Altdorfer in the margins of the *Prayerbook*, we can expand the sense of mission conveyed by means of the selected prayers. In general, the margins of the book offer an ongoing struggle of good versus evil, corruption, and folly. This overall theme is most systematically pursued by Dürer, who not only created the largest number of images (forty-five) but also seems to have begun the pattern of design, which was then passed on to his brother artists and progressively reoriented by each of them in his own way. The method of passing on the separate quires for illustration emerges from a surviving letter fragment by Peutinger to an artist, once believed to be Baldung but now considered to have been Altdorfer (by means of the court historian and adviser to the *Arch*, Johann Stabius): ". . . dear friend, I am sending you herewith three triple-folds. The first sheet is to have on the bottom a scene in the manner of the artistic Trinity, as drawn near the beginning of the prayer of the Virgin according to Roman usage, as done by

Master Cranach and by my good friend Dürer on 29 sheets. The second is to be decorated like the prayer to Saint Andrew, in the above-mentioned manner, and like Saint George in full regalia as a knight on horseback with the dragon."[68] The fact that Altdorfer's folios conform so carefully in both layout and motifs to the model of Dürer, plus the fact that his more playful decorative illustrations of cherubs, animals, and mythic creatures accords well with both Cranach and Baldung as well as Dürer, strongly suggest that he was the final recipient of the *Prayerbook* pages to be decorated.[69] Correlation with the prayer texts, originally a clear consideration in the earlier Dürer images with dominant standing figures, gives way increasingly to what seems to be an independent decorative abundance by later artists, who received less instruction or supervision.

Nonetheless, something of the crusading and chivalric purpose of Maximilian's mission for the Order of St. George emerges from the miniatures, as von Tavel was the first to elucidate.[70] He sees the overall program of the decorative illustrations as conforming to a vision of the struggle between "heaven and earth, life and death, good and evil." This is precisely the world of Dürer's 1513 master-engraving, *Knight, Death, and the Devil* (B. 98), a work contemporary with the *Prayerbook* drawings and one echoed throughout its margins: in the frightening encounter of the same figures (with the knight in headlong flight, fo. 37v); in the equestrian St. George with his two dragons (fo. 23v); in the image of death and the *Landsknecht* (fo. 12r); in the hermit tempted by a woman and the devil (echoing Dürer's engraving, *The Dream of the Doctor*, B. 76; fo. 24v); and in a host of images of heavenly forces in conflict with demons (St. Michael, fo. 26v; God and the devil, fo. 35v; even the contrast of an angel with an old, nude drunkard, fo. 52r).[71] These drawings distinctly emphasize the bestial as well as the pleasurable elements of life that draw one's attention (like the charming drawings themselves!) away from prayers and piety. It is primarily Dürer's later drawings that expand on the isolated saintly figures of his first folios and introduce this abundant universe of activities and distractions to his knightly audience. Hence, musicians play a major role in the ornaments, usually with the basest peasant instruments, bagpipes (with their overtones of phallic sensuality as well as rustic simplicity; fo. 6v).[72] The anonymous associate of Altdorfer also pointedly juxtaposes a Turkish mounted military band with a large statue of a blessing Salvator Mundi beneath the dove of the Holy Spirit on a page (fo. 70r) that invokes Psalm 54, "strangers have risen up against me and oppressors seek after my soul. And they have not set God before them." In addition, the martial virtue of vigilance, symbolized by a crane, is often mocked in the margins by sleepers, such as the tempted hermit (fo. 24v), an old man with a prayerbook (fo. 45r), and an old woman beside her idle distaff (fo. 48v). That old woman also sits beside a large tankard, like other drunkards in the margins (fo. 47r, 52r).

Additional figures of virtue also serve as models for the knights, chiefly the great pagan hero and provider of order, Hercules, who appears twice (fo. 39v, 47r). The first time he is the victor over the Stymphalian birds, those evil and sensuous harpy figures, clearly to be identified with demonic forces (cf. Dürer's painting of the same subject, 1500, Nuremberg, painted for Frederick the Wise of Saxony).[73] Then he is contrasted as a lone and nude figure with club and shield to the world of sensuous sloth, in which a reclining drinker, surrounded by ornamental, oversized

tankards amid rooster- and snake-filled tendrils of foliage provides the antipode to Hercules. This Hercules is the archetype for princes: he not only has the strength to subdue monsters and maintain order, but he also chooses the path of virtue over vice, as in the case of Dürer's engraving, the *Choice of Hercules* (B. 73).[74] Maximilian was identified directly with Hercules in an anonymous woodcut of *Hercules Germanicus* (see fig. 9), and his dynasty's concept of the hero as model was to continue in the use of the Pillars of Hercules as the *plus ultra* in the emblem of Charles V.[75] In one of the dramas staged at court for Maximilian, the emperor took the place of Hercules at the crossroads at a crucial moment of the masque and went on to choose the path of virtue.[76] Hercules, then, is a perfect pagan parallel to St. George or to the biblical lion slayer, Samson, illustrated later in the *Prayerbook* by Breu (fo. 85r).[77] He is a religious and spiritual hero who goes all over the known world to combat evil.

In addition to demons, evil is manifest in the Dürer drawings in the form of both animal life and exotic plant and architectural growths. The sensuous monkey with fruit who accompanies the bagpiper under pipes of Pan (fo. 6v) is simply the first of several such animals.[78] Roosters, whose synonym "cock" still carries sexual overtones in English as well as in German (*Hahn* also means "penis" in German slang) because of the behavior of the barnyard animal, also appear prominently on several of Dürer's pages.[79] A host of other birds appear in the margins, led by the "vigilant" crane that appears alongside a unicorn on fo. 17r in the context of the penitential psalm (130) that speaks of the waiting soul; this interpretation of the bird was supported by the bogus hieroglyph interpretations of Horapollo, a text translated for Maximilian by Pirckheimer in 1514 and illustrated by Dürer (see chapter 1).[80] Antipode to the crane is the dissolute goose or swan, which appears in the company of a monkey and an oriental (fo. 42v), a drunkard (fo. 47r), and atop the head of a worldly peasant woman off to market (fo. 51v).[81] One other animal deserving of mention is the stag, used sparingly by Dürer in the image beneath St. Andrew (fo. 25r) but surely to be understood in a positive spiritual sense, akin to the words of Psalm 42, "As the hart panteth after the water brooks, so panteth my soul after thee O God." Of course, the stag is also a favorite animal of the hunt (see chapter 6), one of Maximilian's own favorite pastimes, and in the case of this miniature the winged lions below the figure (and the feet) of Andrew (a patron saint of Burgundy adopted by Maximilian and his armies) are surely to be identified as the symbol of St. Mark, patron saint of Venice; that the hart attacks these lions associates him with Maximilian, still in an ongoing state of war with Venice.[82] A related animal, the bison, associated with Maximilian's name saint on the verso, fo. 25v, is glossed in the Horapollo manuscript as symbolizing manliness with discretion.[83]

Finally, a word should be said about Dürer's modification of the tradition of floral or acanthus ornament in the margins of manuscripts. The artist has delighted in playfully adapting such decorations in his own experimental forms, including the tangled knots, flourishes, and linear "doodles" that are still representational, despite offering unbroken lines, such as the calligraphic mask on fo. 18v, the lion on 19r or 37v, or the unicorn on 51v. At times the boundary between representation and linear fantasy blurs, and the ornament appears to have overgrown its limits.

This kind of creative border is most evident in the imaginary columns and vases, most of which seem to be dominated by cupid figures. An example at fo. 19r shows a pedestal with grape leaves from which two cupids hold up a hovering, magical globe from which springs a column capped with a horned satyr. On fo. 46r a clearly demonic cauldron is ornamented with the head and feet of goats with wings, while nearby a foliate mask is topped by a flowering vase on whose vines sit a bound satyr and a dead duck. Here Psalm 87 speaks of the cities of Rahab and Babylon and "alien nations," so this fantasy is clearly intended to evoke their foreign, ungodly practices, akin to the anti-Christian world of the Turks.[84] A similar magical statue-cum-cauldron with an egg on lion's feet at the base, on which a putto stands with fantastic garlands appears on fo. 56r, adjacent to the holy sudarium. Once again, the imaginary world offers a contrast to the holy signs and relics, and pagan religion or magic seems to emphasize a dazzling show alongside the true humility of the suffering Christ.[85] Other images are even more ambiguous about whether the decorative ornament is to be taken as part of the deceptive and tempting world of the flesh or else as the abundant outgrowth of the powers of the spirit. In fo. 45r the column topped by a pomegranate obviously appeals to the fruit that was the personal emblem of Maximilian, but the text is Psalm 45, which speaks of God as "exalted among the heathen." The sleeping figure of the old man with closed prayerbook is complemented here by the figure of a cupid with a basket overflowing with fruit, but the text speaks of "the works of the Lord, what desolations he has made in the earth." Thus, this column signifies the conquest by Maximilian over the ungodly foes of Christendom; this is fertility and fecundity in the positive sense of God's kingdom. Such an image repeats itself on fo. 36r, with the Tree of Life, climbed by putti, echoing there the text of Psalm 95, "In His hand are the deep places of the earth. The strength of the hills is His also. . . . For the sea is His also, and he made it."

Dürer's elaborate ornamentation in many of these overabundant images of fertility and paganism offers a utilization of inherited, northern manuscript decorative traditions along with a variation on the newly imported theme of Italianate ornament, known best through prints.[86] Many of the same motifs in his decorative borders reappear in other Dürer drawings as early as the 1510 Fugger Chapel project in Augsburg (Berlin, W. 483, 486), where the cherubs, satyrs, and Italianate columns and vases already appear as ornament at the bottom of the drawings. Harpies and a satyr adorn a classicizing column in a finished presentation drawing (London, British Museum, W. 714) quite close to those of the *Prayerbook* (esp. fo. 19r or the harpies with Hercules on fo. 39v).[87] But the closest comparisons of all with the *Prayerbook* are Dürer's designs in 1517 for courtly armor elements with ornament (W. 678–82, 712; see chapter 6). Again, the supervisor was Konrad Peutinger of Augsburg, the same man who coordinated the decoration of the *Prayerbook*, and the designs were passed along to Coloman Helmschmied, the leading armorer of Augsburg, who was to produce a final work in silver plate (1519), now lost but recorded in documents.[88] The visor of that work was designed by Dürer (Vienna, Albertina, W. 679) to have a bagpiper and dragon flanking the beavor as well as a row of jugs above pomegranates and pearls and a vigilant crane on the stalk of a rose. Jousting knights made up the neck guard (Vienna, Albertina, W. 678),

47

Albrecht Dürer, *Design for Saddle*, ca. 1515–17, ink. The Pierpont
Morgan Library (W. 680), New York. Photo: The Pierpont Morgan
Library (W. 680), New York.

while a saddle (New York, Morgan Library, W. 680; fig. 47) is adorned with a double eagle, dragon (with a unicorn horn), crane, harpy, nude woman, and bagpiper.[89] Thus, these decorated works of armor are adorned with the images of sensual indulgence and worldly pleasure within an abundant growth of foliage, precisely the kinds of excesses to be striven against by Maximilian or other knightly bearers of arms.

This convergence of motifs confirms that Dürer once more repeated his decorative motifs from the *Prayerbook* within the knightly context of Maximilianic patronage and military conflict. We see that his concept of individual struggle pertained not only to the armed conflict against the Turks but also to the inner struggle of righteousness against temptation and sinfulness. Hence, the presence of animals and demons in the population of the borders pits them as adversaries to the knightly audience, as forces to be striven against, monsters like the dragon overcome by St. George himself or the hydra of Hercules, to be defeated in righteous combat. In the process, true faith is tested and renewed, and the "sense of order," violated by these mixed forms, is restored from the "edge of chaos."[90]

Maximilian's patronage of personal prayerbooks actually reached a conclusion with the *Prayerbook*, but he had previously commissioned a luxury manuscript (1486) in the Low Countries, known retroactively as the "Older Prayerbook."[91] That prayerbook derives from the previous

tradition of court manuscripts in Flanders, and it contains the initials of a Flemish master "FB," whose style corresponds to the "Ghent-Bruges" formulas of the late fifteenth century, after the model of the Master of Mary of Burgundy. He has been identified by some scholars as Alexander Bening of Ghent (d. 1519).[92] Rather than the Roman use, the calendar of the Older Prayerbook utilizes the feast days of France and the diocese of Tournai, to which Bruges belonged, with only two German saints (plus saints Maximilian and Friedrich for the Habsburgs). Several favorite Habsburg saints appear in the Older Prayerbook: Barbara, Sebastian, Apollonia, Christopher, Maximilian, and George. Items usually included in Flemish books of hours, such as the offices of the Virgin and of the dead, are omitted here, and the selection of prayers seems to have been as personal as in the later, printed *Prayerbook* (e.g., a pair of psalms before battle as well as selected penitential psalms). In this respect, the printed *Prayerbook* offers a more orthodox compilation of offices, including the office of the Immaculate Virgin and the office of the holy cross, akin to the strictures of a book of hours.[93] Prayers within the Older Prayerbook are generally in Latin, supplemented with several in Flemish; paleography reveals clear inserted passages and additions. Van Buren concludes that the existing work is only a fragment of a "sumptuous and much fuller work," perhaps including the canonical hours of the Virgin and the dead.

As in Flemish court manuscripts, the color illuminations in the Older Prayerbook are less frequent than the decorations by Dürer et al., but they fill five full-page miniatures as well as three initial images. A youthful, surely imaginary portrait of Maximilian appears on fo. 61v, kneeling in prayer before an armored figure of St. Sebastian in front of a Flemish lord's house. Here a single eagle shield of the king of the Romans hangs on a tree behind the (*Bügel-*) crowned Maximilian. The assumption that the illuminator would have had the chance to see Maximilian in person has prompted the usual scholarly dating of this manuscript to Maximilian's visit to the Low Countries after 1486 (with his imprisonment in Bruges in 1488), that is, close to the date of his coronation in Aachen (1486) that gave him title to the depicted shield.[94]

Both prayerbooks were designed for Maximilian's own use, although the Older Prayerbook was a unique, hand-lettered possession, a Franco-Flemish book of hours, prized by princes. By contrast, the printed *Prayerbook* was intended for wider distribution and use among the Order of St. George. In other instances, however, Maximilian received pious donations of sacred texts. Chief among these is a manuscript dedicated to Saint Simpertus, local bishop of Augsburg.[95] This manuscript originated with Maximilian's attendance (23 April 1492) in Ausburg at the festive dedication of the Simpertus Chapel in the church of St. Ulrich and Afra. Pächt suggested that its costly binding, with the eagle of the king of the Romans, was donated to Maximilian on that occasion, when he was admitted to the confraternity of St. Ulrich and Afra.[96] The book contains a text of the life of St. Simpertus, plus a vesper in his honor, a mass, a genealogy, and two prayers. The beautiful calligraphy was produced by Leonhard Wagner, famed calligrapher of that cloister and the purported designer of the *Fraktur* script cut for the *Prayerbook* and *Teuerdank* by Hans Schönsperger of Augsburg.[97] Like other family Habsburg saints of Maximilian, Simpertus (d. 809) came from a noble family: the duke of Lorraine, Ambertus, and his wife Simphorina, allegedly the sister of Charlemagne. On

a full-page miniature (fo. 1v) at the beginning of the manuscript, an enthroned Simpertus blesses his kneeling parents and siblings, presented in smaller scale but with their heraldic arms at his feet, like donors in contemporary (Burgundian—a likely reference to Maximilian and his bride, Mary of Burgundy) costume. He was later included in the roster of Habsburg saints assembled by Mennel (no. 100; see chapter 2), holding an important place as nephew of Charlemagne. Simpertus enjoyed a special cult in Augsburg, especially after his canonization in 1468. After the dedication of the chapel a silver reliquary bust of the saint was presented in October 1493 (commissioned from goldsmith Jörg Seld), with Maximilian listed as a benefactor, an altar shrine was carved by Adolf Daucher.[98] Although Pächt (followed by Krause) assigns the full-page miniatures to the innovative, Netherlandish manner of Hans Holbein the Elder, Augsburg's leading painter of altarpieces, he also ascribes the Simpertus manuscript decorations to a series of Augsburg luxury manuscripts by Georg Beck and his son, Leonhard Beck, who went on to work in woodcuts on the *Teuerdank* as well as the *Habsburg Saints*.[99] In this respect, the ongoing stream of connections between Maximilian and Augsburg artists, including calligraphers like Wagner and miniaturists like Beck, can be seen developing early in the 1490s, shortly after his return from the Low Countries. Holbein the Elder's miniatures (his only known illuminations) initiate the serious contribution by Augsburg artists to Maximilian's artistic projects, employing the very finest talents: Holbein the Elder, Burgkmair, Breu, and Beck, usually under the local supervision of Peutinger.[100]

Maximilian's connections with the Augsburg church of St. Urich and Afra continued unabated in the following decade. He was present for the laying of the cornerstone of the new choir of the church in 1500, at which time he made use of a silver trowel by the same goldsmith, Jörg Seld. That momentous event was commemorated in a painting, now lost but preserved in a copy of 1613; it showed the cardinal with Maximilian in the center, surrounded by a retinue of both secular and sacred patricians.[101] Ulrich and Afra was the chosen site where Maximilian planned to place his stone equestrian portrait statue, designed by Burgkmair for sculptor Gregor Erhart but never executed (see fig. 41, above); the inscription on Burgkmair's drawing records the same date as the painting of the laying of the church cornerstone.[102]

Maximilian had a particular attachment to the city of Augsburg and to the church of St. Ulrich and Afra, under the leadership of its ambitious abbot, Konrad Mörlin (d. 1510). His piety also manifested itself in other projects and donations. One of these was a painted panel by his court artist, Jörg Kölderer, of a miracle (1384) in the parish church of Seefeld.[103] The event was the miraculous bleeding of a host at communion for a noble named Oswald Milser; the wafer was kept as a relic at the site. Maximilian's arms appear at the upper left of this work, and underneath an attached inscription outlines the indulgences attached to pilgrimage to this site. This votive picture commemorates the miracle and its ongoing value, acknowledged even by the emperor (and by one of his followers, whose arms appear on a column of the church below those of Maximilian). A similar pilgrimage site at Frauenstein features a sculpture by Gregor Erhart, the chosen carver for the Augsburg equestrian statue, which shows the popular late medieval theme of the Virgin of Mercy, or *Schutzmantelmadonna*, protecting the faithful under her cloak.[104] Heading one of

the two kneeling groups of figures under the mantle of the Virgin, Erhart includes an unmistakable portrait of the crowned Maximilian. Together with his trusted follower, Florian Waldauf zu Waldenstein, Maximilian donated this handsome sculpture to the country church site in Styria in thanks for his miraculous delivery in 1498 from a snowstorm voyage on the Zuiderzee.[105]

That same rescue from death led Waldauf to make a vow to erect in Hall (St. Nicholas's) a chapel with an endowed prebend and a collection of relics (see chapter 2) in precious metalwork.[106] To commemorate this pious donation, Waldauf set out to write a text, and he commissioned Burgkmair, the recent designer of the equestrian woodcut portrait, to produce 151 woodcut illustrations (145 survive in proof impressions); however, his own death in 1510 ended the project. One of the large illustrations (no. 8, fo. 18v) shows Maximilian and his son, Prince Philip the Fair, with Waldauf, underscoring the imperial association with this favorite adviser and his pet project of religious cult objects. Another woodcut (no. 2, fo. 2v) adapts Burgkmair's frontispiece to Stamler's *Dialogue* (see above) to show the opposed kneeling figures of the pope and emperor, followed again by Philip the Fair and Waldauf, praying underneath a divine vision of the Virgin and the Holy Trinity.[107] A portrait of Maximilian himself (fo. 67; after an earlier portrait of Pope Julius II) accompanies this text: "Emperor Maximilian endowed, graciously confirmed, and established this foundation and institution together with the foundation letter of the holy chapel in Hall and all of its freedoms, privileges, endowments, indulgences, grace, plenary indulgence, and everything else." In addition, woodcut no. 17 (fo. 153) shows a reliquary bust of St. George, bearing the arms of Waldauf, with the following text: "In this image is the skull of St. George, holy knight, martyr, and helper in time of need (*Nothelfer*), who with his Christian knights has earned eternal life, and whom also particularly in German lands princes, counts, lords, knights, and pages hold to be great, invoke, and honor."[108] The miraculous delivery from the storm on the Zuiderzee appears as woodcut no. 3 (fo. 5–9), amid a four-page recounting of the event as the origin of the relics and the Hall chapel: "How Emperor Maximilian plus the Donor and Several Other Advisers of His Imperial Majesty Were on the Sea in Mortal Peril."[109] Thus, within the Burgkmair woodcuts for Waldauf and his reliquary collection, we find the expression of contemporary piety toward the collection of relics and the custom of pious donations for chapels and for endowed clergy, but we also find the extension among his knightly followers of Maximilian's own interest in the cult of St. George and the celebration of the emperor's leadership of the princes of Christendom.

In addition to the contributions made by Maximilian to the relics collection of Waldauf, he made purposeful donations to the religious cult of the "national saint" of Austria, St. Leopold, whose canonization (6 January 1485) had been so energetically promoted by his father, Frederick III.[110] Of course, Maximilian claimed St. Leopold as one of his ancestors and included an image of him as a statue on the *Arch* as well as a statue of him at his tomb (by Stefan Godl; see chapter 2). But he also stage-managed an elaborate ceremony of "translation" of the bones of St. Leopold (15 February 1506) from the old Nicholas Chapel at Klosterneuburg and had them placed in a silver sarcophagus that he commissioned (by 1495).[111] For this occasion and site Rueland Frueauf the Younger painted a cycle of the life of Leopold and votive pictures of the saint (1505, 1507–8 respectively).[112]

The emperor had a genuine desire, akin to the religious educational projects of learned humanists in Germany, to make religious ideas available in print to a large, vernacular audience in the empire. One concrete result was the publication (Nuremberg: Anton Koberger, 1500) of the *Revelations of St. Bridget of Sweden*. Through his protonotary, Florian Waldauf (see above), Maximilian provided a copy of an illustrated 1492 Lübeck edition of the text to Koberger with the charge to publish it "with the figures therein first in Latin and afterward in German."[113] The arms of Waldauf appear right after those of Maximilian among the woodcut illustrations (nos. 2 and 3).

On the most personal level Maximilian's displayed his sincere religious beliefs in the form of a series of eight questions that he submitted for theological commentary to Abbot Trithemius of Sponheim.[114] These questions reveal a critical, even potentially skeptical mind, probing to receive systematic answers to fundamental problems of faith. The knowledge or experience of God by mankind and God's attention to worldly affairs top the list, and considerable concern is voiced about matters of salvation, both for infidels and for condemned souls, as well as questions concerning evil and black magic, such as why God permits witches and their powers to command evil spirits. Maximilian also left indications that he had serious intentions of publishing the answers to these questions for the general Christian populace, for his list of proposed books in his memorandum of the period 1508–15 includes a title, *Book of the 24 Beliefs* (*Buch der 24 Glauben*).[115] In many respects, the 1508 Stamler publication of the *Dialogue* takes up such religious questions. It shows how the joint protection of both pope and emperor makes learned religious disputations possible—as the woodcut title page makes clear (see above)—under the "Fount of True Wisdom" (*Fons Vere Sapiencie/ iusta est religio*).

Maximilian's ambitions to reach a Christian public could have much more self-aggrandizing qualities as well. Like his sponsorship of the cult of St. Leopold, he underscored his personal discovery of the relic of Christ's tunic at the cathedral at Trier (1512).[116] The "seamless robe" relic had been lost for three centuries but was revived as a local cult during Maximilian's Easter vigil in Trier. Maximilian was not shy about trumpeting his role in recovering the relic: he issued broadsheets announcing the new discovery, interpreting it in terms of the importance of a "seamless," that is, nonschismatic, leadership of Christendom. Maximilian also took pains to include this important event within the publicity concerning his own life. A fine Burgkmair woodcut (no. 227; fig. 48a) for *Weisskunig* shows a good likeness of the emperor kneeling in prayer before a pair of bishops, standing at the altar at Trier and holding up the tunic for his pious contemplation (no text for the event was ever completed). In addition, the left tower of the *Arch of Honor* includes a two-part woodcut (fig. 48b; ascribed to Dürer rather than Altdorfer, unlike the other tower woodcuts) of the scene at Trier (left) as well as the veneration of St. Leopold (right). At the left, as if a reduced version of the Burgkmair woodcut of Trier, the emperor stands, in armor and miter crown with a rich mantle and scepter of office, as witness to the presentation of the relic by the bishop, while a kneeling noble takes the place of Burgkmair's emperor. At the right half of the woodcut, through a second arched opening the metalwork reliquary with the bones of St. Leopold are held by a bishop before an altar with the portrait of the saint, as Maximilian, standing in the same ceremonial dress, looks on. The text reads:

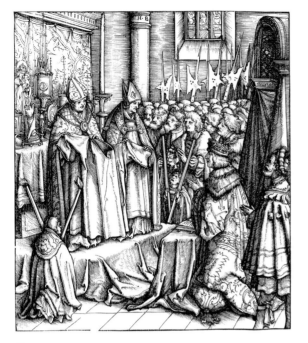

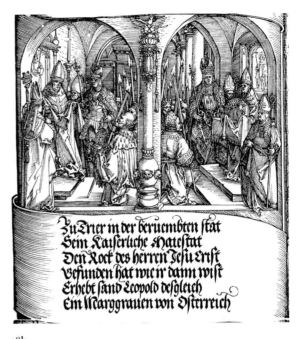

48a

Hans Burgkmair, *Discovery of Seamless Cloak of Christ at Trier,* from *Weisskunig,* ca. 1518, woodcut.

48b

Albrecht Dürer, *Discovery of Seamless Cloak of Christ at Trier* and *Canonization of St. Leopold,* from *Arch of Honor,* ca. 1517–18, woodcut.

His Majesty then came
To Trier the city of great fame.
For there he found and kept from loss
The vestment Christ wore on the cross.[117]

Such self-aggrandizement in religious terms had already led Maximilian during the previous year (1511) to give serious thought to candidacy for the papacy.[118] While rumors swirled concerning the serious illness of Pope Julius II in Rome, the newly widowed Maximilian considered ending the perennial opposition of the pope to his coronation in Rome and his presence in Italian regions claimed by the empire. Already a schismatic "Council of Pisa" had been called with the backing of Maximilian by cardinals opposed to the warlike Julius, but there was a risk of the election of a French pope owing to the prior support of France for the same council. So, with the encouragement of his adviser, Matthäus Lang, Maximilian attempted to assert himself and to offer his candidacy, at least as an antipope, but he was deterred by his in-law, Ferdinand of Spain, who foresaw a total schism as a result, reminiscent of the nadir of Church politics during the fourteenth century. The end result was another diplomatic alliance (see chapter 6): the Holy League of 1511, linking Venice, Spain, England, and the empire with the pope against Louis XII of France. Thus,

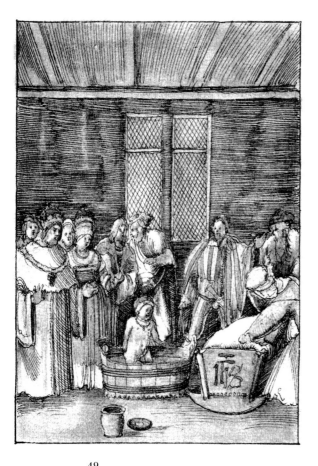

49

Albrecht Altdorfer (attributed), *The First Bath of Baby Maximilian*, from *Historia Friderici et Maximiliani*, ca. 1508–10, ink. Vienna, Haus-, Hof-, und Staatsarchive, Hs. Blau 9, fo. 38r.

the politics of religion was redirected into greater European power politics for Maximilian.

Yet Maximilian's own sense of his leadership in Christendom led him to represent himself as divinely sanctioned, even from birth. The illustrations of both his Latin and his German autobiographies celebrate the omens of his divine election at birth. In the *Historia* images, the first drawing to show Maximilian (no. 16; fig. 49) displays his precocity.[119] As soon as the baby was bathed after his birth, he stood upright in his tub without assistance; in the drawing this event takes place before the eyes of his astonished imperial parents as well as other courtly witnesses and adjacent to a crib adorned with the monogram (IHS) of Christ.

In similar fashion, the *Weisskunig* woodcut (no. 16) that introduces the baby Maximilian shows him in the arms of his wet nurse next to the same crib with the IHS monogram; here, the omens of his importance are purely celestial, in the form of radiances from a triad of stars and a crescent moon. According to the text of the *Weisskunig* (chapter 13), while the baby was still unborn, a king from the land of "Ponto" visited the court, lamenting the sufferings of his people at the hands of the Turks. He speaks: ". . . I shall hope that the child, with which the queen is pregnant, will revenge me with my enemies and humble them thanks to the grace of God, in which we believe." On hearing these words, like Jesus in the womb of Mary at the Visitation, the infant White King, began to stir in confirmation of the vows of the visiting prince. The next chapter recounts that a comet was sighted prior to the birth itself, a sure sign of the importance of the new baby and of God's providence for the imperial couple and their offspring. The comet grew larger and brighter on the actual day of the birth, making the revelation (*Offenbarung*) even more explicit. The text even goes on to make an analogy between the queen and the Virgin Mary, because her labor involved minimal pain (*geringen Schmerzen*). Comets were the sign of the birth or death of a mighty or great person, and contemporary images, especially by Altdorfer, emphasized not only the celestial corona of the Star of Bethlehem at Christ's birth (Berlin; Vienna) but also the colorful comet in the sky at His death on the cross (Nuremberg; Berlin).[120] The text makes the connection explicit: "After the child was born, the comet grew fainter by the hour,

from which one recognized that it was a sign for the future reign and wonderful deeds of the child . . . when the child came to maturity and to rule, it was the mightiest and most victorious, but also the kindest in expression, a wonderful thing to see in one of the mighty and the most mighty. Therein can one recognize again the bold and strong sign of the comet, and its positive appearance, which pointed to the future."[121]

The stars of the horoscope of the new baby were favorable as well, as the next chapter (no. 15) describes. The old White King was knowledgeable about astrology and foresaw "from the constellations" that the child "would come to the highest office in this world, would accomplish many wonderful things, and would endure great wars." The prince of Ponto presided over the baptism, illustrated in a spacious Burgkmair woodcut (no. 17), and he compares his own witness to that of old Simeon at the Presentation of Christ in the temple (Luke 2: 25–32) ". . . when he saw his redeemer [*Heiland*], the savior [*Erlöser*] of humankind. Thanks to divine grace I have lifted the child out of the baptism, that himself or through his issue will revenge me on my enemies and will humble the Turks with a mighty hand."[122] This almost formulaic repetition of the crusader mission would mark Maximilian's life from its outset and was duly stressed in his autobiography. What is so impressive as to seem blasphemous is the equation of Maximilian with Christ himself, of his mother with Mary, and of his baptizer with Simeon. In the next chapter of *Weisskunig* (no. 16) the infant is presented in the church by his royal father, as Christ was presented in the temple: "The king remembered how in Rome he prayed to God almighty that he might be sent children, who would live according to God's will. . . . Thereafter the king had his child brought before the altar, in order to present it to God."

This kind of Christo-mimetic pose by Maximilian continues later in the *Weisskunig*, as the Infancy of Christ is used as the model for stories of the precocity of the young White King. The other main example is woodcuts nos. 22–23, where the event of Christ among the doctors is adapted. In the first woodcut, *How he Learned the Seven Liberal Arts*, corresponding to chapter 20, the young prince stands elevated in the center of a room above seven older men dressed in academic gowns with doctoral caps, yet it is he who instructs them. The following woodcut, by Burgkmair, is labeled *The Cleverness of the Young White King, to Associate with All Classes* [*Ständen*], *with Each According to His Status and His Honor*." The text of the corresponding chapter (no. 21; on "political science") speaks of the prince's awareness of the hierarchies of the Church and of the secular world, but the woodcut shows another view of the prince as elevated above representatives of each class and profession, divided like the Stamler woodcut into sacred and secular spheres of graded ranks. Yet he speaks to them all at once, as in Rembrandt's etching, the *Hundred Guilder Print* (ca. 1649), where Christ addresses a crowd representing all the world.

Like Christ, the young White King was directly exposed to the teachings and temptations of the devil. Burgkmair's woodcut (no. 25; fig. 50) depicts the chapter titled "The Desire of the Young White King to Learn Black Magic [*Schwartzkunst und Zauberei*], and Thereafter the Godly Counterexample." In this imaginative vision, the prince stands at the feet of a cleric in doctoral robes, while above them both two books hang magically on chains from the stars in the heavens;

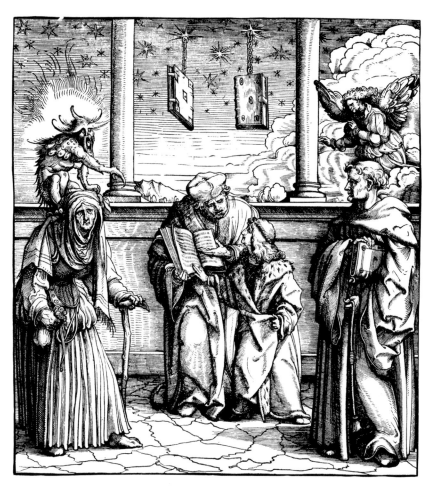

50

Hans Burgkmair, *Young Maximilian Learning Magic,*
from *Weisskunig*, ca. 1512–18, woodcut.

on either side of them are the spirits of good and evil. Evil is depicted by a lame old woman with a
large purse of coins, holding an angry demon on her back, while good appears as an ascetic monk
with a book and an angel above his head. The corresponding chapter (no. 23, "How the Young
White King Learned the Black Art") describes how the prince had to learn to struggle with a
temptation (*Verführung*) toward the newly popular superstition of black magic, "forbidden by the
Christian faith and by imperial law." The old White King challenges his son to master these arts
from their greatest adept practitioner, who tempts him, like Christ, with the promise that such
magic is the art of great lords to raise themselves. But the young prince affirms the first command-
ment toward monotheism and rejects this disbelief and heresy (*Unglauben und Ketzerei*).

A similar episode occurs near the beginning of the departure on his quest by a similar young
prince, Teuerdank, in his verse epic. In chapter 10 the devil himself makes an appearance in order

to tempt the pride and ambition of the hero. In this woodcut illustration by Schäufelein, the devil appears in the guise of a learned academic with a book. His appeals to the hero tempt him toward desire, pride, and dishonor, and his three appeals are rejected successively, as Christ thrice rejects the temptations of the devil (and as Teuerdank survives the successive blandishments of Fürwittig, Unfalo, and Neidelhart, who recapitulate in their names the temptations of chapter 10). Just as Burgkmair's woodcut introduces a positive counterweight to the force of evil, so does *Teuerdank* produce the appearance of an angel (*englisher Geist*) to console the hero after all his trials (chapter 115) and to caution him to follow God's commandments, to avoid pride, and to remain faithful and true. This woodcut is by Burgkmair, and it shows the prince standing in a room opposite a winged angel like the one in the *Weisskunig*.

Direct visits from either heavenly or demonic spirits confirm a spiritual, even Christ-like, importance of figures, and the Maximilian surrogates, Teuerdank and Weisskunig, present intensified fictionalizations of what remained his megalomaniacal sense of personal religious grace. Such a viewpoint, however, had ample precedents in the history of European kingship.[123] A king, through his ceremonial anointing with holy oil or "chrism," in echo of the Old Testament Hebrew kings, received "charismatic" powers, including for the French kings the miraculous ability to cure the disease of scrofula simply by his touch. Of course, late antique history also sanctioned the deification of emperors within the original, pagan framework of the empire. But in the pages of certain medieval treatises, particularly the Tractates by the Norman Anonymous (ca. 1100), justification was provided for seeing kingship both as Christ-like and as representative, in the role of the vicar of Christ on earth.[124] Though these are extreme arguments, fiercely countered by the Church establishment, which abolished the anointing of kings as a sacrament in the twelfth century, they clearly present the king as greater in kind than other mortals, endowed with distinctive spiritual qualities. By this argument, like the kings of the Old Testament, he was "by grace, a *Christus*, that is, a God-man."[125]

Church history lent support to this view by its numbering of kings among the saints.[126] Of course, the Habsburgs themselves promoted Leopold III as the "*Rex perpetuus Austriae*," even as they claimed blood descent from him. From the time of Charlemagne, the concept of the "*Rex dei gratia*" had defined the grace conferred on kings, and the canonization of earlier kings by their ambitious successors (such as Emperor Charles IV promoting the cult of his namesake Charlemagne) had helped to legitimize the ongoing monarchy itself, often within a defined geographical region (Leopold for Austria and Stephen for Hungary among the ancestral, saintly kings claimed by Maximilian).[127]

Often the divine grace of a king was taken to be his success in battle on behalf of his people or his miraculous deliverance from peril. This theme underlies many of the perils of *Teuerdank*, whose verses repeatedly give thanks to God for special protection of the hero. Ultimately, this message of divine grace is conveyed by means of the final chapter and its accompanying Burgkmair woodcut (no. 118). In this image, the triumphant hero stands alone (except for his page and herald, Ehrenhold) in armor above a charmed circle of swords, which symbolizes both the victories of arms of

Teuerdank as well as the wheel of fortune, his heraldic mark on the tunic of Ehrenhold. With the aid of both fortune and God's providence, Teuerdank has survived to perform still more future knightly services and deeds of renown in the world, as the text makes clear:

> One cannot help but wonder much
> That just a single man does such
> A damage to the evil men
> And could oppose them time and again
> .
> He is a man and nothing more
> And thus I marvel all the more
> That he remains in healthy life
> I trust that God in every strife
> Knew from the first this hero bold
> Would wondrous deeds on earth unfold
> To greater glory of the faith
> And thus did God protect this wraith . . .[128]

Taken together, then, these twin pillars of divine election and grace formed the basis of Maximilian's claims: his saintly, royal ancestors (see chapter 2) and his successful deeds. In this respect we can once more return to those remarkable illustrations of the *Zaiger* (figs. 17–19), Jakob Mennel's pictorial digest of his genealogical researches, in which Maximilian portrays his own position at the head of two ladders of sanctity, one (silver) for his imperial office and the other (jeweled) for his holy ancestors.[129] On the ladder of worldly accomplishment, he has reached the summit, but this is the least worthy of the three ladders, according to its presentation, for its substance, silver, is inferior to the gold of sacred office held by other Habsburg ancestors as well as to the jewels of the recognized saints. In addition, each of the saints is accompanied by a guardian angel, and the ladder culminates in a greeting from God Himself, in contrast to the angels before the crescent moon of the worldly ladder (the sacred office ladder has a sun). Yet at the top of this jeweled ladder the figure of Maximilian receives his crown of sainthood by virtue of his asceticism, for his body is unclad and covered with the welts of a thorough flagellation. Here is the ultimate Christo-mimetic imitation, in which the emperor scourges himself in emulation of the Passion and presents himself to God in total physical abasement.

Lest this activity seem too farfetched for so powerful and worldly a figure as Maximilian, we need only consult his personal instructions for his body after his death.[130] Not only was there an extremely modest funeral ceremony, with a simple eulogy and no representatives from the pope or from other Christian kings, but Maximilian also left instructions in his testament that his body should be bound with a girdle and shaved all over, that all his teeth should be pulled out and buried with burning coals, that his body should be scourged and then wrapped in layers of sackcloth, linen, and white silk damask, mixed with chalk and ashes. These remains were to

be displayed publicly for an entire day before being placed in the coffin that he had been carry-
ing with him on all his travels for the previous few years as a memento mori in the tradition of
late medieval *transi* tombs.[131] To commemorate this kind of public humility/humiliation of the
mighty emperor, a death portrait was painted in 1519 (by "Master AA"; Graz), then replicated in
numerous copies.[132]

Related literally to the earthbound notion of humility was the instruction given for the burial
of his body by Maximilian. He directed in his testament that the body be taken to the St. George
Chapel in Wiener Neustadt and buried under the altar in such a manner that the priest would
step on top of it each time mass was said.[133] At the same time, however, the will declares that a
statue of Maximilian be included among his ancestors in the bronze tomb ensemble, to stand in
front of the altar alongside a statue of his father, Frederick III, plus Charlemagne, and two un-
named figures: "But of the great 28 cast statues, should our person, our father, Emperor Charles,
and still two others . . . be placed beside the windows but four images and thus according to the
order be placed on [*ob*] the altar."[134] This conception conforms to late Maximilian visualizations
of his tomb, as recorded by an Altdorfer woodcut on the right tower of the *Arch of Honor* (see
chapter 6, fig. 78). This image shows the tomb of Maximilian's father, horizontal on a medieval
slab *tumba*, while a statue image of Maximilian himself, in full imperial regalia, stands upright on
a pillow before (rather than "on") the altar of a church.[135]

Viewed against the conventions of tombs in the era of Maximilian, especially the subsequent
tombs of the French kings who were his chief rivals, we can see this combination of his humbled
remains with his glorious, standing bronze effigy as the equivalent to the grandest ensembles of
dynastic self-assertion. The bronze suggests resurrection and the triumph in eternity over death
and time. Such an idea is already conveyed in the German *transi* tombs of the Fuggers in Augs-
burg (St. Anne, 1509–12), where the 1510 Dürer designs (Berlin-Dahlem, Vienna, W. 483, 487)
depict shrouded corpses and skulls underneath religious subjects that offer victory over death:
Samson Defeating the Philistines and the *Resurrection of Christ*.[136] In combining mortification of the
flesh with the new hope for resurrection and pride in human accomplishment, Maximilian stands
poised between two eras, between the *danse macabre* of late medieval piety and the new, human-
ist religion of mankind's potential for good, between *representacion de la mort* and *representacion
au vif*.[137] This is the same idea expressed in the phrase excerpted by Kantorowicz, "*dignitas non
moritur*," in which the eternal aspects of the monarch, his "dignity," would survive his mortal body
and contribute to the ongoing permanence of his office.[138] In this respect, Maximilian is but the
last to die of the long chain of revered ancestors who accompany him at this tomb, but he passes
the dignity of his accomplishments and his office on to his Habsburg successors as in the allegori-
cal *Triumphal Chariot*, produced by Dürer and Pirckheimer for Maximilian in 1518 (published as
a posthumous woodcut in 1522; chapter 3). Thus is the imperial office embodied in this latest
holder, whose statue commemorates and perpetuates both holder and office, like a state portrait
in the halls of eternity, the sacred, if dynastic, chapel of the tomb. Here are fused all of the aspects
of sainted kings, akin to the apotheoses of ancient emperors, who then become revered ancestors,

who confer dignity and legitimacy to their heirs and their territories. Significantly, Maximilian places his own statue between his father—and predecessor in office—and Charlemagne, Frankish founder of the Holy Roman Empire of the German Nation seven centuries earlier. Maximilian thereby conquers mortality like the resurrected Christ or the community of the (kingly) saints, and his tomb ensemble, with him at its head, establishes an enduring center, a site for the fusion of the Habsburg dynasty with the dignity of the imperial office.

Later French royal tombs from the time of Charles VIII (d. 1498; St. Denis, destroyed) and Louis XII (d. 1515; St. Denis) showed the king or the royal couple as if in life, kneeling in their royal attire before a *prie-dieu* above the tomb, and eventually added the actual image of their own bodies, naked and dead.[139] Here resurrection and permanence above explicitly contrast with mortality and impermanence below, as in the tomb monuments at Brou by Maximilian's daughter, Margaret of Austria (d. 1530), although there without the upright, kneeling figures in prayer.[140] This triumph through death toward eternal life in reverence for God is also expressed for Maximilian in a posthumous woodcut (fig. 51), produced by Hans Springinklee with a text by Johann Stabius (the two had collaborated earlier on the *Arch*).[141] One striking feature of this woodcut is that the emperor, kneeling in prayer with full regalia before God the Father, is nonetheless presented by most of the saints featured in the *Prayerbook*: the Virgin, St. Andrew, St. Sebastian, St. George, St. Maximilian, St. Barbara, and St. Leopold. Except for his name saint and the patron saints of his two heraldic "heart shield" territories, Austria (Leopold) and Burgundy (Andrew), Maximilian here calls on military saints as his sponsors at the gate of heaven (Andrew's cross also adorned the banners of his armies). The portals are presented in the form of a triumphal arch with a porch, from which God, higher than the saints, addresses His petitioners, blessing: "I came before him with sweet blessings on his head I placed a crown of precious stones [akin to the ladder of jewels; i.e., sainthood and divine grace] and I caused him to rejoice at the sight of my countenance [as in the *Zaiger* miniature of the jeweled ladder]." The saints fulfill their role as intercessors, consistent with the cult of their relics and late medieval appeals for their aid: "Lord save the king and listen to us this day in which we invoke you." Maximilian's own words to God clearly display his sense of reciprocal mirroring of the emperor as His vicar: "Moreover, you O Lord are my supporter: You are my glory and you glorify my reign." Stabius's verses below extol Maximilian's reign, "*Germani gloria regni*," and point out that he now has attained eternal life.[142] Then the emperor is seen to be "united with Christ, with man, with God" (*unitus Christoque homique deoque*), and he is in turn evoked as a saint ("santusque vocari. . . . Sic pius e supera nos respice sede precantes").

Instead of this imagined apotheosis by his loyal court historian, Stabius, Maximilian's actual final hours are given in the account of his other court historian, Mennel, and they reveal the ultimate significance of his religious projects for Maximilian. In another posthumous commemorative woodcut of the emperor Hans Weiditz of Augsburg (fig. 29) shows Mennel reading to the dying emperor.[143] The text tells us that the books from which he read included "Cesari antiquissime et nobillissime Genealogie eius," the latter genealogy emphasizing the final two volumes of the *Geburtsspiegel* (see chapter 2), specifically the *Blesseds and Saints* [*Seligen und Heiligen*] *of the House*

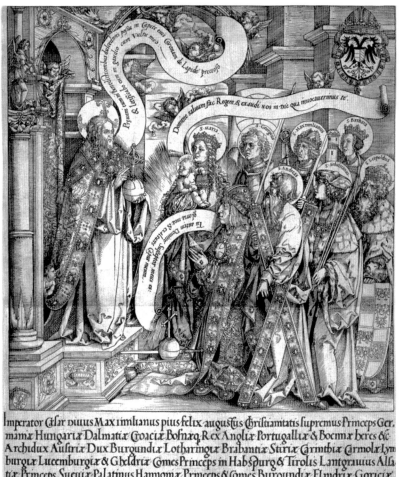

51

Hans Springinklee, *Emperor Maximilian Presented to Heaven by Patron
Saints*, 1519, woodcut. University of Michigan Museum of Art.
Museum purchase 1960/2.38

of Habsburg.[144] Below this scene, the same woodcut shows us the eulogy over Maximilian's closed
coffin, draped in the insignia of the Order of St. George ("sub Crucifixi et militaribus s. Georgi
insgnibus ad Sacrophagu deposito"). Indeed, the bulk of the woodcut is dedicated to celebrating
the importance of the Order of St. George among the other military orders of Christendom as
the most significant legacy of Maximilian. Surrounding a depiction of the Crucifixion lies a circle

of labeled arms of those orders, dominated at the foot of the cross by a crowned St. Andrew's cross within the chain of the Order of the Golden Fleece. In fact, this circle, the text declares, is a mirror (*speculum*) of these defenders of the holy cross, "Maccabees" sanctioned by both pope and emperor.[145]

On the subject of his piety and his religious ambitions, Maximilian himself should have the final word, in the form of yet another project that was never completed: the Arch of Devotion (*Andacht*, according to his memoranda), perhaps planned as part of his tomb, pictorial rather than architectural, like so many of his projects.[146] Intended as the sacred counterpart of the secular *Arch of Honor*, being devised then as well, this Arch of Devotion would also have had three portals, akin to the fusion of heaven with earthly imperial triumph in Stabius's posthumous woodcut. The right opening, Eternal Prayer (*ewig Andacht*) paid tribute to Maximilian's desired seven pious donations (*almuesen*), repeated again in his final will and testament. Each of the seven saints in Stabius's woodcut would have appeared here in the form of a statue, symbolic of each one having received a chapel of his or her own in a town within the realms of Maximilian. George is given pride of place by appearing first on the list and by receiving his chapel at the capital city of Innsbruck. The left portal, Sacred Treasure

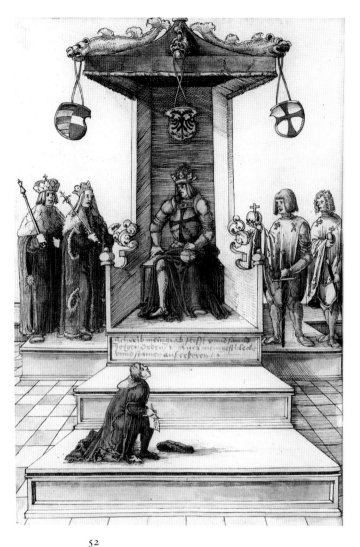

52

Jörg Kölderer, *Marx Treitzsaurwein Taking Dictation from Emperor Maximilian*, 1512, ink. Austrian National Library, picture archives, Vienna + signatures. Cod. Vindob. 2835, fo. 26f.

(*des schatz andacht*) pays tribute to the institutions that Maximilian desired to support, headed by his grave site (*Grabstift*) and an Innsbruck cloister for the ordained St. George brothers (rather than the knights of the larger order), whose red cross arms dominate the remaining cloisters. Finally, the central portal is dedicated to Bodily Prayer (*leibs andacht*), dominated by a pilgrim with a small shield of the arms of the Order of St. George on his hat. Then seven armed exclusive knights (*selstsam ritterschaft*) with swords and the gold cross of Burgundy would stand alongside other kinds of physical piety: annual penitential pilgrims (*jarpüss*), lay brothers sworn to poverty (*willig armuet*),

a nearly nude figure of abasement (*natürlich diemuettigkait*), priest and congregants of "new" devotions, and finally silhouettes (*schatten*) with the arms of the empire, Austria, and Burgundy to represent "contemplation of the end" (*bedenkung des ends*).

The title page of this imagined Arch of Devotion shows Maximilian, crowned and enthroned in the armor of the Order of St. George, whose shield hangs above him, balanced by the joint arms of Austria and Burgundy, alongside the central imperial arms above the throne (fig. 52). As Treitzsaurwein takes dictation at the feet of the emperor, two pairs of listeners bear witness to these plans. One pair is dressed in the garments of the order, as described for the *seltsamer ritter* mentioned in the central portal of "bodily devotion." The other pair is royal, and they wear a pair of distinctive crowns, one quite close to the archduke's crown of Austria sported by St. Leopold and featured at the top of the right tower of the *Arch of Honor*. This, then, is the royal and saintly ancestry of Austria and Burgundy under its own conjoined shield. Thus does the picture physically embody what its caption under the throne dictates on behalf of Maximilian: "Write [of] my Tomb institution and the Order of St. George as well as of my family and ordained descent."[147] Just like the *Prayerbook* project, this image establishing Arch Devotion was intended to represent a definitive act of pious donation by the emperor on behalf of his ancestors and his beloved Order of St. George, and it was these very thoughts that occupied Maximilian on his deathbed.

*Blessed be those happy ages that were strangers to the dreadful fury of these devilish
instruments of artillery, whose inventor I am satisfied is now in Hell, receiving the
reward of his cursed invention, which is the cause that very often a cowardly base hand
takes away the life of the bravest gentleman; and that in the midst of that vigor and
resolution which animates and inflames the bold, a chance bullet (shot perhaps by one
who fled, and was frightened by the very flash the mischievous piece gave, when it
went off) coming nobody knows how, or from where, in a moment puts a period to the
brave designs and the life of one who deserved to have survived many years.*

—MIGUEL DE CERVANTES, *Don Quixote*

5 | Shining Armor: Emperor Maximilian, Chivalry, and War

In the tournaments of Maximilian's day, early in the sixteenth century, after the various forms of single combat, jousts and fighting on foot, came a final form of combat: the melee, or general combat in teams.[1] This particular form of tournament combat was considered an especially vivid instance of the advantage ascribed to tournaments in general—namely, that they simulated the practice of warfare and offered peacetime exercise of military skills.[2] Indeed, in the depiction of his succession of battles and wars within the framework of his fictionalized prose autobiography, *Weisskunig*, Maximilian actually portrayed a world of politics that was practiced as warfare and a world of warfare that was practiced as if a tournament melee. In that text, foes on the battlefield are identified through their heraldic colors or coats of arms; they are virtually interchangeable, like their locations and episodes. They are essentially without motivations, either political or personal, yet bound by rules of warfare, and they fight as kings or generals on behalf of social groups but within an almost ritually isolated field of strife, distant from those societies.[3] In short, the tournament remains the model for this concept of warfare.

To understand the sections of *Weisskunig* that deal with Maximilian's military history, we must begin with his concept of the tournament, its ideals and its practical enactments. In the process, we discover a considerable overlap between concepts of chivalry in peace and war, plus a kinship between Maximilian's culture of warfare and his allied concepts of empire, piety, and princely magnificence.

In his woodcut frieze, the *Triumphal Procession*, the courtly retinue at the beginning of the parade features depictions by Hans Burgkmair of tournament knights in armor as participants in princely

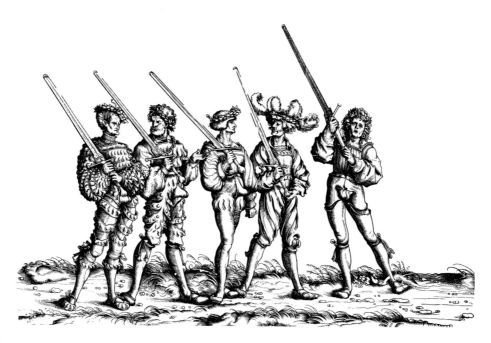

53

Hans Burgkmair, *Imperial Infantry Troops*, from *Triumphal
Procession*, ca. 1516–18, woodcut.

court life, directly after the clusters of hunting masters and musicians and court entertainers. The first
of these tournament contests to be presented in the sequence was the *Gefecht*, the hand-to-hand
fight on foot, with a woodcut depicting groups of five men each with a series of weapons used in
this particular form of tournament combat: flails, quarterstaves, lances, halberds, battleaxes, and swords
with shields of various kinds, including Hungarian shields (*pafessen*, or *Pavesen* in modern German)
(fig. 53). Most of these weapons were standard issue to the modern infantry soldier during Maximil-
ian's day, and the costumes of these warriors on foot corresponds exactly to the dashing outfits with
slashed sleeves, leggings, and footwear worn by the *Landsknecht* infantry of Maximilian's own army.

The next group of tournament participants in the *Procession* consists of both walking and
mounted groups in full armor, along with the following text:

> Much of his time was nobly spent
> In the true knightly tournament
> A source of valor and elation;
> Therefore, upon his instigation
> With knightly spirit and bold heart
> I have improved this fighting art.[4]

Once again, this armor is not adapted for particular kinds of tournament jousting and could as
easily have been worn on the battlefield by mounted cavalry officers, carrying swords and lances.

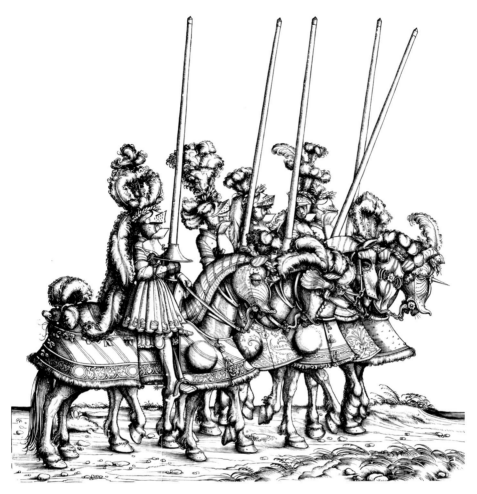

54

Hans Burgkmair, *Tournament Knights in Armor,*

from *Triumphal Procession*, ca. 1516–18, woodcut.

Then follow a series of particular kinds of equestrian jousts, ranging from a "joust of peace"
(because their blunted tips reduced the danger of mortality and served to splinter the lances
rather than disable the opponent)[5] to a "joust of war (*Rennen*, divided into no fewer than ten
different kinds, according to the armor and shields in use), with pointed lances and unprotected
necks (fig. 54). Distinctions are carefully delineated between this variety of jousts, according to
whether they occur over a barrier or as "ordinary," unseparated joust, with bolted protective
saddles and helmets or with simulations of battlefield conditions. In the tournament helms of
the *Gestech* (rather than the sobriety of field armor), colorful heraldic insignia or gaudy plumes
adorned the crest of the jousters. By contrast, with the combination of lighter armor, unpro-
tected neck area, and untipped lances, *Rennen* jousts provided risks akin to those of the cavalry
on the battlefield.

Maximilian so loved these varieties of jousting that he devoted an entire illustrated text project to lightly fictional recountings of his own exploits in tournaments. That book, *Freydal*, also remained incomplete.[6] Originally mentioned in the memoranda dictated to Treitzsaurwein around 1502, *Freydal* appears in a text manuscript with corrections by Maximilian (Vienna, National Library, cod. 2835, 2831*) and was accompanied by a volume of 255 miniatures, one of which is dated 1515 (Vienna, Waffensammlung). Corresponding to five of these miniatures are a quintet of woodcuts (after nos. 82, 88, 97, 101, and 159, respectively) by Albrecht Dürer.[7] The text includes sixty-four repeated cycles of the same pattern of a tournament, beginning with *Rennen, Stechen,* and *Gestech* or *Kampf* conflict on foot, and concluding with a festive mummery. That these events are based on actual encounters by Maximilian with lords and ladies at real tournaments is attested by a list on the first seven quires of the manuscript itemizing all of these noble personages. Yet at the same time the actual events are allegorized, not only by the idealized name of the protagonist but also by the ritualized repetition of the tournament activities in unbroken sequence. The premise of the cycle is a young knight's campaign to prove himself in tournament combat and thereby to earn honor and fame for his name: "... with the cultivation and honor of courtly classes, as befitted his noble being" (*mit den zuchten und eren hoflicher sitten, als sich seinem adellichen wesen zymbt*). Of course, the young knight is a nobleman; his father is a mighty prince (*ein gross mechtiger furst*), and he is born with noble virtue (*angeborener adellicher tugent und schuldiger eerbeweisung*). His father provides young Freydal with a suitably noble steed for his tournament journey as well as with armor and heraldry appropriate to his rank (his colors are white, red, and black, glossed as the colors of purity, fire, and bravery—fo. 5).

To be sure, the transformation of a tournament into an allegory was but a small step, given the interpretation of such elements as heraldic colors (or animals) in symbolic terms by late medieval participants. In addition, *Freydal* provides the admixture of allegory with documentation or autobiography, thereby elevating the significance of Maximilian's youthful activities onto a plane of greater significance. Yet we must not minimize the significance of the actuality of those tournament experiences for Maximilian. They effectively demonstrated his own prowess and confirmed his potential as a high-born noble before his peers, just as they underscored the validity of the many praise-filled descriptions in *Freydal* for each passing tournament accomplishment. In this vein, Dürer's woodcuts (fig. 55) can be seen to be careful copies from the models provided by the court artist, Jörg Kölderer. Each of these has a specificity of armor and heraldry (costume in the case of the mummery, no. 88) that ties it to a specific event, where victor and vanquished can be distinguished and identified, including Maximilian himself in the woodcut of the *Rennen* (no. 97), recognizable from the miniature by means of his red-and-gold striped colors.

If we turn to the Altdorfer woodcut at the top of the right edge of Maximilian's massive composite woodcut *Arch of Honor*, the virtues of this kind of tournament activity are made explicit in the accompanying verse (fig. 56):

From jousting and other knightly game
He derived great pleasure, also fame.

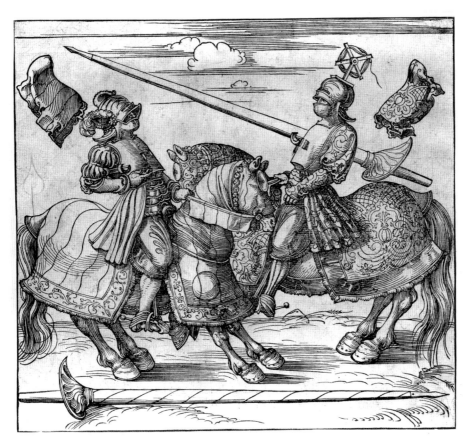

55

Albrecht Dürer, *Rennen (Italian) Joust*, from *Freydal*, 1516, woodcut.

Vienna, Kunsthistorisches Museum.

> By everyone it was believed
> That no prince ever had achieved
> Such excellence and reaped such praise
> Instead of the anguish of early days.[8]

Altdorfer's woodcut is a summary of all the activities enacted successively in *Freydal*. The armor of both the *Rennen* and the *Gestech* are included, and the crowned tip of the *Gestech* lance can be distinguished among other, untipped lances. Two by two, the mounted knights in armor seem to be paired as teams of *Rennen* and *Stechen*. In the left foreground, foot combat takes place with halberds between warriors with helmets and limited armor, and in the right foreground, masked mummers complete the tournament activities (one wears an exotic turban in accord with the foreign costumes favored at such events).

A precis of the values placed on tournament activities in *Freydal* can also be found within the pages of Maximilian's prose, fictionalized autobiography, *Weisskunig*, in which the training of the

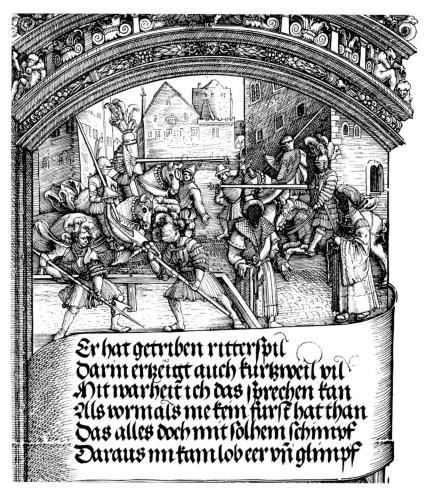

Er hat getriben ritterspil
darin erzeigt auch kurtzweil vil
Mit warheit ich das sprechen kan
Als wormals nie kein fürst hat than
Das alles doch mit solhem schimpf
Daraus im kam lob eer vñ glimpf

56

Albrecht Altdorfer, *Jousting Interests*, from *Arch of Honor*,
ca. 1517–18, woodcut.

young White King includes extensive training in the martial arts. Within a sequence of progressive
schooling in combat skills with various weapons (see below), chapter 46 treats "How the Young
White King Excelled in All Knightly Contests [*Ritterspielen*], Even in German and Italian *Stechen*":

> After the young White King had learned fighting on horseback and on foot sufficiently,
> he began to exert himself in the tournaments with *Rennen* and *Stechen*, because one who
> wished to become famous in such matters needs practice with deeds and not learning from
> books. . . . When he attained maturity and strength, he exerted himself by jousting in full
> armor [*in hohem Zeug zu stechen*] and surpassed everyone in it, because he had inserted his
> lance himself with such skill. He was constantly innovating and performed many a knightly
> court piece [*ritterliches Hofstück*]. When he ever had rest from wars, he had tournaments at

his court and was there himself. His court thus became known throughout the world for this, so that princes, counts, lords, and knights came from many lands, but they were always conquered by the [White] King. To this should be noted that he extended his knightly hand as befitted kingly honor.

Herein lies the attainment of both reputation and honor in the tournament, where success and gentlemanly sportsmanship jointly elicit respect. The White King can distinguish himself as a leading chivalric combatant as well as a gracious ruler.

For Maximilian, military victory overlaps with tournament victory. This attitude carried over in terms of arms and weapons, which were produced so avidly for Maximilian and often employed interchangeably between tournament field and battlefield. This is particularly true of the field armor, known as *küriss* (in the descriptions of the tournament knights of the *Triumphal Procession,* nos. 42–43). This is the same armor worn by Maximilian in the Burgkmair equestrian print of 1508 (see fig. 35). As Tilman Falk discovered in his Burgkmair researches, the connection between these depicted armors in the woodcuts and the latest armor actually designed for Maximilian was intimate, for Burgkmair and his father lived in close proximity to the emperor's leading armorers in Augsburg, the Helmschmieds.[9] In fact, Lorenz Helmschmied (1445–1516) was the leading armorer of the late fifteenth century.[10] He designed important armor ensembles for both Frederick III as well as for Sigmund of Tyrol (Vienna, A62) before becoming in 1491 an official court servant of Maximilian. No fewer than three *kürisse* for Maximilian are ascribed to Lorenz Helmschmied, including the one that he wore in triumph on 29 September 1480 into Luxemburg (Vienna, A60). Lorenz's son, Coloman Helmschmied, went on to follow his father's later works as the most celebrated "Renaissance" armorer for Maximilian, and he also assumed ownership of Thoman Burgkmair's house in Augsburg after the elder Burgkmair died.[11] What the works of all these Helmschmied family representatives display is the dominant design for Maximilianic armor—both jousting and field armor.

Later armor by Helmschmied for Maximilian took on an increasingly rounder and simpler form, termed "classical" by the historians of armor, in contrast to the angularity of the "baroque Gothic" (fig. 57). Dominated by overlapping, scalelike plates and more regular patterns of decoration, these suits because increasingly regularized and evolved into the *Riefelharnisch,* or fluted armor, that also became known as "Maximilian armor," because of the emperor's role in promoting this innovation of form and technology. This device of fluting provided maximal strength with greatly reduced weight, so it had particular advantages over smooth plate in field combat, although the heavier, smooth armor remained popular for tournaments. (Increasingly, armor became more specialized, such that instead of an all-purpose design like the *küriss,* particularized ensembles were developed for combat, *Rennen,* tournament jousts, or tournament foot combat.)

Innsbruck was the other major center for armor made for Maximilian.[12] Although this Tyrolian center already had an active armor foundry under Maximilian's predecessor, Sigmund, the great flowering coincided with his accession in 1490. These designers frequently were called on to produce specific commissions, often for Maximilian and his relatives but also often given as

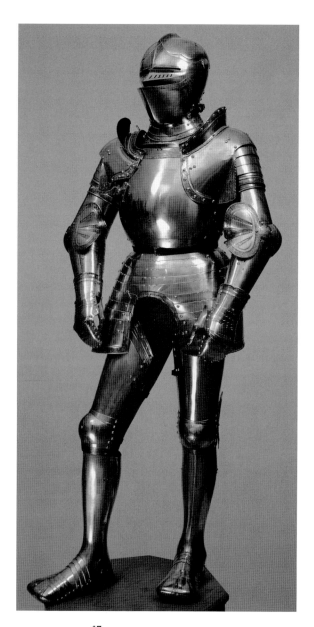

57

Coloman Helmschmied, *Küriss Armor for War and Tournament*, produced at Ambras for Count Andreas von Sonnenburg, before 1511. Vienna, Waffensammlung, A310. Vienna, Kunsthistorisches Museum.

lavish gifts of state diplomacy to leading supporters or desired allies. Some of the motivation for this great expense emerges from the pages of *Weisskunig*, specifically from chapter 48, "How the Young White King Was Skillful in Metal-Working and in Armor Manufacture." The text explains:

> When the young White King learned the knightly games and exercised his body therein, he found that where he otherwise wished to attain praise and fame here, he would also have to learn and master all arts of armoring. He had experienced for himself that often a joust was completed not by means of bodily strength alone, but also with the skillful use of armor. So he learned so industriously that he understood all the masterpieces of armor manufacture and even discovered many new art-concepts that were hidden from others. One could not engage in any knightly game or speak of one without his knowing as an armorer how to give it its proper style and how to judge it. . . . The king spoke to his armorer, "Design according to my taste, for I shall test the joust, not you. Tell me, have you ever jousted [*gerannt und gestochen*]? . . . But this young king surpassed his and all other arms-masters. They followed him and learned much from him. . . . Furthermore, the king erected in his city Innsbruck a great armory. Therein he had many *Renn-* and *Stechen* suits made, which I am unable to describe. . . . The king caused to be made in Innsbruck many cuirasses [*Kürisse*] with this skillful tempering, which was hidden from all others, for kings, princes, and mighty lords. Whoever he offered up [*verehrte*] such a cuirass had great joy in it. For what matters to a king more than armor, in which his body is sheltered in battle?[13]

The leading Innsbruck armorer, an innovator of form worthy of comparison to the Helmschmieds of Augsburg, was Konrad Seusenhofer (documented 1500–d. 1517).[14] Seusenhofer

signed two successive contracts to produce armor exclusively for Maximilian, the first in 1504, the second in 1509. His forte was for exotic and imaginative forms of armor, chiefly the famed "pleated skirt" armor, or *Faltenrock Harnisch*. These largely ceremonial suits made distinctive and personalized gifts, so Seusenhofer was the favored creator of Maximilian's donations.[15] The fantastic creations of Seusenhofer continued in other armor forms imitative of other costume, such as the evocations of slit cloth in the manner of *Landsknecht* uniforms, already present in an unpolished suit for Charles V (Vienna, A186; fig. 58). In such costume armor pieces, the fantasy creations of Seusenhofer and his contemporaries, particularly Coloman Helmschmied, reaffirm the festive character of tournament jousts, so often held on the occasions of weddings or alliances between princes and usually completed by costumed balls and mummeries in dress akin to the fool's mask or bird mask of the more flamboyant armor, as in the fictional *Freydal*.

Decoration, such as the sparking flints of the dukes of Burgundy and the Order of the Golden Fleece, used for the armor of a youthful Charles V and intended for (at least) potential field use, reveals a particular kind of formal display in military affairs that can also be found amid the field weapons made for Maximilian: swords and artillery pieces. Heraldry dominates the decoration on the most magnificent of all the swords created for Maximilian: his ceremonial sword of 1496 by Hans Sumersperger (Vienna, Schatzkammer).[16] The heraldic arms that adorn the blade, hilt, and pommel of this piece are also echoed on the gun barrel of the *Lauerpfeif* ("ambush pipe"), the enormous artillery piece cast for Maximilian in Innsbruck and preserved in a model of 1507 by Peter Löffler (Vienna, Waffensammlung, A 74).[17] The inspection of this cannon by Lhotsky revealed the arms of both Burgundy and Austria, as in the decorative heraldry on the ceremonial sword. Thus, this military piece, certainly part of the essential artillery of Maximilian's army, as the miniatures of the *Triumphal Procession* reveal, both incorporated and defended *das edle Hausz von*

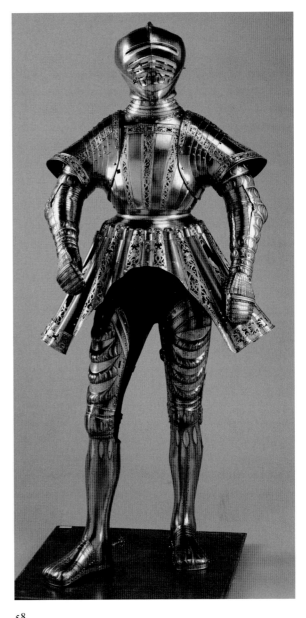

58

Konrad Seusenhofer, *Faltenrock Harnisch* (pleated skirt armor), produced for youthful Charles V, 1512–14. Vienna, Waffensammlung. Vienna, Kunsthistorisches Museum.

Oesterreich ("the noble House of Austria"). In essence, the heraldry of both sword and cannon serves as more than identification and adornment of their martial possessor, Maximilian; those codified signs of territorial possessions stand in reciprocal relationships of power with those instruments of war. Like the mighty ancestral bronze statues at the tomb of Maximilian, the ceremonial sword and the cannon stand as guarantors of Maximilian's cumulative House of Austria, even as they derive some of their own strength in either ceremony or battle from the total, modern strength of that house (and its army). The general heraldic preoccupations of Maximilian were thus put directly to the test in battle and defended by the Habsburg ruler. If the *Arch of Honor* commemorates the result of victory and defense of these territories (as well as the boldest claim to territories in any of Maximilian's art works), then it is through military conflict that those claims can be enacted and confirmed. Hence, heraldic decoration is bound up inextricably with these martial objects as particular proofs of the rulership of Maximilian in both peace and war.

In the pages of *Weisskunig*, we can discover a charming vignette of the role of tournaments as models of combat in the education of noble children. Chapter 17, part of the second section on the proper education of the young prince, follows hard upon the child's baptism. This chapter, "How the Old White King Associated His Young Son with Noble Youths, in Order to Pursue Entertainments [*Kurzweil*] with Him," speaks chiefly about the boy's gifts for language acquisition and his precocious abilities as a diplomat and future ruler, but the illustration (no. 19; fig. 59) by Hans Burgkmair shows a number of military and tournament activities as the proper kind of noble, boyish "entertainment." Included among them are toy cannons, archery with bow, archery with crossbow (at birds in a tree; on the other side of the tree the young naturalist offers a crust of bread to those same birds), and tabletop tournament with toy jousters in the armor of the *Stechen*. In each of these activities, the young White King, alias Maximilian, is clearly identifiable by means of his distinctive tunic and laurel crown, so this illustration offers a kind of prophecy about his future talents in the hunt, the tournament, and the battlefield. In fact, it is the young White King whose *Stecher* in the toy joust has triumphed by squarely hitting and toppling the toy opponent. Thomas and Gamber have uncovered just such toys, in this case two mounted *Renner*, in the Vienna Museum sculpture section (inv. 81, 82).[18] In all likelihood, these bronze toy jousters, ascribed to the same Innsbruck armor makers, were the actual playthings of the young Charles V and Ferdinand I. Much the same kind of boyhood amusement, foreshadowing later prowess in warlike activity, is illustrated in the drawing (no. 19) of the Latin autobiography, *Historia Friderici et Maximiliani*, where his exercises consist of slinging stones, playing with a toy cannon, and shooting crossbows at a target made from a barrel.[19]

From such boyhood activities the taste for tournaments and other paramilitary training takes its cue, and the later chapters of *Weisskunig* concerning the maturation of the prince stress the variety of martial activities he absorbed and mastered. The sequence begins with chapters 37 and 38, the two kinds of archery, handbow from horse and foot as well as crossbow and steel bow. Leonhard Beck's woodcut illustrations indicate that the training ground for these nontournament skills was the archery match with target (no. 38) but primarily the hunt: from horseback

59

Hans Burgkmair, *Children's Mock Tournaments*,
from *Weisskunig*, ca. 1512–18, woodcut.

with bow (bird as target; no. 37), from horseback with crossbow (ground animals as target; no. 39), and in the mountains (chamois as target, no. 40).[20] Such pastimes, practiced in tournaments, also had possible utility in battle, as is clear from the opening lines of chapter 37, concerning the "Turkish" bow: "The old White King had at his court many upright and knightly Husars, who jousted [*Ritterspiele trieben*] on horseback with handbows, according to their custom and who often used it particularly in war. Now the young White King had the capacity, so that he wished to surpass everyone in knightly games. Thus he also learned to ride like the Hussars and to shoot with the handbow."

Another of the overlaps between tournament practice and military actions in battle was combat on foot. Traditionally shunned by noblemen, whose equestrian activities in both joust and battle seemed at odds with this kind of "pedestrian" combat, this infantry like strife was actually promoted by Maximilian.[21] As noted above, we find the *Gefecht* as one of the four combats illustrated by Dürer among the *Freydal* woodcuts. After featuring a sequence of learning experiences in which Maximilian masters various combat weapons and shields in turn, the *Weisskunig* finally recounts "How the Young White King Also Fought Masterfully in Armor" (chapter 45):

When now the young White King had learned how to fight unarmored and with *Pavesen* and *Tartschen* [shields], he considered how particularly needful it would be for him to be able to fight armored on horse and on foot, for in such combats is a mighty [*grossmächtig*] king called upon most. With great earnest seriousness he learned how to fight in armor, at first on foot with the pike and the halberd, afterwards on horseback with the knightly sword and the short dagger, even with the mace and spear [*Reisspiess*].

This chapter is followed by his successes and accomplishments in formal jousting (*in allen Ritterspielen, auch in deutschen und welschem Stechen*), as was the case in the *Triumphal Procession*. The interplay between serious play within tournaments and life-and-death combats in battle thus renders the value of jousting, even on foot, more essential. Particularly with the variety of weapons and armors available to Maximilian's enemies as well as his own noble soldiers, peace-time practice in these skills was imperative for the inevitable outbreak of war shortly thereafter. Attention to details in training leads to later successes in actual combat. Chapter 47 ("How the Young White King Became Familiar with Riding and the Characteristics of Horses") follows with the homily, known in English as "for want of a nail, the shoe was lost":

> Thus must a mighty lord know all kinds of horses and have them properly bridled. Once one of his grooms spoke to the king, telling him that he would surpass his own riding-master. The king answered him by saying: "There is an old proverb, a nail holds a horse-shoe, a horseshoe holds a horse, a horse holds a man, a man holds a castle, a castle holds a city, a city holds a land, a land holds a kingdom, and I say to you: behold me and my might, and you will not say that a stable-hand [*Knecht*] should be over his lord. For whatever lord lives in trusting to his stable-boy and in the power of his horse, he will be deceived and conquered by his enemies. Whichever lord, however, understands a thing for himself, need not abandon himself to another."

This passage could almost be a doctrine for the entire training program of Maximilian's martial arts, not to mention most of his other practical and mechanical arts. His ideal desire as given shape in the chapters of *Weisskunig* was to be the master of all the skills required of his subordinates, especially in battle, so that he could lead by example and never have to depend on lesser men to make his executive decisions. It is significant that he uses the same term, *Knecht*, for his stable-hand as he uses for his infantry land forces in battle, the *Landsknechte*. As we have seen above, the training in *Landsknecht* weapons and combat on foot was also an integral part of military training and the repertoire of needed skills.

Thus, it is also fitting that the subsequent chapter (no. 48, with Burgkmair's woodcut; fig. 60), already examined above, consists of the White King's assimilation of all the skills needed for the production of armor, and in that text, too, the White King tells his craftsmen the principles of their trade; in this case, he becomes a true innovator because he has also had the experience of using armor in both tournaments and battles. "Where does one find a king, who does not

60

Hans Burgkmair, *Maximilian Supervising Armor Production*,
from *Weisskunig*, ca. 1512–18, woodcut.

follow his armor-master?" asks the text, rhetorically, in amazement, as it avers, "But this young
king has surpassed his and all other armor-masters." Also of importance in the context of his
supervision of the *Landsknecht* infantry forces is the adoption of knightly armor making for the
humbler but broader needs of an infantry through the Innsbruck foundries. These more pro-
tective armor shells were worn by the elite corps of the infantry, the so-called *Doppelsöldner*, or
doubly paid mercenaries, of the armies. Such soldiers from the infantry can be seen in the later
woodcuts of the *Triumphal Procession* (nos. 126–28), bearing their weapons of arquebus, lance,
or sword. In *Weisskunig*, the pattern of military chapters is repeated, wherein the young king
sees the desirability of mastering this particular martial art in order to have an advantage over
his enemies.

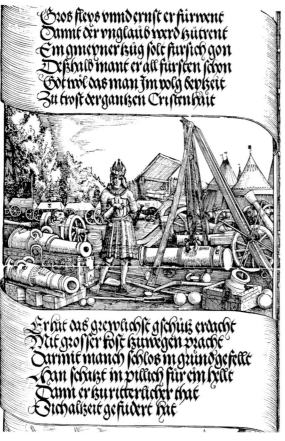

Gros fleys vmd ernst er fürwent
Samit der vnglaub werd zůtrent
Ein gmeyner zůg solt fursich gon
Desßhalb mant er all fursten schon
Got wil das man jm volg beyzeit
Zů trost der gantzen Cristenhait

Er hat das grewlichst gschütz erdacht
Mit grosser kost zůwegen pracht
Darmit manch schlos in grůnd gefellt
Han schütz in billich für ein helt
Dann er zů ritterlicher that
Octzalizeit gefůdert hat

61

Albrecht Altdorfer, *Maximilian's Interest
in Field Artillery*, from *Arch of Honor*,
ca. 1517–18, woodcut.

Artillery formed a major segment of the military resources of Maximilian, along with infantry and cavalry. Thus, when chapter 49 outlines "How Elaborate [*kunstreich*] the Young White King Was with Artillery," it underscores the vital importance of this technology for his campaigns. Already in the *Arch of Honor* Maximilian's love of artillery had been celebrated among the Altdorfer side towers that proclaimed his personal virtues and interests (fig. 61):

> For strong cannons, he declared,
> no expense should now be spared.
> Many castles he then tamed
> for which a hero he's acclaimed.
> That was Maximilian's way
> to do a knightly deed each day.[22]

In the depicted woodcut by Altdorfer for the *Arch of Honor*, Maximilian stands alone within the confines of the *Wagenburg*, composed in the background of linked and covered carriages. He is surrounded by cannon and mortars of all calibers as well as by the shot and cannonballs to be used in firing these weapons. A wooden winch in the foreground can be seen hoisting one of the larger cannons off the ground in order to place it into position for firing, either elevated and braced or else in a portal wheeled carriage. Such artillery was intended to be part of the *Triumphal Procession* as well, between the banners of the Kingdom of Lombardy and the Sacred and Secular Treasures. Although the woodcut was never executed, an image of the artillery was produced within the *Procession* miniatures shortly after 1512 by a member of the Altdorfer workshop.[23] Thomas's close examination of these three miniatures reveals them to be a virtual catalogue of the kinds of artillery available to Maximilian. Also included in the miniatures are carriages with the hand weapons of the infantry, including both halberds and pikes, as well as carts for the gunpowder crusher and tents.

Although art historians are not accustomed to considering artillery pieces as art objects, such items clearly received extensive decorations from their bronze-casters. Moreover, until the standardization of their calibers, each cannon had to have its own projectiles specifically made; hence, each was treated as a unique individual, even receiving a name.[24] An early surviving example used by Maximilian is the *Hauptstück*, made in Innsbruck by Jörg Endorfer in 1487 and named "Catherine" or "Old Kate" (*Alt Kattel*).[25] The same rich haul of copper from Tyrolean

mines that also made Innsbruck a proper site for the production of the bronze statues for Maximilian's tomb had already made it an ideal center for bronze cannon foundries by the time of Maximilian's great-uncle and predecessor, Archduke Sigmund.[26] Adorned with a rich decoration of heraldic arms of Maximilian's claimed territories, many of these cannons proclaim the ownership and greatness of Maximilian, even as they serve the particular function of expanding or protecting those individual territories that constituted the Habsburg dominion. As in the case of tournaments, so too in warfare are such heraldic claims and princely magnificence inextricable from the power that supports them. As Thomas proclaims: "In a comprehensive sense the older kind of armament is probably bound up closer than any other type of art object to the events of state-political events."[27]

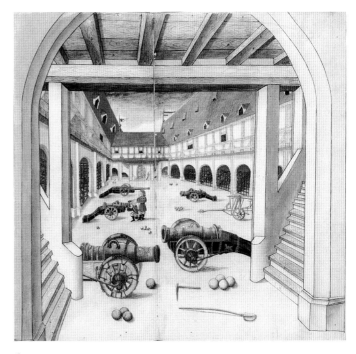

62

Jörg Kölderer, *Innsbruck Armory*, from *Zeugbücher*, ca. 1507, illuminated miniature. Austrian National Library, picture archives, Vienna + signatures. Cod. Vind. 10824.

The *Triumphal Procession* miniatures are only the most luxurious visual record of Maximilian's artillery, but the fuller inventory of his cannon and other weapons was recorded with both text and pictures in a series of three luxury volumes, the *Zeugbücher*, arranged according to territory and ordered after 1515.[28] The supervision of the inventory was the responsibility of Michael Ott, the *Hauszeugmeister*, or court master of ordnance. Prototype drawings of the weapons in three earlier volumes (ca. 1503–7; fig. 62) have been ascribed to the studio of the court artist, Jörg Kölderer, following the survey of the arsenals by Bartholomeus Freisleben (d. 1511), *Hauszeugmeister* under Sigmund as well as Maximilian.[29] In the preface, dated 1503, to the *Zeugbuch* of Freisleben, Maximilian is praised as the greatest field general in terms of weapons in all of history, and he is explicitly compared to Julius Caesar, Pompey, Scipio Africanus, Constantine, Charlemagne, and Barbarossa. In the first two (of three) parts of the inventory, illustrations accompany the descriptions of cannons and other weapons; the creations for Maximilian occupy folios 32–129. The weapons are arranged according to their size, or caliber, beginning with the *Haupstücke*, the heaviest artillery. Each is given its name and distinctive personality in the manner we have been considering; a few are accompanied by plucky verses to show their might. Some provide a distinctive range of origins, almost a summary history of the important developments during the fifteenth century in cannons. The *Scharfmetzen* were all named after famous women of antiquity and myth, 137 of them suggested in 1516 by Dürer's

learned Nuremberg friend, Willibald Pirckheimer.[30] *Basilisks*, as one name ("Crocodile") implies, were usually named after reptiles or birds.

We can interpret the significance of his arsenal for Maximilian by returning to the idealized claims of the text of *Weisskunig*. Chapter 49 addresses this vital subject, "How Clever the Young White King Was with Artillery":

> The young White King in his youth had great joy, curiosity, and inclination for all artillery and related matters, such as sulphur and saltpeter. He expended many a thought on artillery. . . . When he came to rule, he built in his kingdoms many great arsenals for war needs and invented wonderful new cannons. . . . And wherever he positioned himself before some castle or city, he rendered it easily assailable in only a few days or even hours. The king made these crafts in the fear of God and for the sanctity of his soul and in perfect silence. . . all kings were worried about his great good guns and his brave people. How wonderful this king was! And he conducted all of his wars exclusively according to justice. He was the bravest, most righteous, and most merciful. Should anyone think that I have said too much here, then he should not listen to my text, but rather ask the learned scholars or read history.

The woodcut illustration (no. 51) to the *Weisskunig* chapter on artillery pays tribute to the technological innovations by Maximilian. Burgkmair shows the king in consultation with his casters, as he inspects a large, decorated cannon already on its wheeled carriage. Scattered around the foundry are cannonballs of various sizes as well as smaller field guns and a small mortar (on which Burgkmair placed his initials). In many ways this ensemble of weapons echoes the variety of products displayed in the Altdorfer woodcut from the *Arch of Honor*, but in keeping with the text's ongoing assertion of Maximilian's mastery of all crafts, surpassing even the skills of his specialized craftsmen, he is shown as the inventor and supervisor of these works.

As the text of *Weisskunig* makes clear, artillery was an essential part of Maximilian's military tactics. Indeed, it was an indispensable part of modern warfare throughout Europe, whether employed by Turks or French, and the widely held cliché that noblemen lamented the advent of these arms as "devilish instruments" (to use the words of Don Quixote) simply did not hold for Maximilian and his army.[31] Siege weapons and portable cannon offered an additional advantage (or at least parity with an enemy) in battle alongside both infantry and cavalry, the other two arms of attack. As Hale contends: "By the second decade of the sixteenth century, when cannon and portable firearms first became really effective on the battlefield, they were owned by all the powers . . . [and] revolutionized the conduct but not the outcome of wars."[32] In this light, it was his efficient and standardized organization of artillery that gave Maximilian a competitive advantage in warfare with cannons. He helped to change artillery attacks from ponderous and immobile siege weapons to lighter, more versatile and transportable guns, whose standard calibers and stronger castings made them both efficient and durable. Like the idea of a royal standing army, the portable cannon had been utilized since the midfifteenth century in France, so that many of

Maximilian's military priorities were reactive to his traditional foes. Nonetheless, he strove always to provide technological innovations and efficiency for his artillery, and *Weisskunig* provides the apology or special pleading for his view of this element of war. Yet at the same time, as the *Zeug-bücher* demonstrate clearly, he took a deep, personal interest in such cannons as distinctive objects, each with its own name, personality, decoration, and even verses. Thus, armaments of this kind were intricately bound up in the same kind of heraldic displays and valorous self-assertion as knightly armor or any other weapon of virtuous combat. As *Le Jouvencel*, a midfifteenth-century Burgundian romance by Jean de Bueil, points out to the ideal knight: "One should take every advantage in war, for faults are always dearly paid for. And one should always accomplish one's purpose, if not by force, then by cleverness."[33]

Also included in the *Zeugbücher* were the arsenals of weapons for the infantrymen, or *Land-sknechte*: pikes, halberds, shields, even ropes, pulleys, tents, and gunpowder. In short, all of the objects for foot combat, tested by the White King, were included with the artillery in Maximilian's visual inventories. And these were dominant weapons for the large infantry conflicts of the early sixteenth century. Here, too, we need to examine an apparent conflict between Maximilian's love of tournament valor and armor, on the one hand, and his warm promotion of infantry on the other. Another of the clichés of military history is that the ideals of the knightly class on horseback were eclipsed by the rise of modern, large-scale infantry masses. Certainly the defeat of Charles the Rash by Swiss pikemen in 1476–77 provides evidence for this view, and Maximilian would have been acutely conscious of the tactical narrowness of his aristocratic, Burgundian father-in-law against this kind of disciplined phalanx of pikemen.[34] Of course, on one level, the innovations in armor were designed not merely to transfer the equestrian combats from peacetime tournaments into wartime battles; they also served expressly to protect a noble warrior against those very pikes and arrows of the emerging infantry. Thus, some of the technological innovations of "Maximilianic" armor—particularly the pleating process on rounder shapes that at once increased surface resistance while lowering the encumbering weight of a knight—can be seen as a response in favor of mounted knights in their combat against pikemen (or archers).[35]

But Maximilian responded to the standing army of the French kings as well as to the infamous Swiss mercenaries with his own assembled, disciplined troops; indeed, he is known to history as the "father of the *Landsknechte*."[36] Once again, the paradigms of knight/warrior and professional infantryman overlap, and the real situation in armies is a complex blend rather than an absolute contrast of these two types. Just as for the White King, such infantry skills were important now for the nobles who led other soldiers into battle and even fought alongside them, dismounted from their traditional perches atop horses.[37] For example, Maximilian himself led his troops into battle with a pike on his shoulder in the battle of Ghent (June 1485).[38] In addition, the common trait of valor linked both infantry soldiers and noblemen; no longer was the distinction between them significant in a kind of warfare increasingly dominated by professionals. "Nobles had become career soldiers, and professional soldiers ennobled."[39] Maximilian delegated commands to a number of noble, independent lieutenants, particularly Duke Albrecht the Courageous of Saxony

and Prince Rudolf of Anhalt.[40] The example of the Swiss dictated that units, rather than individuals would be decisive in future battles. Thus, Maximilian strove in vain at the annual Diets of the empire for approval of a permanent, standing army, and he made many of the same kinds of reforms in his own forces within the Austrian lands that were under his direct control.[41] Led by nobles on horseback, these fighting units were composed largely of infantry.

In addition, the *Landsknechten* derived particular pride and visibility by means of their colorful costumes, and they participated in the organization of the armies under the same heraldic insignia that often appeared on armor or artillery. The uniforms of the German army were famous in their day for emulating the fashionable "slashed" garments of nobles as well as the prominent codpiece and feathered beret of jaunty modishness.[42] These uniforms, in turn, were themselves imitated in the exotic armor of Konrad Seusenhofer and Coloman Helmschmied, mentioned above. That such uniforms were sources of considerable pride, both for their wearers as well as for their countrymen, can be seen in the numerous prints by Dürer and his contemporaries of such soldiers in their modish garments; the nationalist orientation of such works is confirmed by the production of opposing images of the German soldiers' chief antagonists, the Swiss.[43]

Moxey's examination of the texts and images of soldiers by Dürer's followers in Nuremberg confirms that these figures incorporated feelings, such as the following, spoken by a standard-bearer (early 1530s) by Sebald Beham:

I want to let my flag fly
In a just and worthy war
And diligently serve a lord
Who makes war for honor and renown.[44]

Already at the turn of the century, Dürer's engraving of the *Standard-Bearer* (B. 87, ca. 1502–3) features the principal heroic figure from the ranks of the *Landsknechten*, a selection confirmed by the Swiss soldier-artist, Urs Graf in his majestic *Standard-Bearers* (such as the 1514 chiaroscuro drawing in Basel).[45] The Dürer figure is clearly identifiable as one of Maximilian's troops, because his banner bears the device of the Golden Fleece, the St. Andrew's cross housing a pair of sparking flints. Flints and Andrew's crosses are virtually ubiquitous as the decorations of standards for Maximilian's armies, as seen in the battles depicted on the triumphal floats of the *Procession*. Like the military Order of Saint George, the banner of the Golden Fleece, inherited by Maximilian from the armies of his father-in-law, Charles the Rash, gave the troops a sense of identity with their noble leader and a kinship with the trappings previously reserved, like armor, for the noble warrior. This kind of organization under such standards was the inevitable consequence of the new kind of national army after the midfifteenth century, for infantry groups were organized under the banner of the prince rather than under the feudal sign of an individual commander.[46] Uniforms and standards also provided military discipline and organization for the vastly larger forces led into battle. They also led to the extinction of military heralds, who had formerly served to distinguish the alliances of the complexes of groups under varying heraldic insignia, and to the rise of drummers, fifers, and

trumpeters as instruments of military cohesion.[47] The striking presence of these newer elements is readily apparent in images, such as Altdorfer's etchings of 1510 (W. 109–10) of a *Landsknecht* fifer and a drummer, and especially in the *Triumphal Procession* woodcuts (ascribed to Leonhard Beck, nos. 115–17), where the trumpeters and drummers, preceding heralds, appear on horseback with imperial flags.[48]

In many respects, then, this new, disciplined, large-scale army was seen by Altdorfer to be a projection of the emperor himself, bearing his arms and carrying out the skills that he refined in himself as its leader. This is the same message of Maximilian in the role of leader that is celebrated in Altdorfer's woodcut with soldiers in camp on the left tower of the *Arch of Honor* (fig. 63). Wearing his imperial crown and standing in the center amid armored soldiers with various weapons, Maximilian is celebrated by Stabius's text for his ability to converse in seven languages. These several images suggest an important moral for Maximilian: to stress his integrative leadership, his ability to provide "close relations" and to call on allies in times of great war [*grossen krig*].

Thus, for the emperor there was a considerable carryover from the personal display of heraldry in a tournament to the use of such arms in standards for his army in war. By no accident, the identification of the various armies in *Weisskunig* is provided by colors: Maximilian is the White King, the French are blue, the Hungarians green, and so on; other forces are identified by their heraldry (the duke of Burgundy is the "King of Flints") or symbolic animal attributes, almost like totems (the doge of Venice as the king of fish, or Ludovico il Moro Sforza as the king of the serpent, because of the heraldic device of Milan).[49] Both the cannons and the infantry that he marshaled in conjunction with the traditional mounted nobility of the cavalry bore his personal arms, which were the very same Burgundian arms that had served as the nemesis of the Valois kings of France throughout the fifteenth century.

63

Albrecht Altdorfer, *Maximilian Converses with His Troops*, from *Arch of Honor*, ca. 1517–18, woodcut.

If such diversity of men could unite under the emperor's own standard, then in a larger sense the triple-armed military branches, too, were united under his personal leadership. For that reason, Maximilian felt himself compelled to be the master of all skills required of his separate forces: artillery, infantry, and cavalry. All of these armed forces played major roles in his battles, and all are featured in varying degrees within his pictorial commemorations of his military campaigns. These consist largely of the stylized triumphal floats of the *Procession* and of the series of individual battles in both the *Arch of Honor* historical scenes and the illustrations to *Weisskunig*.

What is striking about all of these images of war is that they contradict the cliché of military history that sees mounted and armored knights as incompatible with either modern mass infantry with pikes or else with modern artillery for siege or battle. Repeatedly, the visual images confirm for Maximilian the complementarity of these military forces alongside one another in conflict. We see the respective units fighting their counterparts, cavalry against cavalry and infantry against infantry. We see the degree to which war is an offensive and tactical pitched battle, in contrast to the defensive resistance of cities behind bastions that would develop later in the sixteenth century.[50] Cavalry still had an important role to play as "shock troops," who could either help to break a siege or disperse the equivalent arm of the rival army.[51] This very continuity from the tournament to the battlefield in combat on horseback (with the new techniques of mounting or couching lances into hooks on the armor)[52] meant that both the armor that distinguished them and the chivalric values that continued to sustain them carried over for noble warriors within the modern army. Thus, it should hardly surprise that the *küriss* could be modified for particular tournament use and then returned to its general, field-armor function for the same noble owner.

The other chief element about the new army was its overall subordination to leadership by the king or emperor rather than the separate feudal forces of earlier centuries. Personal honor was exemplified by the sovereign, like the uniforms and standards that consolidated the armies under his banner, but the honor and fame of service to that sovereign was the goal and the result of victory on the battlefield.[53] The Burgundian military ordinance of 1473, a model inherited by Maximilian from his father-in-law, Charles the Rash, argues for its captains: ". . . the duty . . . to which the love and obedience that they owe toward my said lord should principally move them, and for the exaltation of his house, and also their own honor and renown, which is found in the way my said lord can, by means of their good service, achieve the defeat of his enemies."[54] This military loyalty, founded on admiration and service to the sovereign, is a feudal chivalry transmuted into what Vale has dubbed "national chivalry," confirmed by the rewards to soliders of knighthood and admission to chivalric orders as a result of their deeds on the battlefield.[55]

In this respect, then, the charismatic leadership and the sharpened skills of Maximilian in all aspects of combat were the twin pillars of his ability to command his troops, whether nobleman or *Landsknecht*. An example of this leadership is provided in the text of *Weisskunig* for the Battle of Therouanne (chapter 75). In this anecdote, it is the valor and skill of the White King that distinguish him rather than his title or trappings:

The young White King captured a notable nobleman in the battle, whose life he spared. But the nobleman did not know that he was the king, but instead held him to be a captain. When the battle ended and the young White King dismounted, sat down on a stack of logs, and removed his helmet in order to rest, the noble prisoner saw his face and thought: This is not the young White King, for they would not have let him go into battle, but rather for a captain, who leads such an army, he is too young; on account of the reverence, such as one only shows to a king, he thought that it must be someone special.

Then the White King commands his noble prisoner to report back to his lord, the Blue King, that the battle has been lost; of course, the Blue King is nowhere near the field of battle, so he serves as a foil to the bravery and accomplishment of the young White King.[56]

The link between tournament valor and military victory, between personal grace and divine favor, is made explicit in the generalized, introductory woodcut to the historical scenes on the *Arch of Honor*. This woodcut image shows a richly armored Maximilian standing alone on the field of battle, sword in hand (fig. 64). He is circled on the ground by the very items that we have considered

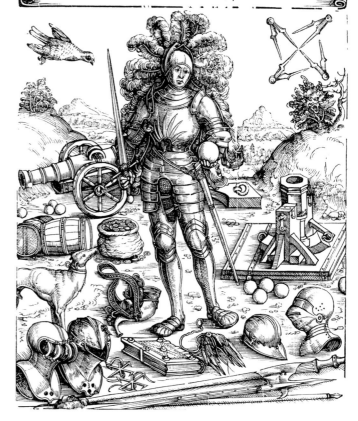

Bot hat sein gnad an im erzaigt
Dann er zu frumkeit was genaigt
Geschickt zu ritterlichem scherz
Darzu stund im sein mut und herz
Das fing er an in seiner tugent
Darin er wuchs mit grosser tugent

64

Albrecht Dürer workshop, *Young Maximilian as Master of War and Jousts*, from *Arch of Honor*, ca. 1517–18, woodcut.

throughout this chapter: helmets of every kind, whether restricted to particular jousts or suitable for warfare, pointed weapons (spears, pikes, and halberds), artillery, and shot (both mortars and field cannons). The text provides the terse but ample exegesis for this concept of the ruler as master of martial arts:

The Lord to him his grace has shown
And ever more pious he has grown.
Adept to play a knightly part,

For this he had the wish and heart.
From early youth he practiced same;
His greatest virtue it became.[57]

In the process of displaying his prowess in valorous acts, as the *Arch* text claims for the Battle of Therouanne: "Praise and glory were thence his banner."

. . . the ornamental customs of that strange and brilliant life led by rich people, who hunt and shoot and give balls and pay each other visits . . .

—PROUST, *In Search of Lost Time*

. . . The practice of hunting big game is more appropriate and necessary for kings and princes than any other. Hunting is an image of war: in it there are stratagems, traps, and snares for conquering the enemy safely; in short, it is a practice that harms no one and gives pleasure to many; and the best thing about it is that it is not for everyone, as other forms of hunting are, except for hawking, which also is only for kings and great lords.

—CERVANTES, *Don Quixote*

6 | Magnificence and Dignity: Princely Pastimes

Although the *Triumphal Procession* is predicated on the emulation of ancient Roman rites of military victory (chapter 3), nonetheless a large portion of that cycle of woodcuts bears the unmistakable stamp of Maximilian's nonmilitary claims. In fact, the bulk of the woodcuts, entrusted to Burgkmair at the beginning of the frieze, present an entirely separate set of princely concerns. After an initial fanfare by a nude herald on a griffin, followed by the equivalent of a military fanfare by fifers and drummers (chapter 5), the first two large groups of marchers consist entirely of courtly figures outside the realm of combat: first hunters and then musicians and entertainers. Because no activity of Maximilian remains completely distinct from warfare, both hunting and music as well supported the virtues of strength and bravery to be fostered during peacetime for a future time of war. Nonetheless, hunting and music, along with jousting, the activity that follows the musicians and entertainers in the *Triumphal Procession*, were the principal, abiding passions of Maximilian's life at court when he was not on the battlefield.

Because such prerogatives were reserved exclusively to noble or princely patrons, such activities also served to promote the visible grandeur and dignity of Maximilian as emperor, and also to situate him within the highest peer group.[1] Visual imagery as well as objects created in the service of these princely activities reveal the great importance for Maximilian of hunting, music, and heraldry—the exclusive province of individuals and families with coats of arms and titles patent. Beyond this dignity of noble rank Maximilian also reserved unto himself another princely activity, which could advance his majesty as fully in peacetime as war itself: diplomacy and territorial claims. Taken together, these diverse activities embodied his virtues of princeliness.

THE HUNT

The *Procession* begins with representatives of the hunt, the consuming passion of Maximilian's lifetime.[2] In the *Procession*, the first hunter is a mounted falconer, identified by name (Hans Teuschel) and followed by five other falconers. According to the dictated text of Maximilian:

> The Emperor, planning constantly,
> Has raised the art of falconry,
> Making joys of summer and winter the same,
> And ordering me to take my aim
> The quest of pleasure of every sort
> At all times with this feathered sport.[3]

Burgkmair's woodcuts fulfill the dictations to the letter; meanwhile, around the title frame fly a brace of falcons in pursuit of their varied prey: a heron, a vulture, and a duck.

Within the *Historia Friderici et Maximiliani* drawings, this kind of modest hunt was used to illustrate the prince's deeds in youth (no. 23, *De eius gestis infine pueritiae*); in the series it follows right after the toy crossbows and cannons that he played with as an infant (no. 19, *De eius gestis in ultimis infantiae annis*; see chapter 5).[4] Another of the drawings by the young Altdorfer shows Maximilian as a grown boy imitating real hunters in pursuit of game animals (fig. 65); instead the boy chases barn fowl with both hounds and with the long spears used for small mountain quarry, such as ibex and chamois (see below). The text specifically points to his secret escapes from book learning in order to pursue such exercises fervently, in addition to his combat training with weapons. In addition to his youth (also marked by the archducal hat on his head, prior to his later adoption of a crown, fo. 58r, no. 29), the boy's insecurity as a novice hunter is evident in his decision to hunt while wearing armor for additional protection.

For the significance of hawking or falconry the pages of *Weisskunig* as usual assess how such experiences are understood to form an integral part of the education of the young, ideal prince. Chapter 39, "How the Young White King Found Particular Delight in Going on Falcon Hunts [*Beiz*]," begins with a memorandum to himself that such activity could divert him from more sinful pursuits. As usual in *Weisskunig*, the king's skills in falconry are celebrated with specific details of his passion:

> He spared no costs but had . . . falcons brought from Tartary, the heathen land, from Russia and Prussia, from Rhodes and from many other ends of the earth. All kings of the earth knew that he gladly hunted with falcons, for which reason many falcons were sent to him and presented. He had at his court 15 falcon-masters and more than sixty falcon attendants, who did nothing else but prepare the falcons for their hunts. . . . Since the young king seldom stayed long at one place but rather traveled most of the time from one kingdom to the other, he hunted with falcons while under way, wherever he had the free time and the opportunity. . . . Even when he made war, and war was almost always made against him, he

did not allow it to interfere with the time allotted for falcon hunting. His passion for the noble falcon hunt was so great that whenever he knew where herons, vultures, ducks, magpies, or crows could be found, even if the spot lay far from his path, there he went, with no poor trail, no small storm, neither heat nor cold able to hinder him."[5]

As is also usual in *Weisskunig*, the king's innovations are celebrated in the text. In the case of falcon hunting, he introduced vultures as prey ("an especially bold and merry *Beiz*") and also stocked (the term is "enclosed and tended" [*hegen and hüten*]) his hunting regions with both heron and ducks. In the accompanying illustration (no. 41) to *Weisskunig*, the young king looses blinders off the eyes of his bird. Escorted by a hound and his assistants, he rides through marshes in pursuit of their quarry, as falcons target a fleeing heron. Later, *Weisskunig*, chapter 42 ("How the Young White King Delighted in Birding [*Voglerei*]"), describes how an older king installed various *Vogelmeister*, master bird-keepers, in various parts of his realm in order to capture songbirds for him and release them in his living quarters as a delight (one even followed him with a songbird during his falcon hunts). Here his interests in music (see below) and in hunting overlap.

65

Albrecht Altdorfer (attributed), *Young Archduke Maximilian Hunts Birds in the Castle,* from *Historia Friderici et Maximiliani*, ca. 1508–10, ink. Vienna, Haus-, Hof-, und Staatsarchive, Hs. Blau 9, fo. 48r.

The true significance of falconry for Maximilian is conveyed by an anecdote at the end of chapter 39 of *Weisskunig*. When asked by a follower why he gives so much time over to this activity, the White King brings his interlocutor out on a hunt with the birds, asking him to guess whether a high-flying heron will be caught by the falcon. Despite the visitor's doubts, the tiny hawk succeeds, and the White King says: "Thus do I conquer my enemies." Elaborating on this cryptic observation, he adds: "You work against yourself. If I did not ride on the falcon hunt, where any man can come to me, you would not now be next to me, you would not have spoken with me

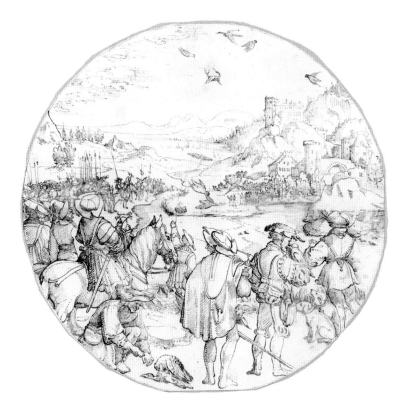

66

Jörg Breu the Elder, *Falcon Hunt*, stained glass window design for
Lermos, ca. 1516, ink. Munich, Staatliche Graphische Sammlung.

this time, and would seldom speak with me. Someone else, however, someone now lesser than
you, him you would have to follow after in great longing." The falcon hunt, the text concludes, "is
a public enjoyment and a hidden wisdom." Indeed, Maximilian used the occasions of his frequent
hunts to host his brother princes as well as royal ambassadors. He even left open the possibility of
receiving more common people, who would not ordinarily have any access to him at all.

Falcon hunts served often as the occasion for general festivity.[6] For example, the falcon hunt
drawing from the cycle of wars and hunts made for Maximilian around 1516 by Jörg Breu of
Augsburg (Munich, Graphische Sammlung; fig. 66) shows a large assembly of visitors along both
sides of a small mountain lake.[7] That roundel also features all moments of the falcon hunt—from
the flushing of game birds from the marshes and the freeing of the eyes of the falcons upon their
release to the actual combat in the air, followed by retrieval by hunting dogs, and the eventual
rewards to the falcon in the form of the flesh of prey. Both the dogs and the mounted hunters
with spears correspond to the youthful Maximilian in the earlier *Historia* drawing, and the artist
has even included technical details of the falcon hunt, such as the tether (jess) that binds some
of the birds to the protected wrists of their handlers. Several curious articles of the falcon hunt

of Maximilian have survived: embroidered and feathered leather hats of the emperor and Bianca Maria Sforza as well as the ornate leather *Luder*, or perches, held by falconers.[8]

Tradition associated falconry with the princes of Europe. For example, the library of Dr. Johann Fuchsmagen, Maximilian's trusted adviser, contained the classic treatise on falconry, penned by an earlier emperor, Frederick II: *De arte venandi cum avibus*.[9] For Frederick, hawking was the noblest of the forms of the hunt; in fact, it was the only truly noble form of hunting, because its conduct had to be learned through training the animals and could not be practiced through artificial aids, such as nets or snares. Of course, Frederick, the last Hohenstaufen emperor, was the perfect model monarch, at once an avid hunter as well as a competent author. Indeed, Maximilian would attempt to emulate his example with treatises on a host of practical matters, including both hunting and fishing.[10]

A memorandum dictated by Maximilian to Marx Treitzsaurwein for his program of project books includes: "*Jegerey . . . Valknerey . . . Vischerey . . .*" (Hunting, Falconry, Fishing). Whereas Frederick's work is characterized by the minutest of natural observations, Maximilian's writing on the hunt remains more distracted and unscientific but equally absorbed in naturalist details of favorite sites and practical procedures for both hunting and fishing. In his *Secret Hunting Book* as well as his *Tyrol Hunting Book* (*Tiroler Jagdbuch*), he records detailed observations on localities as well as instructions for proper dress on the hunt.[11] This same inventory of hunting preserves finds its equivalent for fishing in the *Tyrol Fishery Book* (*Tiroler Fischereibuch*), completed in 1504 by Wolfgang Hohenleiter with the aid of the fish-master, Martin Fritz.[12]

Perhaps as noteworthy as the contents of these books on hunting and fishing are the attractive illustrations to adorn the emperor's own books. These contained full-page miniatures, painted by court artist Jörg Kölderer (three in the *Jagdbuch*, eight in the *Fischereibuch*). These images depict the landscapes with scenes of fishing and hunting, often together. In the "Lange Wiesen" scene, for example, a portrait likeness of Maximilian in his characteristic grey-green hunting costume appears in the central boat fishing on the water, while all around other hunting scenes take place, such as falconry on horseback and a stag hunt. Maximilian appears a second time in the lower left corner, as he pulls up on horseback with his party to question his fisherman at the side of a stream.[13] In the *Achensee* miniature the emperor on horseback in sober hunting costume contrasts markedly with the gaily dressed courtiers around him, who wear bright colors (red and yellow) and hats with gaudy feathers (fig. 67). One of them, mounted alongside Maximilian, reads to him in the manner described in the *Weisskunig* text. These miniatures dramatize the seclusion of the sites, exaggerating the height and sharpness of the mountain crags while retaining a small sense of figure scale within such vast areas. In several of the miniatures, festive parties take place in which women also are present, clad in bright red dresses.

Although fishing is not represented in the *Triumphal Procession* woodcuts, it plays a significant role in the text and illustrations of *Weisskunig*, specifically chapter 41 ("How the Young White King Delighted in Fishing"). The text singles out the mountain lakes, naming them specifically, like the *Fischereibuch*, along with their principal yields. Mountain fishing areas were especially favored,

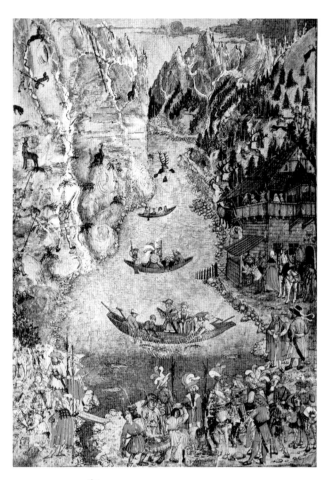

67

Jörg Kölderer, *Achensee*, from *Tiroler Fischereibuch*, 1504, ink on parchment. Vienna, Österreichische Nationalbibliothek, cod. Vind. 7692.

because they also permitted hunting for mountain game, stags and chamois, as in the illustrations by Kölderer. In fact, using the lake as the final obstacle to slow a stag is a favorite technique, practiced by Maximilian and Saxon princes, as illustrated by Lucas Cranach (see below). *Weisskunig* reveals his hunter's sportsman mentality and naturalist's love for both the sites and the sounds of nature. The woodcut illustration of fishing (no. 43) is not by Burgkmair and is weaker than the miniatures, but it features the king with a pole amid his companions on a mountain lakeside. Additional figures in the image employ more technically sophisticated snares, one barrel-like and the other made of a narrowing basket, while a bear hunter sits with his hunting weapon in the right corner.

Hunting, the greatest of Maximilian's passions, is nowhere apostrophized so richly as in the *Weisskunig* text, chapter 40 ("How the young White King was Enthusiastic for the Hunting of Stags, Chamois, Ibex, Boar, and Bears"). Here *fürstlichen Jägerei*, "princely hunting," delimits the land to hunting preserves and game rights of nobles and princes. Again, the "sportsman's" love of the land and his fervor to hunt on it overlap as surely as in the *Field and Stream* publications of modern America: "Thus, he left game preserves [*Wildbret hegen*] in all kingdoms and lands for stags, ibex, chamois, boar, marmots, rabbits, and other animals, and no one might shoot or catch game in his forests and preserves [*Revieren*]. Had the king not preserved the game thus, ibex in particular would have extinguished."

Clear distinctions contrast noble, ancient forms of the hunt and the modern hunt by peasants: "For when handguns came in, people began to shoot ibex, which happened with the peasants, wherever they came across the preserve, with no moderation [*kein Mass halten*—Maximilian's own motto was "Halt Mass!"], but rather exterminate it according to their peasant fashion." Formerly the ibex could boldly test the aim and marksmanship of the noble hunter with a crossbow, but now the animals were vulnerable to musket fire. This lamentation sounds like the clichés uttered about the loss of noble warriors upon the advent of gunpowder in warfare, a criticism that Maximilian never made, because of his delight in artillery as well as infantry tactics (chapter 5).[14]

But in his personal realm of direct encounter with wild animals in the hunt, he bitterly castigated the loss of older, cherished values and traditions, and he linked the offenders with his social inferiors in the country, the peasants. Not only did Maximilian delight in being able to restock this endangered species, ibex, but he even identified it as a "noble creature [*edles Getier*], that was given to the nobility to have its attention."

As with his passion for jousting (chapter 5), Maximilian also became an innovator in techniques of hunting. *Weisskunig* praises him for introducing the "parforce- and park-hunting" of stags (the former is a hunt on horseback, chasing with hounds; the latter is a hunt within circumscribed boundaries of thick enclosures). The text continues:

I want now to say something for myself, I do not believe that a king has ever lived who was such a hunter, nor that in future times there will be his like. He was not a hunter out of habit or pride, but rather a hunter out of inborn nature and royal temperament. I want to report briefly how he preserved hunts and in what manner he conducted hunts. The king had in his kingdoms a chief hunt-master, 14 forest masters, 105 forest assistants and pensioners, who had to care for the forests, trails, hunts, and game within an extraordinarily large district. In addition, he had for his court hunts two hunt masters and 30 hunt assistants. Regularly in his kingdoms more than 1,500 hunting dogs were reserved for his hunts alone. He hunted bears with special gusto and had great joy and pleasure whenever he could spear a bear. As often as he hunted chamois, he went to the peaks in the mountains, climbed the cliffs, and shot the chamois down himself. . . . Someone who was not informed [*eingeweiht*, literally "initiated," further implying the tight circle of associates and peers] might think, reading this, that the young king did nothing else but hawk and hunt, but that does not pertain. Hawking and hunting were the king's pursuits primarily during great wars. The reasons are as follows. . . . If another king withdrew into war, he would have made himself ready a long time in advance; the young White King was always ready for war, because he always hunted and hawked and gladly captured stags and herons in the land of his foes. No king was the equal of the young White King in combat, command, hunting, and hawking. He was an augmenter and admirer of all forests and hunts as well as game and a nurturer of upright, knightly soldiers and of all hunters, for he possessed a combative, noble, and royal nature, that I will now reveal. Not only did he wish to be a prepared hunter, by first enclosing a preserve and then hunting and capturing game, but he was still more prepared to win lands, cities, and castles in war. Although he also was a master falconer, he was a still better master for bringing mighty kings, princes, and lords under his will. The young White King was an unsurpassed hunter, falconer, warrior, and commander and also bested all kings in the four chief virtues, which every king should possess. Whoever is learned in histories and in tales [*Historien und Geschichten*] will not say that I exaggerate. Yet my writing is composed for the greater understanding of the common people [*gemeine Volk*].

Nowhere else is the analogy presented more graphically between the skills and endurance of hunting and those of warfare, practiced by the prince as commander and knight.

Given the aristocratic tenor of most of the narrative in *Weisskunig*, there is little reason to take that final gesture to the common folk at face value. Even more than that text, princely virtues inform the verse romance of *Teuerdank* (completed in 1517). Just as the emperor calls himself the "great hunter" (*gross Waidmann*) in his *Secret Hunting Book*, he also gives over the bulk of adventurous episodes in *Teuerdank* to the hunt. (Of the eighty-eight trials undergone by the hero, thirty-four involve the very animals mentioned in *Weisskunig* and celebrated in the *Triumphal Procession*: fifteen chamois hunted in dangerous mountain crags, eight boars, five stags, three bears, and one bird).[15] Visually, too, the illustrations of *Weisskunig* and *Teuerdank* differ little for the subjects of the hunt. Woodcut no. 40 of *Weisskunig* shows the king, dressed in the same practical clothes as in the *Jagdbuch* miniatures by Kölderer, with an aide at the base of a vertical cliff high in the mountains. A shot from his crossbow has just brought down a chamois, whose frightened companion flees in terror. Across a gorge, two assistants with spears look on in astonishment; above them a pair of hunting dogs corner another chamois. Such scenes recur in abundance within *Teuerdank*, altered chiefly by the presence of the necessary allegorical figures mentioned in the text: both the herald Ehrenhold and the villain of the moment.[16] Within the *Triumphal Procession* woodcuts, ibex and chamois hunting follow directly after falcon hunting (woodcut no. 7), led by a mounted leader, identified in the text by name (Conrad Zuberle). The woodcuts show chamois hunters with the animals as well as with mountain-climbing equipment necessary for their specialized expeditions.[17]

Woodcut no. 42 of *Weisskunig*, directly after both chamois hunting and falconry, features a stag hunt, led by hounds but trailed by the White King on foot, restraining a mastiff. In *Teuerdank*, the first scene with a stag is more dramatic. The illustration shows the king on horseback delivering a coup de grâce with his sword from horseback (no. 13, by Hans Schäufelein; fig. 68). In this case, the picture stresses individual heroism rather than love of either the hunt or the outdoors. A later scene from *Teuerdank*, no. 33, shows the king mounted on horseback with a sword in the process of a *Parforcejagd*, chasing a stag that disappears into the woods.

Surprisingly, there is no chamois hunt among the roundels made for Maximilian by by Jörg Breu at the hunting lodge at Lermos, but the stag hunt in that cycle of drawings is documentary in character, akin to the Kölderer miniatures in the *Jagdbuch* in stressing the setting as well as techniques of the hunt rather than the glory of the emperor-hunter (fig. 69).[18] At the center of the image, a pair of deer stand placidly in a clearing surrounded by trees and hedges; in the right distance a fence is visible as a restraint to the movement of other stags, who are being chased by hounds. This, then, is the *Parkjagd*, conducted by assistants visible in the foreground, one of whom is loading a crossbow, while the rest relax and tend the hounds. Similar figures reappear in woodcut no. 9 of the *Triumphal Procession*, followed by deer hunters with hunting horns and switches, employed in flushing the animals and driving them ahead for the hounds and huntsmen. Then either nets or fences or a body of water set up boundaries, as in the Achensee miniature, to slow the animals up for the kill.

The special esteem given such hunts suggested powerful metaphors in medieval thought.[19] A stag hunt carried the same powerful associations of aristocratic participation but also had its own special rituals, as exemplified by Sir Tristram in Malory's *Morte d'Arthur*: "Stop! What are you doing? Who ever saw a stag cut up in that way? Is that your custom in this country?"[20] The stag is dressed according to a set procedure, then given to the master hunter for *la fourchée*, when the liver and other parts are given to a servant on a fork. Then follows *la curée*, where entrails are rewarded to the dogs as a reward, and *le present*, where the head of the animal, placed on a branch, is offered to the king along with the previously prepared fork, following a procession led by hunting horns. The entire event is serious, hierarchical, and linked to exclusive aristocratic privilege. Indeed, knowledge of the hunt ritual is itself a sign of initiation into the club of noble peers, bonding them through shared activity, much as Frederick II saw hawking as the only truly noble hunt. Even the implements of this ritual carving of a game animal were distinguished from the ordinary. One remarkable set of hunting-knives was produced for Maximilian by his royal knifesmith, Hans Sumersperger.[21] This set (Stift Kremsmünster) consists of a serving knife for offering choice pieces to select noblemen, two heavy knives for cutting and skinning, and a delicate table knife and fork. On the blued ground of the knives rich gilded decoration accords with the elaborate ceremonial swords produced by Sumersperger for Maximilian in 1496 (chapter 5). The serving knife shows an emperor, identified as Sigismund, and an Austrian archduke, identified as Maximilian's kinsman and predecessor in Tyrol, Sigmund, to indicate the original royal ownership of the implements. With prayers to patron Saints Sigmund and George, foliage and stag hunts further decorate the blades.

Aristocratic participants in particular stag hunts appear in representations by Lucas Cranach for the Saxon court.[22] The earliest, a two-part, oversize woodcut *Stag Hunt* (ca. 1506), shows a Saxon

68

Hans Schäufelein, *Teuerdank Hunts a Stag*, from *Teuerdank*, 1517, woodcut.

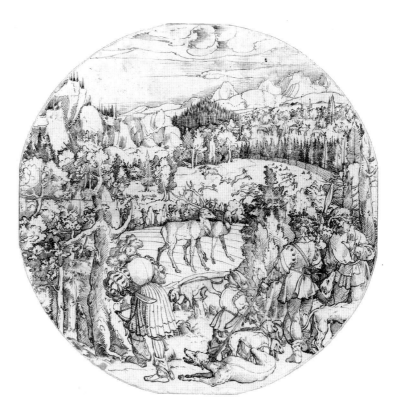

69

Jörg Breu the Elder, *Stag Hunt*, stained glass window design for
Lermos, ca. 1516, ink. Munich, Staatliche Graphische Sammlung.

castle in the background.[23] In addition, several paintings of Saxon stag hunts by Cranach detail stages
of the hunt. One posthumously commemorates a hunt given by Frederick the Wise (d. 1523) for
Maximilian (d. 1519), apparently in 1497 at the time of great tournament festivities in Innsbruck
(1529; Vienna, Kunsthistorisches Museum; see fig. 87).[24] Such pictures suggest, like the surviving com-
memorative tournament books (see below) particular occasions featuring prominent guests enjoying
sport together.[25] The Vienna Cranach picture includes a boat with an audience of women, akin to
the miniatures in Maximilian's hunting and fishing books. Portraits of Duke Johann, Frederick, and
Maximilian himself are also clearly delineated with their hunting gear across the foreground.

More dangerous, if less noble, animals were also hunted by Maximilian: boars and bears. Al-
though neither is illustrated in *Weisskunig*, both are featured as heroic images in *Teuerdank*.[26] In-
variably, these bold encounters feature single combat between one man, armed with a long speak,
and a ferocious beast. A similar woodcut image by Cranach (ca. 1507) shows a Saxon prince on
horseback accompanied by hunting dogs against a boar in the forest.[27] Such encounters, however,
were far from the rule. In Breu's roundel drawing of the *Boar Hunt*, a team of assistants trail a pack
of hounds in running the boar to the ground before dispatching him with spears. This kind of

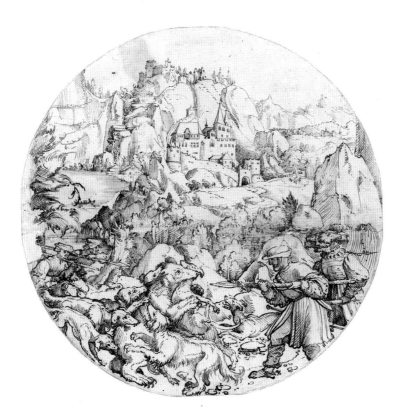

70

Jörg Breu the Elder, *Bear Hunt*, stained glass window design for
Lermos, ca. 1516, ink. Munich, Staatliche Graphische Sammlung.

scene was portrayed more than a century later by Rubens in his several *Boar Hunts* as well as in
his *Wolf and Fox Hunt* (New York, Metropolitan Museum).[28] Bears were usually wounded first by
means of a crossbow and then stuck with a special spear; they, too, were hunted in teams because
of the danger they posed, despite the heroic single encounters pictured in *Teuerdank*. Breu's *Bear
Hunt* roundel (fig. 70), presumably more accurate, pictures Maximilian with a spear in front of the
bear at bay (still vicious, however, as it claws and bites the hounds that assail it), while his assistants
stand ready to protect him in case of a mishap (all before a beautiful setting of forest, crags, and
mountain lake, like the *Jagdbuch* miniatures).

In the *Triumphal Procession*, boar and bear hunters complete the procession of Maximilian's
court hunters behind a chief, identified in the dictation as Wilhelm von Greyssen. Their distinc-
tive weapons of the boar hunters, long, spearlike swords, are visible (no. 12) before the bear hunt-
ers, led by Diepolt von Slandersberg, credited with having "instituted a rare new style in fearsome
bear hunting." The text also refers to "rules of venery," even for this most violent of European
game animals. This structure indicates once more how the hunt, like the tournament, remained
an activity of princely men, governed by strict rules.

Magnificence and Dignity 179

The importance of the hunt for the self-esteem and identity of Maximilian becomes clear from a pair of images that need not have contained this more private form of recreation. The first is the frontispiece, mentioned above, to the 1512 *Privilege Book of the House of Austria*, whose borders are filled with an elaborate miniature of several hunts: hawking, chamois, and stag hunts.[29] Under a heraldic shield of Austria, crowned by the archduke's hat, Maximilian is characterized as "Archidux Austriae Ro Imperii supremus venator" (Archduke of Austria, supreme hunter of the Roman Empire). The other key hunting image is the woodcut by Albrecht Altdorfer for the left tower of the *Arch of Honor* (fig. 71).[30] Maximilian appears in characteristic hunter's dress with horn and knife like a stag hunter; he stands between a forest and a mountain crag, above a fish-stocked lake. The variety of quarry is the same as in the *Triumphal Procession*: chamois, ibex, stag, boar, and bear. The accompanying verses read:

> Field and stream were his concern
> as fearlessly he took his turn
> to hunt for mountain-goat, stag, and boar
> for his enjoyment evermore.
> Many a deer he let survive;
> caught and kept tame and alive.[31]

A novel feature of the woodcut is the large round, crowned wheel, held lightly in the hand of the hunter-emperor. This object has been interpreted as the wheel of fortune, repeated on the livery of Ehrenhold, the herald of *Teuerdank*.[32] Of course, in *Teuerdank* the hero's good fortune and divine providence are stressed repeatedly throughout the text, as he escapes injury during all of his adventures and accidents, including hunts.

Related to this concern for fortune, controlled by the will of God, is one pious practice, instituted by Maximilian and continued to this day. In the *Secret Hunting Book*, Maximilian speaks of rising by 3 a.m. and quickly saying mass before departing for the hunt, but in 1514 he donated four candles to be lighted in perpetuity in the parish church of Wilten bei Innsbruck in memory of the loss of his leading chamois-master, Kaspar Gramaiser, in a fall during a hunt in the mountains. With these candles "we, our court servants, chamois, and other hunters may be protected on hunts against accidents and harm."[33]

Sport of kings since the earliest epochs of art making, hunt scenes have included the lion reliefs of Assyrian kings from Nineveh (seventh century BC; London, British Museum).[34] In addition to the treatise on hawking by Frederick II, mentioned above, a similarly complete survey of hunting was produced by Gaston Phebus, comte de Foix and lord of Bearn (who died, appropriately enough, on a bear hunt in 1391): the *Livre de la chasse*.[35] It, too, offers a detailed naturalist's study of fourteen different varieties of game as well as various breeds of hounds. Such observations not only contributed to the eventual advancement of biological science but also offered testimonial to the intense, personal involvement of noble hunters in their pastime. The sanction for later illustrated treatises, such as the several illuminated versions of Phebus, was established from the outset by

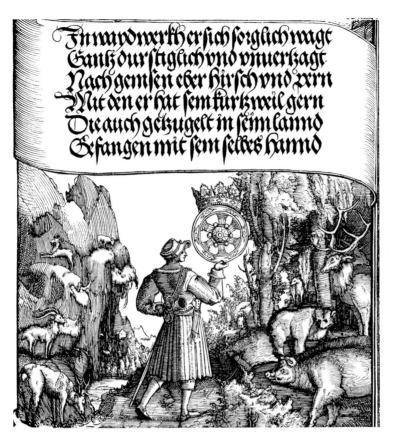

In wayd werth er sich sorglich wagt
Gantz durstiglich vnd vnuertzagt
Nach gemsen eber hirsch vnd reen
Mit den er hat sein kürtzweil gern
Die auch getzugelt in sein lannd
Gefangen mit sein selbes hannd

71

Albrecht Altdorfer, *Maximilian as Hunter,*

from *Arch of Honor,* ca. 1517–18, woodcut.

Frederick's example—not as a sign of learning but as a technical manual to communicate information and accumulated practical experience.

Maximilian's texts about hunting and fishing continue this pragmatic tone in their specific attention to particular sites and the game featured there. Their illustrations also feature the same kinds of site-specific hunting. But the ceremonial and celebratory aspects of the hunt closest to the tone of the *Weisskunig* ideal can only be found in an artwork tribute to Maximilian after his death: a tapestry cycle, designed by Bernard van Orley of Brussels, ca. 1530, on the subject of the hunt.[36] Traditionally titled the *Hunts of Maximilian,* these twelve drawings and their tapestry realizations are conserved in the Louvre.[37] The site of these hunts seems to be the forest of Soignes, a large preserve near Brussels, but each tapestry corresponds to a month of the year, marked by the appropriate sign of the zodiac in its border, as the changing landscapes mark the movement of the seasons. A central figure on horseback in the December tapestry, *The Killing of the Boar,* though traditionally identified as Maximilian, should more properly be seen as his look-alike grandson, Ferdinand. In any case, the cycle pays tribute to the Habsburg love of hunting, staged within the

context of the Netherlands. As Balis points out, the cycle conforms to prescriptions laid down by Gaston Phebus, including elaborate prehunt banquets (similar to the ritualized banquets and masquerades that follow every tournament; see below) and ritual carving (no. 8, with "*fouail*," where the dogs leap for upheld vitals; and "*kurei*," where they are loosed on the sound of horns for their portion of the stag; see also no. 11 for the boar). These hunting scenes combine the action of both *Weisskunig* and *Teuerdank* illustrations with the accuracy of costume and portraiture in the *Triumphal Procession* woodcuts.

Just as images of the hunt ornamented the house or hunting lodge of a prince, so did the activity of the hunt—at once physical and healthy, yet also infused with special skills and the knowledgeable appreciation of nature—adorn the character of its free and noble practitioner.[38] It could be a favored form of training, as Castiglione's *Book of the Courtier* makes clear: "There are also other exercises which, although not immediately dependent upon arms, still have much in common therewith and demand much manly vigor, and chief among these is the hunt, it seems to me, because it has a certain resemblance to war. It is a true pastime for great lords, it befits a courtier, and one understands why it was so much practiced among the ancients."[39] But the true epigraph for the hunt as the crown to noble effort is given by Shakespeare in *As You Like It* (act 4, scene, 2):

> Let's present him to the Duke, like a Roman conquerer;
> and it would do well to set the deer's horns upon his
> head for a branch of victory.

TOURNAMENT SPECTACLE

Like the hunt, knightly games or tournaments (chapter 5) provided a vivid peacetime facsimile for the skills of warfare, as well as a mark of class distinction reserved only for the nobility. Thus, they provided Maximilian's other chief form of leisure activity. Much of this tournament combat and its technology of armor is discussed elsewhere, in conjunction with the martial arts. However, courtly spectacle and entertainments associated with the tournament also formed an important part of princely activity. Like the hunt, practical experience in jousts remained more important than what one could learn of them from books. *Weisskunig* (chapter 46) declares, "one who wants to become famous in this needs practice with deeds and not learning from texts."[40] A king's renown for his practical skills in hunt or tournament makes him a model for his peers, so they flock to him. *Weisskunig* also underscores the analogy between jousts and wars, in which honor can be won or demonstrated, but also the role of tournaments to provide visible magnificence: "Whenever he had respite from wars, he had tournaments held at his court and was in them himself. His court became famous throughout the world as a result, so that from many lands came princes, counts, lords, and knights, who, however, were bested by the king. It should be noted that he extended his knightly hand towards kingly honor, which he then attained in the future memory of the people with great honor."[41]

The verses at the top of the *Arch of Honor* alongside the Altdorfer woodcut image of the emperor's tournaments and entertainments proclaim:

> From jousting and other knightly game
> He derived great pleasure, also fame.
> By everyone it was believed
> That no prince ever had achieved
> Such excellence and reaped such praise
> Instead of the anguish of early days.[42]

Included in the corner of the woodcut (see fig. 56) alongside the three principal forms of jousting (*Rennen, Stechen,* and *Fusskampf*; chapter 5) is a fourth, equally indispensable form of tournament activity: the costume masquerade. Here masked and turbaned courtiers stand and converse, completing the image just as they completed the tournament events with a final festivity.

Tournament spectacle imagery in the *Historia Friderici et Maximiliani* (no. 36, *De eius hasticis certaminibus*) follows directly behind the image of the hunt (no. 35) and after several images of the emperor's clemency and diplomacy (nos. 32–34; see below). In addition, right after the tournament comes an illustration of a masquerade (no. 37, *De eius spectaculis*).[43] In the tournament image, a mounted joust (*Rennen*) takes place, in which a figure, clearly marked as Maximilian by means of Burgundian arms (St. Andrew's cross with inserted flints), strikes his opponent with his lance within a palace courtyard. A large cluster of knights and attendants, including costumed heralds, view the contest. Maximilian regarded such an image of his triumph in jousting as a form of boasting, and he added an autograph annotation to the drawing, "*lyber laudis post mortem*" (better to be praised posthumously).

Luxurious ornamentation on tournament armor makes clear (chapter 5) that jousting was one of the most splendid public displays, a fitting segment within the *Triumphal Procession*'s courtly figures (Burgkmair woodcuts nos. 41–56). Moreover, many of the most splendid tournaments were held on festive occasions, such as an imperial Diet or princely marriage. In accord with traditions of knightly romances, such ordered combats offered a noble form of *Frauendienst*, homage to ladies.[44] Of course, the model for such spectacular tournaments at marriages derives from the Burgundy of Maximilian's father-in-law, Charles the Rash, whose own third marriage to the English princess, Margaret of York in Bruges (1468) already had achieved legendary status.[45]

Because Maximilianic tournaments were not recorded with the kind of scrupulous care that Olivier de la Marche gave to the Burgundian instances, we cannot be sure about their forms and rules, but usually such tournaments were organized around a central fable. At the Bruges marriage in 1468, that fable made Anthony, the Great Bastard of Burgundy, into a protagonist; he was supposed to rescue the Lady of the Ile *celée* from distress and to contest 101 lances and 101 sword blows, as well as to decorate a Golden Tree with the heraldic arms of great champions. The contests were carefully regulated by both judges and heralds, and all the results were duly recorded. Throughout the competition, heraldic arms and colors were invested with special importance,

and ceremonial behavior framed all the combats. Feasts, held as the festive climax of the wedding, included theatrical miming performances, loosely composed around the theme of the labors of Hercules and accompanied by splendidly costumed heraldic animal personifications as well as animal-costumed musicians and entertainers. Documents reveal that in 1495 at Worms on the occasion of the Diet a mass tournament with swords was held, with all of the participants taking the identities of Arthurian knights or heroes of medieval German romances.[46] These festive and ceremonial aspects of tournaments served increasingly as their raison d'être, marked occasions when gentlemen met one another.[47] Indeed, this same combination of pomp and martial display survived to the end of the sixteenth century in the royal context of Elizabethan England's Accession Day Tilts, stage-managed by Sir Henry Lee.[48]

If the *Freydal* illustrations can be trusted to correspond with real Maximilian tournament trappings, the range of colors and decorations was truly splendid and bizarre, comparable to the analogous record-books that preserved the results of other tournaments among German princes. One example is the splendid *Tournament Book of Duke Johann Friedrich the Magnanimous* of Saxony (ca. 1535; Coburg), made by the workshop of Lucas Cranach.[49] This Cranach book commemorates the prowess of the Saxon duke in 146 tournament competitions between 1521 and 1534. Like *Freydal* except for being explicitly documentary rather than fictionalized, this tournament book shows jousting duels on facing pages and gives careful attention to details of costume and outcomes through recorded inscriptions concerning participants, location, and date. At an earlier date, Lucas Cranach had issued commemorative woodcuts for the Saxon court, one as early as 1506 and three in the year 1509 alone, which celebrated a splendid tournament of November 1508 in Wittenberg (fig. 72).[50] Maximilian's own field marshal, Caspar von Lamberg (ca. 1460–1544), also owned a book of 115 pages with 88 depictions of *Rennen* and *Stechen* in gouache, and a posthumous tournament book of Maximilian (ca. 1550–60; Augsburg) was prepared by Hans Burgkmair the Younger after his father's woodcuts to the *Triumphal Procession*.[51]

Like the *Historia* illustration and *Freydal* cycles, and a Hans Burgkmair woodcut for *Weisskunig* (fig. 73), tournaments ended with dances and masquerades (*Mummereien*).[52] These too were based on courtly precedents in Burgundy and Italy, invariably including thematic costumes, usually of an exotic or foreign cast, worn by the guests. In the *Historia* illustration five masked men with feathered hats enter and approach five ladies at table; in the *Arch* woodcut of tournaments by Altdorfer they wear turbans. Only the golden chain and foreground location identify Maximilian in the *Historia*. Burgkmair's costumes feature bird faces and turbans. Dürer's lone woodcut illustration of a masquerade for *Freydal* shows a circle dance with masked men bearing torches; the central woman facing the viewer wears a crown that distinguishes her from her companions (fig. 74). Several men wear golden chains, but here Freydal stands with a feathered hat and a chain in the doorway. Above, a gallery box holds viewers of various classes, including a central crowned woman, whose royal dignity is further marked by a brocade draped over the balcony.[53]

In Burgkmair's *Triumphal Procession* woodcuts the masquerade (nos. 31–32) follows the section of musicians and serves as transition to the long series of tournament armor woodcuts. It is pre-

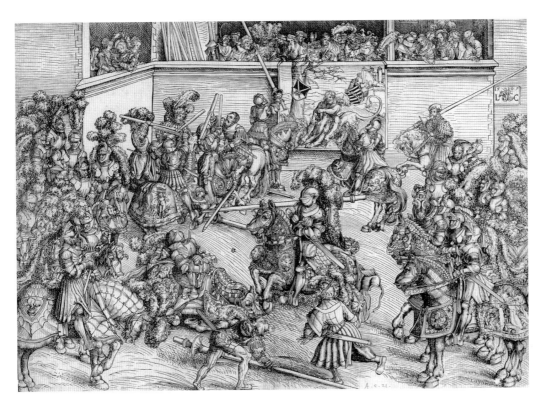

72

Lucas Cranach, *Tournament with Samson Tapestry*, 1509, woodcut.

Sarah Campbell Blaffer Foundation, Houston.

ceded by a cluster of jesters (nos. 27–28) and natural fools (i.e., madmen used for court amusement, nos. 29–30), led by the famous Conrad von der Rosen. The jester cart is drawn by wild ponies, while the natural fools are drawn, appropriately, by asses, whose ears are the very emblem of folly in Sebastian Brant's *Ship of Fools* (1494) as well as on the costumes of fools and jesters. Clearly the masquerade entertainments follow closely upon other delights of court life, offered by musicians and fools. Of course, masquerades also included dancing to court music, generally to fifes and drums (which also served the new infantry forces; chapter 5). Moreover, masquerades offered a temporal license for a carnival atmosphere, marked by the emphatically noncourtly costume roles. Thus, a natural overlap and affinity prevailed between masquerades and both music and folly.

The *Procession* text for Burgkmair's woodcut of masquerade names Peter von Altenhaus, its master. Despite comical or exotic costumes, this text makes clear how the masquerade was reserved for knights and designed for entertainment within decorous limits. Behind the master of the masquerade Burgkmair shows two ranks of mummers carrying burning torches, as in Dürer's woodcut. The *Freydal* illustrations all make masquerades the final event of individual tournaments, so there are sixty-four separate festive entertainments commemorated in the planned text. Most astonishing is their variety of fantastic costumes, which depict alternative classes, personalities,

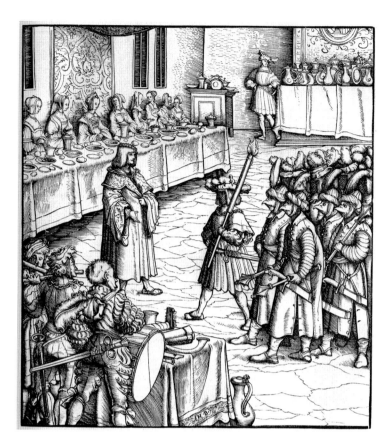

73

Hans Burgkmair, *Masquerade*, from *Weisskunig*, ca. 1512–18, woodcut.

or nationalities. Designed by master tailor Martin Trummer, they included the following motifs: fools, clowns, peasants, hunters, mountain men, monks, Turks, Hungarians, Venetians, Spaniards, Burgundians, as well as giants, apes, and bird-headed creatures, among others.[54] Dances included both row and circle dances, both of which appear among the *Freydal* illustrations, sometimes with torches, as in the Dürer woodcut.[55] Leitner observes that besides dancing, other activities took place at masquerades: distribution of prizes (no. 52, costumes with crowns and motley); mock-tournaments (no. 116, a pike battle between infantry men [*Landsknechten*] and peasants); and obscure courtly ceremonies, perhaps some version of courtly love, or *Minnedienst* (no. 96, in Burgundian costumes, but with apes in mocking imitation of the ceremonial gestures).

The fullest explanation of the variety of *Freydal* illustrations is furnished by the idealized *Weisskunig* text. Included among the learning experiences of the young White King chapter 34 glorifies "How the Young White King Surpassed Other Kings with Banquets and *Mummereien*":

The young White King heard much in his youth about banquets and masquerades, which other kings held. So he had the desire and informed himself with much effort in what

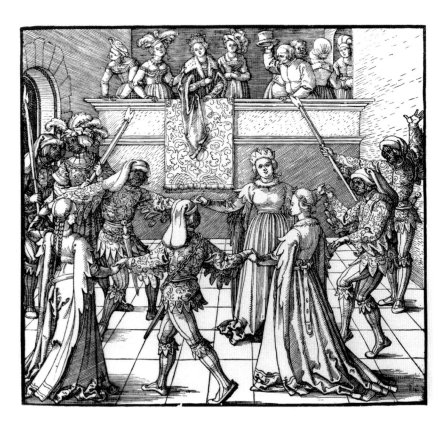

74

Albrecht Dürer, *Masquerade*, from *Freydal*, 1516, woodcut. Vienna, Albertina.

manner and according to what custom such a king would arrange his banquets and mas-
querades. He spared no costs or efforts for them; for no one can invent such a thing by
himself, he must have a procedure, instruction, and experience. . . . These brought him
prizes at tournaments and honor at festivals. Not that he was a spectator, but rather to the
joy of his people and to the honor of the foreign guests he took part in every way and was
particularly glad to masquerade, where he had his own pleasures and each time thought up
a special mask and shape. Although he was the most warlike king, so may anyone see from
my text that he was also the merriest king. . . . I am certain that [his banquets, masquerades,
and festivals] will be written about in their own book [*Freydal*].

A permanent impression of such masquerades appears in an architectural decoration by Maxi-
milian on the Innsbruck Hofburg: the Golden Roof (Goldenes Dachl, 1497–1500).[56] This loge
balcony commemorates the celebrations held in honor of Maximilian's second marriage in 1497 to
Bianca Maria Sforza of Milan. (Innsbruck hosted major tournaments for Maximilian in 1492, 1497,
and 1498.) The balcony also marks the place of intersection in the Old Town of Innsbruck between
the palace and the public, and it surely must have served as the royal box for viewing tournaments

or festivities in the square below, like the Lucas Cranach tournament woodcuts for the Saxon court. The Goldenes Dachl was built by master mason Niklaus Türing and completed by the inscribed date of 1500. Its two stories of multimedia decoration unfold a spectacle of courtly display. The lower zone below the glass windows presents a frieze with reliefs of the territorial arms claimed by Maximilian: Styria, Tyrol, Milan, Burgundy, Germany (single eagle for Maximilian as king of the Romans), Holy Roman Empire (double eagle), Hungary, Austria.[57] The windows are flanked by two giant, painted foot soldiers, *Landsknechten*, bearing banners with the arms of both Tyrol and Germany. This kind of heraldry conforms to both military and tournament usage, to offer a ready means of identifying the combatants in an age that saw the eclipse of specialized heralds who had traditionally fulfilled that role.[58] Like the elevated balcony location, which differentiated the ruling class from its inferiors (note the many balconies in *Freydal* illustrations for royal viewing of masquerades), the use of arms on banners and pennons was a privilege reserved for the upper nobility and served, as noted above, as an integral part of the tournament festivities in Burgundy. The open balcony above presents a figural relief. Above a cloth of honor Maximilian and his new Milanese bride appear in the center. They are accompanied by his first wife, Mary of Burgundy, along with both councilors and court fools, as if in permanent audience at a tournament or masquerade.

The festive event being staged across four panels on the edges of the Goldenes Dachl relief is a wild dance, a *Moriskentanz* ("moors' dance," or "morris-dance" in Elizabethan English). This frenzied competition is waged for a fair woman's favor, in this case the prize of a golden apple held by Bianca Maria. Such an image reappears as illustration 36 of *Freydal*, where a host of masqueraders, clad in the motley of fools, dance wildly around a static figure of a woman, who holds up a golden apple as their prize. Like such a fantastic masquerade performance, the morris-dance is a combination of the foolish and the foreign, here "moorish" (including pseudo-Hebrew inscriptions on the banners of the dancers), music and movement.[59] Moreover, in the courtly tradition of *Frauendienst*, the queen has reduced these splendidly dressed courtiers (one of whom can be identified by his arms as the *Hofmeister*, chief of the Innsbruck Regiment, Michael von Wolkenstein, ca. 1460–1523) to the state of prancing fools.[60]

The Goldenes Dachl is finally climaxed by an open loggia, where the actual monarch and his court would appear. This loggia is crowned on four columns by the gilded copper-tiled roof that gives the structure its name. More than any other architectural creation for Maximilian, except perhaps for the nearby Armorial Tower (Wappenturm; see below), also appended to the Hofburg in Innsbruck, the Goldenes Dachl proudly and permanently displays the courtly splendor of the emperor to his "capital" city. The loggia is further ornamented by festive frescoes, presumably painted by court painter Jörg Kölderer, depicting dancers, musicians, and women in a Mayday play, as well as decorative animals.

One final, verbal work serves to mark the festive world of the masquerade as well as the princely world of the hunt: Conrad Celtis's Latin play, *Ludus Dianae*, produced for Maximilian at Linz in 1501, just as later mythic masques by Ben Jonson were penned for the Stuart royal court in seventeenth-century England.[61] In that work, the goddess of the hunt, Diana, along with her

retinue of satyrs and other forest creatures, crowns the king with her attributes and declares him to be her special favorite, the *venator maximus*, before the entire court, including Bianca Maria, the duke of Milan, as well as the author. The goddess offers to the king her bow and quiver, spear and net, as she proffers her title to hunting skills and venues. Later the play presents the forest god Silvanus, whose praise of Maximilian as the mightiest warrior is accompanied by a charge to the emperor to pursue a crusade, much as the famed Feast of the Pheasant had used courtly entertainments in order to elicit pledges by Philip the Good and the nobles of Burgundy to make a crusade in 1454.[62] Along with this serious side, the *Ludus Dianae* also admixed set dance and music pieces by companies of nymphs, fauns, and satyrs, as well as choral pieces of thanks to the emperor, much as we imagine masquerades to have been staged.

MUSIC

Directly after the hunting segment of the *Triumphal Procession* follow the court musicians (after a single interlude of five court valets attending on the king: cupbearer, cook, barber, tailor, and cobbler).[63] Indeed, musicians head the entire procession. Fifers and drummers, the musicians for both the masquerades and the military, are singled out as the first feature (woodcuts nos. 3–4) of the *Procession*. They are led by "Anthony the fifer," whose verses proclaim his varied roles, both military and festive:

> I, Anthony of Dornstätt, have played my fife
> For Maximilian, great in strife,
> In many lands, on countless journeys,
> In battles fierce and knightly tourneys [*ritterlicher pan*],
> At grave times or in holiday,
> And so in this Triumph with honor I play.
> .
> Serving the Imperial arms
> In knightly joust and war's alarms.
> Always prepared, the fifer blows
> Times gay and stern, as this Triumph shows.[64]

This music conflates tournament and battle, entertaining spectacle and chivalric proving ground. This ability to behave like a prince in peace and in war was the hallmark of Maximilian's ambition and of all his training and experience within the central section of *Weisskunig*. Thus fifers and drummers, appropriate to both the military victories underlying the *Triumphal Procession* as well as beating time for the stately spectacle of that march, were chosen to head this courtly yet military parade.

The first music cluster that appears after the hunters consists of lutenists and viol players (nos. 17–18). These instruments form quiet ensembles, *stillen Hausmusik*, harmonizing compositions of instruments in different registers, often accompanied by singers with similar ranges. The next group of musicians carry wind instruments, both brass and reeds (shawms, trombones, krumm-horns). These louder, more festive instruments sometimes are seen accompanying masquerades rather than fifes and drums. As open-air instruments, trombones and trumpets in particular can be seen on the balconies or on horseback in the context of tournament scenes (for example, Cranach), and they are mentioned (along with rhythmic tambourines) in reports of such tourna-ments, (such as the extensive Burgundian accounts).

The next woodcuts (nos. 21–22) feature portable organs, both "regal" (with reeds) and posi-tive (with pipes alone), led by Master Paul Hofheimer (1459–1537), "monarcha organistarum" and one of the most famous figures of Maximilian's court.[65] Hofheimer had already performed for Maximilian in 1486 at his election as king of the Romans in Frankfurt, after Hofheimer had already been appointed to a lifetime position in the Innsbruck court of Archduke Sigmund. His friendship circle included leading humanist scholars, such as Celtis and Pirckheimer, and he often accompanied Maximilian on travels as a featured entertainer at festive occasions and Diets. In his home base of the parish church of Innsbruck, Hofheimer built a new organ for Maximilian as early as 1491. His acme of success came with the festivities of the Habsburg double wedding of 1515 in Vienna, when Hofheimer was ennobled by the emperor and knighted by King Ladislaus. In addition to his noted mastery as an organist, he was also a celebrated composer, although only a portion of his music was ever published: German *lieder* (art songs), Latin motets, and organ pieces. As head organist, Hofheimer also was the original leader and choirmaster of the "Kapelle," the chorus that sang both sacred and secular songs for the court (see below).

Following the organ cart comes "sweet melody," another ensemble like the first cart, here composed of *tämerlin* (small drum), *quintern* (guitarlike instrument), lute, *rybeben* (viola or rebec), fiddle, harp, and two *rauschpfeiffen* (shawmlike reeds): "And now melodious music springs / From multifarious hums of string. . . ."[66] This chorus of instruments in harmony is followed by the actual choir of singers, headed by "Jorg Slakany (bishop of Vienna)," that is, George Slatkonia (1456–1522), "Kapellmeister."[67] Here, truly, Maximilian's text and deeds align, for his *Hofkapelle*, or court chapel choir, was renowned in Europe. The name "court chapel" derives from the original clerical context of choirs in the churches of the Low Countries during the preceding century. Many *Kapellmeister* were clerics, so the appointment of Slatkonia as bishop of Vienna (1513) as well as imperial councillor (1515) was merited, though he never surrendered his duties as choir-master (since 1501). Slatkonia, quite a learned man in his own right, was a member of Conrad Celtis's Danube Sodality. Like Hofheimer, he bridged the gap between text and music as friend and associate of the humanist poets, particularly Celtis, around Maximilian's court.[68]

Documents reveal that Maximilian's Kapelle was even larger than that of Burgundy. In 1509, the roster consisted of twenty-eight singers, twenty singing boys, and an organist, although not all would have performed at one time.[69] We can see these singers, both boys and men, within the

church space of the woodcut by Hans Weiditz, ca. 1518, *Maximilian Hearing Mass in Augsburg.*[70] While the emperor is shown in the right rear, kneeling at his prie-dieu, the featured figures across the foreground include Hofheimer at his portable "apple regal" with the chorus opposite him. The Hofkapelle once included a number of instrumentalists as well: ten to fifteen trumpeters, two tympanists, four trombonists, a pair of drummers, several pipers and violinists, and two or three lutenists.[71]

In the *Triumphal Procession* woodcut no. 26 (fig. 75), a chorus of about twenty men includes instrumentalists on the trombone and recorder. On the side of the chariot one sees the bishop's arms of Slatkonia accompanied by the figures of Apollo and the nine muses. Each of them is playing a different musical instrument, including the traditional lyre of Apollo (here a *lira da braccia*);[72] however, rather than elevating the muse of music, Calliope, above her sisters, it is instead Clio, the muse of history, who sits opposite Apollo while riding on a long-necked swan. This tribute to the poetic and humanistic arts brings the series of musicians in the *Procession* to a close.[73]

Senn quotes contemporary diplomatic sources who commented on Maximilian's fondness for constant music in his environment.[74] A Frenchman reports in 1492 from Metz that the emperor sat alone in a tapestry-filled room, except for his court fools (whose floats follow the musicians in the *Procession*), but at mealtimes he had ten trumpeters and ten other "loud" wind instruments as well as two large kettledrums, in the manner of Hungarian or Turkish music. A Venetian ambassador in Strasbourg in 1492 reports hearing the emperor's musicians, including fourteen trumpeters, drummers, lutenists, fifers, and violinists, along with a pipe organist. The organ often played in concert with a small viol and a lute in delicate harmony. A Tournai tapestry (ca. 1480) shows Maximilian and his first wife, Mary of Burgundy, surrounded by four singing women, as well as musicians playing fiddle, flute, lute, and harp.

In music history, Maximilian is best remembered for the composers he sponsored, chiefly Heinrich Isaac and Ludwig Senfl. These two remarkable talents were exceptions to the normal rule in European courts (and earlier in Maximilian's own Kapelle)—that progressive music was determined by men trained in the Netherlands.[75] Isaac (ca. 1450–1517), born in Flanders and deceased in Florence, typifies the musical centers of culture during his lifetime, but his contribution to the court of Maximilian remained central, beginning with his first recorded presence in 1496 and his designation as court composer a year later.[76] His presence until 1514 probably corresponds to the exile from Florence of his Medici patrons from 1494 until 1512, although he made numerous visits to Italy during that period as well as to other courts, such as the Saxon court of Frederick the Wise (1497–1500; like Hofheimer). Isaac is celebrated for his protean abilities to compose in all current musical styles, including many forms of *lieder* and *chansons*, the best known of which is his setting, based on an Alpine folk melody, of the poem (sometimes ascribed to Maximilian himself) "Innsbruck, ich muss dich lassen." Today Isaac's best-known music remains his masses and motets, many published posthumously; this sacral music continues his Netherlandish heritage.

One example is his polyphonic motet for six voices, *Virgo prudentissima*, based on a text dedicated to Maximilian by the humanist Johann Vadian; an antiphon of the Magnificat on the feast of the Assumption, its text includes an address by the three archangels—Michael, Gabriel, and

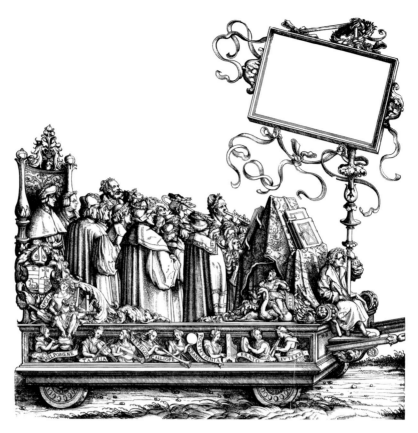

75

Hans Burgkmair, *Choral Music*, from *Triumphal Procession*,
ca. 1516–18, woodcut.

Raphael—on behalf of the empire: "We appeal to you in order that you may pour out to her ears vows and chaste prayers for the Holy Empire and for Emperor Maximilian. May the omnipotent Virgin grant that he overcome his enemies; may she restore peace to the people and safety to the lands. Georgius [Slatkonia] cantor of Augustus [Maximilian] and rector of the chapel, diligent leader of the region of Austria, arranges for you this hymn by means of his devoted care; he commits himself in all things to your pious joy, Mother."[77]

Ludwig Senfl (ca. 1486–1543), Isaac's pupil and successor as court composer in 1517, began in the boy's choir and then served as *Notist* (notator) for the music notations of Isaac for the chorus.[78] His final years were spent at the Wittelsbach court in Munich after the death of Maximilian. His masses, motets, and *lieder* span the full range of music composition in his day, and he also helped collect Isaac's compositions for publication. One of his German *lieder*, "O Herr, ich ru' dein'n Namen an," calls on God's help against the Turks, presumably as a musical exhortation for Maximilian on behalf of a crusade (see chapter 4). Senfl also adapted the music of his Italian contemporary, Costanzo Festa, for Maximilian's funeral motet, "Quis dabit oculis nostris":

Germania, why do you weep?
Music, why are you silent?
Austria, why are you dressed
in mourning, consumed with grief?[79]

Maximilian's reasons for an interest in music, already apparent from the festival and religious contexts of the works' performances, become clear from the apology in chapter 32 of *Weisskunig*, "How the Young White King Learned about Music and String Playing," which is accompanied by a Hans Burgkmair woodcut (fig. 76).

Once he was thinking about King David, that almighty God had conferred so much grace upon him. And he read the psalter, in which he found, "Praise God with song and with the harp." Then he reflected on how very pleasing to God such a thing must be. He also took up King Alexander, who conquered so many kingdoms and lands, and he read his history. Therein was also written: the great King Alexander was often so moved by the lovely singing of people and by the merry string music that he slew his foes. That kindled the heart of the young White King to emulate King David in the praise of God and King Alexander in militancy [*Streitbarkeit*, a major martial virtue for Maximilian]. He learned with diligent effort the arts of singing and of string play, for he occupied himself with two things: the praise of God and the conquest of his enemies, which are for a king the two highest virtues. When he came to be a powerful ruler, he first followed King David in the praise of God. He established a *Kantorei* with lovely singing by human voices, wonderful to hear, and with sweet string play, to "harp" new works. He supported it through and through, as befits a great princely court, and he used the *Kantorei* only for the praise of God in the Christian church. Thereafter he followed King Alexander with the merry string play of militancy and followed Julius Caesar with deeds and surpassed both of them. I will explain clearly: Although the great Alexander compelled wide lands and rejoiced in string music, so did the young White King first utilize the manly-joyous fifes and drum-beats. If he went off to battle, the drums and fifes uplifted not only the hearts of men, but their sound filled the air besides, so that the young King dominated many lands and smote his foes in every respect in battles. Further: although Julius Caesar became the first emperor through his deeds in battle, he had only one party as a foe. This young White King, however, had to make war on all of his neighbors. I will name some of them: the King of France, the powerful people of Switzerland, the mighty lordship of Venice, the emperor of the Turks, the kingdom of Hungary, the fallen kingdom of Bohemia; other enemies, who forgot their oaths, I do not need to mention. He warred these neighbors so fully that he went onto their lands, not they onto his.[80]

This key passage not only indicates the special attachment of Maximilian toward music, but it also underscores the role of all of the princely activities that we have been considering in this chapter, as well as the martial displays of chapter 5. As the strong right arm of the Christian faith,

76

Hans Burgkmair, *Emperor Maximilian Supervising Court
Musicians*, from *Weisskunig*, ca. 1518, woodcut.

Maximilian's duties consisted of martial prowess in the service of the Church and, ultimately, of
God. Hence, his commissioning of religious music was not just the outcome of sacral models in
the chapels of the Low Countries but remained integral to his more active pious purposes. In this
respect, the diary entry of the humanist Cuspinian about the celebrations at the 1515 Habsburg
double wedding in Vienna instructively reveals the public role of Maximilian's religious music:
"The Bishop of Vienna [Slatkonia] celebrated the most solemn office with utmost reverence and
accompanied by an amenable selection of music of diverse kinds. . . . After the nuptials were pro-
nounced by the Cardinal of Gian, all the trumpets were blown, which was wonderful to hear, at
the same time the *cantores* gave out 'Te deum laudamus.' And Magister Paul [Hofheimer], who has
no equal in Germany, responded [that is, alternated with the verses of the choir] on the organ."[81]

 Yet music also could contribute to magnificence in the realm of Maximilian's peaceful pursuits
among his noble and princely peers, whether at tournaments or other festive occasions. Music
thus became instrumental to his purposes in the secular realm as well, and was seen in terms of
its functional effects, such as the exhortation to crusade penned by Senfl, or the martial rhythms

of fife and drum or trumpets in the field of battle.[82] As Cuspinian declared of Maximilian on the subject of music: "The Emperor was a singular lover of music. That is already clear from the fact, confirmed by the Burgkmair woodcut, that all great masters of composition in every musical genre and on all instruments unfolded under his care as if in the most fertile field."[83] Maximilian himself was not an instrumentalist, nor was he a singer. But like King David or Achilles on the harp, he could find in music the harmonious complement to martial activity and to the active exercise of princely virtue.[84]

HERALDRY AND DIPLOMACY

Along with the festivity memorialized on its facade, the Goldenes Dachl in Innsbruck proudly displayed relief coats of arms, representing the largest territories ruled by Maximilian and complemented by the two large paintings of banner-carrying soldiers with the arms of Germany and Tyrol. This same delight in heraldry and what it signifies was commemorated in another Altdorfer woodcut on the right side tower of the *Arch of Honor* (fig. 77).[85] The emperor sits in solemn state, wearing his miter crown (see chapter 3) and holding both orb and sword of his imperial rule. Before him kneels a court official reading a decree, already marked with an imperial seal. The contents of the decree are revealed by means of a third figure, an imperial herald, who wears the double eagle on his herald's mantle and holds a stick as he prepares to gesture toward a chart of nine heraldic arms, arranged in three rows of three. The scene is explained by its verses:

> Austria and Burgundy too
> he raised to kingdoms without ado.
> Both houses thus by his behest
> were soon combined on a single crest.
> For his foresight one day soon
> the heirs would thank him as a boon.[86]

This imperial proclamation of his territories as kingdoms remained a lifelong aspiration of Maximilian, which contributed, as the original German verses make clear, to the elevation of his own family legacy (*erhebt sein hohenn stamm*) and to the lasting use and honor (*nutz und eer*) of his heirs.

Maximilian adorned a remarkable variety of objects with the heraldry of his territories. Certainly earlier princes shared this interest, and Burgundian tournaments and festivities proudly displayed individual coats of arms in public. These colors and heraldic animals served as a rallying point in either tournament or warfare but also served, as Maximilian's verses remind us, to recall both ancestry and political alliances (see chapter 2 on genealogy and kinship). Court heralds interpreted those arms through their genealogical and armorial expertise.[87] Of course, heraldic arms were intimately linked to the right to bear arms; hence, the ceremony and scrutiny of

Er hat getriben ritterspil
darin erzeigt auch kurtzweil vil
Mit warheit ich das sprechen kan
Als vorm als me kein fürst hat than
das alles doch mit sölchem schimpf
Daraus nm kan lob eer vñ glimpf

77

Albrecht Altdorfer, *Maximilian and Heraldry,*
from *Arch of Honor,* ca. 1517–18, woodcut.

shields in the context of tournaments. Thus, this ultimate prerogative of high nobility and princes (imitated by those ambitious to be elevated to a status of bearing family arms) performed a powerful visual role in stately ceremony, such as at funerals (note the importance of heraldry in Maximilian's tomb [chapter 2] or the tomb he completed for his father Frederick III, below).

The most visible public monument of heraldry produced by Maximilian was his Wappenturm, the Armorial Tower (destroyed 1733) of the palace in Innsbruck at the eastern entrance to the Old City.[88] The designer of the Wappenturm was again court artist Jörg Kölderer, and according to an eighteenth-century painting and engraving after the tower in that era, its completion dates, inscribed on the lower and upper sections, were 1496 and 1499. Heraldic arms of Maximilian's claimed territories were arrayed on the tower in rows; each side of the tall structure had three columns of arms with nine shields in each column, making a total of fifty-four territories on public display. At the base of the tower on either side of the arched entryway stood two large painted standard-bearers in armor, akin to the soldiers painted on the Goldenes Dachl but clearly of more noble character; their banners and shields displayed Habsburg and Tyrolean arms, respectively. Above, in a large trilobe sat the arms of the Roman Kingdom of Germany, with the territories of Austria and Burgundy, held by griffins, within the order of the Golden Fleece and crowned by a knightly helmet. Alongside in a circle stood a complementary shield with the arms of Maximilian's second wife, Bianca Maria Sforza, Milan plus Austria, within the German eagle. At the very top of the tower a pair of bust portrait groups appear as if at windows on a royal balcony: first, Maximilian and his two wives, as on the Goldenes Dachl; second, a later royal couple, presumably Ferdinand I and his bride, Anna of Hungary (possibly added or emended in a 1526 restoration of the tower).[89] From these visual documents, the Armorial Tower seems to have been designed by the same Türing workshop that produced the Goldenes Dachl nearby.[90] In light of the relationship between heraldic arms and armor as well as armaments, the location of the tower may be significant. It was built adjacent to that part of the palace where Sigmund, and later Maximilian, both kept their arms and armor;

moreover, Kölderer painted the east front of that armory with an early mural instance of Renaissance architectural decoration (1505).[91]

The arms selected for display on the Armorial Tower in 1496 include both traditional Habsburg dominions, chiefly on the left side, as well as Burgundian realms added through the marriage of Maximilian to Mary of Burgundy in 1477. Five years earlier, as Lhotsky has shown, this basic schema of claims had already been made in the heraldic decorations of a modest pair of pendant portraits of Maximilian's two children, Philip the Fair and Margaret of Austria (Vienna, Coin Cabinet).[92] In this case, the territories are divided, giving Philip (through his portrait) the Austrian lands and Margaret the Burgundian lands (which she eventually ruled as regent).

For the tomb of Frederick III (d. 1493) in Vienna (St. Stephen's), Maximilian retained only the Austrian territories, those ruled by his father.[93] This massive red marble work was begun by Nicholas Gerhaert van Leyden (1468–73) and not completed and installed until 1513 in an act of filial piety. Maximilian celebrates his completion of his father's tomb in another Altdorfer woodcut directly after the one about heraldry, on the right tower of the *Arch of Honor* (fig. 78):

> His father's tomb he built of stone
> and thought thereafter of his own.
> Conceived with great magnificence,
> no other Emperor's was immense
> or costly as this work of art
> which he demanded on his part.[94]

Altdorfer shows the deceased emperor and his heir, each holding word and scepter. The funerary figure lies recumbent under a niche on his *tumba*.

The tomb of Frederick III in Vienna is more elaborate. Below his effigy, heraldic lions (one with the sword) wear helmets with coronals and display some of the arms that ring the *tumba* with heraldry. Beside the emperor a crowned eagle holds his personal motto, "AEIOU."[95] To his right at the top lies the shield of the Order of St. George (chapter 4) with a king's crown. Below a second eagle sits with the emperor's monogram above the arms of the Holy Roman Empire and its double-headed eagle and miter crown. The coronal of the lion with the sword also shows the same Habsburg peacock feathers as featured in the helmet of *Emperor Maximilian on Horseback*, the 1508 multicolor woodcut by Burgkmair (see Fig. 35 in chapter 3). That lion also holds the arms of Austria in the lower left corner of the *tumba*. Continuing the circle of arms, now below the feet of Frederick III, reveals the Habsburg arms, then up the right side (emperor's left) the arms of Styria, Lower Austria, and finally Lombardy, each with an appropriate crown. This monument, then, consolidates both crowns and territories as well as the titles claimed by Maximilian's father. It breaks no new ground in terms of Habsburg territorial assertion but instead summarizes in heraldic symbols the "Domus Austria" (chapter 2) of the dynasty.

The same kind of ceremonial fanfare through heraldic display adorns the ceremonial swords produced for Maximilian around the time of the construction of the Wappenturm.[96] Inscribed

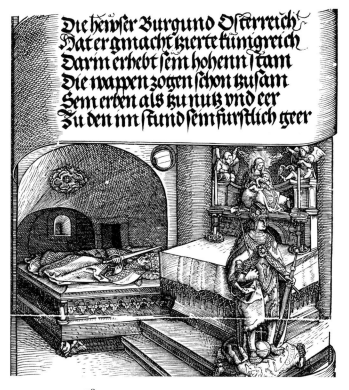

Die hewser Burgun vo Osterreich
Hat er gmacht zierte kümigreich
Darin erhebt sein hohenn stam
Die wappen zogen schon zusam
Sein erben als zu nutz vnd eer
Zu den im stand sein fürstlich geer

78

Albrecht Altdorfer, *Tomb of Frederick III*,
from *Arch of Honor*, ca. 1517–18, woodcut.

"Maximilianus Rex" (with monogram MR) in blued steel and gilded decoration by the royal swordsmith, Hans Sumersperger, in Hall (Tyrol) in 1496, the *Lehensschwert* in Vienna heads this imposing group (Vienna, Schatzkammer). Its original purpose is unknown, although later this sword was carried by the head marshal during solemn ceremonies of oath-taking by the estates before a new archduke of Austria. One side of the blade is devoted to St. George, invoked in an inscription, "Help us holy knight saint George"; another inscription appeals to the Virgin Mary. The other side of the blade, the Mary side, has its own prayerful text. But heraldry dominates the decoration of this ceremonial sword, beginning with the eagle of the German king of the Romans, Maximilian's rank after his coronation at Aachen in 1486. Then, a total of forty-six different coats of arms, twenty-three on each side of the blade, ornament the sword. Here no clear split separates Burgundian from Austrian lands, as in the Armorial Tower and the double portrait, but none are repeated; in addition to the blade, a second set of these same forty-six arms adorns the pommel and hilt of the sword. Lhotsky discerned that the Mary side of the blade took precedence and was ornamented with higher-ranking territories, that is, kingdoms and duchies. Here the claims overlap closely with the roster on the Armorial Tower, and a number of territories are claimed as kingships rather than as lands of lesser status: Bohemia, Dalmatia, Croatia, Bosnia.[97] Like the Wappenturm, these kingdoms date prior to the Spanish alliance of 1496.

The ambition to make Austria into a kingdom of its own, mentioned in the Stabius verse from the *Arch*, had a long history, reaching back to Frederick II and Rudolf IV but also crystallizing in ambitions of Frederick III for the Habsburg territories in Austria. (He constructed his own Arms Wall of 1453 on the St. George Chapel wall of the palace at Wiener Neustadt, containing the fourteen Habsburg lands around a statue of the emperor as well as ninety-three other invented territories derived from earlier Austrian histories).[98] Maximilian, however, had even grander ambitions than his father, which extended beyond Austria to include other kingdoms that he felt were rightly his and his family's after marital alliances with Burgundy, then Spain, then Hungary and Bohemia. He proudly called himself "king and heir of seven Christian kingdoms."[99]

The ceremonial sword was too long to be carried like a normal sword from a belt, and too heavy to be wielded in any conventional sense of a weapon. It also was designed to be read from the tip of its blade back to its hilt, thus oriented clearly toward the sovereign who extended it in a ritual-like dubbing. Ceremonial aspects of this sword are reinforced by the presence of analogous luxury blades with the same kind of blued steel and gilded decoration, in particular the so-called hunting sword in Vienna (D 11) and the long knife in Copenhagen, also made by Sumersperger in Hall in 1496.[100] Not only their heraldic decoration, complemented by the presence of selected personal saints and prayers, but rather their very opulence marks these swords as fit only for a prince at his most ceremonial occasions. In this respect, they confirm the functional utility of the luxury hunting-knife sets by Sumersperger (for example, Stift Kremsmünster), or separate examples (London, Wallace Collection, or New York, Metropolitan Museum), testimony to the princely link between seemingly diverse pastimes of the hunt and the display of noble splendor.[101]

Another seeming incongruity results from the presence of similar heraldic pretensions on the gun barrel of the massive cannon, named "Lauerpfeif" (chapter 5).[102] Produced in bronze before 1507 and recorded in the pictorial inventories of Maximilian's armories as well as in a scale model (Vienna A74), this powerful military weapon displays the arms of new territories claimed by Maximilian during the intervening decade; moreover, its potency as artillery could back up such claims in vastly more practical ways than could any ceremonial sword. Here the drive to rule over seven kingdoms has taken clearer shape. Rather than the four previous claims (Bohemia, Dalmatia, Croatia, and Bosnia), this cannon now presents, along with the eagle of the German kingdom, crowned arms for England (!), Hungary, Bohemia, and Dalmatia, as well as the duchies of both Austria and Burgundy that Maximilian aspired to make into kingdoms in their own right. Doubtless Maximilian himself sanctioned the production of this cannon; his personal ornaments also fill its surface: the emblems of the Golden Fleece (flints, St. Andrew's crosses) as well as the personal emblem of pomegranates. Strikingly, Maximilian did not possess this particular selection of kingdoms, even those he had claimed earlier from the occupied territories of the Turks.[103] That claim to England resulted from the shaky title of the Tudor dynasty as well as the childless death of a pretended son of Edward IV, one Perkins Warbeck, who yielded his title to Maximilian in 1495.[104] Consequently Maximilian also placed the bronze figure of King Arthur among his ancestors of the tomb ensemble (chapter 2).

Further enrichment of these territorial claims were asserted in 1509 in the highly public form of the commemorative coin, produced by Maximilian in honor of his coronation as emperor at Trent the previous year (see chapter 3; fig. 37). After the equestrian portrait of the emperor in armor on the obverse of this coin, the reverse presents two large concentric circles of armorial shields.[105] Now, of course, the double eagle of empire rather than the single-headed eagle of the German kingdom adorns the center of the two circles. The inner circle of heraldry signals the kingdoms claimed by Maximilian, now the canonical seven he had been seeking: Austria, Spain, Bohemia, Portugal, Croatia, Hungary, and England. The outer circle of nineteen other territories completed his most lofty territorial "possessions." This special coin, then, transmitted the same

kind of message to the wider world as the local Armorial Tower at Maximilian's own palace in Innsbruck, so he used its broader reach as a medium to make his boldest claims to date: "Plurimarumque Europe Provinciarum Rex et Princeps Potentissim" (Most powerful King and Prince of provinces and the greater part of Europe).

By the time Maximilian's plans for the *Triumphal Procession* took shape in the miniatures by the Altdorfer workshop and in the woodcut series (nos. 57–88; fig. 79), also produced by Altdorfer, such public claims to territories had become a major element of that cycle.[106] The relationship of territorial claims and heraldic arms to the spectacle of tournaments emerges in the placement of this segment of the *Procession* immediately following the woodcut series devoted to the jousts. The dictated text of 1512 provides a narrative logic to the order of the heraldic banners within the framework of "The Emperor's Journey to his Burgundian Wedding:"

> Austria's noble house now see
> Joined with that of Burgundy.
> For information full and clear
> Observe the arms that now appear,
> Royal escutcheons old and splendid,
> Through marriage marvelously blended.[107]

Thus, Austrian colors are given precedent over Burgundian. Each is preceded by a proper musical flourish, akin to actual festivals: first three drummers and three ranks of trumpeters in Austrian colors before their territories, then Burgundian fifers on horseback leading their contingent. Magnificent banners ("not gonfalons," says the text, "and all with coats of arms, helmets, and crests") proclaim the possessions of the emperor in sequence.[108] They are further distinguished according to whether Maximilian waged war there, in which case the banner-bearer wears armor; otherwise, the costume supposedly is local. Among the Austrian banners are included some of the more exotic claims to kingdoms, including Bohemia and England (no. 75), and Portugal and Moravia (no. 76).[109] Kingdoms of eastern Europe were to have been placed elsewhere, namely in the section "Hungarian War" (miniature no. 58; woodcut never executed): Hungary, Dalmatia, Croatia, Bosnia.[110] Notably, the dictated text clearly distinguishes between territories actually possessed by the Habsburgs and those they claim, such as England, as their rightful future inheritance.

In similar fashion, the arms of newly acquired Spanish kingdoms and territories are reserved to accompany the float by Dürer of *The Marriage of Philip the Fair* (woodcut no. 105; see fig. 5); no woodcuts of these territories were produced, but the miniature cycle does devote five separate folios to these heraldic arms (nos. 12–16), followed by the marriage image miniature by Altdorfer himself.[111] In the Spanish marriage, Maximilian looks on, wearing the miter crown and standing above an anachronistic double-headed imperial eagle shield, as Philip the Fair and Joanna of Spain together hold up a large shield, now quartered with their joint arms as befits either the queen or, more important here, her offspring. The verses confirm this development:

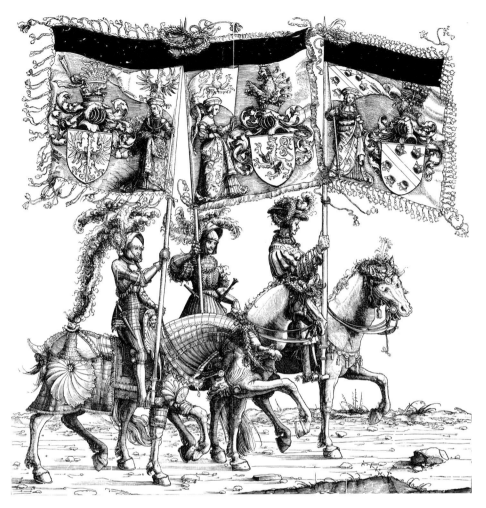

79

Albrecht Altdorfer, *Territories of Austria*, from *Triumphal Procession*, ca. 1516–18, woodcut.

The son of our Emperor gained the hand
Of the heiress to the Spanish land;
Then here to Austria she came
To honor Maximilian's fame.[112]

After the success of the double marriage in Vienna in 1515, the fortunes of Austria and the Habsburgs were joined (for four centuries) to the kingdoms of Bohemia and Hungary through the marriage of Ferdinand of Austria to Anna of Hungary as well as of Ladislaus (Ludwig) of Bohemia to Mary of Habsburg. This event increased both the level of confidence and territorial pretensions of Maximilian. The principal inscription atop the *Arch*, which includes the Vienna

double wedding as its latest historical scene, proclaims Maximilian as "elected Roman Emperor and Head of Christendom; King and heir of seven Christian kingdoms, Archduke of Austria, Duke of Burgundy, and of other mighty principalities and countries of Europe. . . ."[113] The Dürer woodcut on the *Arch* of the double wedding at Vienna resembles its counterparts elsewhere on the *Arch*, featuring the Burgundian or the Spanish alliances (chapter 2 and below; see figs. 3, 5, 6).[114] The verse accompanying this woodcut underscores the majesty of Maximilian and reinforces the prominent heraldry beneath the figures of the three kings, Maximilian with his imperial eagle, plus King Ladislaus of Hungary and King Sigismund of Poland:

The Hungarian, Bohemian, Polish kings
all pay homage at his gatherings.
They visited him on their own accord
to honor him, his crown and his sword.
New marriages and alliances soon
for all Christendom provide a boon.[115]

The German text makes clear the value of this marriage and bond (*heyrat und puntnuss*), namely "breeding and honor" (*zucht und eer*). Indeed, to display these twin qualities could be said to form the larger purpose served by all his princely pomp as well by his proclamation of the heraldic vastness of *sein aigen lanndt*, the Habsburg territories and claims. Thus, these territories adorn the edges of the family tree at the principal place of honor, the top center of the *Arch*, where Maximilian placed his last great display of heraldry. The arms on the left of the genealogy represent the Austrian homelands, already claimed in previous cycles of heraldry, whereas those to the right are more recent acquisitions, including the broadest possible claims allowed through the Spanish inheritance. From this Spanish legacy, fully twenty-four arms bear crowns of kingdoms (including "Insularum Indiaru et maris occ'at," the islands of America). Again precedence is accorded to kingdoms, beginning at the left with Hungary, Portugal, England, Bohemia, Dalmatia, Croatia, and Bosnia—the canonical seven kingdoms. To their number are added "new kingdoms," first revealed in the banners of the *Procession*: Lower Lombardy and Austria. From Spain, the leading kingdoms included the expected ones—Castile, Aragon, and Leon—as well as the Kingdom of the Two Sicilies, Naples, and Jerusalem. Burgundy has not yet been elevated to the status of a kingdom and follows the American Island kingdom. Altogether, the *Arch of Honor* proffers 108 heraldic arms, about a third of them Spanish, compared with the 101 total arms (16 Spanish) in the *Procession* and a "mere" 54 arms (plus some added Spanish arms along with Hungary in the upper story) of the Wappenturm.[116]

Within the *Triumphal Procession* stately ceremony and the display of heraldry honor the princely position of Maximilian. Beyond the *Procession*'s armorial woodcuts of Habsburg territories and after the sequence of earlier battles on banners carried by soldiers, an added banner is dedicated to the "Roman Coronation," that is, the 1486 crowning as king of the Romans at Aachen, followed by *The German Kingdom*, a single-headed eagle like the Wappenturm.[117] The

crown of office is carried on a cushion by a courtier, while a banner shows the personification of the "Roman woman" on a throne with the crown as four angels hold the ceremonial insignia: orb, scepter, sword, and eagle banner. (Two further angels hold instruments of Christ's Passion, including the crown of thorns, as a reminder of the link between this office and its duties as head of Christendom—see chapter 4.) A banner of the imperial eagle is surrounded by the arms of the seven imperial electors. On a second banner the crowned and enthroned Germania, with scepter and sword, appears with the crowned arms of the eagle and the accompanying arms of three archbishoprics (Bremen, Magdeburg, and Salzburg) and three houses (Austria, Bavaria, and Saxony). After the images of war wagons and a general warfare plaque, celebrating the territories conquered by the sword in all the battles (miniature no. 22; no woodcut), comes a celebration of the proposed *Kingdom of Lower Lombardy* (no. 24; no woodcut), then of *The Six New Austrian and Burgundian Kingdoms* on a single miniature.[118] These were territories, already ruled by Maximilian, that he aspired to elevate to kingdoms in order to justify his imperial dignity still further by being a king in his homelands as well as the ruler of (seven) kingdoms to which he staked an external claim. Then he could more accurately be said to be a king of kings or prince of princes in his role as leader of Christendom, *haupt der Cristenhait.*

In addition to the coronation as king of the Romans, several other images in the *Procession* either celebrate imperial status and regalia or else represent the coronation. Behind the new Austrian and Burgundian kingdoms and the artillery (see "Lauerpfeif," above) come two miniatures (nos. 28–29; no woodcuts) of the sacred treasure and secular treasure, respectively.[119] These were also celebrated on Altdorfer's lowest woodcut of the right outer tower of the *Arch*, directly below the image of the tomb of Frederick III, whose verses declare:

> The greatest treasure was his alone
> of gold, of silver, and of precious stone.
> Costly vestments, pearls galore,
> as no other prince had before.
> Of all this in honor of the Lord
> he freely gave of his own accord.[120]

The text notes how such display of riches signaled a prince's magnificence; ironically, Maximilian's father was the one who delighted in luxurious treasure objects, though the son clearly recognized the value of that imperial legacy.[121] In the *Historia*, Frederick's "hobbies" *(De eius dactilothecis aliisque exercitiis)* are illustrated in a drawing of the aged emperor at a table with a scale, weighing and checking his precious possessions, as attendants bring him both an imperial crown and mantle.[122] According to the Grünpeck text, these new ornaments of office cost Frederick an astounding 320,000 gold gulden. The Altdorfer *Arch* woodcut consolidates a single image of the same treasure horde that occupies two *Procession* miniatures, yet clearly pious donations and reliquaries make up a substantial, separate, portion of the treasure, like the famous relic collections of other princes, such as Frederick the Wise of Saxony (chapter 4). In addition, specifically imperial

items, including the miter crown and archduke's hat, stand visible on a special table under a baldachin in the woodcut.

After the succession of funerary statues of Maximilian's ancestors (chapter 2), the *Procession* climaxes with the arrival of the emperor in all of his splendor, preceded by "a goodly number of trumpeters and drummers with the imperial flags on their trumpets, and wearing laurel wreaths" (woodcut nos. 115–17; miniature nos. 37–38) and by heralds (woodcut nos. 118–20; miniature no. 39). An inserted theme, not in the 1513 dictation but added in a letter (26 January 1513), led to the next miniature (no. 40; no woodcut), which included the imperial mother, Eleonore of Portugal, in full regalia on a triumphal chariot, accompanied by four additional women of Maximilian's ancestry.[123] Altdorfer himself provided the glorious following miniature (no. 74; no woodcut) of the imperial banner and imperial sword, borne by Christoph Schenk and an imperial marshal.[124] This forms the prelude to the emperor's own triumphal car, originally with his children and grandchildren (miniature no. 43; cf. Dürer drawing, fig. 33, Vienna, Albertina, W. 671; no woodcut).[125] But what follows the emperor holds added importance: the retinue of German princes, counts, barons, and knights, who complete his own personal magnificence with their own. Like angels, arranged in hierarchies around the holy figures of Madonna and Child as the sign of their ultimate holiness, these German noblemen confirm both the central majesty and the authority of Emperor Maximilian by their presence in his train as well as their willingness to serve him. Woodcuts for this section were never produced, but two glorious miniatures of the princes (nos. 44–45) were executed by Altdorfer himself and are followed by six further images of lesser nobles (nos. 46–51).[126] The verses record some of this message:

> (Princes) The Emperor has chosen for their great worth
>> The princes of illustrious birth
>> Who follow now in brave array
>> And high on horseback make their way.
>> The battle-won kingdoms and princely lands
>> Are shown in the banners they hold in their hands.
> (Counts) No less the honor and circumstance
>> For the counts and barons who now advance;
>> Granting their lofty birth its due,
>> They give the Emperor service true.
>> Knightly precepts they held ever dear
>> And fought for the Empire many a year.

Like the banners of the territories of the Habsburgs, these splendid equestrian figures, presumably portraits, are visually dominated by their own heraldic insignia on massive banners on tournament lances. Thus, they reciprocally glorify and magnify the earlier substantial holdings of the Habsburg lands, underscoring the role of the Habsburgs as princes among princes.

The *Triumphal Procession* therefore finds its ultimate fulfillment as much more than just a cumulative emulation of ancient imperial military triumphs (chapter 3). At the same time, it glorifies the office of emperor as the greatest of princes, particularly in the uniquely German context of these additional powerful nobles. Ultimately, the *Procession* extols the trappings of that imperial office: the sacred and secular treasures, the imperial regalia, the seemingly endless succession of heraldic banners of the emperor's territories. Court life and princely pastimes from the earlier part of the *Procession*, although quite personal passions and private entertainments, thereby can serve as essential elements of Maximilian's imperial magnificence, now on public parade, if only on paper. But that paper pageant could also be distributed to these same brother princes of Germany, at once to confirm their role in the visibly splendid rule of the emperor as well as his own supremacy.

If the cumulative effect of the *Triumphal Procession*, particularly in its fully realized form in accord with the dictated text (rather than in the overlapping fragments of its miniatures and woodcuts) would have been the full dignity of Maximilian's imperial and general princely magnificence, then the consequences of that princeliness would be his ability to negotiate with his brother kings and princes.[127] Such is indeed the other side of the Habsburg coin of constant warfare, when their dignity was infringed by neighboring monarchs, for they also were active participants in the new Renaissance game of diplomacy. Moreover, as the epigraph to chapter 2 in this volume has it, they succeeded better in love than in war by making their finest alliances through those vaunted marriages: *Bella gerant alii / Tu felix Austria nube* (Let others war, / As you, fortunate Austria, marry).

Besides the obvious territorial advantages of these international marriages between the Habsburgs and other ruling houses, the extraordinary pomp on such occasions reconfirmed the majesty of Maximilian's house. As noted above, festive tournaments and masquerades were staged at the time of such marriages, and their pictorial commemoration in various instances of Maximilian's printed artworks makes clear how important the solemn pageantry of weddings could be. These weddings, of course, figured among the crucial historical events included on the *Arch*, woodcuts produced by Dürer himself, in contrast to the other, almost interchangeable battle scenes (chapter 1).[128] As noted above, both text and image of the Vienna double wedding stress the homage paid to Maximilian by the kings visiting him in his territory.

The rejection of a marriage alliance or its cancellation also could be grounds for warfare. This situation is exemplified by Maximilian's celebrated "Brautraub," when his contracted betrothal to Anne of Brittany was negated by Charles VIII of France, who took her as his own bride (1491).[129] Previously, King Charles had already repudiated his commitment (1482) to a peaceful alliance with Maximilian through marriage with Margaret of Austria. Included among the historical woodcuts on the *Arch*, this event formed the final battle scene on the left, with these verses:

His daughter's marriage plans upset
with new designs were quickly met.

Revenge against the French he sought
and battle plans were quickly wrought.
The foe defeated at his hands
thus was deprived of two good lands.[130]

One final image among the historical scenes of the *Arch* deals with the larger question of diplomacy as the inverse of the usual scenes of war. This scene, reminiscent of *Weisskunig* (see below), shows the meeting of two great kings. On a shoreline under banners of the Golden Fleece (Maximilian) and Tudor Rose (Henry VIII), the two form an alliance against France:

The King of England was impressed
how in each war he [Maximilian] did his best.
Therefore he joined in an alliance
to help bolster the defiance
and jointly with the English
his enemy to vanquish.[131]

This *Brüderschaft* forms the kingly counterpart to marriage, joining two sovereigns against a common enemy, in this case France, by means of treaties and "Leagues." Such shifting league alliances became the rule in internecine struggles for Italy during the early sixteenth century, most notably the Holy League against France by Maximilian, the pope, Spain, Venice, and Milan (1495), or the League of Cambrai (1507) against the Turks (and more nearby, Venice) by the same parties as well as France.[132]

To turn to *Weisskunig*, clearly much of the conceptual scheme of that book depends on this kind of international diplomatic interaction among Europe's princes, who are identified not by name, but rather by color or attribute or emblem. As noted, the White (or wise) King, stands for Maximilian as well as his father, Frederick III, and he is opposed by the "Blue" King of France, the "Green" King of Hungary, and the "King of Fish," that is, Venice. He allies himself through marriage with the "King of Flints," Burgundy. Because diplomacy implies parity among all participants, this lightly fantasized world elevates all rulers to the equal status of kingship. In addition, because a title endures despite the passing of its temporary holder, no distinction is made in the names of protagonists or antagonists, except to distinguish the "old" White King (Frederick) from the younger one, Maximilian; however, the Blue King remains unvarying within the text—a constant, undifferentiated French foe, despite the succession of French rulers during the lifetime of Maximilian. Of course, here names and titles are merely modified derivations of the heraldic arms borne by each of the principals either in tournament or in battle (see chapter 5 and above).

Because of the pomp demanded of princely majesty at this level, funeral ceremonies offer major occasions for its display, as the many funeral woodcuts in *Weisskunig* emphasize (nos. 57, 84–85, 124, 128, 144–45, 168, 170, 194, 207, 211, 213). The other major milestone of life, marriage, also displays all the ceremony of state in these illustrations, beginning with woodcut no. 9, where

the pope solemnizes the nuptials of the old White King and his bride before the altar in Rome (the marriage of Frederick III and Eleonore of Portugal in 1452) after welcoming them officially in the previous woodcut. Subsequent coronation of each (nos. 10–11), consecration with the sacrament (no. 12), and solemn procession (no. 13) complete the cycle. The nuptials of Maximilian with Mary of Burgundy are sumptuously illustrated (woodcuts nos. 63–65): first, the meeting, then the costly festive banquet, and finally the marriage ceremony itself, before the altar of a church and in the presence of suitably noble witnesses in splendid costume. Even the festivities surrounding the arrival of Joanna of Castile to meet Philip the Fair are illustrated in a seaside betrothal image (no. 216).

One of the most wonderful instances of the conduct of diplomacy around marriage contracts at the princely level is the woodcut illustration depicting negotiations for the hands of Maximilian's granddaughters, the children of Philip the Fair. As if to underscore the interchangeability of the suitors and of the young ladies as eligible partners and also to emphasize the parity of bearers of heraldic arms and titles, these several images actually modify details in the corner of a single woodcut (nos. 220–22). Enthroned in the center of the illustration is the majestic pair of Maximilian and Philip, each crowned and holding a scepter before a cloth of honor, with attendants off to the side. In the lower right corner of the image is an L-shaped plug, consisting of three well-dressed, kneeling ambassadors, accompanied by a standing attendant, who bears their armorial shield. The first image shows the arms of Portugal, seeking the hand of princess Eleonora. The other two examples substitute different inserted patches with other costumes and heraldic arms to complete the same ceremonial occasion for subsequent petitioners, Denmark for Isabella's hand and Hungary for Mary's hand, respectively.

Weisskunig also abounds with images of diplomatic alliances made between princes, usually shown as individuals in private, presumably secret, conversation. The most beautiful of these meetings is the illustration (no. 130; by Burgkmair) of a treaty (1502) between a young, handsome, Philip and the older Henry (VII) of England, in which the two monarchs meet at the seaside, each crowned and in armor, accompanied by armed followers. Its caption, "the newest English alliance between King Philip, in the name of the Emperor, and the old Henry of England," corresponds to chapter 126, in which the Red-White (the two roses of England) king is slain by his successor (Richard III by Henry VII), who then negotiates with the young White King. It can be compared to a later section of the text, chapter 150, where such an alliance originates between Maximilian, England, and Spain against the French ("How the young White King, the Red-White, and the Brown King Concluded an Alliance [*Bündnis*] against the Blue King"):

After the Blue King had brought the Black-White King under his will, the White King was full of displeasure and sent embassies to the Red-White King, likewise to the Brown [Spain] and had them hold up the affairs [*Praktiken*] and unjust wars that the Blue King continually undertook. He let both the kings entreat for help against the Blue King and declare it to be a scandal and slur for the three of them before all the world that the Blue

King should conduct himself in so uphanded a fashion. That was taken to heart by both kings. They allied themselves with the White King with one accord to oppose the Blue.

This description typifies the ebb and flow of alliances in *Weisskunig*, like the historical color wars in the factional politics of Byzantium. Other illustrations of princely intrigues are interspersed among the later images, for example, no. 183, the League of Cambrai against Venice, here characterized as *The League of the Four Kings, namely the King with Three Crowns [the pope], the Blue King, the Black King, and the White King, against the King of the Fish.* The previous woodcut (no. 182), shows an alliance between "pope [not identified in the woodcut by costume], emperor, Spain, and Hungary," all enthroned along a single bench with attendants in front of them. Even the instability of these alliances is suggested amusingly in later woodcuts, such as no. 190, where the same four kings are shown leaving a common room through four separate doors. In similar fashion, the next image (no. 191) shows the later withdrawal of one ally, the King with the Three Crowns from the others. These shifting ties correspond to the last text portions (chapters 198–216), which chronicle the Italian Wars, the League of Cambrai (1508), and the Holy League of 1511. Similar woodcuts repeat this pattern later (nos. 225–26, 236). One final, beautiful instance of a historical event between ambassadors at the highest level is Burgkmair's rendition of Maximilian's treaties with Russia (no. 237; fig. 80). The portrait character of the emperor at the right is balanced at the left by the distinctive fur-lined hats and long coats of Russian diplomats.[133]

More frequent illustrations of diplomacy in *Weisskunig* woodcuts feature kings receiving or dispatching ambassadors who represent the other courts. Indeed, the pictorial story unfolds with a sequence of these occasions, when the old White King dispatches his ambassadors to search for his bride (no. 2), after which they represent him at the court of the king of Portugal (nos. 3–4). In Burgkmair's beautiful open-air scene, Maximilian's own marriage is arranged on horseback in front of large retinues by his father and his Burgundian father-in-law (no. 54). Another striking Burgkmair woodcut depicts Maximilian receiving the ambassador of the Burgundians, who brings him news of his impending marriage (no. 59). As in the Russian embassy (no. 237), the careful portrait likeness of the emperor dominates in the center of the composition, flanked by the two figures of the courier and a dashing *Landsknecht*. Prior to the marriage itself (nos. 63–65), the two White Kings hold counsel with one another (nos. 60–62). Taken together, these woodcuts emphasize by their numbers and by the seriousness of these meetings how important the marriage negotiations were for both Frederick and Maximilian, and they also underscore the central political and personal significance of Maximilian's first marriage in his biography.

Much the same pattern repeats in the negotiations, including war scenes of intimidation (nos. 121, 127), between the Blue King (France) and the Ermine King (Brittany, on the occasion of the "Brautraub," no. 126), with several exchanges of diplomatic messages. Here, of course, the outcome ended unfavorably for Maximilian; however, as noted above, it shaped his career-long antagonism against France as surely as his own marriage alliance with Burgundy.

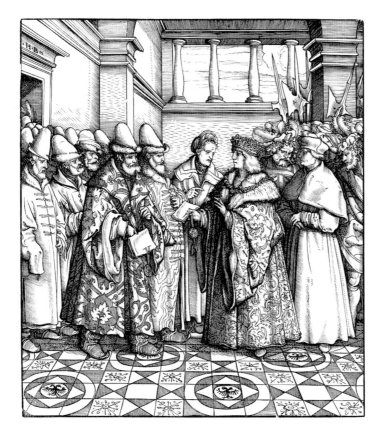

80

Hans Burgkmair, *Treaty Scene*, from *Weisskunig*, ca. 1512–18, woodcut.

Testimony to the importance of marriage in the life of Maximilian can also be found in individual commissions of artworks, chiefly the portraits of his brides. The leading examples of these formal portraits are again those of Bernhard Strigel, the "official" portrait painter of the emperor (see chapters 1 and 3). His portrait of Mary of Burgundy survives in both original (Innsbruck, Ferdinandeum) and replica (Washington, D.C., Dumbarton Oaks). A portrait of Bianca Maria Sforza remains in private hands (replica, possibly by Hans Maler zu Schwaz, in Schloss Ambras).[134] Fittingly, these portraits of his wives correspond closely with the more informal images by Strigel of Maximilian as a "private man," that is as prince rather than as emperor, dressed with a mantle and a soft hat (*Barett*) rather than a crown.[135] In these portraits, he still wears the collar of the Order of the Golden Fleece and holds a scroll in his hand as he gestures out of the picture in the direction of a pendant portrait, presumably either an image of one of his wives with the same windowsill and view out-of-doors, especially the Alpine hunting grounds beloved by Maximilian. Even one of his imperial portraits shows falcons and game animals out the window (Vienna).[136] One other Strigel portrait (1520; Vienna), produced in the wake of the 1515 Vienna double wedding, depicts the full family group of Maximilian and Mary of Burgundy along with their heirs, Philip

the Fair, grandsons Charles and Ferdinand, and the young, adopted heir, Ludwig of Hungary (also painted in a separate portrait [Vienna] by Strigel).[137] The Vienna group portrait bears labels with the names, not of the Habsburgs themselves, but rather with the relatives of Christ, the Holy Kinship (chapter 4); however, the significance of this image lies in its emphasis on dynastic family continuity as well as the recent nuptials of both Ferdinand and Ludwig, marked in the image by bridegroom's crowns of flowers on both their heads.

Paintings were not the only means for commemorating the occasions of such princely marriages. Maximilian utilized both coins and medals to celebrate his taking a bride.[138] The most notable contemporary celebration of his wedding with Mary of Burgundy was a medal, struck by Giovanni Candida after 1477; its portrait of the bride on the reverse complements the profile of a long-tressed Maximilian on the obverse. Ironically, a reissue of images of Mary of Burgundy was initiated after the 1511 death of Bianca Maria Sforza in the form of commemorative silver guldiners.[139] Another commemorative coin, designed by Mantuan Gian Marco Cavalli, was issued in silver with a double portrait of Maximilian and Bianca Maria behind him (1506; reverse with Madonna and Child). In another life rite of passage, a similar commemorative coin was struck for Maximilian for the formal funeral installation of the tomb of Frederick III in Vienna in 1513.[140]

Concerning marriage, an overview of *Teuerdank* reveals its significance as a model for the "carefree" life of the young prince before he takes up his official duties as ruler. The framing narrative of *Teuerdank* is a marriage journey of the young prince to meet his bride. The various adventures that he meets along the way occur largely to a single, as-yet-uncommitted hero and knight. Indeed, the full title conveys this message clearly: *The Dangers and a Part of the Histories of the Worthy, Valiant, and Most Famous Hero and Knight, Lord Teuerdank (Die Gefahren und ein Teil der Geschichten des löblichen, streitbaren und hochberühmten Helden und Ritters, Herrn Theuerdank)*. He still is striving to make his reputation and to live up to the noble blood of his birth, so he will be worthy to accept the hand of Queen Ehrenreich ("Rich in Honor"). Thus, his prowess in both the hunt and the joust is repeatedly put to the test prior to his eventual alliance in marriage and beginnings of a just rule in the final chapters. He is received by his beloved in woodcut no. 98, much like the receptions in *Weisskunig*, but only after receiving a laurel crown from her for various tournament victories (no. 107) does his life change. Thereafter he presides over tribunal judgment (no. 109), then summary execution (nos. 110–12) with all the authority of earned kingship. Even before the marriage ceremonies have taken place (no. 116), the queen announces that he should now take royal leadership responsibility for leading a crusade against the infidel (no. 113).[141]

Maximilian's own notebooks suggest that *Teuerdank* was envisioned as the youthful prelude to the maturity and political responsibility depicted in the *Weisskunig*. So, like marriage itself, the passage from the former text to the latter would have been equivalent to the rite of passage to full, royal adulthood. Only in the central, "apprenticeship" section of *Weisskunig*, where the young White King learns the skills, both intellectual and physical, that he will need as a ruler, does the *Weisskunig* text overlap in any substantial way with the activities (chiefly hunting, noted above) found in *Teuerdank*.

Thus, royal rule provides the fuller significance for the new (and rare) buildings by Maximilian in Innsbruck, his main court center. Both the Goldenes Dachl and the Wappenturm highlighted his territorial claims and his princely status through heraldic arms, presented at the boundary of his castle to the town and the wider world. At the same time, both structures featured portraits of Maximilian accompanied by his two wives and appearing at a balcony above the public square, where ludic pastimes like courtly dancing provided amusement but also marked noble privilege and status for the prince. These constructions demarcate a precinct of princely activity, defined by and also enacted through high-status marriages and territorial possessions. Both the marriages and the territories, inextricably bound up together, provided the foundations and the expressions of princely pastimes.

After the "private" portraits by Strigel, a pair of final painted portraits of Maximilian by Dürer epitomize the qualities of "princely magnificence and dignity." These two well-known oil por-traits in Nuremberg (fig. 81) and Vienna (fig. 82) are based on an informal study from life, done by Dürer in chalks in Ausburg (28 June 1518; Vienna, Albertina, W. 567; fig. 83) at the occasion of the Diet.[142] Although they sit on different supports (Nuremberg, canvas; Vienna, limewood) and present inscriptions in opposing languages (Nuremberg in German; Vienna in Latin), both images present a relaxed, half-length figure in costume like Strigel's "private" poses: soft hat with medallion, loose mantle (fur-lined in Vienna; completed by the chain of the Golden Fleece in Nuremberg). Imperial rank is not absent here; rather, it is proclaimed by a heraldic shield with the double-headed eagle, bearing Austria on a heart shield. Above the imperial arms sits the Habsburg imperial miter crown (chapter 1), and around the shield the collar of the Golden Fleece. But the prevailing mood remains studied informality, where personal appearance prevails over assertions of the august rank of Maximilian. Significant here is the item in his hand: the personal emblem of a pomegranate, substituted for the imperial orb of imperial majesty (also prepared in a separate Dürer black chalk study, dated 1519, now paired in Vienna with the Augsburg portrait study; Al-bertina, W. 635). The date of both the pomegranate drawing and the pictures confirms that they were posthumous tributes, certainly begun after news of the death of Maximilian, whose vital statistics are recorded in both painted inscriptions.

Those inscriptions read like official proclamations of the status of Maximilian and thus re-inforce the message of the crowned armorials on both pictures, but they, too, have a curiously personal appreciation of his princely qualities: "The most almighty, most invincible Emperor Maximilian, who in reason, decorum, wisdom, and manliness / surpassed the multitudes / Also practiced remarkable great deeds and accomplishments.[143] Of course, Dürer received a lifelong pension from Maximilian (chapter 1) as a result of his activities earlier in the decade on the *Arch of Honor* and other projects, so his gratitude toward the emperor was personal as well as patri-otic.[144] Regardless of Dürer's individual connection with Maximilian, these two portraits capture the distinctive aspects of his princely trappings, appropriately symbolized in the emblem of the pomegranate. Stabius presents the authoritative explanation of this symbol in his colophon to the *Arch*: "Its meaning is this: although a pomegranate's exterior is neither very beautiful or endowed

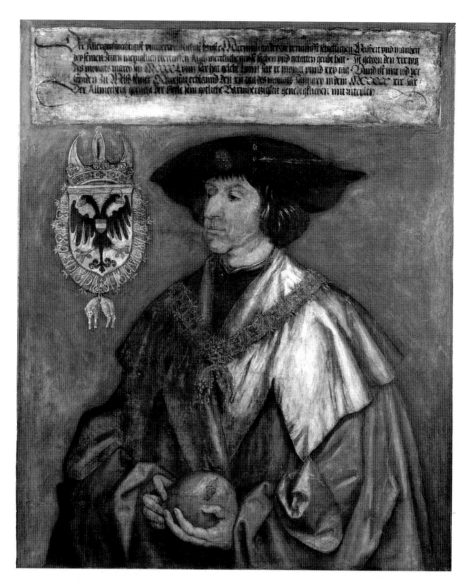

81

Albrecht Dürer, *Maximilian I*, 1519, oil on canvas,
Nuremberg, Germanisches Nationalmuseum.

with a pleasant scent, it is sweet on the inside and is filled with a great many well-shaped seeds. Likewise the Emperor is endowed with many hidden qualities which become more and more apparent each day and continue to bear fruit."[145] Such words echo the characterization Stabius gave earlier in his program to the activities, interests, and pastimes that revealed Maximilian's qualities along the outer reaches of his *Arch*, the area with the woodcuts by Altdorfer: "Now because these subjects cannot properly be said to be triumphal, but do serve as good examples to others, they have not been placed on the Arch of Honor itself, but instead on each side of it."

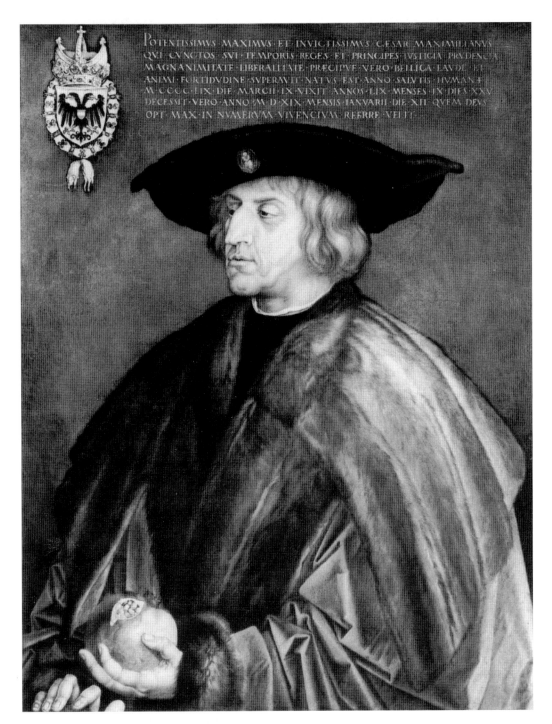

POTENTISSIMVS MAXIMVS ET INVICTISSIMVS CESAR MAXIMILIANVS
QVI CVNCTOS SVI TEMPORIS REGES ET PRINCIPES IVSTICIA PRVDENCIA
MAGNANIMITATE LIBERALITATE PRÆCIPVE VERO BELLICA LAVDE ET
ANIMI FORTIDVDINE SVPERAVIT NATVS EST ANNO SALVTIS HVMANÆ
M CCCC LIX DIE MARCII IX VIXIT ANNOS LIX MENSES IX DIES XXV
DECESSIT VERO ANNO M D XIX MENSIS IANVARII DIE XII QVEM DEVS
OPT MAX IN NVMERVM VIVENCIVM REFERRE VELIT

82

Albrecht Dürer, *Maximilian I*, 1519, oil on panel.

Vienna, Kunsthistorisches Museum.

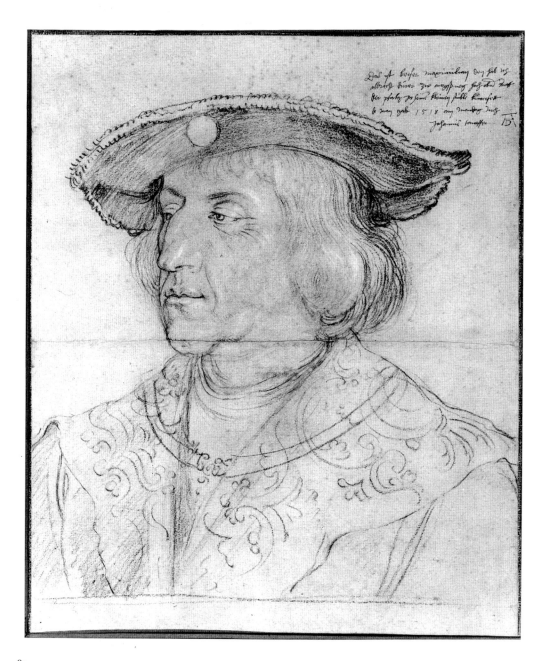

83

Albrecht Dürer, *Maximilian I*, 1518, chalks. Vienna, Albertina.

So too these posthumous portraits. Without ceremony, the dignity and maturity of the prince alone suffice to convey his magnificence, which will become "more apparent each day and continue to bear fruit." The person of the emperor also remains exemplary, the literal embodiment of princeliness itself.

Ah, but a man's reach should exceed his grasp,
Or what's a heaven for?

—ROBERT BROWNING, *"Andrea del Sarto"*

Events do not happen all at once, they happen point for point, they develop according
to pattern. . . . A tale with a lamentable close has yet its stages and times of honor,
and it is right to regard these not from the point of view of the end, but rather in their
own light.

—THOMAS MANN, *Joseph and His Brothers*

I am the state.

—KING LOUIS XIV

7 | Conclusions: Dynasty and/or Nation?

To assess the reception of Maximilian's ideology, one must examine both of his dynastic heirs, Emperor Charles V and King Ferdinand I of Austria-Hungary, as well as his staunchest opponents, led by Elector Frederick the Wise in Saxony. Even the modern historical verdict on Maximilian differs sharply on either side of the Germany/Austria divide.

In the late nineteenth century, when Bismarck's initiatives finally succeeded in realizing nationalist dreams of a consolidated Germany (at the expense of Austria-Hungary, roundly defeated by Prussia in 1866), historians judged Maximilian harshly for pursuing dynastic interests and imperial pipe dreams at the cost of earlier nation building.[1] Chief among these, his first biographer Heinrich Ullmann (1884–91) followed the model of Leopold von Ranke, emphasizing documentation about ducal resistance to Maximilian's ambitions and concluding that the empire was rendered still more factionalized in the wake of Maximilian's personalized and international agendas: "The States had been more intent on internal, Maximilian on external affairs; but neither would the king so far strip himself of his absolute power, nor the States part with so much of their influence, as the other party desired."[2] In this view the early sixteenth-century empire was marked by ever-greater entropy. Territorial lords achieved greater regional control; imperial cities were caught between conflicting demands of the imperial government and the regional ravages of marauding local knights (*Raubritter*). The Protestant Reformation and the Peasant Revolt would soon characterize the 1520s, and by any German reckoning the divisive Reformation irreversibly ruptured national history.

By the later twentieth century a more internationalist outlook, especially in neutral Austria, would refract the view of Maximilian once again. Now the dominant biography by Hermann Wiesflecker saw the imperial glass as half-full instead of half-empty, accepting the Holy Roman Empire as a graspable vision rather than a chimera. Wiesflecker's emperor, built out of late-nineteenth-century studies of Habsburg household documents, emphasizes Maximilian's own proposed imperial reforms as a consolidating process, cruelly rejected by self-interested, recalcitrant dukes.[3] Using those same sources, he goes beyond politics to stress the principal subject of this study: Maximilian's rich contributions to culture and his court life.[4] Even with culture one can stress either failures or accomplishments—Maximilian's megalomaniacal and impossibly numerous projects, few of them actually finished and visible when he died, or else his ambitious overall vision, which so deeply engaged scholars, authors, and the leading artists of the German-speaking world.[5]

By way of conclusions, this chapter will focus on *Rezeption*, the legacy and effectiveness of Maximilian's ideological projects. After all, as rhetoric political image making and self-promotion, they should be judged in terms of their powers of persuasion. The concept of "reception" derives from literary criticism during the 1970s, and it can be divided into "reception history" and "reception aesthetics," charting over time the shifting resonances of a work with succeeding, even contrasting, audiences.[6] Renaissance art reception analysis for shifting meanings has been a model practiced by Kaufmann and Steinberg.[7] Certainly even the most extravagant, truth-stretching claims made by Maximilian continued to serve Habsburg family iconography into the eighteenth century. His imperial posturing also held a particular charisma for polemical intellectuals in the early sixteenth century, who often acted as his verbal promoters. But at the same time, other German ducal courts, chiefly in Saxony and Bavaria, adopted some of these imperial forms and trappings in rival cultural forms, used to promote political resistance.

HABSBURG LEGACIES

The most immediate and lasting acceptance of Maximilian's imagery came from his Habsburg successors, principally Emperor Charles V and his brother, King Ferdinand I of Austria-Hungary. In many respects, the empire claimed by Maximilian—both on paper and with the images and statues of his expanded ancestry—became a fuller reality for these immediate descendants, who exemplify the old motto about Habsburg marriage diplomacy (chapter 6), where marital alliances achieved more for the *Domus Austriae* than war did for its rivals: *Bella gerant alii / Tu felix Austria nube* (Let others war / As you, fortunate Austria, marry). Through the 1496 wedding of his parents—Joanna (the Mad) of Spain with Philip the Fair (d. 1506) of the Habsburg Netherlands, along with Margaret of Austria to Don Juan (d. 1497)—Charles V became heir to their combined lands and strengthened the well-established economic links between Iberia and the Low Countries. In addition, the 1515 Congress of Vienna cemented what would linger into the twentieth century in the form of the Austro-Hungarian Empire by uniting Mary (of Hungary)

with Ladislaus Jagiellon, heir (as Ludwig II) to the kingdom of Bohemia and Hungary, as well as marrying the future Ferdinand I with Ludwig II's sister, Anna. For these two great heirs of Maximilian, his claims provided powerful foundations for their own political ideology.

Yet their respective roles and claims diverged. Charles V, inheriting the mantle of emperor, asserted his military leadership of a universal Christendom, particularly against its principal antagonist, Ottoman Islam, and eventually against the religious and political revolution in his Germanic homelands, the Lutheran Reformation. Ferdinand I, German king, took on his own delegated responsibility for administering the new Austria-Hungary. He also assumed duties for a filial confirmation of Maximilian's own legacy, completing several of the chief unfinished projects of his grandfather, including the tomb in Innsbruck, whose cenotaph was created between 1561 and 1583.[8] Ultimately, he maintained the link between the Austrian line of the Habsburgs and their (nominally) elected office as Holy Roman Emperors, beginning again with himself as emperor (reigned 1556–64) and followed by the election of his son, Maximilian II (reigned 1564–76). But the very events that precipitated his succession to power as ruler in Germany after the death of his Hungarian brother-in-law at the 1526 Battle of Mohács also dictated Ferdinand's commitment to the ongoing Habsburg struggle against Turkish armies on the dynasty's eastern borders (leading to modern Bosnia-Herzegovenia) and even at the very gates of Vienna in 1529.

Although the Holy Roman Empire survived in name until its official dissolution (14 August 1804) under Napoleon, it received renewed significance and vitality under Emperor Charles V (ruled 1519–55).[9] Grandson of Ferdinand and Isabella of Spain as well as Maximilian, Charles soon became the beneficiary and ruler over the new Spanish colonies of the New World, so his sense of global dominion and religious responsibility was further reinforced. Charles was steeped in the Habsburg family mythology and its Burgundian splendor from his youth and upbringing in Mechelen under the direction of his aunt, regent Margaret of Austria. Upon attaining his legal majority in 1515, the future emperor made a "triumphal entry" into Bruges, an actual ceremony (18 April), recorded not in the multiple woodcuts of Maximilian but rather in the traditional luxury medium of manuscript illuminations.[10] Both triumphal arches and tribunes were erected for the occasion, following a program, using both Old Testament and mythological figures, penned by Remy du Puys, court historian to Margaret of Austria.

Charles's initial court artworks were supplied for him and thus essentially the product of the wishes of his guardian aunt or grandfather. For example, a spate of Mechelen court portrait busts, both paintings (Bernhard van Orley) and sculptures (Conrad Meit), echo Maximilian's precedent with the studio of Bernard Strigel.[11] Additionally, the expectations from Maximilian for a young jouster found expression in a grandfather's gift: a child-size set of armor (1512–14), produced in the latest fashion with a flared skirt and strips of gilt silver or etched steel by the imperial armorer in Innsbruck, Konrad Seusenhofer (see fig. 58).[12]

Although Maximilian's coins and medals are not always taken to be his most significant or influential art forms, the young Charles V was honored by a substantial medal in silver (1521), designed by no less than Albrecht Dürer and executed by Hans Krafft in Nuremberg (fig. 84).[13] Like

84

Hans Krafft, after design by Albrecht Dürer,
Portrait Medal of Charles V, 1521, silver.
Nuremberg, Germanisches Nationalmuseum.

Maximilian's images in metal and on paper, this tribute is laden with imperial markers and heraldry. The young, beardless emperor wears the arched crown (*Bügelkrone*) of his office as well as the insignia of the Order of Golden Fleece. Laurel accents the inner and outer rims of the medal. The inscriptions are both official—his imperial title (CAROLUS V RO[manorum] IMPER[ator])—and personal, his motto with twin columns on the reverse (PLUS ULTRA, "further beyond," referring to the Pillars of Hercules).[14] Coats of arms fill out the margin of the obverse, while the reverse shows the double-headed Habsburg imperial eagle whose heart shield heraldry depicts both Austria and Burgundy. This rich image was commissioned by the city council of Nuremberg, which proudly housed the imperial regalia, in anticipation of the emperor's arrival there for a Diet in that year (eventually held instead at Worms, where Charles V notoriously encountered Martin Luther).

The importance of a palace center, never fully realized by Maximilian except in part at Innsbruck, did assume greater meaning for Charles, despite his even more extensive travels while emperor. His grandest palace construction, unfinished, held symbolic significance within his aggressive crusade mentality. To proclaim his conquest and subjugation of the previous Islamic culture of Spain, he built a Renaissance structure (begun by architect Pedro Mechuca in 1527) around a circular court within the very heart of the captured Moorish royal stronghold, the Alhambra, above Granada.[15] Contrasting utterly with existing ornate and labyrinthine Nasrid structures, this inserted palace imposes imperial order through strict geometry and the classical columns of ancient Rome.

Where Maximilian had used composite print ensembles made from woodcuts to provide his portable political claims, Charles V managed to combine luxury with mobility in the form of a different leading medium: tapestries. His mural images were woven and elaborate. His themes emphasize religion, the hunt, and success in war to accord fully with both the aspirations and the programs of Maximilian. More often than not, they were not works directly commissioned by Charles V but rather donations or tributes to the emperor from relatives and prominent subjects.

Earliest of the tapestry tributes to Charles V is a cycle (ca. 1516–18; cartouche on final tapestry) dedicated to the *Legend of Notre Dame du Sablon*.[16] A recognizable portrait of the young prince appears in all three segments of a single tapestry, the fourth of four, accompanied by the kneeling figure of the portly patron of the cycle, Franz von Taxis, imperial postmaster and figure at the court of Margaret of Austria. The tapestry subject chronicles the arrival of a miraculous statue of Virgin and Child, *Our Lady with the Flowering Branch*, at the Brussels church of Notre Dame du Sablon (1348). All historical figures of the narrative events have been transposed to show depictions of the living features of the Habsburg regent family. The final scene shows the entire ducal family, headed by Margaret of Austria, kneeling in prayer before the installed statue on a chapel altar, along with the donor, Taxis, and his wife. Charles and his younger brother Ferdinand serve as litter-bearers for a sacred statue in the central scene, which depicts the arrival (with angels hovering above a canopy) of the image into Brussels from Antwerp. His late father, Philip the Fair, appears in the left scene of the triptych set, and his piety is extolled in the Latin narrative inscription: "The noble-minded prince, having venerated this gift from heaven, receives the sacred object, kneeling, into his hand." Then his two sons receive joint credit for piety in the inscription: "The dukes, the sons and the father, place themselves under the precious litter."[17]

The designer of the tapestry cartoons doubtless was Bernard van Orley (1488–1541), Margaret's appointed court artist as of 1518, whose painted portraits of Charles and siblings date from the same period, 1515–16.[18] Compared with earlier Flemish tapestries, his weavings provided heightened suggestions of depth and also inserted Italianate motifs within the border and frame decorations. Woven in the celebrated ateliers of Brussels, the tapestries feature borders with heraldic arms of Austrian territories; other tapestries from the same cycle include Spanish territorial arms—possessions claimed by Prince Charles—as well as the arms of Philip the Fair, Duke Charles, and Margaret of Austria atop three of the tapestries. Taxis family arms and mottos appear in side borders, along with their home province of Tyrol.

Van Orley would design later suites of tapestries in honor of Charles V, his family, and his associates. One cycle that echoes the concerns of Maximilian with genealogy was produced for the Nassaus, a major ducal family serving the Habsburg regents in Brussels. This *Nassau Genealogy* (ca. 1529–31, destroyed) survives only in designs (Munich; Rennes; New York, Metropolitan Museum; Los Angeles, Getty Museum).[19] Each work pairs male and female equestrian figures as in the Jacob Cornelisz van Oostsanen woodcut cavalcade of the counts of Holland, a recent suite (1518) that culminated with Maximilian, Mary of Burgundy, Philip the Fair, and Charles V.[20]

Closer to Maximilian's passion for hunting, another tapestry cycle, usually called the *Hunts of Maximilian* (chapter 6), was again designed by van Orley (ca. 1528–31), probably at the request of Charles V's sister and regent of the Netherlands (after 1531), Mary of Hungary.[21] This twelve-month series (Paris, Louvre) shows various members of the Habsburg court in the Soignes forest around Brussels (rather than Innsbruck), with the lost Coudenberg Palace and the tower of the City Hall rendered in vivid architectural detail in the first tapestry. As noted above, the mounted figure in the first tapestry, *Departure for the Hunt*, presents a portrait, once identified as Maximilian

but surely Ferdinand (who joined the Habsburgs in Brussels, temporary capital for Charles V in 1531). Heraldry on dog collars includes imperial double eagles as well as emblems of Charles V, further personalizing this tribute to the hunting heritage of Maximilian to glorify the Habsburgs within a larger framework of zodiac and allegorical Latin inscriptions.

Another attributed van Orley tapestry series pays homage to European pretensions toward global dominion: *The Spheres* (ca. 1530–35; Madrid, Patrimonio Nacional).[22] It was donated to Portuguese King John III (1502–57), married to Charles V's younger sister, Catherine, and it celebrates João and Catherine in the guise of Jupiter and Juno. These gods rule jointly over earth, in commemoration of the papal division of the planet between Spain and Portugal with the Treaty of Tordesillas (1494).[23] The globe features an accurate and current map of Portugal's dominions, emphasizing outposts in both Africa and India and identifying specific ports with the royal arms.

In tribute to the empire, van Orley also designed an elaborate tapestry cycle (1524) around the theme of ancient Rome, following the narratives of Romulus and Remus as recounted in Livy.[24] Composed under the powerful influence of Raphael's *Acts of the Apostles* tapestries, recently woven in Brussels (1519–21) for the Vatican from cartoons (1514–16), these designs deploy figures in ornate costume against classical background architecture or landscape. The end of the drawing series culminates with an enthroned Romulus distributing law to the people; when this scene was finally executed in a weaving with richer ornamentation (ca. 1535), its connection to the Habsburgs was made explicit through the inclusion of the Order of the Golden Fleece on a corner figure.

But the closest connection to the precedent of Maximilian lay in elaborate celebration through tapestries of Charles V's own military triumphs in the cause of imperial protection and glory. His rivalry with France in Italy had exploded into open warfare, climaxing in 1525 with the total victory of imperial armies over French forces and celebrated through tapestry designs for the *Battle of Pavia* by Bernard van Orley, woven in seven pieces in Brussels (ca. 1531–33; Naples, Capodimonte Museum).[25] This time the cycle was presented to Charles V by the States General at the royal palace in Brussels in March 1531, the same moment when Mary of Hungary was installed as regent of the Netherlands. Its images include portraits of imperial commanders, and the central scene features the ultimate result, the surrender of Francis I, captured king of France. Half of the scenes stress the panicky flight of French troops with an unprecedented movement in space for tapestry. Significantly, in August 1549, this very cycle was on display at the country residence of Mary of Hungary at Binche, when Charles V and his heir, prince Philip (the future Philip II of Spain), paid a state visit.

The other, most encompassing of all tapestry cycles for Charles V was his vast commemoration of his updated version of the crusade against Islam, specifically against its naval forces: the twelve-part *Conquest of Tunis*.[26] In contrast to the relatively interchangeable renditions of individual battles within Maximilian's woodcut projects, *The Conquest of Tunis* surpasses even *The Battle of Pavia* in its maplike specificity and full documentation of the emperor's crusading Mediterranean campaign. It rivals even the most elaborate recent woodcut documentation of crucial battle scenes, such as Hans Sebald Beham's *Siege of Vienna* (1529), a six-part bird's-eye composite woodcut in circular shape.[27] Indeed, the first tapestry in the cycle shows an exquisitely detailed

local map of the coastline, marked with formations of the invading fleet, departing from Barce-lona. The remaining tapestries are notable for their cast-of-thousands staging within expansive, even atmospheric panoramic topographic landscape backgrounds. Meticulous details of ships—contrasting European galleons with Mediterranean oared galleys—plus costumes, weapons, and specific battlefield tactics and sites provide unmatched documentation. Along with other specific likenesses, designer Jan Vermeyen also included self-portraits, in both the opening map tapestry as well as the tenth scene, *The Sack of Tunis*, where the gated city itself is portrayed. Despite this accuracy, the reconquest of Tunis held larger symbolic and historic significance, echoing the cap-ture of Carthage by ancient (although preimperial) Rome in the Punic Wars.

Again woven in Brussels (1548–54), specifically by the newer atelier of Willem de Panne-maker, this series was designed not by van Orley but rather by Jan Vermeyen (1500–59), a less familiar, less prominent artist, best known earlier for portraits of the Habsburg family while in the service of Margaret of Austria. What sets Vermeyen apart—and helps to account for his vivid doc-umentation of the battles within his tapestry designs—is that he actually accompanied Charles V on this crusade from Spain to Tunis in 1535 and produced drawings on site (this was the period equivalent of modern "embedded" journalists accompanying armies in active war zones).[28] His enormous cartoons (Vienna, Kunsthistorisches Museum) were commissioned in 1546, backed by a contract between Mary of Hungary and the artist; a 1548 letter from Mary to Charles V informs him that despite progress the full suite of cartoons was not yet ready and that a second painter, presumably Pieter Coecke van Aelst, had also been engaged. From these documents we cannot be certain whether the emperor himself originally intended to generate tapestries about the Tunis campaign, although surely Mary of Hungary's principal role in tapestry production is reinforced, and the emperor's awareness and interest in the project is manifest. Mary in fact sent the first version of the tapestry cycle to Charles V at the end of 1550.

The texts on the weavings appear in Castilian as well as Latin, and border ornament includes both the double-headed imperial eagle as well as the arms and personal motto of Charles V. These tapestries were prominently displayed, for example at the wedding of Philip II and Mary Tudor (Winchester Cathedral, 1555), then at Antwerp the following year for a meeting of the Order of the Golden Fleece. Vermeyen did eventually issue etchings of the crusade, produced in col-laboration with the professional etcher, Frans Hogenberg (ca. 1555–60), but there was a time lag between his drawings and their later use either for tapestry cartoons and/or etchings.[29]

Charles V did not frequently commission painted portraits on his own after the youthful im-ages by van Orley in the court of Margaret of Austria. In the year of his coronation at Bologna by Pope Clement VII, however, an allegorical portrait of Charles V as both conqueror and ruler was painted by Parmigianino; the emperor, in armor and with the baton of military command, appears with an infant Hercules, who offers him a globe, below winged Fame, holding a laurel of victory and palm branch of peace.[30]

However, akin to Maximilian's closeness with Dürer, Charles V also enjoyed a special relation-ship with Titian, whose role with the emperor was taken to be a modern replica of the ancient

bond between Alexander the Great and his exclusive painter, Apelles.[31] Titian was accorded the exclusive right to paint Charles's portraits after his first commissions in 1532–33, when they first met in Mantua at the court of Federigo Gonzaga. In that latter year the emperor awarded the artist a patent of nobility as count palatine, Knight of the Golden Spur. According to an early legend, surely apocryphal, Charles V once even condescended to stoop and pick up a brush accidentally dropped by Titian. As pointed out by Marianna Jenkins, Titian virtually invented the conventions of the full-length state portrait, with Charles V as his principal figure.[32] In an earlier pair of portraits, counterpoint between attributes of sword and greyhound contrasted the qualities of strength with dominion. Two later full-length portraits confirmed models for future court likenesses. The first (1548; Madrid, Prado) featured an armored and mounted equestrian action—as imperial commander as well as Christian knight, like Burgkmair's 1508 equestrian woodcuts, *Maximilian* and *St. George*. The second, from the same year presents a seated, informal but enthroned royal figure for contemplation (Munich, Alte Pinakothek).[33] Both works originated when Titian met Charles V in Augsburg at the time of the emperor's decisive military action at Mühlberg against the Schmalkaldic League armies of German cities and Lutheran princes. Two further lost portraits, both titled *Charles V in Armor with Baton*, akin to the Parmigianino figure, stem first from 1532–33 and then from 1548. Together they show his imperial dignity, expressed in his dual roles as protector in war and provider in peace.

The elaborate genealogy incorporated in the life-size bronzes of Maximilian's tomb ensemble (see below for Ferdinand I's completion of this project at Innsbruck) found less of an echo in the far-flung empire of the peripatetic Charles V. Nonetheless, one sculptor who served an equivalent role to Titian as imperial portraitist, the Lombard Leone Leoni (1509–90), also produced essential bronze statues of the monarch in the wake of his encounter after the same Battle of Mühlberg.[34] Most imposing of all is his life-size standing figure, *Charles V Restraining Fury* (1549–55; Madrid, Prado), although as early as 1546 he also planned an equestrian statue similar to Titian's painting.[35] The allegorical standing image is based on Vergil's *Aeneid* (1.400–417), where the Roman poet hails his patron, Emperor Augustus Caesar, through the prophecy of Jupiter to Venus, as the statesman who overcomes raging Fury, bound in brass chains, by closing the gates of war. Thus does the statue assert the emperor's putative Trojan ancestry, while it also implicitly equates the modern universal monarch with the first emperor.[36] Not only is this image of the emperor an allegory as well as a literary allusion, but it even incorporates a heroic ideal in the very body of the commander, for underneath his elaborate armor Leoni famously (if invisibly) has produced the ideal nude body of an antique hero. Of course, the theme of suppressing discord also pays tribute to the emperor's successful conquest over religious rebels in Germany.

Leoni also went on to produce bronze portrait busts of Charles V (ca. 1553; Madrid and ca. 1555; Vienna).[37] As commanding general, he wears armor, richly decorated, including a palm-bearing Victory figure on the right shoulder, as well as the commander's sash. Additional decorative details of religious protection vary: a medallion with the standing Christ in Madrid, with the Madonna in Vienna. The bust is mounted on an imperial eagle as well as two nude but helmeted

figures, usually identified as Mars and Minerva. This powerful artistic model continued to exert strong influence on subsequent generations of Habsburg rulers, chiefly on the sturdy bronze bust of Rudolf II by Adriaen de Vries (1603; Vienna).[38]

A final extension of the idea of the tomb of Maximilian and its dynastic considerations, the tomb of Charles V at the Escorial (1592–98) was commissioned by Philip II for himself and for Charles V.[39] Also produced by Pompeo Leoni, son of Leone, this tomb ensemble features gilded bronze life-size portrait figures of the emperor and his family with their son and heir, Philip II and his three wives. All of them kneel in piety, each group on either side of the high altar in the monastery church of San Lorenzo at the Escorial. These statues show Spanish Habsburgs in perpetual adoration of the holy sacrament and also provide eternal commemoration of their ongoing dynasty. The actual remains of these figures were deposited in a vaulted crypt below the high altar, much as Maximilian intended his own corpse to lie before the altar.

The very name, Charles V, derived from Habsburg admiration for Charles the Great, Charlemagne. Thus was revived the idea of a universal, Christian empire, fostered by Maximilian but fulfilled in the person and dominions of his heir, Charles V, and his namesake Charlemagne.[40] A crusade against Islam, a defense of the Catholic church in Germany against a Protestant league, a coronation by the pope (albeit at his behest in Bologna rather than Rome), and even a European-wide contest with King Francis I of France—all demonstrate that both Charles V's wars and his commitment to the Church emerged from the imperial ideology of Maximilian after the model of Charlemagne.

The ultimate testimonial to the deeds (*res gestae*) of Charles V, akin to the *Arch of Honor* by the Dürer workshop for Maximilian, was a suite of twelve engravings, *The Victories of Charles V* (1555–56), designed by Maarten van Heemskerck, engraved and etched by Dirck Volkertsz. Coornhert.[41] These were not commissioned by the emperor himself or even by his sister, Mary of Hungary, but rather were generated by a professional print publisher in Antwerp, Hieronymus Cock, right after the abdication of the emperor and dedicated to his successor as ruler of the Netherlands, Philip II. In essence, these prints distill the triumphal imagery of the battle tapestries and serve, like the *Arch of Honor*, as graphic variants on the celebratory imagery of triumphal entries. Indeed, Charles V's deeds could be construed as exhortation to his own son to follow in his footsteps, as a model to be followed, as much as a record of accomplishment. The title page of this series shows a central, enthroned Emperor Charles V between the columns of his *impresa*, the Pillars of Hercules, while all around him stand his vanquished adversaries, whose territories thus become part of his dominions: the pope, the king of France, and the dukes of Saxony, Hesse, and Cleves (fig. 85). Only the surly sultan at the far left is not subdued, though he turns to exit in flight, redolent of the defense of Vienna against Ottoman siege (1529). In the words of the caption all of these "cede to the keen eagle, before whom Suleiman [the Ottoman sultan halted at Vienna] flees distraught." Of course, by 1555, with the signed Peace of Augsburg and the new doctrine of local ruler option for religion (*cuius regio, eius religio*) in Germanic regions, this image expressed only wish fulfillment, representing merely a precariously unstable, best-case scenario as of 1547 (the

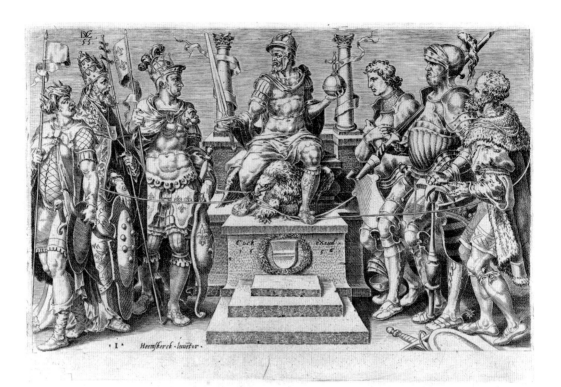

HIC PAPA, ET GALLVS, SAXO, HESSVS, CLIVIVS, ACRI
CONCEDVNT AQVILAE, SELYMVS DAT TERGA PAVORE.

L' *Aguila muy triumphante y no vencida*
De *Carlos Quinto Emperador Romano,*
Nos *muestra que esta gente fue rendida,*
Y como *huyó sus vñas Solimano.*

Cy *fut le Pape, aussy le Roy de France,*
Le *Duc de Saxe, & du Cleuois la suyte,*
Aussy *d'Hessen, vaincuz par la puissance*
I Du *hault Cesar, dont le Tureq print la fuyte.*

85

Maarten van Heemskerck, engraved by Dirck Volkertsz. Coornhert,
Charles V Enthroned amidst His Adversaries, title page of *The Victories
of Charles V*, 1555–56, engraving. Photo: SLUB Dresden/Deutsche
Fotothek/Regine Richter.

last date for images in the prints). *The Victories of Charles V* rivals Maximilian's own projects for its
public relations-oriented optimism, establishing claims to a pan-European and Christian—that
is, Holy Roman—Empire.

From the 1438 election of Duke Albrecht V as German king to 1740, the extinction of their male
line of on the death of Charles VI, only Habsburgs served as Holy Roman Emperors. Moreover, Al-
brecht, serving as Emperor Albrecht II (d. 1439), briefly established earlier claims to a unified realm
with Bohemia and Hungary through his marriage to the daughter of the last Luxemburg emperor.
Ferdinand I made a series of agreements with his older brother, Charles V, over territorial rulership:
in 1522, a Brussels treaty between the two ceded him the Austrian lands in the east and superseded

a prior 1521 family pact at Worms that had awarded Charles universal dominion over Ferdinand as his vassal prince. In 1531, Charles attended the coronation of Ferdinand as king of the Romans at Aachen (confirmed by him in 1532 at the Diet of Nuremberg), which meant that the younger brother assumed responsibility for ruling the German regions (and their unruly Protestants) and for guarding the borders of the empire against the Ottoman Turks. This act made the split definitive between the Spanish-Netherlandish Habsburg lands, subsequently ruled by Philip II after 1556, and Austria-Hungary, awarded first to Ferdinand I and then to his son Maximilian II.[42]

Ferdinand's shifting relationship to Charles V formed the subject of several works, particularly sculpted reliefs, such as the limestone relief (1527; New York, Morgan Library) by Hans Daucher of the two princes, armored and on caparisoned horseback, meeting each other as peers.[43] But the real legacy of Maximilian to Ferdinand was his many unfinished projects, especially those specifically targeted to the German homelands. Ferdinand should be remembered particularly for his filial piety in carrying on both the tomb project and the final disposition of the works on paper. In fact, were it not for Ferdinand's conscientiousness, we would have virtually nothing at all extant of Maximilian's artistic projects.

The tomb of Maximilian, now at the Hofkirche at Innsbruck, was left in a truly truncated state at the time of his death early in 1519. Primary supervisor of the project since 1502, Gilg Sesselschreiber, "painter of Munich," had been dismissed just the year before (1518) because of his inefficient completion of life-size (two meters) statues of Maximilian's ancestors from his own designs; those that were finished were also costly because their casting methods used too much bronze. Even during Sesselschreiber's later years of service, other artists were pressed onto the project. Dürer made drawings of three armored figures for the bronze statues, all cast in Nuremberg: *Theoderic* and *King Arthur,* both produced as statues for Maximilian (1512–13; see fig. 28) by the studio of Peter Vischer, as well as his *Count Albrecht IV of Habsburg* (see fig. 7), carved by wood sculptor Hans Leinberger, then cast (1518) by local founder Stefan Godl.[44] Godl then took over completion of the tomb, replacing Sesselschreiber; as a result Godl, a specialist in bronze-casting, then moved from Nuremberg to Mühlau, near Innsbruck.

As part of the posthumous evaluation process, Jörg Kölderer, Maximilian's court designer, was instructed by Ferdinand to prepare figure studies—both of the existing, cast statuary as well as the planned future statues, presumably based on lost studies by Sesselschreiber (ca. 1522–23, thirty colored drawings; Vienna, Austrian National Library 8329). He (or more likely a second hand) then prepared a second summary, a parchment scroll (ca. 1522–30), to show the progress of the figures.[45] Even so, the tomb still remained incomplete relative to its even more grandiose original plans—some forty ancestor and family figures (twenty-eight completed), once slated for the George Chapel in the Castle at Wiener Neustadt. Beyond those ancestor figures, Ferdinand also commissioned a personal effigy on a tomb, with a kneeling bronze figure of Maximilian (completed 1585), accompanied by four smaller bronze figures of the Cardinal Virtues, rather than a traditional recumbent image like the prior tomb figure on a similar tomb of red marble for Maximilian's own father, Emperor Frederick III, by Nicholas Gerhaert and successors (designed

1468–73, installed 1513; Vienna, St. Stephen's), another dutiful donation by an heir.[46] Ferdinand assumed (1527) that his grandfather's untimely death had prevented his planning a conventional tomb with figure, so he went ahead and ordered one, to be flanked by the ancestor statues.[47] For the sides of that *tumba,* twenty-four marble reliefs of Maximilian's battles, derived from the *Arch,* provided a rich memorial.

Ferdinand also made provisions to complete the other components of the tomb according to Maximilian's own wishes: first, statuettes of Habsburg family saints, although only twenty-three out of a hundred were installed; second, busts of Roman emperors, thirty-four in number (perhaps all completed, but only 21 remain; chapter 3).[48] Godl had begun work casting the saints in 1514, based on preserved designs by Kölderer and carvings by Leonhard Magt. The leader of the small emperor bust project was Jörg Muskat, a portraitist in Augsburg, but most of these were completed after 1517. Magt died in 1532, Godl in 1534, so those projects ground to a halt. Even Kölderer died in 1540, so the one final large figure, *Chlodwig,* was cast in 1550 after a drawing (1548) by the Augsburg master, Christoph Amberger.[49]

After the natural break in construction of the tomb occasioned by the generational shift, Ferdinand resumed his intervention in 1547 and determined in 1553 to build a new structure, the present Hofkirche, as well as to structure the entire ensemble around the new, central *tumba* structure, surmounted by Maximilian.[50] That tomb with figure was designed by Ferdinand's court artist, Francesco Tertio (1556; Vienna, Albertina), as well as Heinrich Vogtherr the Elder. Around 1561, a scale working drawing for the reliefs (Vienna-Ambras KK 4971) was finished by Florian Abel, imperial court painter in Prague.[51] Its rich Italianate vocabulary of corner figures and ornament embeds it in the dominant Netherlandish idiom of its era and reveals how fully the tomb in Innsbruck is the devoted work of Ferdinand as much as of Maximilian. Importantly, the grandson saw his role not only to continue the ruling heritage of his Habsburg family, as Maximilian had supervised the completion of his own father's tomb, but also to continue the priorities and policies set down for the Habsburg Germanic lands half a century earlier.

In contrast to the consolidation of universal empire for Holy Roman Emperor Charles V, Ferdinand I (ruled 1526–64) reigned over a far more local set of political concerns. The 1515 Vienna double marriage, which had effectively instituted the Austro-Hungarian Empire for the Habsburg dynasty, essentially had to fight on the frontiers against Maximilian's adversaries—chiefly the imposing threat of the Ottoman Turks. Their capture of Budapest and subsequent 1529 siege of Vienna placed Ferdinand's forces on the very barricades of defending all of Christendom (even though Heemskerck's 1555 engraving fictionalizes the presence of an armored and mounted Charles at Vienna, and even though Charles ventured against the Turks in the relative remoteness of Tunis). Indeed, Ferdinand acceded to the throne of Austria-Hungary on the death of his Hungarian brother-in-law at a disastrous battle against the Turks at Mohács (1526).

The other threat in the Germanic region was entropy, generated by the emerging Protestant religious divisions, whose rise coincided with the end of Maximilian's reign. Ferdinand's expanded empire of Bohemia and Hungary in particular became a hotbed of Lutheranism, then

Calvinism, during his reign.[52] This irreconcilable conflict within Germany provoked the Schmal-kaldic War, where Charles V did intervene (1547) and achieved victory at the Battle of Mühlberg in defense of Catholicism as the universal religion of the Holy Roman Empire. Thereafter he lost a rematch with Moritz of Saxony (1552), leading to a standstill and the Peace of Augsburg (1555). This ongoing religious and political conflict would eventually lead to the Thirty Years' War (1618–48), set off in the tinderbox of Prague.

Ferdinand I has received less attention as an art patron, yet his pattern of support worked to reinforce his dual aspirations as a ruler.[53] Chief among these is his consolidation of visible ruler-ship—and the fulfillment of Maximilian's elaborate plans for Habsburg dominions—in the new empire through the construction of an elegant, manifestly Italianate summer palace, the Belve-dere (1534–63), within a pleasure-garden atop the Hradschin Hill of Prague, designed by Italian architects, most notably Paolo della Stella of Genoa (d. 1552), who brought his own stonemasons, and his successor, Bonifaz Wohlmut. Like the large palace of Charles V within the Muslim pre-cinct of the Alhambra at Granada in Spain, this building makes a three-dimensional statement from a promontory that had formerly housed a prior dynasty. It too speaks of civilization itself, brought to Bohemia by a new regime with international connections.[54] This kind of message of cultural "progress," associated with Roman imperial imagery, had already been made before in central Europe, at the *villa marmorea* (lost) constructed outside the castle of Buda by the short-lived Matthias Corvinus of Hungary (d. 1490), Maximilian's contemporary and rival.[55] But it was new for Prague, and the Belvedere palace has correctly been seen as a symbolic transfer of culture from the former Jagiellonian dynasty (and its great chief architect, Benedikt Ried, who died in 1534). Moreover, its garden setting, significantly located outside the castle proper, offered a pa-cific rather than a martial image for the new dynasty in its adopted home. Its ornament featured learned relief carvings of both the Trojan War as well as erotic Ovidian myths. Yet it also remained utterly separate from Bohemia and never found real architectural successors.

This is not the place to attempt even a sketch of later Habsburg adoption of Maximilianic iconography as transmitted through his heirs, though that continuing legacy, beginning with Charles V, enjoyed a long afterlife. To cite just two examples, we see both the forms and the ideology of Maximilian's *Arch* recurring in two substantial later Habsburg creations: Rubens's 1635 triumphal entry for the Spanish Archduke Ferdinand in Antwerp, and Johann Fischer von Erlach's celebrated Karlskirche in Vienna (1716–37) for Emperor Charles VI (*nomen est omen*; an-other would-be successor to Charlemagne).

The last great Habsburg entry in the Low Countries was staged at Antwerp in 1635 for the new ruler, Archduke Ferdinand, with Rubens as coordinating designer and his friend Caspar Gevaert as programmer.[56] A remarkable climax to that entry, inserted in the commemorative volume of 1642 as an added feature after the actual event, which became a feature in the annual Antwerp proces-sion, was a *Triumphal Chariot* commemorating Ferdinand's recent military success at the Battle of Calloo (1638; fig. 86).[57] Rubens's roster of female personifications on this heavy cart, shaped like a ship, clearly derives from the precedent by Dürer for Maximilian, the allegorical *Great Chariot*

(1522). Fortuna and Virtus dominate the rear of this craft, where Dürer's Victory had stood; twin figures of Victory here flank a central mast of war trophies (a separate float in the *Procession*) above bound captives (who bring up the rear of the original *Procession*).

In the staged procession for Ferdinand, Rubens also paid specific tribute to the Habsburg dynasty in several arches. The *Arch of Philip IV*, king of Spain and brother of the archduke, shows the wedding of Maximilian to Mary of Burgundy (crowned, in typical Rubens mythic fashion, by the Olympian monarchs, Juno and Jupiter).[58] This same scene adorned the *Small Triumphal Chariot* by Dürer himself within the *Triumphal Procession*, and Rubens's use of it acknowledges its significance as a founding moment of the Habsburg dynasty. On the same *Arch of Philip IV*, Rubens presented portraits of Maximilian and his heirs who formed the latter-day Habsburg kings of Spain: Charles V, Philip III, and Philip IV. The rear of the *Arch of Philip IV* features the Spanish marriage, crucially linking Philip the Fair, Maximilian's son, to Joanna of Castile, subject of another float by the Dürer workshop for the *Procession* and a founding connection between the Habsburgs and the Spanish crown.

Rubens also provided the intervening history of the Habsburgs, including the ultimate division between the sons of Charles V and the sons of Ferdinand I. As part of the *Stage of Welcome*, he presented another scene of current Habsburg family cohesion in a similar meeting (1634) between King Ferdinand III of Hungary and Cardinal-Infante Ferdinand at the victorious Battle of Nördlingen.[59] In spirit, if not in medium or particular details, this image is heir to the Hans Daucher stone relief of Charles V and Ferdinand I. Right after the *Arch of Philip IV* the Infante then encountered an entire *Portico of the Austrian Emperors*, consisting of symmetrical wings of arches with gilded stone sculptures, divided by a portico with an obelisk (traditional symbol of both sun and ruler).[60] Rubens even prepared

86

Peter Paul Rubens, engraved by Theodore van Thulden, *Triumphal Chariot*, from *Pompa Introitus Ferdinandi*, 1638, engraving.

grisaille sketches for each of the emperor statues (seven of the dozen survive). On either side of the central portal in the chronological span of rulers stood Maximilian I and Charles V, respectively. This sequence of standing ruler statues also recalls the ancestor figures on the *Arch* as well as the floats with ancestor statues in the *Triumphal Procession* (miniatures as well as woodcuts). Although certainly the Antwerp procession had many agendas, including petitions on behalf of the locality of Antwerp to its new ruler, Rubens surely knew and extended the foundations of Habsburg iconography, so firmly established by Dürer and the several artists of Maximilian's *Triumphal Procession*, as part of his current mission of royal glorification.

In Vienna, the heartland of Habsburg emperors, the most emphatic later revival of dynastic iconography was effected by Charles VI, basing himself largely on the Christian imperial ideology of his namesake, Charles V.[61] As powerful as any imagery of Charles VI was his building legacy to Vienna, the Karlskirche, or Charles Church.[62] Here all the component parts suggest connection to Rome, both imperial and Catholic. The dome evokes St. Peter's, center of the papacy, so Habsburg piety and support of the Catholic church are immediately highlighted. The portal suggests both a classical temple portico as well as the entrance to St. Peter's by Carlo Maderno. Twin flanking towers not only evoke Roman imperial donations, such as the victory columns of Trajan or Marcus Aurelius, but also the Pillars of Hercules, the celebrated impresa of Charles V. Such columns provide an echo for an emperor who wished to be noted for his own conquering, especially for victories over the Turks along the same frontier as Ferdinand I.

GERMANIC RESPONSES

Ideas and images are successful in terms of how they are received, and thus far Maximilian's pictorial ideology has been examined through its successful propagation (which is, after all, what "propaganda"—a seventeenth-century word used by the Jesuits—aspires to achieve) via his Habsburg descendants.[63] Indeed, that heritage was still being revisited across the span of the nineteenth century, interrupted only by the fall of the Austro-Hungarian Empire during the World War I. Not that this triumphalist narrative was unanimous. Throughout their later histories (and in their modern histories, motivated by nationalist sentiments), both Bohemia and Hungary have continued to view the Habsburgs as foreigners in both language and culture—and often in religion too, as the Reformation spread both Lutheran and Calvinist creeds after the death of Maximilian, especially during the later sixteenth century.

As noted, German historians of the later nineteenth century, led by Ranke and Ulmann, offered their own, Bismarck-era nationalist resistance to Austrian dynastic claims. They saw the Habsburg dynasty more as a hindrance to, than as an instrument of, national unification, and their regional and political differences clearly shaped their views of national history. Like Bohemia and Hungary, German regions within the Holy Roman Empire also showed these same antagonisms, even during Maximilian's own era. Certainly, he had to fight a constant battle against regional

interests and rival dynasties within that loose confederation known as the Holy Roman Empire. Even for what might be considered broader national interests, such as resistance on behalf of all Christendom against the Turks, Maximilian still had to wheedle and cajole the German princes of the Diet. Led by Berthold of Mainz, the prince-archbishop and elector, they were, to say the least, unsympathetic to his campaigns against his perennial nemesis, the kings of France, and they fully resisted his efforts to institute effective taxation (the "common penny") to support his military ventures. They also opposed his vision of an imperial judiciary (*Reichskammergericht*). His centralizing efforts at imperial reform (*Reichsreform*), including new political structures of the judiciary, which began with his first Diet after succession (Worms, 1495), was essentially rebuffed by the estates and codified in the following Diet (Augsburg, 1500).[64] In the case of one region, Switzerland, cultural resistance by the cantons and their famed Swiss mercenaries even led to political, then military resistance—and to final independence as the Swiss Confederation.[65] This basic split, then, centered on competition between emperor and territories, led by the most important regions, such as ore-rich Saxony, and rival dynasties, especially the Wittelsbachs of Bavaria, near the Austrian heartlands of the Habsburgs.

A good bellwether for gauging the success of Maximilian's successes in his political campaigns with territorial princes is one principal, Elector Frederick the Wise of Saxony (1463–1525), from the Ernestine line of the Wettin dynasty.[66] In the dictated text of the *Triumphal Procession*, as well as the illumination of that scene by Albrecht Altdorfer, Frederick heads the list and the depicted row of *Erkoren Fürsten* (Chosen Princes), all high-born and brave, who appear just behind the planned place of the *Triumphal Chariot*.[67] These two men were closely related and allied. Frederick's grandmother was an aunt of Maximilian; his uncle Albrecht was Maximilian's field commander in the Netherlands campaigns. In Maximilian's early years in authority, the two leaders were close. Frederick was actually contracted (1494–98) in feudal fashion as *Hofmeister* (master of the court) to supply mounts to the emperor.[68] Frederick hosted Maximilian several times in Saxony. The two men shared several passions and pastimes, redolent of their shared princeliness.

Like Maximilian, certainly Frederick the Wise outdid many of his contemporaries in piety. His competitive display of devotion focused on a justly celebrated, enormous collection of saintly relics, housed in his Collegiate Church in Wittenberg, for which an illustrated guidebook (*Heiltumbuch*) was published with woodcuts by his court artist, Lucas Cranach.[69] He also visited the Holy Land on pilgrimage (1493), in part to search for more relics. Cranach produced a number of religious images—both prints and paintings—glorifying his patron as well as favorite local patron saints.[70] A good example, the *Princes' Altar* (ca. 1510; Dessau), probably from the Wittenberg Collegiate Church, shows a Virgin and Child with female saints in the center and portraits of Frederick and his brother Johann in prayer on the wings, along with their own favorite saints, Bartholomew and James.

Frederick's leisure activities also closely resemble those of Maximilian, particularly the martial pastimes of hunting and tournaments, often manifested in the art of Lucas Cranach.[71] The earliest hunt scene, a woodcut (ca. 1506) *Stag Hunt*, also expressly shows a Saxon castle in the background.

87

Lucas Cranach, *Deer Hunt with Frederick the Wise and Maximilian I,*

1529, oil on panel. Vienna, Kunsthistorisches Museum.

This kind of imagery turns up later in large Cranach paintings (see chapter 6), particularly the image showing a deer hunt (1529; Vienna; fig. 87), with both late princes, Maximilian and Frederick the Wise, hunting together around the time of a great tournament of Maximilian in Innsbruck (1497).[72] This painting makes clear the staged courtly significance of such an event, as a boat of courtly onlookers, including fashionably dressed women, accompanies the principals. For Frederick's tournament jousts, Cranach also began with several woodcuts, the first from 1506, and three more from 1509 (see fig. 72). Even if they might not have been documentary in character, such tournaments were usually staged within a context of court display and ceremony. A later tournament book for Johann Friedrich the Magnanimous by the Cranach school (ca. 1535; Veste Coburg, Ms. 2) suggests both the competition and the overlay of allegory or playfulness of the decoration, much like the presentation of *Freydal*.[73]

Frederick was able to channel more of his own energies into the construction of a true Renaissance court, which included the construction of several palaces (Wittenberg, Torgau, Lochau) as well as the founding of a university. Like Maximilian, he also patronized scholars, led by Georg Spalatin; poets; and a permanent court painter, Cranach, after being an ongoing earlier patron of Dürer.[74]

Thus, at the time that Maximilian began his reign as emperor, Frederick was still a valued political ally, even a supporter of the *Reichsreform* and a contributor of the "common penny," who shared the friendship as well as many of the same cultural commitments as his Habsburg leader. In 1496, he was even named *Statthalter*, vicar or representative of the emperor, and in 1497, he served that role on the Imperial Court Council (*Hofrat*) as a counterweight to the domination of the prince-bishop Berthold of Mainz.[75] By the end of the century, after Maximilian was embroiled with the French forces in Italy, losing Milan, Frederick left his court (November 1498), with "oaths, letters, and seals broken" after unsuccessful efforts at mediation between the parties.[76] Thereafter, despite the emperor's best efforts, he became a steadfast rival and foe of Maximilian's centralizing plans and increasingly aligned with Berthold of Mainz. Yet he still had the capacity to mediate. He assumed the altered position of *Statthalter* to the new *Reichsregiment* after the contention over finance and governance at the Diet of 1500. His final real service in that role came in 1507, prior to the imperial coronation ceremony of 1508 at Trent, an event that Frederick declined to attend, thus permanently rupturing their relations. By 1509 at the Diet in Worms, he openly led the opposition to Maximilian.

From Frederick's viewpoint, ultimately both he and Maximilian were territorial princes in their respective regions, both dynasts looking out for the betterment of their family interests. For him the Holy Roman Empire at that moment did not supersede the sum of its parts. We can begin to understand that Maximilian himself might have been impelled to more self-serving policies after this desertion of his lieutenant from the imperial cause.

When Maximilian died, his successor was almost assuredly his grandson Charles.[77] But the pope's suspicions of a powerful emperor led to ongoing machinations to mount an "anybody-but-Charles" surrogate for emperor. As evidenced by his frequent political leagues, alliances designed to block the Italian aspirations of Maximilian, Pope Leo X chiefly supported the candidacy of Maximilian's nemesis, King Francis I of France, although his open backing of France actually stiffened the resolve of the German imperial electors (along with expensive bribes, financed with loans from the Fuggers of Augsburg). So Frederick the Wise wound up as the last-ditch opposition candidate before finally demurring, so Charles did receive unanimous election in the end. That he could be the focus of concerted opposition to the emperor makes his subsequent resistance (after the 1521 Diet of Worms) in both political and religious terms to Charles's interdict much more comprehensible. The man who had started out as a pilgrim and relic collector ended his life as the patron and supporter of Luther's Reformation in his own capital, Wittenberg.

During the 1490s, the young and charismatic Maximilian had enjoyed the adoration and the political hopes of a patriotic literary circle, particularly in the border areas near rival France. In Basel and Strasbourg humanistic authors, led by Sebastian Brant (1457–1521) and Jakob Wimpheling (1450–1528), wrote in praise of the new emperor and offered political interpretations of current portents exhorting him to action.[78]

For example, Brant's *Ship of Fools* (Basel, 1494) exhorts the empire to modern greatness: "Our Roman Empire trusts in God / He's granted it a time and fate, / May He still fashion it so great /

That all the world its cause may serve . . ." (56.90–93). He also sees the current empire as heir to German greatness of the past: "The Germans once were highly praised / And so illustrious was their fame, / The Reich was theirs and took their name" (99.140–42). He sees Maximilian as the defender of all Christendom and exhorts him to reconquer the Holy Land from Islam, to make him worthy of wearing the imperial crown:

> Your king is all benignity,
> He'll don for your knight's panoply
> Rebellious lands he will subdue,
> But you must help, he needs you too.
> The noble Maximilian,
> The merits well the Roman crown.
> They'll surely come into his hand. . . .
> The Holy Earth, the Promised Land.
> <div align="center">(99.159–62).</div>

Wimpheling in his aptly titled *Germania* (1501), dedicated to the city council of Strasbourg, sought to prove the Germanness of Charlemagne as well as of his native Alsace, in order to refute any claims to the area by the French. Imperial Rome provided the indigenous character of the region, now appropriately situated within the Holy Roman Empire. Maximilian, a brave warrior and heir to both ancient German valor and ancient Roman *imperium*, is Wimpheling's current culture-hero. The same is true of Heinrich Bebel (1472–1518), a scholar and poet laureate whose "Oration in Praise of Germany" (1504), delivered in Innsbruck, praises his patron and ruler as the new salvation ("*sacratissime Rex . . . Imperator . . . Caesar*") for Germany, which would otherwise splinter politically into the territories of the princes:

> I, for my part believe that you, our emperor, know only too well all that is beneficial and all that is harmful to the German nation. Indeed I am certain that you have before your eyes a clear picture of what needs to be done. When I see how our German princes neglect the public weal in favor of their private interests, and how they waste their days in feuding and pleasure-seeking—a mode of conduct responsible for the disintegration of many cities and realms in the past—I should be fearful of our future as a nation were it not for you, exalted emperor, who, having already saved the empire from certain disintegration, give promise of using your native wisdom and skill to rescue our state, built through our forefathers' courage and retained with their blood, from the brink of annihilation to which sloth and lassitude have brought it.[79]

Ultimately, Maximilian aspired to have both the central authority and a national army akin to the nascent kingdoms of emerging nations elsewhere in Europe, such as England, France, and Spain. His problems with consolidating a German nation lay in his powerful rivals. His own territories, chiefly Austria, and his own Habsburg dynasty were simply the largest, most recently

dominant segments in the contentious Holy Roman Empire. Current rivals in Bavaria—the Wittelsbachs—and even traditional allies in Saxony and Brandenburg, led by Frederick the Wise, always had to wonder and worry whether they were dealing with an emperor of the whole nation or else the leader of the most powerful regional dynasty (one, moreover, that had been excluded systematically from a role as an electoral power in the midfourteenth-century Golden Bull). In some respects, the very success of Habsburg wedding diplomacy and ideology confirms this more parochial verdict of history. Perhaps that turn toward dynastic aggrandizement and preservation emerged out of necessity, the product of historical circumstances and timing.

After all, papal suspicions and constant hostile alliances against him even prevented Maximilian from being formally crowned emperor in Rome as his father, Frederick III, had been (and Charles V was only crowned in Bologna in 1530 by Clement VII in the wake of the infamous Sack of Rome in 1527). The universal empire of Charles V only developed when opportunities for a more local, more national, more truly Germanic empire failed to coalesce on its own. Indeed, within German lands Switzerland had already staged its successful revolt for independence against Maximilian in 1499. Even noting that the true family empire of the Habsburgs, Austria-Hungary, survived until 1918, it always suffered considerable internal friction along linguistic and ethnic fault lines, particularly in Bohemia and Hungary. Germany as a viable, integrated nation shattered utterly right after Maximilian's death in early 1519—chiefly along the confessional lines of the emerging Reformation. It should be reiterated, however, that these fractures, too, were local products of territorial and princely rivalries, which would receive official codification in the 1555 Peace of Augsburg, which declared about religion, *cuius regio eius religio* (in his region, his religion).

Within the history of sixteenth-century Germany, then, dynasty or family finally counted for everything. Moreover, in the long run of European history the Habsburgs simply enjoyed the biggest nonnational dynasty to survive internecine, medieval rivalries. Thus, for the Habsburgs, Maximilian I became the pivotal early modern figure in their restitution. The long view of Maximilian as a would-be "early modern" monarch, trying to build a nation-state around himself and his dynasty, reveals the truth of Browning's maxim in the epigraph to this chapter that "a man's reach should exceed his grasp."

His most dynamic contribution—ultimately, the threat that he posed to his peers in Germany as well—was the emperor's formation of a permanent and modernized military establishment (chapter 5).[80] In order to raise funds for his standing army and to fund his war innovations, such as mobile artillery, he sought to effect taxation with the appeal for a "common penny" while also issuing traditional medieval rallying cries for crusades (chapter 4) on behalf of all Christendom against the Turkish menace and Islam. Aside from the perceived threat by regional electors and dukes that he might centralize a German state against their wishes and local territorial imperatives, Maximilian's mixed messages of medieval and Christian motivations were perceived as at odds with his practice of personal, dynastic, and territorial ambitions. His detractors particularly emphasized his perennial conflicts with France or his local quarrels in the Low Countries rather than larger concerns of the empire, such as the crusade that never happened.

However, without denying the importance of medieval concepts of nobility and blood in his appeals for authority, Maximilian also asserted his achievements and his personal strengths or qualities as arguments for his leadership and right to the power and stature of his title of emperor (as well as his desired title of king). To assert those merits, he was the first ruler ever to make use of the modern European invention of the printing press, for both texts and images, to circulate throughout the breadth of his vast territories (and wider territorial claims). Well before the Catholic Church invented the concept of propaganda (from the phrase "*propaganda fidei*") in its efforts to recover or consolidate the faithful, Maximilian had already embarked on a public relations campaign of his own, addressed to both his peer princes as well as to what was called the common man (*gmeiner man*). His goal, like all rhetoric, especially political rhetoric, was the formation of subjects.

In contrast to the Jesuits, who supplemented their own use of the printing press with powerful buildings and decorations, Maximilian was only able to construct architectural fragments, such as his Goldenes Dachl and his unfinished tomb complex, both now in Innsbruck. Indeed, despite a decade of planning and production, involving delegation to teams of artists, authors, and craftsmen (such as woodblock-cutters), most proposals for his printed projects still remained unfinished at the emperor's death. They reached a wider public only as part of the Habsburg family legacy in the late eighteenth and nineteenth centuries. Both the secular *Weisskunig* and the sacred *Prayerbook* (even though those anachronistic distinctions do not pertain to either work, for each provides a complex mixture of worldly figures within religious structures) still remained torsos at the death of the emperor. The former achieved partial completion with carved but unprinted woodblocks; the latter complemented its magnificently printed text with drawn designs but never saw them realized in woodblocks for multiple illustrations.

Surely the uncompleted tomb of Julius II, commissioned from Michelangelo by the pope, remains the most ambitious and famous of all Renaissance unfinished projects (or, at best, compromised completions).[81] But Julius's own rival and contemporary as head of Christendom, Emperor Maximilian I, also had his own personal and ideological ambitions—both political and spiritual—embodied in the figures of his own unfinished tomb project. Each leader was willing to use art to further his reputation and legacy. Little wonder that Maximilian could even have been rumored to consider standing as a candidate for pope to serve as Julius's successor.

Ultimately, neither the politics nor the art of Emperor Maximilian ever found completion. In any case, the era of Luther that commenced shortly before his death would probably have undermined any political unity that he might have forged, just as it would increasingly assail the reign of his successor, Charles V, both politically and religiously. Like his ambitious planned art projects, the political construction of a truly united German nation in the traditional Holy Roman Empire eluded Maximilian in part because he insisted on such meticulous control and so easily confused personal or dynastic identity with nationhood (*L'état c'est moi*).[82]

Yet in his *Arch of Honor* (frontispiece), he successfully completed on paper at least one major part of his planned *Triumphal Procession*. Thus he achieved a grand legacy in physical terms of scale

and also produced a rich *summa* of his many claims and achievements. On the larger stage of politics, he also created a lasting Habsburg Empire for later emperors, Charles V, Charles VI, and Franz Joseph, based in Austria. Eventually the Berlin of Frederick the Great and Otto von Bismarck would become the center of German-speaking central Europe instead of Habsburg Vienna—and in the process the territorial rivalry of the sixteenth century finally shifted towards the home region of Frederick the Wise over that of Maximilian. Nevertheless, much of the Frederick's militarism and Bismark's political acumen necessarily built on the earlier foundations and heritage established first by Maximilian I, Holy Roman Emperor of the German Nation.

Notes

	Abbreviations and Short References
Eisenbeiss, "Porträts"	Anja Eisenbeiss, "Einprägsamkeit en gros: Die Porträts Kaiser Maximilians I; Ein Herrscherbild gewinnt Gestalt" (Ph.D. diss., University of Heidelberg, 2005)
Innsbruck, 1969	*Maximilian I*, exh. cat. (Innsbruck, 1969)
JKSAK	*Jahrbuch der Kunsthistorischen Sammlungen der Allerhöchsten Kaiserhauses*
JKSW	*Jahrbuch der Kunsthistorischen Sammlungen in Wien*
Laschitzer, *Theuerdank*	Simon Laschitzer, ed. "*Theuerdank*: Die geuerlicheiten vnd einsteils der geschichte des loblichens Streytparen vnd hochberümbten helds vnd Ritters herr Tewrdannckhs," *JKSAK* 8 (1888)
Leitner, *Freydal*	Quirin von Leitner, ed., *Freydal: Des Kaisers Maximilian I; Turniere und Mummereien* (Vienna, 1880–82)
MIÖG	*Mitteilungen des Instituts für österreichische Geschichtsforschung*
Musper, *Teuerdank*	H. Theodor Musper, ed., *Kaiser Maximilians Teuerdank* (Plochingen, 1968)
Nuremberg, 1971	*Albrecht Dürer 1471–1971*, exh. cat. (Nuremberg, 1971)
Schultz, *JKSAK*	Alwin Schultz, ed., "*Der Weisskunig* nach den Dictaten und eigenhändigen Aufzeichnungen Kaiser Maximilians I zusammengestellt von Marx Treitzsaurwein von Ehrentreitz," *JKSAK* 6 (1888).
Strauss, *Prayerbook*	Walter Strauss, ed., *The Book of Hours of the Emperor Maximilian the First* (New York, 1974)
Stuttgart, 1973	*Hans Burgkmair: Das graphische Werk*, exh. cat. (Stuttgart, 1973)
Vienna, 1959	*Maximilian I*, exh. cat. (Vienna, 1959)
Weisskunig, 1956	H. Theodor Musper et al., eds., *Kaiser Maximilians I Weisskunig* (Stuttgart, 1956)

1. Max Weber, *Max Weber on Charisma and Institution Building*, ed. S. N. Eisenstadt (Chicago, 1968); A. M. Hocart, *Kingship* (London, 1927; reprint, Chicago); Sean Wilentz, ed., *Rites of Power. Symbolism, Ritual, and Politics since the Middle Ages* (Philadelphia, 1985); David Kertzer, *Ritual, Politics and Power* (New Haven, Conn., 1988); Allan Ellenius, ed., *Iconography, Propaganda, and Legitimation* (Oxford, 1998); Sergio Bertelli, *The King's Body*, trans. Burr Litchfield (University Park, Pa., 2001).

2. Reinhard Bendix, *Kings or People: Power and the Mandate to Rule* (Berkeley, Calif., 1978); Perry Anderson, *Lineages of the Absolutist State* (London, 1974).

3. Clifford Geertz, "Centers, Kings, and Charisma: Reflections on the Symbolics of Power," in Wilentz, ed., *Rites of Power*, 12–40; Geertz, "Ideology as a Cultural System," in *Interpretation of Cultures* (New York, 1973), 193–233; Geertz, *Negara: The Theater State in Nineteenth-Century Bali* (Princeton, N.J., 1980); Edward Shils, *Tradition* (Chicago, 1981); Shils, *The Constitution of Society* (Chicago, 1982), esp. "The Sacred in Society," 93–175.

4. Peter Burke, *The Fabrication of Louis XIV* (New Haven, Conn., 1992); Louis Marin, *Portrait of the King*, trans. Martha Houle (Minneapolis, 1988).

5. Hajo Holborn, *A History of Modern Germany*, vol. 1, *The Reformation* (London, 1965), 15–37; Geoffrey Barraclough, *The Origins of Modern Germany* (New York, 1963), 316–21.

6. Hermann Wiesflecker, *Kaiser Maximilian I*, 5 vols., esp. vol. 5, *Der Kaiser und seine Umwelt: Hof, Staat, Wirtschaft, Gesellschaft und Kultur* (Munich, 1986), esp. 1–150; Heinz Angermeier, *Die Reichsreform 1410–1555* (Munich, 1986), esp. 145–229; Fritz Hartung, "Imperial Reform, 1485–1495: Its Course and Its Character," in Gerald Strauss, ed., *Pre-Reformation Germany* (New York, 1972), 43–72; Holborn, *History of Modern Germany*, 1:37–55.

7. Thomas Brady, Jr., "Imperial Destinies: A New Biography of the Emperor Maximilian I," *Journal of Modern History* 62 (1990), 298–314.

8. Dieter Wuttke, "Sebastian Brant und Maximilian I: Eine Studie zu Brants Donnerstein-Flugblatt des Jahres 1492," in Otto Herding and Robert Stupperich, eds., *Die Humanisten in ihrer politischen und sozialen Umwelt* (Boppard, 1976), 141–76; Jan-Dirk Müller, "Poet, Prophet, Politiker: Sebastian Brant als Publizist und die Rolle der laikalen Intelligenz um 1500," *Zeitschrift für Literaturwissenschaft und Linguistik* 10 (1980), 102–27; Paul Heitz, *Flugblätter des Sebastian Brant* (Strasbourg, 1915); Wiesflecker, *Kaiser Maximilian I*, 5:340–46.

9. Lewis Spitz, *The Religious Renaissance of the German Humanists* (Cambridge, Mass., 1963); Spitz, *Conrad Celtis: The German Arch-Humanist* (Cambridge, Mass., 1957); Friedrich von Bezold, "Konrad Celtis der deutsche Erzhumanist," *Historische Zeitschrift* 49 (1883), 1–45, 193–228 (reprinted in Bezold, *Aus Mittelalter und Renaissance* [Munich, 1918], 82–152; and later *Konrad Celtis* [Darmstadt, 1959]).

10. Jan-Dirk Müller, *Gedechtnus: Literatur und Hofgesellschaft um Maximilian I* (Munich, 1982).

11. Ibid., 96–103.

12. Otto Benesch and Erwin Auer, *Die Historia Friderici et Maximiliani* (Berlin, 1957); Hans Mielke, *Albrecht Altdorfer*, exh. cat. (Berlin, 1988), 68–83, no. 30.

13. Wiesflecker, *Kaiser Maximilian I*, 1:11–43.

1 | Introduction: Maximilian's Artworlds

1. Pirckheimer's story is recounted by Philipp Melanchthon, *Cronica Carionis aucta* (1563), 562; quoted by Schultz, *JKSAK*, ix. Heinz-Otto Burger, "Der Weisskunig als Literaturdenkmal," in *Weisskunig*, 1956, 15–33, esp. 15–16, 90, doc. 1. Pirckheimer himself went on to pen a history of the Swiss War of 1499, "Bellum Suitense sive Helveticum"; see Willehad Paul Eckert and Christoph von Imhoff, *Willibald Pirckheimer* (Cologne, 1971), 138–72.

2. In emulation of Caesar, *scribena gerere et gesta scribere*. Burger, "Der Weisskunig als Literaturdenkmal," 15, 17; Schultz, *JSAK*, 421–46, esp. 423; for the horoscope quotation, 423ff. On the subject of stars and politics, see the remarks on Sebastian Brant and Maximilian in chapter 7.

3. *Weisskunig*, 1956, 329. Author's translations throughout.

4. Benesch and Auer, *Historia Friderici et Maximiliani*, 14–20, following Albin Czerny, "Der Humanist und Historiograph Kaiser Maximilians I Joseph Grünpeck," *Archiv für österreichischen Geschichte* 73 (1888), 315–64. See also Jan-Dirk Müller, *Gedechtnus*, 58; Hermann Wiesflecker, "Joseph Grünpecks Redaktionen der lateinischen Autobiographie Maximilians I," *MIÖG* 78 (1970), 416–31.

5. Grünpeck had already written a 1496 treatise on the *mala de Franzos* and described it further in *Mentaluagra, alias morbo gallico* (1503), based on his own symptoms. See Jon Arrizabalaga, John Henderson, and Roger French, *The Great Pox: The French Disease in Renaissance Europe* (New Haven, Conn., 1997), 98–99, 109–12.

6. This autobiography of military deeds and kingly maturity was intended to follow fictionalized chronicles of earlier events, namely, the tournaments and hunts (see chapter 6) as well as the winning of a bride, to be recounted in prior books, *Freydal* and *Teuerdank*, respectively, both of them in German vernacular, like *Weisskunig*, so that Maximilian could more easily dictate the outlines of his works. The earliest mention of *Teuerdank* is undated, but it appears in the emperor's memoranda (*Gedenkbuch*) for the period ca. 1505–8 (Vienna, National Library, cod. vindob. ser. 2645, fo. 169r); see *Freydal*, ed. Quirin von Leitner (Vienna, 1880–82), v–vi.

7. The manuscript is in the Vienna Haus-, Hof-, und Staatsarchiv, ms. Böhm no. 24. Benesch and Auer, *Historia Friderici et Maximiliani*, passim. The reattribution to Altdorfer himself rather than to his studio, led by an anonymous "Master" of the *Historia*, was made by Hans Mielke, *Albrecht Altdorfer*, exh. cat. (Berlin, 1988), 68–83, no. 30, with full bibliography.

8. Benesch and Auer, *Historia Friderici et Maximiliani*, 119, 127–28; chapters 13, 48: *De prodigiis et ostentis, quae mortem Friderici imperatoris praecesserunt*. On the various marginal comments on the drawings by Maximilian, 25–26.

9. Benesch and Auer, *Historia Friderici et Maximiliani*, 25–26, 122–23, nos. 26–27, fo. 53r, 54v, captions *De eius bellis, De Terbonensi clade* (Battle of Therouanne, 1479).

10. This chronological anomaly of a teenage Charles (b. 1500) among the drawings argues against assigning the authorship to the young Altdorfer, proposed by Mielke on powerful stylistic grounds. It seems instead to favor the hand of an anonymous Altdorfer follower, the "*Historia* Master," associated with the Master of Pulkau by Benesch. Yet the *Historia* text was never carried further chronologically than the 1508 period and does not even mention the coronation of Maximilian at Trent in that arbitrary but significant year, something unthinkable in any work that would have been updated. Moreover, by 1508 the premature death (25 September 1506) of Charles's father, Philip the Fair, was already well known and had rendered the young man as presumptive heir of Maximilian's titles as well as his father's when he attained his majority (declared in 1515, when he became duke of Burgundy). One can only resolve this seeming contradiction by speculating that if Altdorfer were indeed the artist who penned the dedication drawing, he would have anticipated the eventual presentation of the volume to a more mature Charles than existed at the time of the presumed illustration period according to Mielke and adopted here.

11. Benesch and Auer, *Historia Friderici et Maximiliani*, 24–25.

12. Ibid., 13, 16–27; also given a later German translation, ed. Theodor Ilgen, *Die Geschichte Friedrichs III und Maximilians I von Joseph Grünpeck* (Leipzig, 1891).

13. Benesch and Auer, *Historia Friderici et Maximiliani*, 28, 125–26.

14. MS C of *Weisskunig* (Vienna, National Library, no. 2834), fo. 127b, quoted in Schultz, *JKSAK*, xvi; Benesch and Auer, *Historia Friderici et Maximiliani*, 29.

15. On Peutinger, see Wiesflecker, *Kaiser Maximilian I*, 5:354–55, with references; Müller, *Gedechtnus*, 55–57; Josef Bellot, "Konrad Peutinger und die literarisch-künstlerischen Unternehmungen Kaiser Maximilians I," *Philobiblon* 11 (1967), 171–90; Erich König, *Peutingerstudien* (Munich, 1914); Theodor Herberger, *Conrad Peutinger in seinem Verhältnisse zum Kaiser Maximilian I* (Augsburg, 1851); Christine Maria Horn, "Doctor Conrad Peutingers Beziehungen zu Kaiser Maximilian I" (Ph.D. diss., University of Graz, 1977).

16. The color white, according to the text of *Freydal*, "means so much, transparent, beautiful, lustrous, and pure in commission and ommission" (*durchleughtig, schön, lutter und pur mit tun und Lassen*). Quoted by Burger in *Weisskunig*, 1956, 19.

17. Otto Cartellieri, *The Court of Burgundy* (New York, 1929), esp. 176–80; Richard Vaughan, *Valois Burgundy* (London, 1975), 163–64; Graeme Small, *George Chastellain and the Shaping of Valois Burgundy* (Woodbridge, U.K., 1997).

18. Georg Misch, "Die Stilisierung des eigenen Lebens in dem Ruhmeswerk Kaiser Maximilians, des letzten Ritters," *Nachrichten von der Gesellschaft der Wissenschaften zu Göttingen* (1930), 435–59.

19. Vienna, National Library, no. 2645; Vienna, 1959, 34, no. 100; Theodor Gottlieb, *Die Ambraser Handschriften* (Leipzig, 1900), 58–61. Documents in *JKSAK* 5 (1886), xvi–xviii.

20. Vienna, National Library, no. 2892; Vienna, 1959, 28, no. 78; *Weisskunig*, 1956, 23–24; Gottlieb, *Die Ambraser Handschriften*, 141; Schultz, *JKSAK*, 6.

21. MS F is in Vienna, National Library, no. 3033; Vienna, 1959, 29, no. 85. MS A is in Vienna, National Library, no. 3032; Vienna, 1959, 29, no. 83, dedicated to Maximilian's grandsons and successors, Charles and Ferdinand. Another redaction with corrections, some by Maximilian, was prepared subsequent to MS A; called MS E, it dates

between Christmas of 1514 and Maximilian's own death at the beginning of 1519 (Vienna, National Library, no. 2932; Vienna, 1959, 30, no. 87).

22. MS H, the Question Book, is in Vienna, National Library, no. 3034; Vienna, 1959, 29, no. 84. The Control Book is in Vienna, National Library, no. 7326; Vienna, 1959, 30, no. 87.

23. Stuttgart, 1973, 178–203.

24. David Landau and Peter Parshall, *The Renaissance Print 1470–1550* (New Haven, Conn., 1994), 206–19.

25. Ibid., 190–91; Larry Silver, "Shining Armor: Maximilian I as Holy Roman Emperor," *Museum Studies* (Art Institute of Chicago) 12 (Fall 1986), 8–29.

26. Stuttgart, 1973, 150–66. Burger, in *Weisskunig*, 1956, 28–31, 91, doc. 10, citing *JKSAK* 13 (1892), reg. 8581.

27. Landau and Parshall, *Renaissance Print*, 200–202; *Weisskunig*, 1956, 92–93, doc. 15, citing *JKSAK* 13 (1892), reg. 8594. For the portrait of Paumgartner, see Stuttgart, 1973, no. 76.

28. *Weisskunig*, 1956, 90–91, doc. 6, citing *JKSAK* 3 (1885), reg. 2637.

29. *Weisskunig*, 1956, 95–96, doc. 28, citing *JKSAK* 13 (1892), reg. 8610. The letter also mentions paintings in the Augsburg Rathaus after these *Weisskunig* figures and ancestor figures or relatives. On the Rathaus paintings with their Maximilianic themes, carried out by Jörg Breu along with Ulrich Apt and Ulrich Maurmüller, see Pia Cuneo, *Art and Politics in Early Modern Germany: Jörg Breu the Elder and the Fashioning of Political Identity ca. 1475–1536* (Leiden, 1998), 57–59, 112–18.

30. Erwin Petermann, "Die Zeichnungen," in *Weisskunig*, 1956, 72–89; Karl Rudolph, "'Das Gemäl ist also recht': Die Zeichnungen zum 'Weisskunig' Maximilians I des Vaticanus Latinus 8570," *Römische historische Mitteilungen* 22 (1980), 167–207.

31. Boston Museum, Harvey D. Parker coll., 57B 5.5. My thanks to Barbara Butts for sharing information on MS G. Besides the 52 pen drawings, it contains 119 proofs of the woodcut illustrations.

32. As many as forty-nine details have been altered in the process of woodblock illustration production. Laschitzer, *Theuerdank*, *JKSAK* 8 (1888), 94–103. Campbell Dodgson, "Some Undescribed States of *Teuerdank* Illustrations," *Burlington Magazine* 84 (1944), 47–48; Dodgson, "Zwei verworfene Teuerdankillustrationen," *Jahrbuch der Preussischen Kunstsammlungen* 33 (1912), 284–87. Musper, *Teuerdank*, 19.

33. Stuttgart, 1973, nos. 155–56, 158–60. According to Petermann, "Die Zeichnungen," in *Weisskunig*, 1956, 79–80,

this same process could have served in the case of the earlier *Weisskunig* woodcuts, that is, those already corrected by the time of MS A (cod. 3032; 1514). In MS C (cod. 2834), the *Weisskunig* MS includes an description, fo. 150r, by Treitzsaurwein: "Hierinn ligen copeyen, gemäl, die in den weyssen kunig gehoren, in den ersten tail des puechs; aber der Marx hat zu Ratemberg am Ynn am iiii tag Febr anno xiii jar das gemäl, davon die copeyen sein, in das puech geordnet, darumb das gemäl nichts nucz mer ist (Herein lie copies, sketches, that belong in the *Weisskunig*, in the first part of the book; but Marx [Treitzsaurwein] on February 4, 1513, at Retemberg-on-Inn, ordered the sketches, of which these are copies, in the book; therefore the sketches no longer are necessary)." The original drawings, no longer useful in the process of book composing, have been lost.

34. Michael Baxandall, *The Limewood Sculptors of Renaissance Germany* (New Haven, Conn., 1980), esp. chapter 2.

35. *Weisskunig*, 1956, 92–93, doc. 15.

36. By name: Hans Franck, Cornelis and Willem Liefrinck, Alexander Lindt, Wolfgang Kesch, Claus Seman, and Hans Taberith. Laschitzer, "Heiligen," 148–59; see also Landau and Parshall, *The Renaissance Print*, 206–11.

37. By name: Franck, C. Liefrinck, Lindt, Seman, Taberith. Petermann, "Die Zeichnungen," in *Weisskunig*, 1956, 87.

38. Facsimiles and analyses by Laschitzer, *Theuerdank*; Musper, *Teuerdank*.

39. Laschitzer, *Theuerdank*; Musper, *Teuerdank*, 1968, 13–27. According to Geck, 26, the variety of letters in the printing of *Teuerdank* is such that eight different "D" letters appear on a single page in order to simulate the vagaries of scribal script.

40. Leitner, *Freydal*, vii–xiii, traces the genesis of the two companion books, with his eyes on *Freydal*, also called *Freidhart Comedi*.

41. Leitner, *Freydal*, x; *Weisskunig*, 1956, 92, doc. 14; Thomas Schauerte, *Die Ehrenpforte für Kaiser Maximilian I* (Munich, 2001), 411–12, no. Q20. The letter is preserved along with the *Weisskunig* volume, MS G (Boston, Museum of Fine Arts).

42. Laschitzer, *Theuerdank*, 15–37, describes the earlier versions of the text, recorded in Treitzsaurwein, first in a codex (Vienna, National Library, no. 2867), accompanied with descriptions of the eventual pictures; then in a revised version of ca. 1513–14 (Vienna, National Library, no. 2806). See Vienna, 1959, 22–24, nos. 70–71. A proof edition of *Teuerdank* with woodcuts (Vienna, National Library no. 2833), still lacking seventeen illustrations

but including five sketches to be cut as woodcuts, was produced around 1516 (Laschitzer, *Theuerdank*, 61–64; Vienna, 1959, 24, no. 73). On Pfinzing, see Müller, *Gedechtnus*, 61–62, 68–72.

43. Glenn Waas, *The Legendary Character of Kaiser Maximilian* (New York, 1941), 104–8, 120–23.

44. Franz Schestag, "Kaiser Maximilian I: Triumph," *JKSAK* 1 (1883), 154–83; Eduard Chmelarz, "Die Ehrenpforte des Kaisers Maximilian I," *JKSAK* 4 (1886), 289–319; Thomas Schauerte, *Die Ehrenpforte für Kaiser Maximilian I* (Munich, 2001).

45. For the text and analysis of the Arch of Devotion, see Karl Giehlow, *Kaiser Maximilians I Gebetbuch* (Vienna, 1907), 44, 101–3; see also chapter 4 of this volume.

46. Facsimile edition by Franz Winzinger (Graz, 1972); for the attributions and dating, see Winzinger, "Albrecht Altdorfer und die Miniaturen des Triumphzuges Kaiser Maximilians I," *JKSW* 62 (1966), 157–73; Franz, Winzinger, *Albrecht Altdorfer: Die Gemälde* (hereafter cited as *Gemälde*) (Munich, 1975), 107–19. Out of 109 original miniatures, only 59 survive in the Albertina manuscript; however, the lost designs were copied (Vienna, National Library no. 77; Madrid, National Library, res. 232); see Vienna, 1959, 69–96, nos. 216–74 (Albertina originals), 275–88 (copies). The letter from Maximilian to von Dietrichstein (14 October 1512), declares: "Stabius has also directed the *Triumphal Chariot* (*Triumphwagen*) fully on its way. But we have not yet supervised it."

47. Schestag, "Kaiser Maximilian I," 177–78.

48. For the history of the Dürer designs, see Karl Giehlow, "Dürers Entwürfe für das Triumphrelief Maximilians im Louvre," *JKSAK* 29 (1910), 14–84; Nuremberg, 1971, 145, no. 262.

49. Chmelarz, "Ehrenpforte"; Giehlow, "Urkundenexegese zur Ehrenpforte Maximilians I," in *Beiträge zur Kunstgeschichte Franz Wickhoff gewidmet* (Vienna, 1903), 91–110; Peter Strieder, "Zur Entstehungsgeschichte von Dürers Ehrenpforte für Kaiser Maximilian," *Anzeiger des Germanischen Nationalmuseums* (1954–59), 128–42; Vienna, 1959, 69–78, nos. 350–77; Nuremberg, 1971, 144–45, no. 261; Larry Silver, "Power of the Press: Dürer's *Arch of Honour*," in Irena Zdanowicz, ed., *Albrecht Dürer in the Collection of the National Gallery of Victoria* (Melbourne, 1994), 45–62; Schauerte, *Ehrenpforte*.

50. A letter of 17 February 1518 from Maximilian to Margaret asks her please to return the second set of drawings. M. Le Glay, ed., *Correspondance de l'Empereur Maximilien Ier et de Marguerite d'Autriche* (Paris, 1839), 2:374, no. 661.

51. The best source for the *Arch* is Schauerte, *Ehrenpforte*, 143–67, 258–84, with the accompanying inscriptions; also useful is the comparative study of the military scenes with a set of roundel designs by Jörg Breu the Elder of Augsburg, discussed by Pia Cuneo, "Images of Warfare as Political Legitimization: Jörg Breu the Elder's Rondels for Maximilian I's Hunting Lodge at Lermos (ca. 1516)," in Cuneo, ed., *Artful Armies, Beautiful Battles: Art and Warfare in Early Modern Europe* (Leiden, 2002), 87–105. Translations from the Stabius text of the *Arch* used here come from Walter Strauss, *Albrecht Dürer: The Woodcuts and Woodblocks* (hereafter cited as *Woodcuts*) (New York, 1980), 726–31.

52. "To understand what here is said / A princess he was soon to wed. / Heiress of Burgundy she was; / for him it was the proper cause, / his children's lands by war and peace / thereby to rapidly increase."

53. As Schauerte notes, *Ehrenpforte*, 268 n. 327, Bohemia is missing, because two competing kings of Bohemia, Vladislav and Matthias Corvinus, were currently recognized, and neither was invited by the emperor to Frankfurt for the selection process.

54. "He entered Hungary with might; / Stuhlweissenberg fell after fierce fight. / Half of their kingdom soon was lost / by the Hungarians at great cost. / To end the war they had to swear / Allegiance to Austria thus declare."

55. This 1515 military setback occurred early enough to find its way into the rhymed captions by Stabius for the *Arch*, officially dated to the same year but actually completed a few years later. The verses acknowledge the later loss of Milan prior to the completion of the woodcut ensemble.

56. "He then Venice attacked with might / Routing thousands into wild flight. / Their number must remain untold / Exceeding the dead by manyfold. / In punishing of their frivolous deed / He captured hamlets beyond his need."

57. "To Holland then he took his court / To lend the King of England his support. / Soon great armies were assembled; / The French were much afraid and trembled. / Many of them saw their last day / Terrawan was taken, so was Tornay."

58. "The Hungarian, Bohemian, Polish Kings / All pay homage at his gatherings. / They visited him on their own accord / To honor him, his crown, and his sword. / New marriages and alliances soon / For all Christendom provide a boon."

59. On the tomb of Maximilian, see Vinzenz Oberhammer, *Die Bronzestandbilder des Maximiliangrabmales in der*

Hofkirche zu Innsbruck (Innsbruck, 1935); Erich Egg, *Die Hofkirche in Innsbruck* (Innsbruck, 1974). On the tomb of Frederick III, see *Friedrich III*, exh. cat. (Wiener Neustadt, 1966), 192–96, 386–87; E. Hertlein, "Das Grabmonument Kaiser Friedrichs III (1415–1493) als habsburgisches Denkmal," *Pantheon* 35 (1977), 294–305.

60. Karl Oettinger, *Die Bildhauer Maximilians am Innsbrucker Kaisergrabmal* (Nuremberg, 1966).

61. W. 675–77; cf. Innsbruck, 1969, 163, no. 603, a copy, probably by Kölderer, used as a working drawing. See chapter 2. Recently a Dürer outline ink drawing for the originating Habsburg ancestor, Ottobert (Berlin, Kupferstichkabinett, inv. no. 26812) has been rediscovered; it features fantastic armor, a hybrid of ancient and medieval models. Fritz Koreny, "Ottoprecht Fürscht: Eine unbekannte Zeichnung von Albrecht Dürer–Kaiser Maximilian I und sein Grabmal in der Hofkirche zu Innsbruck," *Jahrbuch der Berliner Museen* 31 (1989), 127–48.

62. Oberhammer, *Bronzestandbilder*, 167–207; Vienna, 1959, 64, no. 209.

63. Formerly at Schloss Ambras, cod. 5333. Oberhammer, *Bronzestandbilder*, 42–56; Vienna, 1959, 64, no. 210. The style of these figures departs considerably from the bronze statues. A copy of the MS is at Munich, Staatsbibliothek, cgm 908.

64. Erich Egg, "Jörg Kölderer und die Donauschule," in *Werden und Wandlung: Studien zur Kunst der Donauschule* (Linz, 1967), 57–62; on the general subject during the Renaissance, see Martin Warnke, *The Court Artist: On the Ancestry of the Modern Artist*, trans. David McLintock (Cambridge, 1993; orig. ed. 1985).

65. Facsimile by Michael Mayr, ed., *Das Jagdbuch Kaiser Maximilians I* (Innsbruck, 1901); Mayr, ed., *Das Fischereibuch Kaiser Maximilians I* (Innsbruck, 1901). Vienna, 1959, 31, no. 90–91; Innsbruck, 1969, 70, nos. 276–77, color plate 3. See chapter 6.

66. *JKSAK* 2 (1884), reg. no. 678: "Dasjenige Hofgemäl nit so gar köstlich ist."

67. Wendelin Boeheim, "Die Zeugbücher Kaiser Maximilians I," *JKSAK* 13 (1892), 94–201; 15 (1894), 295–391; Vienna, 1959, 39, no. 115, fig. 25; 221, no. 604, fig. 84; Innsbruck, 1969, 121–22, nos. 475–77, fig. 94, color plates 7, 9.

68. *JKSAK* 2 (1884), reg. 831, 1057.

69. Ibid., reg. 845. On the relative freedom of court artists compared with their city brethren, see Warnke, *The Court Artist*, esp. 85–92, 159–61, 170–74.

70. Egg, "Jörg Kölderer," 60; on the restorations of Runkelstein, see Larry Silver, "'Die Guten Alten Istory:'

71. Warnke, *The Court Artist*, 102–8. Now see an anthology of studies on Renaissance court artists, Stephen Campbell, ed., *Artists at Court: Image-Making and Identity 1300–1550* (Boston, 2004), esp. the essays by Sherry Lindquist, "'The Will of a Princely Patron' and Artists at the Burgundian Court," 46–56; and Larry Silver, "Civic Courtship: Albrecht Dürer, the Saxon Duke, and the Emperor," 149–62.

Emperor Maximilian I, *Teuerdank,* and the Heldenbuch Tradition," *Jahrbuch des Zentralinstituts für Kunstgeschichte* 2 (1986), 71–106.

72. Elisabeth Dhanens, *Hubert and Jan van Eyck* (Antwerp, 1980), 34–59, 122–73.

73. In this respect, as in so many others, Rubens followed the example of Titian; see Martin Warnke, *Kommentare zu Rubens* (Berlin, 1965); Christopher Brown, "Rubens and the Archdukes," in Werner Thomas and Luc Duerloo, eds., *Albert and Isabella*, exh. cat. (Brussels, 1998), 121–28, passim.

74. Hans Rupprich, *Dürer Schriftlicher Nachlass* (Berlin, 1956), 1:79, no. 26; translation in Conway, 83.

75. Rupprich, *Dürer*, 1:77, no. 24; Schauerte, *Ehrenpforte*, 412, no. Q21; also *JKSAK* 10 (1889), reg. 5789. Sent to the Nuremberg city council from Landau, 12 December 1512.

76. Rupprich, *Dürer*, 1:77–78, no. 25; Schauerte, *Ehrenpforte*, 414, no. Q28; translated by Conway, 82.

77. Stuttgart, 1973, 21–22; Tilman Falk, *Hans Burgkmair: Studien zu Leben und Werke des Augsburger Malers* (Munich, 1968), 69–71; Silver, "Shining Armor."

78. Stuttgart, 1973, no. 12; Falk, *Hans Burgkmair*, 48.

79. Lewis Spitz, *Conrad Celtis*; Erwin Panofsky, "Conrad Celtis and Kunz von der Rosen: Two Problems in Portrait Identification," *Art Bulletin* 24 (1942), 39–43; the classic study is Friedrich von Bezold, *Konrad Celtis: Der deutsche Erzhumanist* (Darmstadt, 1959; orig. ed. 1883); also reprinted in Bezold, *Aus Mittelalter und Renaissance* (Munich, 1918), 82–152.

80. Stuttgart, 1973, 14–15, figs. 17–18; Nuremberg, 1971, 164, no. 289; Friedrich Dörnhöffer, "Über Burgkmair und Dürer," in *Beiträge zur Kunstgeschichte Franz Wickhoff gewidmet* (Vienna, 1903), 111–31.

81. Stuttgart, 1973, 18–19; Falk, *Hans Burgkmair*, 47–52; Panofsky, "Conrad Celtis," 42, 43, figs. 4, 7.

82. The woodcut is probably dated 1507. Stuttgart, 1973, no. 17, fig. 20; Falk, *Hans Burgkmair*, 49–50; Larry Silver, "Germanic Patriotism in the Age of Dürer," in Dagmar Eichberger and Charles Zika, eds., *Dürer and His Culture* (Cambridge, 1998), 40–49; also Dieter Wuttke,

Humanismus als integrative Kraft: Die Philosophia des deutschen 'Erzhumanisten' Conrad Celtis (Nuremberg, 1985). On the play, see Gustav Bauch, *Die Rezeption des Humanismus in Wien* (Breslau, 1903), 154–56.

83. On the Judgment of Paris, especially as an image of the sovereign's own choice between virtue and vice, see Larry Silver, "Forest Primeval: Albrecht Altdorfer and the Early German Wilderness Landscape," *Simiolus* 13 (1983), 36–38; Dieter Koepplin and Tilman Falk, *Lukas Cranach*, exh. cat. (Basel, 1974), 2:613–31. In 1502, Celtis's pupil, Jakob Locher Philomusus [*sic*] presented a dramatization of this subject for Maximilian at Ingolstadt; see Hans Rupprich, *Deutsche Literatur*, 641–42.

84. On the Seven Mechanical Arts, codified in Hugh of St. Victor's *Didascalion* (ca. 1130) and again in the midthirteenth-century *Speculum Doctrinale* by Vincent of Beauvais, see David Summers, *The Judgment of Sense* (Cambridge, 1987), 235–65.

85. Rupprich, *Deutsche Literatur*, 636–37.

86. Gerald Strauss, *Sixteenth-Century Germany: Its Topography and Topographers* (Madison, Wis., 1959); Frank Borchardt, *German Antiquity in Renaissance Myth* (Baltimore, 1971); Paul Joachimsen, *Geschichtsauffassung und Geschichtsschreibung in Deutschland unter dem Einfluss des Humanismus* (Leipzig, 1910); Alphons Lhotsky, *Österreichische Historiographie* (Munich, 1962), 65–78.

87. On the rediscovery of Tacitus, see Paul Joachimsen, "Tacitus im deutschen Humanismus," *Neue Jahrbücher für das klassische Altertum* 14 (1911), 695–717; Hans Tiedemann, *Tacitus und das Nationalbewusstsein der deutschen Humanisten* (Berlin, 1913); Kenneth Schellhase, *Tacitus in Renaissance Political Thought* (Chicago, 1976), 50–65; Borchardt, *German Antiquity*, 177–81.

88. Borchardt, *German Antiquity*, 98–103. On Wimpheling, the standard work remains Charles Schmidt, *Histoire littéraire de l'Alsace* (Paris, 1879), 1:1–188. In English, introductory surveys include Spitz, *The Religious Renaissance of the German Humanists*; Eckhard Bernstein, *German Humanism* (Boston, 1983), 29–39.

89. Borchardt, *German Antiquity*, 110–14. Ulrich Paul, *Studien zur Geschichte des deutschen Nationalbewusstseins im Zeitalter des Humanismus und der Reformation* (Berlin, 1936), 81–82.

90. Joachimsen, *Geschichtsauffassung*, 202–9; König, *Peutingerstudien*, 17–18, 42–60; Falk, *Hans Burgkmair*, 46–47; Stuttgart, 1973, no. 77.

91. König, *Peutingerstudien*, 46–47. A letter from Peutinger to Celtis also speaks of *imagines* planned for the project.

92. Wiesflecker, *Kaiser Maximilian I*, 5:367–68; Joachimsen, *Geschichtsauffassung*, 209–17; Hans Ankwicz-Kleehoven, *Der Wiener Humanist Johannes Cuspinian* (Cologne, 1959), 101–4, 293–301, 309–22; Alphons Lhotsky, *Österreichische Historiographie*, 65–69.

93. On Cuspinian and the 1515 Vienna double wedding, see Ankwicz-Kleehoven, *Der Wiener Humanist*, 78–88; Wiesflecker, 4:181–82. Cuspinian also wrote the commemorative text of the event, usually referred to as the *Diarium*. He thus served the dual role of diplomat and author, akin to the court artists of the Low Countries (van Eyck, Rubens), and he traveled extensively on diplomatic missions in eastern Europe, especially to Hungary.

94. *Weisskunig*, 1956, 223 (chapter 21): "er lass auch geschrift, die da saget von den vergangen geschichten und von der menschen natur und gemuet und von irn stenden. . . ."

95. Müller, *Gedechtnus*, "Heldenbücher als Geschichtstradition im Spätmittelalter," 190–203.

96. Silver, "'Die Guten Alten Istory'"; Müller, *Gedechtnus*, 104–48, Burger, "Der Weisskunig als Literaturdenkmal," 15–33, esp. 21, surveying the fantastic splendor invariably inserted into the descriptive language of Treitzsaurwein: "Alles heisst zierlich, kostlich, kosperlich, wunderplich oder auf das allerschönest geziert, auf das allerzierlichist berait."

97. Musper, *Teuerdank*, fo. 5. Also quoted by Jan-Dirk Müller, *Gedechtnus*, 111–12n7–8.

98. Franz Unterkircher, ed., *Ambraser Heldenbuch*, facsimile ed. (Graz, 1973); Vienna, 1959, 32–33, no. 97; Innsbruck, 1969, 107–8, no. 305. Also Martin Wierschin, "Das Ambraser Heldenbuch Maximilians I," *Der Schlern* 50 (1976), 429–42, 493–97, 557–70.

99. Elaine Tennant, *The Habsburg Chancery Language in Perspective* (Berkeley, Calif., 1985), 165–74, featuring Marx Treitzsaurwein, 157–65.

100. "Aus angeborner art zue den gar alten Historien und geschichten . . . genaigt." Quoted by Wierschin, "Ambraser Heldenbuch," 569, doc. 50.

101. Silver, "'Die Guten Alten Istory,'" 71–81. First documents in *JKSAK* 2, reg. 674–76. See also Walter Haug et al., *Runkelstein: Die Wandmalereien des Sommerhauses* (Wiesbaden, 1982). Kölderer was sent first in 1503 to assess the damage to the frescoes (reg. 721). The later documents for *Runkelstein* are nos. 734–37, 1216; also *JKSAK* 3, reg. 2615, 2751.

102. For the Nine Worthies, see Roger Loomis and Laura Loomis, *Arthurian Legends in Medieval Art*, 37–40; Robert

Wyss, "Die neun Helden," *Zeitschrift für Schweizerische Archäologie und Kunstgeschichte* 17 (1957), 73–106; Horst Schroeder, *Der Topos der Nine Worthies in Literatur und bildender Kunst* (Göttingen, 1971).

103. The classic study of the concept of enduring dignity of office, especially for sixteenth-century French royal tombs, remains Ernst Kantorowicz, *The King's Two Bodies* (Princeton, N.J., 1957), esp. 431–37. See also Erwin Panofsky, *Tomb Sculpture* (New York, 1964), 62–65, 76–81. On the phenomenon of the "disguised portrait" (*verkleideten Porträt*), see Florens Deuchler, "Maximilian und die Kaiserviten Suetons: Ein spätmittelalterliches Herrscherprofil in antiken und christlichen Spiegelungen," in Deuchler, ed., *Von Angesicht zu Angesicht: Porträtstudien, Michael Stettler zum 70. Geburtstag* (Bern, 1983), 129–49.

104. Ibid., 136–37; Vienna, 1959, 1330, no. 431, fig. 62. On the subject of a ruler as Hercules, see Gustav Bruck, "Habsburger als 'Herculier,'" *JKSW*, new series, 14 (1953), 191–98; William McDonald, "Maximilian I of Habsburg and the Veneration of Hercules: On the Revival of Myth and the German Renaissance," *Journal of Medieval and Renaissance Studies* 6 (1976), 139–54. See also Silver, "Forest Primeval," 19–20; Dieter Wuttke, *Die Histori Herculis des Nürnberger Humanisten* (Cologne, 1964).

105. Lhotsky, "Apis Colonna: Fabeln und Theorien über die Abkunft der Habsburger" in *Aufsätze und Vorträge* (Vienna, 1971), 2:69–70, 99; Vienna, National Library, cod. vind. palat. no. 10298.

106. This association was repeated by Bebel and others; see Borchardt, *German Antiquity*, 111–12; McDonald, "Maximilian I of Habsburg and the Veneration of Hercules," 144.

107. Karl Giehlow, "Dürers Entwürfe für das Triumphrelief Maximilians im Louvre: Eine Studie zur Entwicklungsgeschichte des Triumphzuges," *JKSAK* 29 (1910–11), 14–84; Eckert and Imhoff, *Willibald Pirckheimer*, 101–15, 173–77.

108. Karl Giehlow, "Die Hieroglyphenkunde des Humanismus in der Allegorie der Renaissance, besonders der Ehrenpforte des Kaisers Maximilian I," *JKSAK* 32 (1915), 1–229; George Boas, *The Hieroglyphics of Horapollo* (New York, 1950). The codex by Pirckheimer and Dürer is in Vienna, National Library, cod. 3255; Vienna, 1959, 61, no. 200. On the broader Renaissance use of such hieroglyphs, see Rudolf Wittkower, "Hieroglyphics in the Early Renaissance," in *Allegory and the Migration of Symbols* (London, 1977), 113–28.

109. Strauss, *Woodcuts*, 726; Erwin Panofsky, *The Life and Art of Albrecht Dürer* (Princeton, N.J., 1955), 177.

110. Panofsky, *Life and Art of Dürer*, 178–79; Hermann Haupt, "Renaissance-Hieroglyphik in Kaiser Maximilians Ehrenpforte," *Philobiblon* 12 (1968), 253–67.

111. Strauss, *Woodcuts*, 536–37, including the translation of Prickheimer's text extract, below.

112. Giehlow, "Dürers Entwürfe für Triumphrelief," 45–47, 78–79, docs. 5–6. For the Kulmbach drawing, see Strauss, *The Complete Drawings of Albrecht Dürer* (New York, 1974), p. 1805, no. 15 (hereafter cited as *Dürer Drawings*), with the Pirckheimer dedication: "Coronam hanc munitissimus Caesar plantavit, virtus rigavit, Devotus Billibaldus Pirckheimer dedicavit."

113. Panofsky, *Life and Art of Dürer*, 180.

114. Lester Born, "The Perfect Prince. A Study in 13th and 14th Century Ideals," *Speculum* 3 (1928), 470–504; Wilhelm Berges, *Die Fürstenspiegel des hohen und späten Mittelalters* (Leipzig, 1938); see also the general discussion, involving a Habsburg ancestor, Rudolf I, in Erich Kleinschmidt, *Herrscherdarstellung* (Bern, 1974). A related literary advice text in France, also utilizing the motif of the four cardinal virtues, is an epistolary allegory; see Sandra Hindman, *Christine de Pizan's "Epistre Othea"* (Toronto, 1986); for England and more general issues, see Judith Ferster, *Fictions of Advice: The Literature and Politics of Counsel in Late Medieval England* (Philadelphia, 1996).

115. Giehlow, "Dürers Entwürfe für Triumphrelief," 78, doc. 5.

116. Letter to Stabius, 5 June 1517. Giehlow, "Dürers Entwürfe für Triumphrelief," no. 4; Schauerte, *Ehrenpforte*, 417–18, no. Q38. Translated by Strauss, *Woodcuts*, 500.

117. The Strigel claim is made in his signature on the portrait of Cuspinian (coll. Count Wilczek): "Caesar Designaretur Bernardi/nus Strigil. Pictor. Civis Memingen Nobilis Quit Solus/ Edicto Caesare Maximilianu. Ut Olim Apelles Alexan/drum Pingere Iussus Has Imagines Manu Sinistra Per/ Specula Ferme Sexagenarius Viennae Pingebat." See Innsbruck, 1969, 96, no. 363; Gertrud Otto, *Bernhard Strigel* (Munich, 1964), 48, 74, cat. no. 77. On Dürer's portraits of Maximilian, see Nuremberg, 1971, 139–41, nos. 258–59; Vinzenz Oberhammer, "Die vier Bildnisse Kaiser Maximilians I von Albrecht Dürer," *Alte und Moderne Kunst* 14 (1969), 2–14; Larry Silver, "Prints for a Prince: Maximilian, Nuremberg, and the Woodcut," in Jeffrey Chipps Smith, ed., *New Perspectives on the Art of Renaissance Nuremberg* (Austin, Tex., 1985), 8–11; Katherine Crawford Luber, "Albrecht Dürer's

Maximilian Portraits: An Investigation of Versions," *Master Drawings* 29 (1991), 30–47. See also Anja Eisenbeiss, "Einprägsamkeit ein gros: Die Porträts Kaiser Maximilians I; Ein Herrscherbild gewinnt Gestalt" (Ph.D. diss., University of Heidelberg, 2005).

118. Nuremberg, 1971, 150, no. 267; Stephen Scher, *The Currency of Fame: Portrait Medals of the Renaissance*, exh. cat. (New York, 1994), 203–4, no. 77.

119. Winzinger, *Gemälde*, 9, 49–54; Winzinger, *Albrecht Altdorfer Graphik* (Munich, 1973), 22–27; Mielke, *Albrecht Altdorfer*, 68–83, 163–68, 180–95, nos. 30, 78, 89–91.

120. Diane Strickland, "Maximilian as Patron: The 'Prayerbook'" (Ph.D. diss., University of Iowa, 1980), 64–70, quoting Giehlow, *Prayerbook*, 71–75. See the reprint of the letter in translation in Strauss, *Prayerbook*, 325.

121. Quoted by Elisabeth Geck, in Musper, *Teuerdank*, 1968, 23: "Die mittelmassigen Künstler, weil sie beim Malen und bilden seinen Vorschriften gehorchten."

122. On the general sociology of learned advisers for Maximilian, see the excellent overview by Müller, *Gedechtnus*, 43–79.

123. König, *Peutingerstudien*; also Clemens Bauer, "Conrad Peutinger und der Durchbruch des neuen ökonomischen Denkens in der Wende zur Neuzeit," in Hermann Rinn, ed., *Augusta 955–1955* (Munich, 1955), 219–28.

124. 117. Vienna, 1959, 138–40, nos. 444–47; Nuremberg, 1971, 171–75, nos. 307–12, 315; Wiesflecker, *Kaiser Maximilian I*, 5:332–33; Eduard Weiss, "Albrecht Dürers geographische astronomische, und astrologische Tafeln," *JKSAK* 7 (1888), 208–13.

125. Wiesflecker, *Kaiser Maximilian I*, 5:410–500; Garrett Mattingly, *Renaissance Diplomacy* (Boston, 1955).

126. Peter Diedrichs, *Kaiser Maximilian als politischer Publizist* (Jena, 1933); Georg Wagner, "Maximilian I und die politische Propaganda," in Innsbruck, 1969, 33–46. See also William McDonald, *German Medieval Literary Patronage* (Amsterdam, 1973).

127. Jan-Dirk Müller, *Gedechtnus*, 80–95, 180–210.

128. Wiesflecker, *Kaiser Maximilian I*, 5:318–20; Gottlieb, *Ambraser Handschriften*, 61; Rupprich, "Das literarische Werk Kaiser Maximilians I," in Innsbruck, 1969, 48–49.

129. *Weisskunig*, 1956, 226–27.

130. Jan-Dirk Müller, *Gedechtnus*, 65–73, esp. 71–72. See also Hermann Wiesflecker, "Joseph Grünpecks Redaktionen . . . ," *MIÖG* 78 (1970), 416–30.

131. Laschitzer, *Theuerdank*, 68; Otto Burger, *Beiträge zur Kenntnis des Teuerdanks* (Strasbourg, 1901); Josef Strobl, *Kaiser Maximilians I: Anteil am Teuerdank* (Innsbruck, 1907); Heinz Engels, "Der Theuerdank als autobiographische Dichtung," in Musper, *Teuerdank*, 5–12; Müller, *Gedechtnus*, 68–72, 159–69.

132. Otto Kostenzer, "Medizin um 1500," in Innsbruck, 1969, 56–64, nos. 344–60; Wiesflecker, *Kaiser Maximilian I*, 5:337–39. This interest finds expression in the *Teuerdank* scenes (chapters 67, 70) recounting recovery from mortal diseases or life-threatening poisons.

133. Stuttgart, 1973, no. 193, fig. 158. On Lucas Cranach and the Saxon court, see Dieter Koepplin and Tilman Falk, *Lukas Cranach*, 1:185–252. Note also the importance of Kölderer's landscapes in the miniatures for Maximilian's hunting and fishing books.

134. Benesch and Auer, *Historia Friderici et Maximiliani*, 124–25, nos. 33–38. When the pastimes of Frederick III are illustrated, at no. 9 (*De eius dactilothecis aliisque exercitiis*), these interests are accurately depicted as the collection and appraisal of jewels and imperial regalia.

135. Jan-Dirk Müller, *Gedechtnus*, 144–46, 238–46, 277–80.

136. Ibid., 79, 152–90, 246–50; see also his discussion of *lernung* in *Weisskunig*, 144–45, 241–46.

137. *Weisskunig*, 1956, 328.

138. Ibid., 1956, 340.

139. For arguments concerning the importance of virtue even over lineage, see Maurice Keen, "The Idea of Nobility," in *Chivalry* (New Haven, Conn., 1984), 156–61. Closer to Maximilian's world, see Charity Cannon Willard, "The Concept of True Nobility at the Burgundian Court," *Studies in the Renaissance* 14 (1967), 33–49.

140. A comparable, if condensed, single illustration in the *Historia* makes the same point (no. 39, fo. 74v, *De eius excellentissima memoria varietateque sermonis et eloquentia*); Benesch and Auer, *Historia Friderici et Maximiliani*, 125–26, It is succeeded by an image (no. 40) of the approachable monarch, who receives petitions from his subjects; ibid., 126, fo. 76r, *De eieus affabilitate, humanitate et erga omnes libera audientia*.

141. Ibid., 124, no. 32 (*De cultu et dilectione suorum*); 126, no. 41 (*De eius patientia ineffabile et prope divina*); 126, no. 40 (*De eius affabilitate, humanitate et erga omnes libera audientia*).

142. *Weisskunig*, 1956, 327.

143. Baldesar Castiglione, *The book of the Courtier*, trans. Charles S. Singleton (New York, 1959), bk. 1, pp. 14–15. Subsequent references to book and page numbers are made in the text.

144. See the traditional *topos* of *fortitudo* and *sapientia*, of arms and studies, in Ernst Robert Curtius, *European Literature*

and the Latin Middle Ages, trans. Willard Trask (New York, 1953), 173–82; also Jan-Dirk Müller, *Gedechtnus,* 144.

2 | Family Ties: Genealogy as Ideology for Emperor Maximilian I

1. Benesch and Auer, *Historia Friderici et Maximiliani,* see plate 1. Also Vienna, 1959, 115–17, no. 378. The reattribution of the drawings, assigning them to the young Albrecht Altdorfer instead of the anonymous *Historia* Master, was made by Hans Mielke, *Albrecht Altdorfer,* 68–83, no. 30.

2. Arthur Watson, *The Early History of the Tree of Jesse* (Oxford, 1934).

3. A third line, the Albertine, was extinguished with the death of King Ladislaus Postumus of Hungary in 1457. These two Austrian lines were consolidated in the person of Maximilian with the death in 1496 of Archduke Sigmund "the Wealthy" *(Münzreich)* in Innsbruck, which then came into the direct possession of Maximilian as a territory.

4. On the several crowns, Earl Rosenthal, "Die 'Reichskrone,' die 'Wiener Krone,' und die 'Krone Karls des Grossen' um 1520," *JKSW* 66 (1970), 7–48; Hermann Fillitz, *Die Insignien und Kleinodien des Heiligen Römischen Reiches* (Vienna, [1954]), esp. 15–21. This crown was believed to have been created for the coronation of Emperor Otto I. Frederick III wears this crown in all of the illustrations to the *Historia.*

5. Lhotsky, "Apis Colonna," 2:7–102.

6. Benesch and Auer, *Historia Friderici et Maximiliani,* 25; Ilgen, *Geschichte Frederichs III und Maximilians I,* 8–9; J. Chmel, *Die Handschriften der k.k. Hofbibliothek im Wein im Interesse der Geschichte* (Vienna, 1840), 67.

7. Benesch and Auer, *Historia Friderici et Maximiliani,* 29; Mielke, *Albrecht Altdorfer,* 68–72, no. 30.

8. From MS C of *Weisskunig* (Vienna, National Library, 2834), fo. 127v. Quoted from Schultz, *JKSAK,* xvi. Also quoted by Benesch and Auer, *Historie Friderici et Maximiliani,* 29: "und damit ich anfang meines puechs am erkerung zu machen, so hat ich zu der geschrift gestelt figuren, gemalt, damit das der leser mit mund und augen mag versten den grund dises gemelds meines puechs, welchen grund ich gestellt hab, gleichermassen die croniken geschriben und figurirt werden, wie ich dann solches aus andern meinen vordern cronikisten gesehen hab."

9. Simon Laschitzer, "Die Genealogie des Kaisers Maximilian I," *JKSAK* 7 (1888), 1–200. Stuttgart, 1973, nos. 150–66.

10. Herberger, *Conrad Peutinger;* König; *Peutingerstudien;* Horn, "Doctor Conrad Peutingers Bezeihungen"; Wiesflecker, *Kaiser Maximilian I,* vol. 5.

11. Christopher Wood, "Early Archeology and the Book Trade: The Case of Peutinger's *Romanae vetustatis fragmenta* (1505)," *Journal of Medieval and Early Modern Studies* 28 (1998): 83–118.

12. Horn, "Doctor Conrad Peutingers Beziehungen," 35n5. Cuneo, *Art and Politics in Early Modern Germany,* 102–19.

13. Carl Wehmer, "*Ne Italo cedere videamur.* Augsburger Buchdrucker und Schreiber um 1500," in Hermann Rinn, ed. *Augusta 955–1955* (Augsburg, 1955), 145–72. On Burgkmair and Ratdolt, see Falk, *Hans Burgkmair,* 13–18; Paul Geissler, "Erhard Ratdolt," *Lebensbilder aus dem Bayerischen Schwaben* (Munich, 1966), 97ff. Geissler in Stuttgart, 1973, no. 131, recognizes the antiqua font of Ratdolt in the labels of the *Genealogy;* Landau and Parshall, *Renaissance Print,* 177, 180, 184.

14. Silver, "Shining Armor"; Falk, *Hans Burgkmair,* 45–52, 69–86; Landau and Parshall, *Renaissance Print,* 184–91.

15. Falk, *Hans Burgkmair,* 116, doc. 43.

16. H[ildegard] Zimmermann, "Hans Burgkmairs d.Ä. Holzschnittfolge zur Genealogie Kaiser Maximilians I," *Jahrbuch der preussischen Kunstsammlungen* 36 (1915), 40–41, fig. 1.

17. Reg. 5788; 14 October 1512. Quoted by Laschitzer, "Genealogie," 43; Schauerte, *Ehrenpforte,* 411–12, no. Q20.

18. Theodor Frimmel, "Ergänzungen zu Burgkmair's Genealogie des Kaisers Maximilian I," *JKSAK* 10 (1889), 325–52. The emperor's copy, used as the basis for the catalogue by Laschitzer, is Vienna, National Library, cod. 8018.

19. Stuttgart, 1973; Zimmermann, "Hans Burgkmairs d.Ä. Holzschnittfolge," 44–45, fig. 4; Laschitzer, "Genealogie," 43–44.

20. Christopher Wood, "Maximilian I as Archeologist," *Renaissance Quarterly* 57 (2005), 1128–74, esp. 1152–54; see also Peter Hutter, *Germanische Stammväter und römischdeutsches Kaisertum* (Hildesheim, 2000).

21. Paul Geissler, "Hans Burgkmairs Genealogie Kaiser Maximilians I: Zu diesem Augsburger Fund," *Gutenberg Jahrbuch,* 1965, 249–61. Also Stuttgart, 1973, nos. 150–66.

22. Stuttgart, 1973, nos. 163–66. Zimmermann, "Hans Burgkmairs d.Ä. Holzschnittfolge," 56–59, also points out that several woodcuts were edited out or shuffled into a new order in the process of correction, so that the order varies in extant ensembles in Munich, Augsburg, and Wolfenbüttel.

23. On Mennel, see Alphons Lhotsky, "Dr. Jacob Mennel: Ein Vorarlberger in Kreise Maximilians I," in *Aufsätze und Vorträge*, 2:289–311.

24. Vienna, 1959, 55–57, nos. 177, 183–88.

25. Vienna, National Library, cod. 3077, fo. 494, "Beschluss-red." Quoted by Laschitzer, *JKSAK* 4, 75n1: "so ic uss den buechern sonder auch, was ich von den buochsta-ben unnd figuren der alt unnd newen gaistlich unnd weltlichen stifften unnd schrifften als von den sarchen in den kirchen kirchmauren grabstainen auch seelbuecher unnd stifftbuecher dessbleichen von den alten porten unnd thürnen auch altten briefen und siegeln und andern anzaigungen genomen, hierinn gesetzt hab."

26. Marie Tanner, *The Last Descendants of Aeneas: The Habsburgs and the Mythic Image of the Emperor* (New Haven, Conn., 1993), esp. 103, noting 278n135, that a fifteenth-century tract by Heinrich von Klingenberg, bishop of Konstanz, first asserted the link between the Trojans and the Habsburgs; see also Peter Albert, "Die habsburgische Chronik des Konstanzer Bischofs Heinrich von Klingenberg," *Zeitschrift für Geschichte des Oberrheines*, n.s. 20 (1905).

27. Laschitzer, "Genealogy," 16–17, 31–39, traces the succes-sive incarnations of the genealogy.

28. On Trithemius, see Laschitzer, "Genealogie," 17–20; Klaus Arnold, *Johannes Trithemius* (Würzburg, 1973). The spurious German history of Trithemius is discussed along with other myths of national origins by Borchardt, *German Antiquity*, 127–35.

29. Laschitzer, "Genealogie," 20–27.

30. On German historiography during this period, see Paul Joachimsen, *Geschichtsauffassung und Geschichtsschreibung in Deutschland*. On the general issue of the new Renais-sance sense of history, especially for France, see Donald Kelley, *Foundations of Modern Historical Scholarship* (New York, 1970); and for England, Arthur Fergusson, *Clio Unbound* (Durham, N.C., 1979), esp. "Antiquities and the History of Society," 78–125.

31. *Weisskunig*, 1956, chapter 24: "und als er zu seinen jarn kam, sparet er kainen kosten, sonder er schicket aus gelert leut, die nichts anders teten, dann das sy sich in allen stiften, klostern, puechern und bey gelerten leutn erkundigeten alle geschlect der kunig und fursten, und liess solichs alles in schrift bringen, zu er und lob denen kuniglichn und furstlichn geschlechten."

32. Tanner, *Last Descendants of Aeneas*, 107; Coreth, "Dynastisch-politische Ideen Kaiser Maximilians I," 81–105, esp. 88–89; Laschitzer, "Genealogie," 12–13, 34.

33. On the doctrine and practice of indulgences, see Richard Southern, *Western Society and the Church in the Middle Ages* (Harmondsworth, 1970), 136–43; Reinhold Seeberg, *Textbook of the History of Doctrines*, trans. C. E. Hay (Grand Rapids, Mich., 1964), 2:42–47; Bernhard Poschmann, *Der Ablass im Licht der Bussgeschichte* (Bonn, 1948); N. Paulus, *Geschichte des Ablasses im Mittelalter* (Paderborn, 1923); foundationally, Henry C. Lea, *A History of Auricular Confession and Indulgences in the Latin Church* (Philadelphia, 1896).

34. Vienna, 1959, 53–55, nos. 172–74; Benesch and Auer, *Historia Friderici et Maximiliani*, 102–4.

35. Laschitzer, "Heiligen," *JKSAK* 5 (1887), 159–71; Vienna, 1959, 117–18, nos. 380–84. On Beck, see Benesch and Auer, *Historia Friderici et Maxiiliani*, 98–101, Ernst Buch-ner, "Leonard Beck als Maler und Zeichner," in Buchner and Karl Feuchtmay, eds., *Beiträge zur Geschichte der deutschen Kunst II: Augsburger Kunst der Spätgotik und Re-naissance* (Augsburg 1928), 328–414. Beck also undertook major portions of the *Teuerdank* and *Weisskunig* cycles of woodcut illustrations. See also Guido Messling, *Der Augs-burger Maler und Zeichner und sin Umkreis* (Dresden, 2006).

36. Facsimile editions: Laschitzer, *JKSAK* 8; Musper, ed. (Stuttgart, 1968). For Beck's earlier activity as a manu-script illuminator, see Erich Steingräber, "Die Augs-burger Buchmalerei in ihrer Blütezeit," in Hermann Rinn, ed. *Augusta 955–1955* (Augsburg, 1955), 174–76.

37. According to Laschitzer, "Genealogie," 130–31, these common features of the three sketchbooks point to a lost common source, probably compiled by the Kölderer workshop.

38. Chmelarz, "Die Ehrenpforte des Kaisers Maximilian I," 289–319; Giehlow, "Urkundenexegese zur Ehrenpforte Maximilians I," 91–110; Silver, "Power of the Press," 45–62; Schauerte, *Die Ehrenpforte für Kaiser Maximilian I* is the most recent and thorough study.

39. Translation by Strauss, *Woodcuts*, 726–27. Bracketed mate-rial is my insertions.

40. Schauerte, *Ehrenpforte*, esp. 117–42; Peter Strieder, "Zur Entstehungsgeschichte von Dürers Ehrenpforte für Kai-ser Maximilian," 128–42; Giehlow, "Urkundenexegese zur Ehrenpforte Maximilians I," 91–110.

41. Translation in Strauss, *Woodcuts*, 729. The only discussion of the heraldic claims made by the *Arch* is by Schauerte, *Ehrenpforte*, 42–48, 132–37.

42. Translation by Strauss, *Woodcuts*, 728.

43. Most pertinent is the foundational study through the Spanish Habsburgs by Tanner, *The Last Descendants*

of Aeneas. See also A. M. Young, *Troy and Her Legends* (Pittsburgh, 1948). For France, see Amnon Linder, "Ex mala parentela bona sequi seu oriri non potest: The Trojan Ancestry of the Kings of France and the Opus Davidicum of Johannes Angelus de Legonissa," *Bibliotheque d'Humanisme et du Renaissance* 40 (1978), 497–511; George Huppert, "The Trojan Franks and Their Critics," *Studies in the Renaissance* 12 (1965), 227–41. For England, see Sydney Anglo, "The *British History* in Early Tudor Propaganda," *Bulletin of the John Rylands Library* 44 (1961), 17–48. For Germany, the essential survey is Frank Borchardt, *German Antiquity,* esp. 191: "Jordanes's Gothic history is the earliest extant construct of a German-Germanic empire prior to and parallel to the Roman Empire. The importance of this precedent is clear in the light of Renaissance imagination. We have repeatedly confronted German empires, without publicistic intent as with Gobelinus, and with emphatic publicistic intent as with Bebel, Köchlin, Celtis, and Trithemius. The basic patterns of Jordanes's construct (551 A.D.) appear in remarkably similar form in the Renaissance: that is, the antiquity of the origins, the bravery and learning of the heroic figures, the character of the ancient worship, the warlike valor of the people at large, all are summoned to support the German-Germanic nation's worthiness to be heir of the Roman *Imperium.* The antiquity may be Trojan, Macedonian, antediluvian, or of the progeny of Noah, the learning may come from the hands of law-givers or priestesses, the warlike valor may be directed against Rome or against other enemies—in any case the nation is made an equal of Rome."

44. For what follows, Lhotsky, "Apis Colonna," is fundamental, esp. 10–48. See also Anna Coreth, "Maximlian I politische Ideen im Spiegel der Kunst" (Ph.d. diss., University of Vienna, 1940), esp. 40–55. For the influence of Rudolfine family ancestry on the later researches of Mennel, see Kleinschmidt, *Herrscherdarstellung.*

45. Lhotsky, "Apis Colonna," 22–27, who cites similar legends linking other German families with Italy. The chief Habsburg redactor of this legend was Matthias von Neuenburg in the early fourteenth century.

46. Lhotsky, "Apis Colonna," 33–34. In a later redaction, ca. 1475, by Heinrich Gundelfinger, the family is identified as Pierleoni.

47. Cod. 3075, fo. 12v.

48. Coreth, "Maximilian I politische Ideen," 58–89, Lhotsky, "Apis Colonna," 48–68. Further for the links between

49. Tanner, *Last Descendants of Aeneas,* 89–90; Coreth, "Maximilian I politische Ideen," 79–89; Borchardt, *German Antiquity,* 230–44, surveys this encyclopedic tradition of royal history writing.

50. Cod. 3072★, fo. 21, 31ff. Tanner, *Last Descendants of Aeneas,* 70–76, 87–90; Coreth, "Dynastisch-politische Ideen Kaiser Maximilians I," 81–105.

51. Lhotsky, "Apis Colonna," 55–56; Coreth, "Maximilian I politische Ideen," 85–86; Tanner, *Last Descendants of Aeneas,* 91–98.

52. Tanner, *Last Descendants of Aeneas,* 91–98; Vlasta Dvořakova, ed., *Gothic Mural Painting in Bohemia and Moravia* (London, 1964), 53–56; Jozef Neuwirth, in "Der Bildercyclus des Luxemburger Stammbaumes aus Karlstein," in *Forschungen zur Kunstgeschichte Böhmens II* (Prague, 1897). Through the Brabant connection, the genealogy of Charles IV also passed into the library of the dukes of Burgundy, in the history prepared by Edmond de Dynter for Philip the Good in 1445.

53. For this general development, see Borchardt, *German Antiquity*; Gerald Strauss, *Sixteenth-Century Germany*; Ulrich Paul, *Studien zur Geschichte*; Hans Tiedemann, *Tacitus und das Nationalbewusstsein der deutschen Humanisten.*

54. *Zaiger,* cod. 7892, fo. E, F, G.

55. Cod. 3074 ; quoted in Coreth, "Maximilian I politische Ideen," 73.

56. Borchardt, *German Antiquity,* 54, 67, 120. On Wimpheling, see ibid., 98–103, and the general account in Charles Schmidt, *Histoire litteraire de l'Alsace à la fin du XVe et au commencement du XVIe siècle,* I (Paris, 1879). In his general zeal, however, to prove the Germanness of the empire throughout history, Wimpheling sets out to prove that Charlemagne himself was German; thus, he claims Charlemagne as an ancestor of Maximilian: "Maximilianus ex ea domo ac familia genitus est, de qua Caroli Magni stirps propagata fuit." (*Epitoma Germanicarum rerum,* chap. 9, 1505), quoted by Lhotsky, "Apis Colonna," 67n199.

57. Cod. 3072★, fo. 38. The great-grandson of Clovis, Theodopertus, was king of Burgundy. His younger son, Odopertus, is claimed as count of Habsburg. In the *Genealogy,* Provence rather than Burgundy is claimed (cod. 8018), but the younger son, Ottopertus, is still claimed as count of Habsburg (*comitatus Avenspurgensis*). In the *Zaiger,* fos. H, J, Mennel asserts that Odopertus, first German count of Habsburg, built the ancestral

fortress on a crag near the Rhine in Alsace and called it "Habensburg."

58. Lhotsky, "Apis Colonna," 68–75, with tables of the Luxemburg genealogy and the 1518 Stabius genealogy on 98–99; Coreth, "Maximilian I politische Ideen," 89–92.

59. Tanner, *Last Descendants of Aeneas*, 93–98, figs. 43–54; on Pseudo-Berosus, an alleged Babylonian historian, as a source for the Noah descent, see ibid., 87–89; Borchardt, *German Antiquity*, 89–91; also Don Cameron Allen, *The Legend of Noah* (Urbana, Ill., 1949).

60. Cod. 10298; Lhotsky, "Dr. Jacob Mennel," 308n54.

61. Japhet was the son of Noah generally held to be the forefather of Europe; Denis Hay, *Europe: Emergence of an Idea* (New York, 1966). See the world map in the *Nuremberg Chronicle*, 1493, fo. 13. Maximilian was vexed at being associated with Ham and the Africans by Stabius rather than with Europe; Lhotsky, "Apis Colonna," 69n209.

62. Giehlow, "Die Hieroglyphenkunde," 1–32; Frances Yates, *Giordano Bruno and the Hermetic Tradition* (London, 1956). Osiris was also fused with the Italian ancestor, Apis, claimed for a time by Maximilian; Lhotsky, "Apis Colonna," 71–73.

63. On the woodcut, see Vienna, 1959, 133, no. 431, fig. 62. Deuchler, "Maximilian und die Kaiserviten Suetons," 129–49. On Hercules in the Renaissance, see Erwin Panofsky, *Hercules am Scheidewege* (Leipzig, 1930); Janet Cox-Rearick, *Dynasty and Destiny in Medici Art: Pontormo, Leo X, and the Two Cosimos* (Princeton, N.J., 1984), 143–52; L. D. Ettlinger, "Hercules Florentinus," *Mitteilungen des Kunsthistorischen Institutes in Florenz* 22 (1972), 119–42; M.-R. Jung, *Hercule dans la Litterature française du XVIe siècle* (Geneva, 1966); Jonathan Brown and J. R. Elliott, *A Palace for a Prince: The Buen Retiro and the Court of Philip IV* (New Haven, Conn., 1980).

64. Laschitzer, "Heiligen," *JKSAK* 5, 208, no. 94. On Karlstein's cycle of Wenceslaus and Ludmilla, see Dvořakova, *Gothic Mural Painting*, 60–61, Tanner, *Last Descendants of Aeneas*, 97–98.

65. Laschitzer, "Heiligen," *JKSAK* 5, 205, no. 83; Floridus Röhrig, "Die Heiligspreschung Markgraf Leopolds III," in *Friedrich III*, exh. cat. (Wiener Neustadt, 1966), 226–30, 365–68; Röhrig, *Der heilige Leopold*, exh. cat. (Klosterneuburg, 1985). Suntheim wrote a history of the Babenbergs for Stift Klosterneuburg in 1491.

66. Strauss, *Woodcuts*, 496, no. 174; Nuremberg, 1971, no. 358; Dürer print catalogue, B. 116.

67. Wiesflecker, *Kaiser Maximilian I*, 3:332.

68. Schauerte, *Ehrenpforte*, 120, 122, 140–41, 153–54, 329.

69. Cod. 3305. Giehlow, *Kaiser Maximilians I Gebetbuch*, 46; Laschitzer, "Heiligen," *JKSAK* 5, 220–21. See also chapter 4 on the relationship of this calendar to the Order of St. George and Maximilian's devotions in general.

70. Quoted by Laschitzer, "Heiligen," *JKSAK* 5, 221n2. My translation.

71. This theory rests on the papal theory of indulgences, namely that Christ's sacrifice and the subsequent holy actions of His saints provides a spiritual treasury available for use by the living with the consent of the papacy as its executor. The basic work on the origins and developments of the system of indulgences remains Paulus, *Geschichte des Ablasses im Mittelalter*. After initial reservation of the privilege of indulgences to papal pronouncements and the confinement of the power to special occasions, such as the crusades, they then became the prerogative of individual confessors at a deathbed as well as a reward for pilgrims to the churches of the holy apostles in Rome during a jubilee year (begun in 1300). See above, no. 33.

72. Translation by Strauss, *Woodcuts*, 730.

73. For the Wittenberg *Heiltumbuch*, illustrated with woodcuts by Lucas Cranach, the court artist of Frederick the Wise, see Koepplin and Falk, *Lukas Cranach*, 1:185–90, 218–20, nos. 95–100. On the Halle *Heiltumbuch*, see Philip M. Halm and Rudolf Berliner, *Das Hallesche Heiltum* (Berlin, 1931); see also the more general studies by Gabriel von Terey, *Cardinal Albrecht von Brandenburg und das Halle'sche Heiligthumsbuch von 1520* (Strasbourg, 1892); Edgar Wind, "An Allegorical Portrait by Grünewald," *Journal of the Warburg Institute* 1 (1937), 142–62, reprinted in Wind, *The Eloquence of Symbols* (Oxford, 1983), 58–76. For the *Heiltumbuch* of Hall in Tyrol, with woodcuts made by Burgkmair, see Falk, *Hans Burgkmair*, 63–64; Innsbruck, 1969, 85–86, nos. 322–25; Stuttgart, 1973, no. 37. Ashley West examines this Burgkmair project, "Material Remains and Documented Sanctity: Living Saints and Relics," within her dissertation, West, "Hans Burgkmair the Elder (1473–1531)" and the Visualization of Knowledge," (Ph.D. diss., University of Pennsylvania, 2006). Because of the death of the patron of Hall in Tyrol, Florian von Waldauf, in 1510, Burgkmair's *Heiltumbuch* was never published, but a proof set of his woodcuts survives in the Hall parish archive, first published by Josef Garber, "Das Haller Heiltumbuch mit den Unika-Holzschnitten Hans Burgkmairs d. A.," *JKSAK* 32 (1915), 1–177. For the biography of Florian von Waldauf, see Wiesflecker, *Kaiser Maximilian I*, 5:244–47.

74. Karl Hauck, "Geblütsheiligkeit," in *Liber Floridus: Mittellateinische Studien Festschrift Paul Lehmann* (St. Ottilien, 1950), 187–240. Also, Robert Folz, "Zur Frage der heilige Könige: Heiligkeit und Nachleben in der Geschichte des burgundischen Königtums," *Deutsches Archiv für Erforschung des Mittelalters* 14 (1958), 317–44. Hauck, "Geblütsheiligkeit," 194, cites a letter from Bishop Antus to Clovis assuring the ruler that his conversion to Christianity begins a new family history that will adorn and bless all his subsequent noble issue.

75. On Charlemagne as saint, see Matthias Zender, "Die Verehrung des hl. Karl im Gebiet des mittelalterlichen Reiches," in Wolfgang Braunfels and Percy Ernst Schramm, eds., *Karl der Grosse IV: Das Nachleben* (Dusseldorf, 1967), 100–112; also Robert Folz, "Aspects du culte liturgique de Saint Charlemagne en France," in ibid., 77–99; Dietrich Kötzsche, "Darstellungen Karls des Grossen in der lokalen Verehrung des Mittelalters," in ibid., 157–214; Folz, *Le souvenir et la legende de Charlemagne*.

76. In particular, see Marc Bloch, *The Royal Touch*, trans. J. E. Anderson (New York, 1989; orig. ed. 1961).

77. Northrop Frye, "History and Myth in the Bible," in Angus Fletcher, ed., *The Literature of Fact* (New York, 1976), 1–9. Beryl Smalley, *The Bible in the Middle Ages* (London, 1952). On the secular organization of chronicles by means of genealogy, see Gabrielle Spiegel, "Genealogy: Form and Function in Medieval Historical Narrative," *History and Theory* 22 (1983), 43–53; more generally, R. Howard Bloch, *Etymologies and Genealogies* (Chicago, 1983), esp. 30–91.

78. Watson, *Early History of the Tree of Jesse*, 37–46, on trees and genealogy; 47, 129, on Boaz as the root of Christ's genealogy (as per Maximilian's miniature of the *linea Hebrorum*).

79. Robert Alter, *The Art of Biblical Narrative* (New York, 1981), 42–46, 96, 180; on the general question of providence working itself out through history, see M.-D. Chenu, "Theology and the New Awareness of History," in Jerome Taylor and Lester Little, eds., and trans., *Nature, Man, and Society in the Twelfth Century* (Chicago, 1968), esp. 165–77.

80. Paul Joachimsen, *Geschichtsauffassung und Geschichtsschreibung in Deutschland*, 87–91; Borchardt, *German Antiquity*, 84–86. On the production of the Nuremberg Chronicle, see Adrian Wilson, *The Making of the Nuremberg Chronicle* (Amsterdam, 1976).

81. On genealogical symbolism of the tree, see Gerhard Ladner, "Medieval and Modern Understanding of Symbolism: A Comparison," *Speculum* 54 (1979), 223–56; reprinted in Ladner, *Images and Ideas in the Middle Ages: Selected Studies in History and Art* (Rome, 1983), 239–82; on consanguinity in particular, 263ff.

82. Georges Duby, *Chivalrous Society* (Berkeley, Calif., 1977), 135–57; Leopold Genicot, *Les Genealogies* (Turnhout, 1975); R. Howard Bloch, "Kinship," in *Etymologies and Genealogies* 64–87; Constance Brittain Bouchard, *Those of My Blood: Constructing Noble Families in Medieval France* (Philadelphia, 2001), esp. 39–58 on consanguinity.

83. Frances Yates, "Charles V and the Idea of Empire," in *Astraea* (Harmondsworth, 1977), 1–28.

84. David Schneider, *American Kinship: A Cultural Account* (Englewood Cliffs, N.J., 1968), esp. 23–29, 67–69.

85. Hermann Wiesflecker, "Neue Beiträge zur Frage des Kaiser-Papstplanes Maximilians I im Jahre 1511," *MIÖG* 71 (1963), 311–32. Wiesflecker, *Kaiser Maximilian I*, 4:90–93, 532n17 for literature.

86. Quoted by Laschitzer, "Heiligen," *JKSAK* 4, 75–76n2; and Hauck, "Geblütsheiligkeit," 219. My translation.

87. For these kinship term definitions, see George Peter Murdock, *Social Structure* (New York, 1949).

88. For this section, I have benefited greatly from the ideas of Shelley Errington, especially from her unpublished manuscript, "Incestuous Twins and the House Societies of Southeast Asia," for sharing which I am most grateful to her. See also her *Meaning and Power in a Southeast Asian Realm* (Princeton, N.J., 1989); Claude Levi-Strauss, *The Way of the Masks*, trans. Sylvia Modelski (Seattle, 1982), esp. 174–84, for the concept of the "house," an apt analogy to the Habsburg self-definition.

89. Eventually, the split of the Habsburg descendants into an Iberian and an Austrian branch forced a shift from this exogamy toward restrictive endogamy in order to consolidate the vast family patrimony within a tight family circle. This marriage between cousins led to unhappy genetic consequences, most conspicuously the infamous Habsburg jaw, as well as the political split between the regions.

90. David Schönherr, "Geschichte des Grabmals Kaiser Maximilian I und der Hofkirche zu Innsbruck," *JKSAK* 9 (1890), 140–268, reprinted in Schönherr, *Gesammelte Schriften*, Vol. 1 (Innsbruck, 1900), 149–364; Vincenz Oberhammer, *Die Bronzestandbilder des Maximiliangrabmales in der Hofkirche zu Innsbruck* (Innsbruck, 1935); Oettinger, *Die Bildhauer Maximilians am Innsbruck Kaisergrabmal*; Egg, *Die Hofkirche in Innsbruck*; Elisabeth Scheicher, *Das Grabmal Kaiser Maximilians I in der Innsbrucker Hofkirche*

(Vienna, 1986); Jeffrey Chipps Smith, *German Sculpture of the Later Renaissance c. 1520–1580* (Princeton, N.J., 1994), 185–92.

91. Translation by Strauss, *Woodcuts*, 730.

92. *Ruhm und Sinnlichkeit: Innsbrucker Bronzeguss 1500–1650 von Kaiser Maximilian I bis Erzherzog Ferdinand Karl*, exh. cat. (Innsbruck, 1996), 124–97; Elisabeth Scheicher, "Kaiser Maximilian plant sein Grabmal," *JKSW* 93 (1999), 81–118.

93. On the text as well as the cycle as a whole, see Schestag, "Kaiser Maximilian I: Triumph"; Stuttgart, 1973, nos. 204–19. The translations used here are drawn from Stanley Appelbaum, ed., *The Triumph of Maximilian I* (New York, 1964), 14–15.

94. Burgkmair had produced a woodcut cycle of the "Nine Worthies," complemented by a corresponding cycle of female worthies (ca. 1516–19); Stuttgart, 1973, nos. 106–11. On the cycle in general, see Robert L. Wyss, "Die neun Helden," 73–106; Horst Schroeder, *Der Topos der Nine Worthies in Literatur und bildender Kunst* (Göttingen, 1971).

95. Winzinger, *Gemälde*, 49–54, 107–19, esp. nos. 69–73. See also the facsimile volume by Winzinger, *Die Miniaturen zum Triumphzug Kaiser Maximilians I*; and for the dating, Winzinger, "Albrecht Altdorfer und die Miniaturen des Triumphzuges Kaiser Maximilians I," 157–72. Also Mielke, *Albrecht Altdorfer*, 180–87, no. 89.

96. Winzinger, *Gemälde*, 116, offers the hypothesis that this anonymous princess might have been labeled with the name of a third wife of Maximilian, in the event that he had remarried.

97. Court artist Jörg Kölderer and bronze caster Stefan Godl of Nuremberg drew up the inventory, reprinted as *JKSAK* 3, reg. 3011. Cited by Oberhammer, *Bronzestandbilder*, 14–15. The full list of figures comprises the following: Julius Caesar; Theoderic; Arthur; Clovis; Charlemagne; Theobert; Robert (Ottobert); Haug the Great; Radepot; St. Stephen and his wife, Gisela; Godfrey of Bouillon; St. Leopold; Ottakar; Count Albrecht IV; Rudolf I; Albrecht I and his wife, Elisabeth; Albrecht II and his wife, Elisabeth, and their son, Ladislaus Postumus; Leopold III and his wife, Virida; Frederick the Penniless; Sigmund the Wealthy; Ernst the Iron and his wife, Zimburgis of Masovia; Frederick III and his wife, Eleonore of Portugal; Ferdinand (Johann) of Portugal; Mary of Burgundy; Charles the Rash; Philip the Good; Bianca Maria Sforza; Kunigunde; Margaret of Austria; Philip the Fair; Joanna of Castile; Ferdinand of Castile.

98. Oberhammer, *Bronzestandbilder*, 163–207; Vienna, 1959, 64, no. 209; Wilfried Seipel, *Werke für die Ewigkeit: Kaiser Maximilian I und Erzherzog Ferdinand II*, exh. cat. (Vienna, 2002), 131–32, no. 56, which dates the Vienna roll earlier (ca. 1512–13) and posits that it was drawn up as a model for Altdorfer's miniatures; however, the roll offers carefully colored heraldry and attention to costume, and its correspondence with Altdorfer's ancestors is even less close than the discrepancies pointed out with the actual cast bronzes of the tomb.

99. Oberhammer, *Bronzestandbilder*, 85–96, 155–207, 245–320; Egg, *Hofkirche*, 18–31.

100. Innsbruck, 1969, 163–64, nos. 601, 605, fig. 134; Egg, *Hofkirche*, 18, fig. 2; Seipel, *Werke für die Ewigkeit*, 142–43, no. 66. The canvas is a replica in original size.

101. Oberhammer, *Bronzestanbilder*, 267; Egg, *Hofkircher*, 18, citing *JKSAK* 5, reg. 4021, a Maximilian memorandum.

102. Oberhammer, *Bronzestandlbilder*, 288; Egg, *Hofkirche*, 18. Both authors cite the 1510 memo paying "Hans Maler von Schwaz, 15 gulden, for two portraits, on which Mary of Burgundy is painted" (*JKSAK* 2, reg. 997).

103. These technical sequences are developed from the complaints of Löffler to Maximilian, *JKSAK* 2, reg. 949. Oberhammer, *Bronzestandbilder*, 140–41; Oettinger, *Bildhauer*, 13–17.

104. Oberhammer, *Bronzestandbilder*, 179, 319n21.

105. Ibid., 395–98, 540; Oettinger, *Bildhauer*, 4, 25–31; Egg, *Hofkirche*, 19, 25; Innsbruck, 1969, 163, no. 603; Seipel, *Werke für die Ewigkeit*, 128–30, no. 54.

106. Seipel, *Werke für die Ewigkeit*, 130–31, no. 55; Koreny, "Ottoprecht Fürscht," 127–48; Wood, "Maximilian I as Archeologist," 1160–65, discussing the complex armor and its relationship to contemporary knowledge of ancient Roman models, particularly in light of the added inscription at the top of the Berlin drawing in Dürer's own hand: "this image was found in Celia [Cilli] carved in a stone in the year 1516."

107. Oberhammer, *Bronzestandbilder*, 129–33, 533; Oettinger, *Bildhauer*, 22; Egg, *Hofkirche*, 32; Nuremberg, 1971, 382, no. 707. Because the Nuremberg town council demanded in 1514 that the Vischer workshop complete its large bronze tomb of St. Sebald (1519), no further work on the Maximilian tomb was possible from this source. The Dürer *Visierung* for a fourth figure, never executed by the Vischers, is believed to have been a *Charlemagne*.

108. Oettinger, *Bildhauer*, 31–38; Lottliesa Behling, "Zur Frage der Bildschnitzer in der Werkstatt Gilg Sesselschreibers vom Innsbrucker Kaisergrab," *Pantheon* (1965), 31–40.

For an argument by a Stoss specialist, see Zdzislaw Kepinksi, *Veit Stoss* (Warsaw, 1981), 78–79.

109. Sesselschreiber completed the following statues: Ferdinand of Portugal, 1510–16; Ernst the Iron, 1516; Philip the Fair, 1516; Elizabeth of Görz-Tirol, 1516; Kunigunde, 1516; Zimburgis of Masovia, 1516; Mary of Burgundy, 1517; and Rudolf I, 1517.

110. Oberhammer, *Bronzestandbilder*, 97–128; 207–11; Egg, *Horkirche*, 33–42.

111. Albrecht of Habsburg, 1518; Leopold III, 1519; St. Leopold, 1520; Philip the Good, 1521; Margaret of Austria, 1522; Frederick III, 1522; Sigmund the Wealthy, 1523; Frederick the Penniless, 1524; Maria Bianca Sforza, 1525; Charles the Rash, 1526; King Albrecht II, 1526; Albrecht I, 1527; Joanna of Castile, 1528; Duke Albrecht II, 1528–29; Elisabeth of Hungary, 1529–30; Ferdinand the Catholic, 1531; Godfrey of Bouillon, 1533.

112. Oberhammer, *Bronzestandbilder*, 321–89, 538–40; Egg, *Hofkirche*, 49–51; Innsbruck, 1969, 161–62, no. 596.

113. In two places in the codex, there is a reference to "images at the site (*pilder an dem ort*)": fo. 34, St. Bega, and fo. 105v., St. Bonifatius. The following saints were produced: Clovis, Leonhard, Ferreolus, Tarsitia, Oda, Aldegundis, Waldetrudis, Landricus, Firminus, Venantius, Guido, Pharahildis, Ermelindis, Reinburgis, Albertus Magnus, Doda, Simprecht, Roland, Stephen, Jos, Reichardus (Richard of England), Ulrich, and Maximilian. Only the last, the emperor's name saint, is not included in the catalogue of Habsburg saintly kin (listed here in the order of the Beck woodcut cycle as given by Laschitzer, "Heiligen.").

114. Oberhammer, *Bronzestanbilder*, 21–23; Hans Weihrauch, "Studien zur süddeutschen Bronzeplastik," *Münchner Jahrbuch der bildenden Kunst* 3–4 (1952–53), 199–212; Innsbruck, 1969, 161, no. 594; Egg, 52–53; Seipel, *Werke für die Ewigkeit*, 139–40, no. 62.

115. A rediscovered bust of Julius Caesar was recently acquired by Karlsruhe, Bädische Landesmuseum.

116. Reprinted in *JKSAK* I (1883), reg. 480. David von Schönherr, "Geschichte des Grabmals Kaiser Maximilian I und der Hofkirche zu Innsbruck," *JKSAK* II (1890), 140–268, esp. 180–81; Oberhammer, *Bronzestandbilder*, 25. See also Innsbruck, 1969, 68, no. 266; Vienna, 1959, 63, no. 205.

117. The coincidence between the number twenty-eight and the final number extant today may be owing to Ferdinand's understanding that this was the correct number envisaged by Maximilian rather than the forty figures projected in the 1528 reports by Kölderer and Godl (Oberhammer, *Bronzestandbilder*, 14–15). Seipel, *Werke für die Ewigkeit*, 140–41, no. 63, shows the 1528 design plan by Kölderer for the planned tomb in its original site of St. George Chapel, Wiener Neustadt, as well as an alternate design for the Neuklosterkirche in the same city. Both designs show four rows of ancestor figures, two on either side of the newly planned *tumba*, or cenotaph, with effigy (ibid., 123–26, no. 53, the eventual design by Florian Abel, ca. 1561).

118. The principal reason that the figures wound up in Innsbruck was the proximity of their casting foundry in Mühlau, although on the 1517 visit of Antonio de Beatis to Innsbruck, his diary records discussion of a chapel to be built there. In addition, Stabius mentions a design by the emperor himself for such a church: "etiam formam ecclesiae, quam pro eadem sepultura sua aedificare voluit, sua manu figuratam mihi contradit . . ." Quoted by Oberhammer, *Bronzestandbilder*, 26; and by Giehlow, "Dürers Entwürfe für das Triumphrelief," 16, 82–83, anhang 14.

119. *JKSAK* I, reg. 480. Oberhammer, *Bronzestandbilder*, 28: "Aber die grossen achtundzwanzig gegossen pilder sollen unser personn, unser vatter und khaiser Carl und sonst noch zween neben unser am vorderrsten und darnach neben den venster aber vier pilder und also nach der ordnung ob den altärn gestelt werden."

120. For the tradition in general, Panofsky, *Tomb Sculpture*, 62; on Sluter, see Henri David, *Claus Sluter* (Paris, 1951), 19–26, 107–27; Kathleen Morand, *Claus Sluter* (Austin, Tex., 1991), 121–32; *Art from the Burgundian Court*, exh. cat. (Cleveland, 2004), 223–26, no. 80.

121. Ann Roberts, "The Chronology and Political Significance of the Tomb of Mary of Burgundy," *Art Bulletin* 71 (1989), 376–400; Jaap Leeuwenberg, *Beeldhouwkunst in het Rijksmuseum* (Amsterdam, 1972), 40–45; Leeuwenberg, "Die tien bronzen plorannen in het Rijksmuseum te Amsterdam," *Gentsche Bijdragen tot de Kunstgeschiedenis* 13 (1951), 13–59; *Flanders in the Fifteenth Century*, exh. cat. (Detroit, 1960), 264–7, nos. 101–02; C.M.A.A. Lindeman, "De Dateering, herkomst en identificatie der 'Gravenbeeldjes' van Jacques de Gerines," *Oud Holland* 58 (1941), 49–57, 97–105, 161–69, 193–219; J. W. Steyaert, ed., *Laatgotische beeldhoukunst in de Bourgondische Nederlanden*, exh. cat. (Ghent, 1994), 138–41.

122. Hans Weihrauch, *Europäische Bronzestatuetten 15.–18. Jahrhundert* (Braunschweig, 1967); Weihrauch, "Bronze," *Reallexikon zur deutschen Kunstgeschichte*, vol. 2 (Stuttgart, 1948), cols. 1182–1216. Cf. the remarks on the material by Michael Cole, *Cellini and the Principles of Sculpture* (Cambridge, 2002), 13, 43–78; more generally see Rudolf

Wittkower, *Sculpture: Processes and Principles* (New York, 1977); Nicholas Penny, *The Materials of Sculpture* (New Haven, Conn., 1993).

123. Ulrich Steinmann, "Der Bilderschmuck der Stiftskirche zu Halle: Cranachs Passionszyklus und Grünewalds Erasmus-Mauritius-Tafel," *Staatliche Museen zu Berlin: Forschungen und Berichte* 11 (1968), 98ff.; Ludwig Grote, *Matthias Grünewald: Die Erasmus-Mauritius-Tafel* (Stuttgart, 1957). See also Thomas Schauerte, ed., *Der Kardinal*, exh. cat. (Halle, 2006), 2 vols.

124. Wiesflecker, *Kaiser Maximilian I*, 1:130–32, based on the chronicles of Jean Molinet.

125. Oberhammer, *Bronzestandbilder*, 19–20. A Latin translation of Dio was issued in 1490 by George Merula.

126. The Suetonius belonging to Peutinger is in the British Museum, and it was the location of the rediscovered Burgkmair woodcuts of the Caesars for Peutinger's projected *Kaiserbuch* for Maximilian (on which, see chapter 3). Campbell Dodgson, "Die Caesarenköpfe, eine unbeschriebene Folge von Holzschnitten Hans Burgkmairs d. A.," *Beiträge zur Geschichte der deutschen Kunst* 2 (1928), 224–28; Stuttgart, 1973, no. 77.

127. Ann Roberts, "The Chronology and Political Significance of the Tomb of Mary of Burgundy," 376–400.

128. Alphons Lhotsky, "Was heisst 'Haus Österreich'?" in *Aufsätze und Vorträge* (Munich, 1970), 1:344–64.

129. K. Schmid, "Zur Problematik von Familie, Sippe und Geschlecht, Haus und Dynastie beim mittelalterlichen Adel: Vorfragen zum Thema 'Adel und Herrschaft im Mittelalter,'" *Zeitschrift für die Geschichte des Oberrheins* 105 (1957), 56–57. Quoted by Levi-Strauss, *Way of the Masks*, 174.

130. Vienna, National Library, cod. ser. n. 2663. Innsbruck, 1969, 104–5, no. 395. See also Silver, "'Die Guten Alten Istory,'" and below, chapter 6.

131. On the attitude toward history, see Müller, *Gedechtnus*, 190–203, esp. 196–97, 201–2 for Dietrich; on Theoderic in the larger context of German mythic history, see Borchardt, *German Antiquity*, 34, 106, 134, 188. Conrad Celtis planned a never-completed epic on Theoderic.

132. Along with Hungary, Naples, Dalmatia, Portugal, Bohemia, and Austria, which he hoped to elevate to the status of a kingdom. See Egg, *Hofkirche*, 12–13n7; Egg, *Münzen*, 39–40; Coreth, "Dynastisch." The English inheritance appears in woodcut no. 75 of the *Triumphal Procession*, among the "Austrian Territories." On Maximilian's heraldry in general, Peter Halm, "Die 'Fier Gulden Stain' in der Dominikanerkirche zu Augsburg," in Kurt Martin, ed., *Studien zur Geschichte der Europäischen Plastik: Festschrift Theodor Müller* (Munich, 1965), 195–222.

133. Innsbruck, 1969, 66–67, no. 261; Halm, "Die 'Fier Gulden Stain,'" 214

134. The Latin text: "Et deinde plurimos principum seculariu recreationis gratia legedas / Hystorias progenitoru suorum audirelibuit / quibus profector non absque speciali Manlii labore aliquot noctibus perlectis Cesar cum aliquandiu egrotasset tandem febrili egritudine accedente testamento prehabito omnibus postpositis rebus ad celestem Imperatore animu convertens ad sacramentale sese confessionem parare studuit. . . .'"

3 | Translation of Empire

1. Innsbruck, 1969, 161, no. 594; Egg, *Hofkirche*, 52–53; Hans Robert Weihrauch, "Studien zur süddeutschen Bronzeplastik," 203–12. Of the thirty-four planned busts, twenty-one survive in Innsbruck at the Hofkirche, while another, Probus, is at the Bayerischen Nationalmuseum in Munich.

2. Herberger, *Conrad Peutinger*, 23.

3. Seipel, *Werke für die Ewigkeit*, 137–40, nos. 61 (coins), 62 (busts). For the larger context of the emperor's interest in imperial ancestry, see Wood, "Maximilian I as Archeologist," 1129–74, esp. 1155–57. General discussion of ancient coins as historical sources include Francis Haskell, *History and Its Images* (New Haven, Conn., 1993), esp. 13–36; John Cunnally, *Images of the Illustrious: The Numismatic Presence in the Renaissance* (Princeton, N.J., 1999). For the most part, Peutinger's unpublished heads of the Caesars has remained invisible to scholars who chart this general phenomenon.

4. ". . . daz nit albeg die Swaben und auswendig allain berumbt werden, dieweyl man hie und in disem lande auch guet maister vindt." Quoted by Weihrauch, "Studien," 211.

5. Stuttgart, no. 77; Falk, *Hans Burgkmair*, 46–47. The surviving woodcuts were found in the British Museum copy of Suetonius that had once belonged to Peutinger by Campbell Dodgson, "Die Caesarenköpfe," 224–28. Dodgson later found three other woodcuts in Paris. See the dissertation by Ashley West, "Hans Burgkmair the Elder."

6. Erich König, *Konrad Peutingers Briefwechsel* (Munich, 1923), 62, no. 35; cited by Falk, *Hans Burgkmair*, 46.

7. König, *Peutingerstudien*, 47. Three lists, of which two are chronological, are supplemented by the second list, "secundus numerus formas designat," itemizing the woodcut

"forms" for the illustrations, based on Peutinger's own coins. See also, Falk, *Hans Burgkmair*, 115, doc. 30.

8. Weihrauch, "Studien," 204–5; also Scheicher, "Kaiser Maximilian plant sein Grabmal," 81–118. The first eighteen emperors are included without breaks (except for the obvious loss of Augustus and Tiberius, who surely would not have been omitted), and the emperors after Marcus Aurelius (no. 15) include Lucius Verus, Severus Alexander, Gordianus, Philippus Arabs, and Theodosius.

9. They are Augustus, Tiberius, Decius, Aurelianus, Probus, Diocletianus, Constantinus, Valentinianus, Gratianus, Arcadius, Honorius, (Byzantine) Anastasios, Justinian, and Heraklios.

10. For the role of Theoderic the Great in German history, Borchardt, *German Antiquity*, 187–92. This view of the assimilation of Roman Empire with northern Gothic rulership was promulgated by Theoderic's sixth-century historian, Cassiodorus (519).

11. Der keiser so hie seind formiert
 Der merer theil hat wold regirt
 Zu macht das roimisch reich gepracht
 Alzeit nach lob unnd eer gedacht
 Translation by Strauss, *Woodcuts*, 727.

12. Tanner, *The Last Descendants of Aeneas*, 36–51; for Maximilian, 107–9.

13. Gerhardus Kallen, ed., *De concordantia catholica, Nicolai de Cusa Opera Omnia*, vol. 14 (Hamburg 1959–65), summarized and cited by Borchardt, *German Antiquity*, 40–45.

14. Cf. the instances adduced from India and the general definition of true hierarchy by Louis Dumont, *Homo hierarchus*, rev. ed. (Chicago, 1980).

15. Werner Goez, *Translatio imperii: Ein Beitrag zur Geschichte des Geschichtsdenkens und der politischen Theorien im Mittelalter und in der frühen Neuzeit* (Tübingen, 1958). See also Robert Folz, *L'idée d'empire en Occident* (Paris, 1953).

16. Borchardt, *German Antiquity*, 184–87; Goez, *Translatio imperii*, 46–49.

17. Borchardt, *German Antiquity*, 230–33; Goez, *Translatio imperii*, 111–30.

18. Quoted by Borchard, *German Antiquity*, 88, after the English translation by Edwin H. Zeydel of Sebastian Brant, *The Ship of Fools* (New York, 1944), 193.

19. Borchardt, *German Antiquity*, 88, citing Zeydel's translation of Brant, 320.

20. "Cede ideo Octavio, vos cedite Vespasiani, Traiano melior nam quia Caesar adest. Iure locum primum dabitis Maximiliano." Sebastian Brant, *Narrenschiff*, ed. Friederich Zarncke, reprint (Darmstadt, 1964), 197.

21. Translation by Strauss, *Woodcuts*, 726, 731.

22. Chmelarz, "Die Ehrenpforte des Kaisers Maximilian I," 289–319; Giehlow, "Urkundenexegese zur Ehrenpforte Maximilians I," 91–110; Giehlow, "Dürers Entwürfe für das Triumphrelief," 14–84; Pieter Strieder," Zur Entstehungsgeschichte," 128–42; Schauerte, *Erenpforte*, esp. 31–76, 407–26.

23. Reg. 5788. Quoted by Leitner, *Freydal*, x; also Gottlieb, *Ambraser Handschriften*, 45; Schauerte, *Ehrenpforte*, 411–12, no. Q20.

24. Chmelarz, "Die Ehrenpforte," 304. However, in a list of books to be completed by Maximilian, the two projects are listed separately, as "Erenporten" and "Trymphwagen," respectively.

25. Rupprich, *Dürer Schriftlicher Nachlass*, 1:77–78, no. 25; Conway, *Writings of Albrecht Dürer*, 82; Schauerte, *Ehrenpforte*, 414, no. Q28.

26. "6 visierung zu dem triumphwagen von Osterreich mit strichen, die funff falsch." Quoted by Giehlow, "Urkundenexegese," 94; Schauerte, *Ehrenpforte*, 409, no. Q11. The succeeding notice records delivery of sketches for the "Kallikuter mendl" of the *Procession*. In the same memoranda, ca. 1505–8, outlines for a corresponding Aragonese triumph in honor of Philip the Fair are mentioned (Gottlieb, 61): "Dy XII laures in triumpho Regis Arragonum cum curru triumphaly de armis in principio coronice Maxi." Also mentioned in terms of the tributes to other kings is Stabius's predecessor as program adviser, the Viennese scholar Johannes Fuchsmagen (d. 1510).

27. ". . . für ainen Rör, Leder und gewixt tuech, darein er dy Zwen triumf wägen so ich Kn. mt. schicken sol gemacht. . ." Giehlow, "Urkundenexegese," 94; Winzinger, *Gemälde*, 51; Schauerte, *Ehrenpforte*, 411, no. Q19. "item die Hungerischen kunig, item die Portugalischen kunig, item die Behemischen kunig: Fuxmag zu Triumphwagen." Cited by Winzinger, *Gemälde*, 50.

28. Giehlow, "Dürers Entwürfe für das Triumphrelief," 36, who also argues, p. 21, that the related sketch in Dresden, W. 672, was used for the model of a wooden plaque (now in the Louvre) made to commemorate the double wedding at the Vienna Congress in July 1515.

29. Winzinger, *Die Miniaturen*, reproduces the Albertina miniatures in facsimile; also *Maximilian I*, Vienna, 1959, 78–92, nos. 216–74. The Madrid copy is Bibliotheca Nacional, res. 232; a second copy is in the Vienna National Library, cod. min. 77; Vienna, 1959, 92, no. 275.

30. Quoted by Winzinger, *Gemälde*, 51: ". . . einen kleinen triumphwagen, der vor unseren curro triumphali gesetzt

werden muge und zu hinderst in denselben Wagen allein ein kaiserin und zu vorderst drei kunigin neben einand sitzend machen. . . ." The letter goes on to instruct Stabius not to write anything on the drawing but to leave it blank, "for we want to have the names written there with pen (*dann wir die namen mit der federn darein schreiben lassen wellen*)."

31. Winzinger, *Gemälde*, 109, no. 56. The miniature now heads the preserved Albertina parchments but is surely out of its original order. On the drawing, allegedly of Stabius, see Strauss, *Dürer Drawings*, 3:1668, no. 1517/15.

32. Suttgart, 1973, nos. 204–19. Karl Woermann, "Dresdener Burgkmair-Studien," *Zeitschrift für bildende Kunst*, new series, I (1890), 40ff.

33. Silver, "Prints for a Prince," 10, 14–15; Giehlow, "Dürers Entwürfe für das Trimphrelief," 36.

34. Winzinger, *Albrecht Altdorfer Graphik*, (hereafter cited as *Graphik*), 70–74. Only this woodcut is omitted from the attributions to Altdorfer among the corner tower scenes.

35. Quoted by Giehlow, "Urkundenexegese," 101; Schauerte, *Ehrenpforte*, 417–18, no. Q38. Translated by Strauss, *Woodcuts*, 500–501.

36. Quoted Giehlow, "Urkundenexegese," 101; Schauerte, *Ehrenpforte*, 417, Q37. For the controversies surrounding the genealogy of Maximilian, see chapter 2 and the fundamental study by Laschitzer, "Genealogie," *JKSAK* 7 (1888), 1–202.

37. *Correspondance de l'Empereur Maximilien Ier et de Marguerite d'Autriche*, 2:341, 374; nos. 634, 661; Schauerte, *Ehrenpforte*, 415, no. Q30.

38. Quoted by Schauerte, *Ehrenpforte*, 415, no. Q30.

39. Ibid., 420, no. Q46.

40. *JKSAK* 2, reg. 845; Schauerte, *Ehrenpforte*, 409–10, no. Q12. Egg, "Jörg Kölderer," 57–62; Winzinger, *Die Miniaturen*, 22–24.

41. Herberger, *Conrad Peutinger*; Bellot, "Konrad Peutinger."

42. Winzinger, *Die Miniaturen*, 20, quoting C. Th. Gemeiner, *Reichsstadt Regensburgische Chronik* (Regensburg, 1824), 4:191. Horoscope woodcuts produced by Stabius in 1512 for Maximilian (31 May), Cardinal Matthew Lang (30 July), and imperial secretary Jacob de Bannissis (8 August) indicate that Stabius was already present in that year in Dürer's Nuremberg to supervise the *Arch*. See Giehlow, "Dürers Entwürfe für das Triumphrelief," 34; Campbell Dodgson, "Drei Studien," *JKSAK* 29 (1910–11), 7–13.

43. Translation by Conway, *Writings of Albrecht Dürer*; Rupprich, *Dürer Schriftlichen Nachlass*, vol. 1, no. 25; Schauerte, 93, 414, no. Q28.

44. For these artists, see *Meister um Albrecht Dürer*, exh. cat. (Nuremberg, 1961). The fullest analyses of the separation of hands in the *Arch* as well as the *Procession* are given by Schauerte, *Ehrenpforte*, esp. 90, 92–93; Dodgson, *Catalogue of Early German and Flemish Woodcuts*, 1:311–28; also Chmelarz, "Ehrenpforte."

45. Dürer provided the fifth scene at the far left tower, the discovery of the relic at Trier as well as the meeting of Maximilian and Henry VIII and the crucial dynastic weddings: the Burgundian marriage of Maximilian, the Spanish marriage of Philip the Fair, and the double wedding at the Congress of Vienna.

46. It is surprising that he did not also reserve to himself the two throneroom scenes of coronation in Aachen and Milan, but these required less visual vitality and could be safely entrusted, like the family tree, to the meticulous Hans Springinklee. Apparently Springinklee made woodcuts of both the Burgundian and the Spanish betrothals that were later rejected by Dürer and replaced; see Dodgson, 397.

47. Giehlow, "Dürers Entwürfe für das Triumphrelief"; Rainer Schoch, Matthias Mende, and Anna Scherbaum, *Albrecht Dürer: Das druckgraphische Werk* (Munich, 2001–2), 2:470–83, no. 257.

48. Walter Koschatzky and Alice Strobl, *Dürer Drawings: The Albertina Collection* (Greenwich, Conn., 1972), Strauss, *Woodcuts*, 536–42, with translation.

49. Winzinger, *Graphik*, 74–78, 122–25; nos. 76–81, 209–40.

50. For the carvers of these projects, Landau and Parshall, *Renaissance Print*, 206–20. Many of these woodblocks are preserved in the Albertina, Vienna. Schestag, "Kaiser Maximilian I: Triumph." For the *Arch* blocks in the Albertina, see Schauerte, *Ehrenpforte*, 427–50.

51. Koschatzky and Strobl, *Dürer Drawings*, 260–71, nos. 105–10. One of these riders, no. 105, W. 690, appears to be a portrait of Stabius, crowned with laurel.

52. A modified version of the historical scenes of the *Arch* was published posthumously in Nuremberg by Hieronymus Andreae as a souvenir of the emperor. This "book" edition of the woodcuts is still primarily a captioned picture book, akin to the history scenes contained in the *Zaiger*, prepared by Mennel as a digest of the multivolume genealogy, the *Geburtsspiegel* (1518; cod. 7892; see chapter 2). In this format, the facing pictures stand alone successfully, although the battle scenes here follow one another in regular sequence, like Burgkmair's *Weisskunig* illustrations. For this edition, see Dodgson, *Catalogue*, 321–22, following H. Glax, "Uber die vier Ausgaben der

geschichtlichen Vorstellungen der Ehrenpforte Kaiser Maximilians I," *Quellen und Forschungen zur vaterländischen Geschichte, Literatur, und Kunst* (Vienna, 1849), 259.

53. See the survey by Richard Brilliant, *Roman Art* (London, 1974), 119–28, 192–94.

54. Another notable use of the allocution (*adlocutio*) gesture and situation is given by Titian in his portrait of the Alfonso d'Avalos, Marchese del Vasto (1539–41; Madrid, Prado); see Erwin Panofsky, *Problems in Titian Mostly Iconographic* (New York, 1969), 74–77.

55. Translation by Strauss, *Woodcuts*, 731.

56. Silver, "Shining Armor"; Stuttgart, 1973, no. 22; Landau and Parshall, *Renaissance Print*, 188–91.

57. König, *Konrad Peutingers Briefwechsel*, nos. 55–57; Falk, *Hans Burgkmair*, 69–71, 115, doc. nos. 36 a–c.

58. Most recently, Schauerte, *Ehrenpforte*, 42–46; Patrick Werkner, "Der Wappenturm Kaiser Maximilians I in Innsbruck," *Wiener Jahrbuch für Kunstgeschichte* 34 (1981), 101–13. The classic study is F. von Wieser, "Zur Geschichte des Innsbrucker Wappenthurms," *Zeitschrift des Ferdinandeums* (1897), 307–11. See also Oswald Redlich, "Der alte Wappenturm zu Innsbruck," *Ausgewählte Schriften* (Vienna, 1928), 235–50. F. H. Hye, "Die heraldischen Denkmale Kaiser Maximilian I in Tirol," *Der Schlern* 43 (1969), 56–77. The kinship between Wappenturm and the *Arch* was reiterated by Strieder, "Zur Entstehungsgeschichte," 139.

59. Ironically, Maximilian went out of his way to celebrate himself as a builder in one of the images of the Altdorfer side columns, *Maximilian als Baumeister* (W. 75), where the text reads (in the Strauss translation, *Woodcuts*, 730): "Great buildings were his special joy / which future generations could employ. / No expense for this he spared, / more than other princes ever dared, / befitting his imperial pride / for his rule extended far and wide."

60. Innsbruck, 1969, 148, nos. 549–50, cover illustration, fig. 106; Otto, *Bernhard Strigel*, 67, 101, no. 56.

61. Translation by Strauss, *Woodcuts*, 728.

62. Ibid.

63. Translation by Strauss, *Woodcuts*, 727.

64. Compare the angels hovering around the Holy Trinity in Dürer's *Adoration of the Trinity* (1511; Vienna, Kunsthistorisches Museum).

65. Translation by Strauss, *Woodcuts*, 727.

66. The translations are from Appelbaum, *The Triumph of Maximilian I*, 10. The original text, drawn from Vienna cod. 2835, can be found in Schestag, "Kaiser Maximilian I: Triumph," 154–81, and in Horst Appuhn, ed.,

Der Triumphzug Kaiser Maximilians I 1516–1518 (Dortmund, 1979), 171–96.

67. The references are collected with interpretive synthesis in Paully-Wissowa, "Triumphus," *Realencyclopädie der classischen Altertumswissenschaft*, vol. 7A1, cols. 493–511, esp. 503ff. for the typical procession. See also "Triumphbogen" for the forms and the decorations of triumphal arches. The Appian reference to the triumph of Scipio Africanus is from the *Punic Wars*, bk. 9, chap. 66, trans. Horace White (London, 1912), 1:506–9. The Plutarch translation by Bernadotte Perrin (Cambridge, Mass., 1943), 6:440–47. Individual triumphs in Livy offer the largest number of references. See Schauerte, *Ehrenpforte*, 58–64; also "The *Triumphs of Caesar* and Classical Antiquity," in Andrew Martindale, *The Triumphs of Caesar by Andrea Mantegna in the Collection of Her Majesty the Queen at Hampton Court* (London, 1979), 56–74, 178–79: ". . . at least it can be said that by c. 1475 all the main texts had been printed. . ." (56); Jean Michel Massing, "The *Triumph of Caesar* by Benedetto Bordon and Jacobus Argentoratensis: Its Iconography and Influence," *Studies in Imagery, Vol. I: Texts and Images* (London, 2004), 109–12 (orig. *Print Quarterly* 7 [1990], 2–21, esp. 2–5).

68. Martindale, *Triumphs of Caesar*, 50–51, 58. The importance of Valturio was stressed by Giehlow, "Dürers Entwürfe für das Triumphrelief"; Schauerte, *Ehrenpforte*, 60, 80.

69. Appelbaum translation, 10.

70. Ibid., 11.

71. Ibid., 13.

72. Cited by Oberhammer, *Bronzestandbilder*, 20. See above, chapter 1.

73. Appelbaum translation, 15.

74. Ibid., 18.

75. Stuttgart, 1973, nos. 23–26; Falk, *Hans Burgkmair*, 67–68. See also *The New Golden Land*, exh. cat. (Cleveland, 1976).

76. Appelbaum translation, 19.

77. Winzinger, *Graphik*, 74–78, nos. 76–81.

78. Christiane Andersson, "Geschlechtbilder: Dirnen in Kriegsdarstellungen der frühen Neuzeit," in K. Hagemann and R. Proeve, *Landsknechte, Soldatenfrauen und Nationalkrieger: Militär, Krieg und Geschlecterverhältnisse im historischen Wandel* (Frankfurt, 2001). See also the remarks concerning the young camp-follower in Rembrandt's *Nightwatch*, given in Egbert Haverkamp-Begemann, *Rembrandt: The Nightwatch* (Princeton, N.J., 1982), 93–101.

79. Martindale, *Triumphs of Caesar*, passim; on the engraved copies, 78–79, 167–68. See also Jay Levenson, Konrad Oberhuber, and Jacquelyn Sheehan, *Early Italian Engravings from the National Gallery of Art*, exh. cat. (Washington, D.C., 1973), 214–17, no. 82; Keith Christiansen and Suzanne Boorsch, *Andrea Mantegna*, exh. cat. (New York, 1992), 349–92, nos. 108–27.

80. The presence in both the later Dürer and Mantegna of a (winged) victory crowning Caesar as well as his holding a palm branch, symbolizing victory, could spring from common reference to antique literary sources. However, the formal resemblance between Dürer's wheels in his woodcut, with their circular frames around columnar spokes, and the precedent of Mantegna's canvas is striking.

81. Martindale, *Triumphs of Caesar*, 99–100. Jean Michel Massing, "Jacobus Argentoratensis. Etude preliminaire," *Arte Veneta* 31 (1977), 42–52; Massing, "*Triumph of Caesar* by Benedetto Bordon," *Print Quarterly* 7 (1990), 2–21; Horst Appuhn and Christian von Heusinger, *Riesenholzschnitte und Papiertapeten der Renaissance* (Unterschneidheim, 1976), 26–27.

82. Mantegna had sketched but never painted a tenth scene, misnamed "Senators" and reproduced in both drawings and prints (Martindale, *Triumphs of Caesar*, 66) that actually rendered the secretaries and aides described by Appian. Either the engraving after Mantegna or the woodcut by Jacopo could have transmitted this portion of the procession to Maximilian's artists.

83. Martindale, *Triumphs of Caesar*, 100n1.

84. Closer to Mantegna's overlapping figures and quite distinct from Maximilian's enterprise is the ten-part *Triumph of Christ* woodcut frieze by Titian, 1510–11, where Jesus rides the triumphal chariot in a procession led by Adam and Eve. See Martindale, *Triumphs of Caesar*, 101–2; Appuhn and von Heusinger, *Riesenholzschnitte*, 27–31; David Rosand and Michelangelo Muraro, *Titian and the Venetian Woodcut*, exh. cat. (Washington, D.C., 1976), 37–54, no. 1; Peter Dreyer, *Tizian und sein Kreis Holzschnitte*, exh. cat. (Berlin, n.d.), 32–41.

85. The best overview of the phenomenon, with rich bibliography, is Roy Strong, *Art and Power: Renaissance Festivals 1450–1650* (Berkeley, Calif., 1984). The classic study is Werner Weisbach, *Trionfi* (Berlin, 1919). See also Robert Baldwin, "A Bibliography of the Literature on Triumph," in Barbara Wisch and Susan Scott Munshower, eds., *"All the World's a Stage . . .": Art and Pageantry in the Renaissance and Baroque* (University Park, Pa., 1990), 358–85. Regional studies of the period of

Maximilian include Sydney Anglo, *Spectacle, Pageantry, and Early Tudor Policy* (Oxford, 1969); Ralph Giesey, *Cérémonial et puissance souveraine, France Xve–XVIIe siècles* (Paris, 1987); Bonner Mitchell, *Italian Civic Pageantry in the High Renaissance: A Descriptive Bibliography of Triumphal Entries and Selected Other Festivities for State Occasions* (Florence, 1979); John Landwehr, *Splendid Ceremonies: State Entries and Royal Funerals in the Low Countries 1515-1791* (Nieuwkoop, 1971); D. P. Snoep, *Praal en propaganda* (Alphen aan den Rijn, n.d.), 5–15. Little study of actual entries by Maximilian has been made, although his successor, Charles V, has received recent attention: Strong, *Art and Power*, 75–97; Jean Jacquot, ed., *Fêtes et cérémonies au temps de Charles Quint*, vol. 2 of *Les fêtes de la Renaissance* (Paris, 1960). For the 1515 Bruges entry of Charles V, see Sydney Anglo, ed., *La Tryumphante entrée de Charles Prince des Espagne en Bruges 1515* (Amsterdam, 1970).

86. Maximilian received his own ceremonial entry into Ghent on the evening of 18 August 1477 on the occasion of his betrothal to Mary of Burgundy. See Wiesflecker, *Kaiser Maximilian I*, 1:131–32n62. His arches and banners in the Flemish city echoed the petitions offered to other entering rulers: "Gloriosissime princeps, defende nos, ne pereamus. Tu es dux et princeps noster, pugna proelium nostrum." No illustrated program books for this entry—or for Maximilian's 1508 entry as emperor into Ghent—survive. For the 1508 Ghent entry, whose book is lost, see Kervyn van Volkaersbeke, *Joyeuse entrée de l'Empereur Maximilien I à Gand en 1508: Description d'un livre perdu* (Ghent, 1850). In general, see also Irmengard von Roeder-Baumbach, *Versieringen bij blijde inkomsten gebruikt in de Zuidelijke Nederlanden gedurende de 16e en 17e eeuw* (Antwerp, 1943), 10–11, 27–45.

87. Strong, *Art and Power*, 45, citing Bonner Mitchell, "Italian Civic Pageantry in the High Renaissance," *Biblioteca di Bibliografia Italiana* 89 (1979), 83–85. Josef Chartrou, 73–79, *Les entrées solenelles et triomphales à la Renaissance (1484–1551)* (Paris, 1928), stresses the fact, important for Maximilian because of his Sforza connections and sensitivity to the French incursions into northern Italy, that the most classical of the royal entries were made into Milan (Charles VIII in 1494 and Louis XII in 1509); for the French pageants in Italy, see Robert Scheller, "Galla Cisalpina: Louis XII and Italy, 1499–1508," *Simiolus* (1985), 5–60, esp. 31–36, 42–48.

88. Robert Scheller, "Imperial Themes in Art and Literature of the Early French Renaissance: The Period of

Charles VIII," *Simiolus* 12 (1981–82), 5–69; Scheller, "Ensigns of Authority: French Royal Symbolism in the Age of Louis XII," *Simiolus* 13 (1983), 75–141. See esp. "Imperial Themes," 18–20, 37–39, 44–45, 51–52, for Maximilian's heated response to the claims and pretensions of Charles VIII. "Ensigns of Authority" has a good discussion, with bibliography, of French royal entries, 101–3. See also Chartrou, *Les entrées solenelles*; Bernard Guenée and Françoise Lehoux, *Les entrées royales françaises de 1328 à 1515* (Paris, 1968). On the specifics of Louis XII's entries, see Michael Sherman, "Pomp and Circumstance: Pageantry, Politics and Propaganda in France during the Reign of Louis XII, 1498–1515," *Sixteenth Century Journal* 9, no. 4 (1978), 13–32.

89. Ernst Kantorowicz, "The 'King's Advent' and the Enigmatic Panels in the Doors of Santa Sabina," *Art Bulletin* 26 (1944), 207–31; reprinted in Kantorowicz, *Selected Studies* (Locust Valley, Pa., 1965), 37–75.

90. Scheller, "Imperial Themes," 9–10, 57, and "Ensigns of Authority," 103–11; for the imperial crowns, see Rosenthal, "Die 'Reichskrone,'" 7–48.

91. Winzinger, *Die Miniaturen*, 53–57, nos. 37–54; Winzinger, *Gemälde*, 117–18, nos. 74–76.

92. Egg, *Münzen*; Helmut Jungwirth, "Münzen und Medaillen Maximilians I," in Innsbruck, 1969, 65–72.

93. Egg, *Münzen*, 17–18; Innsbruck, 1969, 78, no. 306-3. The model for this coin was the silver real of the Burgundian Netherlands, ruled by Maximilian. After the death of Koch in 1496, the goldsmith Benedick Burkhart succeeded him as chief carver of the coin stamps. He produced a variant on Koch's guldier showing a lily scepter in place of the sword (no. 306-4).

94. Egg, *Münzen*, 18–19, citing *JKSAK* 2, reg. 645, 671.

95. Egg, *Münzen*, 39–40. Innsbruck, 1969, 80, nos. 307-11, 12.

96. Stephen Scher, *The Currency of Fame: Portrait Medals of the Renaissance*, exh. cat. (New York, 1994); George Hill, *A Corpus of Italian Medals of the Renaissance before Cellini* (London, 1930). Maximilian on occasion commissioned commemorative coins from Italian designers: Giovanni Candida for a wedding coin (1477–79; Innsbruck, 1969, no. 317-1, 3), Gian Marco Cavalli (1506; no. 317-4, 5), and Giovanni Maria Pomedelli (undated, 1516-19; no. 317-20), with a portrait of Charles V as king of Spain on the reverse. For a later example, see the Nuremberg silver medal issued in honor of Charles V in 1521 (Nuremberg, 1971, 150, no. 267) after a design by Dürer. On Pisanello, see Luke Syson and Dillian Gordon, *Pisanello: Painter to the Renaissance Court* (London, 2001).

97. Egg, *Münzen*, 33–34.

98. Ibid., *Münzen*, 35; Innsbruck, 1969, 81, no. 317-6, 9.

99. Egg, *Münzen*, 37; Innsbruck, 1969, 80, no. 317-10.

100. Egg, *Münzen*, 39–40; Innsbruck, 1969, 80, no. 317-11, 12. Halm, "Die 'Fier Gulden Stain,'" 202, citing the earlier precedents of Sigmund of Tirol for the knight on the reverse of the half-guldiner as a model for the earlier Ursentaler commemorative (cf. Egg, 37).

101. Egg, *Münzen*, 39.

102. Ludwig von Baldass, "Die Bildnisse Kaiser Maximilians," *JKSAK* 31 (1913), 247–334; Otto, *Bernhard Strigel*, 31. This period also produced an altarpiece on the theme of Constantine (today in Prague, National Museum) that includes a portrait of Maximilian and allegedly was presented as a gift to the Roman church of San Paolo fuori de mura, founded by Constantine. The emperor appears directly above the figure of Constantine, carrying the cross in imitation of Christ's Via dolorosa. According to Otto (31–32), this altarpiece was probably a gift from Maximilian in anticipation of his visit to Rome for the coronation by the pope—an event that never happened because of the opposition by Venice and the Vatican. See also Tanner, *Last Descendants of Aeneas*, 183–91 on Habsburg veneration of Constantine, esp. 189–91 for the Strigel altarpiece.

103. Otto, *Bernhard Strigel*, 65.

104. Innsbruck, 1969, 148, no. 547, ill. 105; Eisenbeiss, "Porträts," 102–9, 262–63. The inscription (DIVI MAXIMILIANI IMPERATORIS FIGURA ANNO CUM ESSE NATUS QUADRAGINTA) is suspect because of the conflict between the date and the proclamation in words of Maximilian as "emperor"; moreover, this unusual crown, partaking of both the arches of the *Bügelkrone* as well as an ornate version of the usual circlet of a king's crown, seems to be almost a fantasy hybrid rather than the more usual, restrained arch-crown of historical depictions. Indeed, it most closely resembles the pretentious French royal crowns with arches adduced by Scheller, "Imperial Themes," 9–10, 57, 67, but it may be either Strigel's imagined version or even the actual imperial crown, rather than the stereotypes of images. Significantly, this crown was replicated in most of the formal, imperial portraits of Maximilian, so it is unlikely to have been very inaccurate; moreover, later imperial coins, which may well have Strigel portraits as models for the likeness of Maximilian, also feature crowns with this same floral ornament and cross above an arch (see below).

105. Otto, *Bernhard Strigel*, 66–67. 101, cat. nos. 55, 56, ills. nos. 124–25. The inscription on the Strasbourg picture, lost in a fire in 1947, reads: "Hanc quam conspicis sui effigiem cum augustae suae prosapiae insignibus. Ipse maximilianus primus austriacus postea-quam argentinae domo viridis insulae ordinis s. joannis hierosolymitani discessit ad comitia imperialia constantiam inde d. erhardo Kienig ejusdem domus tunc commendatori suo intra octennium septenis vicibus ibidem hospiti percharo dono misit die XXIX julii MDVII relictis in eadem viridi insula aliis caesareae munificentiae monumentis." Other replicas survive in Vienna, Munich, Stift St. Florian, and Schloss Ambras; see Innsbruck, 1969, 148, nos. 548–49; Eisenbeiss, "Porträts"; and cover illustration (Vienna). A variant portrait in three-quarters pose (Innsbruck, 1969, 148, no. 550, ill. 106; private collection) is important for introducing the variant imperial crown of the Habsburgs: a miter crown like that atop the central dome of the *Arch* (also worn by the enthroned Maximilian atop the family tree of the *Arch*). For this crown, see Rosenthal, "Die 'Reichskrone,'" with references. This miter crown, apparently devised as a distinctive Habsburg imperial crown, was later emulated in the 1602 Austrian imperial crown made by Rudolph II, for whom see Hermann Fillitz, "Die Insignien und Ornate des Kaisertums Österreich," *JKSW* 52 (1956), 124–26. Maximilian's own imperial miter crown, pictured by Strigel in these portraits, was melted down in Spain by Philip II, according to Fillitz. It resembled the 1602 miter crown except for a lower arch on its sides.

106. Egg, *Münzen*, 38; Innsbruck, 1969, 81, no. 317-17.

107. Silver, "Shining Armor"; Stuttgart, 1973, nos. 21–22; also Landau and Parshall, *Renaissance Print*, 184–92.

108. Stuttgart, 1973, nos. 1–6, 7–10; Falk, *Hans Burgkmair*, 13–20; Landau and Parshall, *Renaissance Print*, 186–91.

109. On Oxford, see Stuttgart, 1973, no. 21a; Campbell Dodgson, "Rare Woodcuts in the Ashmolean Museum, Oxford—II," *Burlington Magazine* 39 (1921), 68–69; on Berlin, see Max Geisberg, "Burgkmairs St. Georg," in *Festschrift für Max J. Friedländer zum 60. Geburtstag* (Leipzig, 1927), 77–80. On Chicago, see Silver, "Shining Armor," and Harold Joachim, "Maximilian I by Burgkmair," *Art Institute of Chicago Quarterly* (March 1961), 5–9.

110. The Cleveland exemplar is Stuttgart, 1973, no. 22a; Harry Francis, "The Equestrian Protrait of the Emperor Maximilian by Hans Burgkmair," *Bulletin of the Cleveland Museum of Art* 39 (1952), 223–25.

111. Cf. Christopher Wood, "Early Archeology and the Book Trade," 83–118; Wood, "Maximilian I as Archeologist," 1158–59.

112. Cf. the additional images of the imperial eagle by Burgkmair: the *Quaternionenadler* of 1510 and the *Reichsadler with University Arms* of 1516; Stuttgart, 1973, nos. 42, 96.

113. Kantorowicz, "The 'King's Advent,'" reprinted in Kantorowicz, *Selected Studies*, 37–75 (for later medieval instances, see 42n20, particularly mentioning the entry of Philip the Good of Burgundy into Ghent in 1458).

114. On Burgkmair and armor, see Silver, "Shining Armor;" Falk, *Hans Burgkmair*, 74–76.

115. Vienna, 1959, 125, no. 406. Percy Ernst Schramm and Hermann Fillitz, *Denkmale des deutschen Könige und Kaiser* (Munich, 1978), 2:97; no. 162. Falk, *Hans Burgkmair*, 71–73; Ludwig von Baldass, "Hans Burgkmairs Entwurf zu Jörg Erharts Reiterstandbildnis Kaiser Maximilians I," *JKSAK* 31 (1913–14), 359–62; Georg Habich, "Das Reiterdenkmal Kaiser Maximilians in Augsburg," *Münchner Jahrbuch der bildenden Kunst* 8 (1913), 255–62; Peter Halm, "Hans Burgkmair als Zeichner," *Münchner Jahrbuch* 13 (1962), 127–30; Fedja Anzelewsky, "Ein unbekannter Entwurf Hans Burgkmairs für das Reiterdenkmal Kaiser Maximilians," in *Festschrift für Peter Metz* (Berlin, 1965), 295–304.

116. The cornerstone inscription, adapted for the rider monument, reads: "Jesu Christo sacrum Maximilianus Ro Caesar August / A.D. III Idus Julias a fudametis / Lapidem hunc primum posuit." Quoted by Habich, "Reiterdenkmal," 255. Falk, *Hans Burgkmair*, 71, notes the crucial change in inscriptions from "Romanorum Caesar" to "Imperator Caesar" after the 1508 coronation. This sensitivity to the importance of the change of title at Trent corresponds to the role of Peutinger in producing the 1508 commemorative woodcut by Burgkmair.

117. Habich, "Reiterdenkmal," 256n2, quoting Fugger's *Ehrenspiegel des Hauses Osterreich*; also Falk, *Hans Burgkmair*, 72, who argues that the site of the monument was actually outside the choir on the north side of the cloister. His evidence is a 1676 engraving of the city view of Augsburg by Simon Grimm showing the block frontally in a corner of the cloister (n. 457).

118. Falk, *Hans Burgkmair*, 71nn448–49; Habich, "Reiterdenkmal," 257.

119. E. F. Bange, "Das Reiterdenkmal Kaiser Maximilians und die Statuette eines Pferdes im Kaiser-Friedrich-Museum," *Jahrbuch der preussischen Kunstsammlungen* 45

(1924), 212–13; Bange, *Die deutschen Bronzestatuetten des 16. Jahrhunderts* (Berlin, 1949), 77–79, 135, no. 132; Gertrud Otto, *Gregor Erhart* (Berlin, 1943), 53–56; William Milliken, "Bronze by Gregor Erhart," *Bulletin of the Cleveland Museum of Art* 39 (1952), 225–26. Maximilian also presumably commissioned from Gregor Erhart the lovely large *Madonna of Mercy* wood sculpture in the Austrian pilgrimage church of Frauenstein, where the emperor's portrait can be seen beneath the protective cloak of the Virgin: see Otto, *Gregor Erhart*, 56–58; also Michael Baxandall, *The Limewood Sculptors of Renaissance Germany*, 294, plate 68; Angela Mohr, *Die Schutzmantel-Madonna von Frauenstein* (Steyr, 1983).

120. Habich, "Reiterdenkmal," 261.

121. Such a ceremonial sword existed among the imperial regalia. See Albrecht Dürer's drawing of it, ca. 1510–11, W. 505 (Nuremberg, Germanisches Nationalmuseum), as well as of the other regalia. See Fillitz, *Die Insignien und Kleinodien des Heiligen Römischen Reiches*; and for the Dürer drawings, Strauss, *Dürer Drawings*, 3:1214–23, nos. 1510/6–10. Dürer's studies were careful preparations for his paintings of *Emperor Charlemagne* and *Emperor Sigismund* (1513; Nuremberg, Germanisches (Nationalmuseum), to be hung in the treasury chamber of the city of Nuremberg, where the imperial regalia were housed (Nuremberg, 1971, 138–39, nos. 251-57; H. Theodor Musper, *Dürers Kaiserbildnisse* [Cologne, 1969]). Maximilian, however, had his own luxury swords, such as the celebrated "Langes Messer" (1496); see Bruno Thomas and Alphons Lhotsky, "Kaiser Maximiliani I's tre pregtsvaerd i Wien eg København / Die Prunkschwerter Kaiser Maximilians I in Wien und Kopenhagen," hereafter cited as "Prunkschwerter," *Vaabenhistoriske Aarbøger* 6 (1950–51), 105–91. See also chapter 6.

122. The emperor on horseback is accompanied by two maidens, the eponymous maidenly representatives of Magdeburg. Herbert von Einem, "Zur Deutung des Magdeburger Reiters," *Zeitschrift für Kunstgeschichte* 16 (1953), 43–56, reprinted in von Einen, *Stil und Uberlieferung* (Düsseldorf, 1971), 104–23. The earliest record of the marketplace location dates from the fourteenth century (50) rather than the midthirteenth century origin of the extant monument. Von Einem hypothesizes a lost Ottonian original, also of stone, in the imperial palace. The connection between Maximilian's Augsburg monument and the *Magdeburg Rider* is mentioned briefly by Falk, *Hans Burgkmair*, 72–73.

123. Von Einem, "Zur Deutung," 47–48: the two earlier sources are Kord Botes, *Niedersächsische Bilderchronik* (1492) and Albert Krantz, *Metropolis*.

124. Von Einem, "Zur Deutung," 52n45; Hartmut Hoffmann, "Die Aachener Theoderichstatue," in Kurt Böhner et al., eds., *Das Erste Jahrtausend*: Kultur und Kunst im werdenden Abendland an Rhein und Ruhr (Düsseldorf, 1962), 1:318–35.

125. See, for Charlemagne and the concept of *translatio imperii*, Folz, *Le souvenir et la légende de Charlemagne*, 41, 142–47, 186–91, 362–67, 413–17, and for the age of Maximilian, 554–57.

126. E. Knaur, *Das Reiterstandbild des Marc Aurel* (Stuttgart, 1967); Harald von Roques de Maumont, *Antike Reiterstandbilder* (Berlin, 1958), 55–60.

127. Jörg Träger, "Der Bamberger Reiter in neuer Sicht," *Zeitschrift für Kunstgeschichte* 33 (1970), 1–20; Herbert von Einem, "Fragen um den Bamberger Reiter," in *Studien zur Geschichte der Europäischen Plastik. Festschrift Theodor Müller* (Munich, 1965), 55–62. An overview of this monument, with bibliography, is Hans Jantzen, *Der Bamberger Reiter* (Stuttgart, 1964), although this author inclines to identify the *Rider* as one of the three magi without offering an explanation for why he appears alone. The Constantine thesis is most thoroughly argued by Otto Hartig, *Der Bamberger Reiter und sein Geheimnis* (Bamberg, 1939), esp. 98–104. The unusual dynamic element of the turned head of the *Rider* is explained by Träger as the vision to Constantine of the cross as his sign of military victory.

128. Innsbruck, 1969, 163, no. 601, ill. 134. The canvas served as a documentary source for the likeness of Rudolf in the preparation of the life-size bronze statue of that ancestor later erected as part of the tomb ensemble of Maximilian (chapter 2). Rudolf also served as a link to Maximilian's family claims to a kinship with St. Ulrich. According to the sixteenth-century Fugger *Ehrenspiegel*, quoted by Habich, "Reiterdenkmal," 256: "Then his majesty wanted to make and have erected here an eternal monument [*Gedächtnus*]. For our beloved lord St. Ulrich was born of the blood of the counts of Kyberg from which family the praiseworthy King of the Romans [i.e., Maximilian] was also born and derived. For the mother of Rudolphus, King of the Romans, Count of Habsburg, was also born countess of Kyberg."

129. Innsbruck, 1969, 156, no. 583, ill. 125. Philipp Maria Halm, "Hans Valkenauer und die Salzburger Marmorplastik," in *Studien zu Süddeutschen Plastik* (Augsburg, 1926),

1:176–83, 222–23; most recently, Wood, "Maximilian I as Archeologist," 1154–55.

130. Percy Ernst Schramm and Hermann Fillitz, *Denkmale der deutschen Könige und Kaiser* (Munich, 1978), 1:178, no. 169, describing the common site of Henry V, Henry IV, Conrad II, Gisela, and Berta. The Staufer grave of Philip of Swabia is 187, no. 190. For Rudolf I, the tomb copied by Hans Knoderer for Maximilian (see above), *Denkmale*, 2:50, no. 1. The final two women are the wife and daugher, respectively, of Emperor Frederick I of Barbarossa.

131. On the Investiture Conflict within the history of the Holy Roman Empire, see James Bryce, *The Holy Roman Empire*, rev. ed. (London, 1905), 153–66.

132. Philipp Halm, 176, citing *JKSAK* 1 (1885), lv. The contract is dated 5 February 1514. The contract also mentions a prior design (*Visierung*), and Halm hypothesizes that this architectural sensibility of design would have been that of Jörg Kölderer, whose Innsbruck Wappenturm was so formative for the *Arch*. See also Wolfgang Czerny, "Hans Valkenauer und die spätgotische Grabmalplastik in der Diözese Salzburg" (Ph.D. diss., University of Vienna, 1982), 104.

133. For the cult of Charlemagne in medieval Germany, see Braunfels and Schramm, eds., *Karl der Grosse IV*, esp. 229–73 (Ernst Günter Grimme, "Karl der Grosse in seiner Stadt"). The elaborate gold and silver book cover of Charlemagne's "coronation evangelary" was produced by an Aachen smith, Hans von Reutlingen, probably for the 1493 Aachen coronation of Maximilian (233, fig. 6), and it shows the Frankish monarch wearing the Habsburg miter crown.

134. Grimme, "Karl der Grosse," 236–37; see also Karl Möseneder, "Lapides vivi: Über die Kreuzkapelle der Burg Karlstein," *Wiener Jahrbuch für Kunstgeschichte* n.s. 34 (1981), 61–62.

135. A similar concept of "living" precious stones as the very edifice of imperial honor appears in the architectural commissions of Emperor Charles IV in Prague and Karlstein Castle after the middle of the fourteenth century. Anton Legner, "Karolinische Edelsteinwände," in Ferdinand Seibt, ed., *Kaiser Karl IV. Staatsmann und Mäzen* (Munich, 1978), 356–62; Legner, "Wände aus Edelstein und Gefässe aus Kristall," and Christel Meier, "Edelsteinallegorese," both in *Die Parler und der Schöne Stil 1350–1400*, exh. cat. (Cologne, 1978), 3:169–82, 185–87, respectively; Möseneder, "Lapides vivi," 39–69.

136. Peter Diedrichs, *Kaiser Maximilian als politischer Publizist*; for a historiographic perspective on this issue of Maximilian's assertion of empire as well as dynasty, see Heinrich Fichtenau, "Reich und Dynastie im politischen Denken Maximilians I," in *Österreich und Europa: Festgabe für Hugo Hantsch* (Graz, 1965), 39–48.

137. Quoted by Fichtenau, "Reich und Dynastie," 45, from Johannes Janssen, ed., *Frankfurts Reichskorrespondenz* II/2, 788, no. 1000 (6 March 1510): "[weil] unser aller eltfordern, die Tewtschen, fur ander nacion redlicher dewrer thatten und sachen geflissen und sonderlich so manlich, trostlich und hart ob unserm hailigen cristenlichen glauben gehalten, umb des willen ir bluet . . . vergossen." See also Diedrichs, *Kaiser Maximilian*, esp. 34–50.

138. Borchardt, *German Antiquity*, 98–103.

139. Ibid., 106–9. See also Gerald Strauss, *Sixteenth-Century Germany*, 29; Spitz, *Conrad Celtis*; Paul, *Studien zur Geschichte des deutschen Nationalbewusstseins*, 74–87. This program was most vividly laid out by Celtis in his ringing inaugural lecture at the University of Ingolstadt (31 August 1492).

140. Oberhammer, *Bronzestandbilden*, 129.

4 | *Caesar Divus*: Leader of Christendom

1. For the woodcut, in a luxury impression (Bamberg, Staatsbibliothek) that includes golden printed passages where costume dictates, see Nuremberg, 1971, 140–41, no. 259; see also Susan Dackerman, *Painted Prints*, exh. cat. (Baltimore, 2003), 129–32, no. 16. On the charcoal portrait drawing (Vienna, Albertina), see Vienna, 1959, 128–29, no. 418, inscribed by Dürer with the emperor's name and the date. See also Vinzenz Oberhammer, "Die vier Bildnisse Kaiser Maximilians I von Albrecht Dürer," *Alte und moderne Kunst* 14 (1969), 2–14; Katherine Crawford Luber, "Albrecht Dürer's Maximilian Portraits: An Investigation of Versions," *Master Drawings* 29 (1991), 30–47.

2. Franz Cumont, *After Life in Roman Paganism* (New York, 1959; orig. ed. 1922), 110–16.

3. As noted above (chapter 3), Peutinger owned a copy of Suetonius (British Museum), in which the unique surviving Burgkmair woodcuts of the heads of emperors for the projected Kaiserbuch were discovered. Deuchler, "Maximilian und die Kaiserviten Suetons."

4. Stuttgart, 1973, no. 77, with the Burgkmair woodcuts for this never-completed opus magnum. See also Nuremberg, 1971, 162–63, no. 286; Falk, *Hans Burgkmair*, 45–47.

Peutinger did publish in 1505 his study of surviving Roman fragments of inscriptions from the Augsburg area: "Romanae vetustatis fragmenta in Augusta."

5. Peter Halm, "Die 'Fier Gulden Stain,'" 195–222; see for Peutinger and Augsburg antiquities, 206–9, with references; also Wood, "Maximilian I as Archaeologist." The preface of the Peutinger "Fragmenta" begins: "D. imperatoris caesaris Maximiliani pii fidelis augusti, invicti et foelicissimi principis. . ." (fo. 1 v.; quoted 208n65, and also reprinted in König, *Konrad Peutingers Briefwechsel*, 62, no. 36.

6. Nuremberg, 1971, 162, no. 285; Goez, *Translatio imperii*, 111–30; Borchardt, *German Antiquity*, 230–33.

7. For the earlier history of this evolving definition of empire, see Folz, *L'idée d'empire en Occident*.

8. Stuttgart, 1973, no. 28; Falk, *Hans Burgkmair*, 69–70.

9. Innsbruck, 1969, 151, no. 564. Fedja Anzelewsky, *Albrecht Dürer: Das malerische Werk* (Berlin, 1971), 187–99, no. 93; for technical aspects, see Katherine Crawford Luber, *Albrecht Dürer and the Venetian Renaissance* (Cambridge, 2005), 77–125; on the relation to earlier Venetian altarpiece models with doges before the Virgin, see Peter Humfrey, "Dürer's Feast of the Rose Garlands: A Venetian Altarpiece," *Bulletin of the National Gallery in Prague* 1 (1991), 21–33.

10. Falk, *Hans Burgkmair*, 70n433; text from König, *Briefwechsel*, 96–97: "Quos coniunge, ut rebellibus devictis missisque sub iugum fides christiana defendatur facilius propagetur que vehementius."

11. Stuttgart, 1973, nos. 21–22; Silver, "Shining Armor"; Landau and Parshall, *Renaissance Print*, 184–91.

12. Wiesflecker, *Kaiser Maximilian I*, 4:6ff.

13. Ibid., 4:29–30, 5:426–27.

14. Koepplin and Falk, *Lukas Cranach*, 1:63–64, no. 14; Landau and Parshall, *Renaissance Print*, 184–92; Silver, "Shining Armor."

15. Andrew Butterfield, *The Sculptures of Andrea Verrocchio* (New Haven, Conn., 1997); Charles Seymour, *The Sculpture of Verrocchio* (London, 1971), 62–64, 164–65; Gunther Passavant, *Verrocchio* (London, 1969), 68–74, 193–94; Christian-Adolf Isermeyer, *Das Reiterbild des Colleoni* (Stuttgart, 1963). The architecture used as the oblique suggestion of a triumphal arch around the St. George of Burgkmair is also based on a Venetian model: the interior of San Marco's; see Falk, *Hans Burgkmair*, 71n442.

16. Sigrid Braunfels-Esche, *Sankt Georg* (Munich, 1976), esp. 25–29, 87–104, 116–25; Wolfgang Volbach, *Der heilige Georg* (Strasbourg, 1917), esp. 7–15, 21–27.

17. For this concept in relation to German art of this period, see Silver, "Forest Primeval," 21–26.

18. The celebration of St. George's Day on 23 April became a major festival of Elizabethan chivalry, when the queen and her knights made solemn public procession in their robes; Roy Strong, *The Cult of Elizabeth* (London, 1977), 164–85. See also Strong, *Van Dyck: Charles I on Horseback* (New York, 1972), 59–63.

19. For the reliquary, now in St. Paul's cathedral, Liège, see Hugo van der Velden, *The Donor's Image: Gerard Loyet and the Votive Portraits of Charles the Bold* (Turnhout, 2000); *Flanders in the Fifteenth Century*, exh. cat. (Detroit, 1960), 298–99, no. 133. See also Florens Deuchler, *Die Burgunderbeute* (Bern, 1963), 234–36, no. 125, featuring one of Charles's battle standards with saint, dragon, and ducal device, "Je lay emprins." A knightly brotherhood of St. George was founded in Burgundy as early as 1390 (Volbach, *Der heilige Georg*, 22–23).

20. *Friedrich III*, exh. cat. (Wiener Neustadt, 1966), 368–70, nos. 170–72; also Hermann Wiesflecker, "Friedrich III und der junge Maximilian," in ibid., 52.

21. *Friedrich III*, 312, nos. 40–41. Schramm and Fillitz, *Denkmale*, 82, no. 104.

22. Walter Winkelbauer, "Der St. Georgs-Ritterorden Kaiser Friedrichs III" (Ph. D. diss., University of Vienna, 1949); Winkelbauer, "Kaiser Maximilian und St. Georg," *Mitteilungen des österreichischen Staatsarchivs* 7 (1954), 523–50; Josef Plösch, "St.-Georgs-Ritterorden und Maximilians I Türkenpläne von 1493/94," in *Festschrift Karl Eder* (Innsbruck, 1959), 33–56; Volbach, *Der heilige Georg*, 24–27. See in general the items in Innsbruck, 1969, 58–64, nos. 231–51; Wiesflecker, *Kaiser Maximilian I*, 5:446–47, 459–61; 1:345–51; 2:151–65.

23. Otto Cartellieri, *The Court of Burgundy* (London, 1929), 56–62. The crusade imperative became stronger after the fall of Constantinople in 1453 and was renewed at the Feast of the Pheasant at Lille in 1454, ibid., 139–53, and it included the vow to engage the sultan in single combat. See also Malcolm Vale, *War and Chivalry*, 33–51.

24. Georges Duby, *The Three Orders*, trans. Arthur Goldhammer (Chicago, 1980); Giles Constable, *Three Studies in Medieval Religious and Social Thought* (Cambridge, 1995), 249–341.

25. Strauss, *Woodcuts*, 729; Winzinger, *Graphik*, 70: "In sorgen gros unnd gferlikait / Hat er beweyst sein dapferkeit / Daryn got Im sein leben frist / des er Im dannckpar worden ist / Dann mit Im insandt Jorgens ordn / Vil streytpar helt seind bruder worden."

26. Strauss, *Woodcuts*, 730; Winzinger, *Graphik*, 70: "Gros fleys vnnd ernst er fürwent / damit der unglaub werd zutrent / Ein gmeyner Zug solt für sich gon / Desshalb mant er all fürsten schon / Got wol das man Im volg beyzeit / Zu trost der gantzen Christenheit."

27. Benesch and Auer, *Historia Friderici et Maximiliani*, 118, no. 10, fo. 26 r: "De novis eius religionis ritibus et caeremoniarumque institutis."

28. London, British Museum, add. MS 25698. Innsbruck, 1969, 60, no. 231; Hanna Dornik-Eger, "Kaiser Friedrich III in Bildern seiner Zeit," in *Friedrich III*, 64–81, esp. 77–78, 369–70, no. 172; illustrated in Braunfels-Esche, *Sankt Georg*, fig. 137.

29. Peter Diedrichs, *Kaiser Maximilian als politischer Publizist*, 36–37, 44–46, 52–53, 77–84; Georg Wagner, "Maximilian I und die politische Propaganda," in Innsbruck, 1969, 33–35, 45. See also Winkelbauer, "Kaiser Maximilian und St. Georg," in Plösch, "St.-Georgs-Ritterorden," 33–56. In addition to this important early episode, the final call for a crusade was launched in 1517–18: Ferdinand Heinrich, "Die Türkenzugsbestrebungen Kaiser Maximilians I in den Jahren 1517 and 1518" (Ph.D. diss., University of Graz, 1958); see Innsbruck, 1969, 64, nos. 253–54, for the calls for crusade by the general assembly of the estates of Austria (1518) and an answering papal call by Leo X.

30. The chief alteration in the year 1490 was the death of the powerful threat from Hungary, Matthias Corvinus, but in that same year Maximilian was named the successor in Tyrol of Archduke Sigmund. The Treaty of Senlis in 1493 finally secured the Low Countries for Maximilian, and in the same year the death of Frederick III enabled the emperor-elect to assume actual power. In the year 1516 Charles V assumed his majority and became official ruler of the Low Countries as well as Spain. In addition, the war with Venice was broken off in 1516, and the eastern boundaries had become stable and allied with the Habsburgs after the double wedding with Hungary in Vienna in 1515. The years around 1502–3 were marked more by astrological prophecy (see below) than by any other political development.

31. This is essentially the view of Diedrichs, following Heinrich Ullman, *Kaiser Maximilian I* (Stuttgart, 1884–91), 1:179; 2:61ff., 90ff.

32. On the commemorative tapestry cycle produced for Charles V after drawings on site by the Dutch artist, Vermeyen, see Hendrik Horn, *Jan Cornelisz. Vermeijen, Painter of Tunis* (Doornspijk, 1986).

33. Wagner, "Maximilian I und die politische Propaganda," 35; Paul Heitz, *Flugblätter des Sebastian Brant* (Strasbourg, 1915).

34. ". . . vil rich und mechtig landt / Sint dir von erbrecht underthon / Dich forcht all welt und nation / Turck, heiden all ertreich wirt gon / Under din gwalt, gebott, und kron . . . ; Uns widerkuom das hillig land / Gott geb den sig dir an die Handt." Quoted by Wagner, "Maximilian I und die politische Propaganda," 35, who also points out the thinly disguised tribute to the AEIOU motto of Frederick III, usually glossed as "alle erdreich osterrich underthan (all the earth subject to Austria)."

35. "Zu eren romscher kuniglicher maiestat von der vereyn der kunigen und anschlag an die turchen." Quoted by Wagner, "Maximilian I und die politische Propaganda," 35: "Darumb geb gott gluck seld und heyl / den kunigen und christen teyl / Und mag sy syghafft uberwinden / And turcken und all iren fyenden / dardurch fryd mit bestantlicheyt / dem reych werdt und der christengeyt / Und ere dem frumen kunig werd / das er sy herr der gantzen erd."

36. Illustrated in Strauss, *Prayerbook*, 328, fig. 3.

37. Silver, "'Die Guten Alten Istory,'" 71–106, esp. 95–98.

38. Chapter 116: "Die kunigin die sprach herr Ich will / Euch nach notturft zu solchem zug / Mit gutem volck versehen gnug / Unnd was Ir darzu bedurfft mer / Der held sprach Ich wil mein beger."

39. Hermann Wiesflecker, "Kaiser Maximilian I: Seine Persönlichkeit und Politik," in Innsbruck, 1969, 3. Rudolf Buchner, "Kaiser Maximilian als geschichtliche Erscheinung," in *Weisskunig*, 1956, 151. For the Latin text, see *JKSAK* 6 (1888), 423, fo. 7a: "Quando Federicus 3us, imperator coniunctus imperatrici Leonore genuerunt natum Maximilianum, tunc vicerex Bosne ac archiepiscopus Saltzburgensis insimul racionabant de tribus prefatis nominibus unum nomen eligendum. Dictus vicerex Bosne tenuit propositum nominandi eum Maximilianum, viso eo quod sanctus Maximilianus, nam imperator ex devotione, quam habebat, eum Georgium nominare et e converso imperatrix, eum Constantinum, tamquam recuperatorem regni Constantinopolitani, quod illis [tunc?] diebus ab Turcis occupatum fuerat atque abstractum Christianis, animum et cor ad hoc sibi novit. Persuadente tamen sibi prefatus vicerex, quod sanctus ille fuit, qui primo gladio postea in sacramentis maiorem partem. Austriae inferioris ad Christi fidem reduxit et notam magnitudinem habuit, quod per hoc

magis iuvenis iste incitaretur, nomen sancti sui sequi et Turcos ab Bosna regnis et Crocia, Dalmacia ac primo Hungaria repellere, qui Turci tunc fortiter prefata regna depopularunt atque invastarunt."

40. "Ain schaleren mit aufgeendem visier anstelle der bischöflichen Infel haben. . ." *JKSAK* 2, reg. 602. The model for this version of the saint was a lost painting made in 1499, probably by Hans Grasser, after an image of the saint in the chapel of Schloss Thaur near Hall.

41. Vienna, 1959, 125–26, no. 407. Freyda Spira's 2006 dissertation, "Originality as Repetition / Repetition as Originality: Daniel Hopfer and the Reinvention of the Medium of Etching" (University of Pennsylvania) on the oeuvre of Hopfer includes a chapter on his portrait etchings.

42. Koepplin and Falk, *Lukas Cranach*, 60–62, no. 11, fig. 16; Landau and Parshall, *Renaissance Print*, 191–92.

43. Vienna, 1959, 185–86, no. 536, fig. 92; Jeffrey Chipps Smith, *German Sculpture of the Later Renaissance*, 270–73, 338–39, 365–66; Thomas Eser, *Hans Daucher: Augsburger Kleinplastik der Renaissance* (Munich, 1996), 159–65, no. 15; Wilfried Seipel, *Kaiser Karl V (1500–1558)*, exh. cat. (Vienna, 2000), 116, no. 11.

44. Vienna, 1959, 121, no. 396; Innsbruck, 1969, 61, no. 241.

45. Laschitzer, "Heiligen," *JKSAK* 5, 217; Karl Giehlow, "Beiträge zur Entstehungsgeschichte des Gebetbuches Kaisers Maximilian I," *JKSAK* 20 (1899), 30–112; esp. 43. See the sketch on parchment by one of Maximilian's court artists for the painted decoration of a St. George Order Chapel (ca. 1515; Innsbruck Ferdinandeum), Innsbruck, 1969, 64, no. 251.

46. Innsbruck, 1969, 144–45, no. 537, fig. 119. Franz Heinz Hye-Kerkdal, "Eine unbekannte St.-Georgskirche in Ambras," *Tiroler Heimat* 27–28 (1963–64), 53–63; Margot Rauch, *Der Georgsaltar Kaiser Maximilians I und die Sammlung spätmittelalterlicher Bildwerke auf Schloss Ambras*, exh. cat. (Innsbruck, 1996), no. 1; Seipel, *Werke für die Ewigkeit*, 66–67, no. 23.

47. Innsbruck, 1969, 62, no. 244, fig. 40; *Friedrich III*, 368–69, no. 170, fig. 26.

48. Innsbruck, 1969, 61–62, no. 242, fig. 39; *Friedrich III*, 369, no. 171, fig. 22.

49. Innsbruck, 1969, 62, nos. 245–46; Vienna, 1959, 18–19, nos. 58–59: "Calendarium per universum religionem militaris ordinis sancti Georgii observandum."

50. The state of research is summarized by Diane Strickland, "Maximilian as Patron." The chief study of this project remains Giehlow, "Beiträge." A recent facsimile

edition with commentary is Walter Strauss, ed., *The Book of Hours of the Emperor Maximilian the First* (New York, 1974), with bibliography, and a facsimile of the Munich fragment has commentary by Hinrich Sieveking, *Das Gebetbuch Kaiser Maximilians: Der Münchner Teil* (Munich, 1987). Most recently see Magdalena Bushart, *Sehen und Erkennen: Albrecht Altdorfers religiöse Bilder* (Munich, 2004), 159–92, a sensitive analysis of the neglected final contributions by Altdorfer.

51. Carl Wehmer, "Mit gemäl und schrift: Kaiser Maximilian I und der Buchdruck," in *In libro humanitas. Festschrift für Wilhelm Hoffmann* (Stuttgart, 1962), 244–75.

52. *JKSAK* 13 (1892), no. 8594; see also *Weisskunig*, 1956, 92–93, doc. no. 15.

53. Reprinted in *Weisskunig*, 1956, 93, doc. 16; from *JKSAK* 13, reg. 8597.

54. Innsbruck, 1969, 63, no. 249; Vienna, 1959, 19, no. 61.

55. Giehlow, "Beiträge," 43–45, 101–2. The dictation to Treitzsaurwein is in Vienna, National Library, no. 2835, fo. 39.

56. On Maximilian's literary projects, see Hans Rupprich, "Das literarische Werk Kaiser Maximilians I," in Innsbruck, 47–50; see also the discussion of the importance of learning for the ruler and his advisers in chapter 6, below.

57. *JKSAK* 6 (1885), 425. Giehlow also refers to the contrast between *Fluch*, a curse, and *Andachtsspruch*, literally devotional speech, or prayer.

58. For the woodblocks of the *Arch* and information in general concerning Dürer woodblocks, see Schauerte, *Ehrenpforte*, 427–50. Scholars have debated about whether the marginal drawings of the *Prayerbook* were a unique decoration for the emperor's copy alone or else a design for replication. Giehlow was followed in his woodcuts argument by Panofsky, *The Life and Art of Albrecht Dürer*, 182; Wehmer, "Mit gemäl und schrift," 245–46; and Strauss, *Prayerbook*, 321. The argument for the uniqueness of the drawings was first advanced by Eduard Chmelarz, "Das Diurnale oder Gebetbuch Kaiser Maximilians I," *JKSAK* 3 (1885), 88–102, esp. 92. This view was later endorsed by Georg Leidinger, *Albrecht Dürers und Cranachs Randzeichnungen im Gebetbuch Kaiser Maximilian I in der Bayrischen Staatsbibliothek zu München* (Munich, 1922), 11; Hans Christoph von Tavel, "Die Randzeichnungen Albrecht Dürers zum Gebetbuch Kaiser Maximilians," *Münchner Jahrbuch der bildenden Kunst* 16 (1965), 56; Sieveking, *Gebetbuch Kaiser Maximilians*, xi–xii. Most recently Bushart, *Sehen und*

Erkennen, 159–60, presents a balanced view but suggests overall that the subtlety of the text-image relationships, directed chiefly at Maximilian as possessor, and the assertively personal and varied signature styles of the drawings (newly admired by connoisseurs, esp. for Dürer and Altdorfer) point to a unicum rather than a design for woodcuts. Among the unpublished recent studies, Strickland opts for the woodcut hypothesis, while the drawings view is maintained by Christa Burgoyne, "The Prayerbook of Emperor Maximilian I: Art Making and Its Circumstances," (M.A. thesis, University of California, Berkeley, 1979).

59. On Ratdolt and Burgkmair, see Falk, *Hans Burgkmair*, 13–20; Stuttgart, 1973, nos. 1–10. On Ratdolt as innovator, see Karl Schottenloher, *Die liturgischen Druckwerke Erhard Ratdolts aus Augsburg 1485–1522 Typen und Bildproben* (Mainz, 1922). Systematic study of Ratdolt is a major research need within the early history of the book.

60. Dürer's mixture of facing inks include fos. 16v–17r, 51v–52r, and 55v–56r (purple with green). Dürer's portion intersects with Burgkmair's in two tones, green and red, fo. 56v–57r, and a similar polychrome junction occurs between Baldung and the Altdorfer workshop, fo. 73v–74r (olive with red), or Baldung and Jörg Breu, fo. 75v–76r (olive with green). Breu, in particular, seems to have delighted in constantly changing inks as he changed pages, and he even mixed green on the same page as Baldung's earlier olive decoration (77v), in the only mixed margin on a single folio in the *Prayerbook*.

61. Giehlow, *Gebetbuch*, 47–48, 52–54.

62. Translations taken from Strauss, *Prayerbook*, here from 46. The earlier prayer, 17, reads: "Almighty and everlasting God, who graciously hearest the voices of them that pray: We humbly beseech thy majesty, that in honor of the blessed and glorious George thou didst choose to conquer the dragon by a maiden, so that by his intercession thou wilt deign to go before our enemies, seen and unseen, lest they do us harm."

63. On Dürer's Charlemagne and his drawing of the ceremonial sword, "Keiser Karls schwert," see Nuremberg, 1971, 138–39, nos. 251, 256.

64. This image occurs at the end of a passage from Psalm 110: "The Lord said unto my lord: Sit thou at my right hand, until I make thine enemies thy footstool. The Lord shall send the rod of thy strength out of Zion: rule in the midst of thine enemies . . ." This text would surely have consoled Maximilian, who felt himself always beset by enemies from the Turks to the French, as well as within the boundaries of the empire. The text adjacent to the Breu David is Psalm 113, and it speaks of how the Lord can also raise up the humble, like David, to "set him with princes, even princes of his people."

65. *Weisskunig*, 1956, 334.

66. Bushart, *Sehen und Erkennen*, 175–76.

67. Malcolm Vale, *War and Chivalry*, 33–62; Gunnar Boalt, Robert Erikson, Harry Glück, and Herman Lantz, *The European Orders of Chivalry* (Carbondale, Ill., 1971).

68. Rather than Jakob Mennel, who resided at Freiburg and would have been the connection to Baldung. Cited and reconstructed by Strauss, *Prayerbook*, 325; originally cited by Giehlow, "Dürer's Entwürfe für das Triumphrelief," 71. The reattribution of the artist intended to Altdorfer rather than Baldung was made by Strickland, "Maximilian as Patron," 67–68. She correctly points out the careful emulation of Dürer's example by Altdorfer in his Trinity (fo. 144r; cf. fo. 21r), mounted knights (fo. 145v; cf. fo. 55v) and standing king (fo. 147v; cf. fo. 25v or 16v). In addition, Altdorfer decorative forms emulate the prior examples of Dürer: fox and rooster (fo. 146v; cf. fo. 34v), column on fantastic base (fo. 147r; cf. fo. 53r), and peasant women (fo.152v, 155v; cf. fo. 51v).

69. Strickland, "Maximilian as Patron," 69–71, reminds us that six quires have been lost from the Besançon portion of the *Prayerbook*; these would surely have been decorated if the project were completed (cf. Strauss, *Prayerbook*, 335, indicating that these quires are numbered XVII, XIX, and XXI–XXIV out of the total of twenty-seven). The fact that Baldung's images are mixed in with those of Breu as well as the Altdorfer workshop serves to indicate that Breu, like Altdorfer, was one of the final artists to work on the project. Bushart, *Sehen und Erkennen*, 160, argues for Altdorfer's role in the missing quires (fos. 119–40), and she considers Altdorfer's decorations for the segments of the Office of the Virgin and the Hours of the Cross to have the integral relationship of Dürer rather than the more uncoordinated approach of the remaining artists, 161-92.

70. Tavel, "Die Randzeichnungen," esp. 55–73. See also the modifications and refinements made to Tavel's interpretation by Ewald Vetter and Christoph Brockhaus, "Das Verhältnis von Text und Bild in Dürers Randzeichnungen zum Gebetbuch Kaiser Maximilians," *Anzeiger des Germanischen Nationalmuseums* (1971–72), 70–121, esp. 85 on the importance of St. George and the crusade program.

71. On the engraving and its meaning, see the monograph by H. Thaussing, *Dürers Ritter Tod und Teufel: Sinnbild und*

Bildsinn (Berlin, 1978). On the subject of death in Dürer and in Baldung as an eternal theme in dialogue with life and sensual self-awareness, see Joseph Koerner, "The Mortification of the Image: Death as Hermeneutic in Hans Baldung Grien," *Representations* 10 (1985), 52–101.

72. See also the decorative frame of fo. 19r; the seductive piping fox of fo. 34v; 38v; trumpeters and drummers, the musicians of court or the battlefield, in the positive context of a psalm of praise, fo. 50r; and the bagpiper with dancing peasants, fo. 56v.

73. Nuremberg, 1971, 276, no. 518; Koeppin and Falk, *Lukas Cranach*, 2:610–11, no. 522; Anzelewsky, *Albrecht Dürer: Das malerische Werk*, 168–70, no. 67.

74. The classic study of the choice of Hercules and in general for the significance of the hero during the Renaissance is Panofsky, *Hercules am Scheidewege*; for the Dürer engraving and other examples of the hero in German art during this period, see Silver, "Forest Primeval," 19–21, with references. On the general identification of Hercules with rulers, see, for example, Cox-Rearick, *Dynasty and Destiny in Medici Art*, or for the later Spanish example of Zurbaran, Jonathan Brown and J. H. Elliott, *A Palace for a King* (New Haven, Conn., 1980), 156–61.

75. For the woodcut, see Vienna, 1959, 133, no. 431. For the emblem, see Earl Rosenthal, "The Invention of the Columnar Device of Emperor Charles V at the Court of Burgundy in Flanders in 1516," *Journal of the Warburg and Courtauld Institutes* 36 (1973), 198, 211. See the later manifestation of Charles VI as Hercules, in Franz Matsche, *Die Kunst im Dienst der Staatsidee Kaiser Karls VI* (Berlin, 1981), 343–71; also the general observations of Bruck, "Habsburger als 'Herculier,'" 191. On the identification of Maximilian with Hercules, see Florens Deuchler, "Maximilian und die Kaiserviten Suetons"; McDonald, "Maximilian of Habsburg and the Veneration of Hercules"; Friedrich Polleross, "From the Exemplum Virtutis to the Apotheosis: Hercules as an Identification Figure in Portraiture. An Example of the Adoption of Classical Forms of Representation," in Allan Ellenius, ed., *Iconography, Propaganda, and Legitimation* (Oxford, 1998), 37–62.

76. Panofsky, *Hercules am Scheidewege*, 85; cf. also the study by Dieter Wuttke, *Die Histori Herculis des Nürnberger Humanisten* (Cologne, 1964), with bibliography, and Koepplin and Falk, *Lukas Cranach*, 626–28, nos. 533–34.

77. Silver, "Forest Primeval," 20–27. On the Christian interpretation of Hercules, see Milton's Nativity Ode, or the study of Marcel Simon, *Hercule et le Christianisme* (Paris, 1955). For the relationship between Samson and Hercules,

see Koepplin and Falk, *Lukas Cranach*, 604–12, and in the following century, W. Tissot, "Simson und Hercules in den Gestaltungen des Barock" (Ph.D. diss., University of Greifswald, 1932). Another parallel between the heroes is their undoing by women, Hercules by Omphale and then Deianeira, Samson by Delilah; see Koepplin and Falk, *Lukas Cranach*, 562–85, nos. 471–73.

78. On the sensuous aspects of monkeys, H. W. Janson, *Apes and Ape Lore in the Middle Ages and the Renaissance* (London, 1952), 199ff., 261ff. See also the ape on fo. 42v, in the company of a swan and a turbaned oriental with camel, called by Tavel part of the trilogy of pictures depicting the theme of "temptation and the foes of the true faith." On fo. 63r, Cranach picks up this motif from Dürer and includes an entire monkey family in the branches of a tree above a couple of resting elk and a fox, and Altdorfer emulates Dürer's monkeys on fo. 111v, with a humanoid family group pouring out a tankard (in the company of a hunter).

79. Tavel, "Die Randzeichnungen," 99, invokes the Christian sense of the rooster, namely his traditional function of awakening, as in the rooster who crowed for St. Peter after his denial. That Dürer was aware of the use of the term *Hahn* for both watercock, or faucet, and penis can be glimpsed in his visual pun of a faucet surmounted with a small cock in the woodcut of the *Men's Bathhouse* (B. 128), placed suggestively in front of the crotch of the lounging figure at the left. See fo. 12r, the scene of the soldier confronting the figure of death, where in the margin, the rooster is contrasted with the vigilant and powerful figure of a falcon, shown elsewhere on the page in victorious conquest of a heron in the sky. As if in corroboration of this *in malo* vision, Dürer places a cock on the top of a fantastic column (fo. 53r), whose sinister face and animal feet strongly suggest pagan and immoral hybrid growth (though Tavel, 114, and Vetter and Brockhaus, "Das Verhältnis," 108, both see this column positively in conjunction with the mariological text, though Vetter and Brockhaus propose that the face on the column is that of the vanquished infidel or evil), opposed to the bishop saint and Christ Child on a donkey on the verso of the same page. If that image can be read ambiguously, with the rooster possibly crowing the good news of the true faith above a column of the vanquished pagans or infidels, the same cannot be said for the silly chickens, who are seduced by the flute-playing fox on fo. 34v. There also can be no ambiguity about the luxuriant growth that includes a rooster head

as well as a snake in the tendrils of the acanthus next to the drunkard and Hercules on fo. 47r.

80. Tavel, 101; Giehlow, "Die Hieroglyphenkunde," 1–21. Panofsky, *Life and Art of Albrecht Dürer*, 189–90, quite properly associates this rendition of the unicorn with the sinister and powerful beast ridden by Pluto and shown by Dürer in his 1516 etching *The Rape on a Unicorn* (B. 72), yet traditionally in the context of courtly love, this animal is also singled out for his gentleness as well as his strength, and in this case the animal might be allegorized as an image of the divine, analogous to David in prayer before the Lord on the opposite page. On the unicorn, see Francis Klingender, *Animals in Art and Thought to the End of the Middle Ages* (Cambridge, Mass., 1971), 463–68. The crane appears, toothless but watchful, as the ornament to St. Apollonia (fo. 24r), above the figures of the knight, death, and the devil (fo. 37v), and superior to the other birds in the margin of fo. 38v, where bagpipers, a hermit, and a lion all coexist below in accord with the psalm (8) text, ". . . and the beasts of the field, the fowl of the air, and the fish of the sea" (Vetter and Brockhaus, "Das Verhältnis," 97). A similar bird with upturned gaze stands above the American Indian and the other creatures of the earth (in which is included an imperial shield) on fo. 41r, so that there may well be some metaphorical identification of this positive bird and Maximilian himself, the vigilant vicar of Christ on earth. In its final appearance (fo. 48v), the crane above, near the watchful dog at the top, contrasts with the sleeping old spinster below but echoes the standing soldier in the corner; the context is a psalm of judgment (97).

81. On the swan and carnality, see Vetter and Brockhaus, "Das Verhältnis," 108n180, also 97n140 for the long neck allegorized as pride.

82. On the stag hunt as a function of courtly love, as well as the identification of the stag with his noble hunter, à la Actaeon, see Klingender, *Animals*, 468–73. Also Marcel Thiebaux, *The Stag of Love* (Ithaca, N.Y., 1977). It may well be significant that St. Maximilian appears on the verso of this page with St. Andrew. The Horapollo text also glosses the deer as a symbol of longevity, and in addition to a lion skin on one side of the *Arch*, Dürer assigns a deer skin for the proud inscription on the other side (Panofsky, *Life and Art of Albrecht Dürer*, 178). Lucas Cranach, the great hunt painter of the dukes of Saxony (see chapter 6) took up Dürer's stag motif in numerous marginal drawings later in the *Prayerbook*: fos. 63r, 63v, 64r, 65r, 66r, but these seem to have no symbolic significance.

83. Vetter and Brockhaus, "Das Verhältnis," 90; Giehlow, "Die Hieroglyphenkunde," 199.

84. The previous psalm (46) declares: "I am God. I will be exalted among the heathen." As Vetter, 100, observes, the final phrase "Dominus virtutum nobiscum . . ." could ambiguously be taken to refer to Maximilian as emperor in addition to God, and it is against such heathens that Maximilian wishes to conquer in the name of God.

85. Tavel, "Die Randzeichnungen," 115–16. Vetter and Brockhaus, "Das Verhältnis," 82, see these juxtaposed images as complementary rather than contrasting, or homologous between the crown of thorns and the laurel crown, and as echoing the glory of God in the garlands held by the cupid; however, the grimacing *Blattmask* at the top cannot easily be taken in a positive light. The cupid should probably be seen in the worldly, pagan tradition of Eros (cf. the Stabius text from the *Arch*), where he acts with Venus as part of the ovations for an emperor. Given Maximilian's own interest in such occult fields as alchemy (see below), it is conceivable that this mysterious image could be taken as somehow tied to the manifold powers of the deity. See also the Dürer drawing from his first trip to Venice (1494; Vienna, Albertina, W. 87), showing not only a pagan subject, the Rape of Europa, but also a garlanded Apollo alongside a turbaned oriental with a skull and a similar, radiating alchemist's globe, labeled "Lutu. s." (that is, "*lutum sapientiae*," or seal of wisdom); see Nuremberg, 1971, 265, no. 505. More generally on Dürer, Altdorfer, and alchemy, see Larry Silver and Pamela Smith, "Splendor in the Grass: The Powers of Nature and Art in the Age of Dürer," in Pamela Smith and Paula Findlen, eds., *Merchants and Marvels: Commerce, Science, and Art in Early Modern Europe* (New York, 2002), 29–62.

86. Tavel, "Die Randzeichnungen," 57. Panofsky, *Life and Art of Albrecht Dürer*, 185–87. On the German reception of the Italian grotesque ornament and its possible interpretation, see Carsten-Peter Warncke, *Die ornamentale Groteske in Deutschland 1500–1650* (Berlin, 1979); also, Valentin Scherer, *Die Ornamentik bei Albrecht Dürer* (Strasbourg, 1902).

87. Giulia Bartrum, *Albrecht Dürer and His Legacy*, exh. cat. (London, 2002), 190, no. 131; see also W. 715, 191, no. 133.

88. Paul Post, "Zum 'silbernen Harnisch' Kaiser Maximilians I von Coloman Kolman mit Ätzentwürfen Albrecht Dürers," *Zeitschrift für historische Waffen- und Kostumkünde*, new series, 6 (1939), 253–58.

89. Charles Talbot, ed. *Dürer in America*, exh. cat. (Washington, D.C., 1971), 80–82, no. xxiv; Cara Denison and

Helen Mules, *European Drawings 1375–1825* (New York, 1981), 60, no. 34.

90. The terms are those of Ernst Gombrich, *The Sense of Order* (Oxford, 1979), with the *Prayerbook* on 251–54 in a general discussion of decorative monsters, "fantasy and menace."

91. Vienna, National Library, cod. vind. 1907. Facsimile ed. by Wolfgang Hilger, *Das ältere Gebetbuch Maximilians I* (Graz, 1973). Giehlow, "Beiträge," 48–51; Vienna, 1959, 13, no. 38. For the wider context of later Flemish manuscript illumination as well as the particulars of this luxury prayerbook, see Thomas Kren and Scot McKendrick, *Illuminating the Renaissance*, exh. cat. (Los Angeles, 2003), 190–98, 305–8, 316–34, 358–61, 374–79, 414–17, esp. 190–91.

92. Kren and McKendrick, *Illuminating the Renaissance*, 126–57; Anne Hagopian van Buren, "The Master of Mary of Burgundy and His Colleagues: The State of Research and Questions of Method," *Zeitschrift für Kunstgeschichte* 38 (1975), 286–309.

93. Strauss, *Prayerbook*, 321, 327–28.

94. Indeed, Giehlow, "Beiträge," 48ff., argues that the manuscript dates from the early sixteenth century on the basis of its partial "Renaissance" paleography. He argues that the sixth prayer postdates the Bruges imprisonment and was conditioned by it: "Rogo te ... ut me nunquam tradas in manus inimicorum meorum." Several other prayers seem to derive from the 1486 coronation, for example, prayers 32–35 ("Tu elegisti me regem populo").

95. London, formerly Seilern coll. (now in the British Museum). Otto Pächt, *Vita Sancti Simperti* (Berlin, 1964); Katharina Krause, *Hans Holbein der Ältere* (Munich, 2002), 76–79.

96. Pächt, *Vita Sancti Simperti*, 10–11n7.

97. Wehmer, "'Mit gemäl und schrift.'" See also Wehmer's facsimile of Wagner's *Proba centum scriptuarum* (Leipzig, 1963).

98. Pächt, *Vita Sancti Simperti*, 12. Both works are lost.

99. See also Erich Steingräber, "Die Augsburger Buchmalerei in ihrer Blütezeit," in Hermann Rinn, ed., *Augusta 955–1955* (Munich, 1955), 173–86; Krause, *Hans Holbein*, 349n138.

100. Although not religious in their subjects, the frescoes (lost) in the old Augsburg City Hall by Jörg Breu the Elder were expressly dedicated to Maximilian to seal the special bond between the emperor and the imperial city; these too were collaborations by Ulrich Maurmüller and Ulrich Apt; see Cuneo, *Art and Politics in Early Modern Germany*, 102–19.

101. Innsbruck, 1969, 58, no. 224, fig. 38.

102. Falk, *Hans Burgkmair*, 71–72: "Imp. Cae. Maximilianus Aug. Chori huius primum a fundmentis lapidem posuit ex aidificatione quae eius solita liberalitate iuuit. Ann M D III kls julias." The calligraphy of the drawing was penned by Leonhard Wagner. Cf. the inscription on the painting of the cornerstone: "JESU CHRISTO SACRUM / MAXIMILIANUS RO. CAESAR AUGUST / AD III. IDUS JULIAS A FUDAMETIS / LAPIDEM HUNG PRIMUM POSUIT / ANNO MD."

103. Innsbruck, 1969, 145, no. 538, plate 5. Documents record a payment to Kölderer for this picture in 1500.

104. For the sculpture, see Otto, *Gregor Erhart*, 56, 89. For the theme, see Baxandall, *The Limewood Sculptors of Renaissance Germany*, 165–72.

105. For Waldauf, see Wiesflecker, *Kaiser Maximilian I*, 5:244–47. For his portrait by Marx Reichlich, see Innsbruck, 1969, 85, no. 322.

106. For the following on Waldauf's collection and the Burgkmair woodcuts for his Heiltumbuch, see Josef Garber, "Das Haller Heiltumbuch," *JKSAK* 32 (1915), esp. 54–172; Falk, *Hans Burgkmair*, 62–64; Innsbruck, 1969, 86, no. 325; Stuttgart, 1973, no. 37. See West, "Hans Burgkmair the Elder."

107. This woodcut of the gathered leaders of the faith shows Maximilian with the double eagle of the empire for his arms, whereas the other woodcut with Philip the Fair shows only the single eagle of the king of the Romans, that is, before the coronation at Trent in 1508; in this respect, the heraldry, within the chain of the Order of the Golden Fleece, most closely resembles the kingdoms portrayed on the Goldenes Dachl in Innsbruck. A portrait of Maximilian appears as woodcut no. 17, Garber fo. 108 (cf. the manuscript drawing of the layout, fig. 1).

108. Observed by Giehlow, "Beiträge," 42n3. The portrait of Waldauf by Marx Reichlich (1500–1505) from the chapel shows the donor accompanied by his name saint, Florian, with the putative features of Maximilian, but in addition St. George stands behind him.

109. This event formed the basis of the episode at sea in the "Unfalo" (Accident) section of *Teuerdank*: chap. 46, fo. 211, woodcut by Schäufelein, altered by Beck. See related rescues at sea by the hero in chaps. 32 (fo. 143), 43 (fo. 194), 64 (fo. 286), and 72 (fo. 324).

110. On Frederick and Leopold, see *Friedrich III*, 226–30, 365–68, nos. 164–69. See also *Der heilige Leopold*, exh. cat. (Klosterneuburg, 1985), esp. 50, 69–74.

111. Wiesflecker, *Kaiser Maximilian I*, 3:332n32.

112. *Heilige Leopold*, 95, 242–44, nos. 215–20; for Frueauf, see Ludwig von Baldass, *Conrad Leib und die beiden Rueland Frueauf* (Vienna, 1946), 55–58.

113. "Mitsambt den figuren darinne begriffen am ersten auf Latein und nachmals Teutsch." Quoted by O. Hase, *Die Koberger*, 2nd ed. (Leipzig, 1885), cliii–iv; Garber, "Das Haller Heiltumbuch," xii–xiv; Nuremberg, 1971, 192–93, no. 365. See also *JKSAK* 2 (1884), reg. 709. The illustrations were provided by the Dürer workshop after his drawings; *Meister um Albrecht Dürer*, exh. cat. (Nuremberg, 1961), no. 397.

114. "Liber octo quaestionum ad Maximilianum Caesarem," 1508. Giehlow, "Beiträge," 40–41; Vienna, 1959, 60, no. 196; Innsbruck, 1969, 105, no. 398; Wiesflecker, *Kaiser Maximilian I*, 5:349.

115. Hans Rupprich, "Literarische Werk," in Innsbruck, 1969, 49. Also included in the list is *Swartzkunnstpuech*, a book on black magic (see below), and *Zauberpuech*, a book of magic.

116. Wiesflecker, *Kaiser Maximilian I*, 4:270–71nn6–9.

117. Strauss, *Woodcuts*, 730. "Zu Trier in der beruembten stat / Sein kaiserliche Maiestat / Den Rock des herren Jesu Crist / Gefunden hat wie ir dann wist / Erhebt sand Leopold desgleich / Ein Marggarven von Osterreich."

118. Wiesflecker, *Kaiser Maximilian I*, 4:91ff.nn2, 11; 5:431–32; Wiesflecker, "Neue Beiträge," 311–32; Wiesflecker, "Kaiser Maximilian I und die Kirche," in W. Baum, ed., *Kirche und Staat in Idee und Geschichte des Abendlandes: Festschrift Ferdinand Maass zum 70. Geburtstag* (Vienna, 1973), 143–65.

119. Benesch and Auer, *Historia Friderici et Maximiliani*, 120, no. 16, fo. 38r: "De tempore et loco nativitatis Maximiliani caesaris, quibusdamque eius gestorum initiis."

120. Larry Silver, "Nature and Nature's God: Landscape and Cosmos of Albrecht Altdorfer," *Art Bulletin* 81 (1999), 194–214.

121. *Weisskunig*, 1956, 325.

122. *Weisskunig*, 1956, 326.

123. The classic study remains Fritz Kern, *Gottesgnadentum und Widerstandsrecht im früheren Mittelalter*, 2nd ed. (Darmstadt, 1954), 1–137. For the French kings, see Bloch, *The Royal Touch*; and Percy Schramm, *Der König von Frankreich* (Weimar, 1939); also Schramm, *A History of the English Coronation* (Oxford, 1937). Related to this sanctity is the cultural fiction of the invisible, eternal "body" of the king, surveyed and magisterially in Kantorowicz, *The King's Two Bodies*; Sergio Bertelli, *The King's Body: Sacred Rituals of Power in Medieval and Early Modern Europe*, trans. Burr Litchfield (University Park, Pa., 2001).

124. Kantorowicz, *King's Two Bodies*, 42–86, studying especially *de consecratione pontificum et regum*, on the ordination and anointing of both pope and king. See also the specifically Germanic claims by Emperor Frederick II, 97–143.

125. Kantorowicz, *The King's Two Bodies*, 46, quoting from *Monumenta Germania Historica*.

126. Robert Folz, "Zur Frage der heiligen Könige: Heiligkeit und Nachleben in der Geschichte des burgundischen Königtums," *Deutsches Archiv für Erforschung des Mittelalters* 14 (1958), 317–44; Hauck, "Geblütsheiligkeit."

127. On the concept of *dei gratia*, see Kern, *Gottesgnadentum*, 79–80, 257–60; on the cult of Charlemagne, see Braunfels and Schramm, eds., *Karl der Grosse IV*, esp. Matthias Zender, "Die Verehrung des hl. Karl im Gebiet des mittelaltarlichen Reiches," 100–112; Folz, *Le souvenir et la legende de Charlemagne*; Folz, *Etudes sur le culte liturgique de Charlemagne dans les eglises de l'empire* (Paris, 1951).

128. "Zu verwundern nit ein klein / Das ein einiges mensch allein / Sovil böser menschen anschleg / Ist enndtgangen so in vil weg. . . . Er ist ein mensch unnd doch nit mer / Darumb ich mich verwunder ser / Das Er noch gesundt bey leben ist / Ich glaub got hab im anfanng gewis t / Das Er durch disen khuenen Heldt / Wel würcken noch in diser welt / Vil sach der Cristenheit zugut / Darumb Er biszher hat behut / Den Held vor aller diser not / Sonnst wer Er lanngst gelegen todt."

129. Vienna, National Library, cod. vindob. 7892, fos. 23r, 25r.

130. Wiesflecker, *Kaiser Maximilian I*, 4:425ff.

131. Oberhammer, *Bronzestandbilder*, 29–30. Kathleen Cohen, *Metamorphosis of a Death Symbol* (Berkeley, Calif., 1973), with details of Maximilian on 56n31. The full testament is published in *JKSAK* 1 (1883), reg. 480.

132. Innsbruck, 1969, 66, no. 259, fig. 42. See also Eisenbeiss, "Porträts," 248–54.

133. Oberhammer, *Bronzestandbilder*, 30, quoting Cuspinian, *De caesaribus et imperatoribus*: "interred there [Wiener Neustadt] under the altar of St. George, so that the priest at the elevation of the holy activity comes to stand above the breast of the corpse." I am also grateful for these observations to the careful research of Deborah Taylor Cashion in her master's thesis on the Maximilian tomb (University of California, Berkeley).

134. "sollen unser personn, unser vatter undkhaiser Carl und sonst noch zween neben unser am vordersten und darnach neben den venstern aber vier pilder und also nach

der ordnung ob den altärn gestellt werden." Quoted and analyzed by Karl Oettinger, "Die Grabmalkonzeptionen Kaiser Maximilians," *Zeitschrift des deutschen Vereins für Kunstwisssenschaft* 19 (1965), 170–84, who, however, understands these directions as the rantings of a fevered and delirious dying man, recalling the original wishes of his father for the George Chapel in Wiener Neustadt.

135. Schauerte, *Ehrenpforte*, 334–35; the basic study of the marble tomb of Frederick III by Nicholas Gerhaert van Leyden remains Friedrich Wimmer and Ernst Klebl, *Das Grabmal Friedrichs des Dritten im Wiener Stephansdom* (Vienna, 1924).

136. Cohen, *Metamorphosis*, 117–18.

137. This is the contrast drawn by Cohen, but it is echoed in the conceptual framework of Philippe Aries, *Hour of Our Death*, trans. Helen Weaver (New York, 1982), part 2. See also the remarks on Renaissance tombs in Panofsky, *Tomb Sculpture*, esp. 76–83, contrasted with the *transis*, 56, and with 63–66 for the double-decker tombs analogous to Maximilian's double effigies of corpse and bronze.

138. Kantorowicz, *King's Two Bodies*, 383–437, esp. 431–37, for the relationship of this concept to the double-decker tombs of France, seen here as analogous to Maximilian's own altar burial. See also his analysis of the funeral of Francis I, 425–26, whose body in its coffin was displayed for about ten days in the hall of the palace, only to give way to a lifelike effigy of the king, made by François Clouet, with "imperial" crown, scepter, and "*main de justice*" alongside with rich materials and heraldic insignia as decoration. See in general for France, Ralph Giesey, *The Royal Funeral Ceremony in Renaissance France* (Geneva, 1960).

139. Cohen, *Metamorphosis*, 133–81. Panofsky, *Tomb Sculpture*, 76–81.

140. Cohen, *Metamorphosis*, 120–32. She argues that these were the living figures of the deceased rather than their transfigured souls on account of the absence of prayer, the presence of crowns and royal robes, and the use of angels to carry heraldic arms rather than to welcome the figures, as in English precedents. Of course, this assertion of dynasty and identity through arms comes quite close to Maximilian's precedent, doubtless known to his own daughter, Margaret. For Brou, see Jens Ludwig Burk, "Conrat Meit-Bildhauer der Renaissance," in Renate Eikelmann, ed., *Conrat Meit: Bildhauer der Renaissance*, exh. cat. (Munich, 2007), 40–50.

141. Innsbruck, 1969, 67–68, no. 265; Vienna, 1959, 135, no. 436, fig. 64. Jeffrey Chipps Smith, *Nuremberg: A Renais-*

sance City 1500–1618, exh. cat. (Austin, Tex., 1983), 157, no. 57. Cited translations are taken from this catalogue entry.

142. "Nunc ad sidereas sedes super astra recept. / Aeterna frueris vita: te gloria Christi."

143. Innsbruck, 66–67, no. 261, fig. 50; Vienna, 1959, 130, no. 423.

144. Vienna, National Library, cod. vindob. 3076–77; Vienna, 1959, 62, nos. 203–4.

145. "Regibus gaudet que alii id circo singula singulis reddendo insignia eiusdem percelebri hoc militari Cruciferorum speculo primu merverunt obtinere locu. Residuoa vero huius Speculi que singula horum ordinum concernunt: laitus qui scire desiderat dicti Manlii libru quem de dMilitaribus Christi ordinibus nuper edidit petat." In the bottom section of text, concerning the cheerful death of the emperor ("felicissimo eius obitu"), the same words as Christ on the cross are repeated by the dying Maximilian: "In manus tuas commendo spiritum meu."

146. Giehlow, "Beiträge," 43, 101–3, appendix 1: "Entwurf zu einer Andachtpforte, nach mündlichen Angaben Kaiser Maximilians I von Marx Treitzsauerwein 1512." Taken from Vienna, National Library, cod. vind. 2835, fo. 26v–30. This program has been disputed by Schauerte, Ehrenpforte, 40–41, who sees instead that the Andachtspforte is rather an earlier, discarded plan for the tomb ensemble that was transformed into the eventual form of the *Arch*.

147. Illustrated, Giehlow, *Gebetbuch*, fig. 1: "Schreib mein grabstifft unnd sand Jorgen orden / auch mein geschlect und stamen auserkoren."

5 | Shining Armor: Emperor Maximilian, Chivalry, and War

1. F. H. Cripps-Day, *A History of the Tournament in England and France* (London, 1918), 82–90; R. Harvey, *Moriz von Craun and the Chivalric World* (Oxford, 1961), 113–216; Sydney Anglo, *The Great Tournament Roll of Westminster* (Oxford, 1968), 19–40.

2. Larry Silver, "*Caesar ludens*: Maximilian I and the Waning Middle Ages," in Penny Schine Gold and Benjamin Sax, eds., *Cultural Visions: Essays in the History of Culture* (Amsterdam/Atlanta, 2000), 173–96.

3. Jan-Dirk Müller, *Gedechtnus*, 137–44.

4. For the *Procession*, see Stanley Appelbaum, ed., *The Triumph of Maximilian I*, with translations; also Schestag, "Kaiser Maximilian I. Triumph"; Appuhn, ed., *Der Triumphzug Kaiser Maximilians I.*

5. Leitner, *Freydal*, xxviii–xxix, xliii–xlv.

6. Leitner, *Freydal*; Müller, *Gedechtnus*, 104–8.

7. *Albrecht Dürer 1471–1971*, exh. cat. (Nuremberg, 1971), 148, no. 265. Strauss, *Woodcuts*, 522–32, nos. 182–86. Notations on woodcut no. 5, a mummery of a torch dance, mention Hieronymus Andreae as the cutter of the block, whereas no. 1, a *Rennen* joust, lists the address of Hans Glaser, *Briefmaler*, or tinter of woodcuts in Nuremberg.

8. Strauss, *Woodcuts*, 730. Winzinger, *Graphik*, 70: "Er hat getriben ritterspil / darin ertzeigt auch kurtzweil vil / Mit warheit ich das sprechen kan / als vormals ine kein furst hat than / Das alles doch mit solhem schimpf / Daraus im kam lob eer un glimpf."

9. Falk, *Hans Burgkmair*, 74–76; Silver, "Shining Armor." A document of 1559 by Hans Burgkmair the Younger, petitioning Emperor Ferdinand I, avers that ". . . his father and he had served our beloved lord's ancestor and brother Emperor Maximilian and Emperor Charles [V] in most praiseworthy memorial [*Gedechtnuss*] with the designing [*mallung*] of armor, likewise with help in etching and understanding the nature of armor both tirelessly and obediently . . ." (cited in Falk, 74n477). On the Helmschmieds in particular, see A. von Reitzenstein, "Die Augsburger Plattnersippe der Helmschmied," *Münchner Jahrbuch der bildenden Kunst*, 3rd ser., 2 (1951), 179–94.

10. Bruno Thomas, "Lorenz Colman (Recte Helmschmid), Armourer of Augsburg," *Apollo Annual*, 1948, 21–24, reprinted in Thomas, *Gesammelte Schriften* (Graz, 1977), 612–16.

11. Bruno Thomas, "Harnischstudien I: Stilgeschichte des deutschen Harnisches von 1500–1530," *JKSW*, new series, 11 (1937), 139–58, reprinted in *Gesammelte Schriften*, 619–38.

12. See *Die Innsbrucker Plattnerkunst*, exh. cat. (Innsbruck, 1954), esp. Bruno Thomas and Ortwin Gamber, "Die Geschichte der Innsbrucker Plattnerkunst," 15–28 (reprinted in Thomas, *Gesammelte Schriften*, 527–40).

13. "Wie der junge Weisse König kunstfertig war in der Plattnerei und Harnischmasterei" (*Weisskunig*, 1956).

14. *Innsbrucker Plattnerkunst*, 20–22, 66–72, nos. 63ff.; Bruno Thomas, "Konrad Seusenhofer Studien," *Konsthistorisk Tidskrift* 18 (1949), 37–70 (reprinted in *Gesammelte Schriften*, 543–76). See also Vienna, 1959, nos. 529–31, 617, 622–24.

15. *Innsbrucker Plattnerkunst*, 21–22, lists a host of recipients for these luxury items, including Henry VIII of England, the duke of Braunschweig, Margrave Ludovico Gonzaga, Ippolito d'Este, King Ludwig of Hungary, and Giuliano Medici. Many specialized suits were also produced for Maximilian and his young heirs, Charles and Ferdinand. Probably his most famous documented gift was a set of suits of armor presented by Maximilian to Henry VIII of England in 1514 (begun 1511 and engraved and gilded in Augsburg in 1512). Another skirt armor suit, also etched and gilded in the style of Daniel Hopfer the Elder of Augsburg, had been produced by Seusenhofer for the young Charles V (Vienna, A 109). Thomas, "Konrad Seusenhofer," 39, fig. 3–5; *Innsbrucker Plattnerkunst*, no. 62; Vienna, 1959, no. 622. The fantastic creations of Seusenhofer continued in other armor forms imitative of other costumes, such as the evocations of slit cloth in the manner of *Landsknecht* uniforms, already present in an unpolished suit for Charles V (Vienna, A 186). Thomas, ibid., 550–51; *Innsbrucker Plattnerkunst*, no. 53; Vienna, 1959, no. 621.

16. Thomas and Lhotsky, "Prunkschwerter," reprinted in Thomas, *Gesammelte Schriften*, 1349–1435; Thomas, "The Hunting Knives of Emperor Maximilian I," *Metropolitan Museum of Art Bulletin* 13 (1955), 201; Vienna, 1959, 173–74, no. 516, fig. 76.

17. Bruno Thomas, "Die Artillerie im Triumphzug Kaiser Maximilians I," *Zeitschrift für historische Waffen- und Kostumkunde* N.F. 6 (1939), 229–35, reprinted in *Gesammelte Schriften*, 1449–55; Alphons Lhotsky, "Die 'Lauerpfeif' als Geschichtsdenkmal," in ibid., 261–63 (orig., *Aufsätze und Vorträge*, 2:323–27).

18. Bruno Thomas and Ortwin Gamber, "Die Waffen," in *Karl V*, exh. cat. (Vienna, 1958), 38, no. 84, reprinted in Thomas, *Gesammelte Schriften*, 164, figs. 67–69. Also Thomas and Gamber, *Innsbrucker Plattnerkunst*, no. 173; August Grosz, "Ritterlich Spielzeug," in *Festschrift für Julius R. von Schlosser* (Vienna, 1927), 209–14.

19. Benesch and Auer, *Historia Friderici et Maximiliani*, 120, fo. 42, no. 19: "De eius gestis in ultimis infantiae annis." The text also speaks of riding on stick horses and holding spear contests as a youth.

20. The captions of these illustrations read as follows: "Skill at shooting with the Turkish bow from all kinds of horse" (no. 37); "Shooting with English and Picardy bows. To be used in the hunt" (no. 38); "How the young White King learned to shoot with the crossbow" (no. 39); and "The young White king with crossbow on a chamois hunt" (no. 40). On the hunt and Maximilian, see Silver, "*Caesar ludens*," 175–81.

21. Leitner, *Freydal*, xlix–lii, "Kampfzeug."

22. Strauss, *Woodcuts*, 730. Winzinger, *Graphik*, 70–74, no. 68: "Er hat das grewlichst gschütz erdacht / Mit grosser kost zuwegen pracht / Darmit manch schlos in grund gefellt / Man schätzt In pillich für ein hellt / Dann er zu ritterlicher that / Sich alzeit gefudert hat."

23. Winzinger, *Die Miniaturen*, 49–50, no. 27. Thomas, "Artillerie."

24. Malcolm Vale, *War and Chivalry* (London, 1981), 145; Peter Krenn, "Heerwesen, Waffe und Turnier unter Kaiser Maximilian," in *Ausstellung Maximilian I Innsbruck*, exh. cat. (Innsbruck, 1969), 88–89.

25. Paris, Musee de l'Armeé. Thomas, "Artillerie," 1449n2.

26. Erich Egg, *Der Tiroler Geschützguss 1400–1600* (Innsbruck, 1961).

27. Thomas, "Artillerie," 1454.

28. Wendelin Boeheim, "Die Zeugbücher Kaiser Maximilians I," *JKSAK* 13 (1892), 94–201; 15 (1894), 295–391; Josef Garber, "Das Zeughaus Kaiser Maximilians I in Innsbruck," *Wiener Jahrbuch für Kunstgeschichte* 5 (1928), 142–60; also Innsbruck, 1969, 121–22, no. 475, plates 7, 9; Vienna, 1959, 221, nos. 604–5.

29. Boeheim, *Zeugbücher*, 101–3. Most recently see Egg, "Jörg Kölderer." The first illustrations of the interior and exterior of the Innsbruck Zeughaus are initialed "IK." Vienna, Austrian National Library, cod. vind. 10 815/16/24.

30. Boeheim, "Zeugbücher," 119.

31. Malcolm Vale, *War and Chivalry*, 129–46, with Cervantes quoted on 129. See also J. R. Hale, "Gunpowder and the Renaissance," in *Renaissance War Studies* (London, 1983), 389–420; Geoffrey Parker, *The Military Revolution* (Cambridge, 1988), 6–44.

32. Hale, "Gunpowder," 390–91.

33. Quoted by Hale, "Gunpowder," 399.

34. For such a view, see Michael Howard, *War in European History* (Oxford, 1976), 16, 56, but for a rejoinder to it, essentially followed here in light of the evidence of Maximilian's own military campaigns, see Malcolm Vale, *War and Chivalry*, 100–128, 147–74.

35. Malcolm Vale, *War and Chivalry*, 121. Note also the presence of horse armor to achieve the same protective effects.

36. Wiesflecker, *Kaiser Maximilian I*, 5:545–54; also, Günter Franz, "Von Ursprung und Brauchtum der Landsknechte," *MIÖG* 61 (1953), 79–98.

37. Wiesflecker, *Kaiser Maximilian I*, 5:506–7. Malcolm Vale, *War and Chivalry*, 124–25, also speaks of the integrated units that combined cavalry and mounted infantry with pikemen in the English and Burgundian armies.

38. Wiesflecker, *Kaiser Maximilian I*, 1:176nn6–7. He also entered both Regensburg (1504) and Cologne (1505) in the uniform of a *Landsknecht* at the head of his troops; 5:518.

39. Malcolm Vale, *War and Chivalry*, 162–63, stressing also the increasing presence in knightly literature of the dedicated soldier rather than the rounded courtier.

40. Wiesflecker, *Kaiser Maximilian I*, 5:508, 530–44.

41. Ibid., 514–15.

42. Ibid., 552; Hans Michael Möller, *Das Regiment der Landsknechte* (Wiesbaden, 1976), 59–60.

43. The most striking Dürer image of a *Landsknecht* is his engraving *Standard-Bearer* (B. 87, ca. 1502–3), a work that was widely imitated, as in the example of Altdorfer (W. 100–101, 106, 109–10, 125–26, 172). For the Swiss side of the imagery, exemplified by Urs Graf, see Christiane Andersson, *Dirnen—Krieger—Narren: Ausgewählte Zeichnungen von Urs Graf* (Basel, 1978), 27–46; also Franz Bächtinger, "Andreaskreuz und Schweizerkreuz: Zur Feindschaft zwischen Landsknechten und Eidgenossen," *Jahrbuch des Bernischen Historischen Museums* 51–52 (1971–72), 205–70; Bächtinger, "Marignano, Zum 'Schlachtfeld' von Urs Graf," *Zeitschrift für schweizerische Archäologie und Kunstgeschichte* 31 (1974), 31–54. On the social function of later popular woodcut prints of soldiers in Nuremberg, see Keith P. F. Moxey, "The Social Function of Secular Woodcuts in Sixteenth-Century Nuremberg," in Jeffrey C. Smith, ed., *New Perspectives on Nuremberg Art of the Sixteenth Century: Five Essays* (Austin, Tex., 1985), 68–81 (see 70n26, on the proud costume of the *Landsknecht*). That German artillery could also have been a source of contemporary pride may also be deduced from Dürer's 1518 etching *Landscape with Cannon*; the arms on the cannon have been identified as those of the city of Nuremberg, and the type of the gun dated to the period 1450–80 by Arthur Bechtold, "Zur Dürers Radierung 'Die grosse Kanone,'" in *Georg Habich zum 60: Geburtstag* (Munich, 1928), 113–19. Also more generally, see Silver, "Germanic Patriotism in the Age of Dürer," 55–59.

44. Moxey, "Secular Function," 68: "Wil unn mein fenlein lassen fliegen / In freyen auffrichtigen kriegen / Und fur vass dienen einem herren / Der kriegen thut nach preyss und ere."

45. Andersson, "Dirnen—Krieger—Norren," 27–28, fig. 20.

46. Malcolm Vale, *War and Chivalry*, 147–51.

47. Ibid., 151–54.

48. The figures of drummers and fifers follow directly after the standard-bearer at the head of Erhard Schön's woodcut frieze, *Company of Mercenaries* (ca. 1532); see Moxey,

"Social Function," figs. 7–9: "Pfeyffen und Drumelschla-
ger gut / Machen knechten eyn freyen mut . . . Auch in
der Ordnung und zu Feld." The legacy of this pictorial
interest in standards and field instruments can be seen
in Hendrik Goltzius's great engravings at the end of the
sixteenth century as well as the larger series by Jacques
de Gheyn of the Dutch military.

49. Jan-Dirk, Müller, *Gedechtnus*, 132.

50. Malcolm Vale, *War and Chivalry*, 171–72: "This period
(from ca. 1450 to ca. 1530) was thus to some extent an
aberration, where conditions of war offered an unusually
fertile soil for some expressions of the cult of chivalry.
After 1534 the battle went into rapid decline and with
it chivalry entered a phase of decay from which it never
recovered." See Howard, *War in European History*, 34:
"The balance which at the end of the 15th century
seemed to have been tilted strongly in favour of the
offensive, with the mobile pike phalanx, the great guns
to blast away opposition, and the revival of cavalry
shock action, had within 25 years been sharply reversed
by the development of fire power on the battlefield."
See also the contemporary case study of the city of
Siena by Simon Pepper and Nicholas Adams, *Firearms
and Fortifications* (Chicago, 1986), stressing the return of
siege-based warfare and consequent advances in military
architecture and civic fortification; Martha Pollak, "Mili-
tary Architecture and Cartography in the Design of the
Early Modern City," in David Buisseret, ed., *Six Studies
in Urban Cartography* (Chicago, 1998), 109–24.

51. Malcolm Vale, *War and Chivalry*, 100–104, citing General
J.F.C. Fuller's analogy between the cavalry forces and
the modern tank squadrons, still known as "cavalry" in
the American army. Vale also depends on the researches
of J. F. Verbruggen, "La tactique militaire des armées de
chevaliers," *Revue du Nord* 29 (1946), 164–68; Verbrug-
gen, "L'art militaire en Europe occidentale du IXe au
XIVe siècle," *Revue Internationale d'Histoire Militaire* 4
(1955), 488–502, on the clusters of cavalry in fighting
groups and the relationship between such groups and
the experience gained in tournaments.

52. Malcolm Vale, *War and Chivalry*, 114–19.

53. Ibid., 167–74, stressing the importance of obedience
as well as the pursuit of virtue and renown during the
Renaissance.

54. Quoted by Malcolm Vale, *War and Chivarly*, 168n124.

55. See also M. H. Keen, "Chivalry, Nobility, and the Man-
at-Arms," in C. T. Allmand, ed., *War, Literature, and Politics
in the Late Middle Ages* (Liverpool, 1976), 32–45.

56. *Weisskunig*, 1956, 352.

57. Strauss, *Woodcuts*, 727: "Got hat sein gnad an im erzaigt /
Dann er zu frumkeit was genaigt / Geschickt zu ritter-
lichen scherz / Darzu stund im sein mut und herz / Das
fing er an in seiner jugent / Darin er wuchs mit grosser
tugent."

6 | Magnificence and Dignity: Princely Pastimes

1. Marcia Vale, *The Gentleman's Recreations* (Cambridge,
1977).

2. For the general subject, see Gerhard Schack, *Der Kreis
um Maximilian I: Der Jagd in der Kunst* (Hamburg, 1963);
Michael Mayr, *Das Jagdbuch Kaiser Maximilians I* (Inns-
bruck, 1901).

3. Appelbaum, *Triumph of Maximilian I*, 2. "Der Kaiser hat
auf sein bedacht / Die Valknerey dahin gebracht."

4. Benesch and Auer, *Historia Friderici et Maximiliani*, 121,
no. 23, fo. 48.

5. *Weisskunig*, 1956. Subsequent quotations from this work
in this chapter are all from this edition, cited by chapter
number in the text.

6. Wiesflecker's study, summarized in *Kaiser Maximilian
I*, 5:399–400, has assembled several major occasions for
national meetings within the framework of outdoor
hunts of one kind or another: 1496 with Ludovico il
Moro and ambassadors of the pope and other Italian
powers at Vintschgau (2:77ff., 86ff.); 1497 with Turkish
ambassadors at Stams (2:156n25); 1513 with the Henry
VIII and his entourage near the battlefield of Guinegate
(4:125–26n65); as well as the momentous first meeting
with the kings of Hungary and Poland near Hartmanns-
dorf (4:188, 200n90).

7. Friedrich Dörnhöffer, "Ein Cyklus von Federzeich-
nungen mit Darstellungen von Kriegen und Jagden
Maximilians I," *JKSAK* 18 (1897), 1–55, esp. 54; Cuneo,
"Images of Warfare as Political Legitimization"; Larry
Silver, "Glass Menageries: Hunts and Battles by Jörg
Breu for Emperor Maximilian I," *Acta Historiae Artium*
44 (2004), 121–27.

8. Vienna, 1959, 217–18, nos. 597–99, fig. 87. All housed in
the Vienna Waffensammlung, nos. D4, D5, D6, D24, D39,
D44, D47, D48.

9. Vienna, 1959, 217, no. 596, from the Vienna Collection
for Sculpture and Decorative Arts, no. 4984. The manu-
script is dated to the late thirteenth century from Italy.
On Frederick II and falconry, see Ernst Kantorowicz,
Kaiser Friedrich der Zweite (Dusseldorf, 1963), 330–36,

stressing the outlook that for this monarch hunting was more than just a peacetime substitute for war but was rather an art form practiced out of love ("*totum procedit ex amore*"). Frederick, too, it seems, drew an analogy between the mastery of the falconer over his powerful charge and the emperor's capacity to discipline his followers (331). Also Klingender, *Animals in Art and Thought to the End of the Middle Ages*, 447–50; Frederick II of Hohenstaufen, *The Art of Falconry*, trans. Casey Wood and F. Marjorie Fyfe (Stanford, Calif., 1943), facsimile ed. by Carl Willemsen (Graz, 1969).

10. Rupprich, "Das literarische Werk Kaiser Maximilians," in Innsbruck, 1969, 49. On the books that were completed, see Vienna, 1959, nos. 90–94; Franz Unterkircher, *Maximilian I: Ein kaiserlicher Auftraggeber illustrierter Handschriften* (Hamburg, 1983), 17–21.

11. Vienna, National Library, cod. vind. 2834, fos. 178–190; ed. Theodor von Karajan, *Maximilians Geheimes Jagdbuch* (Vienna, 1881). In many ways this book is an inventory of the favorite hunting valleys of the River Inn, like the *Tiroler Jagdbuch* itself, organized by Wolfgang Hohenleiter in the year 1500 along with the chief forest master, Karl von Spaur.

12. Vienna, National Library, cod. vind. 7962; Michael Mayr, *Das Fischereibuch Kaiser Maximilians I* (Innsbruck, 1901); Franz Unterkircher, facsimile ed. (Graz, 1967). On the subject of fishing as a courtly activity, the depiction, associated with the style and name of Jan van Eyck, of the Dutch court fishing should be mentioned. This composition has been preserved in a later drawing copy (Louvre; Otto Kurz, "A Fishing Party at the Court of William VI, Count of Holland, Zeeland, and Hainault: Notes on a Drawing in the Louvre," *Oud Holland* 71 [1956], 117–31), and it can be compared to a later painted copy (Versailles) of Dutch nobles at play with falcons; see Paul Post, "Ein verschollenes Jagdbild Jan van Eycks," *Jahrbuch der Preussischen Kunstsammlungen* 52 (1931), 120–32; Robert Mullally, "The So-called Hawking Party at the Court of Philip the Good," *Gazette des Beaux-Arts* 119 (1977), 109–12. A lost otter hunt by van Eyck ("John of Bruges") was recorded in the 1520s by Marcantionio Michiel in the house of Leonico Tomeo at Padua. Most recently, see the overview by Elisabeth Dhanens, *Van Eyck* (New York, [1980]), 155–68.

13. Illustrated in Vienna, 1959, plate 21. See also Innsbruck, 1969, color plate 3 ("Achensee"), with stag hunt and chamois hunt in addition to the fishing. Also Unterkircher, *Maximilian I*, plates 16–20.

14. On the gunpowder debate, see especially Hale, "Gunpowder and the Renaissance," in *Renaissance War Studies*, 389–420.

15. Glenn Waas, *The Legendary Character of Kaiser Maximilian* (New York, 1941).

16. See illustrations to chapters 15, 18, 20, 31, 53, 59, 62, 71 (extremely close to the *Weisskunig* image). Two of the scenes offer spectacular escapes from danger: no. 22, where the hero hangs precariously from a cliff after a slip (cf. nos. 59, 62), and no. 56, where he uses his staff to pole-vault out of danger.

17. Four crossbows of Maximilian have survived in Vienna: Waffensammlung D3, D16, D17, D18. Three of them had gilded and etched bows. Vienna, 1959, 219, no. 600, fig. 86.

18. Cuneo, "Jörg Breu the Elder's Rondels"; Silver, "Glass Menageries."

19. Marcelle Thiebaux, "The Medieval Chase," *Speculum* 42 (1967), 260–74; Thiebaux, *The Stag of Love* (Ithaca, N.Y., 1974); Klingender, *Animals*, 468–76.

20. This near-contemporary but English version of Tristan is quoted by Klingender, *Animals*, 468, who goes on to suggest, 471–72, that "The role played by the stag hunt, both in the Tristan story and in courtly life generally, is so basic that it may be worth enquiring whether the hunted game may not also have served, unconsciously at least, as a symbolic substitute for the lord himself . . . [like] the chivalrous respect for the stag as the royal game and also by the strict game laws introduced by the Normans which made the hunting of the stag a royal prerogative." Elaine Tennant has suggested that the Tristan tale could have been directly available to Maximilian through the version of Gottfried von Strassburg, whose *Tristan* includes a long passage on the breaking up of a hart. Maximilian owned several versions of the older *Tristan* in his Innsbruck library and could have been conscious of the relationship between older knightly values of the hunt as expressed in such literature and his own ethos. See Gottlieb, *Ambraser Handschriften*, 104, nos. 250–52, two parchment and one printed.

21. Innsbruck, 1969, 73, no. 288, fig. 48. Thomas, "The Hunting Knives of Emperor Maximilian I," reprinted in *Gesammelte Schriften*, 1439–46. Four knives are in Kremsmünster; one in the Wallace Collection, London; and a pair of serving knives with one hunting knife in the Metropolitan Museum, New York.

22. Kurt Sternelle, *Lucas Cranach: Die Jagd in der Kunst* (Hamburg, 1963); Koepplin and Falk, *Lukas Cranach*, 1:194–96, 241–49, nos. 137–56.

23. Koepplin and Falk, *Lukas Cranach*, 241–42, no. 138, fig. 100, pointing out that the details of the stag brought to bay in the water from this Cranach woodcut were copied quite closely among the other scenes of hunting on the border miniature of the frontispiece of the important *Privilege Book of the House of Austria*, produced in 1512 (see Innsbruck, 1969, 71–72, no. 284, color plate 11—also see below). Christiane Andersson and Charles Talbot, *From a Mighty Fortress*, exh. cat. (Detroit, 1983), 222–23, no. 120, also discuss the Cranach woodcut. Koepplin and Falk further point out the links between Saxony and Maximilian by recalling that when Cranach was sent out as an ambassador to greet Maximilian in the Low Countries in 1508, he brought along as a gift from Frederick the Wise a picture of a boar shot by the Saxon prince.

24. Koepplin and Falk, *Lukas Cranach*, 1:242–42, no. 139 (copy). *Lucas Cranach der Ältere und seine Werkstatt*, exh. cat. (Vienna, 1972), 22–23, no. 9. See also the analogous Vienna painting by Cranach the Younger of a hunt from 1544, including both Charles V and the Saxon elector, Johann Friedrich (ibid., 31–32, no. 25). Also M. S. Francis, "The Stag Hunt of Lucas Cranach the Elder and Lucas Cranach the Younger," *Bulletin of the Cleveland Museum of Art* 46 (1959), 198.

25. Here, it should be recalled that the "Clavis" appended to the *Teuerdank* text by the editor, Melchior Pfinzing, suggests explicitly to the reader that the hunts and other adventures given to the eponymous hero are based on actual events, including hunts in particular sites, from Maximilian's life. See Waas, *Legendary Character*, particularly on the celebrated "Martinswand" incident. Also Egg-Pfaundler, Erich Egg and Wolfgang Pfaundler, *Kaiser Maximilian I und Tirol* (Innsbruck, 1992), 60–61. In similar fashion, *Freydal* "allegorizes" actual tournaments with real opponents (Leitner, *Freydal*, lv–civ; see below).

26. Boars: no. 17, 19, 35, 38, 41, 61. Bears: nos. 14, 27, 48. Elaine Tennant has again suggested the importance of the boar in Middle High German knightly tales: Sifrit kills one, and Tristan is described in the metaphor of a wild boar who fouls his uncle's wedding bed. The boar remains a favorite dangerous quarry for sport hunters in Europe.

27. Koepplin and Falk, *Lukas Cranach*, 241, no. 137.

28. The *Boar Hunts* include two versions in Dresden and one in Marseille. They distinguish between aristocratic riders and their retainers on foot in a more exposed and vulnerable role. Several of these works (New York,

Marseille) also show the presence of women, as in the hawking or stag hunting scenes, despite the danger of these wild animals. See Arnout Balis, *Hunting Scenes, Corpus Rubenianum Ludwig Burchard*, vol. 18.2, trans. P. S. Falla (London, 1986); also David Rosand, "Rubens's Munich *Lion Hunt*: Its Sources and Significance," *Art Bulletin* 51 (1969), 29–40, esp. 36–37.

29. Vienna, Haus-, Hof-, und Staatsarchiv. Innsbruck, 1969, 71–72, no. 284, color plate 11; Vienna, 1959, 32, no. 95, figs. 22-23; Benesch and Auer, *Historia Friderici et Maximiliani*, 112–12. Unterkircher, 21. The miniature on the facing page contains a Habsburg family tree, signed "AS." The manuscript itself, completed on 19 December 1512, records the privileges accorded to the House of Austria by the citizens and council of the city of Vienna. The adjacent page, the other illumination in the manuscript, shows a Habsburg genealogical tree, culminating in Charles and Ferdinand, in the margins of its Latin text.

30. Winzinger, *Graphik*, no. 70: "In waydwerkh er sich sorglich wagt / Gantz durstiglich un unverzagt / Nach gemsen eber hirsch und pern / Mit den er hat sein kurtzweil gern / Die auch gezugelt in seim land / Gefangen mit sein selbes hannd."

31. Strauss, *Woodcuts*, 730. The translation omits bears, (*pern*). The text mentions "tame" (actually bridled, *gezugelt*) animals but instead stresses that the beasts were "caught with his own hand (*Gefangen mit sein selbes hannd*)."

32. On the illustrations of *Teuerdank* as an ongoing theme, see Elaine Tennant, "'Understanding with the Eyes': The Visual Gloss to Maximilian's *Theuerdank*," in James Poag and Thomas Fox, eds., *Entzauberung der Welt. Deutsche Literatur 1200–1500* (Tübingen, 1989), 211–76, with emphasis on the supernatural as an element in the imagery of the text and images; also Hans-Joachim Ziegeler, "Der betrachtende Leser: Zum Verhältnis von Text und Illustration in Kaiser Maximilians I 'Teuerdank,'" in Egon Kühebacher, ed., *Literatur und bildende Kunst in Tiroler Mittelalter*, Innsbrucker Beiträge zur Kulturwissenschaft, Germanistische Reihe 15 (Innsbruck, 1982), esp. 82–83, a reference I owe to Elaine Tennant.

33. Egg and Pfaundler, *Kaiser Maximilian I und Tirol*, 54–55, 64. The procession with four candles is still celebrated as part of St. Agnes's Day (21 October). An expression still survives in Tyrolean parlance that a "hunter's mass" is particularly rapid.

34. Klingender, *Animals*, esp. 60–62, for Assyria. On the general subject, see Balis, *Hunting Scenes*; W. A. Baillie-Grohman, *Sport in Art*, 2nd ed. (London, 1920). Also

Raimond van Marle, *Iconographie de l'art profane au Moyen Age et à la Renaissance* (The Hague, 1931), 197–278. For England at the end of the sixteenth century, see Marcia Vale, *The Gentleman's Recreations*, 27–57. Vale's sources, like Maximilian, clearly distinguish between hunting, hawking, fowling, and fishing. On later medieval treatises, such as the falconry treatise (see above) by Frederick II, see W. A. and F. Baillie-Grohman, *The Master of the Game by Edward, Second Duke of York* (London, 1904); D. H. Madden, *A Chapter of Medieval History: The Fathers of the Literature of Field Sport and Horses* (London, 1924). For the neo-Assyrian reliefs of Ashurbanipal, see Julian Reade, *Assyrian Sculpture*, 2nd ed. (London, 1998), 72–79.

35. Ed. E. and A. Bossuat (Paris, 1931). C. Couderc, *Livre de la chasse par Gaston Phebus* (Paris, 1909) reproduces the eighty-seven miniatures of the most beautiful Phebus illustrations in the illuminated manuscript of ca. 1410 (Paris, B. N. fr. 616). The English translation by Edward, second duke of York, was published by Baillie-Grohman, as cited above, n. 35.

36. Paul Alfassa, "Les tapisseries des "Chasses de Maximilien,'" *Gazette des Beaux-Arts* 52 (1920), 127–40, 233–56; Roger d'Hulst, *Tapisseries flamands du XIVe au XVIIIe siècle* (Brussels, 1960), 171–82; Sophie Schneebalg-Perelman, *Les Chasses de Maximilien* (Brussels, 1982); Arnout Balis, "De 'jachten van Maximiliaan,' kroonstuk van de hoofse jachticonografie," *Gentsche Bijdragen tot de kunstgeschiedenis* 25 (1979–80), 14–41; Balis, Krista de Jonge, Guy Delmarcel, Amaury Lefébure, *Les Chasses de Maximilien* (Paris, 1993); Thomas Campbell, *Tapestry in the Renaissance: Art and Magnificence*, exh. cat. (New York, 2002), 329–39, nos. 37–40. As Balis's own book on Rubens's hunts makes clear, this is the heroic vision of the noble heritage of the hunt in the Low Countries (*Hunting Scenes*, esp. 50–78); see also Matthias Winner, "Zu Rubens' 'Eberjagd' in Dresden (Landschaft oder Historienbild)," in *Peter Paul Rubens. Werk und Nachruhm* ([Munich], 1981), 157–85. The patron of the cycle is not certainly known, although it was probably Mary of Hungary, regent of the Netherlands and sister of Charles V.

37. Thomas Campbell, *Tapestry in the Renaissance*, 329–39, nos. 37–40; Balis et al., *Les Chasses de Maximilien*. A second set of drawings, also regarded as autograph works of van Orley, survive in Budapest, Leyden, Berlin, and Copenhagen; John Hand, Richard Judson, William Robinson, and Martha Wolff, *The Age of Bruegel: Netherlandish Drawings in the Sixteenth Century*, exh. cat. (Washington, D.C., 1986), 2, 3, 5–6, no. 90.

38. For an early-fifteenth-century precedent in the medium of tapestry, see George Wingfield Digby and Wendy Hifford, *The Devonshire Hunting Tapestries* (London, 1971).

39. Castiglione, *The Book of the Courtier*, ed. Charles Singleton (Garden City, N.Y., 1959), bk, 1, chap. 22, p. 38. See also the English equivalent, penned by Sir Thomas Elyot, *The Book Named the Governour* (London, 1531), fo. 69v: "In huntyne may be an imitacion of batayle, if it be suche as was used amonge them of Persia." Quoted by Marcia Vale, *The Gentleman's Recreations*, 27.

40. *Weisskunig*, 1956, 236: "das ainer, der in den ritterspilen beruembt wolt werdenn, die uebung mit den taten und nit die lernung mit den werken prauchem muesset."

41. Ibid., 236: "Dardurch ist zu merken, dieweil der weiss kunig als ain grosmechtiger herr sovil und soliche tapfere und ernstliche ritterspil getriben hat, das er sein ritterliche hand nach kunigilcher eer gepoten, die er dann in der menschen kunftigen gedächtnus mit grosser eer erlangt hat."

42. Strauss, *Woodcuts*, 730. Winzinger, *Graphik*, 70, no. 71: "Er hat getriben ritterspil / darin ertzeigt auch kurtzweil vil / Mit warheit ich das sprechen kan / als vormals ine kein fürst hat than / Das alles doch mit solhem schimpf / Daraus im kam lob eer un glimpf." Compare the remarks of Sir Thomas Elyot's 1531 *Book named the Governour* (fo. 68v): "[T]o ryde suerly and clene, on a great horse and a roughe [is an exercise very honourable for a man of rank, which] . . . undoubtedly . . . importeth a majestie and drede to inferiour persons, beholding him above the common order of other men, dauntyng a fierce and cruel beast." Quoted by Marcia Vale, *The Gentleman's Recreations*, 11; for tournaments and horsemanship, 11–26, for fencing and dueling, 63–72.

43. Benesch and Auer, *Historia Friderici et Maximiliani*, 124–25, fo. 69r (no. 36), 70v (no. 37). Significantly, the tournament and the masquerade follow each other on facing pages.

44. On the actual tournaments at Maximilian's court, see Wiesflecker, *Kaiser Maximilian I*, 5:391–93. Vienna, 1959, 186 mentions the following special occasions for tournaments: 1486 after Maximilian's election as king of the Romans at Bamberg; 1492, 1497, 1498 at Innsbruck; 1494 after the marriage of his councillor, Polhaim, at Mechelen; and 1515 after the grand Habsburg double marriage in Vienna.

45. Cartellieri, *The Court of Burgundy*, 119–63, esp. 124–34, 157–63. Olivier de la Marche is also quoted on his role as reporter of such jousts, recording these spectacles

for posterity: "It would be a sad pity and loss if such assaults-at-arms were passed over in silence or forgotten. It were cowardly of me if I restrained my pen from describing to the best of my ability all the noble feats that I have seen" (120).

46. Wiesflecker, *Kaiser Maximilian I*, 5:391–92; 2:238n98; on the significance of romance for Maximilian, see Silver, "'Die Guten Alten Istory'"; Müller, *Gedechtnus*, 190–203; Gerhild Williams, "The Arthurian Element in Emperor Maximilian's Autobiographical Writings," *Sixteenth Century Journal* 11 (1980), 3–22.

47. Castiglione confirms this view in *The Book of the Courtier* in praising Guidobaldo, duke of Urbino, in these terms: "where he was not in case with his person to practice the feats of chivalry, as he had done long before, yet did he take very delight to behold them in other men. . . . And upon this at tilt, at tourney, in playing at all sorts of weapon, also in inventing devices, in pastimes, in music, finally in all exercises meet for noble gentlemen, every man strived to show himself such a one, as might be judged worthy of so noble assembly" (Singleton ed., 15).

48. Frances Yates, "Elizabethan Chivalry: The Accession Day Tilts," *Journal of the Warburg and Courtauld Institutes* 20 (1957), 4–25; reprinted in Yates, *Astraea*, 88–111. For earlier Tudor instances, see Sydney Anglo, *Spectacle, Pageantry, and Early Tudor Politics* (Oxford, 1969), esp. 98–123; Anglo, *The Great Tournament Roll of Westminster* (Oxford, 1968).

49. Andersson and Talbot, *From a Mighty Fortress*, 64–65, no. 16, color plate 1; Koepplin and Falk, *Lukas Cranach*, 1:230–31, no. 117, fig. 94; see also the general remarks on 185–96, 227–31. For the history of the tournament and heraldry in Germany, a printed source was published (1530; Simmern: Rodler) by Georg Rüxner, *Anfang, Ursprung, und Herkommen des Thurnirs in Teutscher Nation* (Andersson and Talbot, 380, no. 215).

50. Koepplin and Falk, *Lukas Cranach*, 1:190–93, 227–29, nos. 108–12, color plate 6, fig. 93. The knight with the "A" on his decorations has been identified with Maximilian's "Austria" in the 1506 woodcut; see also 63, no. 14, fig. 17; on Frederick the Wise of Saxony as a tournament opponent of Maximilian, 190–91, 228. Close to Cranach's depiction of a tournament is the canvas painting by Hans Schäufelein of a tournament in a city square (Schloss Tratzberg; for a copy, see Innsbruck, 1969, 126, no. 488, color plate 6).

51. The tournament book is Vienna, National Library, cod. 10831; see Vienna, 1959, 22, no. 67; Innsbruck, 1969,

127, no. 494. The 1529 Burgkmair volume, dedicated to Duke Wilhelm IV of Bavaria, is in Munich, Staatliche Graphische Sammlung, no. 35. See H. Pallmann, *Hans Burgkmair des Jüngeren Turnierbuch von 1529* (Leipzig, 1910); *Welt in Umbruch*, exh. cat. (Augsburg, 1980), 234–38, nos. 613–17. A later tournament book in Munich, made by Hans Ostendorfer of Regensburg, was also dedicated to Duke Wilhelm, while a second, larger version by Burgkmair the Younger (fifty-two folios; Sigmaringen, Hohenzollern coll.) was published in facsimile by Jakob Heinrich von Hefner in 1853 (reprint, Dortmund, 1980). It contains a replication of the first fifteen figures of the Munich book, plus a supplement of mounted jousts in the manner of other tournament books (including the results of a 1553 tournament in Augsburg, 61–69).

52. That Maximilian's tournaments were not exceptional in Germany can also be determined by examining the prints of Master MZ (now identified as Matthäus Zasinger), active around 1500, whose *Tournament with Lances* finds its complement in the engraved *Ball with Card-playing Prince and Princess*, a pair of works that supposedly depict the Munich court of Duke Albrecht IV of Bavaria, whose weapons appear in the *Tournament* under the date. See *Fifteenth-Century Engravings of Northern Europe*, exh. cat. (Washington, D.C., 1968–69), nos. 152–53.

53. This scene is copied fairly closely from the *Freydal* illustration, in the corrected manuscript (Vienna, Kunsthistorisches Museum, Waffensammlung), no. 88 in Leitner's 1882 edition. For *Mummereien* in general, see Leitner, lii–liv; also, Unterkircher, *Maximilian I*, 39–40.

54. Leitner, *Freydal*, v, liin4. In 1502, Maximilian gave this commission: "Maister Martin sol all mumerey so k. Mt. ye gebraucht hat, in ain buch malen lassen (Master Martin shall have painted in a book all mummeries that his royal Majesty has ever used)"—quoted from the memoranda of Maximilian (Haus-, Hof-, und Staatsarchiv, cod. ms. 13, fo. 147) by Leitner, v.

55. Leitner, *Freydal*, liiin2 cites an example of the torch dance, drawn from the Tournament Book of Rüxner and referring to the thirtieth tournament of Heidelberg, 1481: "When the emperor danced, two counts with torches danced before him, four counts followed with torches, then the emperor and a further four counts with torches. Each of them had to perform a *Vordantz* with the women or girls, who would thank him." Rüxner, a herald, at least was well-informed about tournament customs, if not literally accurate in particular instances.

56. Innsbruck, 1969, 153–54, no. 571. Josef Garber, *Das Goldene Dachl* (Innsbruck, 1922); K. Fischnaler, *Das Goldene Dachl Kaiser Maximilians I* (Innsbruck, 1936); Otto von Lutterotti, *Das Goldene Dachl in Innsbruck* (Innsbruck, 1956); Egg and Pfaundler, *Kaiser Maximilian I und Tirol*, 150–53; Franz Heinz Hye-Kerkdal, "Zur Geschichte des Goldenen-Dachl-Gebäudes des 'Neuen Hofes' zu Innsbruck," *Tirol Heimat* 29–30 (1965–66), 149–59; Franz-Heinz Hye, *Das Goldene Dachl Kaiser Maximilians I und die Anfänge der Innsbrucker Residenz* (Innsbruck, 1997); Erich Egg, *Maximilian und Tirol* (Innsbruck, 1969), 24, 150–53; Vinzenz Oberhammer, *Das Goldene Dachl zu Innsbruck* (Innsbruck, 1970); Erwin Pokorny, "Minne und Torheit unter dem Goldenen Dachl: Zur Ikonographie des Prunkerkers Maximilian I in Innsbruck," *JKSW* 4–5 (2002–3), 30–45.

57. Originals in the Ferdinandeum Museum, Innsbruck. Franz Heinz Hye-Kerkdal, "Die heraldischen Denkmale Maximilians I in Tirol," *Der Schlern* 43 (1969), 63ff. On heraldry in general, see below.

58. Marcia Vale, *The Gentleman's Recreations*, 84–99, 148–51. Maurice Keen, *Chivalry* (New Haven, Conn., 1984), 121–42, 210–12.

59. A similar morris-dance was carved for the Tanzsaal of the Munich Town Hall (1480) by Erasmus Grasser; see Baxandall, *The Limewood Sculptors of Renaissance Europe*, 277–78, plate 52; Philipp Maria Halm, *Erasmus Grasser* (Augsburg, 1928), 14, 131–47. An image of morris-dancers in foliate ornament was engraved by Israhel van Meckenem, ca. 1490–1500; see Alan Shestack, *Fifteenth-Century Engravings of Northern Europe*, exh. cat. (Washington, D.C., 1967–68), no. 247. In general, Karl Simon, "Zum Moriskentanz," *Zeitschrift des deutschen Vereins für Kunstwissenschaft* 5 (1938), 25ff.; Dietrich Huschenbett, "Die Frau mit dem Apfel und Frau Venus in Moriskentanz und Fastnachtspiel," in Dieter Harmening et al., eds., *Volkskultur und Geschichte: Festgabe für Josef Düninger zum 65. Geburtstag* (Berlin, 1970), 585–603.

60. Wiesflecker, *Kaiser Maximilian I*, 5:251–54, for von Wolkenstein.

61. Innsbruck, 1969, 102, no. 384; Vienna, 1959, 45–46, no. 140; Wiesflecker, *Kaiser Maximilian I*, 3:83n26; Spitz, *Conrad Celtis* 74. On the Stuart masques of Jonson and Inigo Jones, see Stephen Orgel, *The Illusion of Power* (Berkeley, Calif., 1975); Roy Strong, *Art and Power*, 153–70, with references; Strong also summarizes the spectacular aspects of tournaments in the sixteenth century, 11–18, 50–57, on the "tournoi à theme."

62. Cartellieri, *The Court of Burgundy*, 135–53. The entertainment on that occasion was the story of Jason, an appropriate myth for the founding members of the Order of the Golden Fleece.

63. For Maximilian and music, see Walter Senn, "Maximilian und die Musik," in Innsbruck, 1969, 73–85, with reference to the *Ludus Dianae* on 78–79; Louise Cuyler, *The Emperor Maximilian and Music* (London, 1973); Gernot Gruber, "Beginn der Neuzeit," in Rudolf Flotzinger and Gernot Gruber, eds., *Musikgeschichte Österreichs. Von den Anfängen zum Barock* (Graz, 1977), 173–277; Wiesflecker, *Kaiser Maximilian I*, 5:396–98.

64. Appelbaum, *Triumph of Maximilian I*, 2: "Ich hab gepfiffen offt und gern / Nach rechter art mit gueten Eern. / Dem Kaiser Maximilian/ In Kriegen Ritterlichen Pan / Zu schimpff und ernst allzeit genaigt / Wie solches der Triumph anzeigt."

65. On Hofheimer: Wiesflecker, *Kaiser Maximilian I*, 5:397–98; Senn, "Maximilian und die Musik," 80–81; Hans Joachim Moser, *Paul Hofhaimer*, 2nd ed. (Hildesheim, 1969). For one portrait of Hofheimer, see the Dürer drawing (London, British Museum, W. 573), reproduced in Innsbruck, 1969, 106, no. 399. This identity is confirmed by the comparison of features with the figure identified in the text as Hofheimer in woodcut no. 22 of the *Procession*. See also Bartrum, *Albrecht Dürer and His Legacy*, 200, no. 145, dated c. 1518–21.

66. Appelbaum, *Triumph of Maximilian I*, 5: "Ich hab die suessen Melodey / von Saitenspill gar manicherlay / Quintern, Lautten, Tammerlin, / das alles nach des Kaisers Sin, / Rauschpfeiffen gross dartzue auch klein, / die Harpfen mit getzogen ein."

67. Senn, "Maximilian und die Musik," 78.

68. Hofhaimer, for example, in his later years composed music to the odes of Horace, published in Nuremberg in 1539 by Johann Petreium (Innsbruck, 1969, 198, no. 407; Vienna, 1959, 46–47, no. 144). See also G. Pietzsch, *Zur Pflege der Musik an den deutschen Universitäten bis zur Mitte des 16. Jahrhunderts* (Darmstadt, 1971). Petrus Tritonius (Treybenreif) of Bozen had been working earlier with Celtis, ca. 1494–97, to set Horatian odes to music in the manner of the ancients; the results were published in Augsburg in 1507 as *Melopoiae sive Harmoniae tetracenticae* (Innsbruck, 107, no. 405; Vienna, 1959, 46, no. 142). On Celtis and music, see Spitz, *Conrad Celtis*, 80–81. Tritonius's settings of odes by Celtis formed part of the *Ludus Dianae*, part instrumental and part vocal. A portrait of Slatkonia with his heraldic arms appears

along with Maximilian in the left foreground of a Stri-
gel image, *Death of the Virgin* (1518; formerly Strasbourg,
destroyed). See Innsbruck, 1969, 110–11, no. 422, fig. 78;
Otto, *Berhard Strigel*, 43–44, no. 31, fig. 31.

69. Senn, "Maximilian und die Musik," 74. Slatkonia's
Hofkapelle in Vienna gave rise to the continuous tradi-
tion of the Vienna Boys' Choir.

70. Innsbruck, 1969, 107, no. 403, fig. 74; Vienna, 1959, 127,
no. 413, fig. 59.

71. Senn, "Maximilian und die Musik," 74; Cuyler, *Emperor
Maximilian and Music*, 15–16, 84–85, 95–96.

72. Emmanuel Winternitz, *Musical Instruments and Their Sym-
bolism in Western Art* (New Haven, Conn., 1979), 86–98.

73. Ernst Robert Curtius, *European Literature and the Latin
Middle Ages*, trans. Willard R. Trask (New York, 1953),
228–46; see also Burgkmair's earlier tribute to Maxi-
milian's fostering of the arts, the allegorical woodcut of
the imperial eagle sheltering Apollo and the muses under
its wings along with the seven mechanical arts and Phi-
losophy and the seven liberal arts (Stuttgart, 1973, no. 17,
fig. 20; Silver, "Germanic Patriotism," 47–49; fig. 8, above).

74. Senn, 75. A survey of the Diets and other festive occa-
sions to which the Kapelle and instrumentalists accom-
panied Maximilian is provided by Senn, "Maximilian
und die Musik," 77–80.

75. Senn, "Maximilian und die Musik," 78, suggests that
this might have been one more manifestation of Maxi-
milian's backlash against the hostility shown him by the
Netherlanders, climaxed by his 1488 imprisonment in
Bruges.

76. Senn, "Maximilian und die Musik," 81.

77. Collected in the 1520 anthology of motets, *Liber selec-
tarum cantionum*, edited by Isaac's pupil, Senfl (see below)
at the urging of Peutinger in Augsburg and dedicated
to Maximilian's close adviser, Matthäus Lang, prince-
bishop of Salzburg. Cuyler, *Emperor Maximilian and
Music*, 190–224. Recorded on the *Triumph of Maximilian*
album by the London Ambrosian Singers (Nonesuch
HB-73016).

78. Senn, "Maximilian und die Musik," 82.

79. Recorded by the London Ambrosian Singers, *Triumph
of Maximilian*. Published in 1538 (Nuremberg: Hans
Ott) under Senfl's name; the original composition was
penned on the occasion of the death of Queen Anne of
France in 1514 (Senn, "Maximilian und die Musik," 82).

80. The source for the Alexander passages is Plutarch's
Moralia (2.2), also cited by Castiglione in the *Courtier*:
"Wherefore it is recorded that Alexander was sometimes

so passionately excited by music that, almost in spite of
himself, he was obliged to quit the banquet and table
and rush off to arms. . . . And we read that the bellicose
Lacedemonians and the Cretans used citharas and other
delicate instruments in battle" (chapter 47; see Plutarch,
On Music, chapter 26).

81. Quoted by Cuyler, *Emperor Maximilian and Music*, 95.
See also Senn, "Maximilian und die Musik," 80, citing
the additional performance of a new mass, composed by
either Josquin, de la Rue, or Isaac. Later in the private,
princely festivities the newly commissioned *Lied* by
Senfl, "Lust mag mein Herz," was performed; the text
uses the names of Ludwig and Maria as acrostics.

82. Maximilian had a commander of field music, Augus-
tin Schubinger (1493–1532), a cornet player; Egg and
Pfaundler, *Kaiser Maximilian I und Tirol*, 110.

83. Quoted by Senn, "Maximilian und die Musik," 74.

84. On the virtues of music for noble entertainment in
England, see Marcia Vale, *The Gentleman's Recreations*,
94–99.

85. Winzinger, *Graphik*, no. 72: "Die hewser Burgund und
Osterreich / Hat er gmacht tzierte kunigreich / Darin
erhebt sein hohenn stam / Die wappen zpgen schon
zusam / Sein erben als tzu nutz und eer / Zu den im
stund sein furstlich geer."

86. Strauss, *Woodcuts*, 730.

87. Marcia Vale, *The Gentleman's Recreations*, 92–99; Keen,
Chivalry, 125–42, 210–12. See also the works of A. R.
Wagner, *Heralds and Heraldry in the Middle Ages*, 2nd ed.
(Oxford, 1964); Anthony R. Wagner, *Heralds of England*
(London, 1967); Rodney Dennis, *The Heraldic Imagina-
tion* (London, 1975).

88. Schramm and Fillitz, *Denkmale*, 91–92, no. 141. Egg,
Maximilian und Tirol, 148–49. Most recently see Patrick
Werkner, "Der Wappenturm Kaiser Maximilians I in
Innsbruck," *Wiener Jahrbuch für Kunstgeschichte*, n.s., 34
(1981), 101–13; Schauerte, *Die Ehrenpforte*, 42–48. Impor-
tant older literature includes R. von Wieser, "Zur Ge-
schichte des Innsbrucker Wappenthurms," in *Zeitschrift
des Ferdinandeums* (1897), 307–11; Oswald Redlich, "Der
alte Wappenturm zu Innsbruck," in *Ausgewählte Schriften*
(Vienna, 1928), 235–50.

89. For the several restorations and the probable history of
the Wappenturm, see Werkner. The central portion of
the tower, as recorded in both the engraving and the
painting, is surely not original, despite the presence of a
putative portrait of Kölderer (who was a young artist in
the late 1490s) as a greybeard.

90. Werkner, "Wappenturm," 103, citing the similar conclusions of Karl Oettinger in an unpublished manuscript, "Die Baugeschichte der Innsbrucker Hofburg."

91. Werkner, "Wappenturm," 111–12.

92. Thomas and Lhotsky, "Prunkschwerter," in Thomas, *Gesammelte Schriften*, 1413–14; Lhotsky, *Aufsätze und Vorträge*, vol. 3; Gustav Glück, "Kinderbildnisse aus der Sammlung Margarethens von Osterreich," *JKSAK* 25 (1905), 233–35; M. J. Onghena, *De iconografie van Philips de Schone* (Brussels, 1959), 53, 112–14, no. 32.

93. Schramm and Fillitz, *Denkmale*, 86–87, no. 120; Edgar Hertlein, "Das Grabmonument Kaiser Friedrichs III (1415–1493) als habsburgisches Denkmal," *Pantheon* 35 (1977), 294–305; Alois Kieslinger, "Das Grabmal Friedrichs III," in *Friedrich III*, 192–96, 386–87, no. 204, with bibliography. These seven basic Austrian heartland possessions, however, were supplemented by the arms of thirty smaller territories, chiefly from the southwest German area, arrayed around the base of the *tumba* (Hertlein, 299nn52–53).

94. Strauss, *Woodcuts*, 730; Winzinger, *Graphik*, no. 73: "Seins vaters grab hat er volbracht / Des seinen auch dabey gedacht / Und die mit soher kost volfuert / Als von keim keiser is gespuert / Wan er daran kein gelt nit spart. / Nach kunst sein ding muss haben art."

95. Alphons Lhotsky, "AEIOU. Die 'Devise' Kaiser Friedrichs III und sein Notizbuch," in *Aufsätze und Vorträge*, 2:164–222.

96. Schramm and Fillitz, *Denkmale*, 91, nos. 139–40. Vienna, 1959, 173–74, no. 516, fig. 76; Thomas and Lhotsky, "Prunkschwerter," reprinted in Thomas, *Gesammelte Schriften*, 1349–1428. See also Thomas, "Hunting Knives," reprinted in *Gesammelte Schriften*, 1439–46.

97. For the history of the claims to Austro-Burgundian kingdoms, see Coreth, "Dynastisch-politische," 92–105; Coreth, "Ein Wappenbuch Kaiser Maximilians I," in Leo Santifaller, ed., *Festschrift zur 200-Jahr-Feier der Haus-, Hof-, und Staatsarchivs*, 291–303.

98. Schramm and Fillitz, *Denkmale*, 82, no. 104; *Frederick III*, 312, no. 41, fig. 14; Peter Halm, "Die 'Fier Gulden Stain,'" 201, fig. 9.

99. "Sieben christlicher Königreiche König und Erbe," first recorded in his memoranda of around the year 1502, *JKSAK* I (1883), reg. 230, cited by Lhotsky, "Die 'Lauerpfeif' als Geschichtsdenkmal," in *Aufsätze und Vorträge*, 2:325.

100. Innsbruck, 1969, 72–73, nos. 286-87, figs. 46–47; Vienna, 1959, 174–75, no. 517, fig. 77. Thomas and Lhotsky, "Prunkschwerter."

101. Thomas, "Hunting Knives."

102. Vienna, 1959, 223–24, no. 610; Lhotsky, "Die 'Lauerpfeif,'" in *Aufsätze und Vorträge*, 2:323–27.

103. Bohemia had been a Habsburg claim since the time of Ladislaus Posthumus (d. 1457), duke of Austria and king of both Bohemia and Hungary. In similar fashion, Frederick III had continued to claim both Hungary and Dalmatia, although he never had political control over them.

104. Lhotsky, "Die 'Lauerpfeif,'" 326–27; Heinrich Ulmann, *Kaiser Maximilian I: Auf urkundliche Grundlage dargestellt*, 2 vols. (Stuttgart, 1884–91), 1:263–64. Maximilian also had hopes of an English marriage alliance with the Tudors between Margaret of Austria and Henry VII or between the young Charles V and Mary Tudor (Wiesflecker, *Kaiser Maximilian I*, 3:290, 295).

105. Innsbruck, 1969, no. 317-12, fig. 56; Peter Halm, "Die 'Fier Gulden Stain,'" 202, fig. 12.

106. Winzinger, *Graphik*, 122–25, nos. 209–40, for the woodcuts; Winzinger, *Gemälde*, 49–56, 107–8. The original miniatures of this section of the *Procession* are lost but preserved in two reliable copies in the Vienna National Library (cod. min. 77) and Madrid National Library (res. 232).

107. Appelbaum, *Triumph of Maximilian I*, 9: "Das Edle hauss von Osterreich / wie sich das mit Burgundt vergleicht / wer das will grundtlichs wissen han, / dem thuens nachgehet Wappen sagen, / die Kaiser Maximilian/ durch heyrat hat vermischet schon."

108. "Item darnach sollen die osterreichischen Erblannde alle zu Ross in Paner gefuert werden unnd nit in kirchfanen, mit Schilten helm unnd klainaten."

109. Woodcut numbers in parentheses; these correspond to miniatures nos. 40–41.

110. The miniature was executed, according to Winzinger, by Georg Lemberger; see Winzinger, *Die Miniaturen*, 44, no. 11.

111. Ibid., 44–45, nos. 12–16; for the Altdorfer image of the Spanish wedding, see Winzinger, *Gemälde*, 114, no. 67, an image virtually identical to the Dürer woodcut on the *Arch*. The Spanish arms are Castile, Leon, Aragon, Sicily, Jerusalem, Naples, Granada, etc. but also include "1500 Islands," presumably the new discoveries in the "Indies."

112. Appelbaum, *Triumph of Maximilian I*, 12: "Der heirat mit kunig philipsen Ertzhertzogen zu osterreich, kaiser Maximilians Sun, mit der Erbtochter zu Hispany."

113. Strauss, *Woodcuts*, 726.

114. Joseph Meder, *Dürer-Katalog*, reprint ed. (New York, 1971), 207. The other scenes are the Burgundian marriage, the Spanish marriage, and the diplomatic visit with Henry VIII (see below).

115. Strauss, *Woodcuts*, 729. The original text reads: "Von Hungarn, Peham und Polan / Die werden kunig wolgetan / Komen zu im in sein aigen lanndt / Gross zucht und eer ward in bekandt / New heyrat und puntnuss man macht / Gross nuss der Christenhait das pracht."

116. Werkner, "Wappenturm," 108: Algeciras, Aragon, Biscaya, and Sardinia. The totals of heraldry are taken, except for the Wappenturm (where the distinction between original and added heraldry is conflated), from Thomas and Lhotsky, "Prunkschwerter." Recall that the ceremonial sword had forty-six arms, and the ca. 1494 double portrait had but thirty-four.

117. Never executed as a woodcut; see Winzinger, *Die Miniaturen*, 42–43, no. 8 for the miniature by the Altdorfer workshop.

118. Ibid., 49, no. 24: Archpalatinate, Archduchy, Austrasia, Lorraine, Belgians, Slovania or the Wends, New Austrasia, Austria. For an explanation of these obscure kingdom names, see Coreth, "Dynastisch-politische," 96–102. Many had old historical sources, such as "Austrasia," derived from old Frankish records for the period between Clovis I and Pippin the Short, early sixth to mideighth century. These kinds of rediscovered territories were closely linked to the research into genealogy by Mennel et al. (chapter 2) and were intended to consolidate many of the ancient Burgundian territories claimed in family trees as part of the Merovingian ancestry of the Habsburgs. The desire to revive Lorraine as a kingdom akin to that of a middle kingdom bequeathed to the heirs of Charlemagne had recently been a dream of Charles the Rash, Maximilian's Burgundian father-in-law.

119. Winzinger, *Die Miniaturen*, 50–51, nos. 28–29.

120. Strauss, *Woodcuts*, 730. Winzinger, *Graphik*, no. 74: Den grosten schatz hat er allein / Von silber bold unnd edel stein / von perlem gut auch köstlich gwat / Als nie keim fürsten ward bekannt / davon tzu gotes dienst unnd eer / Vil geben hat und gibt noch mer."

121. On Frederick and jewels in particular, dedicated often to the glorification of imperial insignia, see Hermann Fillitz, "Kaiser Friedrich III und die bildende Kunst," in *Friedrich III*, exh. cat., 186–91; also Alphons Lhotsky, *Die Geschichte der Sammlungen (Festschrift des Kunsthistorischen Museums zur Feier des 50-jährigen Bestandes II)* (Vienna, 1941–45), 55–58, 60–64. It seems that it was Frederick III who devised the miter crown of the Habsburgs and also promoted the celebrated archduke's hat, both featured on his tomb as well as on the *Arch of Honor* of Maximilian (56–57). On Maximilian's treasures, see 78–91, 101 (tapestries); Lhotsky concludes that for Maximilian these "are not finally to be understood as the result of a *point d'honneur* and the *conscious* involvement in the arts is the result of the conceptual world of Maximilian I for the *splendor* of the dynasty" (107; italics in the original). See also Peter Krendl, "Über Hosenbandorden, 'Feder' und andere burgundische Kleinodien Karls des Kühnen," *Zeitschrift des historischen Vereins für Steuermark* 72 (1981), 7–26, a reference I owe to Elaine Tennant.

122. Benesch and Auer, *Historia Friderici et Maximiliani*, 118, no. 9.

123. Winzinger, *Die Miniaturen*, 54, no. 40, with the text of the letter, calling only for an "empress and three queens."

124. Winzinger, *Gemälde*, 117, no. 74.

125. The history of the Dürer drawing (Albertina) and its vicissitudes before becoming transformed into *the Triumphal Chariot* of 1518 (woodcut 1522; program by Pirckheimer) is traced by Karl Giehlow, "Dürers Entwürfe für das Triumphrelief."

126. Winzinger, *Gemälde*, 118, nos. 75–76; *Die Miniaturen*, 55–56, nos. 44–51. The roster of names is given by Appelbaum, *Triumph of Maximilian I*, 16–17: "Darnach sollen Reytten die fursten, unnd albegen funf neben ainannder mit Iren Pannern, wie Sy hernach mit Iren Namen begriffen sein, Unnd Ire named sollen in Ire paner, das ain Jeder fuert, geschriben sein."

127. Wiesflecker, *Kaiser Maximilian I*, 5:410–500, "Universale Kaiserpolitik. Weltreichspläne." On the general phenomenon of diplomacy, see Garrett Mattingly, *Renaissance Diplomacy*.

128. In both *Weisskunig* and *Teuerdank*, whose fictionalized natures do not hold the same documentary status as the *Arch*, these scenes of marriage are rendered as repeatable rituals with no real need for portrait likenesses and as typical royal events in an unfolding general history. As a result, within those narratives, the illustrations of royal marriages are assigned to lesser artists, whereas these topics were assigned to the leading artist, Dürer, on this most public—and historical—project. This insight should be credited to Elaine Tennant and her overall reflections on Maximilian's fictions and their visual representations.

129. Wiesflecker, *Kaiser Maximilian I*, 1:329ff.

130. Strauss, *Woodcuts*, 728. The "two good lands" lost to France were Artois and Burgundy.

131. Ibid.

132. Wiesflecker, *Kaiser Maximilian I*, 2:48ff., esp. n. 42; 4:23ff., esp. n. 1; Wiesflecker, "Maximilian I und die Heilige Liga von Venedig (1495)," in *Festschrift W.*

Sas-Zaloziecky zum 60. Geburtstag (Graz, 1956), 178–99.
In general, see Mattingly, *Renaissance Diplomacy*.

133. On Maximilian's embassies to the Russians, yet another
of his diplomatic moves intended to outflank the Turks,
see Wiesflecker, *Kaiser Maximilian I*, 5:413n22, 420n54,
470.

134. Otto, *Bernhard Strigel*, 69–70, 102, nos. 62–64, figs. 130–
31; Innsbruck, 1969, 23–24, nos. 71–72, fig. 4; cf. also
the earlier, similar profile portrait of Mary of Burgundy,
attributed to Niklas Reiser (?), 17, no. 34, fig. 3. See
Eisenbeiss, "Porträts," 116–17.

135. Otto, *Bernhard Strigel*, 68–69, 102, nos. 58–60, figs. 126–
28 (Vienna, Berlin-Dahlem, Lugano); Innsbruck, 1969,
148, nos. 551-52, color plate 1. See Eisenbeiss, "Porträts,"
239–44.

136. Innsbruck, 1969, 148, no. 549, title page illustration. The
Lugano portrait also shows a falcon hunt above the tree
out of the window (no. 552, color plate 1).

137. Otto, *Bernhard Strigel*, 67–68, 101, no. 57, color plate,
no. 61, fig. 129. Eisenbeiss, "Porträts," 32, 244–45, 280–81.

138. Egg, *Münzen*, 40–44; Innsbruck, 1969, nos. 317-1/2/3/4.
Eisenbeiss, "Porträts," 76–84.

139. Many of the commemorative coins, *Schaumünze*, with
Maximilian and Mary of Burgundy bear the date 1479
but were issued later. There are two main different
kinds of portraits of Mary on the reverse of these coins,
one bareheaded and the other in a characteristic high
pointed cap of around 1480 in the Low Countries.
Eisenbeiss, "Porträts."

140. Egg, *Münzen*, 45–46.

141. Elaine Tennant reminds me that the virtuous bride even
refuses to consummate their marriage until Teuerdank
proves to her satisfaction that he is serving God rather
than trying simply to increase his own fame and glory.

142. Anzelewsky, *Albrecht Dürer: Das malerische Werk*, 250–54,
nos. 145-46; Oberhammer, "Die vier Bildnisse"; Nurem-
berg, 1971, 139–41, no. 258 (Nuremberg); Vienna, 1959,
128–30, nos. 418–19, 421 (studies; W. 567, 635); Silver,
"Prints for a Prince," 8–10; Luber, "Albrecht Dürer's
Maximilian Portraits."

143. Text on the Nuremberg painting (Germanisches
Nationalmuseum), as cited in Oberhammer, "Die vier
Bildnisse": "Der Allergrosmechtigist unuberwindli-
chist Kayser Maximilian der in vernunfft schicklicheit
Weisheit und manheit / bey seinen Zeiten menigklich
ubertroffen Auch merckliche grosse sachen und getat-
ten geubt hat. . . ." Similar phrases obtain in the Vienna
Latin text: "potentissiums maximus et invictissimus

caesar Maximilianus qui cunctos sui temporis reges et
principes iusticia prudencia magna-nimitate liberali-
tate praecipue vero bellica laude et animi fortitudine
superavit."

144. Rupprich, *Dürer Schriftlicher Nachlass*, 1:79–80, no. 26;
English translation by William Martin Conway, *Literary
Remains of Albrecht Dürer* (Cambridge, 1889), 83.

145. Strauss, *Woodcuts*, 731. See also Oberhammer, "Die vier
Bildnisse," 10, for the reference, derived from J. J. Fug-
ger, that the fruit commemorates the 1492 victory over
Islam in the Spanish kingdom of Granada, an idea also
advanced by Lhotsky in discussing the symbol, *Geschichte
der Sammlungen*, 77n10, no. 3.

7 | Conclusions: Dynasty and /or Nation?

1. For an overview of the later history of the Habsburg
dominions, see Robert Kann, *A History of the Habsburg
Empire 1526–1918* (Berkeley, Calif., 1974), esp. 274–76 for
the Austro-Prussian War.

2. Ullmann, *Kaiser Maximilian I*; Leopold von Ranke,
Deutsche Geschichte im Zeitalter der Reformation (Leipzig,
1881–82); the quotation is taken from the English trans-
lation by Sarah Austin, *History of the Reformation in Ger-
many* (London, 1905), 94. This view appears in English
in Geoffrey Barraclough, *The Origins of Modern Germany*
(Oxford, 1988). On German historiography of the Holy
Roman Empire, contrasting "posture and power" see
Gerald Strauss, "The Holy Roman Empire Revisited,"
Central European History 11 (1978), 290–301; Volker Press,
"The Holy Roman Empire in German History," in E. I.
Kouri and Tom Scott, eds., *Politics and Society in Reforma-
tion Europe: Essays for Sir Geoffrey Elton on His 65th Birth-
day* (London, 1987), 51–77; Thomas Brady, Jr., "Some
Peculiarities of German Histories in the Early Modern
Era," in Andrew Fix and Susan Karant-Nunn, eds., *Ger-
mania Illustrata: Essays on Early Modern Germany Presented
to Gerald Strauss* (Kirksville, Mo., 1992), 196–216. Brady
notes, 199, that Ranke and his disciples believed that
the Reformation era after Maximilian provided the
first great German moment of national spirit "without
regard to a foreign model," identifying German history
with the fortunes of Protestantism, as they "tended to
summarize the whole of German history under the
heading 'From Luther to Bismarck.'"

3. Hermann Wiesflecker, *Maximilian I. Die Fundamente des
habsburgischen Weltreiches* (Vienna, 1991), a one-volume
digest of his five-volume biography (Vienna 1971–86).

4. His crowning volume in particular, vol. 5 (Vienna, 1986), features this subject, subtitled *Das Kaiser und seine Umwelt. Hof, Staat, Wirtschaft, Gesellschaft und Kultur.* The other principal contribution to this analysis from the same moment derives from literary history, Jan-Dirk Müller, *Gedechtnus.*

5. Silver, "Germanic Patriotism"; most recently—significantly, focused on one of the rare completed art projects—see Schauerte, *Die Ehrenpforte.*

6. The principal figure of this approach is Hans Robert Jauss, *Toward an Aesthetic of Reception,* trans. Timothy Bahti (Minneapolis, 1982). See also the anthology by Rainer Warning, ed., *Rezeptionsästhetik, Theorie und Praxis* (Munich, 1975); Robert Holub, *Reception Theory: A Critical Introduction* (1984). A related literary critical approach is "reader-response" criticism, associated with Wolfgang Iser, *The Act of Reading: A Theory of Aesthetic Response* (Baltimore, 1978). One comment on this approach by an art historian is Michael Ann Holly, *Past Looking: Historical Imagination and the Rhetoric of the Image* (Ithaca, N.Y., 1996), 195–207, noting the distinction between reception history and reception aesthetics, as derived from Wolfgang Kemp, *Der Betrachter ist im Bild: Kunstwissenschaft und Rezeptionsästhetik,* 2nd ed. (Cologne, 1985).

7. Thomas DaCosta Kaufmann, "Hermeneutics in the History of Art: Remarks on the Reception of Dürer in the Sixteenth and Early Seventeenth Centuries," Jeffrey Chipps Smith, ed., *New Perspectives on the Art of Renaissance Nuremberg. Five Essays* (Austin, Tex., 1985), 22–39. Leo Steinberg has made a career in his analysis of canonical Renaissance masterworks by such artists as Michelangelo and Leonardo in tracing their copies and imitations over time. See Steinberg, *Leonardo's Incessant "Last Supper"* (Cambridge, Mass., 2001), esp. 227–71; Steinberg, "A Corner of the *Last Judgment,*" *Daedalus* 109 (1980), 207–73; Steinberg, "The Line of Fate in Michelangelo's Painting," *Critical Inquiry* 7 (1980), 411–54; Steinberg, "Who's Who in Michelangelo's *Creation of Adam*: A Chronology of the Picture's Reluctant Self-Revelation," *Art Bulletin* 74 (1992), 552–66.

8. Egg, *Hofkirche,* 54–63. See also Wilfried Seipel, *Kaiser Ferdinand I 1503–1564* exh. cat. (Vienna, 2003).

9. The anniversary celebrations of the birth of Charles V in 1500 led to a spate of important new examinations in the form of biographies and exhibitions. The two most significant exhibitions were: Hugo Soly and Johan van de Wiele, eds., *Carolus: Charles Quint 1500–1558,* exh. cat. (Ghent, 1999); and Wilfried Seipel, *Kaiser Karl V (1500–1558): Macht und Ohnmacht Europas* (Vienna, 2000). Other overviews of Charles's art patronage include Roy Strong, *Art and Power: Renaissance Festivals 1450–1650* (Berkeley, Calif., 1984), 78–119; Hugh Trevor-Roper, *Princes and Artists: Patronage and Ideology at Four Habsburg Courts, 1517–1633* (New York, 1976), 10–45. A fine critical biography is Wim Blockmans, *Emperor Charles V 1500–1558,* trans. Isola van den Hoven-Vardon (London, 2002); another notable contemporary shorter assessment is William Maltby, *The Reign of Charles V* (New York, 2002). Still essential is Karl Brandi, *The Emperor Charles V,* trans. C. V. Wedgwood (London, 1939; orig. ed. Munich, 1937–41), significantly subtitled *The Growth and Destiny of a Man and of a World-Empire.* Most recently see the collection, Alfred Koheler, Barbara Haider, and Christine Ottner, eds., *Karl V 1500–1558: Neue Perspektiven seiner Herrschaft in Europa und Übersee* (Vienna, 2002). For the Habsburg interactions between Charles V and Ferdinand I, see Jean Bérenger, *A History of the Habsburg Empire 1273–1700,* trans. C. A. Simpson (London, 1994; orig. ed. 1990), esp. 139–54 for Charles, 123–38 for Maximilian. See also Frances Yates, "Charles V and the Idea of the Empire," in *Astraea,* 1–28.

10. Vienna, National Library, cod. 2591, thirty full-page miniatures, three half-page. Anglo, *La tryumphante entrée de Charles*; Soly and Wiele, *Carolus,* 194, no. 41. A printed version of this text was also produced (Paris: Gilles de Gourmont, 1515). For the contribution of these stagings in the wider context of Netherlandish entries, see Roeder-Baumbach, *Versieringen bij blijde inkomsten,* esp. 10–11, 28–34, 40–45, 76–78, 91–95, 98, 109–10.

11. Soly and Wiele, *Carolus,* 192–93, nos. 39–40 (for Strigel, 166–67, no. 4).

12. Vienna, Kunsthistorisches Museum, Hofjagd und Rüstkammer, inv. A109. Soly and Wiele, *Carolus,* 191–92, no. 38.

13. Smith, *Nuremberg,* 235, no. 138; Scher, *The Currency of Fame,* 203–4, no. 77; Soly and Wiele, *Carolus,* 247, no. 126; Seipel, *Kaiser Karl V,* 136, no. 75. For the Maximilian material, Egg, *Münzen.*

14. On both the crowns and the mottos, see the fundamental works by Rosenthal, "Die 'Reichskrone,'" esp. 37–39; and Rosenthal, "*Plus ultra,* non plus ultra, and the Columnar Device of Emperor Charles V," *Journal of the Warburg and Courtauld Institutes* 34 (1971), 204–28.

15. The use of classical orders and the circular courtyard in the center are based on Raphael's Villa Madama, Rome. See Earl Rosenthal, *The Palace of Charles V in Granada* (Princeton, N.J., 1985).

16. Brussels, Musées Royaux d'Art et d'Histoire. Campbell, *Tapestry in the Renaissance*, 168–74, no. 16; Roger d'Hulst, *Vlaamse wandtapijten van de XIVde tot de XVIIIde eeuw* (Brussels, 1960), 140–46.

17. Thomas Campbell, *Tapestry in the Renaissance*, 168, 174.

18. John David Farmer, "Bernard van Orley of Brussels" (Ph.D. diss., Princeton University, 1981), esp. 304–8; Maryan Ainsworth, "Bernart van Orley as a Designer of Tapestry" (Ph.D. diss., Yale University, 1982), esp. 36–39.

19. The series was lost in a fire in 1760. Campbell, *Tapestry in the Renaissance*, 299–300, fig. 142; Ainsworth, "Bernart van Orley," 78–79, 173–75; C. W. Fock, "Nieuws over de tapijten, bekend als de Nassause Genealogie," *Oud Holland* 84 (1969), 1–28.

20. Seipel, *Kaiser Karl V*, 113, no. 7, part of eighteen woodblocks, printed on a frieze of fourteen sheets. Printed by Doen Pietersz in Antwerp after the model of Maximilian's *Triumphal Procession* equestrian figures. See Larry Silver, "*Blijde Uitgave*: Early Dutch Large Woodcuts and Local Politics," in Arnout Balis, Paul Huvenne, Jeanine Lambrecht, and Christine Van Mulders, eds., *Florissant, Bijdragen tot de kunstgeschiedenis der Nederlanden (15de–17de eeuw)* (Brussels, 2005), 65–77.

21. Preparatory designs survive in a pair of sets, one dispersed, the other (copies?) in Paris (Louvre). Campbell, *Tapestry in the Renaissance*, 329–39, nos. 37–40; Ainsworth, "Bernart van Orley," 80–87, 164–69; d'Hulst, *Vlaamse wandtapijten*, 171–82; Balis, et al., *Les chasses de Maximilien*.

22. Three pieces, each of them a different sphere: celestial (supported by Hercules), armillary (supported by Atlas), terrestrial (protected by Jupiter and Juno). Campbell, *Tapestry in the Renaissance*, 268, 300; Antonio Dominguez Ortiz, Concah Herrero Carretero, José Godoy, *Resplendence of the Spanish Monarchy*, exh. cat. (New York, 1991), 55–67; Lisa Jardine and Jerry Brotton, *Global Interests. Renaissance Art between East and West* (Ithaca, N.Y., 2000), 119.

23. To consolidate this global empire, in 1543, Philip II, son of Charles V, married Maria of Portugal, daughter of John III and niece of Charles V. Despite claims that the two divinities are royal portraits, these heroic, but generic van Orley faces seem out of character with the demands of likenesses from life.

24. Four surviving drawings, signed with van Orley's monogram and dated 1524 (Munich), at variance with the final weavings; tapestries in Spanish Royal Collections, La Granja. Ainsworth, "Bernart van Orley," 73, 76–78, 118–20, 158–60; Campbell, *Tapestry in the Renaissance*, 295–96, 300, figs. 138–39, 143; Guy Delmarcel, *Golden Weavings: Flemish Tapestries of the Spanish Crown* (Munich, 1993), 64–91; Delmarcel, *Flemish Tapestry* (New York, 1999), 102–3; see 142–46 for Raphael's *Acts of the Apostles* series, woven in Brussels, for which see also Sharon Fermor, *The Raphael Tapestry Cartoons: Narrative, Decoration, Design* (London, 1996); John Shearman, *Raphael's Cartoons in the Collection of Her Majesty the Queen and the Tapestries for the Sistine Chapel* (London, 1972).

25. All seven large drawings survive (Paris, Louvre). Campbell, *Tapestry in the Renaissance*, 296–97, 321–28, nos. 35–36; Ainsworth, "Bernart van Orley," 170–73; d'Hulst, *Vlaamse wandtapijten*, 147–56.

26. Campbell, *Tapestry in the Renaissance*, 384–91, 428–34; Seipel, *Kaiser Karl V*, 196–205; Wilfried Seipel, *Der Kriegszug Kaiser Karls V gegen Tunis: Kartons und Tapisserien* (Vienna, 2000); Hendrik Horn, *Jan Cornelisz. Vermeyen, Painter of Charles V and His Conquest of Tunis* (Doornspijk, 1989).

27. Original in Vienna, Historical Museum of the City. Seipel, *Kaiser Karl V*, 191–93, no. 143; Landau and Parshall, *Renaissance Print*, 226–28, figs. 233–34. The block cutting and 1530 publication of this ensemble was the work of Nicolaus Meldemann, a print colorist (*briefmaler*) in Nuremberg, with a local privilege granted by the municipal council. Sebald Beham reworked his image from on-site drawings by an anonymous artist, who climbed the tower of the cathedral of St. Stephen, high point of the city. Ironically, compared to the luxury medium, high cost, and restricted audience of Charles V's tapestry cycle, Meldemann's dedication speaks of trying to reduce the cost of paper for his documentation to make it affordable for the "common man (*gemeiner mann*)."

28. This uniquely eyewitness reportage is paralleled only by Pieter Coecke van Aelst of Antwerp, who went to Istanbul with the hopes of producing a cycle of tapestries on Ottoman life and places for the sultan; when this project fell through, it still formed the foundation for a suite of figures in procession across ten woodcuts, published posthumously under the title *Customs and Fashions of the Turks* (1553). See Campbell, *Tapestry in the Renaissance*, 384–91, fig. 178; Georges Marlier, *La Renaissance flamande: Pierre Coecke d'Alost* (Brussels, 1966), 55–87. Jardine and Brotton, *Global Interests*, 82–115, argue that this projected tapestry cycle for Istanbul would have been a status commission, establishing parity between the sultan and the emperor (or his relations, such as John III of Portugal with *The Spheres*). According to Campbell,

Tapestry in the Renaissance, the parallels are not fortuitous: in contrast to Horn (on Vermeyen) and Marlier (on Coecke), the authors of the catalogue see Coecke as a collaborator with Vermeyen on the *Tunis* cartoons.

29. Seipel, *Kriegszug Kaiser Karls V*, 29–34, figs. 17–23.

30. This painting has been owned by Rosenberg and Stiebel, New York: Luba Freedman, *Titian's Portraits through Aretino's Lens* (University Park, Pa., 1995), 73–75, fig. 24; *The Age of Correggio and the Carracci*, exh. cat. (Washington, D.C., 1986), 172–74, no. 62. This picture is mentioned by Vasari (1906 ed., 5:229). According to Brigitta Walbe, *Studien zur Entwicklung des allegorischen Porträts in Frankreich von seinen Anfängen bis zur Regierungszeit König Heinrich II* (Glückstadt, 1974), 2–4, fig. 31, the same iconography, derived from Roman coins, appears on a medal made for King Francis I. The emperor's emblem, the Pillars of Hercules, tied to his motto, *plus ultra* ("farther still"), appears on the scabbard of his sword.

31. Artur Rosenauer, "Karl V und Tizian," in Koheler et al., *Karl V (1500–1558)*, 57–66; Karl Schütz, "Karl V und die Entstehung des höfischen Porträts," in Seipel, *Kaiser Karl V*, 55–63; Sylvia Ferino-Pagden, "Des Herrschers 'natürliches' Idealbild: Tizians Bildnisse Karls V," in Seipel, *Kaiser Karl V*, 65–76, with references; Hilliard Goldfarb, "Titian: *Colore & Ingengo* in the Service of Power," in *Titian and Rubens. Power, Politics, and Style*, exh. cat. (Boston, 1998), 3–27; Didier Bodart, "La Codification de l'image imperiale de Charles-Quint par Titien," *Revue des archéologues et historiens d'art de Louvain* 30 (1997), 61–78; Justus Müller Hofstede, "Rubens und Tizian. Das Bild Karl V," *Münchner Jahrbuch der bildenden Kunst* 18 (1967), 33–96; Herbert von Einem, *Karl V und Tizian* (Cologne, 1960). For the general phenomenon of the court artist in the Renaissance and the comparison to Apelles, see Warnke, *The Court Artist*, esp. 40–41 on Apelles, 201, 216, 232, 239, on Titian and Charles V.

32. Marianna Jenkins, *The State Portrait: Its Origins and Evolution* (New York, 1947).

33. Ibid.; Freedman, *Titian's Portraits*, "Charles V: The *Concetto* of the Emperor," 115–43; Panofsky, *Problems in Titian Mostly Iconographic*, 7–8, 82–87, 182–86: "As the portrait of Charles V in an armchair is the first self-sufficient, unallegorical, and unceremonial single portrait . . . to show the subject seated but in full-length, so is the portrait of Charles V on horseback the first self-sufficient, unallegorical, and unceremonial equestrian portrait in the history of painting" (84). The almost studied

informality—replacing a scepter of power with a cane for gout—of the Munich seated portrait suggests the frankness with dignity of the emperor as a sitter for his favorite portraitist. Freedman, 133–43, stresses an association with Roman imperial seated portraits in scenes of *Liberalitas*, the ritual that concluded a time of warfare and inaugurated a time of peace, a perfect counterpoint to his martial equestrian portrait.

34. John Pope-Hennessy, *Italian High Renaissance and Baroque Sculpture* (London, 1970), 85–86, 96–97, 103, 400–403. Leoni left Milan for Brussels in 1548 and made further visits to the imperial court in Augsburg (1551) and Brussels (1556). According to Pope-Hennessy, *Charles V Restraining Fury* was commissioned in 1549, and cast in two parts: the emperor in 1551, the Fury in 1553, only to be completed in Spain by his sculptor son, Pompeo Leoni in 1564.

35. Georg Kugler, "Macht und Mäzenatentum," in Seipel, *Kaiser Karl V*, 47–55, esp. 54; Trevor-Roper, *Princes and Artists*, 31–33; Michael Mezzatesta, "Imperial Themes in the Art of Leone Leoni" (Ph.D. diss., New York University, 1980), 41–43.

36. *The Aeneid of Virgil*, trans. Allen Mandelbaum (Toronto, 1971), 11:

> Then a Trojan
> Caesar shall rise out of that splendid line.
> His empire's boundary shall be the Ocean;
> the only border to his fame, the stars . . .
> .
> The gruesome gates
> of war, with tightly welded iron plates,
> shall be shut fast. Within, unholy Rage
> shall sit on his ferocious weapons, bound
> behind his back by a hundred knots of brass;
> he shall groan horribly with bloody lips.

37. Seipel, *Kaiser Karl V*, 321–22, nos. 356–57. Here the armor is identified with the 1544 suit worn at the Battle of Mühlberg, portrayed by Titian in the 1548 equestrian portrait and still preserved in Madrid, Royal Armory (A 164–87). The Vienna bust was presented to Cardinal Granvelle, the minister of Charles V. Also Ulrich Middeldorf, "On Some Portrait Busts Attributed to Leone Leoni," *Burlington Magazine* 177 (1975), 84–91.

38. Frits Scholten, *Adriaen de Vries (1556–1626), Imperial Sculptor*, exh. cat. (Amsterdam, 1998), 140–43, no. 13; see also the relief (1609), 172–75, no. 22. As pointed out in the same volume, Rosemarie Mulcahy, "Adriaen de Vries in the Workshop of Pompeo Leoni," 46–51, the

connection between the Leoni lineage and de Vries was direct.

39. Rosemarie Mulcahy, *The Decoration of the Royal Basilica of El Escorial* (Cambridge, 1994), 189–211; Pope-Hennessy, *Italian High Renaissance and Baroque Sculpture*, 403–4, plate 107. Charles originally planned to be entombed in the cathedral of Granada, the final conquest in Iberia of a Moorish stronghold and the site of his uncompleted palace within the Alhambra. Charles V is accompanied by his wife, Empress Isabel, their daughter, Empress Maria, and Charles's sisters: Eleonor, queen of France; and Maria, queen of Hungary.

40. Folz, *Le souvenir et la légende de Charlemagne*; Yates, "Charles V and the Idea of the Empire," in *Astraea*, 1–28.

41. Soly and Wiele, *Carolus*, 311–18, no. 227; Seipel, *Kaiser Karl V,* 354–61, nos. 423–34; Bob van den Boogert and Jacqueline Kerkhoff, *Maria van Hongarije 1505–1558*, exh. cat. (Utrecht, 1993), 260–62, no. 201; Bart Rosier, "The Victories of Charles V: A Series of Prints by Maarten van Heemskerck, 1555–56," *Simiolus* 20 (1990–91), 24–38. The title page notes that Cock produced the prints "of his own accord" and dedicated them to "the great Philip, son of the divine Charles V." In chronological sequence the subjects are Battle of Pavia (1525), Sack of Rome (1527), Besieging the Pope (1527), Rescue of Vienna (1529), Mission to the Indians (1530), Fall of Tunis (1535), Surrender of Duke of Cleve (1543), Imperial Camp at Ingolstadt (1546), Battle of Mühlberg with Surrender of Johann Frederick of Saxony (1547), Surrender of German Cities (1547), Obeisance of Philip, duke of Hesse (1547).

42. Bérenger, *History of the Habsburg Empire 1237–1700*, 155–209. Helmut Koenigsberger, *The Habsburgs and Europe 1515–1660* (Ithaca, N.Y., 1971), 1–63; Kann, *History of the Habsburg Empire 1526–1918*, 1–45; Paula Sutter Fichtner, *Ferdinand I of Austria: The Politics of Dynasticism in the Age of the Reformation* (New York, 1982), esp. 86–90; also Fichtner, *Emperor Maximilian I* (New Haven, Conn., 2001), esp. 13–18, 25–31, 50–58; Ernst Laubach, *Ferdinand I als Kaiser* (Münster, 2001); Seipel, *Kaiser Ferdinand I.*

43. Illustrated in Seipel, *Kaiser Karl V*, 24, fig. 11. Smith, *German Sculpture of the Later Renaissance*, 365–67, see also 338–39, fig. 300, *Charles V on Horseback* (Innsbruck, Ferdinandeum); Karl Feuchtmayr, "Die Begegnung Karls V und Ferdinands I von Hans Daucher," *Münchner Jahrbuch der bildenden Kunst* 10 (1933), ix–xiii. For the 1532 medal by Peter Flötner depicting Charles V and Ferdinand I, with Mary of Hungary on the reverse, see Seipel, *Kaiser*

Karl V, 139–40, no. 49. On Daucher in general, see Thomas Eser, *Hans Daucher. Augsburger Kleinplastik der Renaissance* (Munich, 1996).

44. On the tomb, see Oberhammer, *Bronzestandbilder*; Oettinger, *Die Bildhauer*; and especially Egg, *Hofkirche*. One other statue of the emperor's ancestors at the tomb, *Zimburgis of Masovia*, was also produced in Nuremberg (1514) by wood sculptor Veit Stoss, then cast by Sesselschreiber (succeeded by Godl, a bronze specialist, in 1518). The idea of a set of standing figures embodying the genealogy of the emperor derives from Burgundian models, albeit on a smaller scale. At the time of the transition, Sesselschreiber had only finished eleven figures, of which three were recast because of faults (Theobert of Burgundy, Eleonora of Portugal, and Ladislaus Posthumus). In short, eight statues (and several armorial shields) in ten years, so the dismissal is easy to understand. Recently a fourth Dürer drawing for the tomb ancestors has been attributed: *Ottobert*, the founder of the Habsburg dynasty (1515; Berlin, Kupferstichkabinett inv. nr. KdZ 26812); Seipel, *Werke für die Ewigkeit*, 130–31; Koreny, "Ottoprecht Fürscht."

45. Seipel, *Werke für die Ewigkeit*, 131–32, no. 56; Egg, *Hofkirche*, 18–21; Oberhammer, *Bronzestandbilder*, 163–207. A copy of the Ambras parchment survives in Munich (ca. 1550; Staatsbibliothek 908).

46. Alois Kiesling, "Das Grabmal Friedrichs III," in *Friedrich III.*, exh. cat., 192–96, 386–87, no. 204; Hertlein, "Das Grabmonument Kaiser Friedrichs III." According to Maximilian's own wishes, his own standing effigy, flanked by Frederick and Charlemagne (and four unknown ancestor figures) would have stood foremost (*am vordersten*), with the other figures in the nave and choir on high pedestals, presumably between columns.

47. Egg, *Hofkirche*, 54–62; Oberhammer, *Bronzestandbilder*, 32–34.

48. Seipel, *Werke für die Ewigkeit*, 139–40, no. 62; Egg, *Hofkirche*, 49–62.

49. 1548, Dresden, inv. C 2196; Egg, *Hofkirche*, 44–48, fig. 11, one of seven designs for statues, including Charlemagne, made by Amberger. The cast was made in one piece by Gregor Löffler, in Innsbruck since 1544.

50. Egg, *Hofkirche*, 54–72.

51. Seipel, *Werke für die Ewigkeit*, 123–26, no. 53.

52. Winfried Eberhard, "Bohemia, Moravia and Austria," "David Daniel," and "Hungary," in Andrew Pettegree, ed., *The Early Reformation in Europe* (Cambridge, 1992), 23–48, 49–69; David Daniel, "Calvinism in Hungary:

The Theological and Ecclesiastical Transition to the Reformed Faith," in Andrew Pettegree, Alastair Duke, and Gillian Lewis, eds., *Calvinism in Europe 1540–1620* (Cambridge, 1994), 205–30; Philip Benedict, *Christ's Churches Purely Reformed. A Social History of Calvinism* (New Haven, Conn., 2002), 271–80.

53. Seipel, *Kaiser Ferdinand I.*

54. Thomas DaCosta Kaufmann, *Court, Cloister and City. The Art and Culture of Central Europe 1450-1800* (Chicago, 1995), 143–45; Ferdinand Seibt, ed., *Renaissance in Böhmen* (Munich, 1985), 52–55.

55. Jan Bialostocki, *The Art of the Renaissance in Eastern Europe* (Ithaca, N.Y., 1976), 6–9, 13–15; see also 74–75 for the Belvedere in Prague; also *Matthias Corvinus und die Renaissance in Ungarn*, exh. cat. (Schallaburg, 1982).

56. John Martin, *The Decorations for the Pompa Introitus Ferdinandi: Corpus Rubenianum Ludwig Burchard XVI* (Brussels, 1972); Julius Held, *The Oil Sketches of Peter Paul Rubens* (Princeton, N.J., 1980), 219–48; see also Elizabeth McGrath, "Le declin d'Anvers et les décorations de Rubens pour l'entrée du Prince Ferdinand en 1635," in Jacquot, ed., *Fêtes de la Renaissance*, 3:173–86, with comparisons to previous Antwerp entries.

57. Martin, *Decorations*, 216–21, nos. 56–56a. The oil sketch survives in Antwerp, Koninklijk Museum; see also Held, *Oil Sketches*, 388–90, no. 289.

58. Martin, *Decorations*, 66–100, nos. 5–20; Held, *Oil Sketches*, 229.

59. Martin, *Decorations*, 63–64, no. 4a; Held, *Oil Sketches*, 228–29, no. 147. The finished canvas survives (Vienna, Kunsthistorisches Museum).

60. Martin, *Decorations*, 100–131, nos. 21–33b; Held, *Oil Sketches*, 230–34, nos. 150–57. For Maximilian, wearing the Order of the Golden Fleece and the imperial crown, Rubens relied on a portrait tradition, chiefly deriving from Hubert Goltzius's 1557 Antwerp print series, reprinted with chiaroscuro woodcuts by Christoffel Jegher; the sketch survives in Oxford, Ashmolean Museum (Held, no. 154). Held, 233, explicitly compares the image of Maximilian to the statue of Frederick III on the *Arch*. Rubens's portrait of Charles V derives from Titian, fresh in the artist's memory after his trip to the royal collection in Madrid at the end of the 1520s. See Hofstede, "Rubens und Tizian."

61. Franz Matsche, *Die Kunst im Dienst der Staatsidee Kaiser Karls VI* (Berlin, 1981), esp. 78–133, 240–332. This book provides a learned and thoughtful exegesis on the Habsburg imperial legacy. An additional twist on the identification with Charles V was Charles VI's claims to rulership of Spain, precipitating the contentious War of Spanish Succession. The name "Charles" was also related further back in time to both Charlemagne, the first Holy Roman Emperor, as well as the Burgundian Charles the Rash, father-in-law of Maximilian I.

62. Kaufmann, *Court, Cloister and City*, 300–302. Hans Sedlmayr, *Johann Bernhard Fischer von Erlach* (Vienna, 1976), 174ff.

63. For the Jesuits and propaganda, see Evonne Levy, *Propaganda and the Jesuit Baroque* (Berkeley, Calif., 2004); John O'Malley, Gauvin Bailey, Steven Harris, and Frank Kennedy, eds., *The Jesuits: Cultures, Sciences, and the Arts, 1540–1773* (Toronto, 1999); Jeffrey Chipps Smith, *Sensuous Worship: Jesuits and the Art of the Early Catholic Reformation of Germany* (Princeton, N.J., 2002). For the wider political context, see Ellenius, *Iconography, Propaganda, and Legitimation*.

64. Volker Press, "The Habsburg Lands: The Holy Roman Empire, 1400–1555," in Thomas Brady, Jr., Heiko Oberman, and James Tracy, eds., *Handbook of European History 1400–1600* (Leiden, 1994), vol. 1:437–66, esp. 446–48, with references; Wiesflecker, *Kaiser Maximilian I*, 5:1–150; Fritz Hartung, "Imperial Reform, 1485–95: Its Course and Its Character," in Gerald Strauss, ed., *Pre-Reformation Germany* (New York, 1972), 73–135. Still useful is Leopold von Ranke, *History of the Reformation in Germany*, trans. Sarah Austin (London, 1905), vol. 1, bk. 1, 40–110.

65. Brady, *Turning Swiss*.

66. Ingetraut Ludolphy, *Friedrich der Weise: Kurfürst von Sachsen 1463–1525* (Göttingen, 1984); Wiesflecker, *Kaiser Maximilian I*, 5:35–42.

67. For the translation of this program, see Appelbaum, *The Triumph of Maximilian I*, 16; for the Altdorfer image, see Winzinger, *Gemälde*, 118, fig. 75. He is given pride of place, paired only with the Wittelsbach duke, Albrecht of Bavaria.

68. Ludolphy, *Friedrich der Weise*, 137–238, spanning emperors from Frederick III to Charles V.

69. Ibid., 351–58; Koepplin and Falk, *Lukas Cranach*, 1:186–91, 218–20, nos. 95–101.

70. Ludolphy, *Friedrich der Weise*, 109–10; Carl Christensen, *Princes and Propaganda: Electoral Saxon Art of the Reformation* (Kirksville, Mo., 1992), 13–27, with references.

71. Claus Grimm, Johannes Erichsen, and Evamaria Brockhoff, eds., "Cranach als Hofmaler," in *Lucas Cranach*, exh. cat. (Kronach, 1994), 309–22; Sternelle, *Lucas Cranach*;

Koepplin and Falk, *Lukas Cranach*, 1:194–96, 241–49, nos. 137–56.

72. Koepplin and Falk, *Lukas Cranach*, 1:242–43, no. 139 (copy); *Lucas Cranach der Ältere*, exh. cat. (Vienna, 1972), 22–23, no. 9. The original was commissioned by Frederick's brother and successor, Johann the Steadfast (d. 1532), who was also present on the occasion. The background setting, however, is not Innsbruck but rather a substitute Saxon site, Mansfeld, identified by its castle. See also H. S. Francis, "Stag Hunt by Lucas Cranach the Elder and Lucas Cranach the Younger," *Cleveland Museum Bulletin* 46 (1959), 198–205.

73. Andersson and Talbot, *From a Mighty Fortress*, exh. cat., 84–85, no. 16.

74. Ludolphy, *Friedrich der Weise*, 75–136. Larry Silver, "Civic Courtship: Albrecht Dürer, the Saxon Duke, and the Emperor," in Stephen Campbell, ed., *Artists at Court: Image-Making and Identity 1300–1550* (Boston, 2004), 149–62; Edgar Bierende, *Lucas Cranach d.Ä. und der deutsche Humanismus. Tafelmalerei im Kontext von Rhetorik, Chroniken und Fürstenspiegeln* (Munich, 2002), a richly textured address of this basic topic. See also Grimm et al., *Lucas Cranach*, esp. the following essays: Christiane Andersson, "Die Spalatin-Chronik und ihre Illustrationen aus der Cranach-Werkstatt," 208–17; Monika und Dietrich Lücke, "Lucas Cranach in Wittenberg," 59–65; Dieter Stievermann, "Lucas Cranach und der kursächsische Hof," 66–77; Franz Matsche, "Lucas Cranachs mythologische Darstellungen," 77–88.

75. Ludolphy, *Friedrich der Weise*, 145–68; Wiesflecker, *Kaiser Maximilian I*, 2:282–83.

76. Ludolphy, *Friedrich der Weise*, 168–74, 175–204.

77. Ibid., 204–41; Wiesflecker, *Kaiser Maximilian I*, 4:404–19, 455–61; Brandi, *Emperor Charles V*, 95–114.

78. Sebastian Brant, *The Ship of Fools*, trans. Edwin Zeydel (New York, 1944) is the source of the Brant citations. Subsequent references are provided parenthetically in the text, by chapter and line number. For Wimpheling, *Germania*, trans. Ernst Martin (Strasbourg, 1885). For general background, see Heinz Otto Burger, *Renaissance, Humanismus, Reformation: Deutsche Literatur im europäische Kontext* (Bad Homburg, 1969); Borchardt, *German Antiquity*. On Brant, see Jan-Dirk Müller, "Poet, Prophet, Politiker"; Wuttke, "Sebastian Brant und Maximilian I"; Spitz, *The Religious Renaissance of the German Humanists*.

79. Quoted from the translation by Gerald Stauss, ed., *Manifestations of Discontent in Germany on the Eve of the Reformation* (Bloomington, Ind., 1971), 65–66.

80. Keith Moxey, "Mercenary Warriors and the 'Rod of God,'" in *Peasants, Warriors, and Wives* (Chicago, 1989), 67–100. The larger phenomenon linking the growth of centralized national political structures with taxation and royal bureaucracy is strongly argued by Charles Tilly, *Coercion, Capital, and European States, AD 990–1992* (Oxford, 1992); Brian Downing, *The Military Revolution and Political Change: Origins of Democracy and Autocracy in Early Modern Europe* (Princeton, N.J., 1992).

81. Charles Stinger, *The Renaissance in Rome* (Bloomington, Ind., 1985), esp. 235–91.

82. Louis Marin, *Portrait of the King*, trans. Martha Houle (Minneapolis, 1988; orig. ed. 1981); see also Peter Burke, *The Fabrication of Louis XIV* (New Haven, Conn., 1992).

Bibliography

For abbreviations and short references, see the list at the beginning of the endotes.

| Works and Editions by Maximilian

Correspondance de l'Empereur Maximilien Ier et de Marguerite d'Autriche sa fille, gouvernante de Pays-bas de 1507 à 1519, ed. M. Le Glay, 2 vols. (Paris, 1839)

Das Fischereibuch Kaiser Maximilians I, ed. Michael Mayr (Innsbruck, 1901)

"Fragmente einer lateinischen Autobiographie Kaiser Maximilians I," in Alwin Schultz, ed., "Der Weisskunig nach den Dictaten . . ." (see entry below), 421–46

Freydal: Des Kaisers Maximilian I: Turniere und Mummereien, ed. Quirin von Leitner (Vienna,1880–82)

Das Jagdbuch Kaiser Maximilians I, ed. Michael Mayr (Innsbruck, 1901)

Kaiser Maximilians Teuerdank, ed. H. Theodor Musper, facsimile ed. (Plochingen, 1968)

Kaiser Maximilians I Weisskunig, ed. H. Theodor Musper, Rudolf Buchner, Heinz-Otto Burger, and Erwin Petermann, facsimile ed. (Stuttgart, 1956)

"*Theuerdank*: Die geuerlicheiten vnd einsteils der geschichte des loblichens Streytparen vnd hochberümbten helds vnd Ritters herr Tewrdannckhs," ed. Simon Laschitzer, *JKSAK* 8 (1888)

"*Der Weisskunig* nach den Dictaten und eigenhändigen Aufzeichnungen Kaiser Maximilians I zusammengestellt von Marx Treitzsaurwein von Ehrentreitz," ed. Alwin Schultz *JKSAK* 6 (1888)

| Secondary Sources

Aiken, J. P., "Pseudo-Ancestors in the Genealogical Projects of Maximilian I," *Renaissance and Reformation* 1 (1977), 8–16

Albrecht Dürer 1471–1971, exh. cat. (Nuremberg, 1971)

Althoff, Gerd, *Inszenierte Herrschaft: Geschichtsschreibung und politisches Handeln im Mittelalter* (Darmstadt, 2003)

Althoff, Gerd, *Die Macht der Rituale: Symbolik und Herrschaft im Mittelalter* (Darmstadt, 2003)

Anderson, Perry, *Lineages of the Absolutist State* (London, 1974)

Angermeier, Heinz, *Die Reichsreform 1410–1555* (Munich, 1986)

Anglo, Sydney, *Spectacle, Pageantry, and Early Tudor Politics* (Oxford, 1969)

Anglo, Sydney, ed., *La tryumphante entrée de Charles Prince des Espagnes en Bruges 1515: A Facsimile with an Introduction* (Amsterdam, 1970)

Ankwicz-Kleehoven, Hans, "Das Totenbildnis Kaiser Maximilians I," *Wiener Jahrbuch für Kunstgeschichte* 11 (1937), 59–68

Ankwicz-Kleehoven, Hans, *Der Wiener Humanist Johannes Cuspinian* (Cologne, 1959)

Anzelewsky, Fedja, *Albrecht Dürer: Das malerische Werk*, 2nd ed. (Berlin, 1991; orig. ed., 1971)

Anzelewsky, Fedja, *Albrecht Dürer: His Art and Life*, trans. Heide Grieve (New York, 1980)

Anzelewsky, Fedja, *Dürer-Studien* (Berlin, 1983)

Anzelewsky, Fedja, "Ein unbekannter Entwurf Hans Burgkmairs für das Reiterdenkmal Kaiser Maximilians," in Ursula Schlegel and Claus Zoege von Mantenffel, eds., *Festschrift für Peter Metz* (Berlin, 1965), 295–304

Appelbaum, Stanley, ed., *The Triumph of Maximilian I* (New York, 1964)

Appuhn, Horst, ed., *Der Triumphzug Kaiser Maximilians I 1516–1518* (Dortmund, 1979)

Appuhn, Horst, and Christian von Heusinger, *Riesenholzschnitte und Papiertapeten der Renaissance* (Unterschneidheim, 1976)

Arnold, Klaus, *Johannes Trithemius* (Würzburg, 1973)

Ausstellung Maximilian I Innsbruck, exh. cat. (Innsbruck, 1969)

Baldass, Ludwig von, "Die Bildnisse Kaiser Maximilians," *JKSAK* 31 (1913), 247–334

Baldass, Ludwig von, *Der Künstlerkreis Kaiser Maximilian* (Vienna, 1923)

Balis, Arnout, *Hunting Scenes, Corpus Rubenianum Ludwig Burchard*, vol. 18.2, trans. P. S. Falla (London, 1986)

Balis, Arnout, et al., *Les chasses de Maximilien* (Paris, 1993)

Bartrum, Giulia, *Albrecht Dürer and His Legacy*, exh. cat. (London, 2002)

Baxandall, Michael, *The Limewood Sculptors of Renaissance Germany* (New Haven, Conn., 1980)

Behling, Lottlisa, "Zur Frage der Bildschnitzer in der Werkstatt Gilg Sesselschreibers vom Innsbrucker Kaisergrab," *Pantheon* (1965), 31–40

Bellot, Josef, "Konrad Peutinger und die literarisch-künstlerischen Unternehmungen Kaiser Maximilians I," *Philobiblon* 11 (1967), 171–90

Bendix, Reinhard, *Kings or People: Power and the Mandate to Rule* (Berkeley, Calif., 1978)

Benecke, Gerhard, *Maximilian I 1459–1519: An Analytical Biography* (London, 1982)

Benesch, Otto, and Erwin Auer, *Die Historia Friderici et Maximiliani* (Berlin, 1957)

Bérenger, Jean, *A History of the Habsburg Empire 1273–1700*, trans. C. A. Simpson (London, 1994; orig. ed. 1990)

Berges, Wilhelm, *Die Fürstenspiegel des hohen und späten Mittelalters* (Leipzig, 1938)

Bertelli, Sergio, *The King's Body: Sacred Rituals of Power in Medieval and Early Modern Europe*, trans. Burr Litchfield (University Park, Pa., 2001)

Bezold, Friedrich von, *Konrad Celtis: Der deutsche Erzhumanist* (Darmstadt, 1959)

Bialostocki, Jan, *The Art of the Renaissance in Eastern Europe* (Ithaca, N.Y., 1976)

Bierende, Edgar, *Lucas Cranach d. Ä. und der deutsche Humanismus: Tafelmalerei im Kontext von Rhetorik, Chroniken und Fürstenspiegeln* (Munich, 2002)

Bloch, Marc, *The Royal Touch*, trans. J. E. Anderson (New York, 1989; orig. ed. 1961)

Bloch, R. Howard, *Etymologies and Genealogies* (Chicago, 1983)

Boeheim, Wendelin, "Die Zeugbücher Kaiser Maximilians I," *JKSAK* 13 (1892), 94–201; 15 (1894), 295–391

Böhm, Christoph, *Die Reichsstadt Augsburg und Kaiser Maximilian*, Abhandlungen zur Geschichte der Stadt Augsburg, 36 (Sigmaringen, 1998)

Boogert, Bob van den, and Jacqueline Kerkhoff, *Maria van Hongarije 1505–1558*, exh. cat. (Utrecht, 1993)

Borchardt, Frank, *German Antiquity in Renaissance Myth* (Baltimore, 1971)

Brady, Thomas, Jr., "Imperial Destinies: A New Biography of the Emperor Maximilian I," *Journal of Modern History* 62 (1990), 298–314

Brady, Thomas, Jr. "Some Peculiarities of German Histories in the Early Modern Era," in Andrew Fix and Susan Karant-Nunn, eds., *Germania Illustrata: Essays on Early Modern Germany Presented to Gerald Strauss* (Kirksville, Mo., 1992), 196–216

Brady, Thomas, Jr. *Turning Swiss: Cities and Empire, 1450–1550* (Cambridge, 1985)

Brandi, Karl, *The Emperor Charles V: The Growth and Destiny of a Man and of a World-Empire*, trans. C. V. Wedgwood (London, 1939; orig. ed. Munich, 1937–41)

Brann, Noel, "Conrad Celtis and the 'Druid' Abbot Trithemius: An Inquiry into Patriotic Humanism," *Renaissance and Reformation* 3 (1979), 16–28

Braunfels, Wolfgang, and Percy Ernst Schramm, eds., *Karl der Grosse IV: Das Nachleben* (Dusseldorf, 1967)

Braunfels-Esche, Sigrid, *Sankt Georg* (Munich, 1976)

Bruck, Gustav, "Habsburger als 'Herculier,'" *JKSW*, new series, 14 (1950), 191–98

Bryce, James, *The Holy Roman Empire*, rev. ed. (London, 1905)

Buchner, Ernst, "Leonard Beck als Maler und Zeichner," in Ernst Buchner and Karl Feuchtmayr, eds., *Beiträge zur Geschichte der deutschen Kunst* (Augsburg, 1928), 2:328–414

Burger, Heinz Otto, *Renaissance, Humanismus, Reformation: Deutsche Literatur im europäische Kontext* (Bad Homburg, 1969)

Burgoyne, Christa, "The Prayerbook of Emperor Maximilian I: Art Making and Its Circumstances" (M.A. thesis, University of California, Berkeley, 1979)

Burke, Peter, *The Fabrication of Louis XIV* (New Haven, Conn., 1992)

Burkhard, Arthur, *Hans Burgkmair d. Ä.* (Berlin, 1932)

Bushart, Magdalena, *Sehen und Erkennen: Albrecht Altdorfers religiöse Bilder* (Munich, 2004)

Campbell, Stephen, ed., *Artists at Court: Image-Making and Identity 1300–1550* (Boston, 2004)

Campbell, Thomas, *Tapestry in the Renaissance: Art and Magnificence*, exh. cat. (New York, 2002)

Cartellieri, Otto, *The Court of Burgundy* (London, 1929)

Chmel, J., *Die Handschriften der k.k. Hofbibliothek im Wien im Interesse der Geschichte* (Vienna, 1840)

Chmelarz, Eduard, "Die Ehrenpforte des Kaisers Maximilian I," *JKSAK* 4 (1886), 289–319

Cohen, Kathleen, *Metamorphosis of a Death Symbol* (Berkeley, Calif., 1973)

Conway, William Martin, eds., *Writings of Albrecht Dürer* (London, 1958; orig. ed. 1889)

Coreth, Anna, "Dynastisch-politische Ideen Kaiser Maximilians I, *Mitteilungen des Österreichischen Staatsarchivs* 3 (1950), 81–105

Coreth, Anna, "Maximilian I politische Ideen im Speigel der Kunst" (Ph.D. diss., University of Vienna, 1940)

Cremer, Folkhard, *"Kindlichait, Junglichait, Mandlichait, Tewlichait": Eine Untersuchung zur Text-Bild-Redaktion des Autobiographieprojektes Kaiser Maximilians I und zur Einordnung der Erziehungsgeschichte des "Weisskunig,"* Deutsche Hochschulschriften, 1076 (Egelsbach, 1995)

Cuneo, Pia, *Art and Politics in Early Modern Germany: Jörg Breu the Elder and the Fashioning of Political Identity ca. 1475–1536* (Leiden, 1998)

Cuneo, Pia, "Images of Warfare as Political Legitimization: Jörg Breu the Elder's Rondels for Maximilian I's Hunting Lodge at Lermos (ca. 1516)," in Cuneo, ed., *Artful Armies, Beautiful Battles: Art and Warfare in Early Modern Europe* (Leiden, 2002), 87–105

Cuyler, Louise, *The Emperor Maximilian and Music* (London, 1973)

Deuchler, Florens, *Die Burgunderbeute* (Bern, 1963)

Deuchler, Florens, "Maximilian und die Kaiserviten Suetons: Ein spätmittelalterliches Herrscherprofil in antiken und christlichen Spiegelungen," in Deuchler, ed., *Von Angesicht zu Angesicht: Porträtstudien. Michael Stettler zum 70. Geburtstag* (Bern, 1983), 129–49

Dickens, A. G., *The German Nation and Martin Luther* (London, 1974)

Diedrichs, Peter, *Kaiser Maximilian als politischer Publizist* (Jena, 1933)

Dodgson, Campbell, *Catalogue of Early German and Flemish Woodcuts Preserved in the Department of Prints and Drawings in the British Museum*, 2 vols. (London, 1903)

Dodgson, Campbell, "Drei Studien," *JKSAK* 29 (1910–11), 1–13

Dodgson, Campbell, "Eine unbeschriebene Folge von Holzschnitten Hans Burgkmairs d. Ä.," in Ernst Buchner and Karl Feuchtmayr, eds., *Beiträge zur Geschichte der deutschen Kunst* (Augsburg, 1928), 2:224–28.

Dörnhöffer, Friedrich, "Ein Cyklus von Federzeichnungen mit Darstellungen von Kriegen und Jagden Maximilians I," *JKSAK* 18 (1897), 1–55

Dörnhöffer, Friedrich, "Über Burgkmair und Dürer," in *Beiträge zur Kunstgeschichte, Franz Wickhoff gewidmet* (Vienna, 1903), 111–31

Dornik-Eger, Hanna, *Albrecht Dürer und die Druckgraphik für Kaiser Maximilian I* (Vienna, 1971)

Dornik-Eger, Hanna, "Kaiser Friedrich III in Bildern seiner Zeit," in *Friedrich III*, exh. cat. (Wiener Neustadt, 1966), 64–86

Downing, Brian, *The Military Revolution and Political Change: Origins of Democracy and Autocracy in Early Modern Europe* (Princeton, N.J., 1992)

DuBoulay, F.R.H., *Germany in the Later Middle Ages* (New York, 1983)

Eckert, Willehad Paul, and Christoph von Imhoff, *Willibald Pirckheimer: Dürers Freund im Spiegel seines Lebens, seiner Werke und seiner Umwelt* (Cologne, 1971)

Eger, Hanna, "Ikonographie Kaiser Friedrichs III" (Ph.D. diss., University of Vienna, 1965)

Egg, Erich, *Die Hofkirche in Innsbruck: Das Grabdenkmal Kaiser Maximilians I und die Silberne Kapelle* (Innsbruck, 1974)

Egg, Erich, "Jörg Kölderer und die Donauschule," in *Werden und Wandlung: Studien zur Kunst derDonauschule* (Linz, 1967), 57–62

Egg, Erich, *Die Münzen Kaiser Maximilians I* (Innsbruck, 1969)

Egg, Erich, and Wolfgang Pfaundler, *Kaiser Maximilian I und Tirol* (Innsbruck, 1992)

Eichberger, Dagmar, *Women of Distinction: Margaret of York/Margaret of Austria*, exh. cat. (Mechelen, 2005)

Eikelmann, Renate, ed., *Conrat Meit: Bildhauer der Renaissance*, exh. cat. (Munich, 2006)

Eisenbeiss, Anja, "Einprägsamkeit en gros: Die Porträts Kaiser Maximilians I; Ein Herrscherbild gewinnt Gestalt" (Ph.D. diss., University of Heidelberg, 2005)

Ellenius, Allan, ed., *Iconography, Propaganda, and Legitimation* (Oxford, 1998)

Erben, Dietrich, "Die Jagd, der Krieg und der Friede," in Wolfgang Augustyn, ed., *PAX: Beiträge zu Idee und Darstellung des Friedens* (Munich, 2003), 361–81

Eser, Thomas, *Hans Daucher: Augsburger Kleinplastik der Renaissance* (Munich, 1996)

Falk, Tilman, *Hans Burgkmair: Studien zu Leben und Werke des Augsburger Malers* (Munich, 1968)

Fergusson, Arthur, *Clio Unbound* (Durham, N.C., 1979)

Fichtenau, Heinrich, *Der junge Maximilian (1459–1482)* (Munich, 1959)

Fichtenau, Heinrich, "Reich und Dynastie im politischen Denken Maximilians I," in *Österreich und Europa: Festgabe für Hugo Hantsch zum 70. Geburtstag* (Graz, 1965), 39–48

Fichtner, Paula Sutter, *Ferdinand I of Austria: The Politics of Dynasticism in the Age of Reformation* (New York, 1982)

Fillitz, Hermann, "Die Insignien und Ornate des Kaisertums Österreich," *JKSW* 52 (1956), 123–46

Fillitz, Hermann, *Die Schatzkammer in Wien: Symbole abendländischen Kaisertums* (Vienna, 1997; orig. ed. 1986)

Folz, Robert, *L'idée d'empire en Occident* (Paris, 1953)

Folz, Robert, *Le souvenir et la légende de Charlemagne dans l'empire germanique medieval* (Paris, 1950)

Franz, Günter, "Von Ursprung und Brauchtum der Landsknechte," *Mitteilung des Instituts für Österreichische Geschichtsforschung* 61 (1953), 79–98

Friedrich III, exh. cat. (Wiener Neustadt, 1966)

Füssel, Stephan, *Emperor Maximilian and the Media of His Day: The Theuerdank of 1517* (Munich, 2003)

Garber, Josef, *Das Goldene Dachl* (Innsbruck, 1922)

Garber, Josef, "Das Haller Heiltumbuch mit den Unika-Holzschnitten Hans Burgkmairs d. A.," *JKSAK* 32 (1915), 1–177, plus frontmatter.

Garber, Josef, "Das Zeughaus Kaiser Maximilians I in Innsbruck," *Wiener Jahrbuch für Kunstgeschichte* 5 (1928), 142–60

Geertz, Clifford, "Centers, Kings, and Charisma: Reflections on the Symbolics of Power," in Sean Wilentz, ed., *Rites of Power: Symbolism, Ritual, and Politics since the Middle Ages* (Philadelphia, 1985), 12–40

Geertz, Clifford, "Ideology as a Cultural System," in *Interpretation of Cultures* (New York, 1973), 192–233

Geertz, Clifford, *Negara: The Theater State in Nineteenth-Century Bali* (Princeton, N.J., 1980)

Giehlow, Karl, "Beiträge zur Entstehungsgeschichte des Gebetbuches Kaisers Maximilian I," *JKSAK* 20 (1899), 30–112

Giehlow, Karl, "Dürers Entwürfe für das Triumphrelief Maximilians im Louvre: Eine Studie zur Entwicklungsgeschichte des Triumphzuges," *JKSAK* 29 (1910–11), 14–84

Giehlow, Karl, "Dürers Stich 'Melencolia I' und der maximilianische Humanistenkreis," *Mitteilungen der Gesellschaft für vielfältigende Kunst* 26 (1903), 29–41; 27 (1904), 6–18, 57–68

Giehlow, Karl, "Die Hieroglyphenkunde des Humanismus in der Allegorie der Renaissance, besonders der Ehrenpforte des Kaisers Maximillian I," *JKSAK* 32 (1915), 1–229

Giehlow, Karl, *Kaiser Maximilians I Gebetbuch mit Zeichnungen von Albrecht Dürer und anderen Künstlern* (Vienna, 1907)

Giehlow, Karl, "Urkundenexegese zur Ehrenpforte Maximilians I," in *Beiträge zur Kunstgeschichte Franz Wickhoff gewidmet* (Vienna, 1903), 91–110

Giesey, Ralph, *Cérémonial et puissance souveraine, France XVe–XVIIe siècles* (Paris, 1987)

Goez, Werner, *Translatio imperii: Ein Beitrag zur Geschichte des Geschichtsdenkens und der politischen Theorien im Mittelalter und in der frühen Neuzeit* (Tübingen, 1958)

Gombrich, Ernst, *The Sense of Order* (Oxford, 1979)

Gottlieb, Theodor, *Die Ambraser Handschriften: Beitrag zur Geschichte der Wiener Hofbibliothek I; Büchersammlung Kaiser Maximilians I* (Leipzig, 1900)

Grimm, Claus, Johannes Erichsen, and Evamarie Brockhoff, eds., *Lucas Cranach*, exh. cat. (Kronach, 1994)

Groebner, Valentin, *Der Schein der Person: Steckbrief, Ausweis und Kontrolle im Europa des Mittelalters* (Munich, 2004)

Grote, Ludwig, "Kaiser Maximilian in der Schedelschen Weltchronik," *Mitteilungen des Vereins für Geschichte der Stadt Nürnberg* 62 (1975), 60–83

Guillaud, Jacqueline, and Maurice Guillaud, eds., *Altdorfer and Fantastic Realism in German Art*, exh. cat. (Paris, 1984)

Günther, Hubertus, "Das Projekt Kaiser Maximilians für sein Grabmal," in Jean Balsamo, ed., *Les funérailles à la Renaissance* (Geneva, 2002), 77–111

Habich, Georg, "Das Reiterdenkmal Kaiser Maximilians in Augsburg," *Münchner Jahrbuch der bildenden Kunst* 8 (1913), 255–62

Hale, J. R., *Artists and Warfare in the Renaissance* (New Haven, Conn., 1990)

Hale, J. R., *Renaissance War Studies* (London, 1983)

Halm, Peter, "Die 'Fier Gulden Stain' in der Domini-
kanerkirche zu Augsburg," in Kurt Martin, ed., *Studien
zur Geschichte der Europäischen Plastik: Festschrift Theodor
Müller* (Munich, 1965), 195–222

Halm, Philipp Maria, "Hans Valkenauer und die Salzburger
Marmorplastik," in *Studien zu Süddeutschen Plastik*
(Augsburg, 1926), 1:176–83, 222–23

Hans Burgkmair: Das graphische Werk, exh. cat. (Stuttgart, 1973)

Hasse, Claus-Peter, "Otto der Grosse und Magdeburg: Das
Nachleben eines Kaisers in seiner Stadt," in Matthias
Puhle, ed., *Otto der Grosse: Magdeburg und Europa* (Mainz,
2001), 427–43

Hauck, Karl, "Geblütsheiligkeit," in Bernhard Bischoff and
Suso Brechter, eds., *Liber Floridus: Mittellateinische Studien
Festschrift Paul Lehmann* (St. Ottilien, 1950), 187–240

Haug, Walter, et al., *Runkelstein: Die Wandmalereien des Sommer-
hauses* (Wiesbaden, 1982)

Haupt, Hermann, "Renaissance-Hieroglyphik in Kaiser
Maximilians Ehrenpforte," *Philobiblon* 12 (1968), 253–67

Der heilige Leopold, exh. cat. (Klosterneuburg, 1985)

Heitz, Paul, *Flugblätter des Sebastian Brant* (Strasbourg, 1915)

Herberger, Theodor, *Conrad Peutinger in seinem Verhältnisse
zum Kaiser Maximilian I* (Augsburg, 1851)

Hertlein, Edgar, "Das Grabmonument Kaiser Friedrichs III
(1415–1493) als habsburgisches Denkmal," *Pantheon* 35
(1977), 294–305

*Hispania-Austria: Die Katholischen Könige, Maximilian I und die
Anfänge der Casa de Austria in Spanien, Kunst um 1492*,
exh. cat. (Innsbruck, 1992)

Hocart, A. M., *Kingship* (London, 1927)

Holborn, Hajo, *A History of Modern Germany*, vol. 1, *The
Reformation* (London, 1965)

Horn, Christine Maria, "Doctor Conrad Peutingers Bezieh-
ungen zu Kaiser Maximilian I" (Ph. D. diss., University
of Graz, 1977)

Humfrey, Peter, "Dürer's Feast of the Rose Garlands: A Vene-
tian Altarpiece," *Bulletin of the National Gallery in Prague*
1 (1991), 21–3

Hye, Franz-Heinz, "Der Doppeladler als Symbol für Kaiser
und Reich," *MIÖG* 81 (1973), 63–100

Hye, Franz-Heinz, *Das Goldene Dachl Kaiser Maximilians I und
die Anfänge der Innsbrucker Residenz* (Innsbruck, 1997)

Hye, Franz-Heinz, "Die heraldischen Denkmale Maxi-
milians I und die Anfänge der Innsbrucker Residenz,"
Der Schlern 43 (1969), 56–77

Hye, Franz-Heinz, "Der Wappenturm—zur Vorgeschichte
einer heraldisch-künstlerischen Idee," *Festschrift für Erich
Egg* (Innsbruck, 1970), 99–109

Ilgen, Theodor, *Die Geschichte Friedrichs III und Maximilians I
von Joseph Grünpeck* (Leipzig, 1891)

Die Innsbrucker Plattnerkunst, exh. cat. (Innsbruck, 1954)

Jacquot, Jean, ed., *Les fêtes de la Renaissance*, 3 vols. (Paris,
1956–75)

Jardine, Lisa, and Jerry Brotton, *Global Interests: Renaissance Art
between East and West* (Ithaca, N.Y., 2000)

Jenkins, Marianna, *The State Portrait, Its Origin and Evolution*
(New York, 1947)

Joachimsen, Paul, *Geschichtsauffassung und Geschichtsschreibung
in Deutschland unter dem Einfluss des Humanismus*
(Leipzig, 1910)

Johannesson, Kurt, "The Portrait of the Prince as a Rhetori-
cal Genre," in Allan Ellenius, ed., *Iconography, Propaganda,
and Legitimation* (Oxford, 1998), 11–36

Kann, Robert, *A History of the Habsburg Empire 1526–1918*
(Berkeley, Calif., 1974)

Kantorowicz, Ernst, *The King's Two Bodies: A Study in Medieval
Political Theology* (Princeton, N.J., 1957)

Kantorowicz, Ernst, *Selected Studies* (Locust Valley, Pa., 1965)

Kaufmann, Thomas DaCosta, *Court, Cloister and City: The Art
and Culture of Central Europe 1450–1800* (Chicago, 1995)

Kaufmann, Thomas DaCosta, "Hermeneutics in the His-
tory of Art: Remarks on the Reception of Dürer in the
Sixteenth and Early Seventeenth Centuries," in Jeffrey
Chipps Smith, ed., *New Perspectives on the Art of Renais-
sance Nuremberg: Five Essays* (Austin, Tex., 1985), 22–39

Kaulbach, Hans-Martin, *Neues vom "Weisskunig": Geschichte
und Selbstdarstellung Kaiser Maximilians I in Holzschnitten*,
exh. cat. (Stuttgart, 1994)

Keen, Maurice, *Chivalry* (New Haven, Conn., 1984)

Keen, M[aurice] H., "Chivalry, Nobility, and the Man-at-
Arms," in C. T. Allmand, ed., *War, Literature, and Politics in
the Late Middle Ages* (Liverpool, 1976), 32–45

Kelley, Donald, *Foundations of Modern Historical Scholarship*
(New York, 1970)

Kern, Fritz, *Gottesgnadentum und Widerstandsrecht im früheren
Mittelalter*, 2nd ed. (Darmstadt, 1954)

Kertzer, David, *Ritual, Politics and Power* (New Haven, Conn.,
1988)

Kleinschmidt, Erich, *Herrscherdarstellung: Zur Disposition mit-
telalterlichen Aussage verhaltens, untersucht an Texten über
Rudolf I von Habsburg* (Bern, 1974)

Klingender, Francis, *Animals in Art and Thought to the End of
the Middle Ages* (Cambridge, Mass., 1971)

König, Erich, *Peutingerstudien* (Munich, 1914)

Koenigsberger, Helmut, *The Habsburgs and Europe 1515–1660*
(Ithaca, N.Y., 1971)

Koepplin, Dieter, and Tilman Falk, *Lukas Cranach*, 2 vols., exh. cat. (Basel, 1974)

Koheler, Alfred, Barbara Haider, and Christine Ottner, eds., *Karl V 1500–1558: Neue Perspektiven seiner Herrschaft in Europa und Übersee* (Vienna, 2002)

Koreny, Fritz, "Ottoprecht Fürscht: Eine unbekannte Zeichnung von Albrecht Dürer–Kaiser Maximilian I und sein Grabmal in der Hofkirche zu Innsbruck," *Jahrbuch der Berliner Museen* 31 (1989), 127–48

Körner, Hans, *Grabmonumente des Mittelalters* (Darmstadt, 1997)

Koschatzky, Walter, and Alice Strobl, *Dürer Drawings: The Albertina Collection* (Greenwich, Conn., 1972)

Kren, Thomas, and Scot McKendrick, *Illuminating the Renaissance*, exh. cat. (Los Angeles, 2003)

Krieger, Leonard, *National Consciousness, History, and Political Culture in Early Modern Europe* (Baltimore, 1975), 67–98

Kurz, Otto, "A Fishing Party at the Court of William VI, Count of Holland, Zeeland, and Hainault: Notes on a Drawing in the Louvre," *Oud Holland* 71 (1956), 117–31

Ladner, Gerhard, "Medieval and Modern Understanding of Symbolism: A Comparison," in *Images and Ideas in the Middle Ages: Selected Studies in History and Art* (Rome, 1983), 239–82

Landau, David, and Peter Parshall, *The Renaissance Print 1470–1550* (New Haven, Conn., 1994)

Landwehr, John, *Splendid Ceremonies: State Entries and Royal Funerals in the Low Countries 1515–1791* (Nieuwkoop, 1971)

Laschitzer, Simon, "Die Genealogie des Kaisers Maximilian I.," *JKSAK* 7 (1888), 1–200

Laschitzer, Simon, "Die Heiligen aus der Sipp-, Mag-, und Schwägerschaft des Kaisers Maximilian I.," *JKSAK* 4 (1886), 70–289; 5 (1887), 117–262

Laubach, Ernst, *Ferdinand I als Kaiser* (Münster, 2001)

Leeuwenberg, Jaap, "Die tien bronzen plorannen in het Rijksmuseum te Amsterdam," *Gentsche Bijdragen tot de Kunstgeschiedenis* 13 (1951), 13–59

Leitner, Quirin von, ed., Introduction to *Freydal: Des Kaisers Maximilian I. Turniere und Mummereien* (Vienna, 1880–82)

Lhotsky, Alphons, "Apis Colonna: Fabeln und Theorien über die Abkunft der Habsburger," in *Aufsätze und Vorträge* (Vienna, 1971), 2:7–103

Lhotsky, Alphons, "Dr. Jakob Mennel: Ein Vorarlberger in Kreise Maximilians I.," in *Aufsätze und Vorträge* (Vienna, 1971), 2:289–311

Lhotsky, Alphons, *Die Geschichte der Sammlungen (Festschrift des Kunsthistorischen Museums zur Feier des 50-jährigen Bestandes II)* (Vienna, 1941–45), 75–108

Lhotsky, Alphons, *Österreichische Historiographie* (Munich, 1962)

Lhotsky, Alphons, "Was heisst 'Haus Österreich'?" in *Aufsätze und Vorträge* (Munich, 1970), 1:344–64

Lieb, Norbert, "Augsburgs Anteil an der Kunst der Maximilianszeit," in Götz Freiherr von Pölnitz, ed., *Jakob Fugger, Kaiser Maximilian und Augsburg 1459–1959* (Augsburg, 1959), 59–76

Luber, Katherine Crawford, *Albrecht Dürer and the Venetian Renaissance* (Cambridge, 2005)

Luber, Katherine Crawford, "Albrecht Dürer's Maximilian Portraits: An Investigation of Versions," *Master Drawings* 29 (1991), 30–47

Ludolphy, Ingetraut, *Friedrich der Weise: Kurfürst von Sachsen 1463–1525* (Göttingen, 1984)

Luh, Peter, *Der Allegorische Reischsadler von Conrad Celtis und Hans Burgkmair: Ein Werbeblatt für das Collegium poetarum et mathematicorum in Wien* (Frankfurt, 2001)

Luh, Peter, *Kaiser Maximilian gewidmet: Die unvollendete Werkausgabe des Conrad Celtis und ihre Holzschnitte* (Frankfurt, 2001)

Lüken, Sven, "Kaiser Maximilian I und seine Ehrenpforte," *Zeitschrift für Kunstgeschichte* 61 (1998), 449–90

Lutterotti, Otto von, *Das Goldene Dachl in Innsbruck* (Innsbruck, 1956)

Madersbacher, Lukas, "Malerei und Bild 1430 bis 1520," in Artur Rosenauer et al., *Geschichte der bildenden Kunst in Österreich III: Spätmittelalter und Renaissance* (Munich, 2003), 394–410

Marin, Louis, *Portrait of the King*, trans. Martha Houle (Minneapolis, 1988; orig. ed. 1981)

Martindale, Andrew, *The Triumphs of Caesar by Andrea Mantegna in the Collection of Her Majesty the Queen at Hampton Court* (London, 1979)

Matsche, Franz, *Die Kunst im Dienst der Staatsidee Kaiser Karls VI* (Berlin, 1981)

Matthias Corvinus und die Renaissance in Ungarn, exh. cat. (Schallaburg, 1982)

Mattingly, Garrett, *Renaissance Diplomacy* (Boston, 1955)

Maximilian I, exh. cat. (Vienna, 1959)

Mayr, Joseph Karl, "Das Grab Kaiser Maximilians I.," *Mitteilungen des Österreichischen Staatsarchivs* 3 (1950), 467–92

McDonald, William, "Maximilian I of Habsburg and the Veneration of Hercules: On the Revival of Myth and the German Renaissance," *Journal of Medieval and Renaissance Studies* 6 (1976), 139–54

Meister um Albrecht Dürer, exh. cat. (Nuremberg, 1961)

Messling, Guido, *Der Augsburger Maler und Zeichner Leonhard Beck und sein Umkreis* (Dresden, 2006)

Mielke, Hans, *Albrecht Altdorfer*, exh. cat. (Berlin, 1988)

Misch, Georg, "Die Stilisierung des eigenen Lebens in dem Ruhmeswerk Kaiser Maximilians, des letzten Ritters," *Nachrichten von der Gesellschaft der Wissenschaften zu Göttingen* (1930), 435–59

Mohr, Angela, *Die Schutzmantel-Madonna von Frauenstein* (Steyr, 1983)

Morrall, Andrew, *Jörg Breu the Elder: Art, Culture and Belief in Reformation Augsburg* (Aldershot, 2001)

Moxey, Keith, *Peasants, Warriors, and Wives: Popular Imagery in the Reformation* (Chicago, 1989)

Müller, Gernot Michael, *Die "Germania generalis" des Conrad Celtis* (Tübingen, 2001)

Müller, Heinrich, *Albrecht Dürer Waffen und Rüstungen*, exh. cat. (Berlin, 2002)

Müller, Jan-Dirk, *Gedechtnus: Literatur und Hofgesellschaft um Maximilian I* (Munich, 1982)

Müller, Jan-Dirk, "Poet, Prophet, Politiker: Sebastian Brant als Publizist und die Rolle der laikalen Intelligenz um 1500," *Zeitschrift für Literaturwissenschaft und Linguistik* 10 (1980), 102–27

Müller, Mathias, "Albrecht Altdorfer: Die rapide Entwicklung seines figürlichen Stils von 1514 bis 1516, in den Jahren der Ausführung des Miniaturtriumphzuges für Kaiser Maximilian I," in Achim Gnann and Heinz Widauer, eds., *Festschrift Konrad Oberhuber* (Milan, 2000), 239–54

Müller, Mathias, "Albrecht Dürer und das Kunstleben am Kaiserhof Maximilians I," in *Albrecht Dürer*, exh. cat. (Vienna, 2003), 89–101

Müller, Mathias, "Die Kunstpatronanz Ferdinands I im Spiegel der Zeitgenössischen Druckgraphik," in *Ferdinand I 1503–1564*, exh. cat. (Vienna, 2003), 215–29

Musper, H. Theodor, *Dürers Kaiserbildnisse* (Cologne, 1969)

Musper, H. Theodor, ed., *Kaiser Maximilians Teuerdank* (Stuttgart, 1968)

Musper, H. Theodor, et al., eds., *Kaiser Maximilians I Weisskunig* (Stuttgart, 1956)

Muther, Richard, *German Book Illustration of the Gothic Period and the Early Renaissance (1460–1530)*, trans. Ralph Shaw (Metuchen, N.J., 1972; orig. ed. 1884)

Oberhaidacher, Jörg, "Ein 'unbekannte' Werk des Jörg Muskat," *Wiener Jahrbuch für Kunstgeschichte* 36 (1983), 213–20

Oberhammer, Vinzenz, *Die Bronzestandbilder des Maximiliangrabmales in der Hofkirche zu Innsbruck* (Innsbruck, 1935)

Oberhammer, Vinzenz, *Das Goldene Dachl zu Innsbruck* (Innsbruck, 1970)

Oberhammer, Vinzenz, "Das Grabmal des Kaisers," in *Ausstellung Maximilian I* (Innsbruck, 1969), 107–12

Oberhammer, Vinzenz, "Die vier Bildnisse Kaiser Maximilians I von Albrecht Dürer," *Alte und moderne Kunst* 14 (1969), 2–14

Oettinger, Karl, *Die Bildhauer Maximilians am Innsbrucker Kaisergrabmal* (Nuremberg, 1966)

Oettinger, Karl, "Die Grabmalkonzeptionen Kaiser Maximilians," *Zeitschrift des deutschen Vereins für Kunstwissenschaft* 19 (1965), 170–84

Onghena, M. J., *De iconographie van Philips de Schone* (Brussels, 1959)

Ottner, Gerlinde, "Entstehung, Organisation und Stil einer Hofwerkstatt Kaiser Maximilians I: Jörg Kölderer und die neue Darstellungsweise der Landschaft" (Ph.D. diss., University of Salzburg, 1996)

Otto, Gertrud, *Bernhard Strigel* (Munich, 1964)

Panofsky, Erwin, "Conrad Celtis and Kunz von der Rosen: Two Problems in Portrait Identification," *Art Bulletin* 24 (1942), 39–43

Panofsky, Erwin, *Hercules am Scheidewege* (Leipzig, 1930)

Panofsky, Erwin, *The Life and Art of Albrecht Dürer*, 4th ed. (Princeton, N.J., 1955; orig. ed. 1943)

Panofsky, Erwin, *Tomb Sculpture* (New York, 1964)

Parker, Geoffrey, *The Military Revolution* (Cambridge, 1988)

Paul, Ulrich, *Studien zur Geschichte des deutschen Nationalbewusstseins im Zeitalter des Humanismus und der Reformation* (Berlin, 1936)

Perkinson, Stephen, "From an 'Art the Memoire' to the Art of Portraiture: Printed Effigy Books of the Sixteenth Century," *Sixteenth Century Journal* 33 (2002), 687–723

Petermann, Erwin, "Die Zeichnungen," in Theodor Masper, ed., *Kaiser Maximilians I Weisskung* (Stuttgart, 1956), 72–89

Plösch, Josef, "St.-Georgs-Ritterorden und Maximilians I Türkenpläne von 1493/94," in *Festschrift Karl Eder* (Innsbruck, 1959), 33–56

Pokorny, Erwin, "Minne und Torheit unter dem Goldenen Dachl: Zur Ikonographie des Prunkerkers Maximilians I in Innsbruck," *JKSW* 4–5 (2002–3), 30–45

Polleross, Friedrich, "Das frühneuzeitliche Bildnis als Quelle," in Josef Pauser, Martin Schentz, and Thomas Winkelbauer, eds., "Quellenkunde der Habsburgermonarchie (16.–18. Jahrhundert): Ein exemplarisches Handbuch," special issue, *MIÖG* 44 (2004), 1006–30

Polleross, Friedrich, *Das sakrale Identifikationsporträt: Ein höfischer Bildtypus vom 13. bis zum 20. Jahrhundert* (Worms, 1988)

Post, Paul, "Ein verschollenes Jagdbild Jan van Eycks," *Jahrbuch der Preussischen Kunstsammlungen* 52 (1931), 120–32

Post, Paul, "Zum 'silbernen Harnisch' Kaiser Maximilians
I von Colomon Kolman mit Ätzentwürfen Albrecht
Dürers," *Zeitschrift für historische Waffen- und Kostum-
künde*, new series, 6 (1939), 253–58

Press, Volker, "The Holy Roman Empire in German History,"
in E. I. Kouri and Tom Scott, eds., *Politics and Society in
Reformation Europe: Essays for Sir Geoffrey Elton on His
65th Birthday* (London, 1987), 51–77

Reitzenstein, A. von, "Die Augsburger Plattnersippe der
Helmschmied," *Münchner Jahrbuch der bildenden Kunst*,
3rd ser., 2 (1951), 179–94

Riedl, Kurt, "Der Quellenwert des 'Weisskunig' als
Geschichtsquelle: Untersucht am 3. Teil 1499–1514"
(Ph.D. diss., University of Graz, 1969)

Rinn, Hermann, ed., *Augusta 955–1955* (Munich, 1955)

Roeder-Baumbach, Irmengard von, *Versieringen bij blijde
inkomsten gebruikt in de Zuidelijke Nederlanden gedurende
de 16e en 17e eeuw* (Antwerp, 1943)

Rosand, David, "Rubens's Munich *Lion Hunt*: Its Sources and
Significance," *Art Bulletin* 51 (1969), 29–40

Rosario, Iva, *Art and Propaganda: Charles IV of Bohemia,
1346–1378* (Woodbridge, U.K., 2000)

Rosenthal, Earl, "The Invention of the Columnar Device
of Emperor Charles V at the Court of Burgundy in
Flanders in 1516," *Journal of the Warburg and Courtauld
Institutes* 36 (1973), 198–230

Rosenthal, Earl, *The Palace of Charles V in Granada* (Princeton,
N.J., 1985)

Rosenthal, Earl, "Die 'Reichskrone,' die 'Wiener Krone,'
und die 'Krone Karls des Grossen' um 1520," *JKSW* 66
(1970), 7–48

Rosier, Bart, "*The Victories of Charles V*: A Series of Prints
by Maarten van Heemskerck, 1555–56," *Simiolus* 20
(1990–91), 24–38

Rudolf, Karl, "'Das Gemäl ist also recht': Die Zeichnungen
zum 'Weisskunig' Maximilians I des Vaticanus Latinus
8570," *Römische historische Mitteilungen* 22 (1980),
167–207

Rudolf, Karl, "Illustrationen und Historiographie bei Maxi-
milian I: Der Weisse Kunig," *Römische historische Mit-
teilungen* 25 (1983), 35–109

Rudolf, Karl Friedrich, "Maximilian I und die bildliche
Darstellung," *Das Bildnis Kaiser Maximilians I auf Münzen
und Medaillen*, exh. cat. (Innsbruck, 1992), 15–28

Rupprich, Hans, *Dürer Schriftlicher Nachlass*, 3 vols. (Berlin,
1956)

Rupprich, Hans, *Geschichte der deutschen Literatur IV/I: Vom
späten Mittelalter bix zum Barock*. Part 1, *Das ausgehende
Millelalter, Humanismus und Renaissance 1370–1520*
(Munich, 1970)

Sallaberger, Johann, *Kardinal Matthäus Lang von Wellenburg
(1468–1540)* (Salzburg, 1997)

Saurma-Jeltsch, Lieselotte, "Karl der Grosse im Spätmittel-
alter: Zum Wandel einer Politischen Ikone," in Thomas
Kraus and Klaus Pabst, eds., *Karl der Grosse und Sein
Nachleben in Geschichte: Kunst und Literatur* (Aachen,
2002–3), 421–61

Schack, Gerhard, *Der Kreis um Maximilian I: Der Jagd in der
Kunst* (Hamburg, 1963)

Schauerte, Thomas, *Albrecht Dürer: Das grosse Glück*, exh. cat.
(Osnabruck, 2003)

Schauerte, Thomas, *Die Ehrenpforte für Kaiser Maximilian I*
(Munich, 2001)

Schauerte, Thomas, *Die Kardinal: Albrecht von Bradenburg;
Renaissance fürst und Mäzel*, 2 vols, exh. cat. (Halle, 2006)

Scheicher, Elisabeth, *Das Grabmal Kaiser Maximilians I. in der
Innsbrucker Hofkirche* (Vienna, 1986)

Scheicher, Elisabeth, "Kaiser Maximilian plant sein Grabmal,"
JKSW 93 (1999), 81–118

Scheller, Robert, "Ensigns of Authority: French Royal Symbol-
ism in the Age of Louis XII," *Simiolus* 13 (1983), 75–141

Scheller, Robert, "Galla Cisalpina: Louis XII and Italy,
1499–1508," *Simiolus* 15 (1985), 5–60

Scheller, Robert, "Imperial Themes in Art and Literature of
the Early French Renaissance: The Period of Charles
VIII," *Simiolus* 12 (1981–82), 5–69

Schenk, Gerrit Jasper, *Zeremoniell und Politik: Herrschereinzüge
im spätmittelalterlichen Reich* (Cologne, 2003)

Scher, Stephen, *The Currency of Fame: Portrait Medals of the
Renaissance*, exh. cat. (New York, 1994)

Schestag, Franz, "Kaiser Maximilian I: Triumph," *JKSAK* 1
(1883), 154–81

Schmidt, Charles, *Histoire litteraire de l'Alsace à la fin du XVe et
au commencement du XVIe siècle* (Paris, 1879)

Schmidt, Gerhard, "Bildnisse eines Schwierigen: Beiträge zur
Ikonographie Kaiser Friedrichs III," *Aachener Kunstblätter*
60 (1994), 347–58

Schneider, David, *American Kinship: A Cultural Account* (Engle-
wood Cliffs, N.J., 1968)

Schoch, Rainer, Matthias Mende, and Anna Scherbaum, *Albrecht
Dürer: Das druckgraphische Werk*, 2 vols. (Munich, 2001–2)

Schönherr, David von, *Gesammelte Schriften*, vol. 1 (Innsbruck,
1900), 149–364

Schonherr, David von, "Geschichte des Grabmals Kaiser
Maximilian I und der Hofkirche zu Innsbruck," *JKSAK*
11 (1890), 140–268

Schramm, Percy Ernst, and Hermann Fillitz, *Denkmale der deutschen Könige und Kaiser*, 2 vols. (Munich, 1978)

Schroeder, Horst, *Der Topos der Nine Worthies in Literatur und bildender Kunst* (Göttingen, 1971)

Schütz, Karl, "Die Entstehung des höfischen Repräsentationsporträts in der Zeit Kaiser Maximilians I," in Wilfried Seipel, ed., *Werke für Ewigkeit: Kaiser Maximilian I und Erzherzog Ferdinand II*, exh. cat. (Vienna, 2002), 16–18

Schütz, Karl, "Maximilian und die Kunst," *Hispania Austria: Die Katholischen Könige Maximilian und die Anfang der Casa Austria in Spanien*, exh. cat. (Milan, 1992), 155–82

Seibt, Ferdinand, ed., *Renaissance in Böhmen* (Munich, 1985)

Seipel, Wilfried, *Kaiser Ferdinand I 1503–1564: Das Werden der habsburgermonarchie*, exh. cat. (Vienna, 2003)

Seipel, Wilfried, *Kaiser Karl V (1500–1558): Macht und Ohnmacht Europas*, exh. cat. (Vienna, 2000)

Seipel, Wilfried, *Werke für die Ewigkeit: Kaiser Maximilian I und Erzherzog Ferdinand II*, exh. cat. (Vienna, 2002)

Sherman, Michael, "Pomp and Circumstance: Pageantry, Politics and Propaganda in France during the Reign of Louis XII, 1498–1515," *Sixteenth Century Journal* 9, no. 4 (1978), 13–32

Shils, Edward, *The Constitution of Society* (Chicago, 1982)

Shils, Edward, *Tradition* (Chicago, 1981)

Sieveking, Hinrich, *Das Gebetbuch Kaiser Maximilians: Der Münchner Teil* (Munich, 1987)

Silver, Larry, "*Caesar ludens*: Maximilian I and the Waning Middle Ages," in Penny Schine Gold and Benjamin Sax, eds., *Cultural Visions: Essays in the History of Culture* (Amsterdam, 2000), 173–96

Silver, Larry, "Civic Courtship: Albrecht Dürer, the Saxon Duke, and the Emperor," in Stephen Campbell, ed., *Artists at Court: Image-Making and Identity 1300–1550* (Boston, 2004), 149–62

Silver, Larry, "The Face Is Familiar: German Renaissance Portrait Multiples in Prints and Medals," *Word and Image* 19 (2003), 6–21

Silver, Larry, "Forest Primeval: Albrecht Altdorfer and the Early German Wilderness Landscape," *Simiolus* 13 (1983), 19–43

Silver, Larry, "Germanic Patriotism in the Age of Dürer," in Dagmar Eichberger and Charles Zika, eds., *Dürer and His Culture* (Cambridge, 1998), 38–68

Silver, Larry, "Glass Menageries: Hunts and Battles by Jörg Breu for Emperor Maximilian I," *Acta Historiae Artium* 44 (2004), 121–27

Silver, Larry, "'Die Guten Alten Istory': Emperor Maximilian I, *Teuerdank*, and the Heldenbuch Tradition," *Jahrbuch des Zentralinstituts für Kunstgeschichte* 2 (1986), 71–106

Silver, Larry, "Paper Pageants: The Triumphs of Maximilian I," in Barbara Wollesen-Wisch and Susan Munshower, eds., "*All the World's a Stage*": *Art and Pageantry in the Renaissance and Baroque*, Papers in Art History from the Pennsylvania State University, 6 (University Park, Pa., 1990), 292–331

Silver, Larry, "Power of the Press: Dürer's *Arch of Honour*," in Irena Zdanowicz, ed., *Albrecht Dürer in the Collection of the National Gallery of Victoria* (Melbourne, 1994), 45–62

Silver, Larry, "Prints for a Prince: Maximilian, Nuremberg, and the Woodcut," in Jeffrey Chipps Smith, ed., *New Perspectives on the Art of Renaissance Nuremberg* (Austin, Tex., 1985), 9–31

Silver, Larry, "Shining Armor: Maximilian I as Holy Roman Emperor," *Museum Studies* (Art Institute of Chicago) 12 (Fall 1986), 8–29

Silver, Larry, and Pamela Smith, "Splendor in the Grass: The Powers of Nature and Art in the Age of Dürer," in Pamela Smith and Paula Findlen, eds., *Merchants and Marvels: Commerce, Science, and Art in Early Modern Europe* (New York, 2002), 29–62

Simon, Marcel, *Hercule et le Christianisme* (Paris, 1955)

Small, Graeme, *George Chastellain and the Shaping of Valois Burgundy* (Woodbridge, U.K., 1997)

Smith, Jeffrey Chipps, *German Sculpture of the Later Renaissance, c. 1520–1580* (Princeton, N.J., 1994)

Smith, Jeffrey Chipps, ed., *New Perspectives on Nuremberg Art of the Sixteenth Century: Five Essays* (Austin, Tex., 1985)

Smith, Jeffrey Chipps, *Nuremberg: A Renaissance City 1500–1618*, exh. cat. (Austin, Tex., 1983)

Snoep, D. P., *Praal en propaganda* (Alphen aan den Rijn, n.d.)

Soly, Hugo, ed. *Karl der V und seine Zeit: 1500–1558* (Cologne, 2003)

Soly, Hugo, and Johan van de Wiele, eds., *Carolus: Charles Quint 1500–1558*, exh. cat. (Ghent, 1999)

Spira, Freyda, "Originality as Repetition / Repetition as Originality: Daniel Hopfer and the Reinvention of the Medium of Etching," (Ph.D. diss., University of Pennsylvania, 2006)

Spitz, Lewis, *Conrad Celtis. The German Arch-Humanist* (Cambridge, Mass., 1957)

Spitz, Lewis, *The Religious Renaissance of the German Humanists* (Cambridge, Mass., 1963)

Steingräber, Erich, "Die Augsburger Buchmalerei in ihrer Blütezeit," in Hermann Rinn, ed., *Augusta 955–1955* (Munich, 1955), 173–86

Sternelle, Kurt, *Lucas Cranach: Die Jagd in der Kunst* (Hamburg, 1963)

Strauss, Gerald, "The Holy Roman Empire Revisited," *Central European History* 11 (1978), 290–301

Strauss, Gerald, ed., *Pre-Reformation Germany* (New York, 1972)

Strauss, Gerald, *Sixteenth-Century Germany: Its Topography and Topographers* (Madison, Wis., 1959)

Strauss, Walter, *Albrecht Dürer: The Woodcuts and Woodblocks* (New York, 1980)

Strauss, Walter, ed., *The Book of Hours of the Emperor Maximilian the First* (New York, 1974)

Strauss, Walter, *The Complete Drawings of Albrecht Dürer*, 6 vols. (New York, 1974)

Strickland, Diane, "Maximilian as Patron: The 'Prayerbook,'" (Ph.D. diss., University of Iowa, 1980)

Strieder, Peter, *Albrecht Dürer: Paintings, Prints, Drawings*, trans. Nancy Gordon and Walter Strauss (New York, 1981)

Strieder, Peter, "Zur Entstehungsgeschichte von Dürers Ehrenpforte für Kaiser Maximilian," *Anzeiger des Germanischen Nationalmuseums* (1954–59), 128–42

Strobl, Josef, *Kaiser Maximilians I: Anteil am Teuerdank* (Innsbruck, 1907)

Strong, Roy, *Art and Power: Renaissance Festivals 1450–1650* (Berkeley, Calif., 1984)

Suckale, Robert, "Die Porträts Kaiser Karls IV: Als Bedeutungsträger," in Martin Büchsal and Peter Schmidt, eds., *Das Porträt vor der Erfindung des Porträts* (Mainz, 2003), 191–204

Summers, David, *The Judgment of Sense* (Cambridge, 1987)

Syson, Luke, "Circulating a Likeness? Coin Portraits in Late Fifteenth-Century Italy," in Nicholas Mann and Luke Syson, eds., *The Image of the Individual: Portraits in the Renaissance*, exh. cat. (London, 1998), 113–25

Talbot, Charles, ed., *Dürer in America*, exh. cat. (Washington, D.C., 1971)

Tanner, Marie, *The Last Descendants of Aeneas: The Habsburgs and the Mythic Image of the Emperor* (New Haven, Conn., 1993)

Tavel, Hans Christoph von, "Die Randzeichnungen Albrecht Dürers zum Gebetbuch Kaiser Maximilians," *Münchner Jahrbuch der bildenden Kunst* 16 (1965), 55–120

Tennant, Elaine, "'Understanding with the Eyes': The Visual Gloss to Maximilian's *Theuerdank*," in James Poag and Thomas Fox, eds., *Entzauberung der Welt: Deutsche Literatur 1200–1500* (Tübingen, 1989)

Thaussing, H., *Dürers Ritter Tod und Teufel: Sinnbild und Bildsinn* (Berlin, 1978)

Thomas, Bruno, *Gesammelte Schriften* (Graz, 1977)

Thomas, Bruno, "Harnischstudien I: Stilgeschichte des deutschen Harnisches von 1500–1530," *JKSW* N.F. 11 (1937), 139–58

Thomas, Bruno, "The Hunting Knives of Emperor Maximilian I," *Metropolitan Museum of Art Bulletin* 13 (1955), 201–8

Thomas, Bruno, "Konrad Seusenhofer Studien," *Konsthistorisk Tidskrift* 18 (1949), 37–70

Thomas, Bruno, and Alphons Lhotsky, "Kejsar Maximiliani I's tre pragtsvaerd i Wien og København/Die Prunkschwerter Maximilians I in Wien und Kopenhagen," *Vaabenhistoriske Aarbøger* 6 (1950–51), 105–91

Tiedemann, Hans, *Tacitus und das Nationalbewusstsein der deutschen Humanisten am Ende des 15. und Anfang des 16. Jahrhunderts* (Berlin, 1913)

Tilly, Charles, *Coercion, Capital, and European States, AD 990–1992* (Oxford, 1992)

Trevor-Roper, Hugh, *Princes and Artists: Patronage and Ideology at Four Habsburg Courts, 1517–1633* (New York, 1976)

Ullmann, Heinrich, *Kaiser Maximilian I: Auf urkundliche Grundlage dargestellt*, 2 vols. (Stuttgart, 1884–91)

Unterkircher, Franz, *Maximilian I: Ein kaiserlicher Auftraggeber illustrierter Handschriften* (Hamburg, 1983)

Vale, Malcolm, *War and Chivalry* (London, 1981)

Vale, Marcia, *The Gentleman's Recreations* (Cambridge, 1977)

Velden, Hugo van der, *The Donor's Image: Gerard Loyet and the Votive Portraits of Charles the Bold* (Turnhout, 2000)

Vetter, Ewald, and Christoph Brockhaus, "Das Verhältnis von Text und Bild in Dürers Randzeichnungen zum Gebetbuch Kaiser Maximilians," *Anzeiger des Germanischen Nationalmuseums* (1971–72), 70–121

Volbach, Wolfgang, *Der heilige Georg* (Strasbourg, 1917)

Waas, Glenn, *The Legendary Character of Kaiser Maximilian* (New York, 1941)

Warnke, Martin, *The Court Artist: On the Ancestry of the Modern Artist*, trans. David McLintock (Cambridge, 1993; orig. ed. 1985)

Wehmer, Carl, "Mit gemäl und schrift: Kaiser Maximilian I und der Buchdruck," in *In libro humanitas: Festschrift für Wilhelm Hoffmann zum sechzigsten Geburtstag* (Stuttgart, 1962), 244–75

Wehmer, Carl, "Ne Italo cedere videamur: Augsburger Buchdrucker und Schreiber um 1500," in Hermann Rinn, ed., *Augusta 955–1955* (Augsburg, 1955), 145–72

Weihrauch, Hans, *Europäische Bronzestatuetten 15.–18. Jahrhundert* (Braunschweig, 1967)

Weihrauch, Hans, "Studien zur süddeutschen Bronzeplastik," *Münchner Jahrbuch der bildenden Kunst* 3–4 (1952–53), 199–215

Werkner, Patrick, "Der Wappenturm Kaiser Maximilians I in Innsbruck," *Wiener Jahrbuch für Kunstgeschichte* 34 (1981), 101–13

West, Ashley, "Hans Burgkmair the Elder (1473–1531) and the Visualization of Knowledge" (Ph.D. diss., University of Pennsylvania, 2006)

Wiesflecker, Hermann, *Kaiser Maximilian I*, 5 vols. (Vienna, 1971–Munich, 1986)

Wiesflecker, Hermann, "Kaiser Maximilian und die Kirche," in W. Baum ed., *Kirche und Staat in Idee und Geschichte des Abendlandes: Festschrift Ferdinand Maas zum 70. Geburtstag* (Vienna, 1973), 143–65

Wiesflecker, Hermann, *Maximilian I: Die Fundamente des habsburgischen Weltreiches* (Vienna, 1991)

Wiesflecker, Hermann, "Neue Beiträge zur Frage des Kaiser-Papstplanes Maximilians I im Jahre 1511," *MIÖG* 71 (1963), 311–32

Wiesflecker-Friedhuber, Inge, "Maximilian I und der St. Georgs-Ritterorden," in Franz Nikolasch, ed., *Studien zur Geschichte von Millstatt und Kärnten* (Klagenfurt, 1997), 431–53

Wiesflecker-Friedhuber, Inge, ed., *Quellen zur Geschichte Maximilians I und seiner Zeit* (Darmstadt, 1996)

Wilentz, Sean, ed. *Rites of Power: Symbolism, Ritual, and Politics since the Middle Ages* (Philadelphia, 1985)

Willard, Charity Cannon, "The Concept of True Nobility at the Burgundian Court," *Studies in the Renaissance* 14 (1967), 33–49

Williams, Gerhild, "The Arthurian Elements in Emperor Maximilian's Autobiographical Writings," *Sixteenth Century Journal* 11 (1980), 3–22

Williams, Gerhild Scholz-, "The Literary World of Maximilian I: An Annotated Bibliography," *Sixteenth Century Bibliography* 21 (1982)

Winkelbauer, Walter, "Kaiser Maximilian und St. Georg," *Mitteilungen des österreichischen Staatsarchivs* 7 (1954), 523–50

Winzinger, Franz, *Albrecht Altdorfer: Die Gemälde* (Munich, 1975)

Winzinger, Franz, *Albrecht Altdorfer Graphik* (Munich, 1963)

Winzinger, Franz, "Albrecht Altdorfer und die Miniaturen des Triumphzugs Kaiser Maximilians I," *JKSW* 62 (1966), 157–73

Winzinger, Franz, *Die Miniaturen zum Triumphzug Kaiser Maximilians I*, facsimile ed. (Graz, 1972)

Wood, Christopher, "Early Archeology and the Book Trade: The Case of Peutinger's *Romanae vetustatis fragmenta* (1505)," *Journal of Medieval and Early Modern Studies* 28 (1998), 83–118

Wood, Christopher, "Maximilian I as Archeologist," *Renaissance Quarterly* 57 (2005), 1128–74

Wuttke, Dieter, "Dürer und Celtis: Von der Bedeutung des Jahres 1500 für den deutschen Humanismus. Jahrhundertfeier als symbolische Form," *Journal of Medieval and Renaissance Studies* 10 (1980), 73–129

Wuttke, Dieter, *Die Histori Herculis des Nürnberger Humanisten* (Cologne, 1964)

Wuttke, Dieter, *Humanismus als integrative Kraft: Die Philosophia des deutschen Erzhumanisten Conrad Celtis* (Nuremberg, 1985)

Wuttke, Dieter, "Sebastian Brant und Maximilian I: Eine Studie zu Brants Donnerstein-Flugblatt des Jahres 1492," in Otto Herding and Robert Stupperich, eds., *Die Humanisten in ihrer politischen und sozialen Umwelt* (Boppard, 1976), 141–76

Wyss, Robert, "Die neun Helden," *Zeitschrift für Schweizerische Archäologie und Kunstgeschichte* 17 (1957), 73–106

Yates, Frances, *Astraea* (Harmodsworth, 1977)

Ziegeler, Hans-Joachim, "Der betrachtende Leser: Zum Verhältnis von Text und Illustration in Kaiser Maximilians I 'Teuerdank,'" in Egon Kühebacher, ed., *Literatur und bildende Kunst in Tiroler Mittelalter*, Innsbrucker Beiträge zur Kulturwissenschaft, Germanistische Reihe 15 (Innsbruck, 1982)

Index